German Folk Art

GERMAN FOLK ART

BY ERNST SCHLEE

 KODANSHA INTERNATIONAL LTD.
Tokyo, New York & San Francisco

Translated from the German *Volkskunst in Deutschland*
by Otto Ballin

Copyright © 1980 Office du Livre S.A.
Published by Kodansha International, 2–12–21 Otowa,
Bunkyo-ku, Tokyo 112, Japan and
Kodansha International/U.S.A., 10 East 53 Street,
New York, N.Y., 10022 and 44 Montgomery Street,
San Francisco, California 94104, U.S.A.

Distributors
United States:
Kodansha International/U.S.A., Ltd., through Harper & Row,
Publishers, Inc., 10 East 53 Street, New York, N.Y. 10022.

Canada:
Fitzhenry and Whiteside Ltd.,
150 Lesmill Road, Don Mills, Ontario M3B 2T5.

Europe:
Boxerbooks, Inc., Limmatstrasse 111, 8031 Zurich.

The Far East:
Toppan Company (S) Pte. Ltd., No. 38, Liu Fang Road,
Jurong Town, Singapore 2262.

LCC: 79-92578
ISBN: 0-87011-356-9
JBC: 3072-787820-2361

First edition, 1980

Table of Contents

Introduction

If today one speaks of 'folk art', one ought to state clearly what this term means. For decades it has been bandied about with widely differing shades of meaning, uncritically debased and even deliberately misused. It has been in turn a battle cry, a confession, an ideological slogan, a deprecating term of abuse, an advertising slogan or even a provocative insult. Ever since the word was first used it has often been given an ideological slant. It contains two concepts which have to be constantly redefined—if they can be defined at all. The meaning and value of each can be debated and indeed have been—explicitly or implicitly—totally denied. Where neither 'folk' nor 'art' are valued, the very existence of folk art becomes questionable. Again, the two words are said by some to be mutually contradictory, one excluding the possibility of the other—a most questionable, potentially explosive mixture. Finally, we find tendencies which aim, separately and with widely differing supporting arguments, to eliminate both words, 'folk' as well as 'art', from the current scholary vocabulary, which would mean passing two death sentences on folk art.

The word turns up, probably for the first time, in a nationalist political text, the *People's Book for the Year 1845*, edited by K. L. Biernatzki. This was an almanac issued for the duchies of Schleswig, Holstein and Lauenburg, which at that time belonged to Denmark. In an article entitled 'The Art of Carving', H. Biernatzki says that, for the sake of the national idea that had arisen among Germans under Danish rule, it was necessary to stimulate an appreciation of the arts. He wrote: 'Only in scholarship are we nationally conscious and free. Art is not confined to time or place, it is all-embracing. But we have lost our feeling for it, along with other finer sentiments. It is high time that with our awakening national awareness this aspect of the spirit of our people, too, should be developed. The cultivation of artistic appreciation stimulates a fine feature of popular education; it adds a melodious note to our monotonous movement', by which he meant the nationalist movement. He then went on to praise 'the art of wood-carving or wood sculpture' as the art form which had at one time flourished in this part of the country. It was said to have been rooted in the soil of the Fatherland, an instructive, holy art, 'in the true sense of the word, a *Volkskunst*' (folk art). The people should return to their own way of life, and an understanding of the arts should contribute to this. 'It is in the nature of art that it does not belong to individuals or to the upper classes only.'

This concept of a 'climax of wood-carving' in the past is based especially on the high esteem enjoyed by early German wood sculpture and the crafts of the late Middle Ages and of the Renaissance,

in which the nationalists saw the very embodiment of the German character. Their Romantic ideas were sustained by the belief that almost everybody was involved in the creation of these traditional treasures: firstly the artists and craftsmen, but also peasants and townsmen. By the middle of the nineteenth century in the north of Germany these wooden monuments of late medieval and early modern times had become collectors' items. They were generally carved in oak and therefore also had non-artistic associations, since the oak-tree was regarded as a national symbol. This idea was a revival of an eighteenth-century heritage. It started with the glorification of the oak in the paintings of Caspar David Friedrich and his predecessors, such as Pascha Johann Friedrich Weitsch.[1] A direct line of succession led to the furnishing of smoking-rooms in Renaissance style and in 'natural oak', which became almost obligatory for the German middle classes during the boom years of the 1870s.

The passages quoted are symptomatic. As one gets nearer the end of the century, the term 'folk art' appears more and more frequently in widely differing contexts. It is often connected with vague and idealized notions of a peculiar national art that can be understood by anyone, however uneducated, who is 'of the people' and so truly belongs to the nation. However, Biernatzki had in mind a narrower meaning, even in 1845. True, he does quote Brüggemann's Bordesholm altar of 1521 as an outstanding old German wood-carving, but he cites as an example of folk art a small piece of wood-carving of quite different type: 'The writer of these lines possesses a carving in oak, done with a pocket-knife by a shepherd from Löhrsdorf in the 'twenties; it represents a leaping horse near a giant's bed (prehistoric grave). The artist probably took the motif from a two-third coin, as seems to be indicated by the Latin inscription. The whole work is truly a masterpiece, beautifully and vividly executed, and highly praised by experts. The maker is otherwise quite unknown, perhaps no longer with us.'[2]

This passage contains several ideas that only much later were to become part of scholarly discussion: the simple, naive countryman (not necessarily a peasant) as creative artist; then the 'lowering of cultural values', in this case the transfer of the coin design to an art form requiring less ability. Generally the term 'folk art' acquired this connotation in everyday language only in the 1890s. By then the problems, so much discussed from the middle of the century onwards, of the work of artisans and home industries, had sunk into oblivion.

Among the country folk, now mainly seen as peasants, a large

number of buildings, utensils and ornaments was discovered which fascinated those who shared this newly awakened interest. Here was a world of forms, objects and images where the old appeared new, refreshing, naive, natural, and at the same time original: folk art. It was at last recognized as *art*. To understand this discovery properly in its historical setting, the state of artistic development at the end of the century must be examined. Only at a very late date did folklore become an independent subject of study. Before this it was restricted in scope by its origins in philology, the history of religion and law, and public finance. Almost no attention was paid to the artefacts that properly belonged to folk art. This emergent discipline certainly had no accepted means of categorizing visible, apparent, and tangible phenomena. In many respects it lacks them still.

One must not expect a concise definition of folk art. The term is a collective one for many different things. Even the word 'art' does not allow of definition, and many smart people invoke the saying: 'there is no such thing as art, there are only works of art'. The other component, 'folk', is equally unclear. What does it mean in connection with art?

Let it be said firstly that the objects covered by the term 'folk art'—let us call them 'works of folk art'—have one thing in common. They do not, to express it negatively, belong to the élite of artistic works which now form the subject of art history, conventionally seen. They comprise rather a wide variety of traditional artefacts. We can trace in an almost linear progression how they acquired an independent existence. This acquisition of independence has been called a debasement, indicating displacement to a lower social stratum, and in consequence implying a negative development of artistic values: artistic creation becomes disjointed, loses its precise form and individual quality, and becomes more or less misunderstood or even trivial. This would mean that it ceases to be art, and that all we have is deformed art, 'non-art'.

If we regard as art worthy of consideration only the works of genius that characterize an epoch or are perhaps even more than epoch-making, or only work that has found approval in higher social circles; if, to put it more simply, we see in art history only a single stream of development in historical sequence, we shall perceive only one side of reality. For in that stream we also find several channels, pools and so on, where the flow stops, or where the water stagnates and a different flora develops. The relationship of folk art to the art that is the concern of the art historian may be described as contemporary but unequal. Social or regional spheres develop, which for one reason or another do not take part, or at least do not do so fully, in the general changes in the style of the period. This does not mean that there is only stagnation or deterioration. Indeed, under favourable conditions a transformation may take place which can produce outstanding results. It is under such conditions that folk art arises. In some cases the achievement may be very modest, but in others works may attain a very high artistic standard. Remarkably enough, folk art is no mere by-product, but an entity with an individual character in its own right.

It would be wrong to set folk art in rigid opposition to conventional art as if it were a wholly independent, self-sufficient subject. This has often been done without realizing the contradiction. Some writers on the subject speak of 'genre art' as opposed to folk art—as if folk art were lacking in style. What they really mean is the genre of the period; they ought to use the term 'period-genre', but even this would not be really appropriate. Some writers claim that folk art is influenced here and there by the art of the period, as if folk art were an entity by itself, with its own origin and tradition. This is not at all so: so-called folk art is basically an off-shoot of a plant nourished by the style of the times. According to many descriptions stylized form is the very essence of folk art. It therefore cannot be presented as standing in contrast to genre art. Two concepts of style are mixed up here. For this very reason we should distinguish between genre, the style of the period, and stylized form (simplification to a more regular, schematic, non-representational form).

Art produced by an artist or master has also been described as in opposition to folk art. Such terms are inaccurate, because they exclusively emphasize individual achievement in contrast to that which is anonymous. They do not touch the essence of folk art—or at most only one of its facets. For folk art, too, has its masterpieces, and quite often the names of masters stand out among the nameless multitude through their particular talent.

Finally, some writers have devised a formula which shifts the two contrasting art forms into the social field: peasant art and urban art. This again is an unwarrantable generalization. Confining folk art to the peasantry means making an inadmissible equation of country dwellers with 'peasants', while the idea of 'urban art' overlooks the diversity of the town population. True, the contrasting milieux of town and country, of townsman and peasant, played a part in the creation of folk art, but again we are only dealing with one facet of the whole. We shall demonstrate that the countryside, the realm of the peasant, was by no means always at the receiving end and that the towns, the realm of the burgher and artisan, were not always the givers. If one wants to differentiate according to locality one has to be more specific. Even the familiar device of classing small-town inhabitants among country folk is inadequate.

The term 'folk art' did not arise out of a systematic concept, and it covers more than can be defined to everyone's satisfaction. Its significance stems from a convention that arose when a certain outlook became dominant in the development of Western culture and art. It carries a risk of misunderstanding, but it seems to be irreplaceable at the moment. We might adopt Walter Hävernick's suggestion and speak of 'temporary group art' instead of folk art,[3] but by doing so we should be abandoning the connection between its apparently or really disparate elements. In addition we would constantly have to use the plural and speak of 'group arts'. The addition of the word 'temporary' is superfluous. Anything called art necessarily involves something subject to the historical law of growth and decay.

This book retains throughout the term 'folk art', without ruling out, where necessary, criticism of concepts popularly associated with it, in particular the circumstances which help to explain the term's real meaning. These factors will be discussed in the last chapter.

Above all, folk art must be strictly dissociated from everything which was definitely not regarded as folk art at the time the term was coined, but rather the contrary, such as factory goods, manufactured en masse by industrial means. They should never be included in the term 'folk art', as has recently been suggested by Adelhart Zippelius:[4] this would be a distortion of its true original meaning. The time has certainly come to give industrial products their recognition in terms of aesthetic and cultural history. For decades industrial products have undeniably helped—*mutatis mutandis*—to fulfil functions formerly carried out by folk-art products. However, nothing is gained by declaring, contrary to the origin and the history of the term, that industrial goods are folk art. This does not help understanding and distorts the language.

Since the publication of the last comprehensive work on our subject, detailed studies have yielded much new information. Because of the volume of present-day knowledge, and not only for this reason, it is now hardly possible to expand the scope of the theme as widely as used to be done: to begin, say, with house-building and end with a sheet of pictures. Dwelling-house construction now offers such a vast field of new insights that no summary account could do justice to it. Historical research and new scientific methods have revealed much about medieval techniques. It is clear that, for example, it is an undue simplification to deduce modern house types from early historical buildings or peculiar ethnic features. Only when we know in detail the development of the practice of timbering, for instance, can we begin to understand the particular form of the North German long-house (one-roomed dwelling), set in its landscape; its room structure and external appearance, too, are conditioned by the setting. Forms that appear to be of ancient design sometimes turn out to be of quite recent origin. In fact architectural research has forced us to give up many old familiar concepts. We shall therefore confine ourselves to an outline dealing with external ornamentation which is, to a certain extent, independent of the construction and general function of the house. In doing so we shall deliberately ignore the fact that 'folk architecture' exists as a branch of folk art, and that structure plays an important aesthetic part in popular buildings as well as exterior adornment.

We shall also have to omit consideration of some other factors which rightly or wrongly are often regarded as part of folk art: national dress, imagery, pictures and toys. These are touched on only marginally: for instance, embroidery on national costume is treated as a form of two-dimensional decoration. The artistic appearance of the object and everything connected with it must be the centre of interest. Three-dimensional effects, as in a dwelling, will also be discussed. Pictures as a whole are again a wide-ranging theme that poses certain specific requirements. Here, too, research has made considerable progress during recent decades and the findings have been made available in standard publications. Folk artefacts in paper are therefore only considered where the paper has been used as a material, for instance worked with scissors. One may disagree with such limitations, but separation of the inseparable is always necessary. The most difficult aspect of the subject is to define its limits. Wherever it seemed appropriate we have resisted just naming many items in favour of examining characteristic ones in more detail.

Types of Folk Art

The word 'folk art' is used here to mean the created, material and figurative components of the life of the common people *(Volk)*. It can be recognized only by examining it as a historical phenomenon which took shape within the social and cultural context of a limited period. It is this socio-historical aspect which causes artistic activity to take on the characteristics of 'group art'. Forms are prescribed and symbols of communication established which express specific customs and *mores*. In this way folk art extends into the realm of folklore.

The fact that social groups of very different kinds can become 'purveyors' of a specific form needs no explanation. Various examples could be quoted, such as peasants in a more or less well-defined region whose social status is clearly differentiated between rich and poor. Crofters, farm labourers and village paupers are often excluded, but they, too, aspire, as far as they can, to adhere to these standards. The transmitters may include those who place orders for the objects concerned, those who buy them as finished goods, or independent producers. The latter again may be either specialists or laymen and their activities must be classified into men's, women's and family work. The principals must be artisans with specialist qualifications who live in the vicinity of the producers. Although noble ladies and even princesses did their own spinning and embroidering well into the nineteenth century, it was necessarily the small man who gave orders to the village blacksmith. Both of them bought pottery through the nearest market. Such goods might come from far away, either by land or by river, or even from across the sea; alternatively they might be made locally, in the same village. Such wares occur in various forms and fulfil the purpose for which they are intended in a variety of ways. None of these considerations can be regarded as the sole means of judging whether or not an object belongs in the category of folk art. Moreover, the transaction may be carried out in different ways. The goods may be exchanged directly between the maker and the user, in the case of an order for ready-made articles, or be dealt with by pedlars, independent merchants or manufacturers' employees, or else reach the buyer by way of some long-distance commerce carried on through a highly-qualified middleman. None of these means of distribution can claim to provide a sole criterion for defining folk art.

In the literature a stylistic criterion is sometimes mentioned. Attempts have been made to ascribe to folk art certain characteristics that are generally valid in the representation of images: two-dimensional, preference for symmetry, lack of perspective and so on. It is true that when folk art is examined in broad outline it seems to combine many of these characteristics. Even a superficial glance at the illustrations in this book, however, will show that they are by no means constant. This cannot be explained by suggesting that folk art has taken on certain features of genre art, as if it had always been a sharply defined, age-old entity. Its origins can only be understood in the light of the historical circumstances prevailing in Europe, and Germany in particular, during the late Middle Ages.

In the towns highly specialized, very able artisans' guilds had arisen which gave the citizens' day-to-day life a pronounced individuality. What was formerly—for want of another explanation—attributed to ethnic differences between tribes or clans may rather have arisen from the process of individualization resulting in turn from the development of urban culture. This is not the place for a discussion of the difficult question how and why well-defined art provinces emerged with styles called after the regions of the Lower Rhine, Cologne, Ulm, Lower Franconia etc. These specific features mostly developed in the towns whence they spread into the surrounding countryside and eventually came to affect whole regions. This process entered a new phase during the sixteenth century.

At this point we must examine Lenz Kriss-Rettenbeck's statement of what he understands by the term folk art.[5] It 'starts with the new era at the end of the fifteenth and the beginning of the sixteenth century and ends towards the close of the nineteenth century.... It involves the application of science to the principles whereby men live, to their conduct, and thus also to their art.' The leading spirits of the Renaissance such as Dürer and Leonardo da Vinci made art academic. It became concrete 'by the study, development and application, central and linear perspective, by the achievement of atmospheric depth through calculated, phenomenally realistic light effects, and by the use of chiaroscuro. Art could represent the empirically ascertained amount of light in air and water, the experimentally and mathematically determined reflection of colour, and the tangible nature of the surface of objects. It could indicate tactile qualities, use morphology, anatomy and physiognomy, undertake systematic studies of mime and gesture, investigate proportion, and calculate systems of measurement.' Thus art at its summit became an organized cosmos of scientific knowledge, a philosophical system, and from the outset anyone who wanted to be accepted in leading social and intellectual circles had to be steeped in this way of thinking. Those who were merely talented might be satisfied with imitating or copying other artists' styles or rules like an obedient disciple. The superior intellect really mastered the principles and processes of insight and perception. The genius used them to give material form

to his personal vision. Folk art, however, had no share in all this: it remained outside the mainstream of life in the academic and educated world, and developed its own spheres of influence as a natural result of the new spiritual and social climate.

Such spheres of influence could vary widely in kind and extent. Their particular character could be expressed in a few or in many different forms. The peasants of a single parish like Ostenfeld near Husum, which is characterized throughout by peculiarities of houses, household goods and dress, could constitute one such sphere. Another could occur in a district consisting of four parishes such as the Vierlande near Hamburg, which created its own pattern of life, because of, or in spite of, the vicinity of the city. Such distinctions could be expressed in some minor aspect of life found over a much broader area; Old Bavarian pottery, for example, spread from its origin in the Kröning area over a very wide stretch of territory, right into the Tyrol. Just as dialects develop largely as a consequence of historical changes in language, so changes in the shapes of houses, objects and ornaments start from a single centre—a point of innovation or distribution—and then move outwards in space and time, sometimes criss-crossing and overlapping each other. In the process certain forms were retained long after they had been discarded by the leading social classes in their rapid progress. Local and regional developments also helped to differentiate and enrich the whole.

If these phenomena were marked on a map, the result would be an extremely chequered picture; this is specially true of Germany in the second half of the eighteenth century. Techniques of house construction, types of implements and so on can be recorded in this way; the German folklore atlas contains several maps illustrating the distribution of so-called material culture. Artistic features, on the other hand, cannot be quantified or reduced to a few types in the same way. So far all attempts to establish a credible geography of folk art have failed. Yet, the geographical milieu is a powerful influence on every feature of folk art. A study of the way certain types spread often helps us understand their significance. This is particularly true where a particular folk-art region clearly depends on an urban centre. Among the classic examples of this are the districts around Hamburg (Vierlande, Altes Land, Elbe marshes), and the pottery and wood-carving centres on important traffic routes, in which case it is necessary to know where their markets are located.

Compared with neighbouring countries Germany is a land of unusual variety. This results in part from its geographical make-up, with all the economic implications but primarily from its political and social history. Pressures from outside played a leading part, and religion was another important factor.

The folk art of Upper Bavaria is very closely linked with that of other Alpine countries, and many details of that of North Germany become more intelligible when seen against the Scandinavian background. Since the beginning of the modern era the folk culture of the Netherlands has exerted an influence on northern Germany, and also to a lesser extent southwards along the Rhine. In the east there was constant contact with the Slavic peoples, who had their own customs. Along with these international contacts one must bear in mind the division of Germany into small principalities after the Thirty Years' War. The effect of all these factors on the total picture can only be assessed accurately by examining individual cases.

Regional and local social groups were not the only purveyors of folk art. People could also transmit it by virtue of their calling, as sailors, miners or Alpine cowherds. Groups of this kind were not homogeneous; nor was the peasantry uniform. Great differences arose in the size of farms, fertility of the soil, forms of inheritance, types of economic activity and degree of legal freedom. Large landed estates worked by bondsmen were hardly affected by folk art. In this negative aspect, too, the sixteenth century was decisive: at that time great estates were formed by squeezing out the peasants, particularly in the north and east of Germany. A large segment of the German people was thus excluded from this form of activity. Parallel with this came the development of large peasant holdings. This led to the establishment of farming regions all along the coast of the North Sea with a cultural life that varied greatly according to the geographical features.

While the general situation in Germany around the middle of the sixteenth century favoured the birth of folk art, the prevailing conditions in the world of art also contributed their share. Since the publication of Robert Hedicke's monograph on Cornelis Floris and the Floris Decoration (Berlin, 1913) it has become clear that the German–Dutch 'Nordic Renaissance' cannot be fully understood by simply applying the classical categories of architecture, sculpture and painting. During the period from about 1550 to 1650 there was no steady development in these fields and no continuous line of artists or monuments. The chief emphasis in the arts was on the decorative side.[6] The literature on this phase of art history concentrates on apparently isolated pieces, architectural elements, ornaments, interior decorations, furniture and so on.

It is true that folk art is by no means concerned only with decoration, but decoration does play a substantial part in it. The second half of the century, with its lack of autonomous native architecture, sculpture and painting, was a period of innovation and relaxation of the old rules; one can easily imagine that this atmosphere made the rise of folk art possible. The clearest signs of this are to be seen in decoration. The objects so decorated, furniture and utensils for instance, often preserve the traditional form. The volume, quality and effect of this flood of decorative patterns are overwhelming; they were printed as woodcuts and copper engravings, and could be applied to all kinds of arts and crafts. The movement spread astonishingly quickly, even to remote workshops. This led to individual development here and there, often in places far from the major centres. As these patterns spread by direct and indirect routes they met with a variety of responses. A brief survey of three examples will serve as an illustration of such local adaptation.

Without any obvious reason a new style of pottery appeared in the little town of Wanfried-on-the-Werra in the years before 1600.[7] In this ware some see the beginning of what subsequently came to be known as 'peasant pottery', which was produced in almost every region of Germany. The impetus was thought to have come from

238,
246

Nuremberg, probably because of the type of drawing with which these dishes and plates were decorated. The precision of the graphic treatment suggests this origin; it is almost elegant when compared with later earthenware. It was obviously produced not in response to local demand, but rather for export. Alfred Höck emphasizes the efforts of Count Moritz of Hesse (1572–1632) to promote trade in his country in general.[8] The fact that the Wanfried potters did not form a guild indicates that they were protected and encouraged from above.

As we know from the wide distribution of the unmistakable Wanfried ware, it was exported on an extensive scale almost from the start. Deliveries were made to Belgium, Holland, the south of England and Denmark.[9] On German soil most specimens are to be found in Bremen. They also occur along the route to Bremen, on the banks of the rivers Werra and Weser, from Osnabrück in the west to Lüneburg in the east. Wanfried ware is not found immediately south and east of Wanfried—obviously land transport was not feasible. At this time Bremen was the transit port for further transport overseas. There is evidence of this pottery even from as far afield as Jamestown, Virginia. The conclusion is obvious: an established route became the vehicle for distributing products which were made chiefly because this means of distribution was available. The river Werra is navigable downstream from Wanfried, which for a time was the collecting point for trade between Thuringia (and other South German towns) and Bremen. The basis of the trade down the Weser will have been the export of sandstone, which had been developed in the sixteenth century, although most of it was carried on from places further down the river. Wanfried itself traded chiefly in fruit, grain and woad (a dye) from Thuringia.

The outbreak of the Thirty Years' War seems to have caused a rapid decline in output after about two decades. Production continued, but later ware only reached local markets and its quality deteriorated.

Three hundred and fifty-five of the verified examples, mainly shards, are dated. This suggests that the makers could count on a rapid turnover. Some of the crockery was apparently made for Catholic customers, as is indicated by the portraits of saints, but most of the localities where Wanfried ware occurs are in Protestant territory. A few pieces, such as the jug of the Bremen smiths' guild (1601), and a few items with coats of arms, show that they were ordered especially.

Production started in the 1580s and reached its peak between 1605 and 1615. At that time there were at least two workshops in full operation. For the rest, the details of the beginnings of Wanfried ware are not entirely clear; neighbouring places, such as Treffurt, may have had a share in the work. We know the names of some Wanfried potters. Three masters moved there from other parts of Hesse. However, Wanfried ware cannot be distinguished from that of the surrounding countryside. All the evidence indicates that it constitutes the beginning of an entirely new development. The suggestion that Wanfried ware goes back to the König family, which moved there from Treffurt, cannot be sustained.

It is clear from the records that stoves, too, were manufactured. All that is really known is flat ware, such as dishes, and a few 'upright' pieces such as jugs. A characteristic of Friedland pottery is the light, reddish-brown to orange-coloured glaze. After light preliminary incision the decoration of figures is added in a whitish clay slip. After preliminary drying the inside picture is sketched in by incising the outline. Green dots are put on with the glaze. In the case of simple motifs the preliminary incision may be omitted. The broad edges ('flags') have an outer rim of dots enclosing circular lines; inside these are interlaced scrolls or curved garlands with series of lines. The base is generally covered with a representational motif: half- or full-length figures of a man, a woman or a couple. Animals are also featured, including birds, a deer, a stag, a hare, a pig and three fish. Religious themes, too, occur: the Fall, the resurrection of Christ, Saint Lawrence, an angel and on a larger dish of 1612 (now in the Staatliche Kunstsammlungen, Cassel), ascribed by Naumann to the Wanfried district, the whole scene round the table at the Last Supper. Another large dish (in the Fitzwilliam Museum, Cambridge), shows the Annunciation, with Mary under a canopy, and has a multi-figured hunting frieze on the rim. Some motifs are simple; they include the sun, a heart, a cushion, a crest, a potter's wheel and—characteristic of Wanfried ware—a few pea-pods on a tendril. Various blossoms, trees, bunches of grapes as well as rosettes, flourishes and stars also occur. On the better pieces the incising tool and the *malhorn* (a cow's horn used for applying slip decoration) are wielded with remarkable sureness and the motifs boldly fitted into the field. Underlying the graphic form with its repetitive design the influence of Renaissance drawing is apparent, even in the layers of strokes which indicate shadows or modelling. But at every turn modifications, leading to the distortion of human and animal forms in various ways, can be discerned. The figures extend right up to the edge of the vessel and the proportions are dealt with very arbitrarily, even the outlines being formalized. However, all this is executed with remarkable authority and with the feeling for homogeneous style which always characterizes Wanfried ware. Of course, imitators very soon appeared in 240 other localities; though pottery of a regional character apparently spread in other parts of Hesse, it obviously originated in Wanfried.

A second example comes from the northern border region. A 'school' of furniture carving was already established in the 1560s, 135 largely on Danish soil, centred around the small town of Ribe but extending into Schleswig as far as the Tønder area and showing pronounced local characteristics. On the panelling of pulpits, on the back of pews and on secular furniture such as wall cupboards and chests, Gothic and Renaissance ornaments mingle in abundance. Especially typical are the fronts of large wall cupboards with wooden frames comprising up to twelve panels, five of them movable as doors—a definitely Gothic motif of which we shall have more to say in the chapter on furniture. The tracery and fluting still point back to the fifteenth century. But now the motifs include medallions with human heads and dense, herbaceous foliage springing from vases, or growing out of masks, filling the rectangle or distributed over a lozenge-shaped facet, and these are known to be of Renaissance

origin. In some examples both trends are combined with daring individuality. The whole style is a very successful synthesis of heterogeneous elements.

Some pieces, such as a cupboard façade dated 1564, privately owned, are signed by a craftsman named Bertel Snedker. The name of Bertel Snedker introduces a particular regional tradition within the area which was to continue for about a century and in which several workshops seem to have taken part. It arose independently of the general trend in the development of craftsmanship. One of the workshops, associated with the signature 'Made Moversen', had already lost its original vitality toward the end of the century, and the ornament became arid and stiff. A work dated 1620 (in the museum at Tønder), on the other hand, retains much of Bertel Snedker's powerful treatment of ample foliage. Among the followers of this earliest known master were the workshops that arose later south and north of Ribe and its immediate surroundings.[10]

This strongly individual style was probably possible only because it developed in such a remote area. Its influence was confined to a limited district and its patrons were local men, such as a church congregation and a few well-to-do persons, probably farmers or in one case perhaps a clergyman. The fronts of the cupboards were presumably made to measure and the name of the customer is often carved as part of the decoration, or at least combined with a pious saying (in Danish). This style no doubt owes its origin to the maritime trade carried on from Ribe. Exactly what gave the original impetus and created the style remains obscure. This type of furniture and the pottery of Wanfried both appeared spontaneously and developed a completely individual form of expression. In both cases the medium of distribution was a group of artisans' workshops isolated from the main art centres. The Wanfried potters, even more than the woodcarvers of Ribe, were obliged to work in a uniform style because they had to maintain a steady interest in their goods in far distant markets. They developed a standard article which was ideally calculated to provide a model for rural craftsmen. The wood-carvers of Ribe felt no such ties to an already established form; in their case the customers had a voice in defining it. The latter were concerned, if only for reasons of prestige, to maintain existing standards of workmanship when it came to ordering the household's most important item, the wardrobe. In both cases circumstances led to standardization of the shape of the product and to a characteristic formal development which was completely independent of trends in urban style. In both cases the basic element in the decoration was derived from an older tradition and remained fundamentally unchanged. This is also true of the third example.

During the Middle Ages brass-beating developed as a flourishing industry in a place near Aix-la-Chapelle where zinc oxide was found. Its centre was the town of Dinant. Articles beaten from brass sheets, known as *Dinanderien* (Dinant wares), were produced in large quantities. At first they were mainly sold in France, but from the middle of the thirteenth century onwards they were widely distributed through the Hanseatic League. They were marketed by means of a series of depots. Dinant was completely destroyed by Duke Philip of Burgundy in 1466 and its key position in the trade could not be recovered. Many of those engaged in this industry emigrated and established themselves in Aix-la-Chapelle and various smaller places in the surrounding country.[11] Aix-la-Chapelle became the heir to Dinant because the nearby territory was particularly rich in zinc ore. Production on a large scale was started here during the middle of the fifteenth century by an enterprising man named Daniel van der Kammen, probably a Fleming. A guild of brass-beaters was founded in 1450. The craftsmen obtained the brass sheeting from an officially licensed furnace, which even at this early stage was a kind of factory. In 1559 there were sixty-eight master craftsmen processing the sheets. From the smelting of the ore to the finishing of the vessels everything was systematically organized. The physical labour, such as beating the bowls over the forms (probably of iron), was left to journeymen, the masters having become merchants. In the whole of German economic history this is one of the earliest examples of an enterprise closely approximating to an organized factory. However, it may be assumed that, apart from procuring the raw material and its initial treatment, the making and marketing of stoneware in the Lower Rhine region functioned in a similar manner.

Around the middle of the sixteenth century brass-processing had become the principal trade of Aix-la-Chapelle. However, the territory belonging to the city, the 'Aachen Empire', took an increasing part in it. The town council could not prevent some workshops from moving away into the country. During the seventeenth century both the town and the region lost most of them. Quite a number of new furnaces were set up and beaters settled around Stolberg. 'They built their furnaces and mills in the valleys of the rivers Inde and Vicht, and the streams of Münster and Wehe, in the Stolberg section of Jülich, in the magistracies Eschweiler, Wilhelmstein, Schönfort, and Notberg as well as the district of the imperial abbey of Cornelimünster.'[12] This was a consequence of the political and religious conditions that resulted from the Counter-reformation. At the same time attempts were made to situate the processing closer to the sources of raw materials and power, i.e., the zinc ore mines and the waterways. Brass-working thus became a rural craft, although the key role of the urban entrepreneur was not hereby lessened. The brass-beaters were not required to observe the rule of other crafts which forced apprentices to become journeymen, and the tendency to move into the country therefore showed its influence on the product. The result was a mass-produced article, made in the country and distributed through the marketing centres to a wide circle of customers. In the course of the sixteenth century Nuremberg became a competitor, but even today it is impossible to distinguish Nuremberg products from those of Aix-la-Chapelle. This is particularly true of very large brass bowls beaten out over blocks with representational or decorative patterns.[13] They can be classified as folk art by virtue of the large number made, the manner of production and their type. These bowls are most striking pieces. There is also an ever-increasing number of brass implements, mainly dating from the eighteenth century. They could have been produced anywhere in the country, but most of them came direct from the main centres, especially the workshops around Stol-

berg. There were foot-warmers, ash-pans, warming pans, stove-guards and other artefacts. In the conventional view these are just examples of peasant folk art. In fact they were just as much in demand among the middle classes, but they survived much longer in peasant households.

This example shows how futile it is to try to contrast peasant and urban art. Technical considerations forced workshops out of the towns already in the later Middle Ages, and this was even more true from the sixteenth century onwards, in spite of all the privileges enjoyed by the towns. This applies particularly to workshops that constituted a fire risk, such as potteries. Thus pottery became a largely rural craft and tended to be combined with other small-scale peasant activities. In the case of pottery this development was further encouraged by the desirability of settling as near as possible to clay deposits and the source of fuel. From the end of the Middle Ages onwards diminishing supplies of wood made it increasingly costly in the towns. The increase of population in the country added to the inducements. Those unable to find employment in agriculture turned to handcrafts and could work more cheaply than town-dwellers. All these circumstances did not by any means make the country districts independent of urban trade, but they contributed to the trend that made the villages partners in the work and introduced many innovations into the life-style of country folk. The term 'peasant art' ignores these facts, although it is true that the peasants, as the most well-established section of the country population, set the tone for their neighbours.

These three examples differ widely in the nature of the products, the economic structure (ranging from a centrally managed enterprise to an informal craft fraternity), and the manner in which the goods were distributed. Nevertheless they have in common a local, at the most regional scale. The manufacture of brass articles was confined to a limited region largely because of the monopoly on brass sheeting.

Pottery production depended on the transport facilities available for the finished goods. The making of furniture around Ribe was closely tied to the proximity of its customers. In addition it was probably dependent to some degree on the supply of oak, perhaps from Norway. In all three cases the work was done by expertly trained craftsmen in villages and small towns far from important urban centres. The type of product depended more or less on the outlet, on its potential customers, and could change only under its own momentum. In all three cases the workers developed a sort of insularity, a growing sense of alienation, from fashionable trends in the world of art. In any case the basic form of the implements was inherited. Up to a point the potential development of the decoration remained latent. This means that variations were confined by the degree of inflexibility of the established forms. They were inhibited by the limitations of the individual craftsman, by the amount of imagination he could bring to bear. One can hardly speak of rules governing form; nevertheless, there was a certain consistency, sometimes in the direction of growth and revival, sometimes toward rigidity and hardening. It is possible to discover new forms which have their own artistic significance while preserving a link with established convention.

So far as craftsmanship is concerned, on the other hand, there was a gradual tendency towards do-it-yourself work by self-taught amateurs, who tried to turn their dexterity into a trade. Here we are in the first place thinking of women's work. If there are standard forms in this field, typical representations of objects and decorative motifs, such norms derive from the need to adapt to a specific function. If these bounds are breached or significantly extended, the norm may be superseded. Established convention may be suspended and an individual artistic style achieved. This provides a very fruitful soil for folk art in the proper sense. In the following chapters this point will be brought out again and again, and we shall return to it in the conclusion.

House Decoration

Previous publications on folk art as a rule start with a description of types of settlements and forms of houses. After all, the house is the biggest and the most comprehensive item among all the material objects of folk art. Attention is traditionally concentrated on 'the peasant house'. Undeniably, such houses are of vital importance in shaping the culture of a region. This importance attaches to their position, grouping, arrangement, the plan of settlement, the colour and composition of the visible building materials, and most of all their cubic shape. In our time we are witnessing the disappearance, not only of the traditional building materials, but also of a whole world of once familiar images and concepts, some of which are already becoming strange to us. All the evidence preserved in open-air museums and agencies for the preservation of national monuments will hardly suffice to reconstruct in our imagination the appearance of an entire village as it could still frequently be seen only two generations ago. This means that our material heritage of so-called folkloristic objects of rural origin has become divorced from the setting in which it belonged and functioned, and as a result of this displacement it has become alien to us. It is hard to imagine these objects in a living context, and in default of detailed study such an effort of the imagination ultimately becomes impossible.

Barely two generations ago the peasant houses of Germany could be divided into broad types by simply looking at them. Such a procedure was over-simplified and lacked a sound historical basis. Since then, research into the historical evolution of secular rural and urban building has become a branch of architectural history and historical folklore. The lacunae in our knowledge of past building methods are beginning to be filled in. Nowadays anyone who wants to trace the genealogy of the most characteristic forms of house would have to work within the confines of a branch of knowledge with its own terminology, and concern himself with technical, economic, social and other factors that are relevant. Since constructive forces were involved, the term 'folk architecture' is acceptable.[14] We have limited the concept here, since to cover the house as a whole would be to tackle an endless subject. However, we cannot exclude what may be described as house decoration, which in the first place means beautifying, but can also imply adding emphasis, distinction and demonstrative effects. Its real meaning has to be traced in each individual case.

The concept of the timber house as a unit had fully developed by the end of the Middle Ages, although ideas differed about the construction of the inner framework and the walls. In the town house there were self-contained storeys. In the North German long-house we find an ingenious classic method of compartmental building resulting from the development of the carpenter's art, which can be followed step by step. Its progress can be followed on maps. It appears to have originated in the region around the upper Weser river, at least as far as the most important ideas regarding the construction of the inner framework are concerned.[15] Further south, particularly along the middle Rhine and in Franconia, a rhythmic formation of the panelled wall was developed during the late Middle Ages. Bracing by wooden uprights was the main factor in this process. During the fifteenth century decoration appeared on the timbers that were visible on the outside of the house, at first in towns, but soon afterwards, wherever it was feasible, also in the peasant house. The motif for this decoration was provided by enriching the outlines of the struts in contrast to the panel-work. The slant of a head or foot brace was bent or fitted with a projection, and sometimes the struts crossed. Foot supports had already been formed into triangular shapes during the 11 Middle Ages and together with the struts and ledge provided a large enclosed surface very suitable for richly carved decoration. They supplied a wonderful outlet for the mannerism that became fashionable in the sixteenth century, with its increasing tendency to decorate everything.

Only a few examples can be given here of the extensive and many-faceted chapter of cultural history embodied in panel carvings, especially those of central and northern Germany. Whole cycles of themes, decorative, sometimes grotesque, and often representational, are to be found beneath the upper storeys. Their projecting supports were still modelled into figures in a fashion inherited from the late 358– Gothic era. In the sixteenth century decoration of wooden wall sur- 359 faces led to continuous sequences of half-rosettes or even whole rosettes, and to a large number of patterns. The carvings at Goslar were 11 executed by the wood sculptor Simon Stappen. He did similar work at Brunswick, where he decorated the 'Huneborstel House' at 2A Burgplatz, erected in 1536. This is one of the rare cases where the name of the carpenter or wood-carver is known.

The Harz mountains are particularly rich in house façades of this type. The typical motifs, particularly on the stays, seem to have spread northward rapidly. Not long ago whole rows of such decorated houses could be seen in Hanseatic cities. Even during the sixteenth century the spread of this style can be traced as far as the Swedish province of Schonen (Skåne), which was then still part of Denmark. This diffusion was obviously the work of German carpenters.

1 Peasant house in the Altes Land, near Hamburg. 18th century.

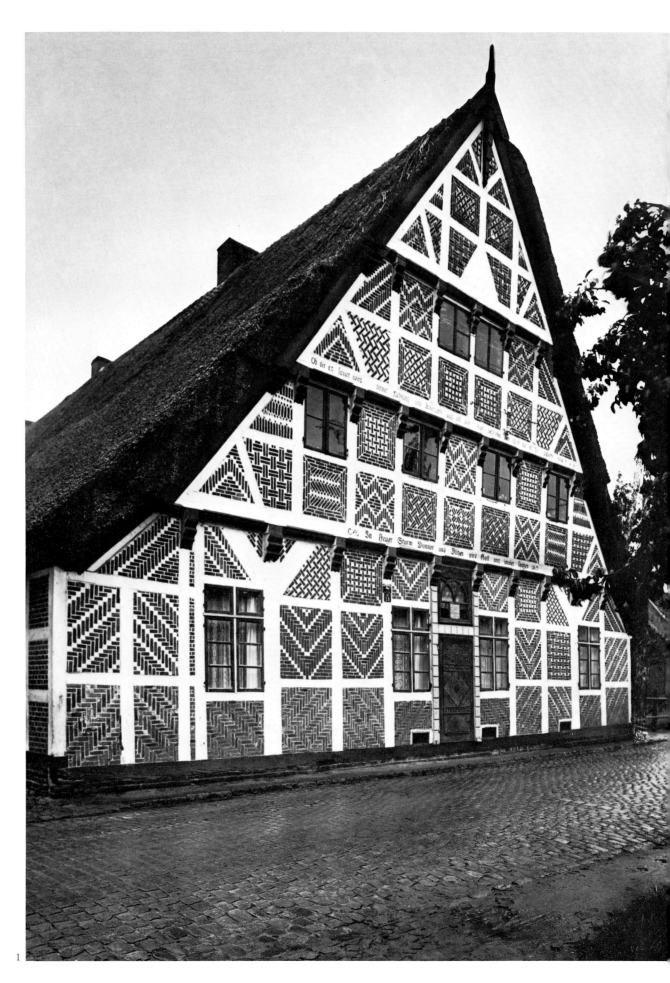

1

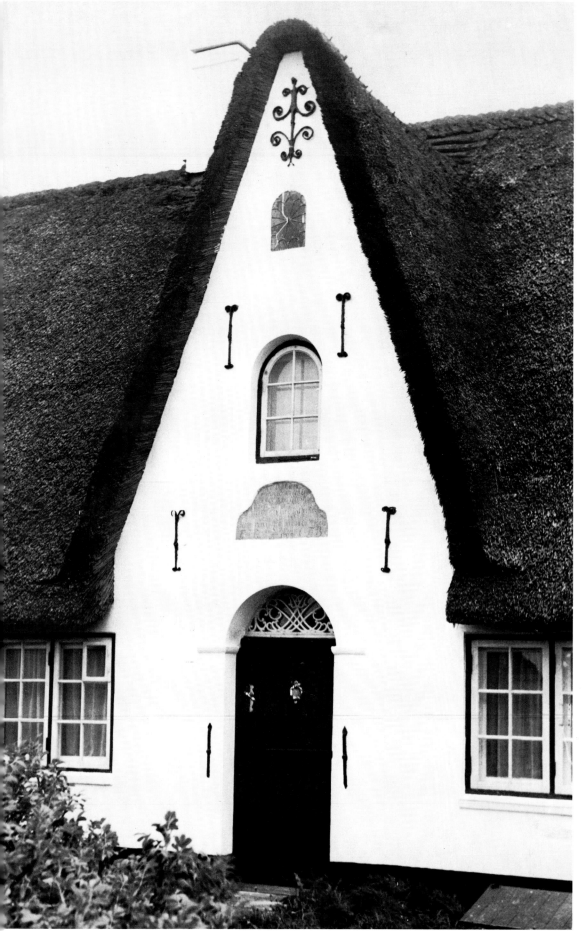

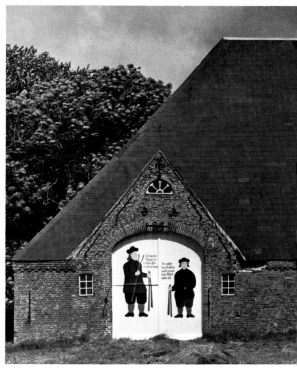

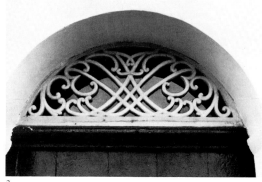

2

3

2 Cross-gable with entrance door of the 'White House'. Whitewashed brick. 1763. Kampen on Sylt, north Friesland, Schleswig.

3 Fan-light of the 'White House' with reverse monogram of the owner, F. J. B.

4 Olufshof, Kathrinenheerd, Eiderstedt peninsula, Schleswig.

5–7 Cramp-irons. Wrought iron. Middle of 19th century. Boldixum, island of Föhr, north Friesland, Schleswig.

8 Stone tablet. Sandstone slab. 1750. From Nieblum, island of Föhr.

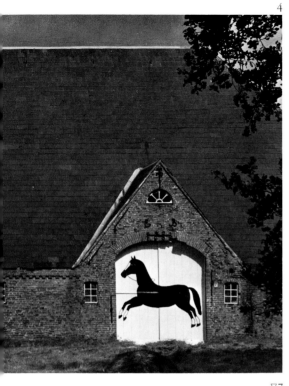

4

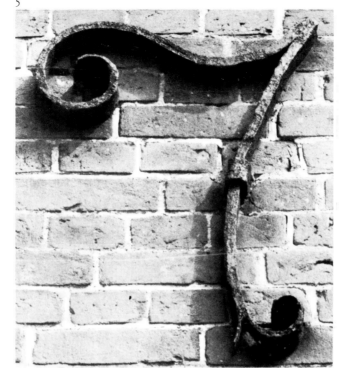

5

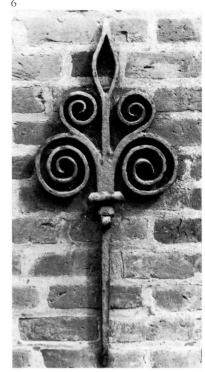

6

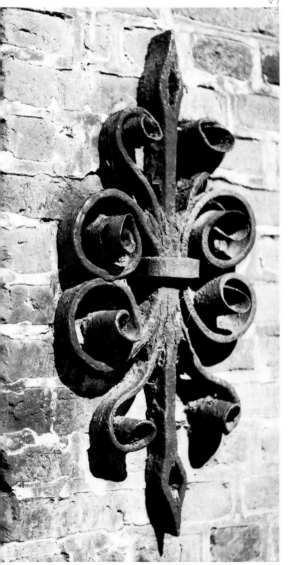

▽7

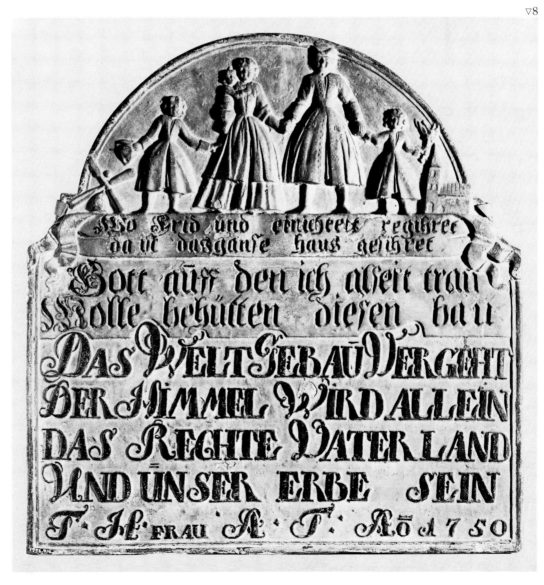

▽8

Wo Fried und einicheit regiret
da ist dasgantze haus geziret

Gott auff den ich alzeit trau
Wolle behüten diesen bau
DAS WELT GEBAU VERGEHT
DER HIMMEL WIRD ALLEIN
DAS RECHTE VATER LAND
UND UNSER ERBE SEIN
T H FRAU A T Aō d 1750

19

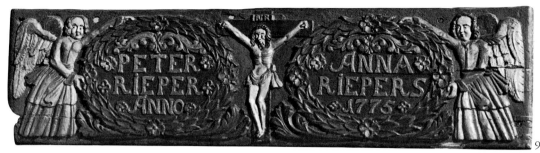

9 Lintel. Oak, painted. 1775. From Bremen.

10 Bay on the upper floors of a Burgher's House, the 'Haus zur Sonne', Wetzlar, dated 14 June 1607.

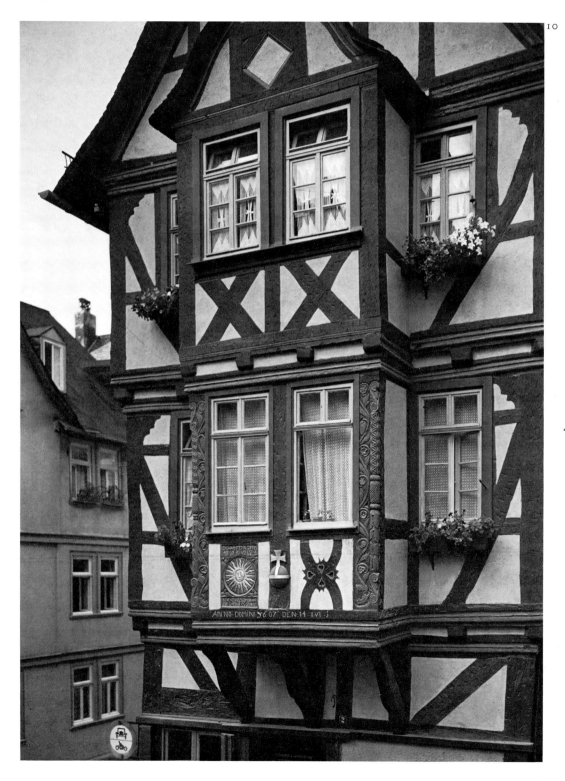

11 Detail of gutter wall of a house at Goslar, Harz mountains.

12 Gable of a house in Rissbach near Traben-Trarbach on the Moselle.

13 Gable of a house at Kölbe, near Marburg an der Lahn, Hesse. 19th century.

11

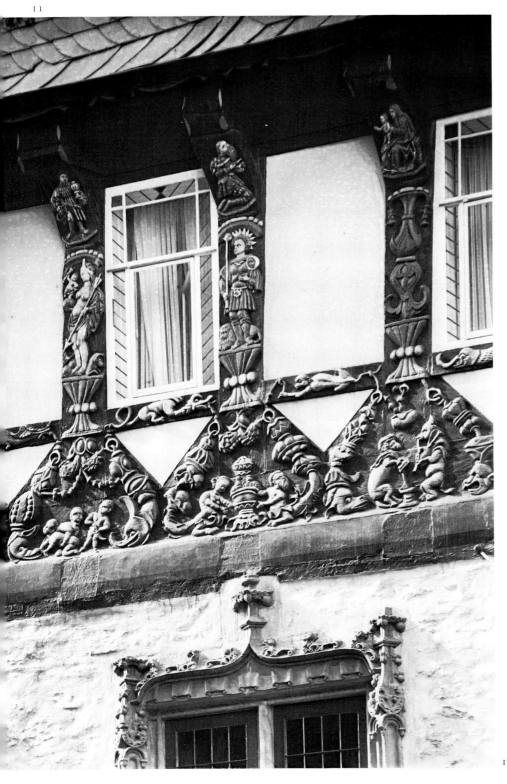

12

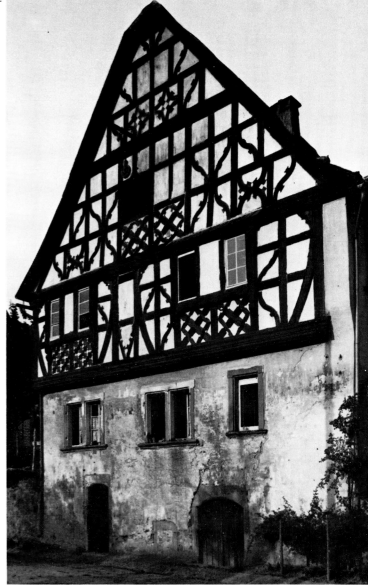

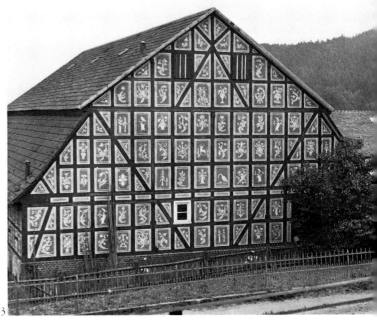

13

14 Weather-vane. Wrought iron. 1717. From the Winser Elbmarsch.

15 Weather-vane. Wrought iron. 1894. From Nordsehl, Schaumburg-Lippe district.

16 Dinner bell. Wrought iron. 1869. On the house 'Beim Hutterer' in Irlach, parish of Pleiskirchen, Altötting district, Bavaria.

17 Gable decoration and weather-vane. Wood and iron. Forged, 19th century. Altes Land, near Hamburg. Water-colour by Ursula Becker, painted 1935.

18–19 Gable planks from peasant houses in Lower Saxony. Wood. 19th century.

14

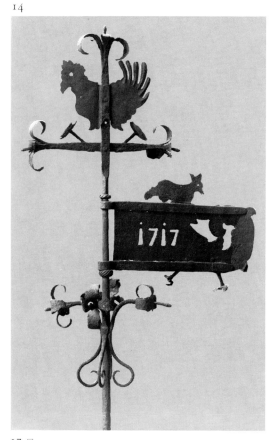

15

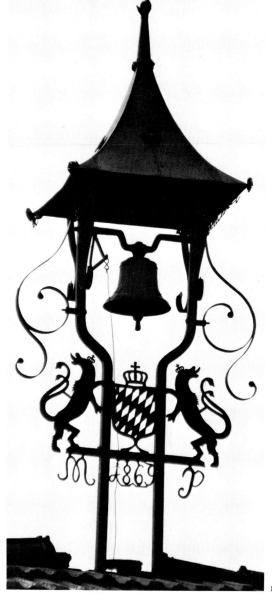

16

17 ▽

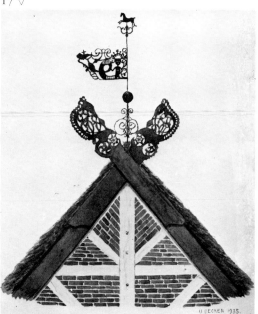

18 ▽

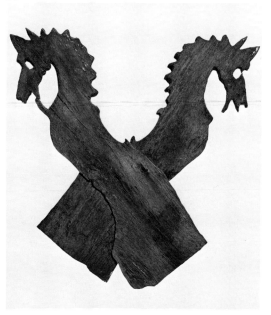

19

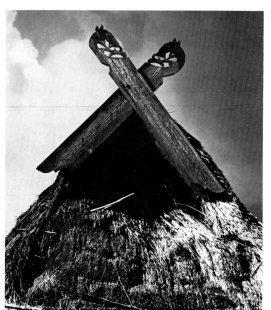

22

20–21 Sections of planks on barns. Softwood. *Circa* 1800. Miesbach district, Upper Bavaria.

22 Gable wall of a barn with criss-crossing woodwork, section. Miesbach district, Upper Bavaria.

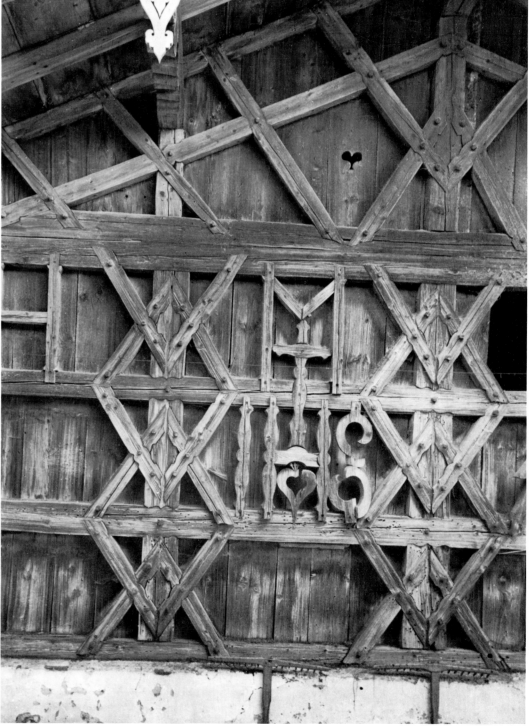

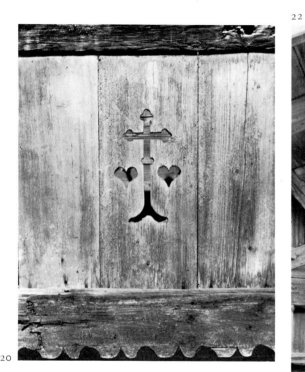

20

21

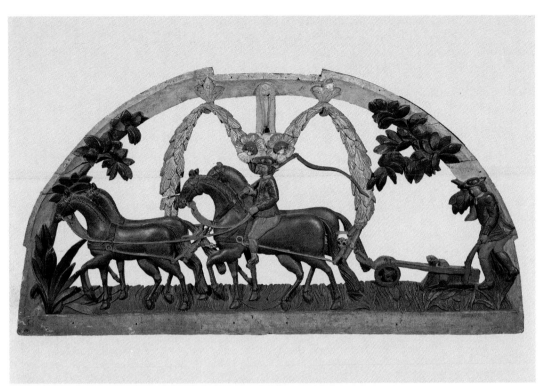

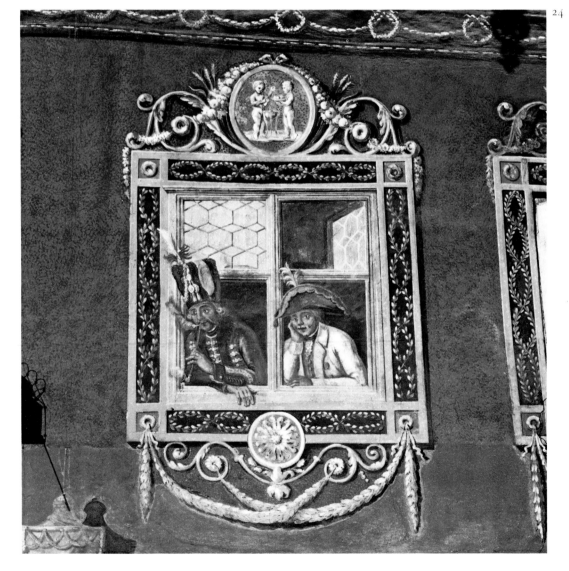

23 Entrance-door fan-light. Oak. *Circa* 1790–1800. From the Wilstermarsch, Holstein.

24 Part of the façade of the inn 'Zum Husaren', Garmisch, Upper Bavaria. Painted about 1800.

23

24

24

The framed structure, whose construction was now fully mastered, also gained ground in parts of southern Germany, where log houses or walls supported by planks had been the chief or sole architectural form before this time. In Bavaria walls of this type around part of the living quarters built by the log construction method supported the upper floor as a 'surround'. In Upper Bavarian sheds this form could also be turned inside out so that the timbering could be done from the inside. This resulted in a very lively pattern of crossed or interwoven struts in several layers, forming a series of interlacing lozenges. Even the rafters became visible from the outside by means of crossed stays. Additional struts between the planks could take the form of letters or signs. Our example from the area around Miesbach bears the owner's initials, HM, and the monogram of Christ with cross and heart. The total effect is considerably enhanced by the fact that the edges of the timbers curve in and out slightly where they dovetail. This swallow-tail, originally just meant to strengthen the bond, now becomes part of the decoration. The heads of the wooden nails emphasize the angle points of the structure and enhance the plastic, spatial effect evoked by the open parts of the wall.

A very important aspect of the timber-frame building in both static and three-dimensional terms was the way it allowed the upper floors to jut out above the lower ones. This largely governs the impression made by houses in many parts of central and northern Germany. Even peasant houses adopted the protruding gable as an architectural motif, although they had no upper floors and there was no need to gain extra space. This is true, for instance, of the very impressive houses in the Münster region of Oldenburg, examples of which can be seen in the open-air museum at Cloppenburg. It can also be seen in peasant houses of the Altes Land, where the nearby city of Hamburg served as a model, and on the island of Fehmarn, where the architecture of Lübeck invited imitation. In the towns, too, lavish gables can be found over houses of old-fashioned construction.[16] This way of creating a façade was an urban development which was afterwards transferred to the country. It originally made no sense at all there, certainly not in regions where the Lower German long-house predominated, because all the houses were detached and stood by themselves in their own grounds. It was not until the sixteenth century, when villages became more densely built up and dwelling forms were fully developed, that alignment toward the street became important. People began to build the short side of the house to face the street and to elaborate the entrance as an imposing gable.[17] The amount of timber used was often far in excess of what was necessary. The gable became a status symbol, an important feature even of middle-class housing.

The framework itself, with the graphic effect of its horizontally, vertically and diagonally interlacing timbers, the intermediate spaces sometimes filled with different types of walling, can give a highly individual appearance to the building. Anyone who has learned to recognize the statics of a structure by looking at the way the members have been put together should be able to deduce where and when the building originated. In this respect timber-frame houses are more eloquent, literally more transparent, than houses with massive walls.

A striking example can be seen in the Alemannic and Swabian regions. Here the wall trusses are spaced well apart, and instead of interposed cross-bars interwoven stays are used—a much earlier type of construction which had been superseded in other parts of the country during the Middle Ages. In this region decorative woodwork seldom occurs—another out-dated trend. Indeed 'all the ornamentation of the framework—except for secondary carving and painting—begins with the constructional securing of the structure'[18], i.e., after the classic timber-frame construction had reached its height of development during the late Middle Ages. A distinctly decorative effect can already be seen in the construction. Anyone who approaches these buildings with an understanding of spatial values and the possibilities of bonding squared timber (jointing, mortising, dovetailing etc.), can form an appreciation of the aesthetic effect, almost like that achieved by Constructivism in the art of modern engineering. This is not the place to follow up this idea in detail. However, it is important for a proper appreciation of folk art to bear in mind that here the purely functional becomes, unintentionally but inescapably, an aesthetic phenomenon. This is a fact of fundamental significance for the general concept of folk art.

The appearance of a half-timber house or of the wall of such a house can be greatly varied by addition of colour. In certain regions all the visible woodwork is painted, sometimes white, but also light blue or dark red. Since such differences are strikingly obvious even on a superficial tour of a district, there is a tendency to distinguish between 'colour regions'. However, such regional colour customs are often of recent date, and mostly originated during the nineteenth century, as new and cheaper paints became available. These recent developments in house decoration cannot be compared with the use of colour on costume or implements (for instance milk pails); nor are they comparable with coloured farm wagons, because these were largely the result of orders from members of the upper classes, to make them more easily distinguishable in case of requisition for use in time of war.

When the frames are whitewashed or filled in with rough cast brickwork, some very attractive—doubtless intentional—colour effects are obtained. Red bricks, as used in northern Germany from at least the eighteenth century onwards, provide possibilities for highly characteristic grouping when laid at an angle inside the frame or in a herring-bone pattern. A few decades ago some more or less representational motifs such as windmills or so-called 'thunder brooms' *(Donnerbesen)* could still be found. The pattern became more pronounced when the joints were marked out in white. The peasants in the Altes Land near Hamburg made the most of this combined effect of red and white. The size of the constituent parts was reduced by splitting up the bricks, so providing a richer decorative pattern. About eighty years ago Oskar Schwindrazheim was still able to compile a whole catalogue of such patterns of framework decorations in the Altes Land. A frequently applied method was that of incised plaster, in which the pattern of white plaster and red brick surfaces was enriched with linear drawings. It could produce an impression similar to that of embroidery, almost like glittering tinsel.[19]

In other regions the timber framework of rural buildings simply had a constructional function. In Hesse particularly all the ornamentation was concentrated on the filling-in surfaces. The use of incised plaster gives this part of the country a particular character. It is found in the Dill district, the upper Lahn, the whole of Upper Hesse, the Wetterau, and the region around Wetzlar, and spreads into Lower Hesse as far as the southern slopes of the Vogelsberg. More modest versions can be found as far afield as Franconia, along the upper Main valley and in Thuringia, as well as in Württemberg and Baden. Sections of the wall framework are, as usual, filled with sticks and brushwood and the mesh is covered with clay. Further layers have an admixture of lime and the topmost layer is of pure lime. While the flat surface is still soft it is roughened with a board with nails or a wooden stamp. The plasterer then draws a pattern with a spoon-shaped iron spatula by smoothing lines or surfaces, painting them wholly or partly with whitewash, and sometimes even adding a little plastic modelling. A flattened zone along the edge of the woodwork creates the effect of a frame. The most original effect is achieved by a very simple process. Ordinary figures are pressed into the smooth plaster directly with the roughening stamp: concentric circles, rectangles set within one another, horizontal crosses and so on—various forms which blend well with the framework of the wall timber.

The alternative procedure, already described, chiefly produced designs like those which potters incised or painted on their vessels. There are blossoms and leaves in bold outline, a tree, a branch with a bird and even, where a larger surface was available, more ambitious interlaced ornaments and vases or baskets full of flowers. Figures are interspersed, including men and women, even a man and woman toasting each other, riders, hunters, men threshing, and musicians, always with their female counterpart. A horse may be portrayed above a stable door. It is remarkable that religious subjects are rare, apart from an occasional cross or monogram of Christ. The contrast with South German façade painting is noteworthy and probably due to the difference in religious denomination. In Hesse the Protestant element of the population appears to be dominant. Sometimes a pious message is even incised on the outside of a house. It would be interesting to follow up the wealth of motifs more closely. They might be compared with those on wall plaquettes on the Lower Rhine and in Württemberg, and on North German painted window-panes. It is true that the selection and grouping of the subjects appear incidental and arbitrary. Yet it is surely possible to envisage a decorative style which, in the case of incised plaster, was probably chosen by the individual owner or perhaps left to the builder and his assistants. In any case it could not be compared with the number of painted window-panes in a house, since this was usually a collection of gifts. A clue might be provided by a gable-wall in Sichertshausen which looks like a huge pictorial broad sheet. In this particular case the builder was also the owner.[20]

The range of colours was largely confined to white and grey. There are variations in the execution and in patterns, but little sign of steady development. The bulk of what is preserved is of nineteenth-century origin. The heyday of this type of folk art covers about the same period as that of the Marburg wares. It begins early in the nineteenth century and reached its zenith in the third and fourth quarter. We know the names of a number of families of plasterers who enjoyed a particularly high reputation as decorators: Dönges in the district of Biedenkopf, the Ludwig family in Dreihausen among others. Toward the end of the nineteenth century a distinctive change occurred with the appearance of painted timber framework, at first red but later in blue, in competition with the decorated plaster ornamentation. A strip of plaster might also be painted to give the appearance of more massive timber work. In places like Westphalia where timber was readily available, the use of large quantities of wood in building was a status symbol and a demonstration of affluence.[21]

In Hesse the decorated plaster was worked smoothly into the spaces provided by the carpenter. In neighbouring Westphalia wide surfaces were preferred, particularly in the centre of the gable where geometrical patterns adhere strictly to the lines of the woodwork. This is achieved by following the line of the decorative timber struts that lie graduated above each other in the axis of the gable. The decorated plaster might be said to replace timber motifs. A whole separate book would be needed to explore fully the question of mutual interaction of framework and panel patterns in all its many variations, even where the tradition is sufficiently well preserved to make this possible. From Hesse eastwards the form of the plaster decoration soon becomes much simpler. In Thuringia it is often confined to mere wavy lines.

The external aspect of the wall of a house can also be embellished by a suitable design for the facing. Timbering, especially of the gable triangle, suggests that the joints were formed into simple shapes, as in the Spreewald where timbered gable walls were superimposed on cube-shaped houses. This resulted in lozenge and herring-bone patterns which could impart a sense of movement to a whole row of house-fronts. In other regions, such as Westphalia, contrasting coloured zones occur on timbered gables. A more vivid effect was achieved by the use of slate facing. This is found in parts of central Germany, in southern Westphalia and most strikingly in the Lausitz (Lusatia) region of Saxony.[22] The wall, with its rigid outline, could be given a large undulating pattern by a fan-shaped arrangement, like a hand of cards, and the purely graphic effect enhanced by delicate relief. Even a heart shape sometimes occurs, but this is probably the most complicated form that can be achieved by this method. The decorative effect of slate facing is mainly achieved by overlapping the layers.

A whole new aspect of wall ornamentation opens up when we turn to buildings with massive white façades painted by professional artists from the south. The construction and facing do not interfere in any way. The painter is simply confronted by a plain, light surface, broken only by the openings in the wall. Façade painting, unlike timber-frame decoration, should be classified as art history. It was adopted by the most ambitious architects for decorating wall surfaces as well as for producing simulated architectural elements and spatial effects. After cautious beginnings during the Middle Ages, façade painting reached its zenith during the sixteenth century. During the

26

first half of that century, particularly in the work of Hans Holbein the Younger, it already covered all the surfaces of town-house façades, at least on the upper floors, combining decoration with architectural illusion.[23] The close ties between the Imperial free cities of Augsburg, Ulm and Nuremberg and Italian cities made southern Germany particularly receptive to the idea of enriching their streets by paintings. Whether they are naive or sophisticated, they can make a powerful impact. As these paintings were exposed to the weather, we know more about them from drawings and old pictures of the towns than from surviving examples. In Alpine regions this kind of façade painting was also adopted in the countryside. In many cases the walls of peasant houses were less broken up by windows than those of town houses. The transition to the sphere of folk art took place mainly during the eighteenth century under the creative impetus of the Baroque. Upper Bavaria, too, was affected by this, especially the Werdenfels district: one thinks of Mittenwald, Ober- and Unterammergau, the Chiemsee district and the Lech valley.

24
25 Two examples will suffice to illustrate this trend: the so-called Pilate House in Oberammergau, painted in 1784, and the inn 'Zum Husaren' in Garmisch, painted about 1800. They represent at least two phases of the development. The painting on the Pilate House starts, true to the tradition of sixteenth-century mannerism, with the actual wall timbers and aims at a visual transformation of the areas between the openings. This unpretentious but dignified gabled house is painted on the side with the gutter to represent the palace of Pontius Pilate. In front of the simple entrance door is portrayed a round portico with columns carrying a balcony. On this gallery, under an architectural canopy, Pilate is seated on his throne. Two mercenaries are exhibiting Christ to the people. On both sides winding staircases lead up to a platform, and on galleries above the windows are the priests and representatives of the Jewish people. On the right, a man is walking down the stairs.

On the gabled façade of the house, facing the street, the central part is similarly turned into a projecting structure with columns. Above the balustrade, about level with the guttering, in front of a painted niche, Christ is shown rising from the tomb as two frightened guards run away. All this architecture belongs to the late Baroque—the style had been out of date for decades but here it is still a living force. The painted themes relate to each other, as do the simulated ledges and windows on all sides. Whereas on most town houses the architecture form suggested by the painting only occurs on the main façade, in this case it covers the whole detached building. Of course, the illusion is destroyed as soon as the viewer steps outside the axis of reference. This suggests the basic naivety behind such a daring undertaking. With the Pilate House the great art of illusionistic façade decoration has strayed into a side-path of its own and become folk art.

The artist's name is known: Franz Zwinck. We have his signature on five façade paintings and eleven others are ascribed to him. Tradition has it that he learned his trade in Augsburg. He was well versed in the many themes of the Baroque tradition, pictorial as well as decorative, and he varied it freely in his own personal style. On some façades he ignored the real form of the building and boldly painted pictures with a free flowing outline on to the surface of the wall (for instance on the Gerold House at Oberammergau, signed and dated 1778). The formal principles conventionally applied to every type of folk art are not valid here. All the elements have been borrowed directly from highly skilled handcrafts or even from the fine arts. If this is to be called folk art, it can only be for the apparently contradictory reason that in this case highly sophisticated techniques have been employed in a naive manner. The painter must have been a man of profound faith who was not concerned with whether a style was appropriate or not but was willing to take a risk.

Our second example is a case in which Baroque boldness has been transformed into harmless deception with a grain of self-mockery. The artist who decorated the front of the inn 'Zum Husaren' in Gar- 24 misch left the body of the wall untouched but put a frame round it, and also around its parts. The main entrance is surrounded by columns with lions on top and by pilasters supporting vases; the windows are enclosed with a kind of picture frame. Above these is a relief medallion decorated with scrolls and festoons, all executed with a sort of classicism à la bourgeoise. One window seems to be open and two men are looking out of the opening, the hussar who gives the house its name and a civilian with a three-cornered hat. From the beginning the temptation to this type of optical illusion is inherent in the art of façade painting. It is part of its very nature and was already noticeable during its mannerist heyday. These two men are examples of figures painted near an entrance to deter, warn, or at least give those about to enter a momentary illusion that they are being watched. In this case it cannot have been meant very seriously.

Decoration of the house as a whole, not just the wall, offers a far-reaching field of possibilities; the dwelling might be just a pleasant object for passers-by to look at, or might serve to make a neighbour jealous. The decoration might simply conform to a fashionable trend, or else might represent something—it is very difficult to say which motivation might prevail. Part of the decoration of a house could be an expression of faith as with pious sayings and pictures, words of blessing and admonition to envious passers-by. The front door received particular attention. The ornamentation of the lintel, door panel and frame could provide indications of the owner's status. These are just a few examples of the almost infinite variety of possible embellishments.

In the area of the North German long-house the 'Grotdür' (great door), the large entrance on the small side, provided the main access. Most of the decoration was therefore concentrated around this door. In Westphalia especially this gave rise to a separate branch of folk art.[24] In the 1930s the wealth of subjects in the wood-carvings on door-posts and lintels was of great interest to scholars studying symbols and emblems. They suspected that this was the repository of an ancient ancestral tradition. In fact it was merely the result of the new taste for decoration which first appeared in sixteenth-century mannerism. The wavy tendrils design was a continuation of a pattern widespread in early days, but during the eighteenth century variations developed, often confined to limited localities. The decoration

which in the castle and the patrician dwelling-house was chiselled in stone, particularly around the portals, appeared also in the peasant house and often in the middle-class home—carved in wood on the timber-frame façade. The new element in this bas-relief carving and later painting is generally a plant, climbing out of vases on the door-posts toward the head-piece. The lintel bears the inscription: a blessing or the intertwined initials of the names of saints, the names of the original owners and, in rare cases, those of the builder. There is an extraordinary variety and wealth of themes, particularly in eastern Westphalia, in the district of Höxter. Columns are a frequent ornament on door-posts, indicating the change from older designs to Baroque and Classicism.

The variants of ornamentation on the 'great door' of the Westphalian long-house and their distribution from a nucleus on the upper Weser, form a distinct chapter in North German folk art. Owing to the large number of surviving specimens we can follow the changes in pattern that occurred as a result of their dispersion through the region.[25] This is a historical phenomenon resulting from tendencies with their own dynamic. In each case the life-style must be traced from district to district if we are to recognize the promoting and retarding forces which were involved here. Not only decorative forms but also the prevailing types of construction should always be considered in the light of economic factors, such as the size of an individual's holdings. Studies of Westphalian building methods, initiated by Jost Trier and continued by Josef Schepers, have thrown much light on this development.[26]

The panels of the 'great door' were generally left without special decoration. In some regions along the southern part of the North Sea coast the large wooden panels were sometimes bisected by diagonal lines and the triangular fields painted in contrasting colours (green and white, or light blue and white). This treatment is based on a Dutch model. Possibly from Holland, too, came the German marsh-lands custom of painting large pictures of horses on the panels of the 'great door', although it may have spread from large noble estates. 4 The last remaining example of this on German soil is to be found on the Eiderstedt peninsula, well known for its large country houses. This building, the Olufshof at Kathrinenheerd, has another 'great door' with a picture of two threshers holding their flails. Like the horse, they have long been the subject of legendary tales, but originally they simply indicated what went on behind that door, namely threshing the grain harvest. The enormous grain storage areas in the centre of the house were especially erected for this purpose during the sixteenth and seventeenth centuries. A door on another Eiderstedt estate, 'Die Marne', near Garding, bears the picture of a gamekeeper. He plays the part of a watchman, and an accompanying text reads:

> If any man in this house swore,
> He would be quickly shown the door;
> For fear the wrath of heaven should fall
> With punishment upon us all.[27]

This figure's function as a guard is obvious; the same motivation is also recognizable in some rather primitively painted figures of soldiers on South German barn doors (one example can be seen at Unterreitzing near Triftern, Lower Bavaria).[28]

The decoration of house doors is another extensive theme, which it is quite impossible to deal with fully here. Two examples indicate the wide range of possibilities: the double door panel from Jehlhof 55 in the Miesbach district, which is very typical of softwood joinery in Upper Bavaria, and that of the so-called 'White House' at Kampen 2 on the island of Sylt, dated to 1763, an equally representative example from northern Friesland. Clearly, the characteristic features of the houses on this island—the pointed cross-gable without side-walls, the entrance with the central stone tablet above it, the window, dormer-window and cramp-irons—are arranged with a view to their relationship to each other, and are planned as a whole. The door leads into a vestibule which runs across the house and has no window, but receives some light from the fanlight of the door. The transoms of this fanlight consist of a cut-out reverse monogram, F. J. B., the 3 initials of the original founder—an elegant piece of open-work calligraphy. The original builder must have designed the front of the house as a whole.

In North Germany the fanlight of the entrance door is often strongly emphasized. The finest examples of this are found in the Wilstermarsch area, where a picture of a ploughman (the owner) is set into it, again in open-work. The same subject appears in a more 23 simple form, just as an indication of the owner's calling, in east Friesland.[29]

The exterior of a house may also be decorated with single patterns applied to the wall. In northern Germany, when the frame structure of the outer wall was replaced by solid brick, it became necessary to join the bricks to the inner frame by means of cramp-irons. In the eighteenth century these iron braces became expressive symbols. 2 Simple rods were used at first, but these were later transformed into 5–7 numbers, letters and ornamental shapes, were given the form of building dates, builders' monograms, fleurs-de-lis, lively loops—a whole wrought-iron calligraphy which blends charmingly with the lines of the brickwork. The numbers show the passage of time: the correct year can be deduced even when the figures are not complete or are out of order, perhaps as a result of rebuilding. When the light shines at an angle upon a brick wall fitted with cramp-irons, this creates a surprisingly vivid play of shapes. Later in the eighteenth century skilled blacksmiths used reverse monograms to develop elaborate gratings which could imprint their character upon the whole wall.

In some regions of Germany where solid brick buildings predominated, the house was lent distinction by a stone tablet, generally chiselled into the wall above the entrance. In Holland this tablet often took the form of a small token in relief, whose motif was connected not with the occupier but with the name of the house itself. This custom was widely copied in north-western Germany. Elsewhere, however, we find texts with the same content, similar to those carved in the wood of timber-frame houses; they include pious sayings, religious symbols, names or coats of arms of the owners, and an

occasional word of warning for the passer-by. Typically, the development of pictorial tablets and inscriptions of this type in north Friesland goes hand in hand with the elaboration of the iron wall-braces.
2, 8 Only in these two ways could a brick wall become a medium of expression. These stone tablets are similar to tombstones, at least in the way they are worked. Even in the style of such signs a limited rural area may show individual characteristics. On the houses in a small town like Apenrade (Åbenrå) in north Schleswig these stones are almost eloquent. The island of Røm (now, like Apenrade, part of Denmark) developed its own speciality: a pair of carefully worked sandstone posts carrying the garden gate, which took over the func-
8 tion of the stone tablets on houses. An example from 1750 placed above a miller's house on the island of Föhr, shows the family as it was when the house was built. The couple had three children, one still an infant. On the left appears the sign of the owner's occupation, a windmill, on the right the symbol of his faith, a church. Three sayings are added, carefully graded in style and size of script:

1. In peace, in unity and sweet content
 You find the house's finest ornament.
2. As I trust in the Lord's good grace
 He will forever guard this place.
3. The world around us will pass
 And heaven alone remain
 As our true home and fatherland
 And our rightful domain.

Then follow the initials of the owner: T. H., his wife A. T., and the date A. D. 1750. The sequence is not without meaning. First the owner invokes domestic peace, then the Lord's protection for the building and finally makes reference to the hereafter. This sounds almost like the indispensable tripartite division of the conventional sermon.

Antiquarians everywhere have investigated the meaning of the inscriptions on houses. It can often be observed that Protestants prefer biblical quotations and Catholics popular sayings.[30] In Westphalia variations of the texts can be traced from place to place and related to changes in the structure of the house frame into which they are incised. This is an indication of the high standing of the craftsmen who developed and spread knowledge of the basic structure of the houses as well as the store of sayings, and thereby made their contribution to the cultural history of the countryside.[31] As mentioned above, the frame structure of the house had reached an advanced stage. In the upper Weser region this was achieved during the late Middle Ages, largely by replacing the anchor beam by the roof beam. This in turn meant that the building of houses could no longer be undertaken by amateurs but required, even in villages, an expert carpenter. It was he who was responsible for the rapid spread of innovations. There must have been a very swift development in the craft of carpentry all over Germany, particularly during the sixteenth century. German carpenters soon carried their art northwards as far as southern Sweden, where inscriptions in German and German methods of structural joinery may be found.

In many regions, but mainly in northern Germany, there arose a feeling that the large, compact peasant houses would benefit visually from a looser touch in the decoration above the ridge of the roof. The weather-vane, while it certainly serves a useful purpose, was seldom a purely functional object. Here the village blacksmith came into his 14, 17 own. The main vane of the weathercock was cut from a thick sheet of metal into an artistic form, often after the model of cocks or saints' figures on church towers. The farmer also liked to be represented with his wagon or plough. In many instances a leaping horse is found and, as on church steeples, a weathercock, sometimes together with a hen. Some typical specimens are illustrated here. Highly artistic examples could at one time be seen in the Schauenburg district. The long upright iron rod, the axis of the weather-vane, sometimes bore a very elaborate piece of testimony to the smith's handiwork. There are spirals, flourishes, volutes, straight and wavy cross-bars, coronets, petals and spheres—a charming range of shapes and figures, sometimes symbolizing man's reaching for the skies or else a playful mobile exposed to the winds. Here and there, notably in Westphalia, one can distinguish the work of a particular blacksmith. The variety of forms allowed for individual modes of expression. This is most certainly true of some villages in the Sauerland.

The wooden wind-vanes installed on the topmost ridge of straw 18, 19 or thatched roofs stand out above them with their cut-out shapes and these, too, differ from one place to another. Over large areas of Lower Saxony horses' heads are found. In other parts of the country, such as the marshes of the Lower Elbe, swans are to be seen, north of the Wiehen mountains (Westphalia) cocks or peacocks, and in Siegerland sitting rabbits. Elsewhere, there occurs, above the triangle, a carved upright pole, variously called a coxcomb, a stork's stool or (in Holstein) a 'turning cudgel'. It is often finished off with a star-shaped knob. Quite early the idea arose that gable decorations of this type indicated the ancestry of the builder or owner. This interpretation has persisted for a long time but it can be completely discarded. Such gable decorations should rather be associated with the custom of putting up horses' heads (i. e. skulls) in other parts of the house or in the grounds as magic means of warding off evil. However, this is not the place to follow up such speculations. The actual figures are in any event mostly of more recent origin. Those regions where able carpenters and joiners took a prominent part in decorating the interior of the houses are also those where the ends of the boards of the rooftops were lavishly ornamented.

House Interiors

Of all the rich and varied heritage of works of folk art which have come down to us, a very large part is closely connected with dwellings and their contents. Because of its central importance it seems advisable to examine this sphere as a whole. Let us state right away that there are not many sources which provide descriptions of living habits. It would be all too easy simply to compile a list of the material from living quarters that survives, and to deduce from this an imaginary picture of what might be called 'life-style'.

The words 'to live somewhere' imply an activity, an attitude, and the term 'life-style' denotes a set of conventions that govern a community in action, at rest, or in its social life. These conventions alone make the arrangement of a room and its contents meaningful and intelligible. The mere possession of furniture and the choice of interior decoration may often be an indication of affluence rather than of custom. What actually went on in these rooms and how far were these activities regulated? How can one justify speaking about a life-style when we have, for instance, traditional information that during the winter months the peasants on the island of Fehmarn spent most of the day in bed? They were prosperous enough to possess comfortably equipped living-rooms that could be heated, but they did not use them—or only to a limited extent. Fuel was scarce and expensive. For want of wood and peat, cow dung was burned for the most urgent needs—indeed, this was still the custom on the islands of north Friesland only a generation ago. The mere ownership of expensive equipment is by no means always an expression of a civilized way of living. Nowadays we are all far too inclined to equate mere possession of goods with civilized living, which is a great mistake.

Rooms in peasant houses are generally regarded as the best guide to popular customs. They established the standard and maintained the most stable tradition, although this is not often preserved in an authentic form. Museums tend to offer a more or less haphazard arrangement of whatever happens to be found in their collection. Open-air museums provide a more reliable impression because the houses are exhibited as a whole and the rooms inside them are displayed in their proper relationship to the rest of the dwelling, so that one can actually walk through them.

The form of living-room which determined popular residential habits in Germany originated in southern Germany and spread northward beyond the country's borders. This was a room with a stove heated from outside. Whether this room originally developed from a bathroom or some other early form has been much debated, but this point cannot be discussed here. As it spread northward during the fifteenth and sixteenth centuries into the region dominated by the North German long-house it came up against a frame-and-room structure into which it did not fit naturally. All the evidence indicates that it was first introduced as a kind of boxing-in process. The house itself was a single room into which another smaller box-like room was inserted. The central fire-place retained its various functions: it was used for preparing food and fodder, it served as a source of warmth and light, and it provided the smoke that passed through the crops stored above, so preserving them. This combination of functions and all the ensuing problems of space utilization and construction must be borne in mind if we are to understand the difficulties involved in incorporating the stove-room into the house. As a result of these practical considerations the room becomes a separate part of the house and appears to be added on to the building rather than integrated into it. It has a lower ceiling than the rest of the house, e. g. the huge vestibule, and is fitted with guttering. The internal framework, too, is quite different in construction from that of the rest of the house. It would, however, be wrong to conclude that the room was added from outside. The development of the shape of the dwelling area originated from inside. The starting-point was a box-like room, often of very limited size. The stove-room was heated from the principal fire-place, and the smoke was put to use for preserving the crops. This principle led to easier acceptance of such rooms in areas to the north of the long-house regions, such as Schleswig, where at an earlier date the fire-place was fitted with a chimney to draw off the smoke. In this area the harvest was stored on the floor and the smoke was not used to preserve it. In the North German long-house the lack of a chimney was the most obvious feature until the nineteenth century. The inhabitants lived in a smoky atmosphere all the time except when they were in the stove-room, but this did not necessarily mean that they were backward or old-fashioned. The practical advantages of the all-purpose fire-place were preferred to the comfort of a smoke-free residence. Only radical reforms of peasant life towards the end of the eighteenth century, such as the abolition of communal holdings, made it possible to abandon the use of smoke for food preservation, to introduce a means of eliminating it from the house, and thereby improve living conditions outside the stove-room.

This development can only be treated here in highly simplified fashion. The basic principle is that of 'boxing', i.e., of putting smaller spatial units inside bigger ones. This tendency can be seen in

other features of popular dwellings, particularly in the arrangement of the sleeping-places. These consisted of movable beds, the best known being the North German 'built-in' or wall beds. These consisted of little cells behind the wainscoting, closed off by wooden doors or hangings of heavy material. The bed might be described as a space within a space, like the room inside the house. This spatial arrangement was initially due to the need for economy in heating. In some parts of the country this arrangement continued until a radical re-organization of the house, involving the inter-relationship of all the interior rooms, was undertaken much later. A few rare specimens of box-shaped beds are preserved in central German regions. Basically they are survivors of the ancient tradition of the bedstead draped with curtains, which remained in general use in Upper Bavaria and Westphalia well into the nineteenth century. The etiquette for greeting a guest illustrates the fact that in North Germany a room was regarded as a space within a space or, which was originally the same thing, a house inside a house. It is recorded that in the manor-house of Pinneberg the master of the house greeted a guest first in the hall with 'Good day', and then again in the living-room with 'Welcome'—shaking hands on both occasions.[32] Correspondingly we are told by the chronicler Neocorus[33] that in the sixteenth century in Dithmarschen (Ditmarsh) the bridegroom received the bride on their wedding day in front of the door, took her hand, whirled her around three times and gently swung her into the house. He repeated the process on entering the living-room, then still called a *Piesel*.[34]

The spatial order of the living-room itself reflects the orderliness of the whole household. Especially in southern Germany the determining features are the stove in the inner corner and the household shrine in the outer corner of the room. In pre- or early medieval rooms with different sources of light and heat there were evidently different rules of arrangement, as can be ascertained from ancient legal records.[35] A variety of pattern can be envisaged, but it is impossible to establish a reliable reconstruction for the Middle Ages if one thinks of systematic rules. As far as the domestic shrine is concerned, the living-room retained a measure of sacredness right down to the present day—it might even be called a precinct. This illustrates the general trend whereby objects have come to lose their original meaningful function.

In the north of Germany the domestic shrine has a different counterpart in the shape of the Masters' *(Hörn)* Corner, the place of honour for the heads of the family. The Scandinavian tradition, which preserved such concepts of the proper order of things longer than elsewhere, shows the meaning of this arrangement clearly. This seat of honour was the very centre of the patriarchal household. It was situated at the head of the long table around which the whole family gathered, their places being fixed by their rank in the household. The seating order at the main meal is of great interest because it manifests the social order so vividly. This was most strikingly demonstrated on festive occasions; the practice has religious overtones.

Criteria of this type helped to determine such traditional arrangements as the relationship of the bench fixed against the wall to the individual seat and particularly to the armchair. The *Hörnschapp* type of cupboard which is closely associated with the Scandinavian tradition, was commonly used in Dithmarschen and the surrounding countryside until late in the eighteenth century. It only makes sense if it is seen as the repository of the household treasures, set in an ordained position next to the place of honour occupied by the master of the house and in his care. Concepts of this kind show clearly what is meant by the term 'life-style'.

There is another angle to this question. There must have been a meaningful connection between the customary arrangement of the dwelling and the dowry of a bride or marriageable daughter. The importance of transferring the bride's possessions to the dwelling of the young couple is well known. This public exhibition of the dowry served as a decisive statement of the bride's status. The vehicle which transported her goods was generally known as the *Kammerwagen* (chamber wagon), and could sometimes be more significant for the prestige of a budding housewife than the equipment of the living-rooms in which she later dwelled. In South Germany the main item in the 'chamber wagon' was always the wardrobe. One might ask whether its general shape and ornamentation were not often designed specifically to make a fine impression on the great day. It was destined for the bed-chamber, as the word 'chamber wagon' indicates. It contained all the necessities for the sleeping quarters of the couple, not for the living-room.

In North Germany the main item in the bride's portion was undoubtedly the chest. Like the wardrobe, this was not a piece of living-room furniture. It was placed in the vestibule or in an unheated room which also served as a store-room. In the living-room itself, with its built-in wall-spaces, bed and cupboard, there was no room for the bedstead, wardrobe or chest to show to advantage. The preference in the north for wall beds meant that there was no need for a movable bed such as was the principal item, next to the wardrobe, in a bride's portion in many other German regions. It was not a piece of furniture but was used only for storing bedding. In North German peasant homes bridal chests often accumulated over several generations, mostly in storage places such as lofts. It appears that their role as a showpiece did not last long after the wedding.

Today it is hardly possible to visualize precisely the conditions which once prevailed in such matters, much as this would be desirable for an evaluation of individual pieces and of the furnishings as a whole. A systematic study of inventories of deceased persons' estates might still afford an occasional insight, but so far this has very rarely been undertaken. One of the many unanswered questions in connection with furniture concerns the value that was attached to inherited furniture which no longer conformed to current fashion. How far were people prepared to bring such pieces up to date by altering or re-painting them in the currently fashionable style? It is only from examples of this treatment that we could deduce the degree of value attached to the old and the new, and so learn what was regarded as precious, beautiful, representative, etc., and what was expected in regard to uniformity of style such as we take for granted today.

and, as in Württemberg, the couch between stove and wall or the steps leading up to the bedchamber. A unique feature found in Lower Swabia is the covering of the sides of the stoves with painted tiles; we shall have more to say about them in the chapter on ceramics. The stoves themselves, their construction of tiles and their ornamentation, are too large a subject to deal with here. A regional feature is the retreat *(Kabinettle)*, a corner separated from the room by a wooden partition, found in Franconia. This indicates a greater demand for privacy and intimacy, and a tendency toward specialization. This tendency spread very widely during the nineteenth century until it finally destroyed the former close links between the household community and the table.[40] Some rooms near Hirschberg merit special mention because of the outstanding painting on their walls and ceilings. Large rambling scrolls or strongly contrasting patterns based on imitation of marble convey an impression of festive excitement, as well as of certain restlessness, over the whole surface.[41]

In spite of all the changes in household and living modes, in many rooms of Catholic areas the sacred corner, the domestic shrine, still survives up to the present day. Here we find the crucifix, the 'deity of the home', surrounded by devotional pictures. The objects placed here include symbols of holy days or seasons. In Protestant homes, in Württemberg for instance, the corresponding corner of the room often contains a shelf for the Bible, prayer-book and hymnal.

The adaption of the room with the stove to the North German long-house proceeded step by step, but at a different pace in different regions. About thirty years ago Josef Schepers studied several phases of development of rural living quarters and the way living space was used. He based his observations on Westphalia, where plentiful information is available on the development of housing, at a time when these developments could still be discerned in buildings that were still standing. Some of these exemplified developments in a particular area, while others exemplified the oldest type of building.[42] They provide vivid illustrations of the fact that examples from different periods coexist.

Stage 1: In the Dutch region of Twente the so-called Losshaus was still standing, a building without division into rooms. The smoke from the fire-place penetrated into every corner and the impression of the interior was 'rough and ready'. Any concern for quality of life had to take second place to economic requirements (preservation of the grain by the smoke). The single-room dwelling had to serve all the needs of the men and animals that lived in it.

Stage 2: The peasant home of the Münsterland has adopted the living-room. Certain activities no longer take place in the general hall but rather in the kitchen, which was now a separate room, and in the 'winter room'. The functions of 'dwelling' are distributed over several parts of the house, often changing according to the seasons.

Stage 3: The Sauerland house contains a living-room in late eighteenth-century style. The old way of living, which had been tied to the room with the fire-place, is discarded in favour of a room in which all the occupants could conduct their everyday affairs.

Stage 4: Apart from examples from the second stage, the Münsterland provided a new development in the nineteenth century: several living-rooms next to each other, including a 'best room' and a little room beside the main one. Specialization had reached the stage of distribution over several rooms.

Stage 5: Modernization has prevailed. The main focus of habitation is located 'between the country house and the stables'. The dining-room and drawing room are copied from the town house.

The first stages in this sequence mark the decisive change which took place from the fifteenth century onward, affecting the whole range of the North German long-house at different times. North of this area, in Holstein and even more so in Schleswig, the room with the stove clashed with the existing room with the wall stove, known as the *Pesel*. As a result, right up to the north of Jutland there were two types of living-room in most houses: the ordinary room *(Dörns)* and the *Pesel*, which had the dual function of festive room and granary. It soon lost its fire-place because everyday life was generally conducted in the *Dörns*.

We shall discuss the living quarters in the northernmost German regions in rather more detail because from the nature of their equipment we can formulate, though not conclusively answer, certain questions of general importance.[43] Their specific character does not lie in their furnishing, because box-type furniture does not occur there and the seating, at least up to the seventeenth century and sometimes later, was fixed to the wall. Movable equipment, i.e. furniture proper, was confined to the table and very few chairs. Since the stove consisted only of a comparatively small box of cast-iron plates without a large superstructure, it did not dominate the room as the South German tile-stove did. When the living-rooms were tidied up they gave the impression of being empty. The north Frisian expression for tidying, *te kant,* means that everything is put back against the walls. The table belongs in front of the wall-bench. Even the individual seats, which were introduced later, usually stood against the wall and were put in front of the table only when they were being used. One might even say that the life of the inhabitants was largely spent along the sides of their living-rooms. This trend, antiquated as it appears, persisted in some places right into the present century. To sit down on a special individual seat rather than on a particular part of the wall-bench, to sit on a separate chair in the room, was the privilege of the head of the household. It expressed the patriarchal principle that governed peasant family life.

The room appeared particularly empty because all containers, including beds, were concealed behind wooden wainscoting into which small and large cupboards, even clock-cases, were set. Thus by moving the wall of the room into line with the front of the furniture the available space was greatly restricted. This became necessary when heating materials became scarce toward the beginning of the modern era. To go to bed the inhabitants climbed through openings in the wall into wall-beds enclosed by wooden doors or curtains.

The overall aspect of the room was therefore determined by the arrangement of the walls, including their colour and decoration. The room panels of the North German regions, mainly in the area from the Vierlande to north Schleswig, preserved sixteenth-century ideas of proportion right into the nineteenth century. They consist of a

framework with comparatively small surfaces. About a quarter of the way from the top the panelling is traversed by a cornice, or at least by a shelf. The flaps and doors to the partitioned sections lie flat against the surface. The openings to the beds are often difficult to see at first glance. In the eighteenth century a more façade-like arrangement with a symmetrical tendency came to the fore. Frames like portals surround the beds and later even the wall-cupboards.

The iron stove, fuelled from the kitchen, had the advantage of warming the room quickly. The section of the wall where it stood was covered with wall tiles. These stored the heat and gave it off slowly. Wall tiles, especially in the coastal regions, were readily available from Holland. They also prevented any moisture from creeping in from outside. Thus in the eighteenth century and even later living-rooms covered all over with Dutch tiles, belonging to sailors, are found on the islands.

The spatial arrangements should be understood as a means of forming a functional setting for a patriarchal community. The technicalities of the residents' trade, and the economic, social and cultural conditions which governed the development and regional differentiation of housing must be taken into consideration. The pace-setters for the more elaborate type of room fixtures were the areas dominated by large-scale farmers. The marshlands especially flourished in the early capitalistic period of the sixteenth century. Later other regions, such as the islands of north Friesland, which derived their prosperity mostly from sea voyages to Greenland during the eighteenth century, followed suit.

The area in which farm-house living-rooms take on a more pronounced individual form has its heart in the country around Hamburg, the Altes Land and the Vierlande. The influence of the nearby thriving commercial centre of Hamburg is immediately apparent. The farmers profited from the city's need for their produce, and adapted urban items of equipment to their own way of living. Among these was panelling interior walls and facing outer walls with Dutch tiles. One of the oldest preserved rooms, dated 1653, transferred from Neuengamme to the Historisches Museum, Hanover, already features the division of panelled walls into zones that was becoming the rule. The base is of brick, covered with tiles. Above this comes the framework of the panelling to the height of the sliding wall-bed doors, divided into two sections and ending at the lintel. Above this the panelling continues right to the ceiling. The upper surfaces of the sliding doors are particularly vividly decorated, as are some of the panels, on which the topmost area features a carved arch with an intarsia star inside. The ceiling is coffered and on the surfaces of the beams are carvings in Renaissance style.[44] The overall impression is determined by the interaction of the unpainted dark oak panels and the glittering bluish tiles.[45]

This order governs the scheme of arrangement for the next two centuries. The frame level with the lintel may be elaborated into a cornice and finish off the panel at the top. The panel may also extend over the brickwork base at the bottom. The pattern of the wooden panels remained more or less the same. A room from 1681, which stood at Neuengamme, known only from pictures, shows wood

panelling on three walls. A little later, the people of the Vierlande constructed the living-room in a corner of the dwelling. After this wainscoting is confined to one inner wall, the one from which a door leads to a small chamber next to it. Only after the end of the seventeenth century did facing with wall tiles become a general feature, often at the expense of the wooden wall covering. In the Vierlande confining panelling to the one wall did not lead to a kind of façade with an architectural motif. It remained a joiner's job with framed panels. Alongside these constructional motifs, the style of decoration which had begun with intarsia stars survived well into the nineteenth century. The themes changed but, like the furniture from this area, joiner's work on walls was dominated by plain woodwork inlaid patterns. 27, 29

The influence of the carpenters' and joiners' crafts, which was very strongly entrenched in Hamburg, extended northward into the marshlands on the right bank of the Elbe. Here the large farmers who dominated the area arranged their long-houses differently from those in the Vierlande. A large group of joiners settled in this area, mostly at Wewelsfleth, certainly also at Wilster, and were apparently closely linked with builders who not only built houses but also equipped them. Large vestibules extended through the whole length of the house, terminating at the room that could be heated (the *Dörns*) and at the unheated summer room. There is no small chamber such as is found south of the Elbe. The particularly grand house form which developed in the marshlands of the river Elbe apparently dates from the early eighteenth century. With it there emerged the classic arrangement of living quarters. The room with the stove, which was primarily a living-room during the winter but served as a bedroom all the year round, was next to the summer room, which was generally larger and was reserved for festive occasions or as a bedroom for visitors; in this we may see a combination of the rivalry between the *Dörns* and the older *Pesel* referred to earlier. The heated *Dörns* is always fitted with coffered wainscoting of unpainted oak, and the summer room with coloured large-scale decoration, often on the wall, panelling and ceiling.

The rooms of the Wilstermarsch[46] have become well known because many of them are showpieces which have been transferred into museums. Collectors have dispersed their panels in all directions; they can be found anywhere between Holmenkollen near Oslo and Garmisch in Upper Bavaria as often as on the island of Sylt. One example even found its way into the imperial palace in Berlin. Impressive examples are on view in the Museum für Kunst und Gewerbe in Hamburg, in the Germanisches Nationalmuseum, Nuremberg, the Schleswig-Holsteinische Landesmuseum, Schleswig, the Municipal Museum, Flensburg and the Open-Air Museum in Kiel.

When a particularly fine room arrangement of 1750, from the house of Peter Hass in Grosswisch, was built into the Altonaer Museum in Hamburg, the museum authorities unfortunately yielded to the temptation to combine the beautifully painted ceiling of the summer room with the panelling of the smaller *Dörns* in order to enlarge it. The same procedure has been adopted elsewhere. This

created a false impression of spaciousness and the wall structure was dislocated. But it is in precisely this feature that the Wilstermarsch heated room *(Dörns)* excels. The coffering of the inner walls retains proportions which probably stem from the seventeenth century. The wainscoting is fitted with wide, raised inserts, some of which are octagonal and perforated, others hexagonal and cranked. The inner surface often shows an intarsial star—a legacy from the seventeenth century. The glazed wall cupboard above a door and the frame of a spy window through which the inhabitants could look out into the vestibule may be decorated with carving. Rooms with this kind of arrangement appear very refined, an effect emphasized by the restrained use of colour. The stove is constructed of cast-iron plates; the portion of the wall behind it is usually tiled and topped by the clothes-drier for small garments; some brass utensils hang nearby. The overall impression is created by the harmony of the undyed materials. If the room is in a corner of the house, both outer walls are covered with tiles. A cupboard is set in the corner. It may be of the wall type or stand on a base, and its front blends with the forms of the panel. There is very little furniture; the table with baluster legs, like its surroundings, reflects the Baroque tradition.

Where the living-rooms of smaller farms differ from those of larger ones is in the width of the embossed surfaces, in the abundance of carving and sometimes also in the height of the rooms. The scheme as a whole and the system of wall arrangement are essentially the same. Even the change of style toward the end of the eighteenth century had only a limited effect. The decoration of the panels became flatter and the individual forms more sparse and severe. Only in the course of the nineteenth century did the system as a whole cease to function.

The relationship of rooms in the Wilstermarsch to those in nearby south Dithmarschen deserves some attention. This area, too, was dominated by large farmers but the Wilstermarsch style was not adopted and even the furniture was significantly modified. Housing here seems to have gone through an extensive transformation toward the end of the eighteenth century, so that the older forms of living-room are no longer found. The famous *Pesel* of the powerful farmer Markus Swin at Lehe near Lunden, a masterpiece of craftsmanship dated 1568, probably had more modest successors; it can hardly have created a new school. What remained of the original can be seen in the Dithmarscher Landesmuseum at Meldorf.

Here, in the Municipal Museum in Flensburg, and in the Schleswig-Holsteinisches Museum in Schleswig are living-rooms from the southern part of Dithmarschen dating from the period of renewal around 1800 which have a common origin. The traditional coffering of the wainscoting is missing, its place being taken by impressions of façades, pillared portals and arches marking the openings to the beds and wall cupboards. Fluted grooves, with curved tops and capitals, form a curious mixture with bas-relief carving on the door panels and Regency garlands above the doors. In the decorative detail reddish-brown paint on the large surfaces contrasts with patches of colour and gilding.

The Eiderstedt peninsula, north of Dithmarschen, with its large barns was never affected by the long-house type of dwelling. It can boast only a few individual façade-like wall panels.

An individual form of room arrangement is found in the rest of north Friesland, between Husum and Tønder (which, since 1920, has been Danish).[47] The inner framework, of recognizable medieval origin, allowed only comparatively small rooms. On the islands, the so-called Utlanden, a few such houses are still standing. An early exemplar of equipment in Renaissance style is preserved in a room *(Dörns)* of 1637 which has been transported from Nieblum on Föhr to the museum in Flensburg. There are wooden interior walls with openings for wall beds; all the other receptacles, too, are built into the wall, and a fixed bench runs along the window wall. The ceiling dips, following the house frame, toward the window—a feature which gives rooms constructed in this way their characteristic lighting. The coffering of the wainscoting, corresponding to that of the Elbe marshlands, still bears the same decoration: arches with scale patterns and scrolls.

The *Dörns* of north Friesland create a peculiar effect determined by their function in a sternly patriarchal, yet intimate way of life. True, the system as a whole remained constant for a long time—until far into the nineteenth century—yet very different variations developed in the equipment, contrary to what happened in Wilstermarsch. Here people often had to be satisfied with softwood, which was painted with small, stereotype landscapes, as in the example from Sylt in the Municipal Museum, Flensburg. Quite often the interior wall was constructed of upright tongued boards instead of a framework with panels, when no opening for small spaces was required. From a distance this may superficially resemble medieval living-room walls from Tyrol. The interiors from the small Hallig Hooge alone—the oldest is dated 1688 (Municipal Museum, Flensburg)—show how much variety of equipment and arrangement was possible in such a restricted area. (Other Hallig rooms can be seen in the Germanisches Nationalmuseum, Nuremberg, the Altonaer Museum in Hamburg and on the Hallig itself.) They may have been considerably influenced by the fact that they were designed for ships' captains with worldwide experience and for captains of whalers. The artisans, joiners and painters probably lived in Husum. From there the islands were supplied with most of their requirements. The wall tiles were usually brought from Holland by the sailors themselves.

The capacity of the houses on Hallig was severely restricted by the extremely difficult building conditions. On the larger islands of Sylt, Amrum and particularly Föhr, space and prosperity allowed for a second living-room, the *Pesel*. It was usually very different from the *Dörns*: it was larger, often had brick flooring and was without heating facilities. The walls, too, when painted, were deliberately decorated in different colours. However, the interior walls had recesses for beds, as did the *Dörns*, and one could enter the bed-space from either room. For the rest of the time the *Pesel* was a store-room and was ordinarily treated as a room to put things away. It came into its own on family occasions. Then it was tidied up, decorated and, if necessary, heated with braziers. Some of the older houses also had a 'death door'. This was a bricked-up or firmly locked door which was only broken open

25 Façade (overlooking the garden) of the so-called 'Pilate House', Oberammergau, Upper Bavaria. Painted by Franz Zwinck, 1784. Detail.

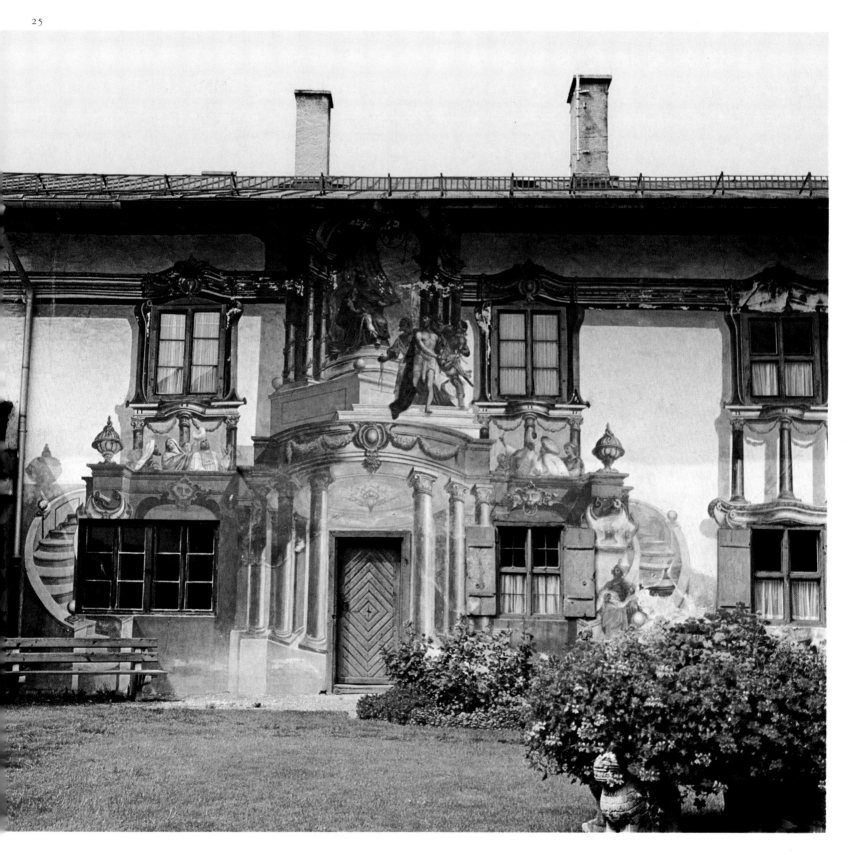

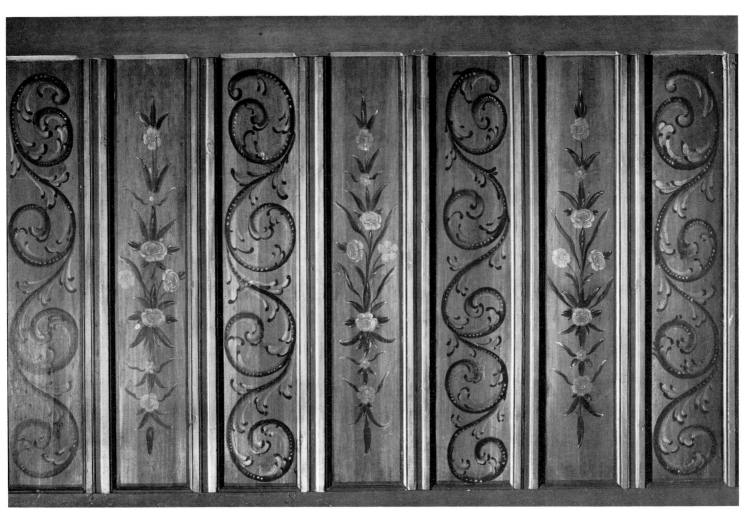

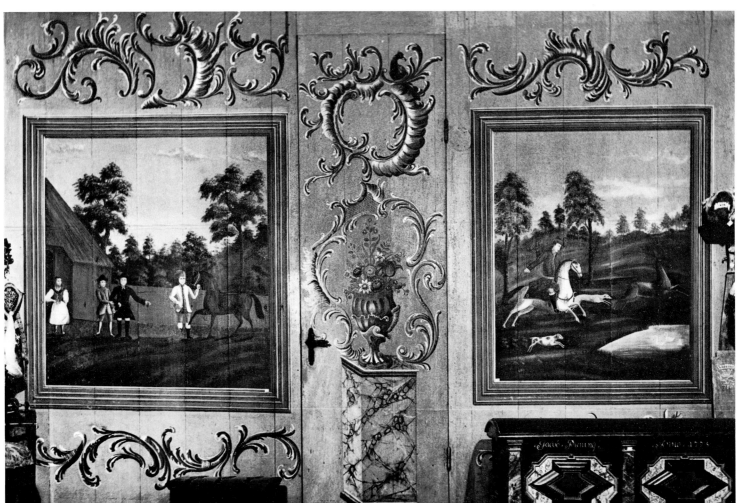

26 Room panelling. Softwood, painted. End of 18th century. From Viöl, Schleswig.

27 Wall panel from a room. Pine, painted. *Circa* 1772. From the 'Haus Robert Rave', Moorhusen, Steinburg district, Holstein.

28 Detail of a painted ceiling in the room of a peasant house on the island of Fehmarn. *Circa* 1780.

29 Corner of a summer room ('summer house') from Honigfleth, Wilstermarsch, Holstein. First painted during the middle of the 18th century.

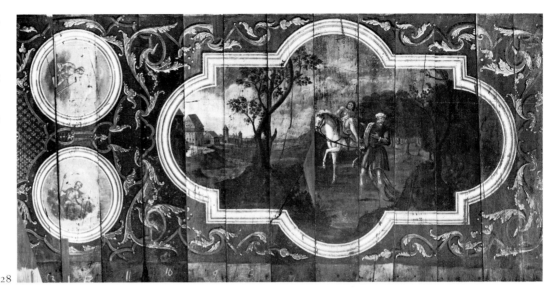

28

29

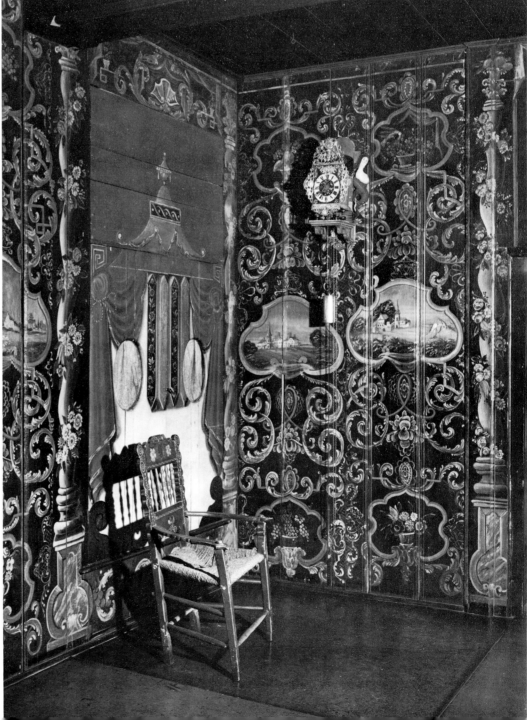

30 Pesel (summer parlour) in a peasant house from Ostenfeld, near Husum, Schleswig. 1673. Built on to an older house.

31 Room *(Dörns)* from Hallig Hooge, Schleswig. 1669.

32 Room *(Dörns)* from the Boie Lau House at Westerbüttel, Dithmarschen. 1792.

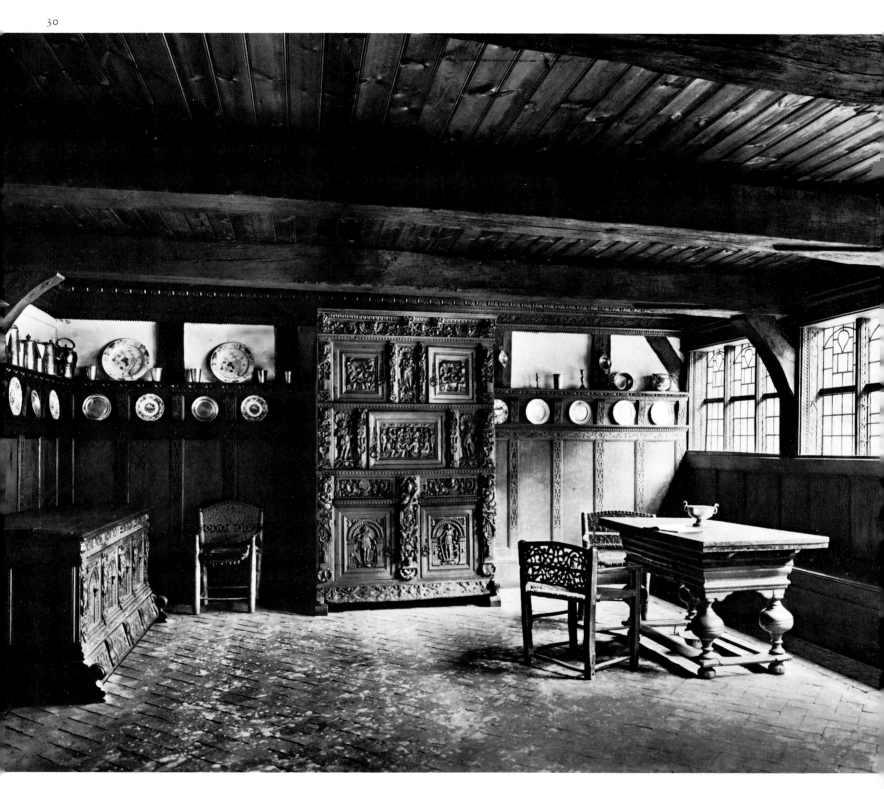

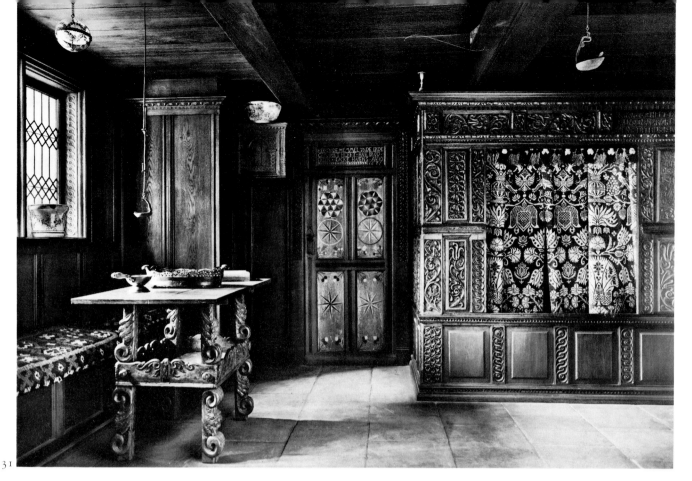

31

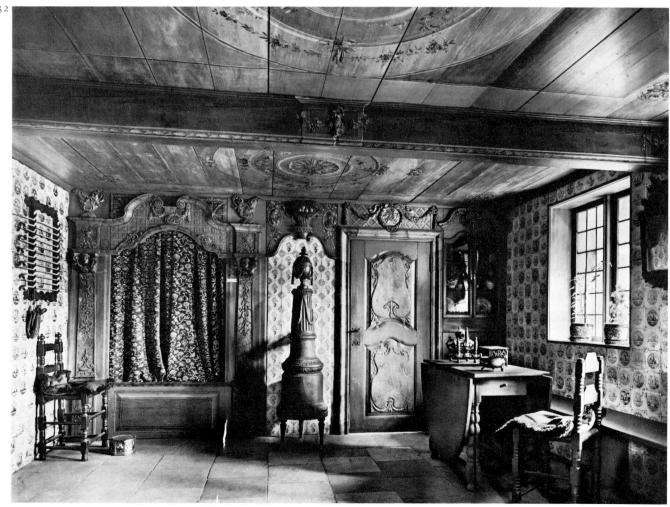

32

33 Room *(Dörns)* from the Albert Reimers House, Grosswisch near Wewelsfleth, Wilstermarsch, Holstein. 1759 (or a little later).

35 Inglenook in a room *(Dörns)* from Bendfeld, Probstei, Holstein. *Circa* 1720.

34 Room from Nieblum, island of Föhr, north Friesland, Schleswig. 1637.

35 ▷

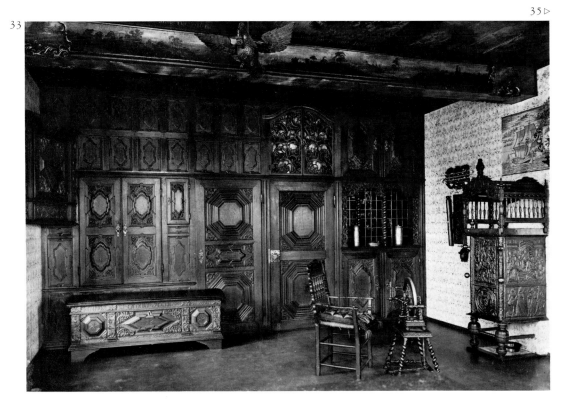

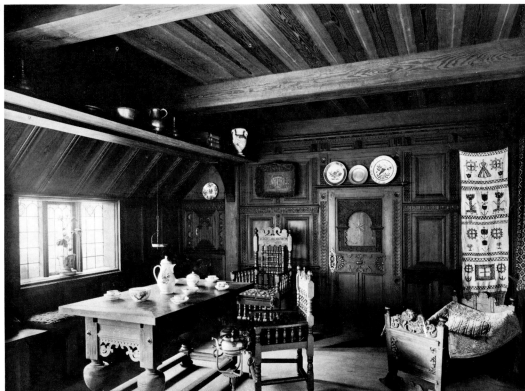

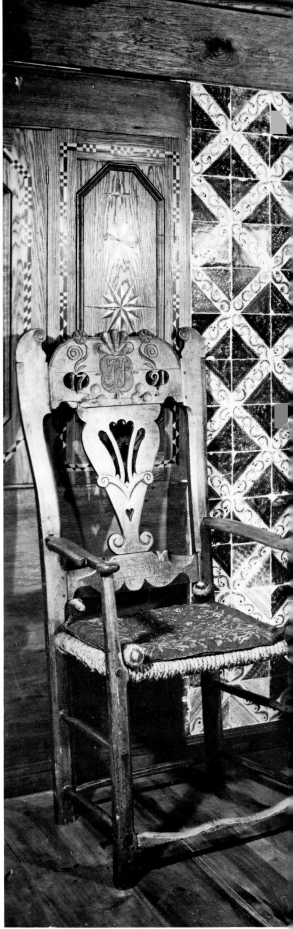

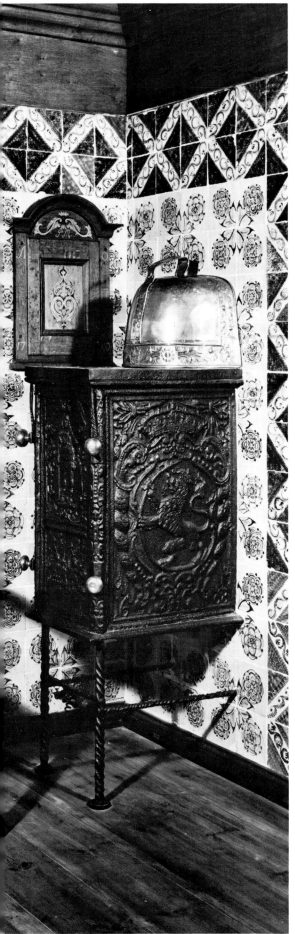

36 Room from Kirchwerder, Vierlande, near Hamburg. 1812.

37 Room (*Dörns*) from Schönberg, Probstei, Holstein. 1723.

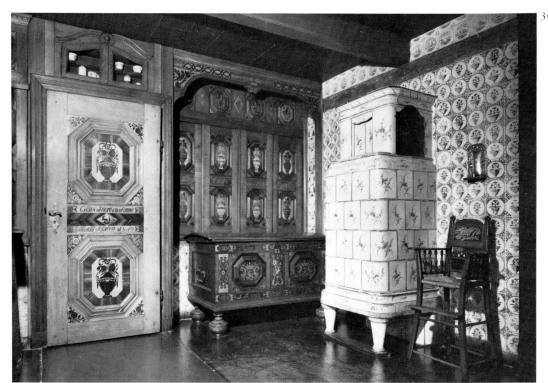

36

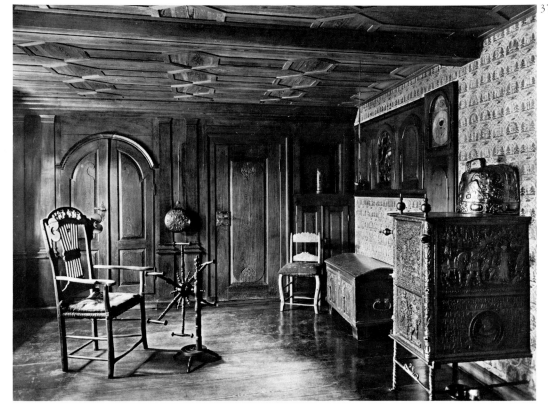

37

38 Room of the main house from Kleinenheerse, Min-
dener Land. 1780.

39 Room at Grossenohe, near Kappel, Forchheim dis-
trict, Upper Franconia.

40 Room in the Rambart-Hof (?), Dreisam valley, near
Freiburg, Breisgau, Baden.

38

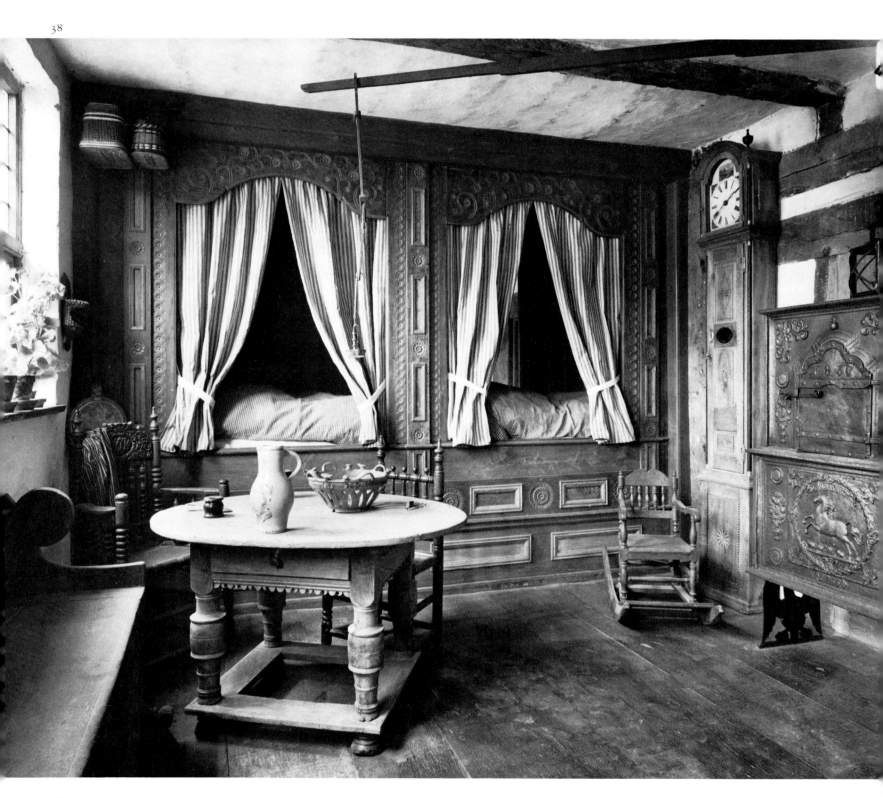

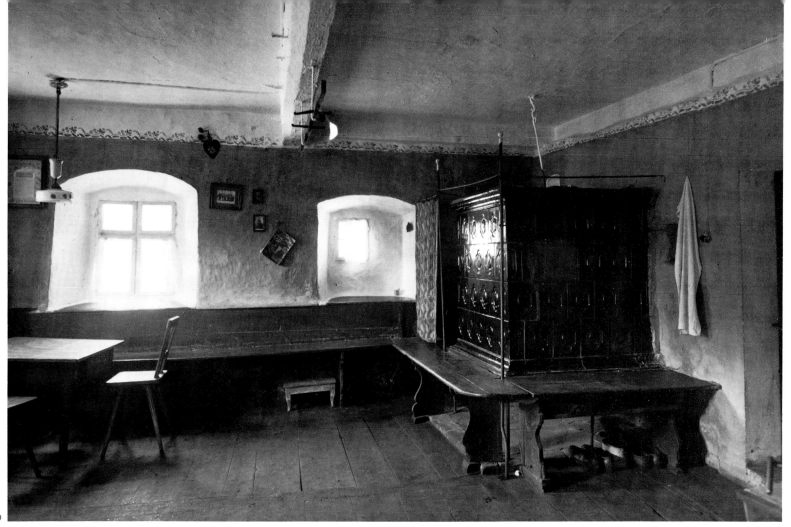

39

40

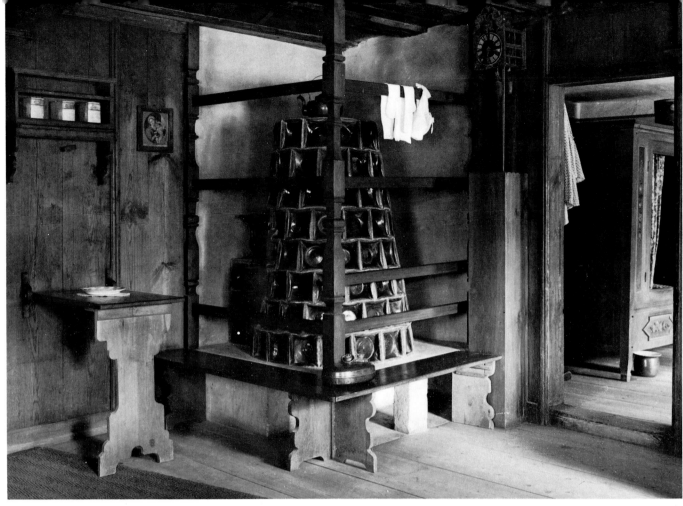

41

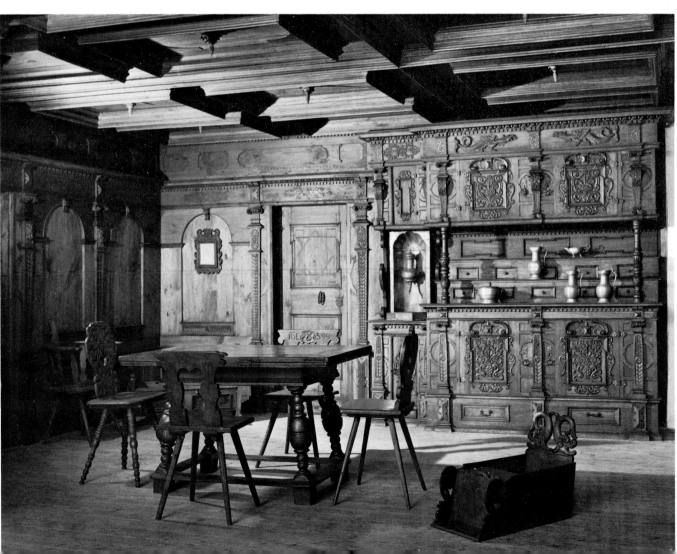

42

41 So-called 'Upper room' of a peasant house in Unter-
hasel, Thuringia. 1667.

42 Room from Thurgau, Switzerland. 1666.

43 Room in the so-called 'King's House' on the Hans
Wharf, Hallig Hooge, north Friesland, Schleswig. After
1776.

43

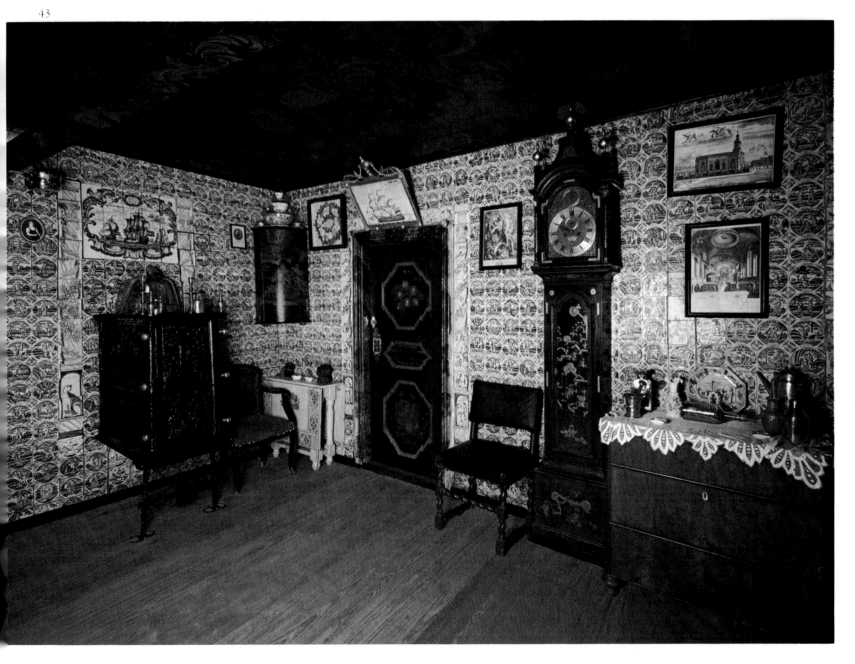

44 Room from the Inn valley, Tyrol. 1702.

45 Inglenook in a room from Sonthofen, Allgäu. Beginning of 19th century.

46 Room in Schliersee. 1842.

47 Room from the Eggental, Allgäu. 1806.

44
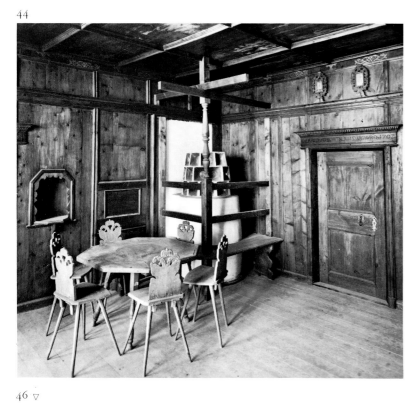

45
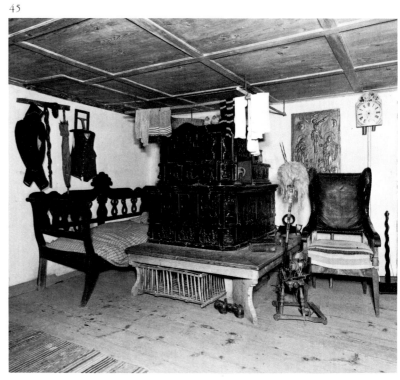

46 ▽
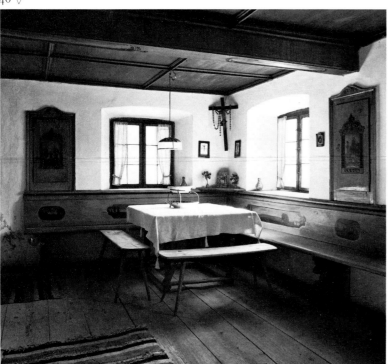

47 ▽
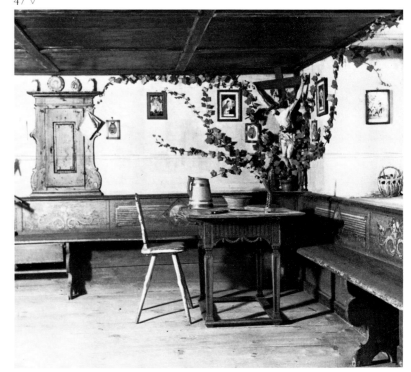

48 Door of a room *(Dörns)* from the Peterswarf on Hallig Nordmarsch, north Friesland. Oak, painted in colours. 1774.

49 Door of a room. Frame and panel. Softwood, painted *circa* 1800. From the island of Föhr, north Friesland, Schleswig.

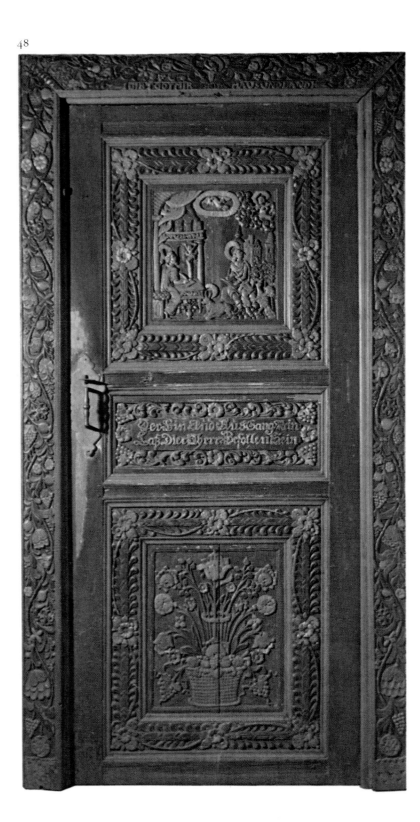

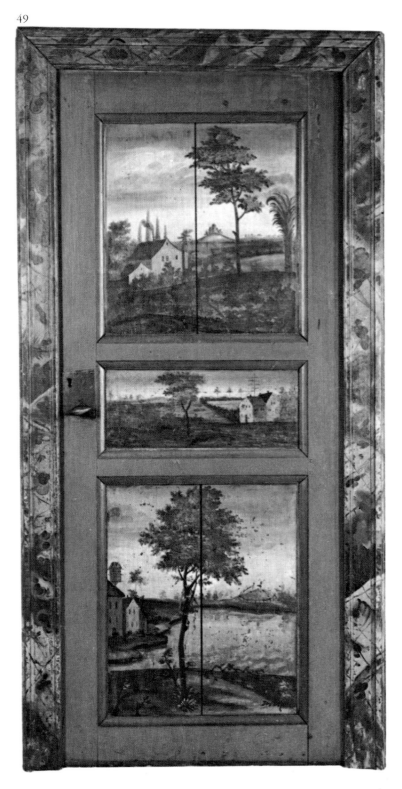

54 Door of a room. Pine. End of 18th century. From
the island of Föhr, north Friesland, Schleswig.

55 Entrance door to the Jehlhof, near Gotzing, Mies-
bach district, Bavaria. 18th century.

54

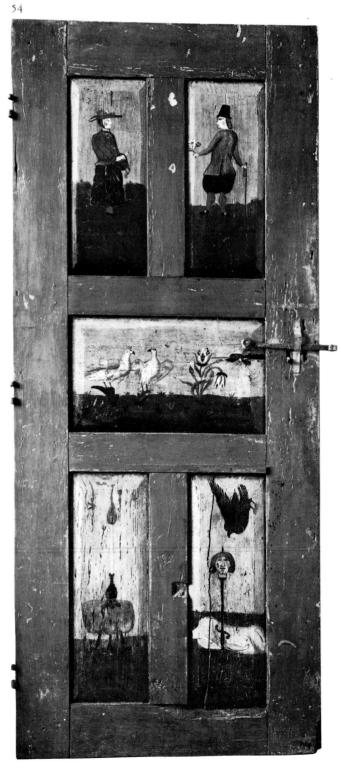

55

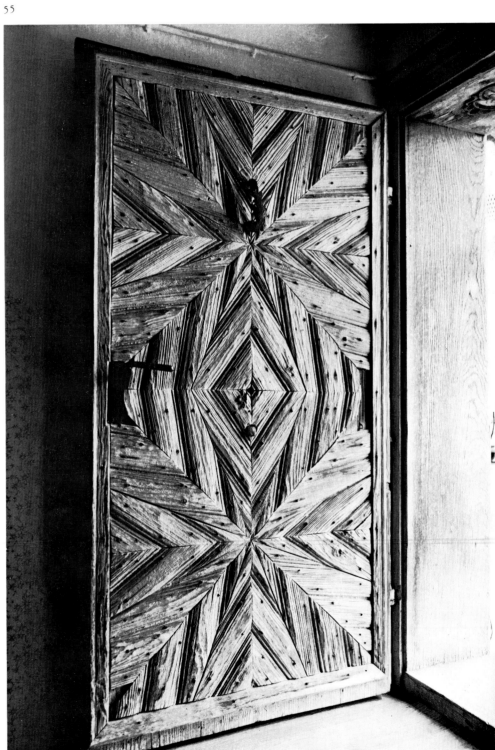

to allow a corpse to be taken from the house, whereupon it was closed again immediately. It led directly from the *Pesel* into the open. In the Elbe marshes it had a parallel in the 'bride's door' which was only opened to release the daughter for her wedding. There was to be no return for either the dead person or the bride. Such arrangements convey an idea of the archaic beliefs which influenced living conditions in the not very distant past.

Apart from such ancient relics, a religious spirit pervaded the house that found expression in the rooms. The domestic shrine had no true counterpart in the North German room. The people's faith was often expressed in sayings; the word meant more than the image, though that, too, was by no means unknown—from paintings on walls and ceilings to painted wall tiles and woven chair cushions. In this respect north Friesland excelled. In its Renaissance wall panelling as well as in religious symbols, it preserved the spirit of the sixteenth century, the age of the Reformation. Sayings were carved into the struts of the framework of the wainscoting in bas-relief. The severe Roman lettering fitted like a frieze into the oval rods and embossed mouldings, yet stood out clearly. For instance, in a room on the island of Föhr, between the ceiling and the window lintel, we read in monumental letters: 'Delight thyself also in the Lord; and He shall give thee the desires of thine heart.' Or: 'Commit thy way unto the Lord; trust also in Him; and He shall bring it to pass.' (Psalms, 37). The door panels also bore quotations from the Bible or other pious sayings, quite often reminders of our fleeting lives:

> Whether you open or close this door,
> Remember, O man, you'll soon be no more.

Door panels generally carried weighty sayings. Everybody had to pass by them, handle them or stop in front of them. From the island of Föhr comes such a door panel, probably from the early eighteenth century, which is now exhibited in the Schleswig-Holsteinisches Landesmuseum, Schleswig. It contains three appeals: 'Forsake me not, O Lord: O my God, be not far from me' (Psalms, 38); and: 'O man, thou art like the flower of the field/that blooms beautifully to-day and is blown on the morrow.' This last saying is surrounded with flowering tendrils. They represent roses and tulips, the flowers which symbolize life and its decay on tombstones of this and later eras. In another house at Nieblum on Föhr are the words:

> Be my guardian day and night,
> That I may dwell in safety.

In this case only the beading with the inscription is preserved, but it can be deduced from the text that is was set above the opening to the wall beds. Where the wall beds were enclosed behind wooden doors, pious admonitions were generally placed on the door panels in pictures and in writing. We have four door panels from the openings of wall beds in a house at Wrixum on Föhr, each painted with one of the four principal virtues. Faith opens the sequence:

> The men of faith cling to the word of God
> While through life's stations of the cross they plod.
> It may the cross or wine of joy provide —
> The faithful ever take it in their stride.

Furniture: general

From the 1820s onwards painters have sometimes noted and recorded in their sketchbooks the characteristic quality of rural, mostly peasant furniture. Toward the end of the nineteenth century it began to arouse more general interest. People began to appreciate its structure, its ornamentation with painting, carving, and intarsia, or simply to emphasize the decorative quality of its construction. What was particularly appreciated was its 'pictorial quality', mainly because during the nineteenth century the art of painting was generally regarded as superior to all others. This no doubt was the reason why early publications on the subject dwelt largely on rural furniture which excelled in linear two-dimensional decoration: works of this type were Franz Zell's illustrated book of 1899 on the furniture of the Bavarian highlands and Justus Brinckmann's monograph of 1894 on the Museum für Kunst und Gewerbe in Hamburg, with its display of intarsia furniture from the Vierlande near Hamburg. As happened in many other fields of folklore research, subsequent studies of the preserved material were largely confined to areas of limited local interest. Basing their ideas on superficial appearance, scholars began to talk of 'painted peasant furniture'. This in turn gave rise to a parallel category of 'carved peasant furniture', and thus fixed in the minds of many people the unfortunate idea of a contrast. True, each form of decoration may exist exclusively in certain regions and certain periods, but their essential features can only be understood if they are studied in connection with each other.

The most varied demands may be made on a piece of furniture. It must serve certain practical purposes, and its manufacture depends on the availability of suitable timber and on craftsmen's skills. It is a symbol of status and of wealth and represents, in the domestic setting, the standards of a certain social group. Its primary function is to satisfy both the practical and the expressive concept of what a dwelling is supposed to mean. These concepts may not always coincide with actual day-to-day practice, and often the display may be excessive. Differences between function and display existed in the traditional way of life of all classes in society, just as they still exist today. Inherited property and age-old habits have always been exposed to conservative and innovative tendencies. More than virtually any other traditional item, furniture exemplifies the choice that has to be made between them. It is impossible to express this process statistically, i. e., to quantify comparable phenomena. Not only the function but even the origins of individual pieces of furniture are too complicated for this, and it would be even less feasible in the case of all domestic equipment. In any case, the process whereby furniture developed into an art form cannot be expressed in figures.[48]

It is commonly accepted that the chest, as an item of furniture for storing things, is earlier than the cupboard. However, such a statement is meaningless in this general form unless one defines what is to be stored. It is correct in the case of outer clothing: before this was hung up in a wardrobe, it was stored in a chest. However, cupboards for other purposes existed earlier. The North Germans from the late Middle Ages on, derived the word *Schrank* (cupboard, wardrobe) from *Schranke,* i.e. a wall closing off a niche. Originally, therefore, it was not something movable, not a piece of furniture. In contrast, the portable southern German box and container were movable. In North Germany the wardrobe as a receptacle for clothing only came into general use during the seventeenth century, and in the rural setting even later. This was probably due to changes in clothing fashions, in the bulging clothes that came in with the Baroque, and to increases in the quantity of clothes to be kept. This indicates that the choice between chest and wardrobe was not just an arbitrary one. When the North German chest was emptied of outer clothing it became mainly a repository for linen and underclothing. This presupposes that linen was becoming an increasingly common article of daily use. Up to the end of the eighteenth century a woman's skirt consisted of sheepskin worn next to the skin without underclothing, particularly in remote areas like the islands of north Friesland. Bed-linen, too, was only introduced later. In the course of centuries the stock of underclothing in households increased. This was due not only to increasing affluence or refinements of cleanliness, but to the necessity to do as little laundering as possible. There were good reasons for this, which we do not need to discuss here. The chest thus took over the function of a receptacle for linen in North Germany and thereby remained indispensable. As we know from the model arrangement of the 'chamber wagon' in southern Germany, here, too, the wardrobe was used to house articles of flax and linen, and the interior was much more frequently partitioned than it was in the north. One part served to hang outer clothing, while spun yarn, underclothing etc. were stored in other compartments. If such aspects are neglected wrong conclusions are all too easily formed, in this case regarding the continued use of the chest in the north. The relative importance of chest and wardrobe, their place in the home, their status as an heirloom and their possible re-use as a part of the dowry in later generations after repainting or alteration—all these different matters undergo endless changes from time to time and from place to place.

Investigations of changes in popular furniture over time—that is, of their history—are easily influenced by preconceived ideas about the conditions in which men lived. One of these notions is that 'the peasant' made his own household implements. A number of articles are made of natural wood as it comes to hand, without any craftsmanship, just as a knot in the wood may be given a function in the framework of a house. This may be a survival of an ancient custom among unskilled people. But primitive forms like this, even when made from a single piece of timber, may be disregarded here. This book is a study of true craftwork, the use of regularly prepared material such as boards, square timber and mouldings. Other prerequisites are proper

tools for fitting, joining and decorating. Everything should proceed systematically and creatively, not just accidentally. The terminology involved in this procedure, the mortising, dove-tailing, rebating etc., cannot be discussed here. At first these terms were used by both carpenters and joiners, but the two branches separated at an early stage and the dispute about the borderline between them continued until recent times. A single example will illustrate the importance which is attached to the distinction. We may quote one example: it used to be believed that certain forms of furniture were carpenter's jobs, others joiner's work. Even the different words used for the joiner, *Kontormacher* or *Schnitker* (North Germany) and *Schreiner* (South Germany), show that the criterion is not the construction method, but the product. Generally speaking the plane was the mark of joiner's work; the carpenter only smoothed the wood with an axe.

A feature more significant than is generally realized is surely the division of work within the workshops. When a late eighteenth-century carpenter in Dithmarschen undertook to supply room fittings decorated with carving, he was, of necessity, acting as an entrepreneur. He employed specialists, since large and competent rural workshops were operating in this region even in the seventeenth century, where craftsmen of different types and grades worked together. The same must have been true of the workshops where the more expensive South German furniture of a later period was produced, although we have no written evidence to this effect. We know from a report dated 1755 that in the district of Cleve chair-makers from Holland, i.e. turners, were employed in joiners' workshops.[49] Other craftsmen were required when it came to producing chairs with woven seats, such as basket-makers or specialized weavers of chair-seats. In this way the craft of furniture-making expanded in various directions. At times it might also be incorporated in larger enterprises. Contrary to all the rules of the authorities and the guilds, and sometimes even encouraged by them, a division of labour took place, and more or less specialized experts began to co-operate. Since the Middle Ages turners had an important share in making furniture. They concentrated chiefly on trestle-type furniture, mainly chairs and stretchers.

The craft of the chair-maker arose in the post-medieval period. It appears that the chair-maker was more strictly confined to the one product than the *Tischler* (table-maker), *Kontormacher* (counter-maker), or *Schreiner* (cabinet-maker) who made shrines or cupboards. The main characteristics of these trades which determined their limits, apart from use of the plane, is the preparation of a framework, and later the use of glue and veneers. The Lower German term *Schnitker,* which was still in use during the seventeenth century, does not refer to carving in the modern sense of the word; carvers were called *Bildensnider* (picture-carvers). The *Schnitker* also made doors, staircases and so on, and could be roughly classified as carpenters. It is therefore not admissible to ascribe certain forms of chest such as the four-footed chest, or some types of chair such as the poster chair, to carpenters while assigning the box chest and board chair to joiners. True, the four-footed chest and poster chair are the earlier forms and it is quite possible that at one time carpentry embraced items that

later became the exclusive work of joiners. However, carpentry covered a much wider field and was closely bound up with other branches of building, from the timber business to building contractors. In North Germany at least there was also a connection with the construction and the running of mills.

Defining the borderline between different trades becomes particularly difficult in an urban context. Rural craftsmen who worked with wood and often also supplied urban demands encountered problems involving guild rights in an entirely different form from their fellow artisans in the cities. Attachments fixed to the wall of a room could not be separated, either in theory or in practice, from carpenter's work on the building. The same applies to the well of the staircase, which in parts of Hesse received very lavish attention. Unfortunately we know very little about the origins of the craftsmen who executed the work, or how this branch of the trade developed in the countryside. Regulations and control measures do not give a true picture of real conditions and events. Comparison of one region with another reveals important differences. A farm labourer who did minor repair jobs in addition to his work on the land cannot really be compared with a timber merchant who also promoted merchandise in his capacity as a building contractor. The former could be found anywhere in the countryside, whereas the latter could only hope to succeed in an area with plenty of large-scale farmers. A workshop of medium size carried out orders in regard to carpentry on buildings, and this included furniture. The winter months and slack periods were occupied with making goods for the market. The markets on the borders of the Geest region in North Germany supplied large quantities of wooden articles for the marshlands where handcrafts were not yet well developed or hardly existed, and where wood was not available. Products made mostly in the country, i. e. in the Geest region, were sold in the small towns to the country folk from the marshlands. This is true not only of rough goods like fence-posts, gates and all kind of vehicles and agricultural implements, but also of chairs and small items of furniture. Around 1800, and probably much earlier, they could be bought, for instance, in the market of Heide in Holstein.[50] In the larger towns supplies of goods for the lower classes were regulated in different ways. In Augsburg and Munich country joiners brought their own furniture and implements to market. In Frankfurt such competition with the town joiners was prohibited. The reason for the difference in attitudes was probably varying concern for the welfare of the urban craftsmen.

As early as the 1880s Justus Brinckmann started to trace collectors' pieces for his Kunstgewerbemuseum in Hamburg in the farm-houses of the district around the city. He found there not only country-made furniture such as chests and chairs with rich intarsia decorations of the Vierlande, but also some Baroque showpieces which the wealthy burghers of Hamburg came to regard as old-fashioned during the nineteenth century and passed on to country folk. This clearly illustrates that the term 'farm furniture' cannot be defined within fixed limits. In Hamburg styles persisted from one decade to the next, and furniture was constantly transferred from town to countryside, creating a peculiar interrelationship.

All this indicates that rural demand was not always met from the nearest village, market centre or town. For various reasons there must have been at an early date places or areas that produced a surplus of furniture for sale through the market. The classic example in southern Germany is Tölz. The rivers always provided a transport route from inland centres. Furniture from Tölz was carried largely along the river Isar to the market in Munich.

In the seventeenth century the regions along the North Sea coast and their hinterland imported a lot of furniture from Holland, which arrived by sea. We know of a prohibition dated 1636 forbidding the importation 'of large carved and other Dutch chests and trunks and other unnecessary articles'.[51] In the eighteenth century there was a large increase in imports of English furniture. This went not only to the houses of gentry and wealthy bourgeois, but also to those of seafaring folk and farmers in the coastal region. A parishioner at Ording on Eiderstedt, for instance, donated to the local church a cupboard that had come from northern Russia. A very large ceremonial chair from Norway stood for at least a century on the island of Föhr before it came into a private collection in the 1920s. This sort of thing was not uncommon. There may have been isolated cases of furnishings that were brought home by a sailor for a special occasion. These examples nevertheless show that the marshlands, which had no forests, were dependent on imports for furniture as well as other implements. From the southern Netherlands came tables topped with, or completely constructed of, 'Belgian marble'. They became showpieces in the *Pesels* of the larger farm-houses. Around 1600 the joiners of Bremen were also supplying a wide area along the North Sea coast. Generally their wares comprised the more expensive pieces, especially chests, for otherwise sea transport would not have been worth while.

At Husum there is evidence of an organized move to satisfy the demand for simpler furniture over a wide area. A large number of joiners, mostly of them known locally as *Schnitker*, had worked there since the sixteenth century as furniture-makers. Their chests were in very great demand all over the region and showed characteristic local features. As may be expected, there are no written sources of information about their methods of production and trade, but the status of the joiners' craft can be clearly deduced from various circumstances that are known. 'Husum chests' were simple boxes made of dovetailed oak boards. The front usually had some sparse decoration with motifs of mounting in bas-relief and scaly stripes on the sides. They could be found all over the former dukedom of Schleswig and in parts of Holstein.

It may be assumed that these chests were mass-produced during the winter months and slack periods. They were made for the market, primarily no doubt the one at the Husum, and were geared to a standard demand. Until far in the eighteenth century they retained a form of decoration that seems to have been established during the late sixteenth century.

The combination of a standard article, a group of workshops, and outlets through markets is a prerequisite for the development of the furniture trade, as it is for that of other rural handcrafts. For the rest

of the time there was plenty of work for joiners to do in fitting houses in Husum with equipment fixed to the wall. This somewhat reduced the demand for real furniture. There was also much less demand here for box-type furniture than in southern Germany, because household utensils were largely stored in wall cupboards. Cupboards are therefore not so standardized, and movable bedsteads are virtually unknown. Since the joiners mostly worked in oak they did not use paint.

The most movable items—in daily use as well as for trade—were chairs. Large consignments, including even quite simple chairs, must have been transported over long distances. They went, for instance, from Flensburg to Norway and other countries overseas, whence the timber for making them had first been imported.[52] A wealthy farmer in south Dithmarschen, Vollmacht Hansen of Kronprinzenkoog, once ordered three dozen mahogany chairs, at the price of eight *Reichstaler* each, because the governor, a representative of the king of Denmark, was going to stay with him during a tour of the country.[53] They were presumably supplied from Hamburg or Altona, or perhaps even from England.

To highlight one more aspect of the commerce in rural joinery: during the latter half of the eighteenth century a very productive clockmakers' trade was established, but in many cases this was not organized in guilds. The well-known Black Forest clocks, mostly without their cabinets, were traded over long distances, certainly all over Germany. There was a demand for workmen who could make the many clock-faces required and for a number of painters. In addition there was always a demand for furniture-like clock housing. This provided work for clockmakers in regions like Angeln and north Schleswig, who supplied goods for sale locally. They depended on joiners of equal standing, but the latter could hardly have confined themselves to the making of clock casings. They must have made other furniture to keep their workshops going. In many cases the making-up of clocks was a sideline which gave seasonal employment to small peasants and farm labourers.

Several other variants in working conditions could be mentioned, but these examples must suffice.

Types of Cupboard and Painted Furniture

If we were to provide an overall picture of the many forms of popular cupboard or wardrobe, more information would be needed about the purpose they served than can be obtained from previous publications. Obviously no other piece of domestic furniture offers more opportunities for a façade, but in examining the latter it is important to know whether the practical division of the interior is reflected on the outside. A bold façade with large surfaces may hide a number of very small drawers inside, or vice versa. By simply lifting the top of a chest the inside is completely revealed, but in a cupboard the proportion of fixed parts to those which are hinged and can be opened may vary widely. There is very little information about the interior fittings of such pieces, particularly in their original form. In many cases it is

difficult, if not impossible, now to reconstruct the original arrangement. Yet the way of opening the cupboard clearly depended on the nature of the contents and their use.

It is easier to trace the history of forms of furniture and particularly of cupboards in North Germany than in the south because there are more surviving examples, and traditions going back to the Middle Ages can be followed. Cupboards built into interior walls were the rule toward the end of the medieval era. The box-shaped wardrobe pushed into a wall niche generally rested on runners. At the top of the front was a cross-board with chip carving. The front stood flush with the wall of the room. It was made from upright pieces of timber, and only one third to one half of it could be opened. It had two or three doors, one above the other, each with its own lock. The principal decorations were iron fittings—an essential part of the structure because they held together the planks which were simply placed next to each other, in the same way that the hoops of a barrel hold the staves. When this old-fashioned construction was abandoned because the timbers could be properly joined, carved decoration on the planks of the front was introduced. Often most ornamentation is on the fixed side parts of the front rather than on the doors. At a more advanced stage the doors are not placed immediately above one another, but have a cross-piece in between them connecting one side plank with another. This was the beginning of true joiner's framework construction. This technical progress enabled the craftsmen to produce wider wardrobes, and also led to changes in function and in the proportion of the surfaces, which now appear as fixed panels or swivel-mounted flaps.

This is the basis of the classic north-west German form of cupboard during the late Middle Ages: the sideboard. The inside division consists of at least three tiers, and this division is discernible from the outside. The characteristic feature is the centre flap. It can be lowered to a horizontal position, held by a chain or iron support, where it forms a proper serving shelf. The opening below has usually two doors and is divided on the inside by an upright board, as is the part above them; hence they are sometimes described as 'five-door cupboards'. In some cases the lower portion has room only for one door. If the single door is less than one-third as broad as the drawer to which it gives access, there must have been different ways of putting in or taking out the contents than those we know today.

The wide, rather heavy sideboard with a façade of many surfaces is a typical piece of display furniture. It was originally designed for grand urban houses, and a number of aristocratic examples have been preserved. The tradition is mainly concerned with the rural version, because this type remained in use for much longer. In more sophisticated urban circles it was retained until the middle of the seventeenth century. Most of the elaborately decorated specimens with picturesque carvings, of which even the names of the craftsmen are known, have decorative themes which suggest that they were showpieces. The centre area, the sideboard proper, often bears a representation of the Last Supper or the baptism of Christ. This indicates that festive meals and domestic celebrations such as children's baptisms used to take place in front of this façade, which is only to be expected

in the case of a display sideboard. One of the earliest dated specimens, made in 1546 at Meldorf (now in the Schleswig-Holsteinisches Landesmuseum, Schleswig),[54] has farming family crests on the main panel; on a side panel is the pathetic motif of a man sitting rather helplessly while a dog fusses round him. It probably represents Lazarus, who seems to be out of context in this picture. Presumably the main panel bore the image of Dives, the wealthy glutton, a scene often portrayed in the sixteenth century as an admonition to the affluent, sometimes on mantle-pieces and even on drinking vessels (for instance, Rhineland stoneware). This sideboard traditionally stood in the 'hall' of the North German middle-class home as well as in the *Pesel* of the farm-house. If the house was sold it remained *in situ*, being regarded as part of the structure. The chronicler of Dithmarschen, Neocorus, reports about 1600 that the farmers of Dithmarschen used it to store 'their best glasses and silver tableware'. The interior division into smaller drawers which could be locked separately suggests this function. This special sideboard, the *Schenkschiewe*, was not an article of daily use. In some regions it remained the main showpiece well into the eighteenth century, being used chiefly for festive occasions, even though later the central flap

104 functioned more as a door than as a display shelf.

The façades can best be understood as an art form if they are seen in relation to their function. They are composed of small surfaces, some fixed, others mobile, of different sizes and positions, some upright, others diagonal. Walter Passarge has made a stylistic analysis of this kind of sideboard *(Schenkschiewe)* in a highly perceptive study; he sees the enclosure in the wall and the divisions of the surface as a relic of the Gothic era. Only when the cupboard was detached from the wall did it become a piece of furniture in the true sense of the word. In style it is a product of the Renaissance.[55] In the mid-seventeenth century, when the sideboard became an independent piece of furniture, standing freely in front of the wall, it began to adopt

42 features of contemporary style. The shape might also be modified; it
115, could be fitted with a retractable centre portion, or it might disappear
116 completely as a distinct type of furniture.

A whole detailed monograph could easily be devoted to the *Schenkschiewe*. In the statutes of Hamburg joiners it was the recognized 'masterpiece' by which the craftsman's fitness for guild membership was judged. This is rather surprising in view of the fact that hardly a single specimen from Hamburg has survived. The joiner-carvers of Flensburg, too, had to make a *Schenkschiewe* to qualify as master craftsmen. The most impressive surviving examples that have been

110 preserved are those from Dithmarschen, where the farmers grew rich during the early capitalistic era through selling their wheat. They were obviously very partial to showpieces of this kind. The people of the neighbouring parish of Ostenfeld, who also benefited from the same boom and adopted the contemporary life-style procured

30 *Schenkschiewen* from the workshops at Husum. Other inhabitants of Schleswig who had smaller houses and living-rooms were satisfied with more modest models. A positively austere form occurs at Angeln, while in western north Schleswig quite elaborate specimens were still to be seen in the sixteenth century.

The *Schenkschiewe* sideboard illustrates the tendency for pieces of furniture which had been inherited from the late Middle Ages to undergo a separate line of development in certain local areas. Rural examples diverged from current urban trends. This is also true of other types of furniture, such as the post wardrobe *(Stollenschrank)* or the corner cupboard, which derived from an older tradition still surviving in Scandinavia. The latter could be seen in Dithmarschen and adjoining areas until the end of the eighteenth century. However, since it is impossible to discuss all varieties of popular furniture, we must confine ourselves to the principal forms: the wardrobe and the chest. This is, therefore, an appropriate point to examine painted clothes cupboards as a special branch of folk art.

From the point of view of folk art the clothes cupboard is the most important item. From the seventeenth century onwards it became the focus of representational and decorative interest. This was certainly the case in central and southern Germany. It is widely accepted that changes in urban attitudes to dress were responsible for making the wardrobe the successor of the clothes chest. Deneke may be right when he says that rural people, unlike townsfolk, saw no necessity to change their habits at a certain point in time, and to hang up their clothes instead of folding them and laying them in a chest.[56] However, it is quite possible that the rural population followed the fashionable type of furniture and manner of clothes just as they adopted so many other customs for which there was no immediate practical reason. It seems that this movement started no later than the second half of the seventeenth century, but it evolved much more rapidly in some areas than in others. Its progress cannot be followed equally clearly everywhere. In most cases we know only the final result: the double-door wardrobe with a strongly developed façade. Half the interior is open space, reserved for hanging clothes; the other half may have shelves or drawers, the upper shelf being generally built in to take hats and similar articles. The importance of the wardrobe is due to the fact that it was the place where the bride stored her clothing and household goods when she arrived in her new home. This is one reason why it cannot be directly compared with household cupboards or with showpieces like some dressers.

A suitable point of departure is the simple form of upright box with a plain front and a small lintel, standing on side walls which extend below the base or on runners. Wardrobes of this severe form occur in north Friesland. They are decorated with painting; closely framed areas with emblematic motifs fill the panels. A similar form may have existed in South Germany, for instance in Altbayern, but here the painting was confined to decorative motifs and was done with stencils. Two seventeenth-century wardrobe doors from Tölz, with stencil painting in the manner of the Upper German art of intar- 124
sia, may have come from such a piece.[57]

The towns set the fashion for rural cupboards from the start. In northern Germany the massive cupboards in the houses of burghers in the Hanseatic cities exercised a strong influence as models. This is particularly true of the characteristic double-door façade, based on Dutch prototypes. These pieces have a high base with drawers on ball feet. The large body has vertical uprights with turned half-columns 112

on either side. The whole is topped by a wide cornice with a raised carved cartouche in the centre. In addition Bremen, Lübeck and Danzig developed their own special version of the wardrobe, as indeed did Frankfurt-on-Main, Ulm and other major centres. Dutch Baroque motifs were always prominent.

The influence of such models on popular furniture varied a good deal. In some cases, for instance, restrictions were imposed by lack of space, but in all the numerous variations the imprint of this style remains clearly perceptible. Sculptured parts were gradually flattened, protrusions and convolutions simplified, and the effects originally produced by material and carving replaced by painting. The craftsmanship of the embossed panels and their elaboration was reduced to frames of projecting moulding until the final form bore only a remote resemblance to the model. In the north of Germany these stages of simplification can be traced from Hamburg northward into Denmark, where they sometimes resulted in very original solutions. But we can scarcely speak of regional types, each with an identifiable centre of production. The demand seems to have been sporadic and to have been met on the spot. This is easy to understand since here, in the northernmost part of Germany, the chest maintained its place as part of the bride's dowry, and houses usually had ample cupboard space in their walls.

A comparative survey of all the different regions would be impossible. Such a study would have to investigate the connection between the interior fittings and the outward appearance of the façade, and how the exterior becomes independent of or follows the ornamental trend characteristic of all the box-like furniture in each locality. The structure of wardrobes diverged from that of chests when they adopted the massive façades of Dutch linen cupboards. In Oldenburg, for example, an architectonic arrangement reminiscent of the late Renaissance persisted for a long time on wardrobes and other furniture. The overall form of the façade no longer reflects the divisions of the interior. There are countless variations in the motifs of interwoven beadings with double slender inset lines around the surfaces of the panels, and of embellishment with stars and other patterns. These variations are particularly notable in the Schaumburg area. The wardrobes in Westphalia are more restrained; their fronts are divided into squares and the bas-relief carving on fields with simple frames makes a surprisingly lively and decorative impression. Wardrobes north of the river Main seem, on the whole, to be variants of a basic pattern in which the proportions between base, body and cornice are balanced. Painting adds to the ornamentation in various ways. It can provide a setting for embossed, carved or planed decorations, or an imitation of wood grain or marbling, or else it may be the direct medium of pictorial or decorative ornament.

In many other regions painting limits or replaces lively forms of construction and embossed adornment, just as it does on the simple cupboards of north Friesland. This becomes increasingly true as one moves to the areas in the south where softwood was more generally used for making furniture. The statement that painting can be substituted for veneering as a refinement of the material for elegant furniture is particularly applicable to cupboards. The effect is not always achieved by imitating valuable wood grain. Imaginative decoration may disguise the poor quality of the wood and create a magnificent overall impression.

Imitation wood grain often produces individual and very effective painted decoration. Slight variations in the shades of wood are emphasized to give colourful contrasts, and mottled graining is stylized to form rhythmic surface patterns. In this way some very impressive wardrobe façades were produced in the Lausitz and in Silesia. In these areas the arrangement of the coloured sections is the only thing which indicates that they were intended to be an imitation of veneered surfaces executed in different grains of wood. Compared with these the wardrobe façades of south-west Germany seem rather tame. The surrounds are executed in a single shade and enclose loosely coloured motifs, generally flower-pots and bunches of flowers. Torsten Gebhard, investigating this subject in Altbayern, says that local researchers should be concentrating on the problem of organizing the many existing variations into some kind of chronological and geographical order. This might also lead to identifying some individual achievements, such as the wardrobe decorations by the Rössler family who lived in Untermünkheim in Hohenlohe, Württemberg. Its most prominent member was Johann Michael Rössler (1791–1849). He was assisted by his younger brother Johann Friedrich, who later moved to Eschenbach, and other members of the family. The individuality of his painting is unmistakable: he favoured a blue or green base with longitudinal and diagonal stripes, mostly in bright red, and a pair of figures arranged over the wardrobe doors; he portrayed busts, half-length figures, and occasionally one at full length. He sometimes showed the farmer and his wife in an arched section, above and below bunches and baskets of flowers, in a framework which often included rococo scrolls and flower garlands. In later years Rössler also turned his hand to replacing painted motifs by stuck-on printed graphic designs.

If the various types of cupboard are surveyed with a view to grouping them according to their decoration, this inevitably leads one into the topic of popular painting, which has exercised more influence on the decoration of cupboards and wardrobes than on anything else. Yet painting should not be seen in isolation, especially in the case of South German furniture. It serves quite different purposes: to cover carved ornamentation, imitate other materials, decorate surfaces, and introduce pictorial representation into clearly demarcated areas. These functions can often overlap. In this way even the most popular type of cupboard may be a legitimate heir to the decorative art that was so zealously practised in the churches and palaces of South Germany in the Rococo period. An example is a wardrobe dated 1830 from Mangfallgau. The façade is topped by a broken pediment with a high perforated head-piece which has an inserted medallion showing the Lamb of God, a heart, an anchor and a crown. The struts of the main body have volutes above and below, and in between them are embossed rosettes. On the doors of the wardrobe are four fields framed with elaborate carvings and covered with paintings showing Christ and Mary pointing to their hearts, and two scenes from the New Testament (the parable of the toilers in the

vineyard and the story of the captain of Capernaum). The side walls have representations of the seasons in the form of *putti* with attributes. The overall impression is one of colourful splendour, with the mottled red and green surfaces, the gilding on the embossed parts, the Rococo effects, and the transformation of the finer nuances of the style into a more robust medium of expression. This type of decoration proved to be very adaptable. Toward the middle of the nineteenth century it reappeared with the Rococo revival.

Other examples of South German furniture cannot be examined here. With some variations, in which later styles, particularly classical decorations, were adopted, the tradition continued until the second half of the nineteenth century. This phenomenon can only be understood if it is seen as a result of patronage by the Catholic Church, which kept craftsmanship at a very high level and perpetuated traditional forms of decoration.

Painted furniture cannot be distinguished from painted small utensils and painted wainscoting in rooms. The borderline is fluid, just as it is in the field of furniture carving. We are dealing here merely with a few outstanding aspects of popular painting as a whole.

We can treat only in broad outline developments in the relationship between furniture painting and the general arrangement of living-rooms.

It is certain that in general it was very rare during the Middle Ages for whole rooms, including walls and ceilings to be painted. We must add something here to our previous remarks on the furnishing of living-rooms. A cubic room is preserved in a farm-house at Tyrl-brunn, in the parish of Freutmoss, Traunstein district, Upper Bavaria, in which all the walls are covered with seventeenth-century painting. At the base is an area with medallions, tendrils and a strip filled with linear designs. Above this the whole wall up to the ceiling is covered with delicate outlines of tendrils and leaves. Some figures are fitted into it; they include St. George fighting the dragon while the princess prays and looks on; St. Lawrence with the grid-iron; St. Florian with a large flag, extinguishing a fire in a burning building, and other saints. The colours—red, green, yellow and blue—stand out brightly on the whitewashed background.

Similar features can be found in middle-class houses in smaller towns, even in North Germany. Ceilings painted during the sixteenth and seventeenth century have been preserved. One of the chief occupations of skilled painters was the decoration of large surfaces, and especially because of this demand guilds insisted that a master craftsman must be able to paint scenic pictures. Some wealthier clients even required textile hangings as wall decorations, after the fashion set by the courts. In Scandinavia this tradition persisted well into the nineteenth century. This suggests that from the beginning of the modern era the coloured decoration came to be concentrated on individual pieces of furniture in the room. This development may have helped to accelerate the trend to movable furniture by freeing pieces from their position fixed to the wall. Under these circumstances wardrobe, chest and bed could develop into showpieces set off by neutral walls, and often came to bear pictorial representations of religious or other themes.

However, for practical purposes painting with the aid of a stencil was regarded as a legitimate procedure and played an important part, at least in southern Germany, during the sixteenth and seventeenth centuries. It was in fact customary at the beginning of the modern era to use mechanical aids to help with the decoration of large surfaces.[58] Even during the late Middle Ages the painting of plain wooden furniture was often mechanized. This is impressively demonstrated by a cupboard from Klingenberg in Saxony, a piece of church furniture now in the Staatliches Museum für Volkskunst, Dresden.[59] The researches of Torsten Gebhard have demonstrated the vital importance of stencilling in the later stages of furniture painting. Stencilling was much encouraged during the sixteenth century, when intarsia decoration was imported from Italy, since this was particularly suitable for stencilled designs. It was easy to imprint Renaissance ornamentation patterns on the bare wood in black, which immediately produced a superficial impression of the decorative effect produced by the difficult and costly art of intarsia through the contrast between different types of wood. This process was practised in Upper Bavaria—and surely not only there—well into the seventeenth century. After passing through several intermediate stages furniture painting developed into a flourishing form of popular art, and many pieces were soon entirely covered with stencilling. The best known example of this phase of furniture painting is the four-poster bed dated 1655 from Tölz, Upper Bavaria, now in the Bayerisches Nationalmuseum, Munich. The fact that the motifs are derived from intarsia art is strongly suggested by the portrayal of buildings, very like those which Tyrolean *ébénistes* employed so skilfully in wooden mosaic. In the Tölz piece the different nuances of wood grain are exploited to form contrasting coloured patterns, a reddish shade harmonizing well with the white surfaces. Although the origin of the technique is clearly apparent, the translation from wood into coloured pigment has been completely successful. The painter's individual touch is given free play in the friezes of flowers. At the same time, or even earlier, plain areas of furniture were decorated with woodcuts painted in colours. An example of this process is a four-poster bed from Upper Bavaria or the Tyrol dated 1583, now in the Werdenfels Heimatmuseum, Garmisch-Partenkirchen.

Even in this early phase Upper Bavarian furniture painting reveals local variations. The characteristic architectural motif of the gate turret appears on furniture in the Miesbach district from about 1600 until 1610 and continues until about 1750. In the Ruhpolding area it does not occur before the end of the seventeenth century but survives until the late eighteenth century. Here the pattern tends toward ornamental stylization. Many examples of this style could be quoted to illustrate the conditions which prevailed at least in various areas of Bavaria; up to the middle of the eighteenth century it would be misleading to speak of a single pattern for each region of Bavaria. After 1760–70 there is so much material that distinct local trends can be discerned. The comprehensive exhibition of 'Popular Furniture from Upper Bavaria', arranged in 1975 by the Bayerisches Nationalmuseum, opened the way to a more accurate understanding of local styles as well as of the development of furniture throughout the

country. It showed that in most cases, articles were made near the place where they were used, so that they can be classified according to specific localities, although of course there are still a number of pieces that are difficult to identify and many questions remain to be answered.

The Upper Bavarian town of Tölz occupied a special position. From the sixteenth century onward it produced goods that were transported to the market by way of the river Isar and were bought by the rural population in Lower Bavaria and the Upper Palatinate. Some of it was sold through Munich. The workshops at Tölz are so well documented that we have a complete picture of the development of furniture painting in this locality. It began with the transfer of intarsia design into paint mentioned above. From about 1650 until 1710–20 there was a period of exclusively religious themes, usually pictures of Christ and Mary, and sometimes, but rarely, a few saints. Then, until about 1770–80, a retrogressive stage followed. On a base stippled in black and green only holy monograms appear, apart from a few flowers. The wardrobe remains the main piece of furniture and becomes taller.

Around 1770 a decisive change occurs. The proportions of the wardrobe now conform to those of other regions. The front corners are mitred. The last traces of the emphatic division of the front which characterizes Renaissance furniture were the projecting mouldings on the rear corners and on the edges of the doors. At this stage production seems to have risen by leaps and bounds. The number of pieces is so great and the decoration so uniform that one could almost speak of mass production. We know of many workshops and names of joiners, but it has not yet been possible to ascribe any piece, out of all the many that are preserved, to an individual workplace or joiner. It should also be mentioned that furniture made for export is no different from that which was sold in the countryside around Tölz. The first appearance of this 'mass-produced furniture' in the late eighteenth century caused a twenty-year break in the continuous development of ornamentation. Flower decoration declined to the point of meaninglessness. Instead the current urban fashion of using paint to imitate veneering and strip-worked intarsia was adopted. Thus enriched by colour, the stripwork survived as a frame for the plain surfaces in the next phase. Very large, disc-shaped roses were added on a blue or green speckled base; these are strongly characteristic of Tölz work. About this time an essential expression of religious faith, emphasized by its position, was the Sacred Heart, often accompanied by the names or monograms of members of the Holy Family. In due course, soon after 1800, the custom of dividing the surface into panels gave way to overall decoration. However, the rule of juxtaposed forms and systematically composed designs was maintained. At this time fewer wardrobes and four-posters painted with figures are found. The formal finish soon reveals the fact that the joiners of Tölz had little experience in painting human figures. Furniture of this type was produced during a short period between about 1820 and 1830. This suggests that such pieces may have been made for occasional special customers.

About 1800 a separate group of furniture came into being from an independent workshop, probably situated in the vicinity of Tölz. It is remarkable chiefly because it proves that the technique of using copper engravings on furniture for representations of religious figures was practised a few years earlier than the painted version.

There are very few examples of the last stage of development in Tölz decorated furniture. Wardrobes in speckled green, from about the middle of the nineteenth century, with foliage and ornaments painted on them in the style of earlier mass-produced furniture, now have coloured lithographs of religious subjects glued on to them. Another group of wardrobes from the late period, about 1835–40, with a light blue base and Rococo shell patterns, does not conform to the style of the mass-produced pieces to the same extent. Obviously there were workshops in Tölz which as well as producing pieces with the decoration common to Upper Bavaria, managed to develop their own individual style.[60]

This is a straightforward account of the development of a specific type in one limited locality. It cannot be applied to a wider region. In the eighteenth century the 'individualization' of small districts was very marked. It is most pronounced in the choice of colour, where individual taste played an important part. The general tendencies of Baroque style, and especially of the Rococo, took a long time to penetrate; the process was still continuing well into the nineteenth century. Gislind Ritz has traced some of these variations, particularly in Bavaria, where the overall development must always be seen in the light of the remarkably strong tradition in the Tyrol and Upper Austria. It is hardly possible to establish a general rule, because apparent or real lines of direct development in any one locality are periodically observed by the effects of changing taste. In mountainous areas separate valley communities can still be discerned. Elsewhere major and minor urban centres, or perhaps a particularly productive monastery workshop, exercised a greater influence. Attempts have been made to trace regional choices of colour, but scholars tend to forget that, apart from aesthetic preferences, economic considerations will have played a part. For instance, during the eighteenth century Paris blue, a rich, deep shade, became available. In choosing a basic colour for mass-manufactured furniture this blue would obviously be the first choice, if only because of its low price, although it was sometimes used in a mixture with green.

This is not the place to attempt a definition of the characteristics of all the many regional styles of furniture decoration. In any case scholarly research has not yet produced enough information for comparative study. A few relevant observations may be made on the subject of chests. However, the Upper Lausitz district deserves to be singled out, for it introduces a distinctive note into the picture of furniture painting in Germany, even in regard to other districts in Saxony. Painting here became astonishingly independent of the fashionable patterns of decoration prevailing elsewhere at the time. The fronts of wardrobes are treated as a single surface and covered with generously soaring lines in bright colours. These lines often wind around a flaming red escutcheon for an inscription, or form plants like tulips and star blossoms, but on the whole convey an impression of great waves. Copious use of white increases the effect,

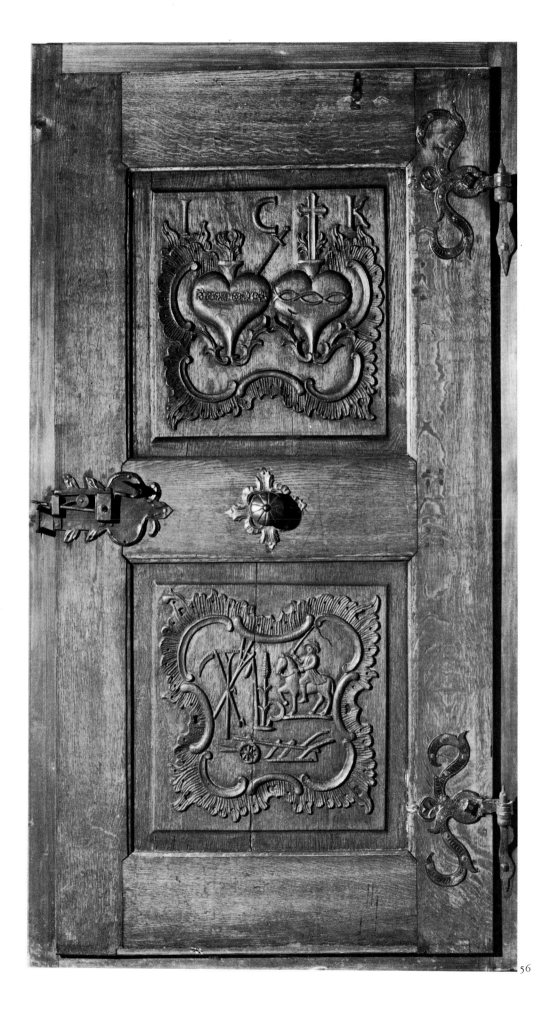

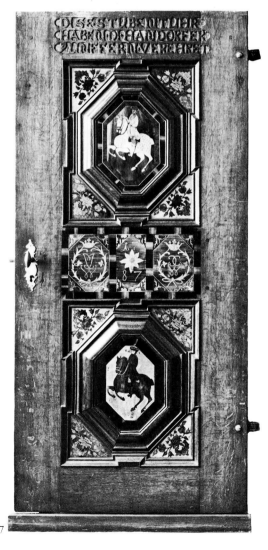

56 Door of a room. Oak. Latter half of 18th century. From Wertingen, Swabia, Bavaria.

57 Door of a room. Oak with intarsia decoration. 1787. From Handorf, Winser Elbmarsch, Lower Saxony.

56 57

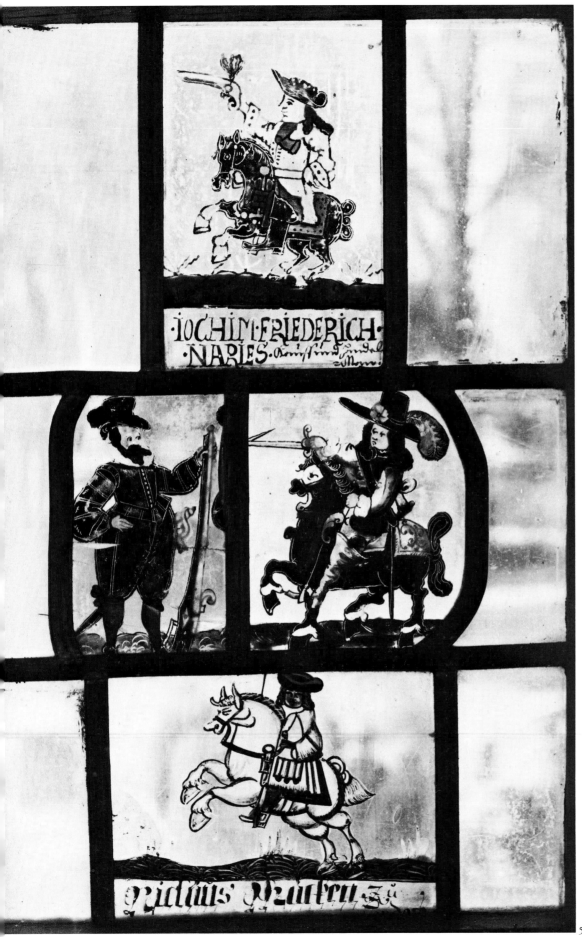

58 Tablet with four painted window-panes. Glass with colourful painting and *Schwarzlotmalerei*. Latter half of 17th century.

59 Painted oval window-pane. Glass with *Schwarzlotmalerei*. *Circa* 1593. From Schleswig-Holstein.

60 Painted window-pane. Glass with *Schwarzlotmalerei*. 1690. From Dithmarschen.

61 Painted window-pane. 18th century. From Sehestedt, Holstein.

62 Painted window-pane. Glass with *Schwarzlotmalerei*. End of 17th century.

63 Painted window-pane. 1767. From Schleswig-Holstein (Wilstermarsch?).

58 59

Hauß Huß · 1690

Jochim. Tode

Seit Wilkomen Ihr Herren.

Thomas Lehm=
berg · 1767.

WM 4?

64 Painted window-pane. *Circa* 1640. From Südfelde, Oldenburg.

66 Painted window-pane. Middle of 17th century. From Schleswig-Holstein, (Kiel?).

67 Fragment of painted window-pane. Middle of 17th century. From Lower Saxony.

65 Painted window-pane. First half of 18th century. From Schleswig-Holstein (Eiderstedt?).

64

65

66

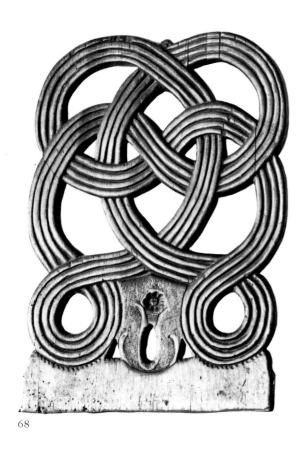

68

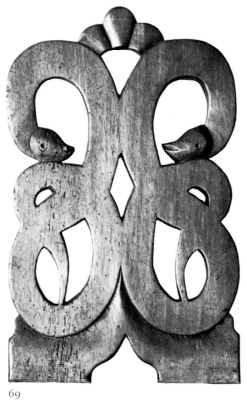

69

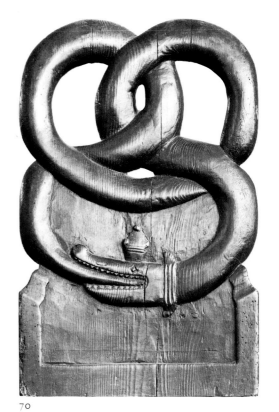

70

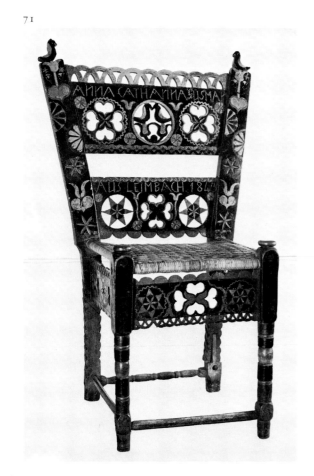

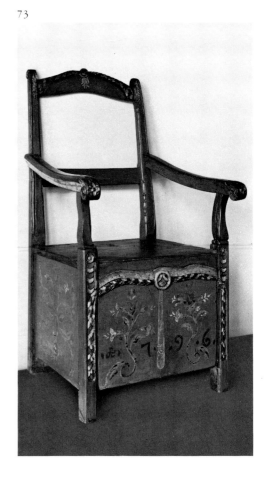

73

68 Back-rest of a wooden board chair. Walnut. *Circa* 1820. From Kippenheim, near Lahr, Baden.

69 Back-rest of a wooden board chair. Walnut. Middle of 18th century. From the Black Forest, Baden-Württemberg.

70 Back-rest of a wooden board chair. Softwood. *Circa* 1830. From Steincke, Gifhorn district, Lower Saxony.

71 Bridal chair. Beech. 1843. From the Schwalm, Hesse.

72 Armchair. Oak. 1807. From Kirchbaitzen, Fallingbostel district, Lower Saxony.

73 Box seat. Oak and softwood, painted. 1796. From Daun, Rhineland-Palatinate.

74 Back of a coach-seat. Soft- and hardwood. End of 18th century. From Moorrege, near Uetersen, Krempermarsch, Holstein.

74

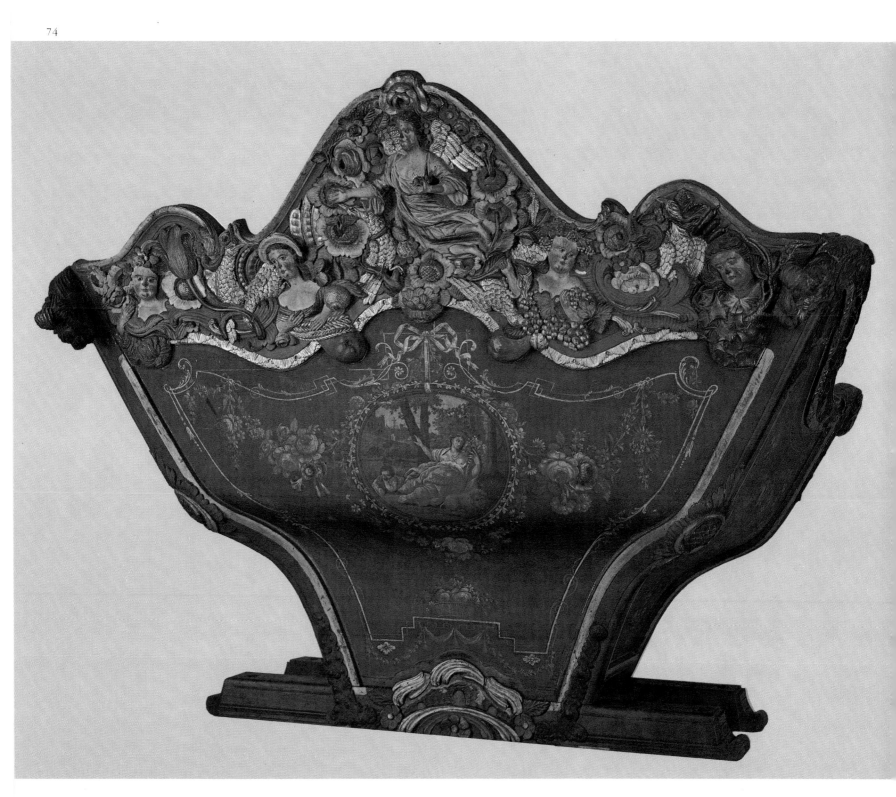

82 Table. Softwood. 18th or 19th century. From the neighbourhood of Wasserburg, Bavaria.

84 Table with surround. Softwood, painted. From Degerndorf.

83 Table. Apple and oak. 1832. From the Rhön mountains.

85 Table. Softwood. 19th century. From the Rhön mountains, Bavaria.

82
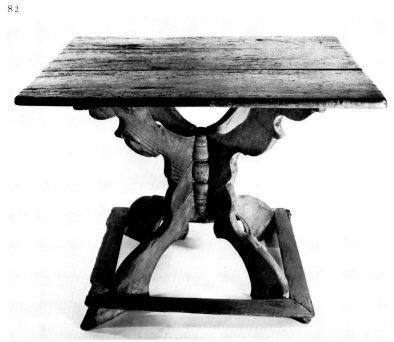

83
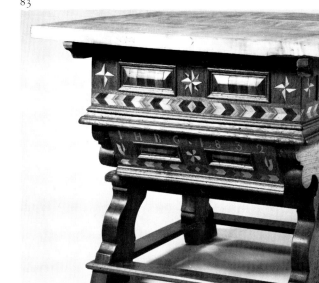

84▽
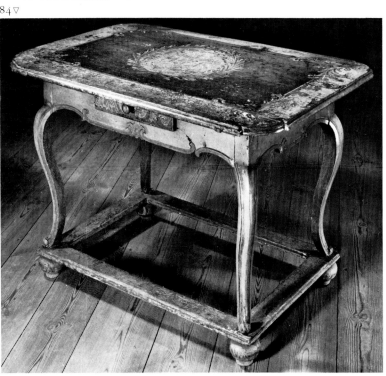

85▽
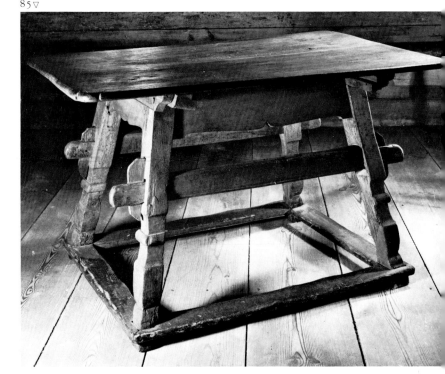

86

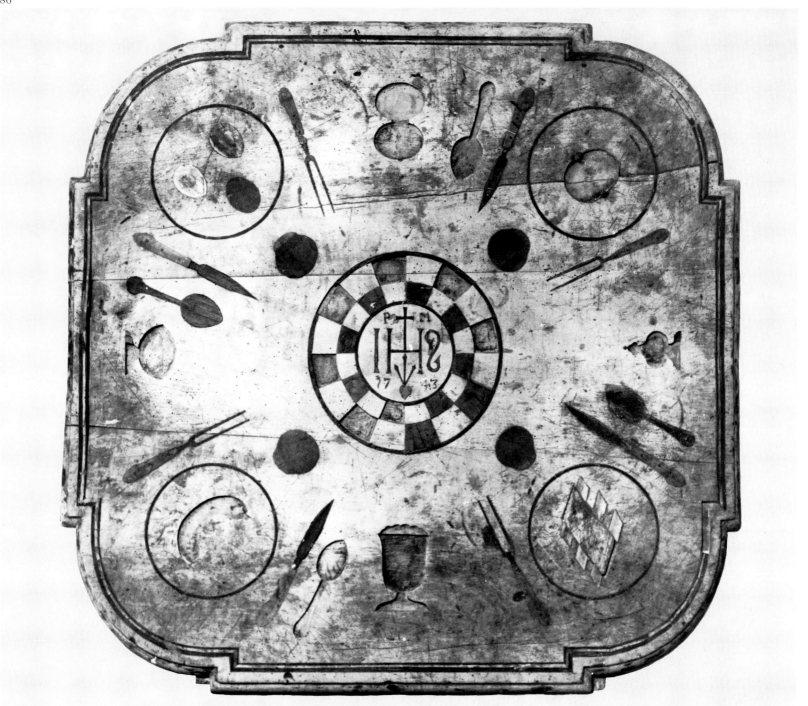

87　Furniture from Hesse. Various kinds of wood. 18th century.

88　Bedroom furniture, with four-poster bed and chest, both painted. From Oberhasel, Thuringia.

89　Head- and foot-end of a bed. Spruce, painted. 1781. From Degerndorf, near Blannenburg, Rosenheim district.

90　Four-poster bed. Oak. 18th century. From Ravensberg, Westphalia.

91　Four-poster bed. Softwood. Latter half of 18th century. From the Waldshut district.

87

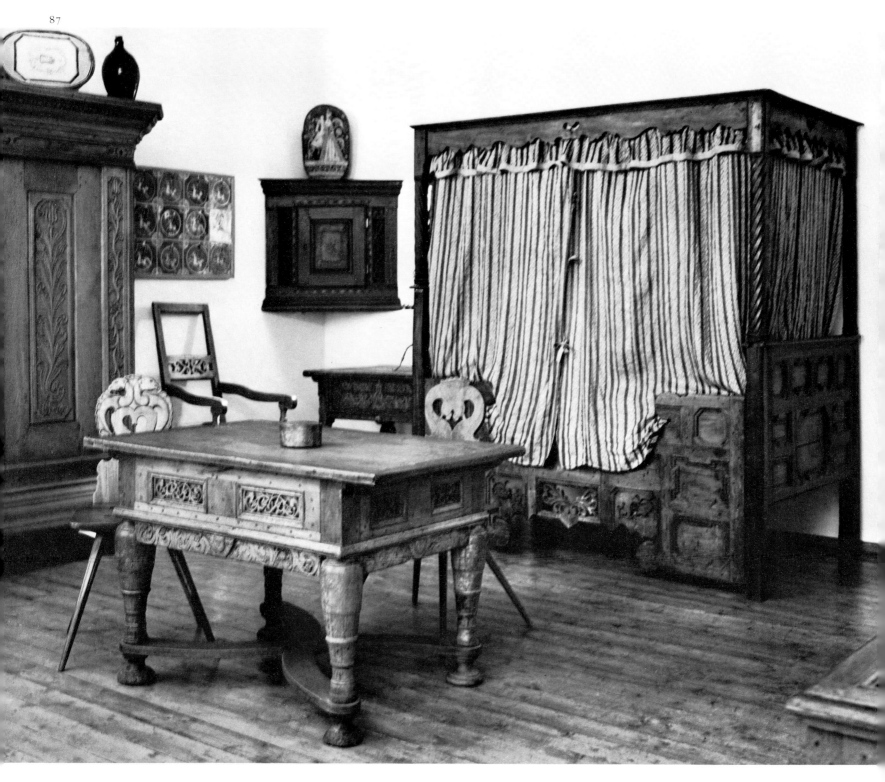

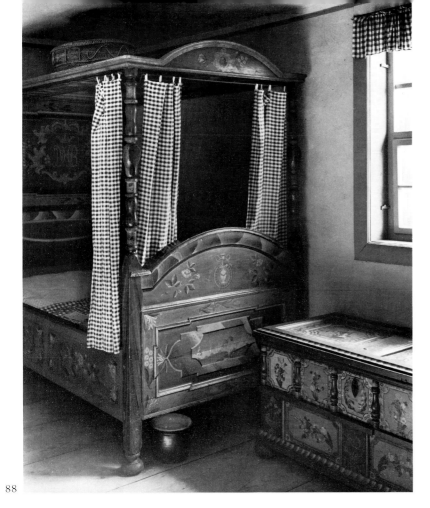

88

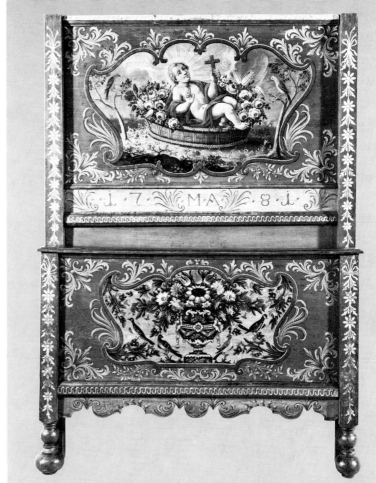

89

90

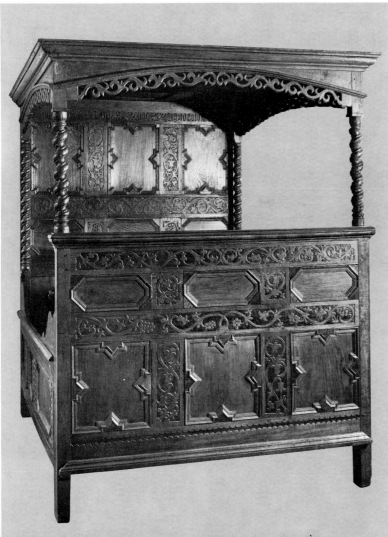

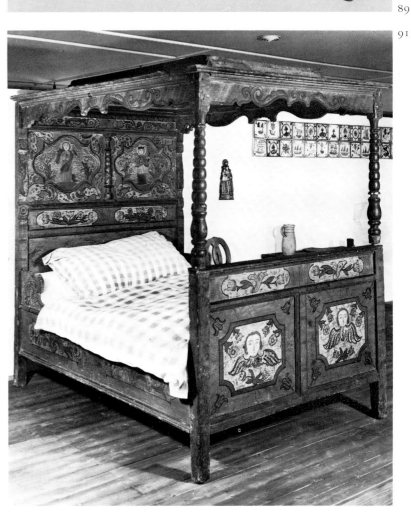

91

73

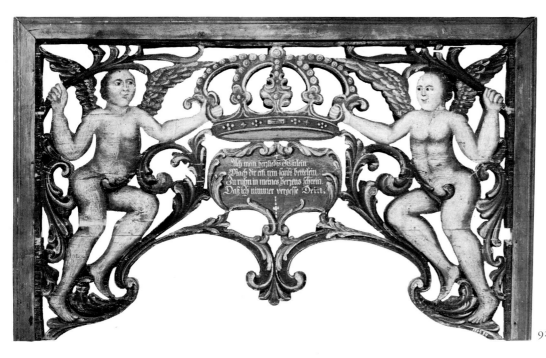

92 Board surmounting a wall-bed opening. Wood, painted fretwork. Late 18th century. From Humptrup, north Friesland, Schleswig.

93 Box bed. Softwood, painted. *Circa* 1800. From Kamm, near Passau. Lower Bavaria.

94 Bedstead. Softwood. Middle of 19th century. From Obstätt, Ebersberg district, Upper Bavaria.

95 Canopy above the bed in Plate 89.

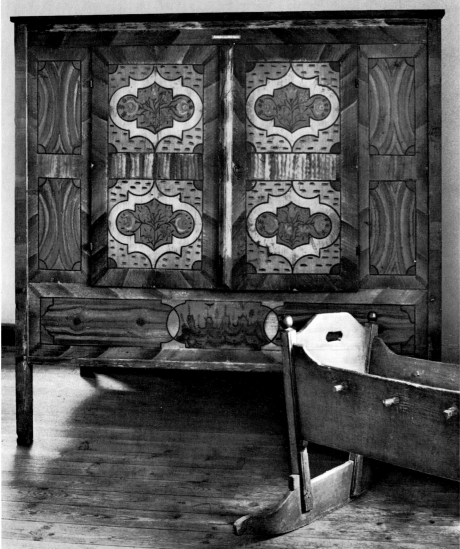

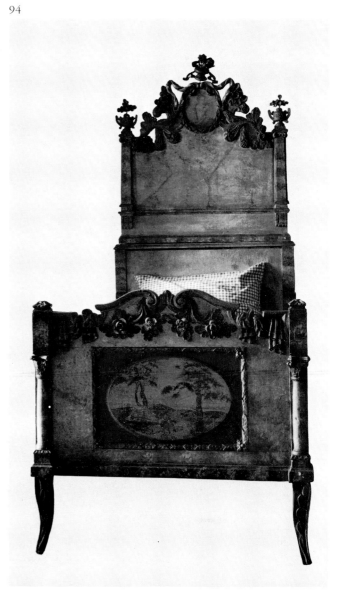

96

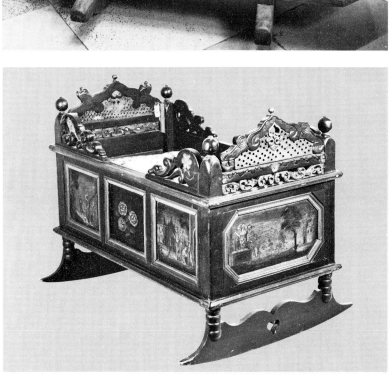

97

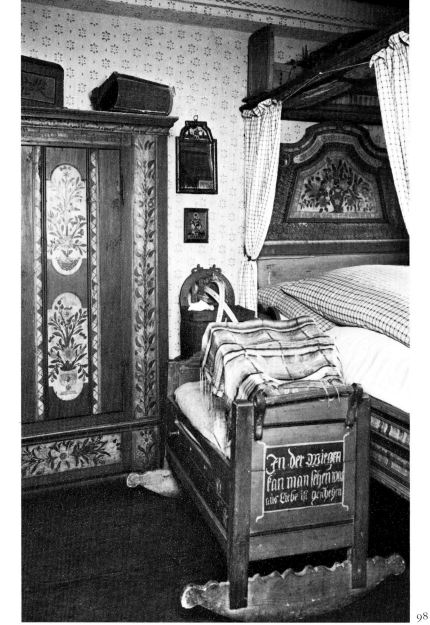

98

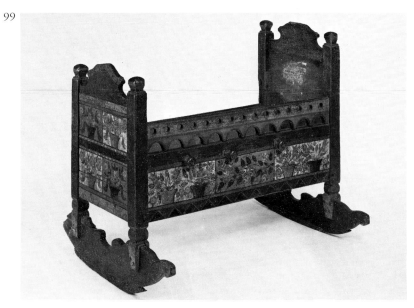

99

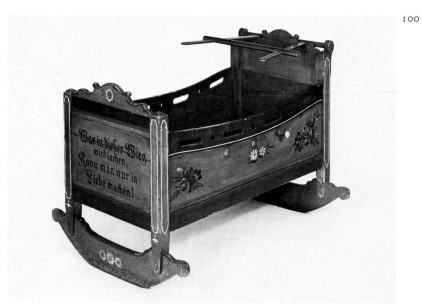

100

96 Cradle. Oak. *Circa* 1800. From Mausbach, Aix-la-Chapelle district, North Rhine-Westphalia.

97 Cradle. Oak and pine, painted. Middle of 18th century. From north Friesland.

98 Corner of bedroom with four-poster. 1793; cradle and wardrobe 1835. From the Feuchtwangen area.

99 Cradle. Softwood, painted. 19th century. From the Feuchtwangen area.

100 Cradle. Softwood, painted. 19th century. From Lower Franconia or Württemberg–Franconia.

101 Cradle. Oak. 1810. From the Vierlande, near Hamburg.

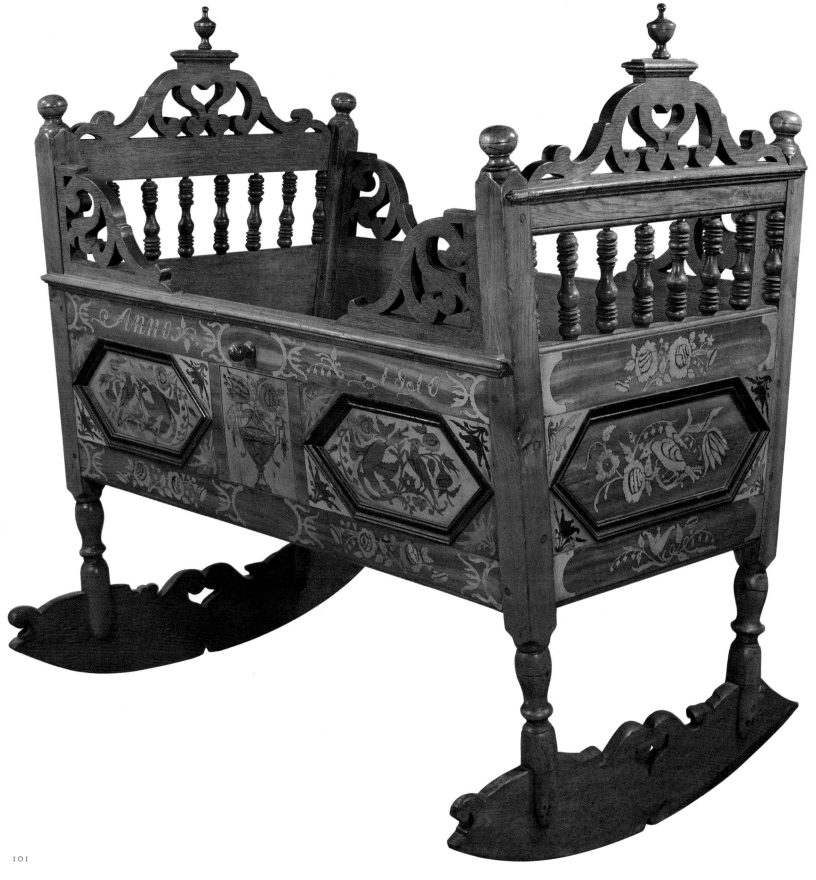

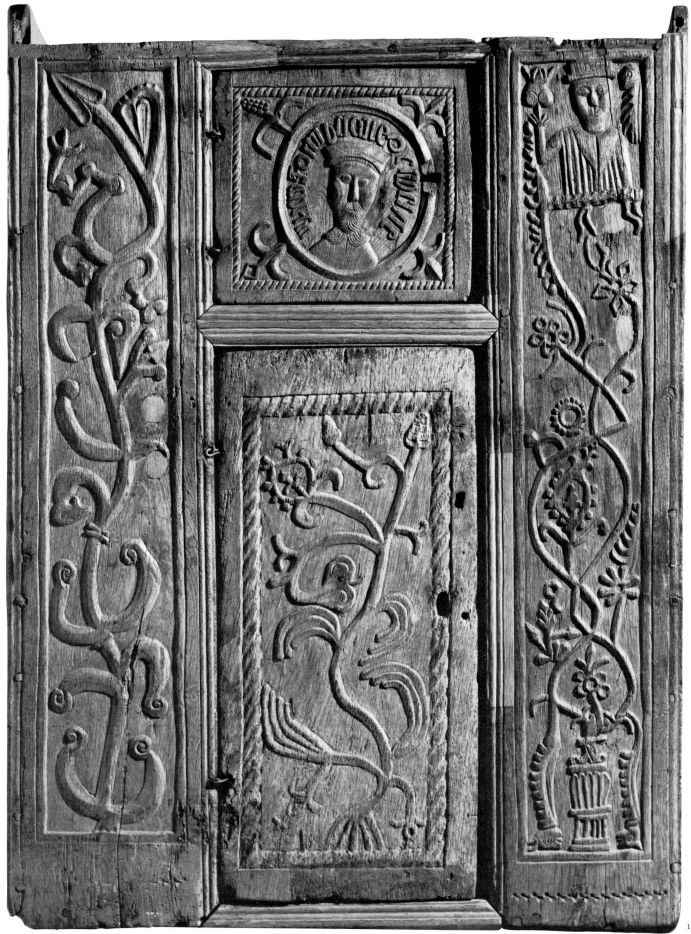

102 Bench cupboard. Oak. Latter half of 16th century. From
Lindholm, north Friesland, Schleswig.

103 Wall cupboard *(Schenkschiewe)*. Oak. First half of 17th
century. From the Schleswig region.

104 Wall cupboard *(Schenkschiewe)*. Oak. First half of 16th
century. From Angeln (?), Schleswig.

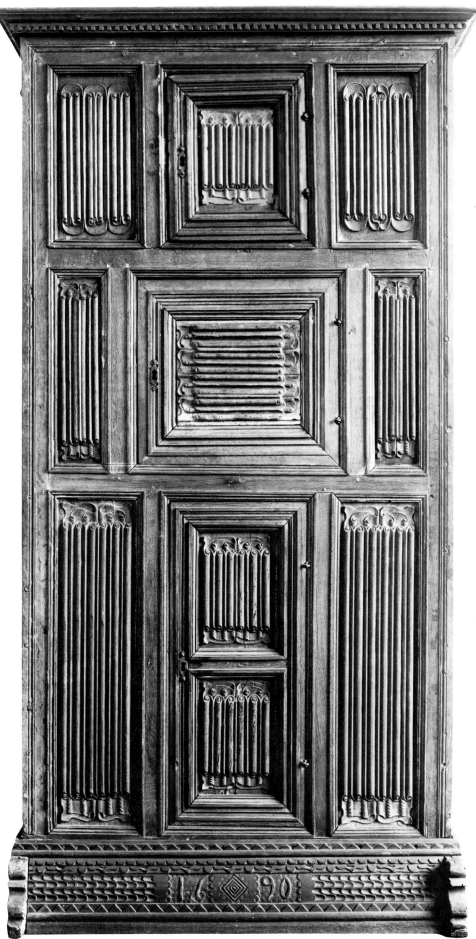

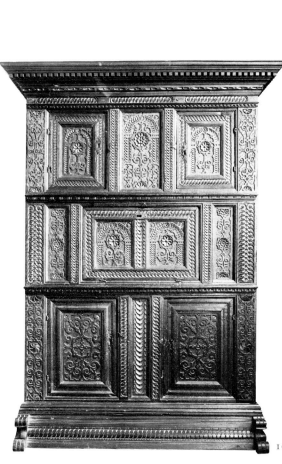

103 104

105 Bench cupboard. Oak. 1593. From Nord-Lindholm, north Friesland.

106 Panel of a wardrobe door. Oak. 1824. From Hof Redeker (called Strunk), Isingsdorf, Halle district, Westphalia.

107 Panel board of a piece of furniture. Oak. Latter half of 18th century. From Hof Mönk, Bardüttingdorf, Herford district, Westphalia.

108–110 Sideboard (*Schenkschiewe*). Oak. 1550. From Dithmarschen.

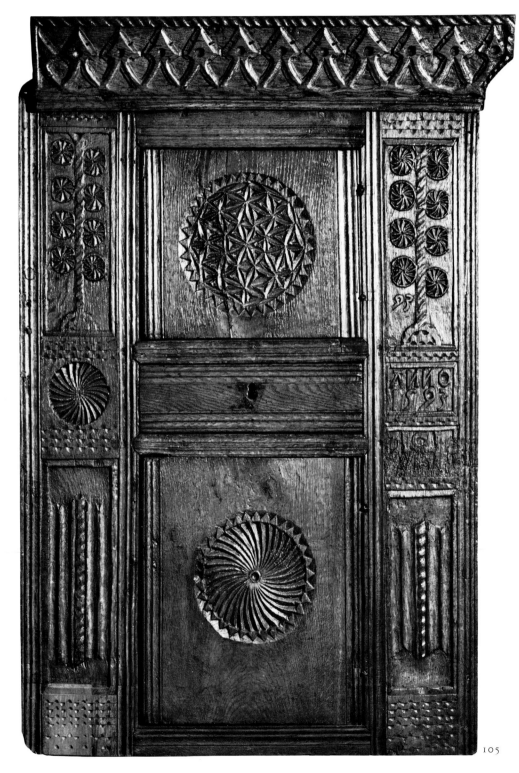

105

106

107

108

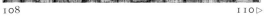

110▷

109

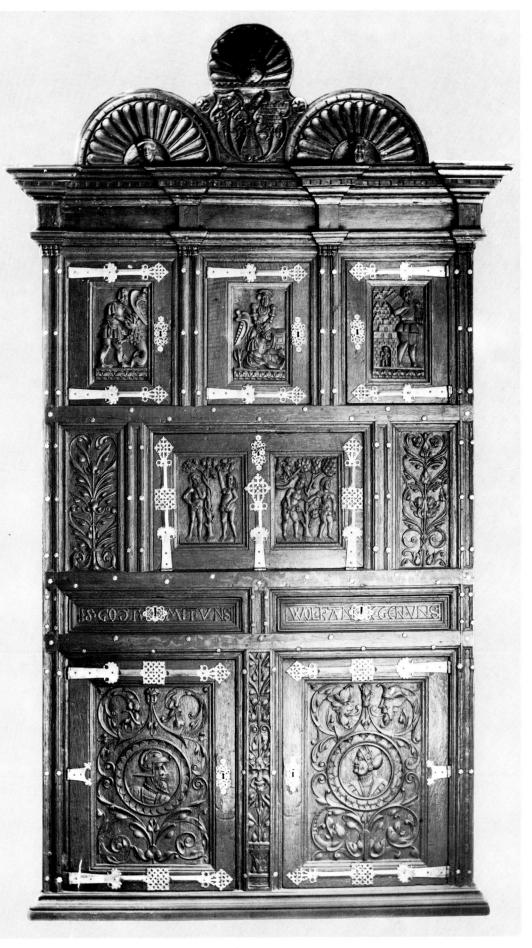

121 Wardrobe. Fir, painted. *Circa* 1810. From the area around Langenburg, Crailsheim district.

122 Wardrobe. Spruce, painted. Beginning of 19th century. From the Giant mountains, Silesia.

123 Wardrobe. Spruce, painted. 1749. Vicinity of Miesbach, Upper Bavaria.

124 Pair of wardrobe doors. Softwood, painted. Beginning of 17th century. Probably made in Tölz, Upper Bavaria.

125 Wardrobe. Spruce, painted. 1825. From central Franconia.

121

122

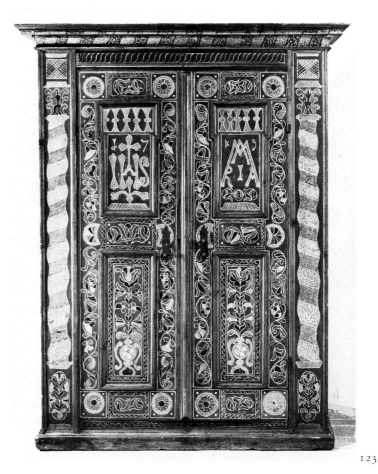

123

124

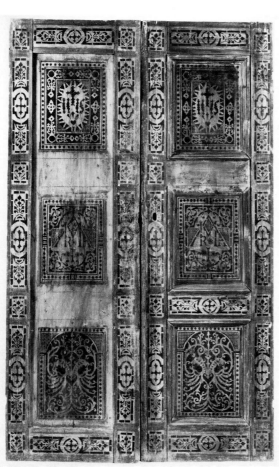

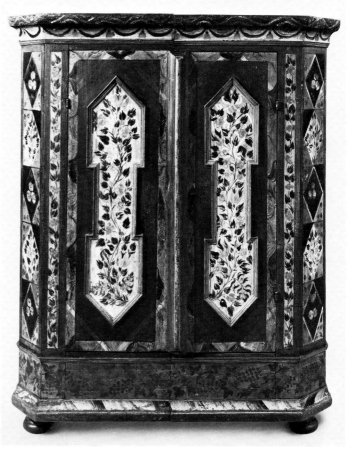

125

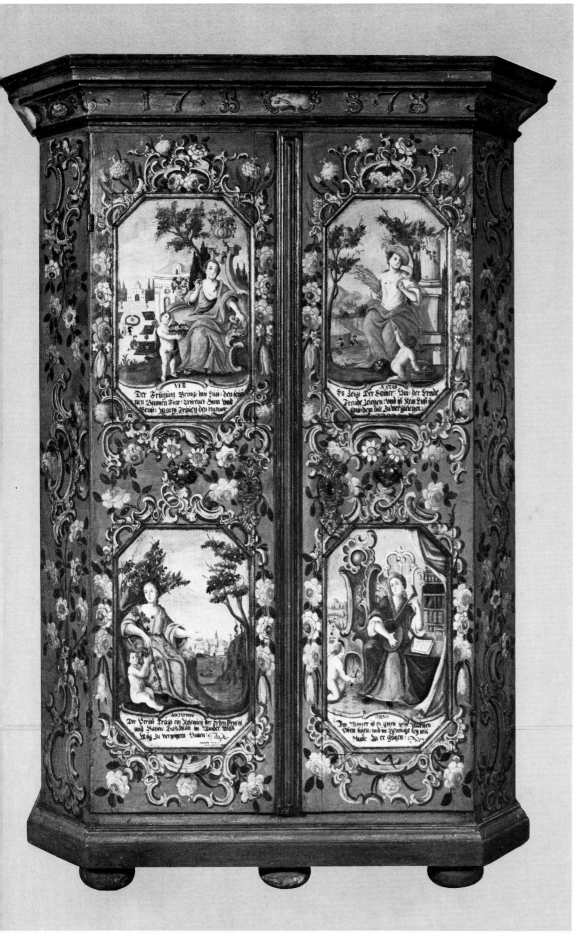

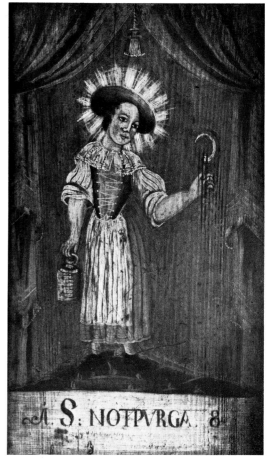

A. S. NOTPVRGA. 8.

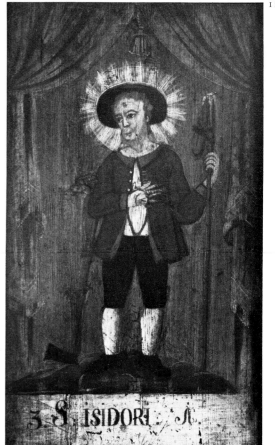

3. S. ISIDORI. A.

126 Wardrobe. Softwood, painted. 1778. From Leitzachtal-Aibling, Rosenheim district, Upper Bavaria.

127–128 Details of the front of a wardrobe. Softwood, painted. 1831. Made at Tölz, Upper Bavaria.

129 Wardrobe. Softwood, painted. 1786. Formerly in the Jodlbauernhof, Hagnberg, parish of Fischbach, Miesbach district, Upper Bavaria.

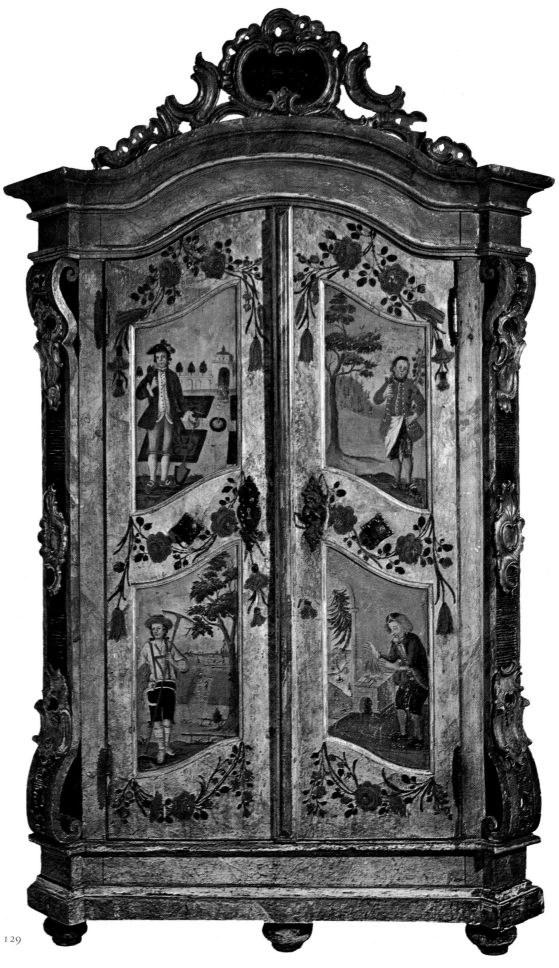

129

130 Treasure chest, a so-called 'Landesblock'. Oak. Medieval. In the church at Land-kirchen, island of Fehmarn, Holstein.

131 Chest on supports. Softwood; oak. Ornaments painted in black and red. 15th or 16th century (?). From the country around Wasserburg am Inn, Upper Bavaria.

132 Chest on supports. Oak. *Circa* 1400. From Holzacker, north Friesland district.

131

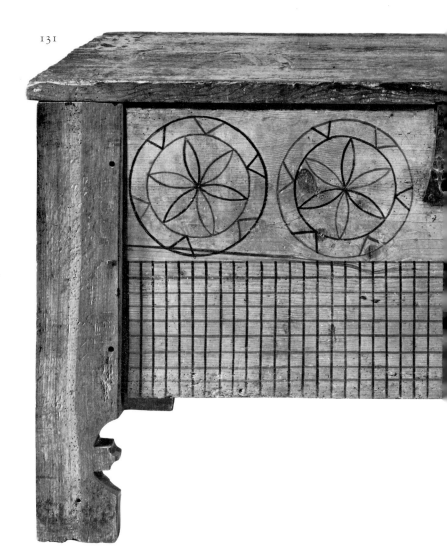

130

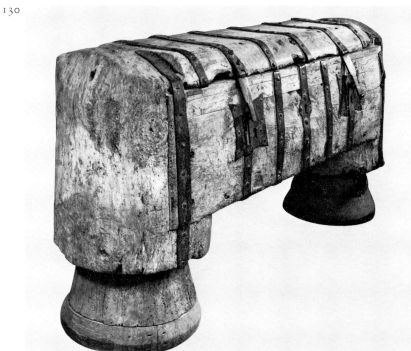

133

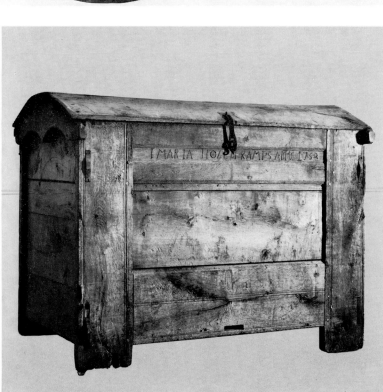

134 ▽

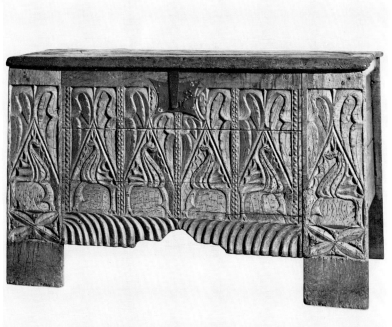

133 Grain storage chest. Oak. 1752. From the Artland.

134 Front of a chest. Oak. 16th century. Acquired at Lunden, Dithmarschen.

135 Chest. Oak. *Circa* 1600. From Sillerupsgaard, Hadersleben (Haderslev) district, north Schleswig (now Danish).

132

135

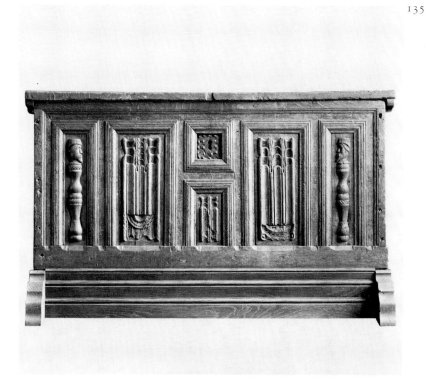

141 Chest. Softwood, painted. 1811. From Franconia.

142 Chest. Softwood, painted. End of 18th century. From the Bavarian Forest.

143 Chest. Softwood (?). *Circa* 1800. From the Giant mountains, Silesia.

144 Chest. Softwood, painted. 1782. From the Rosenheim district (?), Upper Bavaria.

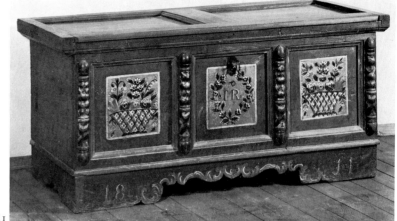

141

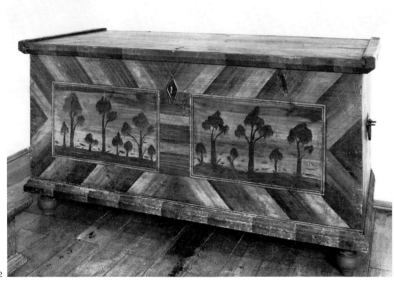

142

143

144

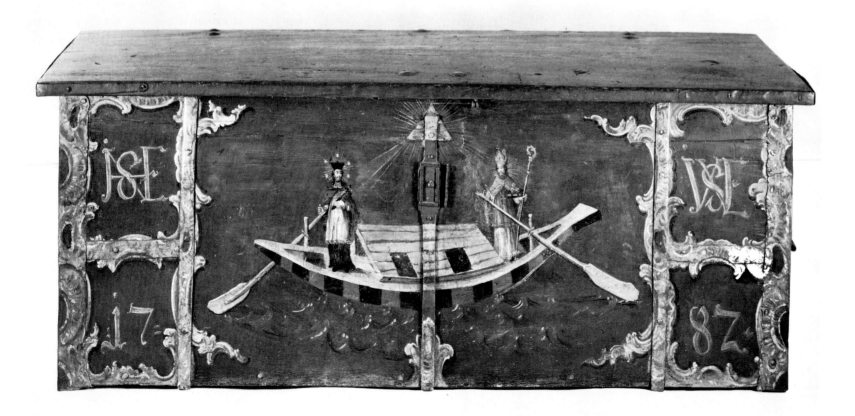

145 Chest. Fir, painted. 1833. In the Kaupen, Burg, Spreewald.

146 Detail of a chest. Spruce. End of 18th century. From a parson's house near Eberswalde, Mark Brandenburg.

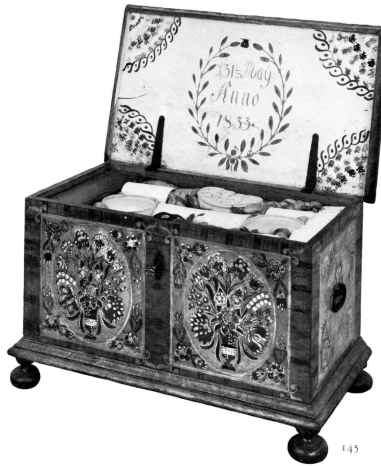

145

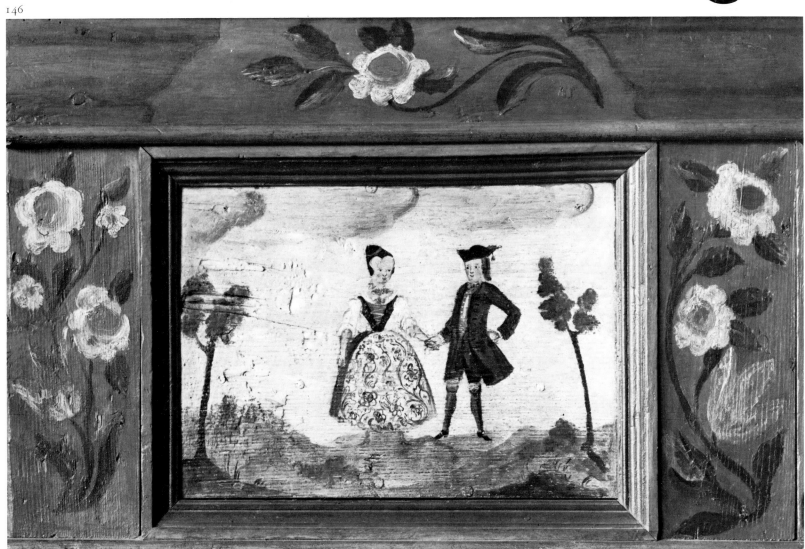

146

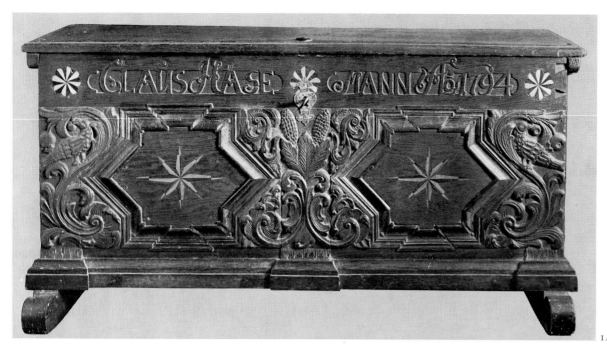

147

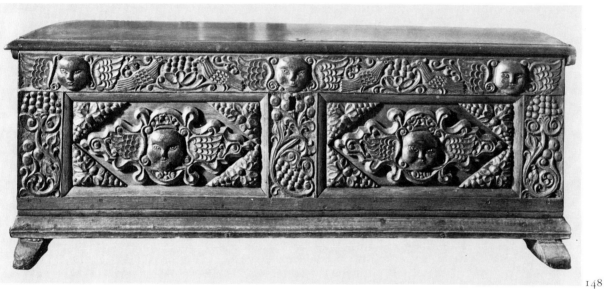

148

149

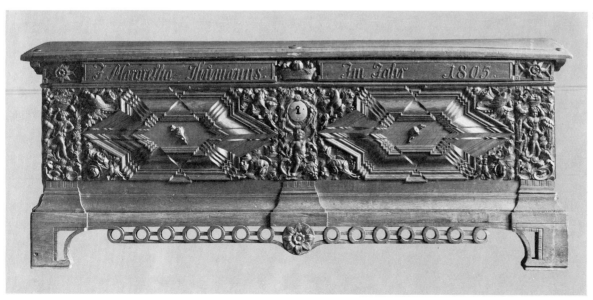

147 Chest. Oak. 1794. From Klein-Sonnendeich, Pinneberg district, Holstein.

148 Chest. Oak. Latter half of 18th century. From south Dithmarschen.

149 Bridal chest of Margretha Thumann. Oak. 1805. From the Wilstermarsch.

restrained in the background colour, but all the brighter in the curves. The finest examples were made between 1730 and 1790. They preserve a feeling of Baroque richness without the artificialities of Rococo style. Hardly anywhere else in Germany did popular painting achieve such a degree of independent artistic mastery, something that cannot be measured by any criteria of contemporary art. Friedrich Sieber, in a detailed study, recently endorsed the very old theory that both the furniture and the painting were created in the Moravian Brethren's settlement at Herrenhut, situated between Zittau and Löbau. According to Sieber, popular furniture from the Herrenhut workshops was thus entirely, or at any rate predominantly, the work of Moravian joiners. They used forms which were familiar to them from their own homeland for the benefit of the Herrenhut district. Neighbouring workshops soon followed their example.[61]

Chests

It would be impossible for a book such as this to provide anything like a complete history of the development of furniture. We shall pass over such questions as how far chests with a roof-like lid can be regarded as the origin of medieval and later containers and are thus a living piece of history where they are still found—in regions outside Germany, in any case. Neither does the bench fixed to the wall shaped like a container belong here.

An appropriate point of departure is the time when the medieval chest, many examples of which survive in North Germany, clearly enters the general history of furniture by developing specific popular forms. The quantity of surviving evidence from the sixteenth century onward is enormous, especially in North Germany. It could be used as a basis for a geography of folk art by classing particular types of chest according to their locality. Many publications already cover much of the preserved material, but these are as a rule confined to simple description. In 1941 Otto Bramm produced a map of Germany on which he marked the most important types of rural chests.[62] Conclusions drawn from other kinds of furniture are confirmed by this map: in North Germany older specimens are preserved in larger numbers. This is not just a result of the northern preference for oak, but stems from the fact that the old methods of construction persisted in this region for longer.

From the seventeenth century onwards the chest as a piece of furniture, both for use and ornament, survived only in rural areas. It was no longer seen in fashionable homes, except in the servants' quarters.[63] No new graphic patterns for chests were devised after about 1600. This is a clear indication that, unlike wardrobes, chests had become part of the folk-art repertoire and explains why, in cases where the chest could still hold its own alongside the wardrobe, it developed a distinct regional individuality. It no longer followed fashionable bourgeois trends, but was left to develop on its own—a precondition for real folk art.

It may perhaps be useful to establish the basic methods of construction because they indicate that the maker of the chest was indeed a craftsman. Techniques have their own line of historical development. Marking their spread on a map may be informative, as has been proved by researches into the construction of framework houses.

The decorative treatment of a piece of furniture will always depend to some extent on its basic construction, although it may sometimes be in contradiction to it, or at least independent of it. Behind a chest façade suggesting box construction, an older frame based on the four-post principle may be hidden. The modern mind is tuned to a functional approach and rebels against such contradictions, demanding conformity. Otto Bramm reminds us:

> We must remember that in times when craftsmen thought in structural terms, such as the late Romantic, high Gothic and high Renaissance eras, furniture had to show its construction more clearly than in periods when the emphasis was on the graphic element, such as the early Romantic, late Gothic, early Renaissance, Baroque and Rococo periods. In the case of chests this means that the vertical lines of the four-post type were appropriate to the late Romantic and high Gothic styles, while the horizontal feeling of the box chest was better suited to the Renaissance. In both cases the construction of the chest and the architectural style of the period were closely connected.[64]

This cannot be denied, but it must be emphasized that such concepts as conformity to the style of a period do not really apply in the realm of folk art. Often its attraction lies precisely in its unorthodoxy. This problem and the changing attitudes to its appreciation will be discussed in the final chapter. At this stage we need only point out that the notion that the decoration of a piece should interpret its construction may be only a passing fashion, confined to craftsmen of the twentieth century. The village artisan of two hundred years ago would not hesitate to give a box chest a façade which had no reference to its basic construction. It is in any case questionable whether one may regard any single pattern of construction as representing the style of a period; this has already become clear from our discussion of the sideboard *(Schenkschiewe)*.

It is certainly possible to state after a brief examination that the 130, four-post type of chest is older than the box type. This may depend 133 on such matters as the way the craft developed or the availability of materials. The four-post shape looks much better in hardwood than in softwood. Where Bramm's map appears to show their respective distribution, we really have the result of the interaction of both these factors. However, nineteenth-century chests from the Vierlande show that such rational explanations may be completely superseded by others. Here chests for men and for women were produced concurrently, and the deciding factor was the type of construction: as a rule the men's chests were of the four-post type, while those designed for women were box chests. The decoration of both types is similar in 139 style, but emphasizes rather than hides the difference in construction. This confirms a rule which is generally applicable to articles from a localized environment: certain forms were adopted because they had a definite meaning, often without any relation to the standards set

by the socially dominant classes who followed fashionable trends. Can the appearance of the two types of chests be associated with that of the two sexes? Is the four-post style allocated to the male because it is generally taller, just as men's chairs were higher than women's? Or has the stylized, more elaborate design a 'masculine' effect and the squat, relaxed appearance of the box chest rather a feminine one? Such questions may seem absurd but they are not altogether without validity. There is, in any case, no question of the difference being of the same order as that between benches or chairs, where, because men are usually taller than women, the higher seat was allocated to the man and the lower to the woman. In short: we must accept facts as they are and realize that such things cannot be explained logically by means of a map of distribution or a scheme of development.

The forms of popular chests in Germany can be classified in different ways—the distinction between four-post and box chests is only one of them. Other criteria may be the shape of the lid, the size (bridal chest, servants' chests), or the function (for grain, meat or linen storage); another is the type of wood used. Bramm maintains that the installation of wooden floors upon which the chests were to be placed, the need for cleanliness and various other practical considerations all played a part in differentiating the forms of chests. None of these lines of enquiry is very productive. The extremely variegated total picture can only be understood if each region is examined in detail to see how its particular form developed and changed, both in construction and in decoration. A search for generalized rules is unrewarding, especially if ornamentation, the real artistic element, is included. A statement occurs in the literature to the effect that in southern Germany the decorated sides of a chest were generally divided into an odd number of panels, but in the north always into an even number. This is not correct. Chests from seventeenth-century Bremen, for instance, generally have five such panels. Differences occur even within a comparatively small area: early eighteenth-century chests from the Eiderstedt peninsula have arched panels like those of neighbouring Dithmarschen but only three of them, whereas in Dithmarschen there are usually four.

150, 151 From the late seventeenth century onwards the trunk type became more and more widely accepted and assumed special functions, even in bourgeois homes. Its lid is rounded and the box shape is perpetuated in the rim of the top. Metal mountings again come into their own, both for better security and as decoration. The popularity of trunk-type chests and the fact that they are generally large suggests that they had to satisfy a new demand. The general fondness for them may be due to the change from woollen blankets to feather beds which required more space for storing spare coverlets, since these were lighter but bulkier. The trunk form is another example of closer contact between rural and urban forms. One can often judge from the type of fittings—iron or brass mountings, modest or elaborate mountings, with or without leather covering—to which group, rural or urban, an individual specimen belongs.

An examination of the development of chests in the small rural community of Probstei in the east of Holstein shows how impossible it is to reduce the wide variety of types to a precise formula.[65] There

was no shortage of oak and the craftsmen might therefore have continued making four-post chests which, according to Bramm, could best be made from hardwood. However, quite early—not later than the seventeenth century—they began to make oak box chests with 138 bases, i.e. of a type which Bramm considers more suitable for softwood; then they switched suddenly to the trunk type, but continued to use oak. The box chests were generally painted and worked with intarsia; in the case of trunk-type ones there was no mounting and the decoration was carried out entirely in intarsia. Thus in one small locality the development of patterns shifted and intersected according to the requirements of the time. Only very detailed investigations, such as those by Ulrich Bauche in the Vierlande, can clarify the changes which took place from phase to phase.[66] Research of this kind is currently in progress in the Oldenburg Münsterland. A certain amount of data from various regions and dates is available, but there are still great gaps.

Ellen Redlefsen has proved, by comparing styles and forms, how the large and expensive oak chests built around 1600 by the Flensburg carver Heinrich Ringelink for noblemen and burghers had popular successors in the surrounding Elbe countryside, particularly the Angeln region. The process can be followed for about a century. The biblical scenes which Ringelink used to include in the four parts of the front of the chest were gradually abandoned. However, he began by taking over the arrangement of Renaissance ornaments in toto. Around the middle of the seventeenth century these were reduced, stylized and in the end flattened and debased. Church fittings, like the pulpit in Rüllschau dated 1642 and the gallery in the same church which was added a year later, provide useful evidence suggesting that they came from a workshop in north Angeln. This has not yet been identified. It is more important to study the regionally circumscribed process of transition from one stage to another than to try to ascertain the name and origin of the master.

Similar, locally restricted areas of influence can be traced here and there, but the circumstances differ in each case. For instance, around 1600 Eckernförde, not far from Flensburg, was also the centre of a flourishing joiners' industry with very characteristic chests as its main product. Yet well into the seventeenth century, the clientèle consisted almost exclusively of country gentry who followed the trend of the times. Chests, which had gone out of fashion by then, were no longer required. There was no demand for them among the peasants who lived on the estates, and consequently no more chests were made at Eckernförde. Not far away at Husum there seems to have been no local type of chest of the superior kind. Here the rural demand for chests did not get under way until the more sophisticated bourgeois customers had dropped out. The joiners of Husum still clung to patterns of decoration that had survived since the Renaissance.

Although there was a demand for chests throughout the country it was not always met by local production of a specific type. True, there are regions in which the chief types developed continuously along comparatively independent lines. Among them are the marshy districts on the right bank of the Elbe such as Wilstermarsch and

Krempermarsch. Here, as in many other places, the original post-medieval form is the box chest with four arched panels in front. Well into the eighteenth century these areas were ornamented with intarsia decoration, particularly the double-headed eagle. In the latter half of the century, after several intermediate shapes, a type similar to that found east of the mouth of the Elbe developed. The façade was divided into two horizontal panels, the vertical stays decorated with carving and the panels filled with wavy outlines carved in relief. This is another example of the influence exerted by furniture craftsmen in Hamburg, which persisted here until after 1800. The chests were obviously made by a number of rural joiners living in Wewelsfleth and other villages, who must have been geared to a large and homogeneous output, as demanded by the wealthy farmers who dominated the life of the area.

147, 149 (margin note)

A comparison of the chests characteristic of Schleswig-Holstein folk art from the sixteenth century to the nineteenth shows an extremely wide variety of types, almost always made of oak and sparsely painted. Unlike the regions further south, soon after 1800 the popular forms peculiar to the locality began to decline, and around the middle of the nineteenth century they disappeared. Their southern counterparts, the painted wardrobes and cupboards which occupied a similar rôle in the rural household, preserved their specific regional character until the 1860s.

Many more or less clearly differentiated local varieties of chest were developed in North and central Germany. They are found around Oldenburg, in Westphalia, along the Lower Rhine, in Hesse and so one. It is often difficult to be sure whether an urban centre determined the local style or whether a class of wealthy farmers encouraged local craftsmen to produce furniture of fairly uniform appearance and quantity. The names of brides who received such chests as part of their dowry are often incised, together with the date, so that the pieces can sometimes, with laborious effort, be traced back to their original owners. With luck the owner's property and social status can be established, indicating the purpose which the piece was designed to serve. No such investigations have been completed yet, and those of W. Müller-Wulckow of Oldenburg have not even begun. The open-air museum at Cloppenburg has only recently embarked on a systematic study of the district and of all the available evidence, including the records of country joiners.

Chest fronts developed a very characteristic style in east Friesland. The four arched areas were covered with bas-relief in a rather uniform pattern. Well into the seventeenth century these chests continued to be influenced by the five-area type from Bremen, with its carved grooving in the Gothic tradition modified by the spirit of the Renaissance. Later, the four areas—with or without arching—were covered with 'tulip tree' motifs in bas-relief. Alternately they were ornamented with metal mounting combined with rosettes; this might extend over large surfaces, just as in chip carving.

In the adjoining Münsterland of Oldenburg we find an entirely different type of chest front. Flat areas are carved out of the wood of the front boards in bas-relief without any motif constructed by the joiner. Within these areas large winding tendrils grow into clusters of blossoms. This seems to be an original form with no parallels in contemporary style. In Hümmling in Westphalia equally individual but different tendrils occur, alternating with stylized scale-like patterns and stars. Such designs, which have an individual stamp, must come from a definite source, probably a village workshop which did not survive for long.

In southern Westphalia and particularly in Bergenland a type of chest occurs where the front forms a single panel covered with carving. Scrolled bas-relief winds from an almost heraldic central motif across the whole surface. Sometimes the influence of contemporary Rococo style may be discerned, but the motifs in the accompanying frame retain forms derived from the Renaissance, such as interweaving ribbons, flakes, arcades and similar patterns. Even where the overall arrangement of the chest front is fixed, the variety of effects is astonishing. The basic construction, whether the chest stood on four posts or a base, can also influence the general appearance. Widely whirling tendrils rising from the legs toward the centre can give the box an 'elastic' look. These tendrils may turn into dragons with fish-like tails. In the north-west of Germany animal forms with dragon heads often emerge from sweeping ornamental scrolls. Sometimes the impression of a structure built up of several layers may be created by the insertion of drawers between the base and the box.

Along the Lower Rhine the four arcades are sometimes replaced by cartouches with wavy outlines derived from the Rococo style but used, in this case, with a severity reminiscent of the Renaissance. As a rule the division of the façade into four slender, strictly rectangular areas remains. Beginnings of an architectural arrangement may suddenly be interrupted by completely different forms such as hearts. These may be surrounded by scrolls, or lose their solid balance by the introduction of art forms belonging to the joiner's craft, such as corner mouldings. In the course of two centuries a variety of compositions and facings was accumulated for use in new combinations, to which no rigid rules of artistic purity seemed to apply. This variety is the essence of the artistic wealth of folk art, and its application to the façades of chests is one of its most fruitful and profitable manifestations.

In chests from Hesse, likewise, the front is often described as composed of fields of different shapes and sizes. There are arcades, coffers, upright or horizontal, simple or twisted or extended with short ornamental strips to fill the front completely. This type of surface composition is also found in specimens from south Westphalia, but there the effect was enriched by filling the panels variously either with carvings or with intarsia—both often being used on a single specimen. In Hesse, or to be more precise in the Rhön mountains, the older tradition of chest construction, the four-post type, remained in use until the nineteenth century, at least for boxes for storing flour. Not only the mode of construction survived, so too did the early form of incised decoration by stringing simple motifs Cf. 131 together in strips.[67]

At the same time a parallel development was taking place on bridal chests, which were also built on the four-post principle, with luxuriant ornamentation on the double front boards. Decorative tech-

niques included the sculptural effect of plant shapes derived from acanthus foliage as well as pictorial intarsia motifs. This style was particularly prominent in the region around the upper Lahn. The University Museum in Marburg contains specimens of chests with fronts showing the most daring combination of decorations. The moulding on some of the framework between carved and ribbed friezes above and below is completely covered with intarsia patterns. On the main fields receding fillings alternate with raised and twisted beadings. Every part is full of vitality, and even the base board is raised and perforated. There is even some painting, although this is mostly confined to details, such as a mask or other bas-relief motif, or to the whole base of the chest. In a few cases, for example a chest from the workshop of the master-joiner Johann Debus Ordmüller at Damphausen, in the district of Biedenkopf, the five main panels are covered with figure motifs in bright colours. An exuberant vitality is expressed in the play of combined and varied decorative forms. The mood alternates between aridity and sudden liveliness, through the transformation of traditional elements and the daring combination of elements which might generally be regarded as incompatible.

In southern Germany the patterns of arrangement, framing and carved ornamentation give way wherever the front of the chest is painted. The emphasis shifts to the centre of the fields and the main concentrations of colour and form are in bunches of flowers, star patterns and other decorative work.

Right across Germany from Württemberg to East Prussia there is a broad zone in which box chests mainly have façades divided by
141 glued, turned or split rods—a style virtually unknown in the north-west. Thuringia and Upper Franconia are particularly rich in splendid examples. The areas between the balusters are covered with painting, but architectural frame motifs such as arcades are sometimes introduced. There are fewer carved ornaments; the transition to mainly painted furniture becomes obvious.

When one looks at the map there are no clear-cut boundaries, especially as South Germany has only a sparse store of the more elaborate chests. In this area the wardrobe is of prime importance. Yet the Black Forest created some magnificent examples, with three simply framed arched fields containing bright and lively bunches of painted flowers on a dark background. In the region near Lake Constance the painter could indicate simulated frames and then let his decorative Rococo scrolls, tendrils, etc. spill over these borders. However, there seems to be no point in considering painted chests separately. On the whole their composition follows closely the model of the wardrobes for which they were the pace-setters. The common elements in the various types of box furniture are more evident in the painted decoration than in the joinery or carvings because the latter are more influenced by structural considerations, even though the chest front offers a ready-made surface.

If we confine ourselves to characteristic local forms, the close resemblance of wardrobe and chest decoration shows up particularly clearly in the Lower Lausitz. Here the wardrobe fronts as described above are paralleled by equally lively painting on chest façades. An early model of uniformity in furniture decoration is provided by

Upper Bavaria. Chests from the seventeenth century painted with architectural patterns derived from Tyrolean and north Italian intarsia decoration, found in the vicinity of Miesbach and Tölz, display the same wealth of patterns as contemporary cupboards, wardrobes and beds. They almost create the impression of the 'suite' we know in interior decoration today. It therefore makes little sense to treat the chest as a separate entity. This is where a more generalized term like 'painted furniture' comes in, and the type of furniture in terms of joinery is relatively unimportant. Conformity between wardrobes and chests is, of course, also found elsewhere. In east Friesland and in Westphalia similar or identical motifs of carved decoration can be found on both types of box furniture. In districts like the area round Bielefeld, where fine bedsteads were an indispensable part of the bride's dowry, they too, share the same type of ornamentation. But 90 the fact remains that painting obscures and restricts the share of the wood-worker in determining the construction and materials of the end-product.

Chairs

No discussion of popular seating arrangements should fail to emphasize the difference between the post chair and the board chair. The former was the predominant form in North Germany, along the Lower Rhine, in Westphalia, northern Lower Saxony and particularly in Schleswig-Holstein; the latter was commonly used in the rest of Germany. The post chair consists of a frame of four posts, the rear pair of which rises above the seat and, together with rungs, beadings 73 or boards, forms a back-rest. Often the front pair, too, is raised to support arm-rests; in this case it is of course called an armchair. The seat is fixed between the four posts. It generally consists of a web of straw, rushes or hemp fibre stretched over rods. In the Lower Rhine area and in parts of Westphalia one meets a variation with only three posts; the one at the back has a board fixed to it to constitute the back-rest and is connected with the two other posts by struts. The three-legged version has the advantage of standing firmly on an uneven surface.

The legs of a board chair are set into a strong board, sometimes 40, 4 reinforced by struts which are generally spread out to form the actual 44, 4 seat. The back-rest, too, is often a board, enlivened by fretwork per- 52, 5 forations, which is let into the seat. The board chair is quite obviously 68, 7 the later form. It was imported into Germany from Italy, probably 75, 8 during the sixteenth century, and with its simpler construction soon 87 ousted the post chair, which was forced out into north-western parts of the country. Only a few examples of the post chair are found in the whole area between the extreme south and the northernmost 29, 3 regions of Germany. A local group which is confined to Hesse will 32,38 be dealt with separately. 43

The four-post armchair with arm-rests occurs in many variations. The posts are either cut squarely or turned. In cases where the back- 71,73 rest is also composed entirely of turned rods, we can discern a tra- 76, 7 dition which derives from the early Middle Ages. At the height of 435

76 the Middle Ages back-rests with a kind of board at the upper end appear; they persisted well into the nineteenth century. The general 73, 77 effect depends largely on the way the posts are arranged. Steep and narrow chair-frames are found as well as broad ones, and some have posts sloping either away from or toward each other. These variations are occasionally the result of local traditions. Armchairs from the par- 30 ish of Ostenfeld near Husum, which often have turned posts, are squat and heavy, while their counterparts in the Probstei soar 33, 37 upwards, but do not convey a rigid impression, since they have sweeping contours and seem to be held together by clamps.

On the whole the post armchair embodies an old tradition, not only in its manner of construction but also in the rôle it plays in domestic life. It is the seat of the master of the house, or if there are two of them then of the father and mother of the family. We cannot pursue here the important implications of this for cultural history, related to the fact that personal references to the chair's owner are often found in the ornamentation of the back-rest board and particularly in inscriptions giving his name and the date. A young couple who took over a household had the right to claim a new pair of armchairs, the man's usually being taller than the woman's. In the ceremony of conducting the bride (or bridegroom) into the home this chair must have played an important part. Many details are known of the celebration held when a new head of the household took over, but little information is available about particular houses where it occurred; nor do many pieces of furniture connected with it seem to have survived. However, it is significant that the form of the post chair is preserved in the Hessian bridal dowry chairs. Made 71 of beechwood, without arm-rests, and lavishly embellished in vivid colours, these highly regarded artefacts occur in the upper Lahn area, the district of Biedenkopf across the Schwalm and the adjoining district (Gericht) of Schönstein right into Lower Hesse. The surviving specimens belong to a period covering a span of about a hundred years starting from, say, 1760. The use of colour increased shortly after the turn of the century, at first to emphasize details. Twenty years later the whole piece was covered with even brighter colours.

The importance attached to the bridal chair, compared with other seats, is due to the part it played in traditional wedding customs. According to Karl Rumpf, a colourful chair of this kind was placed on top of the bridal coach, and must have been its most prominent feature. To make the back-rest as ostentatious as possible it was widened towards the top. This accounts for the characteristic curve in the two back posts. The Hessian examples therefore have spiral or twisted forms under the seat, though these are not necessarily 'turned' in the true technical sense of the word. Upwards from the seat the posts diverge, which means there can be no turner's work where they are made in a single piece. Turning was quite feasible, on the other hand, on the straight front posts. The two boards of the back-rest are connected by a small baluster and can thus be given more colourful decorations such as open-work carving, incised drawing or a coloured frame. Motifs which occur include circles with stars, hearts (single and in groups), chip carving either covering parts of the surface or as a frieze, festoons and symmetrical scrolls, pyramids,

plants, tendrils, large tulips, lions facing one another and crowns; furthermore there are inscriptions, such as girl's names (sometimes also those of men) and dates. The combination of motifs and techniques varies widely, indicating that many different workshops were involved.

The appearance of very similar bridal chairs at Jamund near Köslin, Pomerania tempted Alois Riegl in 1890 to assume that this characteristic form of chair is a survival of a very ancient Germanic tradition which was once common to the north of Germany, Scandinavia and Ireland. Others, too, were prompted to draw similar conclusions by the remarkable parallel features that can be found. We believe rather that these parallel developments arose from similar conditions. Simpler forms of the Jamund chair occur also in other parts of north-east Germany, for instance in the Marienburg Werder.[68] Examples of what were apparently bridal chairs and ancient-looking post chairs with decorated back-rests also occur elsewhere—in central Hesse, for instance, e. g. at Maden (district of Fritzlar-Homberg),[69] although not in such numbers or with so much individuality. By the nineteenth century the post armchair was regarded in some areas as out of date and was relegated to the old folk's quarters. A few isolated examples are found in South Germany, for instance in Bavaria[70] and in the Palatinate.

In other parts of the country, too, the posts, mainly the front pair, are sometimes curved and bent. The effect is to make the armchair seem to be offering a hospitable invitation to the guest to be seated. This 'gesture' remains confined to popular chairs. In general it must be acknowledged that the post construction lends importance, even dignity, more by the place of the chair in the house than by its size, or decoration. A register of chair styles would have to include all the relevant factors: the overall proportions, the amount of turner's work, any special features of construction, the shape of the arm-rests, back-rest, side-rests etc. The decoration of the flat areas and the carving of the boards and balusters would only be a secondary consideration. Chairs are incredibly varied in form, quite apart from the stylistic changes that result over time. They demonstrate the truth of our definition of folk art as endogenous development of a given type of object, within a limited social environment, leading to acquisition of a distinct, independent character unrelated to fashionable trends. Instead of 'character' one might speak of 'expression': the expression 296 of concepts in a unique stylistic idiom. In areas where the post chair 298 predominates the seat has no upholstery affixed to it, but was usually 299 covered with loose cushions. Cushions made in pairs, with identical 302 colourful decorations, added to the impressive effect. Such cushions 303 were always to be found both in town houses and in rural dwellings. 305

A tour of German territories paying particular attention to the characteristic forms of chairs would give a very uneven picture, because not every region had an equally strong individual style. There is no obvious reason why, in certain areas, chairs should have been given a specific shape or why many different forms should have existed alongside each other. (The question is equally applicable to local styles as they affected other branches of folk art.) Helmuth Thomsen compared the forms taken by chairs in the marshland

regions of the Lower Elbe. He found that there were distinct differences between them, although they all owed something to the urban model of Hamburg. The vicinity of this city stimulated more elaborate treatment in all kinds of household equipment. It provided rural artisans with the stimulus to experiment, instead of merely resulting in uniformity throughout the surrounding region. This becomes very clear in the case of chairs. In the late eighteenth century post chairs built up from turned parts are predominant in the Altes Land as well as the islands of Finkenwärder. The lively outlines of the distinctive back-rest boards, with their bas-relief, names and dates, and the vividly coloured painting all strike a festive note. These were apparently the models for chairs made on the opposite bank of the Elbe, mainly those at Blankenese, where many sailors and pilots lived, and where the overall impression is rather more severe: struts are less frequent, carving is simpler, and painting in several colours is entirely absent. On the left bank of the Elbe there is a pronounced difference between chairs made in the marshlands and in the sandy uplands. In the whole of the region between Stade and Hamburg and further up river they lack ornament, colour and inscriptions.

The same contrast can be seen on the right bank of the Elbe, in Holstein. Chairs from the sandy uplands around Pinneberg are simpler in form, similar to those of the uplands on the left bank. Nearby Kremper- and Wilstermarsch, on the other hand, have their own types which again are more elaborate, like those of the Altes Land, although less uniform. The posts are round or angular, and the boards of the back-rests stronger in the modelling of their carved decoration, which resembles the carvings on the chests and room panels in the same region. The ornamentation is richer on chairs with angular posts, which become broad supports for the back-rest and have lively surfaces and contours. There is a big difference between the chairs of the Altes Land and those of the Wilstermarsch. It has been suggested that this may be due to closer ties between the latter area and the Netherlands. This explanation is not convincing because models which could have exerted such an influence hardly exist in the Netherlands.

The marshlands down river from Hamburg, such as the Vierlande, also developed their own individual style. In the course of two centuries they produced only chairs with angular posts and an upright stance that looks stiff. The back-rest consists of a wide board covered with intarsia decoration. The historical development of the intarsia motifs can be followed. In the first half of the nineteenth century bas-relief patterns sometimes appear as decorations on the flat surfaces. Only the cross-struts are round; they replaced the somewhat clumsy angular posts.

While the chairs from the Vierlande served as a prototype for those made at Winsermarsch on the left bank of the Elbe, they made no impact on neighbouring Ochsenwärder Marsch on the right bank. The chairs of the Winsermarsch differ from those in the Vierlande mainly in having no rods turned on the lathe.

The marshlands around Hamburg exemplify the multiplicity of forms that exists. This diversity becomes even more pronounced in western Schleswig. At Eiderstedt there is a form of armchair which is evidently confined to this locality. Next to it, in the coastal strip to the north, we encounter armchairs built up from turned rods which look medieval, and alongside them is a colourful and astonishing variety of forms. One finds, especially on the island of Sylt, some examples of the Windsor chair, of English origin. This again points to a connection with the north, since the Windsor chair was widely adopted in Norway, spreading from there to Härjedalen.[71]

The island of Sylt received a small off-shoot of this powerful influence, so to say. If one tried to compile a map of Germany showing the areas in which different shapes occur, one would obtain a completely confused picture. Major developments which are easily explained historically seem to undergo localized variations which are sometimes no more than the work of a lone individual. On the other hand there are amazing similarities in the form of chairs from far distant areas: those in north-west Germany, for instance, recur in very similar form in the vicinity of Danzig and in East Prussia.

A very individual form of the post chair was produced in the parish of Ostenfeld near Husum. The population of this tiny district has been somewhat isolated from the surrounding country since the sixteenth century. At that time this parish must have had a fair share in the economic boom of the nearby port of Husum. It adopted the 'long-house' and became a pioneer in this compared with regions further north. It also took over other innovations which marked urban life at the beginning of the modern era. The boom was followed in the seventeenth century by a hundred years of stagnation. The effect of this can even be seen on chairs made between about 1760 and 1860, most of which have thick turned posts, a correspondingly awkward, heavy stance, and crude back-rest boards with some open-work or bas-relief decoration. As on Hessian bridal chairs, balusters with small rods often occur between the boards, and the upper end is sometimes finished off with a row of small buttons twisted on a cord. The carvings on the back-rests include a large variety of motifs. Open-work tendrils unfold in round patterns reminiscent of the Renaissance; incised linear forms are mostly clumsy. Some timeless motifs retain their original vigour. Since most back-rest boards bear the original owner's name and the date some detailed information about them can be assembled. An insight can be gained into their relative prosperity at different dates and family relationships. In regard to furniture in general the parish apparently remained dependent on craftsmen from the town of Husum, but the chairs give the impression of having been made in the village. Chairs from Ostenfeld occur today in a few private collections, but most of them are now museum pieces. One finds them in such collections as those at Hamburg, Schleswig, Husum, Nuremberg, Copenhagen and Stockholm.

The board chair is characterized by a stout seat board with four legs (mostly round or polygonal and sloping outward) set into it. The back-rest—board or rods—is also fixed into the seat board. The only part that can really be elaborated is the back-rest board, especially in respect of its outline which can be modified in many ways. It is mortised into the seat with a wide pin, generally narrows at hip level and broadens out again higher up. Various ornamental motifs have been

adapted to this basic pattern. Some have an almost heraldic appearance: the double-headed eagle plays a big part, and occurs again and again in chairs from widely separated regions. Lions standing upright and holding a shield can also be easily fitted to this form. Such heraldic subjects may have found their way into the repertoire of popular furniture-makers as early as the seventeenth century. In the eighteenth century medallions, round or oval in shape, were taken over from contemporary fashion. Straight or rectangular arrangements, perhaps arched on top, hint at classical models.

There is no doubt that the seventeenth century left a lasting stamp on conventional forms. This is particularly obvious on back-rests, which achieved a sculptural effect through their carvings. The relief work around the handle-grip boasted an infinite variety of knotted flourishes, scrolls, shells and loops winding around each other, as well as foliage derived from the acanthus ornaments of the high Baroque. Another favourite is the motif of two sinuous and intertwined snakes, either as flat bands or, more usually, having bosses from which they are fitted into the pattern. Winding bands and knots may be derived from this snake motif, or else perhaps the reverse tendency occurred. Deneke is right in saying that they are not derived from ancient, perhaps northern, strap work.[72] By detailed comparison special local or regional forms could perhaps be traced which might even lead in the end to identification of specific workshops. At the moment it appears that no research of this nature is taking place, and in the meantime the sources from which such detailed information could be derived are drying up. Dealers and collectors have transported chairs over great distances from their place of origin. This is true not only of recent times but even of the era when the chairs were made, when they were already dispatched all over the country as merchandise. A few regional peculiarities stand out; the lion theme, for instance, was a special favourite in Hesse. Also confined to Hesse is the predilection for pairs of birds—swans, storks and pelicans—with their beaks on their chests. The winding snake has a wider context: we meet it in Tyrol, Alsace, the Black Forest area, Swabia and Franconia. A single snake tying itself into knots and biting its own tail appears on the back-rests of several chairs in Lower Saxony, indicating that chairs of this kind, too, were traded over long distances and could be imitated elsewhere. It is also possible that pattern books circulated by chair-makers led to the spread of established forms.[73]

Forrer recognized at an early date that back-rest boards demonstrate particularly clearly the process of 'dissolution' of a decorative motif. The double-headed eagle, for instance, was originally taken over from a higher social stratum, with a descriptive intent, so to speak; it then underwent a process of simplification; by omitting relief work all emphasis was placed on the outline; this led to pure fretwork, the main element was represented by perforation which acquired a significance of its own.[74] The interplay of sweeping outlines and playfully curved perforations created a form which almost entirely obscured the origin of the motif as the representation of an eagle. The opening in the middle also served as a handle-grip. Because of this practical function it was always located in the upper half of the back-rest and thus influenced the arrangement and design of the whole, especially when it represented the mouth-piece of a mask. Winding bands underwent several different variations. It is possible that this is how they came to form the motif of the two interlaced hearts which occurs, for instance, in Württemberg. This could be achieved by dissolving the knotted twirls into simple and more familiar forms arranged around two axes of symmetry. 'Dissolving' is perhaps not quite the right word here. On these back-rests the image of a real object is laboriously transformed through very many stages into a variety of forms, and ends up as mere vague outlines and perforations. We need not discuss how much of the process is perhaps due to misunderstanding of the original motif, how much to simplifying the technique of manufacture, and how much to sheer incompetence or to an ongoing feeling for appropriateness of style. To assemble series of examples in order to observe the supposed development step by step from, say, a well-shaped double eagle to outlines that only have a vague resemblance to one, would involve one in pure speculation. The historical process undoubtedly sometimes skipped certain phases. Some forms which may appear to be the end result of a long line of development may just as well derive from a more or less original innovation. Curved forms for cutting out in plain material, even paper, were much in vogue in the Baroque era. The same trend can be seen in the back-rest boards of post or board chairs, even when the latter had an arcade design.

Where the back-rest as a whole did not depict anything important it could be incised or take up an inscription or a bas-relief decoration, such as heads of angels, heraldic motifs, ornaments, names, dates, and sometimes whole scenes, perhaps from the lives of peasants or herdsmen. Although painting was not uncommon on board chair backrests in Austria, it was seldom found in Germany. On the whole painted chairs and tables did not play an important part. This is an obvious consequence of the function of the chair and its particular role in equipping the dwelling. The act of sitting in one obliges the sitter to adopt a certain posture. One conventional rule was that it was unbecoming to lean against the back-rest. Of all pieces of furniture the chair most resembles an implement, but such rules show that its form is not only to be judged by its function. The chair confers on the individual who sits upon it a certain right to do so—in a way that a bench, for instance, does not. The posture adopted by the sitter is a social act, and not exclusively a matter of personal comfort; it requires a certain discipline and bearing.

Minor Objects

33, 184 In north-west Germany it was customary to put a clothes-holder over the familiar iron stove, i. e. a wooden device with four turned feet at the corners, fitted with little turned rods and thin bars, which rested on the rim of the top of the stove. It was used to dry small garments and other materials and had knobs at the sides on which to hang other articles which needed the warmth of the stove. It thus corresponds to the poles and struts placed around tiled stoves in South and central Germany. Clothes-holders of this kind could be suspended from roof beams or built around the oven as a kind of fire-guard. The oldest examples known to the author date back to around 1780, the latest to the first decade of the nineteenth century. In decorated form their use was confined to a single generation.

They occur in an area between Westphalia and the river Eider, apparently not extending far inland. North of the Eider they were superseded by iron hooks suspended from the ceiling above or beside the stove. Right up to the nineteenth century rooms in this area had low ceilings, so that such an arrangement was practicable. This suggests that the wooden clothes-drier was a logical development in a region where it was usual to build rooms with higher ceilings. This, too, was related to the general progress which took place in the second half of the eighteenth century and in the North Sea marshlands led to far-reaching innovations in housing. Historical connections of this kind are not always recognized, which is why, in reconstructed rooms in museums, these clothes-driers are sometimes found on the stove, although they do not belong there because they originated in a different period or region.[75] The reason why none of them were made after 1810 is probably because the construction of the stove changed: the simple box-like side stove was replaced by a draught stove with an iron or ceramic superstructure that left no room for a wooden device of this sort.

The clothes-holder had to be high enough to leave enough room for a top piece which acted as a heat-retaining hood on the stove, set firmly against the wall so that food could be kept warm underneath. It was generally made of brass sheeting or potter's clay, rarely of wood. In the marshlands to the right of the mouth of the Elbe attempts were made to give the clothes-drier a light and elegant appearance. A special focus for decoration was the arched front piece, carved with Baroque plant and flower motifs, grapes and birds. The theme of the ornaments remained remarkably uniform. The centre was often decorated with a medallion bearing a monogram, supported by lions or *putti,* with the date in the other space.

Around 1800 examples appeared with straight profiled beading,

heralding the Regency style; otherwise Rococo forms predominated. A specimen dated 1794, elaborately ornamented with open-work carving, is exhibited in the provincial museum at Dithmarschen. The most richly decorated ones were obtained at an early date by Justus Brinckmann for the Museum für Kunst und Gewerbe, Hamburg.[76]

For at least three decades, then, the clothes-drier seems to have been a standard part of the equipment of a room *(Dörns)*. Monograms and dates on them may signify that they were part of the bride's dowry. Of course, they may only have been ordered once it was certain what kind of stove they were to be placed on, because stoves differed in width and the posts on which the clothes-driers stood had to be adjusted accordingly. Clothes-driers show how an implement that served a very prosaic purpose could become a first-class ornament, though like mangle-boards they remained household utensils.

The clothes-holder belongs to a group of folk-art objects which may be classified as 'minor objects of furnishing'. They are distinguished from the small wooden implements dealt with below because, although they are movable and therefore count as furniture, they are kept in a fixed place in the room or on the wall.

In the same regions where the clothes-drier developed into an ornament, the pipe-rack underwent a similar process, following the Dutch precedent. Long clay-pipes of Dutch type were not, like their later successors, hung up on a hook, but were placed on a frame-like rack which had two supports for each pipe, or else stood upright on a kind of shelf, tapered upwards so that the pipes could stand at an angle, in a corner of the room. Both devices were artistically ornamented, particularly the flat wall frame. Like clothes-driers, they are found mainly in coastal areas where Dutch influence was strongest. In mountainous regions simpler forms occur that have vertical struts with notches to hold the pipes.

The most elaborately decorated examples are again those from the marshlands along the river Elbe. The smaller ones consist of a board, lying flat against the wall with notched struts, perforated with fret-saw work that results in a delicate ornament. Attractive use is made of variations on familiar motifs, such as a medallion with monogram, scrolls, tendrils and blossoms, flower baskets, birds and angels' heads. The two finest examples, both made on the west coast of Schleswig-Holstein and surely by the same master craftsman, are now in the Altonaer Museum, Hamburg, and the Nordiska Museet, Stockholm, respectively.[77] Further north, and in other parts of the coastal region, simple wooden board frames were usually favoured, but their cross-struts are worked in an attractive fashion.[78]

39–41
44, 45
53

228

35, 37
275–
277

32, 19

Minor objects of furnishing (treated here as a separate category), like other kinds, shows marked evidence of its geographical distribution. Judging by museum collections and publications, the centre and the south of Germany occupy a minor place in the total output. True, wall cupboards and hanging cupboards occur everywhere, but in the south they conform more closely to certain standard types because mass manufacture for the market was more developed here. Spectacular casings for wall clocks are found everywhere, for which the celebrated clock-makers of the Black Forest region were mainly responsible. However, Black Forest clocks, like vestibule clocks, were often dispatched without casings, especially to distant destinations, and the casing was then added on their arrival and given the favourite local form. Wall mirrors, considered as objects of folk art, seem to occur more frequently in the south than the north. Clothes-driers, pipe-racks, plate boards, triangular boards, stools and other minor objects of furnishing were apparently not given the same degree of attention in the south—not, at least, if one may judge by the specimens that have been preserved. Obviously regional influences are at work: they can be discerned in household utensils but it is difficult, if not impossible, to pinpoint them accurately. Possibly the oak favoured in the north may have encouraged decorative elaboration.

The towel-holder which, according to tradition, played an important part on festive occasions, occurs generally in a standard form. It held a special 'show towel' with a woven pattern or, more often, fancy embroidery. The towel kept for everyday use was often hidden behind it. The holder was generally a roll, rod or spindle mounted in front of a decorated wall board with a projecting box. In the Lower Rhine region particularly fancy examples occur, some of them liberally sprinkled with open-work carving on the box.[79] The holder can also consist of a frame of turned rods fixed to the wall with a narrow side that can be swivelled round. On the ends of the rods small birds are often carved, using the wood-turner's technique.[80] More ambitious pieces were modelled on examples in churches, where they were placed near the font. Pictures of baptisms show that the towel-holder, as an example of pure turner's work, can be traced back in time to the Middle Ages, when it already seems to have been widespread.

The same is true of wooden candelabra which hung from ceiling, either in the shape of a crown or with movable arms. During the Middle Ages and often long afterwards the wood turner was the principal maker of table wares. He filled an important role in society and found plenty of scope for his activities in producing implements and accessories of a light and mobile kind. In this context one is reminded of the craftsmen who made the older types of chair and bed, whose works were less fragile, and thus less vulnerable, than the turner's minor products. In regions such as East Prussia, where there is no other small decorative furniture, the crown-shaped candelabra still occur, their frame consisting of metal rods.

There is a great variety of board, lattice and rod constructions which, in addition to major items of furniture such as cupboard, chest and table, are not only very handy household assets but can also make the living-room more comfortable and lend it a certain individuality. They can also be daintily and attractively decorated. This category includes shelves and holders for plates and spoons, wall cupboards with glass fronts or fully enclosed, consoles for wall clocks, casings for clockworks or weights, and footstools—in short, a wide range of useful and ingenious articles. Publications on popular furniture mostly neglect them; those on South German furniture hardly ever mention even a single example.

The variety of forms taken by spoon-holders is astonishing. They usually consist of a shelf, with holes or notches on the edge in which the spoons were inserted; this was fixed to a board on the wall. It used to be said of a very poorly equipped home, 'There isn't a spoon on the wall there'. In modest households a leather strap served to hold the family spoons on the wall. Descriptions survive of the scene as it was repeated day by day: after the meal every member of the household carefully licked his spoon clean and put it back into the loop in the strap. A more elaborate display of spoons in a decorated holder suggested that nobody was in want of anything there. Once an implement has acquired this kind of significance it soon becomes an extra item which is only a showpiece without any practical use. In this way spoon-holders and spoons were sometimes 'debased' to mere objects of ostentation. Where wooden spoons were replaced by ones made of pewter or brass, the obvious choice was a holder of the same metal. One might say that the assembled spoons 'represented' their users between meals. The spoon is a personal item—if only a temporary one—which stands for the person and may often have been his only visible piece of personal property about the house. Spoon-baskets or -boxes like those of Hesse[81] did not lend themselves to such demonstrations, but the containers were decorated with painting or carving. Particularly affectionate attention was lavished on spoon-boards in north Friesland. The board against the wall was decorated with chip carving and, like the carving on some mangle-boards, favoured rosette pyramid motifs. This motif travelled from Holland to other coastal regions. The Germanisches Museum in Nuremberg possesses a remarkably fine specimen dated 1753.[82]

In Westphalia and on the Lower Rhine wooden plate-boards were sometimes copied in clay. The notches for inserting the spoons are often arranged in three tiers. The long rear board is usually cut in a decorative outline, sometimes much perforated and carved in a variety of delicate shapes: stars, knots and loops, sometimes script or pictures of objects like the implements of Christ's Passion.[83]

In many cases the display of spoons is combined with wooden plates which simply consist of a round board. Every plate rests on a pair of pins which are driven into a board and the stack is held by two rods at the sides; this is the usual form in North Germany. Wall-brackets with shelves and racks to display crockery always provide a fruitful source of variations on practical and decorative themes.

A very advanced form of display fixture has a triangular shape and is called a 'pyramid' or *Tresor*. It may have originated in Holland and then spread over north-west Germany and further north to Amager near Copenhagen and as far as western Sweden. This light-weight fitting was designed to hold highly valued small glass ornaments and ceramic pieces such as cups, tea caddies, or small candlesticks. The

specimens in museums are lavishly decorated with sawn-out cross-pieces and carved details. They occur in an infinite variety of forms which illustrate clearly how the maker's taste dictated the style of such personal gifts. The three shelves often jut out over the slanting supports. On the front edges or in the angles are sawn-out and carved scrolls, volutes, leaves and other designs. On the top there may be a cartouche or a medallion with a monogram, and at the bottom a carved pair of birds. In its tendency to ostentation and its capricious form this article is a product of Rococo taste, but this does not preclude a specimen from Flensburg, dated 1760, being decorated in a strictly Renaissance manner.[84] The basic form is very variable: the front edges of the boards may be turned forward or back. Some upright struts may be added, and then the total effect is completely different.

Another type of hanging board for the same purpose has three equal-sized shelves connected by vertical struts which carry, indeed consist of, the ornamentation. Fewer of these have been preserved than triangular boards. They too occur from the mountainous region to north Schleswig, as well as outside Germany. A third shelf-type device should at least be mentioned: the corner board with four shelves that diminish in size toward the top, the boards likewise tapering to a point at the sides. The free edge is sawn out in vivid contours—it might be called curved—and the visible surface is often decorated with carvings.

Salt-boxes

185, A special place in this category of minor objects of furnishing is occu-
186 pied by wooden salt containers. In Lower Saxony and in Westphalia these occur in a remarkable form: boxes of heavy oak boards are shaped like a house with a gable roof. They hang on the wall near the stove with the surmounting gable front turned toward the room. The housewife can put her hand inside through a round hole in the triangular gable façade, which is normally closed and has a revolving disc. The gable side of a fine example in the Westfälisches Museum, Münster bears an incised inscription: 'Oh, Oh, Clevercook, the round hole do not overlook.' In addition there are some stylized tendrils in bas-relief, more like waving lines, which rise out of a pot-like form and follow the contour of the gable edges. Judging by the examples preserved in museums, the gable wall has undergone some very fanciful transformations. In the country around Brunswick, rigid house shapes become swinging contours, often continued on the gable edges in open-work; or they may take on plant forms, or end on both sides in horses' heads; or else they may unite to form a crowning flower. In Westphalia the gable form is more strictly
186 maintained and sometimes extended to form a rectangle; open-work decoration is confined to the top and the ornament shifted to the surface area. From a heart (in bas-relief) grows the chain of tulips familiar to us from the fronts of chests, which fills the whole gable front. (There is a specimen dated 1851 in the municipal museum,

Bochum.) In some cases symmetrical tendrils grow out of the heart and shoot upward in graceful lines, with banana-shaped 'leaves' that fill the whole surface and terminate in a pair of tulip blossoms. The effect is almost that of an *art nouveau* work from around 1900, but the date carved in the heart, 1757, is authentic.

Another form of salt-box is similarly flexible in style. It too is 185 found in Westphalia as well as in Lübeck. It is a desk-like trapezoid box with a hinged lid. It is suspended on its smaller side which is extended upwards and treated as the focus of the decoration. The carved forms on the front correspond to those on the raised part at the back; they are bushy blossoms in bas-relief or pairs of birds. The ornamental part may also be cut out in the shape of a lyre, like the back-rests of some board chairs. (There is an example in the municipal museum, Duisburg.) An inscription—usually the name and date—is rarely omitted. It is noticeable that while the incision is often clumsy, the decoration is well carved. This suggests that, like mangle-boards, the finished pieces were sold without any inscription and that the name was added afterwards.[85]

A quick glance at other countries may be of interest in this connection. In South Tyrol and in Italy a salt container in the shape of a building with a round opening in the gable front is also a favourite form.[86] However, here the building is clearly a church, or at least a simplified version of a church tower, and the object is designed to hold sacred salt; in other words it is not a kitchen utensil. It is reminiscent of the ship-type spice boxes of the Middle Ages, many exquisite forms of which were collected by the French kings. In the late Middle Ages under the dukes of Burgundy the fashion enjoyed a revival in the form of ships as drinking cups, containers for salt and incense; there was a very wide range of sacred and profane applications. The ship form was regarded as a talisman against the poisoning of food and spices, when such safeguards were often necessary. The same consideration also applied to the salt containers shaped as buildings, especially where they represented churches.

Salt-boxes with a raised back against the wall have a counterpart 185, in spoon-boxes or -baskets from Hesse. Karl Rumpf has studied these 182 closely.[87] Their construction corresponds, more or less, to that of post chairs. The walls are perforated in several places to allow air to pass 71 through. They are decorated all over with fretwork, carving and incising. The prominence given to the object and the inscribing of names show that the spoon-basket, at least in the Schwalm area, was traditionally part of a bride's dowry. It would be pointless to speculate on the possible symbolic meaning of the motifs of the ornamentation; it should, however, be remembered that the spice-containers of medieval rulers in the form of ships also held eating utensils, which had to be protected against poisoning just as much as the spices did. The spoon-basket, and its similarities with the spice-container, therefore have a significance to the student of cultural history. A detailed investigation of these connections, which should also include drinking vessels in the form of ships, has yet to be undertaken. True, the danger of poisoning was greater among the mighty; however, it is interesting to draw comparisons between the castle and the peasant's house in respect of table customs and utensils.

Small Wooden Objects

Small portable wooden objects of artistic workmanship may be distinguished from small pieces of furniture. Here we have in mind objects that do not form part of the actual furnishing of dwellings and that originally served practical purposes, or were even implements. Their special characteristic was that they were given at weddings or by suitors and fiancés to their loved ones. The common term 'wooing gift' is too summary; on the other hand tradition frequently does not tell us to what extent the giving of such presents was an obligatory custom. In early literature we often find the idea expressed that a boy would himself make the gift for his sweetheart. This was the basis of the notion that folk art was an activity engaged in by everyone. This idea is, however, not generally true. Often such gifts were indeed produced by the person who gave them, but more frequently they were made by an artisan and the suitor or bridegroom either commissioned his gift or bought it on the market.

The making and acquisition of stereotyped presents vary from one district to another. Wealthy farmers hired artisans to work for them; small farmers and labourers tried to make them themselves. But we do also know of works apparently made by laymen which occur in several completely identical exemplars, differing only in the names inscribed on them. Such objects were made by one and the same villager—either an artisan or not—who then passed them on to others. Other pieces bear an indication that merchants were involved: this explains why bentwood boxes from Berchtesgaden or Thuringia appear in northern Germany. Many other objects produced by male artists were also designed for use by men: shaving boxes and other containers such as pipe-cases, watch-stands etc., as well as boot-jacks and sailors' gear. The return gifts made by the girl to her suitor or fiancé were not invariably made by the person herself but might be such articles as a hymnbook or watch-chain, which had to be bought.

Boxes occur in inexhaustible variety, but there are certain standard forms that may be distinguished. They vary not only in form but also in their importance for folk art, which lies partly in the degree of technical skill displayed.

In North Germany a kind of lockable box is a familiar object; it seems to originate in the medieval box for letters or documents.[88] These little boxes, owned by burghers and peasants, presumably contained papers and other precious objects that were not kept in the *Hörnschapp* or in the *Schenkschiewe*. This container tends to be flat and square. As regards its size, it may be placed between the large number of chests (as objects of furniture) on one hand and little containers for jewellery on the other. If the latter were kept in a chest or cupboard, the bigger ones were meant to stand freely. In central and South Germany there are companion-pieces, although these are not 176 so frequently of this type. In the North German ones the decoration consists of a net-like mounting cut in bas relief into the stout wooden walls. This indicates their late sixteenth-century origin.

The next size is considerably smaller. Such boxes were apparently made in huge quantities and in a variety of shapes. Handy sizes pre163— vail, and their special purpose, if indeed they had one, cannot be easily ascertained. Pen- or slate-boxes such as schoolchildren still used two 168 generations ago are traditionally often referred to as 'shaving-boxes'. Carved hunting motifs or inscriptions often show that they were used 164 by men. In other pieces the division into compartments indicates that they were made to hold matches and suchlike.[89] Symbols of love, such as cooing doves on a heart, inscribed in an amateurish way, suggest that they were used by women or girls, which may also be true of the object shown, which has a sliding lid. 164,

Many boxes with snap lids and chip carving, or else carved with 166 plant motifs, were no doubt used mainly for keeping precious articles 163 such as jewellery, souvenirs, letters etc. Many of these look like love gifts, and developed out of the elegant medieval 'love chests', whose exact purpose remains an open question. Nor is it easy to define the characteristics of these South German boxes, which are frequently decorated in all kinds of bismuth colours and with figures, or of those from North Germany carved in relief, bas-relief or with chip carving.

Among a multitude of variants one form stands out which is repeatedly found in different regions: the box, of fairly constant size, with a gently curving lid and all the surfaces covered with chip carving. It is found in North Germany and in Scandinavia.[90] This distribution suggests that it was produced in one central place, possibly in Germany, and then traded over wide distances. It is striking that it bears no inscriptions. The otherwise very variable type of 'chest covered with chip carving' is rarely found in a special form; perhaps the specimen mentioned is unique.

Elsewhere each box has its own characteristics. The fact that the narrow longish ones, especially those with a sliding lid, are not made up of small boards but are carved in one piece points to the work of an amateur. Some special forms appear that are important for the development of folk art: for example, sliding covers instead of snap 164, lids to close the boxes, a feature we have already mentioned, as well 166 as the extension of the bottom of the box on the shorter side so that the end can serve as a handle; as with desk-shaped salt-boxes, these 185 can also be hung from the wall. This special type was often used until recently by schoolchildren for their slates, slate-pencils, primers etc. The sliding lid was often painted.[91] Long boxes for candles were also frequently given this shape,[92] but they could also look quite different. A type of box found in the northernmost part of Germany must be regarded as very ancient in origin: the casing is placed between two gable-like walls, as in early forms of chest.

An interesting range of boxes in different shapes was made by Lödde Rachtsen (1696–1758), the Greenland sailor from Hallig 174, Hooge in north Friesland, who must do duty here for many of his 175 fellows. It was about the middle of the eighteenth century that he carved, especially for his daughter Stinke and also for himself, all manner of receptacles and implements that were in use in his environment: chests, trunks for the voyage, nearly cube-shaped 'hat-boxes', sewing-boxes shaped like a desk with a diagonal lid, small flat boxes with sliding lids, boxes with gables etc. One example of each of these pieces has survived, all clearly of the same origin;[93] it may well be that formerly some others were in the set. For his own use, too, Rachtsen bought and carved boxes of various kinds. These bear inscriptions

and renderings of whales and other animals he hunted, as well as of Rachtsen himself and his wife. Companion-pieces of this kind are, however, rare as are clues to indicate a precise locality of manufacture. Occasionally religious motifs occur, as do symbols designating the maker's profession.

The term 'Berchtesgadener Trücherl' is very vague; it relates to boxes painted as gaily as bentwood ones, usually in bismuth, but also to those with straight sides into which are incised or cut rosettes or other designs in chip carving or engraving, or else sacred monograms. The 'Berchtesgadener Trücherl' may also refer to pieces with several layers which resemble a miniature version of a certain type of chest. Each implement can be properly understood only in the context in which it was made and used.

The carved decoration on various types of chest is also hard to classify systematically. The origin of chip carving, which was so popular, cannot be ascertained for sure, but its use from the sixteenth to the 163 nineteenth century can be traced. It is found in North Germany already at an early date, usually on unbroken surfaces. In the early stages it was confined to vertical rosettes. In South Germany and particularly in the Alpine regions, on the other hand, small implements have continued to feature rosettes in chip carving and whirls right down to the present day. Of carved boxes in general we may say that direct comparisons can hardly be made with similar exemplars made for the upper strata of society. Drawers for public and legal documents continued to exist in the early modern era under the name of 'guild drawers'. Receptacles for private use by people of high social status were veneered and decorated with intarsia, or made to stand out in some other way, for instance by mosaic work. Boxes decorated with carving seem to have become a separate category at least by about the middle of the seventeenth century.

Jars form an entirely separate group. Those used to contain snuff kept to the form of those used by the upper classes, although they were made of poorer material. They were probably made by specialists and dealt in by merchants. They were given the shape of bags, shoes or feet, bottles, tiny books etc. Sailors also liked Dutch shapes which had all sorts of intricate carving. The little boxes which men kept in their trouser pockets often had fairly lurid pictures on them. Women 171 had similar articles as needle-boxes. A needle-box of larger dimensions was also used by sail-makers on board ship. There are charming specimens in which this functional article was given the shape of a 162 fish, for example. In jewellery of this kind a great variety of forms can be found. The makers displayed considerable imagination and achieved original results. The play of forms and figures connected 357 with objects used for smoking, notably pipe-bowls, differs distinctly from the severe forms found on boxes for keeping objects in, which kept to customary designs; the latter were either scenic or bizarre and grotesque. Sometimes they deteriorated to the point of absurdity, and it would seem more appropriate to discuss them in the context of stick-handles and the like.

Watches were for a long time worn only on special occasions, as an object to indicate one's status. When not worn they would be kept in a special case, and were also used as clocks, where they were not mere articles of decoration. Wooden clock-stands appeared in the latter half of the eighteenth century, replacing those made of ceramics and precious materials. Those produced in wood-carving areas, especially Upper Bavaria and Thuringia, were distributed by merchants or hawkers throughout Germany; others were made by amateur artisans all over the country. It is impossible to discuss the entire range of forms. Innumerable motifs occur, framing the clock-face in a hundred different ways, often quite playful: for example, the round aperture might be transformed into a human face or mouth (or the jaws of a lion). Frequently Baroque ideas are taken over. We find the hour-glass and other symbols of this transitory life, or piling up of contemporary motifs such as urns, vases, and draperies into strange superstructures topped by angels with fluttering wings. Where figures in the round were not considered suitable, two-dimensional clasps occur, as for instance in certain north Frisian specimens. These recur in another context, for example mounted on pieces of furniture, but in that case they lack the aperture for the dial.

The tray or salver is confined to North Germany and to the adjoining part of Denmark.[94] They were used for serving things at table 156 and consist of flat pieces of wood with a fairly high rim. Others were used by women for storing articles of dress that they did not want to get squashed. Others again fulfilled the same function as much larger bentwood boxes. It has been noted that on such trays a godfather would present a child's clothes at the baptismal ceremony.[95] Normally it would be kept in the chest on top of a tightly-packed pile of fabrics. The base and the centre of these trays were often painted or carved, and the frame cut out in open-work to form great curves. Many pieces with a great deal of decoration were made for a particular individual, as one can see from the monogram or inscription. It should be noted that these trays were confined to a single area of North Germany which extended into Denmark. This is an instructive example of such regionally limited practices; other territories that produced a lot of wooden articles did not know this kind of tray, and they were not traded. This is all the more surprising in that these articles were so practical.

It is likewise surprising that certain very ordinary wooden objects which, as one might presume, could be made in the simplest fashion had special places of production and were traded over wide areas. Among them were large round painted boards from Thuringia, 202 stiffened by a ridged moulding and having a handle; these were used for serving large flat cakes.[96] Likewise confined to certain districts was an object used by milkmaids, a piece of wood placed on their shoulders, from which they suspended buckets for the milk as they carried it back home from the pasture. To avoid spilling the milk wooden floats were placed on top of it. These objects were decorated, which suggests that farm servants and others would take an interest in the routes the milkmaids took when they went a-milking, for this gave them a chance for an unobserved rendezvous. In nineteenth-century 'folk-art painting' such encounters on the pasture are often depicted. The author knows of only two floats of this kind. In the Blankenese district on the Lower Elbe there are pairs of crossed bars with a knob for lifting them off, carved with rosettes in chip carving. One

150 Coffer chest. Oak. Iron mountings, painted. 1823. From Blankenese, near Hamburg.

151 Trunk (with wheels). Oak with brass fittings, painted. 1723. From Seesen am Harz.

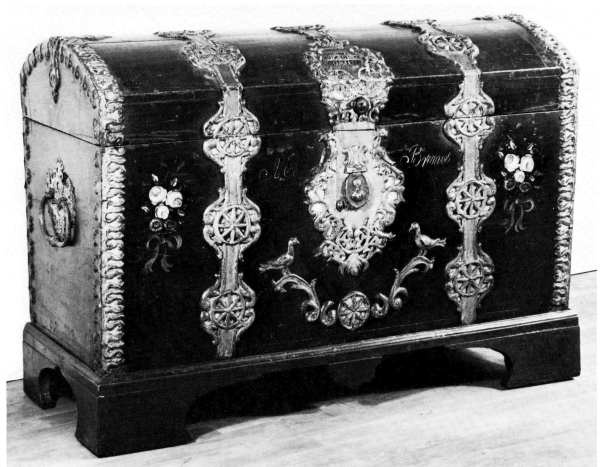

150

151

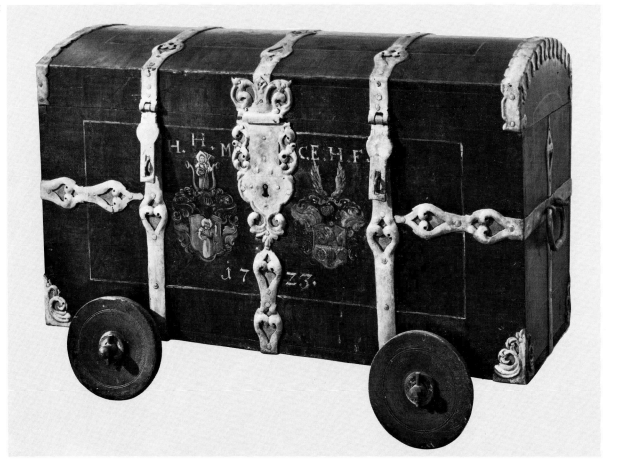

152 Chest of the Guild of Shoemakers and Saddlers of Rottweil. Spruce, painted. 1642.

153 Hanging cupboard. Scots pine with glass front. 18th century. From Kellinghusen, Holstein.

154 Hanging cupboard. Oak. 17th century. Probably from Angeln, Schleswig.

155 Hanging cupboard. Hard- and softwood. Latter half of 18th century. From Eiderstedt, Schleswig.

152

153

154

155

156

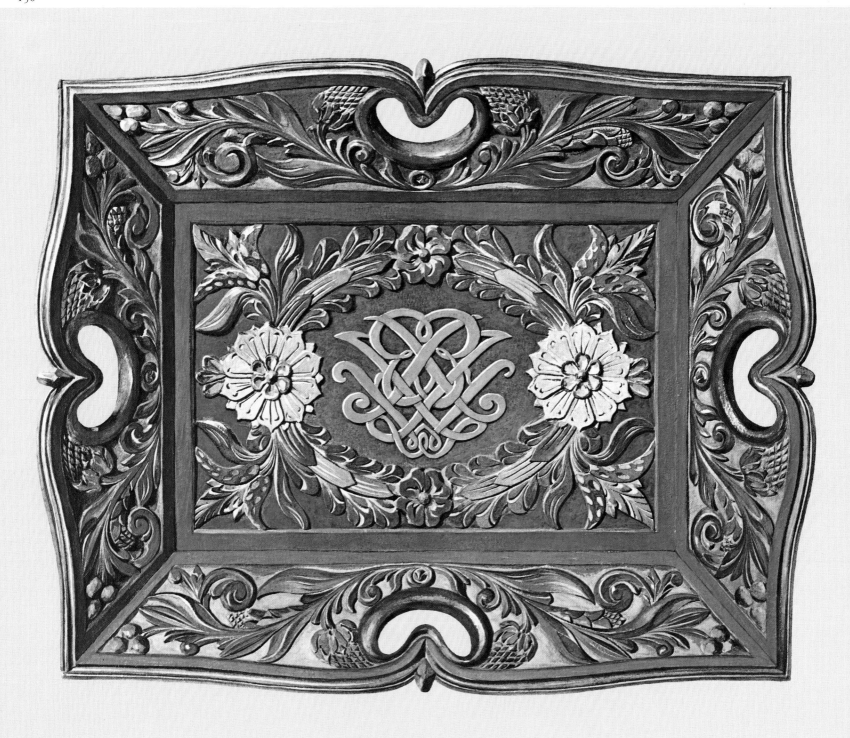

157 Bentwood box. Fir, painted. First half of 19th century. From Silesia.

158 Bentwood box. Softwood, painted. Beginning of 19th century. Acquired from Klein-Ecklingen, near Celle, Lower Saxony.

159 Bentwood box. Fir. Latter half of 18th century.

160 Bentwood box. Fir, painted. *Circa* 1840. Used in eastern Lower Saxony.

161 Bentwood box. Fir, painted. 19th century.

157

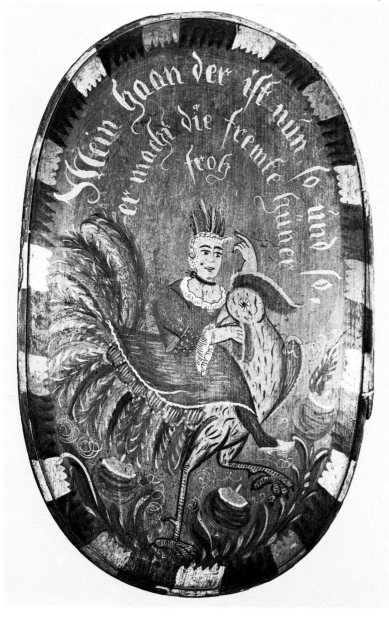

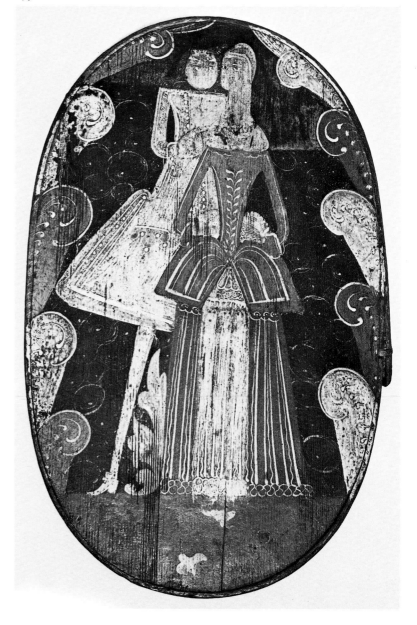

158 159

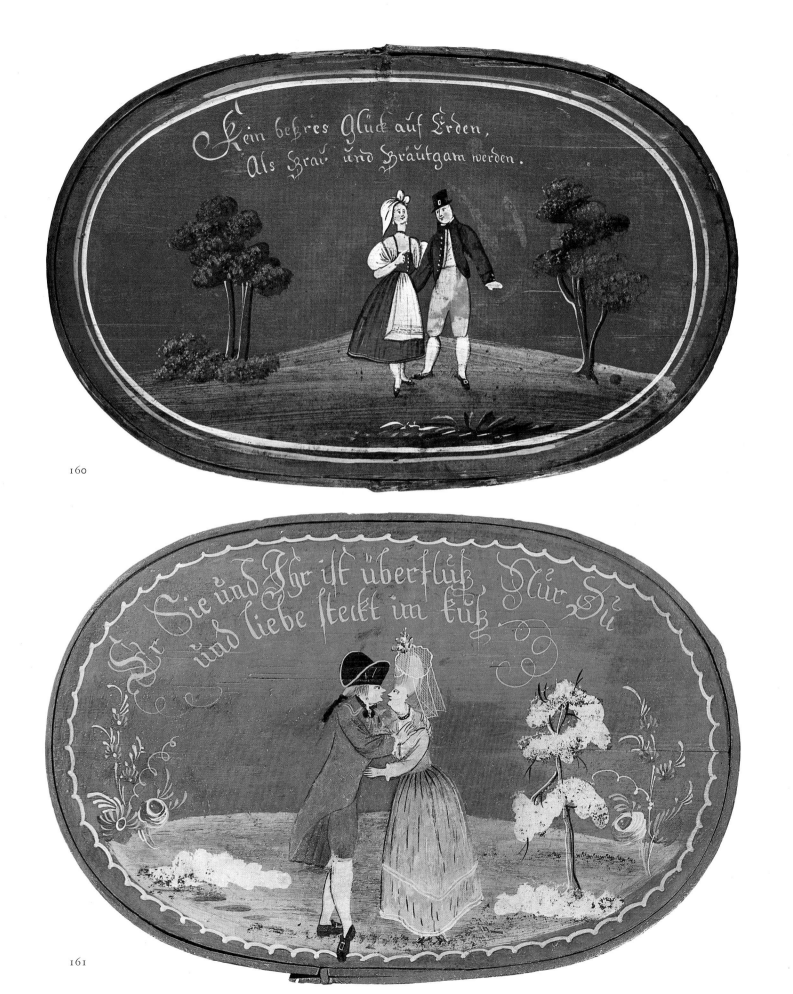

160

161

162

163 164

162 Box for sailmaker's needles. Wood. 19th century (?). Acquired at Husum, Schleswig.

163 Box. Oak. 1735. From north Friesland.

164 Box. Oak. Early 19th century. From the island of Föhr, north Friesland, Schleswig.

165 Box for clay pipes (detail of the front wall). Pine, painted. Late 18th century. From the island of Föhr, north Friesland, Schleswig.

166 Box. Oak. 18th century. From the island of Sylt, north Friesland, Schleswig.

167 Box. Oak. *Circa* 1580. From North Germany.

165

166

167

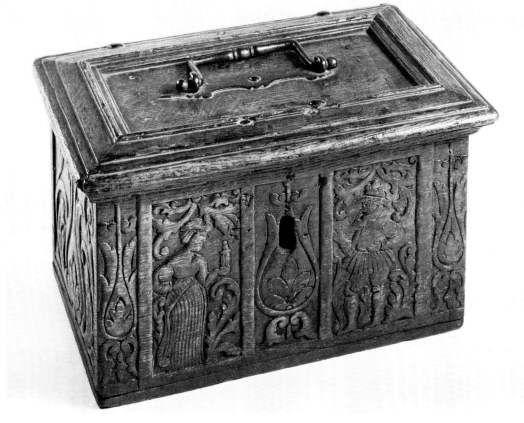

115

168 Box for shaving kit. Wood. 18th–19th century. From Archsum, north Friesland, Schleswig.

169 Small box, carved from wood. 17th–18th century. From Bavaria (or Tyrol?).

170 Bentwood box. Softwood. From the island of Sylt, north Friesland, Schleswig.

171 Box for sewing-needles in the form of a miniature warming oven. Beech and oak. 1802. From north Friesland, Schleswig.

172 Small box. Oak, coopered. 18th–19th century. From the island of Sylt, north Friesland, Schleswig.

173 Wall clock. Wooden dial with lacquer painting. *Circa* 1840. Black Forest.

168

169

170

171▽

172

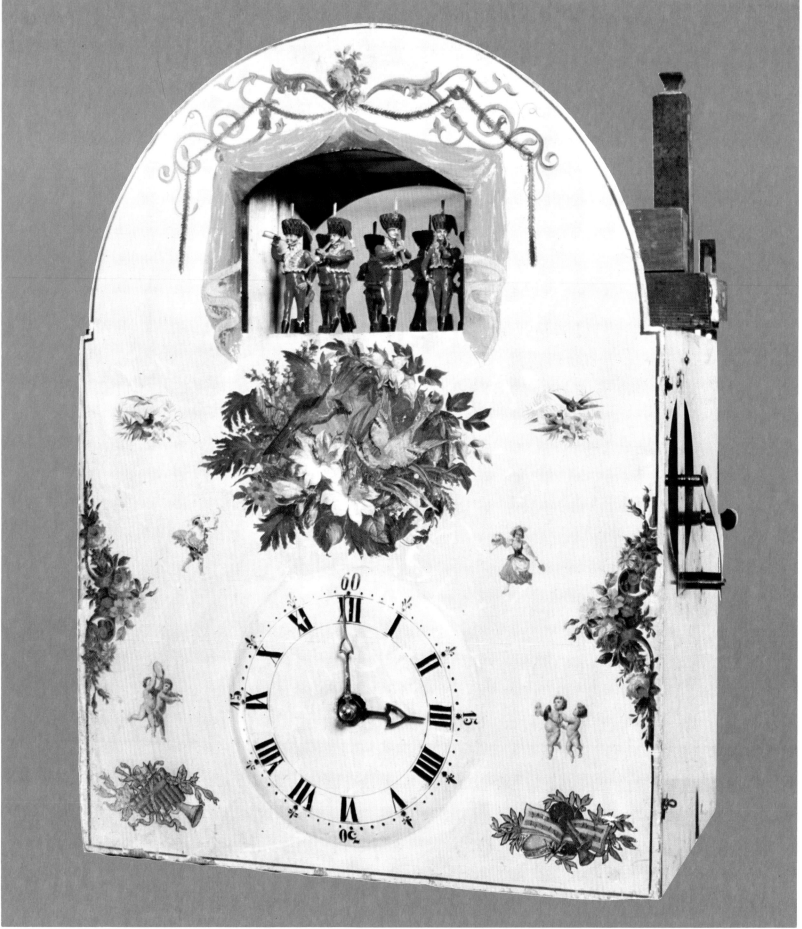

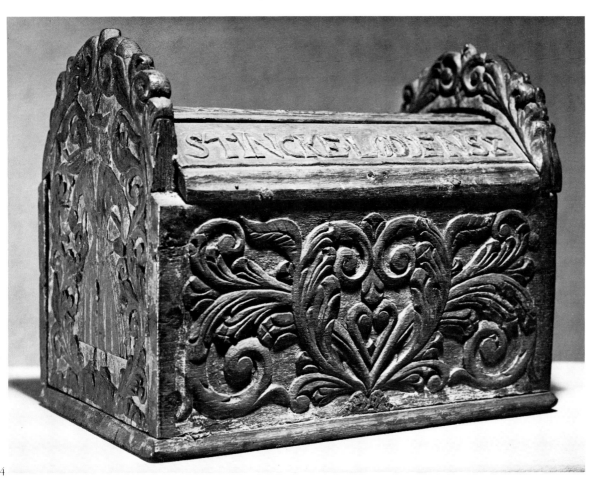

174

174 Box with sliding lid. Oak. Dated 1749. From the Hallig Hooge, north Friesland, Schleswig.

175 Sextant-case. Oak, painted. 1750. From the Hallig Hooge, north Friesland, Schleswig.

176 Small box. Softwood, painted. Latter half of 17th century.

175

176

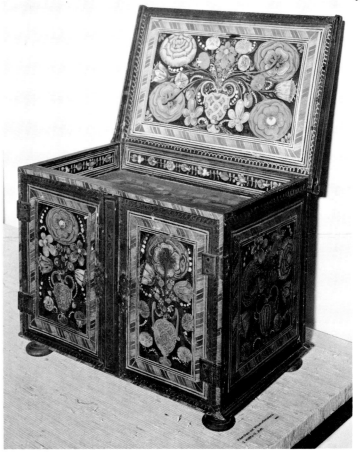

118

177 Standing clock. Casing of softwood. *Circa* 1840. Mechanism by Diedrich Wilhelm Färber, Neukirchen, Rhineland.

178 Standing clock. Casing of pine, painted. 1783 (mechanism 1765). From north Friesland.

179 Wall clock. Wooden clock-face with lacquer painting. *Circa* 1850. Black Forest.

180 Face of a wall clock. Oak. 1740. From the mainland of north Friesland.

177

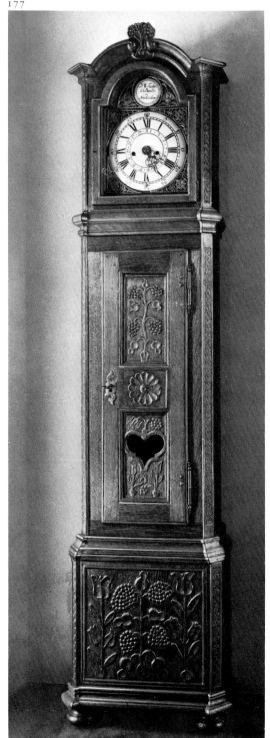

178

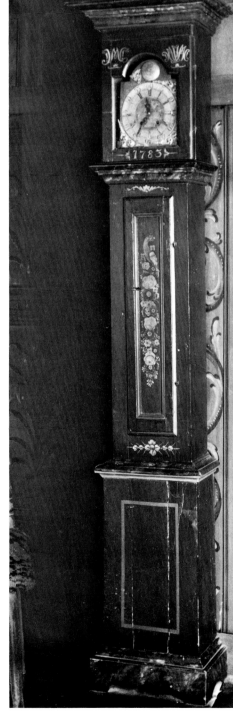

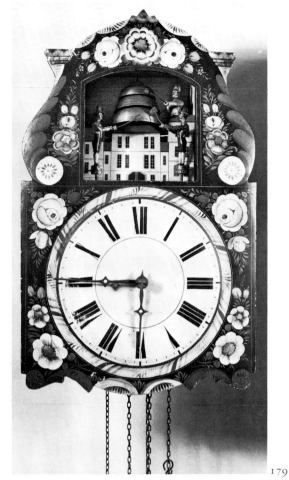

179

180

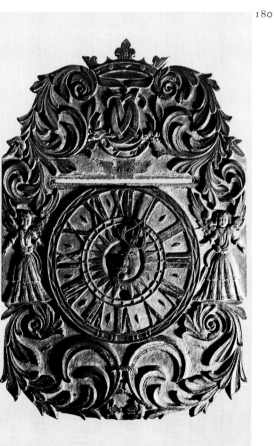

181 Portable barrel. Beech (?). 19th century. From Oberaudorf am Inn, Bavaria.

182 Basket for spoons. Wood. 19th century. From the Schwalm, Hesse.

183 Jug. Wood, coopered and painted. 19th century. From Mistelgau, Franconia.

184 Stove-surround. Oak. Dated 1806. Wilstermarsch, Holstein.

185 Salt-box. Oak. 1787. From Langeberge, near Osterkappeln, Osnabrück.

186 Salt-box. Oak. 18th or 19th century. From Achim, Verden district, Lower Saxony.

187 Spoon-board. Oak, painted. 19th century. From the Osnabrück region, Lower Saxony.

188 Plate-rack. Lime, painted. 1787. From the Altes Land, near Hamburg.

189 Spoon-board. Softwood, painted, with pewter spoons. 19th century. From Bentheim, Lower Saxony.

181

183▽

182

184

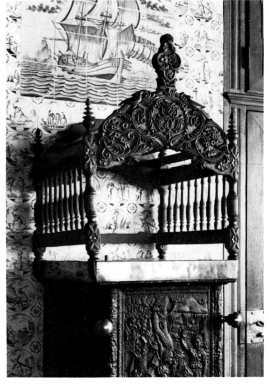

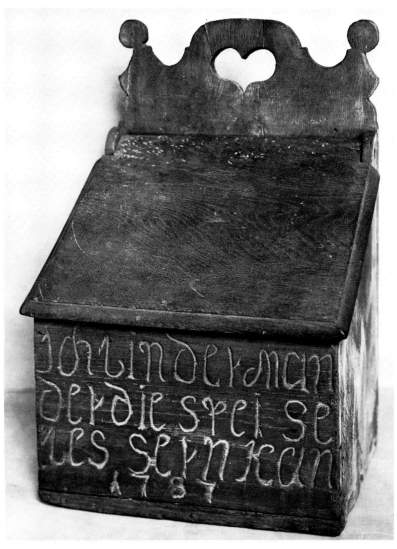

185

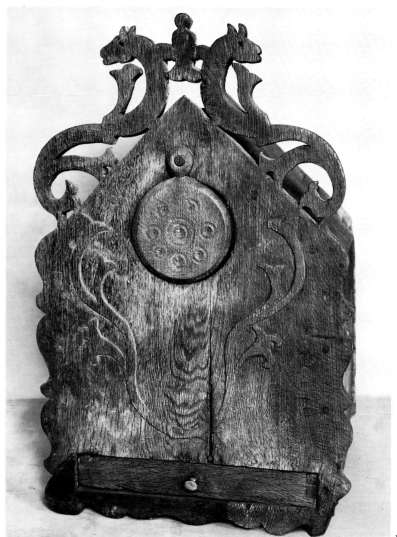

186

187

▽188

189

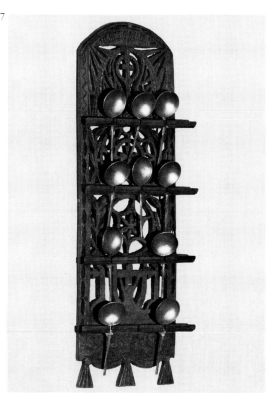

190

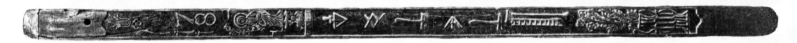

191

192 193▽ 194▽

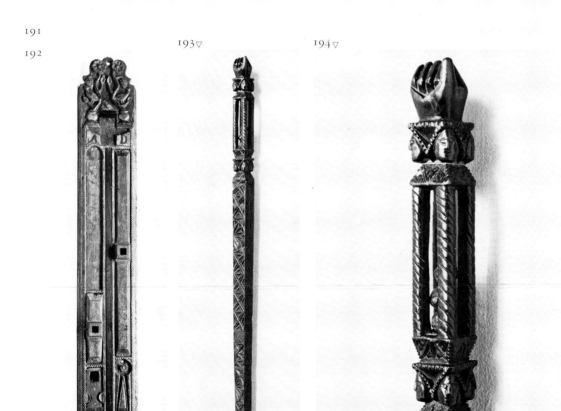

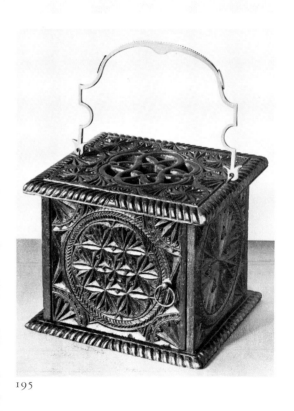

195

190 Weaving-frame (cloth-holder). Wood. 1858. From the Mohrungen district, East Prussia.

191 Measuring-rod. Fruit wood. 1718. Origin unknown.

192 Container for a 'Jakobstab'. Oak. 1736. From the island of Sylt, north Friesland, Schleswig.

193–194 Ell measure. 18th century. From north Friesland (?).

195 Foot-warmer. Oak. 18th century. From north Friesland.

196 Pipe-rack. Lime and oak, painted. *Circa* 1800. From Dithmarschen.

197 Bird-cage. Apple-wood, oak and wire. First half of 19th century. From central Franconia.

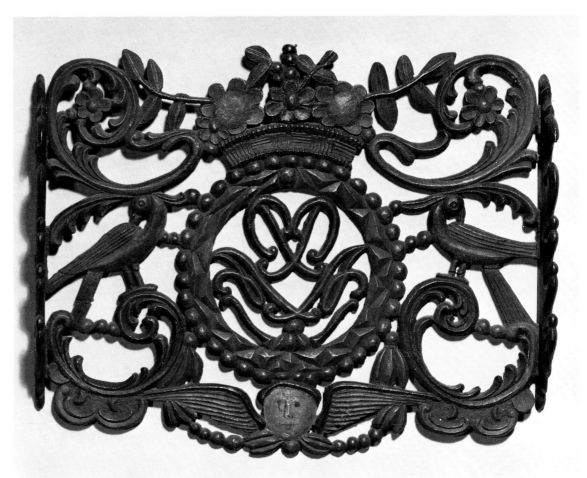

196

197

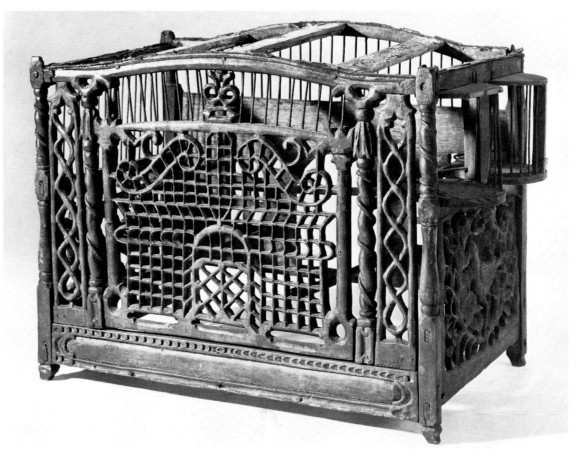

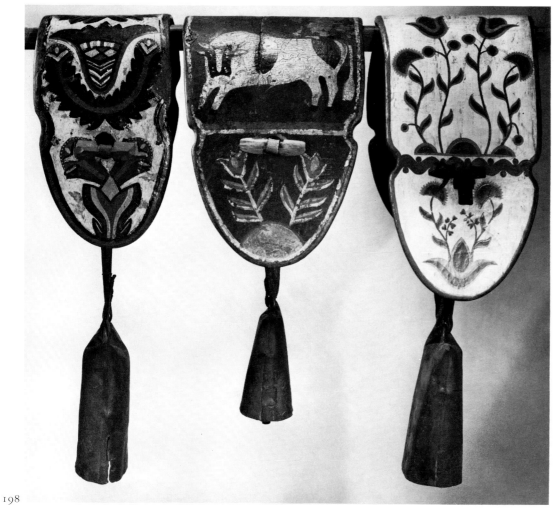

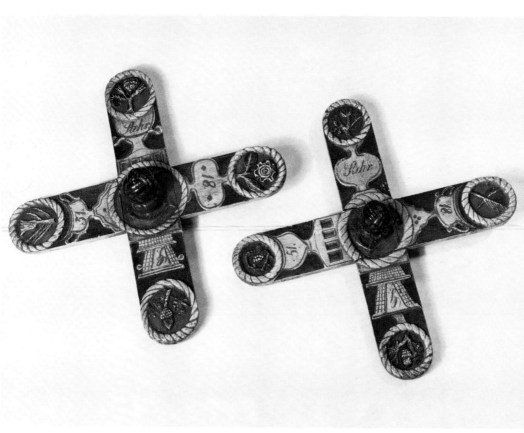

198

199

198 Three-bell collar for cattle. Beech, multi-coloured. 19th century. From Franconia.

199 Pair of bucket crosses. Oak, painted in colours. 1851. Blankenese, near Hamburg.

200–201 Milk-pail float. Open-work wooden plate, oak. Plate 200: from Gravenstein, Alsen (Als) island, north Schleswig. Plate 201: from Alsen (Als) island, north Schleswig. Dated 1785.

202 Cake-board. Softwood, painted. 1865. From Thuringia (?).

200

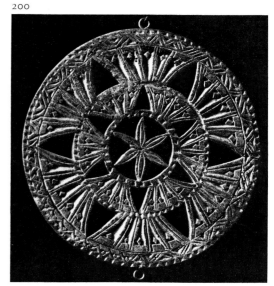

201▽

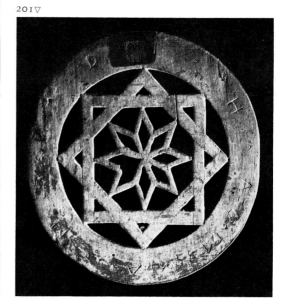

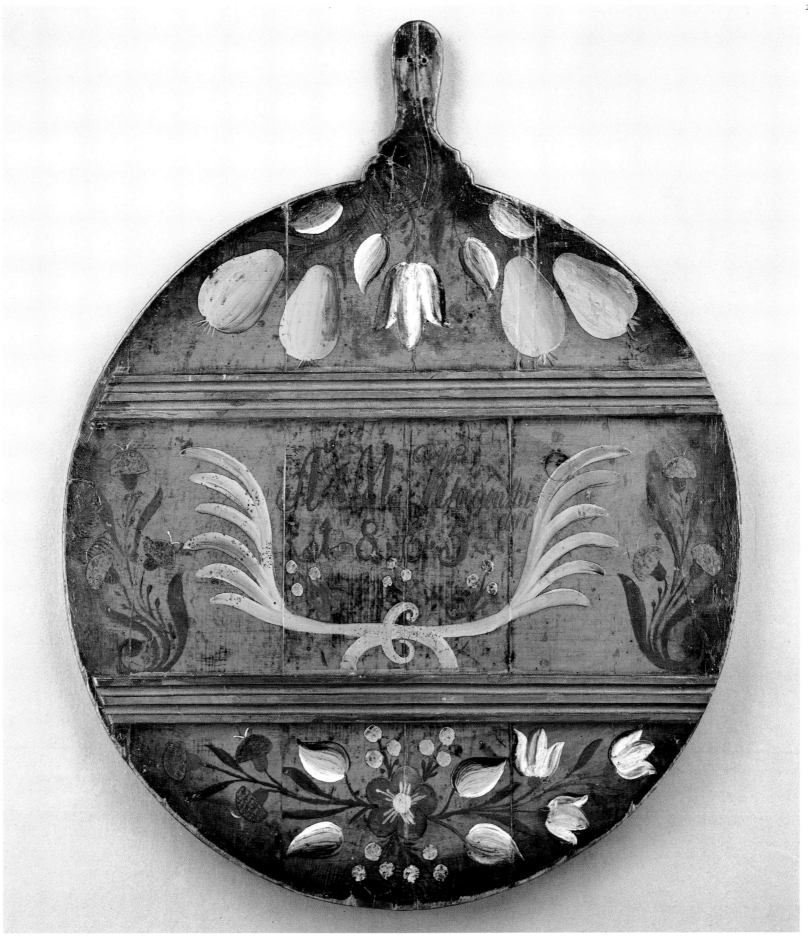

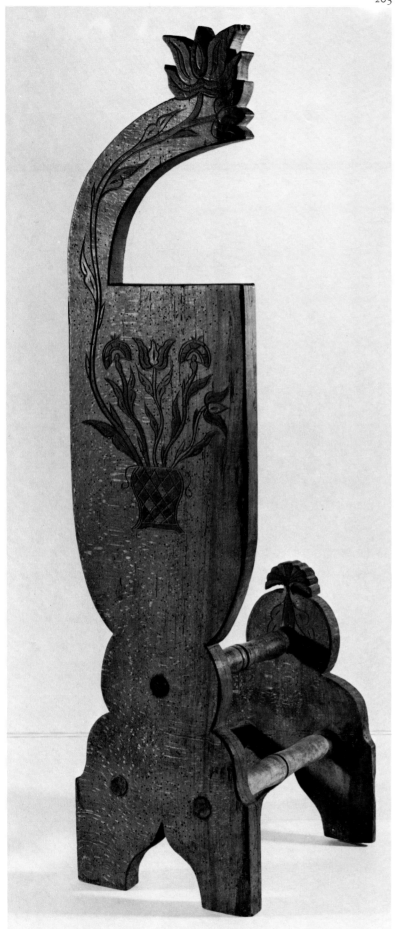

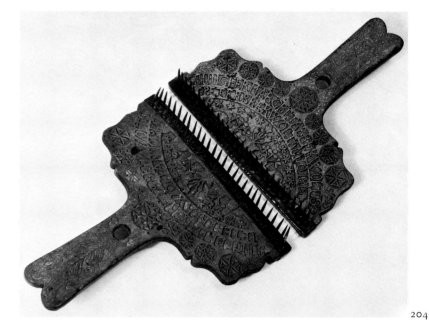

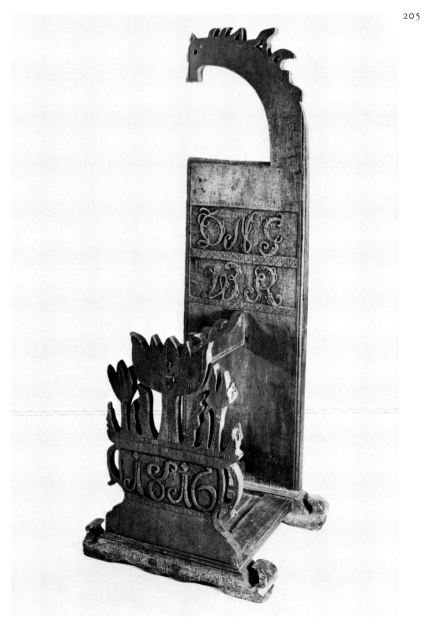

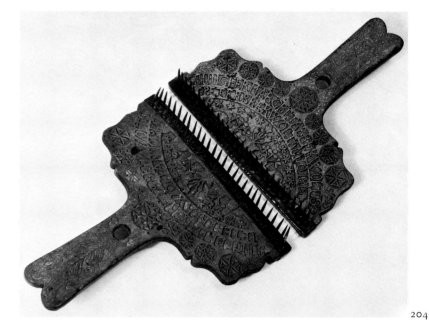

203

204

205

126

203 Flax swingle. Beech. 19th century. From the Marburg region, Hesse.

204 Pair of wool-combs. Oak, with shallow incision and chip carving. Dated 1815. From Blankenese, near Hamburg.

205 Swingle. Beech. 1816. From Schleswig-Holstein.

206 Three mangle-boards. Oak and beech, painted. Undated, but before 1756 and 1781. From north Friesland, Schleswig.

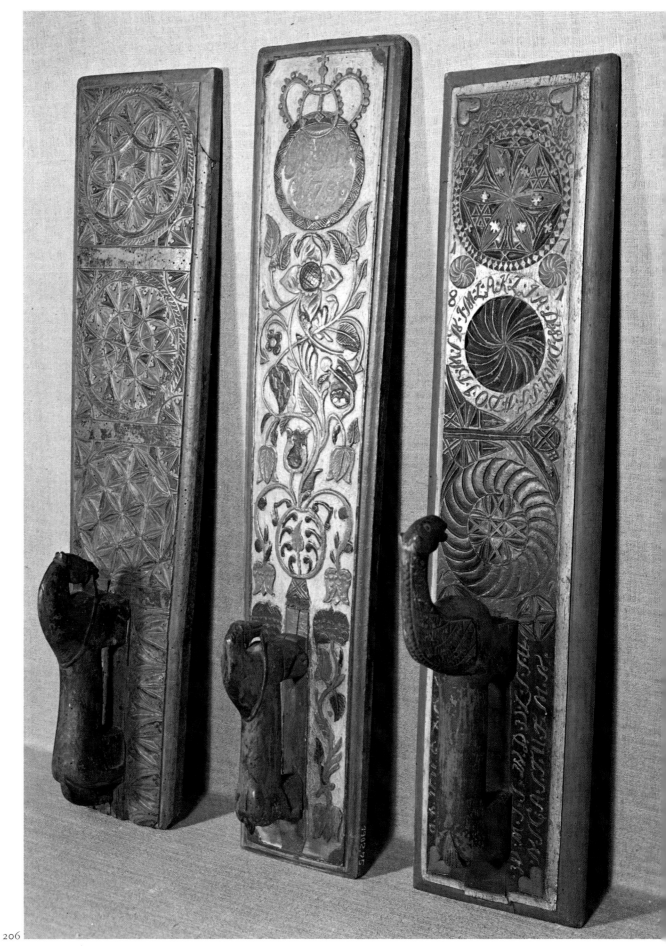

206

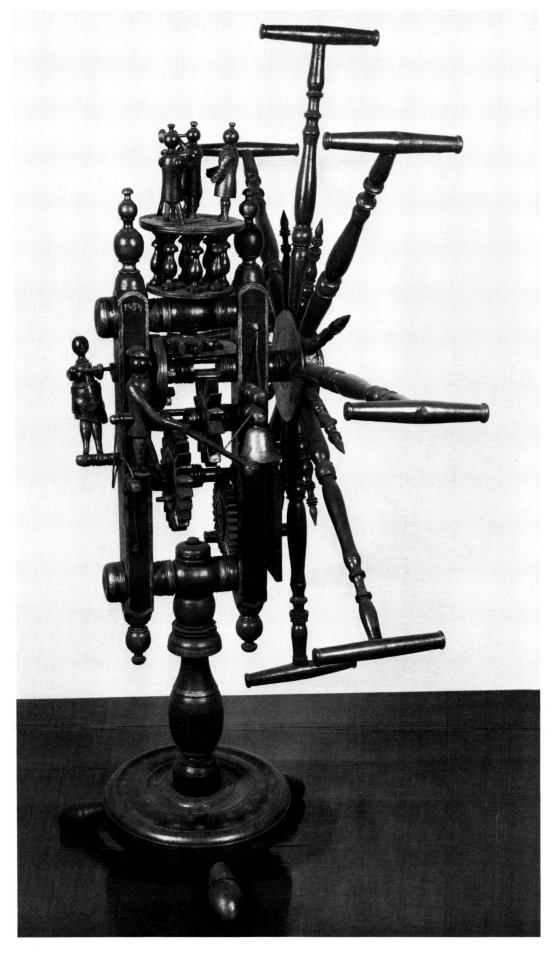

207 Yarn-winder. Various kinds of wood, turned. Latter half of 18th century. Acquired from Uetersen, Holstein.

208 Spinning-wheel. Beech. 18th or 19th century. From Hesse.

◁207

▽208

specimen is in the Altonaer Museum, Hamburg. Another pair, also in this museum, dating from 1851, was destined for a woman named S. Stehr. It features vases and medallions in bas-relief illustrating, it appears, symbols of the seasons: rose, ear, acorn and barren tree.

200, 201 Another type was used in northern Schleswig: round wooden plates without a handle, pierced through with star patterns and frequently covered with chip carving; the knob of the Blankenese model, by contrast, was certainly more refined. Slight differences of this kind can tell us a great deal. In north Friesland the object was handled directly without embarrassment—like eating with one's fingers instead of with a fork. The introduction of handles points to a differentiation in the way implements like this were used. Thousands of years ago the mallet was transformed into an axe with a shaft, a feature that was to be copied again and again right up to the nineteenth century. Also in the cast of mangle-boards a distinction has to be made between the later ones that have a handle and the earlier ones that do not.

206, 212 Mangle-boards became especially representative of folk art, especially in North Germany. It was here that they developed, much more than they did in the south, into a kind of criterion by which folk-art styles may be distinguished according to area of production. Ornamental mangle-boards are disseminated over the north-west of Europe, from Holland to Scandinavia, a region that may be regarded as a single entity. The most distinctive feature once again is the chip carving covering the entire surface. Such mangle-boards with chip carving may be found everywhere from the coast of the English Channel to western Norway and central Sweden; they seem to have been confined in the main to coastal regions, and in some parts they are found down to the nineteenth century, strangely enough with horse-shaped handles.

A detailed study of the development of decorated mangle-boards has yet to be undertaken. It would bring to light some noteworthy points, both as regards features common to areas that were far apart geographically, and as regards the existence of small, even minute, 'cultural provinces' as one might term them. Exquisite pieces have been preserved, such as those from the workshops at Eckernförde, intended for the use of the daughters of aristocratic landowners. During the seventeenth century a decorated mangle-board would be part of a bride's outfit, whether she was of noble or bourgeois background.[97] From those that have been preserved one can trace how variations were added, from the sixteenth century onwards, to suit the population at large. Renaissance mounting came to play a major part in this. During the seventeenth century Dutch influence made itself felt in the regions to the north and east of Holland. One particularly Dutch feature is the long and elegant mangle-board without a handle whose narrower end often peters out in a cut-out decorative feature consisting of pyramids of rosettes and intertwined bands. This was much emulated in German coastal areas. North Friesland seems to have acted as an intermediary to areas in the far north. This may be explained by the fact that many peasants here became seafarers. In Norway several mangle-boards of an apparently north Frisian type have been discovered; they had panels for inscriptions which were either not filled in at all or bore names incised in primitive fashion. If we consider all the circumstances, Svein Molaug's conclusion is plausible: north Frisian mangle-boards must have been exported in large numbers to Norway.[98] This flourishing retail business was carried on from the major entrepots, and probably also from all markets; it was a kind of trade from one sailor to another, hardly registered in historical documents. Not only the products themselves but also the designs they bore were disseminated in this way.

Towards the middle of the eighteenth century a new wave began: the rigid types of decoration on mangle-boards were soon replaced by a new form of decoration of plants and figures. By this time a wealth of forms existed that characterized region after region, local conditions being determinant. Near the estuary of the Elbe, for example, a type asserted itself, which, under the influence of Hamburg, adopted the identical acanthus scroll and developed it greatly— a design also prevalent in furniture. It was the carpenters' job to include such mangle-boards in a bride's trousseau. Outside the fertile marshes mangle-boards were produced with less artistry. On closer inspection of the vast number in museums one gains the impression that many of these luxuriously decorated boards were hardly ever used; rather they served as a kind of symbol, placed on the wall of a room to demonstrate either the status of the daughter of the house or the marriage of her parents. This is also true of many other implements we shall now go on to mention.

No other small wooden object for women's use contributed so much to human and social relationships as did the mangle-board, but some played a similar role. Implements for working raw materials such as wool and flax—for spinning or weaving in addition to such demanding handcrafts as embroidery, lace-making and plaiting etc.—all are to be found among 'love gifts'. Each would deserve detailed attention but we must confine ourselves to a few brief remarks.

The important rôle this range of objects plays in folk art as a whole is illustrated by the products of the fishing villages on the island of Rügen. The objects from the workshops at Mönchgut are unique and unmistakable: clothes-beaters, swingle-boards for beating the 213, wooden particles out of dried flax, combs or boards for weaving bands 214 and distaffs. Many of them have survived. The weaving boards, 210, although generally stereotyped, show lively imagination in the way 211 the initial form was modified. These wooden objects have been termed 'the only contribution made to German folk art by the area whence it originated'.[99] We are told that neither in furniture nor in textiles, nor indeed in any other field of activity, did artisans on monastic estates show any desire for decoration or take pleasure in artistic creation. This may be an exaggeration; after all, an interesting type of chair did occur there, although only in a few instances.[100] Both here and elsewhere the local predilection for decorating small wooden objects may be connected with proximity to the sea; men had to do something to fill in the long periods of waiting.

In other parts of North Germany weaving combs are also decorated imaginatively with carvings, especially on the upper part which serves as a handle; at Mönchgut on Rügen, and elsewhere too,

209 we find two pairs of facing animals, for instance horses, birds (including cocks), and probably lions and so on. But the top of the board is rounded off in a regular way with an arch, often in an extremely intricate design. The rectangular pieces from the monastic estates, however, are invariably broad on top and the frieze of open-work is always repeated right up to the edge. This expresses a sense of form markedly different from that in western districts; we find this in similar implements over wide areas of eastern Germany and eastern European countries as well. In this particular example, and especially in those ornamented with open-work, we find a tendency for them not to end in a rounded or pointed form, but to broaden out towards the top and then to break off abruptly, so to speak. In eastern Europe as far away as the Balkans distaffs have ornamental tops in playful forms without any functional purpose; these must have served as a model. Some of these pieces call to mind a hand with outstretched heavily ornamented fingers, whereas the ends of similar western pieces might rather be compared to an arch, cupola or gable.

We could draw a map of Germany showing the areas in which these forms prevail, but that would be only the beginning of our problems, not a solution to them. In so far as differences of form over time can be explained by technological developments, some sense may be made of the geographical distribution. It is not clear whether there are any differences of substance here, or whether creative ideas are involved for which there is no readily available historical explanation.

Among the vast wealth of small wooden objects that exists we may mention another piece, the foot-warmer—a cube-shaped (rarely 195 octagonal) box carried by a metal handle. A metal or earthenware basin with glowing coals was placed into the casing, as with companion-pieces made of thick brass. Women would take such objects to church to keep their feet warm during long Protestant services; this was certainly the reason why they were so elaborately decorated. Foot-warmers in North Germany also had designs in chip carving with much the same range of motifs that one finds on mangle-boards, but there are far fewer variants, for no apparent reason. Presumably foot-warmers were produced by artisans rather than by carpenters and were then traded and also produced on commission. The brass foot-warmers, which were indeed so produced and marketed, served as a model for those made of wood. They were evidently produced with an eye to the owner's concern to display her social status when going to church. Those which have sides in open-work that allow the heat to escape are rather stereotyped.

For each of these implements one could paint a 'folk-art picture' to illustrate its use. The foot-warmers' purpose in church entitles them to be regarded as articles made for the entire community, to which a separate chapter is devoted (cf. pp. 214 f.). They should be considered together with other obligatory articles of women's costume, hymnbooks, Sunday handkerchiefs, boxes for smelling-salts and the like.

A completely different context applies to an implement often mistakenly termed a 'shoe last'. This is a piece of wood shaped like a person's foot and decorated all over with patterns in chip carving. Before 1900 Justus Brinckmann obtained for his museum a specimen with traces of leather and pins,[101] and since then the pieces that have been preserved have been generally regarded as shoemakers' lasts. In support of such an attribution is a reference to the Lübeck shoe-makers' guild having such a last.[102] Brinckmann's specimen, however, was the only one to be so misused among the many that have survived over a large region stretching from Holland to Pomerania. Actually objects of this kind were designed and used for darning stockings, a task which girls and women could not do with a 'toadstool' or 'egg' owing to the thickness of such stockings. If we can speak of any of these small wooden objects having significance as a love gift, then this is certainly the case with such 'shoe lasts', for stockings were often very closely knitted (often even simulating the calves of the leg), so that they had the firmness of long-legged boots and could stand upright unaided. A darning tool was thus an essential item in the equipment of any woman or girl.

Although used in different ways, all these wooden implements have something in common, as can be seen especially in the decoration on the North German ones. Besides the implements already mentioned there are various objects employed in the production of textiles: boards and frames for working flax, scrapers to clean and pre- 204 pare wool and flax (in Hesse, for example, so-called 'flax combs' to 208 ripple flax), distaff tops, small frames to wind and spool yarn, moulds 190 and buckets for balls of yarn and skeins, cloth-holders for the loom, 193 ell measures, clothes-beaters, sewing-boxes—in short all the handy 194 little things used by women and girls when performing work of this 215 kind; one may also mention those used in harvesting, such as the instrument for binding sheaves of corn, rakes, and tools used in the care of livestock. Let us consider first those fine Bavarian 'cream measures', which were used to take off the cream from milk. Among domestic implements there were some, used in particular by women, like the receptacle for matches or—used in South and central Germany—the stand (with a handle) for a hot pan when it was placed on the table; frames for wall and hand mirrors; and finally brush-holders. Lamp-stands, also placed on the table, took on a specific regional shape. The most distinct one is that of several flat pieces of wood, cut out in a V shape, with their ends placed in the central post, so that the outstretched arms serve as legs at the bottom and as lamp-holders at the top; the latter are cut out in the shape of animal heads. Frames of this typical shape are found in Pomerania[103] and in Sweden. These common features extending across the Baltic may derive from political links during the seventeenth century, but may also be based on earlier relationships; for the same shape also appears on a reel in north Friesland (one such specimen is in the Germanisches Nationalmuseum, Nuremberg).[104] The identical notion also affected the design of tables.

The repertoire of these objects is in the main very different from that of larger items of furniture, and in particular from those produced by carpenters, as well as from simple tools used in everyday life in the home, stables, barn or field; it also differs from looms and even 33, 20 from spinning wheels. They were usually produced by skilled artisans; and it was they who demonstrated their talents in shaping dis-

taffs. The simple notched spindles of Franconia were followed by distaffs decorated with carved birds and bells in Weizacker (Pomerania), East Prussian scrapers, and the finely carved distaff-tops of central Franconia. Reels featuring a variety of scenes appear in eastern Franconia, carved and painted ones in East Prussia.

Cf. 37,
207

The painter Carl Christian Magnussen (1821–96), who in the 1870s attempted to revive folk art in his north Frisian homeland, had armchairs covered entirely with chip-carved designs; this showed how he had misunderstood the tradition he so much admired. There are some such chairs with chip carving, but in general the composition of their decoration differs entirely from that of the small implements just mentioned, and to the eyes of the connoisseur Magnussen's chairs are of a strangely hybrid kind. Apparently he did not realize that the decoration of furniture and of small objects is conceived in a different spirit. This is true at least of north Friesland, the area where he worked and where carving was so popular. In other regions, such as Hesse, the two branches were closer together. Karl Rumpf was right in emphasizing that in his area of study, and in particular on the river Schwalm, salt-boxes hanging from the wall, spoon-baskets and bridal chairs share the same structural idea and decorative repertoire.[105] This surely suggests that the same artisans produced both furniture and small objects. It was a similar story in the marshes along the Lower Elbe: on wall panels and on furniture ornamental forms appear which strongly resemble those on mangle-boards and foot-warmers as well as on stove bars—and the decoration on carriages, too. These common features go hand in hand with the small number of types of small wooden objects. Here a highly developed craft produces both small and large pieces. This is likewise the case in the Probstei district, and especially in the Vierlande. Elementary woodwork is in any case less bound to contemporary style and more bound to tradition, and yet richer in imagination, freer and more readily developed.

71, 182

74

In order to distinguish the varied regional conditions that influenced the development of wooden implements it would be necessary to make exact analyses and far-reaching comparative studies. The borderline between a small object and an article of furniture may perhaps tell us a great deal about the relationship between domestic crafts, craft work by trained artisans, trade, marketing and hawking. To these three sources of folk art one may add, in ports and seafaring areas, the import of implements from distant lands.

Some small pieces of furniture can be included within the range of implements, so far as their form is concerned: for example, the spoon-board suspended from the wall, the plate-board, or a combination of the two. The spoons themselves which were used in everyday life, on the other hand, were not part of this canon; like clothes-pegs, they usually developed in the course of domestic trade carried on by unskilled persons; they wore out quickly and were traded by the dozen. There was, of course, also decorated cutlery and so-called 'bridal spoons'. As a rule such individual pieces are characterized by the fact that their handles bore figures, as in equivalent implements for upper-class use. A canon did not exist for them in Germany, it appears. Nut-crackers have their own queer forms, frequently with

187–
189

renderings of figures, and of course also differ technically in having a lever and screw effect.

413,
414

In order to consider folk art systematically it is important to note that these differences are significant in that they serve to delimit various areas of production. Carving is not always just carving, and a wooden implement may belong to one of several different categories. Its shape often indicates what sort of role it plays in domestic or village life; in certain circumstances it may even render it impractical, leading to a situation in which, alongside the implement of symbolic significance, people have a second one for practical use. The differentiation provides important clues to regional and local variants. Implements that in regard to their practical usage are far apart from one another may approximate in their symbolic role, and vice versa. Despite all this variety there evolved a category of objects that was thought suited to be given a more or less fixed form, so that it could fulfil its symbolic significance as an obligatory gift or as evidence of status (e.g. marriageability). The idiom of form is not just one for expressing expediency, or even just wealth or way of life, property or prestige; rather it serves to convey meaning and to exemplify the social order far beyond the immediate domestic sphere.

Due to these circumstances it is understandable that the implements mentioned above are in a different category from bentwood boxes and toys that were produced domestically and traded over wide areas. Moulds for baking are a law unto themselves: they have their own repertoire of forms, not easy to comprehend so far as regional varieties are concerned; the form is governed by the exigencies of the craft concerned, that of baker or pastry-maker. The same is true of objects for calico-printing and of woodworking implements, especially planes. In the case of butter and cheese moulds, however, there is hardly any link with the implement involved; they are regionally differentiated, and one has to find out who the producer was and why the traditional shape acquired the form it did. Evidently this had something to do with the nature of society in general: for example, Westphalia, which is rich in folk art, has relatively few ornamental wooden implements, whereas in Saxony, in particular in mining areas, there was a strong interest in mobile mechanical figures made of wood. This goes to show that tracing wood-carving as a category does not get us very far; only the material and the implement are common. Big differences may remain between products, for example between Bavarian Christmas cribs, Württemberg moulds, Silesian honey jars, model ships from the coastal areas and mangle-boards, the standard North German implement.

It is harder to define the implements used in wine-growing areas, such as wine-presses and receptacles for storage, such as one can find in the Wine Museum at Speyer. In Alpine dairies one finds the blades of scythes and whetstone-holders, as well as implements for processing milk; in pastoral areas those needed for livestock, many of which are preserved in the superb Pastoral Museum at Hersbruck, Franconia. Its impressive collection of yokes with bells for oxen and the like shows how an object may become a kind of symbol of the people's life in a particular area. On barrels and similar hooped containers, used especially in viticultural regions, bentwood implements

198

181

and receptacles (yokes with bells, bentwood boxes), the scope for decoration of the wooden parts is limited from the start. Staves for casks, barrels and vats as well as bentwood, which has to be thin so that it is supple enough for this purpose, can be decorated only on the surface. Thus we find painting, and possibly burnt-in designs, but no deep notching. The decoration is concentrated on the more solid flat surfaces, such as barrel bottoms and box lids.

Painted Bentwood Boxes

A type of folk art that became very common in Germany and was produced in large quantities was the painted bentwood box. As early as the Middle Ages thin shavings of conifer wood were bent into shape to form the walls of large or small boxes and lids. The plain bottom and lid boards were then tacked on. The ends were sewn together with root fibre or bark, or in the case of small boxes glued into place. Even as late as the nineteenth century large quantities of these boxes were made and used for every conceivable purpose, such as storing articles as varied as headgear, toys, ornaments, foodstuffs and ointments, right down to shoe polish.

Output reached huge proportions as early as the eighteenth century. This became a cottage industry in the Salzburg district (in the Viechtau), in Berchtesgaden (where box-makers are first mentioned in 1541), in the Gröden valley, in Nuremberg, Altdorf and Sonneberg. The areas of Tachau and Taus in the Bohemian forest, the Erzgebirge and particularly Thuringia also took part in it. Box-makers who had been driven out of Salzburg in 1732–3 because of their Protestant faith moved to East Prussia and to the Hanover area, continuing their trade in Einbeck and in Göttingen. Before the bentwood box was replaced by one made of tin it went through a phase of semi-mechanical manufacture, in which the chips for the sides were cut out in large quantities by means of stencils. In the Herzig factory at Hermsdorf in the Giant mountains in 1871 a woman worker glued from 720 to 900 small boxes per working day.[106] This was the final phase of a development which had started in prehistoric times and flourished at least from the late Middle Ages onwards.

Hubert van Eyck's picture of the birth of St. John, dated 1415–17, gives us a view of the inside of a chest, on which two bentboard boxes appear to have been painted. Such boxes were put into chests to protect delicate garments from pressure and dust and were used in the same way until quite recently. At a date as early as that of the Bronze Age tomb in Trindhöj (Jutland) headgear was protected by a bentwood box.[107] The fact that boxes were so frequently employed in this manner encouraged them to be made in a standard oval size (38–50 cm long, 17–23 cm high) and to be painted in colour. From the seventeenth century onwards, if not earlier, they formed part of a bride's dowry or were a popular wedding present. In some regions the multi-coloured bentwood box could regularly be seen on the luggage coach that brought the goods and chattels of the young wife to her husband's house. It was used to store bonnets, ribbons, kerchiefs, and sometimes ornaments and clothing accessories. Smaller,

round boxes were painted, too, but with simpler patterns not comparable with the fashionable decorations of those used for bonnets or bridal gear.

The earliest surviving specimen of a painted bentwood box was made in the fourteenth century and is now in the museum in Brunswick. Bonnet boxes of typical size and shape exist only from the seventeenth century, however. A round one in the Württembergische Landesmuseum dated 1644 gives an idea of the elaborate way boxes might be painted at that time.[108] The Adam and Eve motif on the lid and the flaming heart inside clearly indicate that this one was a love token. The second half of the century saw the beginning of a series which carried on traditional forms and paintings for more than 200 years. The Schleswig-Holsteinisches Landesmuseum owns an outstanding early example dated 1674, and the St. Annen Museum in Lübeck one of 1682. The earlier pieces, up to the eighteenth century, are painted so that the oval face is vertical and a single figure or even a couple fit well into the surface. On the specimen dated 1674 the lid shows a gentleman in fashionable clothing, wearing white breeches and a long coat, a wide-brimmed hat over long curls, and carrying a sword on a wide sash. He could be the donor or a suitor, perhaps a bridegroom—at any rate, a man of standing who had many imitators during the eighteenth century. More frequently still he could be seen with his beloved. This emphasizes the true function of the present, often reiterated in sayings like: 'I love you with all my heart.'

In the seventeenth century the couple, arms linked, fashionably dressed, embracing each other or standing stiffly side by side, without biblical allegories such as Adam and Eve, became the leading theme of pictures on the lids of bentwood boxes. Religious themes appear infrequently, which indicates that they were widely distributed without regard to confessional differences. Pictures of saints may appear on boxes from Berchtesgaden. As a single figure an angel sometimes occurs, indicated by wings but dressed in contemporary garments. In the unusual case of the picture being painted horizontally, the motif might be a pair of angels with a pious saying in the centre. Heads of angels, not being associated with any particular sect, might be adopted even when the general theme was secular.

There must have been several conventional occasions for giving presents. These are indicated in the picture motifs and the sayings, whose meaning was clearer at that time than it is today. Birth and baptism could have been among such occasions, accompanied by the verse: 'A mother's faith and the Lord's way/Renew themselves from day to day.'[109] 'It is no bother, we shall have another' might go with the picture of a woman with a child in swaddling-clothes. Many boxes depict a stork or a similar allusion, considered appropriate on the occasion of a wedding. A box in the Schleswig-Holsteinisches Landesmuseum shows a man smoking a pipe and rocking an infant in a cradle with his right hand, with the verse: 'As the women will, the cradles do fill.' Such a box was surely intended to hold christening clothes and other children's garments.

Eighteenth-century motifs include themes which cannot easily be attributed to specific purposes, such as three red-coated soldiers with 157

Painted Glasses, Window-Panes and Bakery Moulds

Painted bentwood boxes have a parallel in a very different group of painted functional articles for daily use. The categories mentioned in the title of this chapter include quite a few of them, each with its own range of motifs and a tradition which developed along lines dictated by the material.

426–433 Among objects with a particularly well-defined tradition are glasses and bottles for brandy with corresponding goblets, tall and stemmed glasses of different shapes, painted in enamel colours. Most of them are for beer, but they may, of course, also have been used for various other drinks. Like bentwood boxes they are adorned with representational or abstract decorations typical of the genre. They were made in small-town or rural workshops, mostly near some glass-works, because they had to be returned to the furnace to be annealed.[125] They were distributed in large quantities through markets and by pedlars. If the boxes were almost exclusively presents for the womenfolk, mainly love tokens, these handy-sized drinking vessels were gifts for men. They often found their way into the pockets and packs of itinerant artisans, as shown by the painted craft symbols which are a popular theme. If we disregard specially-ordered examples for the rich gentry or perhaps for guilds and rifle clubs, the rest are all of a cheap standard type which had a wide sale. They were mostly conventional in form and style of painting, and it is therefore hardly possible to trace them back to specific areas or definite glass-works. The method of distribution over long distances was similar to that of bentwood boxes. The roaming habit or 'wanderlust' of the artisans was a further factor in spreading them widely. (Dispersion by antique dealers and collectors in our own day would be a third reason.) Where the glasses bear personal names in addition to simple, mostly amorous rhymes, they were often ordered by somebody living near a glassworks, but this is seldom true of simple pieces.

432 The motifs provide the best indication that these were designed as presents for one's beloved. There are pictures of couples, simply standing, dancing or turned toward each other. The same sentiment can also be expressed by doves, by hearts pierced with arrows, joined with chains, burning or blossoming, with birds sitting on them or painted with a figure 3, a symbol for true faith, surrounded by thorns. In addition there are animal fables—these, too, paralleled by the pictures on bentwood boxes. Quite a different type entered the repertoire from the masculine world, including rather coarse, even erotic, scenes imagined or experienced by students and journeymen, such as are sometimes found in albums of the sixteenth and seventeenth century. More surprising in this connection is the variety of religious motifs such as the Virgin, Pietà, apostles and saints; shrines also appear. Apparently these were not regarded as in any way incompatible with the pleasures of life—not, at least, with those which can be obtained from a bottle.

Unlike the painting on boxes, the pattern is concentrated on the main items which stand freely without a background on the surface. They are organized in a heraldic manner and the painter does not mind leaving some of the space untreated. This may partly be due to the influence of ceramic decoration and, of course, to the fact that glass should remain transparent. Publications on the subject speak of 'folk glassware';[126] however, it is difficult to draw a line between these pieces and more elaborate ones, although the nature of the glass itself may indicate higher quality. Where there are names or escutcheons they clearly indicate a special order. The style of painting also hints at the type of customer for whom the vessels cater. The least specific examples, i.e. those that might have been sold to any kind of clientèle, are the freely painted bouquets of flowers, mainly roses, which became so common in the nineteenth century. Only an inscription like 'souvenir' or 'two friends' may suggest a special occasion.

These painted glasses are remarkable for the colourful brilliance of the paintings, which are generally on a modest scale and fall into areas clearly defined by the nature of the paint and the process of painting and firing. The viscous flow of the mixture of oil and enamel dust on a saturated brush results in effects rather like the slipwork which comes from a potter's *Malhorn*. Variations in the overall effect frequently arise from the shade of the glass, which ranges from green to colourless. They can also be caused by the reflection of the reverse side of the vessel shining through. On frosted glass the colours stand out deep and rich against the white background. The grace and flexibility of the painter's stroke can be seen in the contours of the main motif, which are often underlined in black. The same skill is also apparent in the spirals, scrolls and loops which sometimes form framing strips on the small surfaces of octagonal bottles.

All investigations into the exact origins of this painted glassware have so far succeeded only in allocating them to large regions. Lipp distinguishes a North German area comprising Westphalia, Lower Saxony, Schleswig-Holstein, Mecklenburg, Brandenburg and Pomerania from a central German zone including the Palatinate, the middle Rhine valley, Hesse, Thuringia, Saxony and Silesia, and from a South German one to which the rest of the country belongs, together with Switzerland, the Tyrol and Austria. His suggested divisions are not entirely convincing. Local characteristics are not eas-

ily defined and some areas were altogether unproductive in this craft.

On the other hand it is sometimes possible to connect a specific glassworks with an individual piece or to assign precise localities to a particular type. For instance, the number 3 as a codeword for 'faith' presupposes a South German dialect; in North Germany it would be an insoluble riddle.* The Lower Saxon horse with a crown indicates North Germany but no more precise conclusion can be reached. Motifs of miners suggest a nearby mining district, but nothing more definite. Local groups can be identified by comparing the forms. All glass-makers seem to have adhered closely to the most popular patterns. This was most pronounced where glass painters, as skilled workmen, were induced to take up jobs in remote areas. The glassworks of Hesse, Thuringia and Saxony were particularly productive. In the late eighteenth century craftsmen made their way from these centres to various parts of Germany, including the north. It is not always clear whether they continued glass painting in their new places of work. We know as little of the specific glassworks in North Germany as we know about the places where bentwood boxes were painted, although there were many such works in eastern Holstein and other well-wooded areas.

A branch of pictorial tradition going back to the late Middle Ages was that of 'Cabinet Panes'. They became an established feature, and for generations maintained their place in the living quarters of the 58–67 rural population. They are usually small decorative panes—sometimes single, sometimes divided—which were originally incorporated into the windows of the living quarters of the gentry and other affluent citizens. According to the medieval custom they were also presented on special occasions to churches and town halls. Thus they even have a technical connection with the traditional glazing of medieval church windows. The process is different from that of enamel painting: the colours remain transparent after they are put on the glass and fired.

The magnificent development of cabinet panes in the late Middle Ages and even more during the sixteenth century in Switzerland and in southern Germany is well attested. Long lists of works by important glass painters with large workshops could be compiled. Their successors, the 'minor masters', were also much occupied with drawing picturesque motifs from all spheres of life on panes. The themes ranged from religious motifs to secular subjects drawn from the contemporary world. One favourite was heraldry. The owner of a house claimed a place in society by displaying his coat of arms. More often this belonged to the donor of the pane which, in a town hall, was often a circle of free burghers, and in a parish a corporation such as an artisan's guild, who wanted to make themselves known in this way. Each pane was often connected with the others by its motif, which formed part of a cycle, both in the style and in the theme. House-owners sometimes ordered a whole sequence, which might depict biblical subjects, seasonal symbols, the main virtues and so on. There were also simple decorative patterns, architecturally framed

contemporary ornaments, or even a series of simple flower or bird illustrations.[127]

There was an additional reason why coats of arms and inscribed names were depicted on these panes. They were often presents for friends and neighbours and they therefore served as reminders of a friend of the family. It was a general neighbourly duty to contribute to the building of a house whenever it was necessary. Just as neighbours might provide some of the timber or offer practical help, so they assisted with any particularly costly parts, one of which was the glazing of the windows. It was also traditional to donate a window pane when a young couple established a new household or took over the farm from their parents. In return the neighbours were invited for 'window beer'. The occasion for the presentation of the gift is not usually apparent from the motif of the picture or from the inscription. The general impression is that, apart from its material contribution to the equipment of the dwelling, it was a symbol of congratulation, as well as a token of the recipient's standing and popularity among his neighbours—something akin to what we now call a status symbol.

Another aspect must be remembered. Painted windows were not traded in the markets but were made to fill a definite order. In the sixteenth century the main centres for the painting of cabinet panes for the more affluent citizens were, apart from Swiss cities, the South German towns of Strasbourg, Freiburg, Augsburg and Nuremberg. Customers often sent orders for drawings and panes from distant places. For reasons which are not easily apparent the pleasant custom of giving meaningful presents by contributing to the household decorating was confined to affluent urban citizens in southern Germany and was not taken up by the rural population here. Toward the end of the sixteenth century the custom gradually fell into disuse.

The cabinet pane as a friendly gift among the bourgeoisie, a pious donation to the church or a decorative piece of equipment was as well known in North Germany as in the south. Lübeck seems to have been one of the places where they were much in vogue, as was Bremen, where thousands of panes with escutcheons decorated the city hall, the municipal offices and the houses of patricians. The senate was particularly generous in presenting window panes and earned for the town the name *Brema Vitrea*, the 'Bremen of Glass'.[128] Very few specimens have been preserved.

The custom survived much longer in the villages of Lower Saxony and Schleswig-Holstein. In order to qualify as a master glazier in Flensburg at the beginning of the seventeenth century, the candidate had to 'make two windows, each one ell high and three quarters wide, with a painted history'.[129] In 1750 the painters' office in Hamburg still required glass painting as a qualification for becoming a master. Münster still demanded it in 1791.[130] This was hardly justified any longer by actual demand in the towns; but in an area stretching from Holland through Westphalia and Lower Saxony as far as Danzig there was a considerable rural revival of the craft in the eighteenth century. The tradition was carried on by glaziers in small towns and villages from the sixteenth century to the eighteenth. Judging by the surviving material it seems to have been concentrated mainly in the

* In some German dialects the pronunciation of the word *Treue* (faith, fidelity) resembles that of *drei* (three).

northern part of this region. However, examples from places like Brunswick and Halberstadt indicate a connection with the earlier flourishing fashion in southern Germany. An accurate picture of later window painting must include the Netherlands and Scandinavia. According to Lexow the spread of cabinet panes, especially in the seventeenth century, shows a cultural influence from the west, which started from Holland and affected North Germany and Denmark. This movement reached Bergen on the west coast of Norway, then the most important town in the country, and extended northward to Stavanger and Trondheim.[131] Nothing more than occasional traces occur in Sweden, except in Gotland.

Paintings of room interiors in Holland in the seventeenth century and examples preserved from Norway show how the small panes were fitted into the glazing of the whole window. Except for remnants in a few churches they can be seen nowadays only in museums, where the lead frames are not original. Obviously, the motifs in the churches are all of a religious nature—the panes are donations from pious members of the community. This applies equally to Catholic and to Protestant areas.

In the north of Germany panes—painted or plain—were called *Ruten* because of their rhomboid shape. The description originated at a time when the lead rods which support the glass were still set diagonally into the frames as they were during the late Middle Ages. The name continued to be applied to the rectangular panes which were generally introduced during the seventeenth century, and to the occasional round or oval ones. The predominance of the rectangular shape was obviously a result of the manufacturing method, the cutting and stretching of the blown glass cylinder. The proportions of contemporary windows demanded a standard size of pane.

The custom was kept alive during the seventeenth century partly because the ruling princes supported it strongly. For example, Dukes Johann Adolf (1575–1616) and Frederick III (1597–1659) of Schleswig-Holstein-Gottorf honoured their friends, when they built their houses, with presents of panes bearing the ducal coat of arms. The recipients also included faithful servants, like the court tailor and ducal gamekeeper. The duchess, princes and princesses also followed this custom. From surviving invoices a long list of recipients of such favours can be compiled. A few such panes are preserved. In many cases only the cost is noted and the number of panes indicated— sometimes up to fourteen at one time for a single recipient. In this case the coat of arms was probably made up of fourteen panes. It may, of course, only have been a conventional invoicing method and the receiver of the gift have simply been given a number of panes fixed according to his station.[132] Higher dignitaries received other signs of favour, from a gold goblet to the 'penny of grace', a minted medallion. This suggests that the gift of windows had largely become a bourgeois custom by the seventeenth century. It is reported that in the duchy of Lauenburg panes with the ducal coat of arms could be found even in peasant homes.[133] Some of the panes with escutcheons of noblemen that have been preserved may therefore have been presents to tenant farmers. However, within the ranks of the country gentry the custom of giving panes remained in vogue for a long time.

The house of a certain Heilwig von Ahlefeldt in Kiel, for instance, boasted twenty-four windows on its façade, all decorated with panes bearing coats of arms. They were donated by various citizens, the town council of Rendsburg and members of noble families. In claims for destruction or compensation for war damage the 'pedigree' of the panes was a factor. The landed gentry and the citizens obviously supplied the model for the large number of rural imitators. Rural panes sometimes predominate in present-day collections simply because country people tend to cling to established customs. Popular rural inns could, according to the records, have played the role of intermediaries.

The traditional acknowledgement of these gifts by the recipient, the 'window beer' party, was an important feature of rural life. Even before 1600 records of episcopal visitations suggest that elaborate festivities were held; legal restrictions soon followed, repeated until 1800, directed mainly against excesses but also designed to curb over-spending on this custom. After 1800 no more panes were presented, though the words 'window beer' and 'window fitting' were still used. They remained in common use till about 1870, but meant no more than drinking and dancing parties which were often organized in private houses to raise money.

Until about 1800 glaziers' and painters' workshops could hold their own in the small towns and rural areas of North Germany. We have definite reports about them from Bergedorf, Wilster, Elmshorn, Glückstadt, Husum, Neumünster, Rendsburg, Schleswig, Kiel and Flensburg, to mention only the northernmost region.

There are certain types of window motifs than can be specifically regarded as part of the folk-art repertoire: scenes of country and farm life. Some years ago Otto Lauffer made them the subject of a special study.[134] Seen as a whole, they form a kind of self-portrait of the country folk in characteristic aspects of their existence which, in some cases, is partly determined by this habit of giving presents. They are shown at work, both as farmers and as artisans, sometimes in simplified form. Such scenes frequently relate to a festive occasion. A gentleman on horseback is shown riding along firing a large pistol 64 in salute, while the lady next to him offers him a drink. This theme of offering a glass or a tankard recurs frequently, apparently as a hint at the wife's duty to look after the master of the house or perhaps 60, 63 just as an indication of the way in which guests invited to the festivities were received. The men are even shown performing heavy tasks, such as ploughing, in their best clothes. This is a way of symbolizing the man's calling. The depiction of ploughing means 'I am a farmer', not 'this is what it looks like when I plough'; his clothes demonstrate that he is a man of standing, not that he always dresses in that fashion. Many motifs of popular pictures can only be understood symbolically, rather like the genteel couples on bentwood boxes. There is therefore no contradiction between illustration and reality, nor need one regard these pictures as examples of wishful thinking. There was never any doubt that the upper classes were regarded as the models. When the person to be honoured is shown 61 sitting in a fine carriage, the picture does not necessarily represent reality. On panes from Lower Saxony a field cart is generally shown

with the couple sitting behind the coachman. Obviously this does not indicate a bridal couple. Some additional texts suggest that they are guests going to 'window beer' festivities. This probably also applies to individuals of either sex of whom the text tells us only the name, sometimes the date and perhaps the address. Occasionally musicians are shown, individually or as a band.

Following the fashion set by the gentry and burghers, the country folk, too, display coats of arms on their panes, sometimes with words, including a name, which gives the clue to a motif in the picture. As border patterns motifs of the sixteenth and seventeenth century survive well into the eighteenth; these consist of scrolls, volutes, garlands and heads of angels.

Panes from the same area are often so much alike as to enforce the conclusion that they were made by the same glazier and painter. Stroke for stroke, the same rider lifts his whip in greeting, the same woman offers him a drink, the same couple reclines in the coach. In cases where the same date is mentioned it is certain that the donors met for the same feast. Duplication of presents was no problem for the recipient. For the donors it was even desirable to conform to the conventional pattern. Observance of the custom was more important than personal taste.

The origin of the panes can also be traced where they form series. The village glazier had his pattern book, a few of which have survived. One that belonged to the brothers Johann and Hinrich Warner, glaziers in Dithmarschen (now in the Dithmarscher Landesmuseum, Meldorf) dates from the beginning and middle of the eighteenth century. It contains patterns of escutcheons, riders, and sailing ships as well as religious and allegorical themes.[135] It is plainly designed for rural customers and differs considerably from other patterns (the precise origin of which is unknown) in the Museum für Kunst und Gewerbe, Hamburg. They depict scenes from workaday life: a potter at his wheel, a cook, and a teacher. Unlike the patterns for rural customers, these drawings always include the surroundings in correct perspective: the kitchen, a classroom with many children etc.[136]

The country glaziers held a special position thanks to their training and their wide travels as journeymen. This is made abundantly clear by the few surviving diaries kept by such men during their travelling years which sometimes record motifs suitable for window panes.[137] Apart from this heritage of motifs there are other collections of patterns. The glazier Johann Hinrich Stumpfeldt, born in 1698 in Plön, Holstein, who belonged to a family of glaziers known there since 1691, possessed about a hundred books, including some with models for his painting, mostly copper engravings. He records particularly: 'three books of flowers' (together 62 sheets), 'a flowerbook painted with red ochre' (26 sheets), 'a book of multi-coloured flowers' (18 sheets), and 'coloured foliage and various flowers' (18 sheets). Other volumes contain: 'diverse heads' (52 sheets), 'apostles' (20 sheets), 'arms' (21 sheets), 'ships and inserted pictures' (32 sheets), 'letters & stars' (47 sheets), and 'several names (calligraphically drawn)' (20 sheets). 'A volume of drawings' contained 37 sheets. He also had a number of recipes for mixing colours and coloured inks.[138]

The design selected by a simple painter of panes from all these models could be modest but attractive in its formal setting. Bentwood painting started as a cottage industry largely for a distant, unknown clientèle. The glass painter had to satisfy his immediate public. Quite often the simplest means were the most successful. The flourishes forming faces, hats with feathers, heads of fiery horses, or noisy pistols are mostly stereotypes. Their charm lies in a naivety which takes itself seriously. Yet it is true that even the conventional formula for, say, a picture of a horse, may contain an element of imagination. Despite the simplification, the painter still employed an expressive stroke which evokes a spontaneous freshness.

A world of forms ruled by widely different considerations is revealed in moulds for pastry and confectionery,[139] including those for wax, fat and rice. This category has an almost unlimited variety of motifs and for many decades has attracted the attention of students of mythology and other specialists. Within the wide field of moulded pastry, including dough modelled by hand, the most varied combinations of forms occur. The most frequent are wooden moulds into which dough is pressed, waffle-irons for flat bakery products, and forms used to cut shapes out of thinly rolled dough. In addition to these differences in preparation methods, moulded pastry can also be classified according to the various types of dough used or the festivity for which the confectionery was made. A particular form developed, for instance, for marzipan or gum tragacanth, for sweetmeats, and all kinds of gingerbread; other forms apply to puddings, wedding cakes etc. Such distinctions are closely connected with a certain repertoire of pictorial motifs, some of which go back to very old traditions. The continuity of these traditions should nevertheless not be overrated. At the beginning of the modern era, when folk-art craftsmen took over the special task of making everyday objects, there was still a surviving medieval tradition of supplying specially formed pastry, cultivated in the monasteries, but also practised in secular bakeries. Religious motifs for festive occasions of the church calendar predominate, but secular themes are also in evidence. The traditional medieval motifs are of a very high artistic calibre and cannot be classified simply as folk art. Pastry moulds which were obviously designed for general popular use occur only from the late sixteenth century onwards. We can only give a brief account of them here. The cycle adopted religious motifs, not excluding even the Passion of Christ. It must have been considered an act of piety to eat such pastry representations during Passion week or at Easter. The subject of Adam and Eve was very popular, perhaps because it fitted in with a variety of occasions. Foremost among secular patterns are pictures from upper-class life. Ordinary folk both envied and admired them, wished to have their image in front of them, and finally to eat them. Ladies and gentlemen stand there in their Baroque finery, sometimes in pairs as they do on bentwood boxes. They ride or drive past—a supreme example of wish-fulfilment—in a coach or a luxurious horse-drawn sleigh. Sometimes it may simply be a wedding-coach, but there is no point in pressing these assumptions too far. To drive in a coach or a sleigh was *ipso facto* a privilege of the higher classes. The pictures include all kinds of animals, some of them difficult to

285–
288,
403–
407

405–
407

406

identify. Stags sometimes hold medicinal herbs in their mouths, sometimes pull a sleigh. A picture of a lamb hints at a religious connection, that of a cockerel at a pedagogic one. The cock was depicted on the cover of the child's first reader. Magic meaning can be found in the shapes of letters: eating a baked alphabet was supposed to help children to learn it. Samson conquering the lion, eaten in the form of pudding or rice, could make the consumer strong, and St. George too occurs in the same context.

403
359

This world of Baroque forms and figures persisted until the end of the eighteenth century and expanded in the *Biedermeier* period to embrace the whole gamut of daily and festive life, in the manner of the subjects on picture sheets. Their size was reduced as other types of pastry came to be included.

Bentwood box painting was developed in limited areas as a cottage industry and window panes were painted by local artisans, but it is much more difficult to fathom the production methods in the case of moulds for the baking trade. Just as the fabric printer, like the book printer, had to be able to cut blocks, so the cutting of bakery moulds was largely carried out by bakers, and therefore such moulds might be made anywhere. No one can be sure where the original forms were first devised. Specialist mould-cutters were also active, particularly in southern Germany, in places where there was an established wood-working cottage industry. Monograms were often branded into the wood but it is difficult to assign these to definite masters; in any case, the monogram was more likely to be that of the owner than that of the maker. Itinerant traders and markets dispersed the ready-made articles over a wide area and we cannot trace their origin or follow their travels. The patterns spread in the wake of the models, i. e., they were copied over and over again. Where medieval mould-cutters preferred circular and rhombic patterns, later folk tradition favoured rectangles. This meant that the cut-out shape made of dough had to be loosened with a knife. The size of the pieces depended mainly on the consistency of the dough and the price of its ingredients. As far as the nature of the material allowed, pastries grew larger during the nineteenth century and continued to do so at the beginning of the twentieth, with increasing affluence and the availability of cheap sugar or syrup. This is particularly true of the simple pastry figures baked in North Germany at Christmas. In some places such figures, originally 12–15 cm high, grew ten- to twentyfold. The presentation of outsize pieces of pastry on festive occasions such as weddings had long served to express wishes for general prosperity. The larger the pastry, the more likely the fulfilment of the wish! In Dithmarschen around 1500 the bridal bread grew almost to life size. It was stuffed and adorned with raisins, hearts, hands, children, cribs and loops, as we are told by the chronicler Neocorus.

Peculiarities in the width and height of the moulds and a variety of motifs occur in many parts of Germany. In this respect Nuremberg, the ginger-bread town, took the lead. Many such regional specialities survive to this day. One need only mention the popular *Springerle* from Württemberg, an aniseed pastry with its own traditional form, or the *Printen* from Aix-la-Chapelle. Königsberg and Lübeck became capitals of marzipan making, and developed their own range of shapes and a picture tradition for the moulds which are best made of sulphur.

Cake moulds are mostly made from pear or beechwood and are carved in a characteristic style. The moulds into which the dough was to be pressed were carved with a hollow round knife, or rather by forming patterns of cuts and strokes confined roughly to a single plane. Animal fur, curls of hair, fish scales, leaves and grass could be represented in this way by systematic notching. Even patterns derived from fabrics and clothing were delineated in bentwood. From the crinkled surface of these moulds only a few larger forms emerge. The neck of a horse, a wagon wheel or in human figures a long-legged boot may provide a clue to the whole design. Besides these there are also mould forms that display all degrees of plastic and naive pictorial simplification. As early as the sixteenth century an overall style developed which may be considered the popular version of the relief style in the fine art of the period.

In addition to the subjects discussed in this chapter others could be mentioned, such as small clay plaques made by potters. On the 236 Lower Rhine and in Württemberg these were set in the sides of the stoves. Other examples would be stove and fire-place plates made of cast iron. To explain the motifs, themes and forms of these objects it would be necessary to discuss in detail the conditions in which they were made and sold. An established tradition deriving from a local artisan or foundry often leads to standardization when taken over by large-scale manufacturers and the objects distributed over long distances. The distance factor applies particularly to painted faience tiles 32, 33, that found their way from Dutch and German centres into very many 35–37, houses, and not only wealthy patrons. To elucidate all facets of 43 objects in popular use and their ornamentation would require an exploration of graphic models ranging from early devotional pictures to pamphlets, Bible illustrations and books of emblems and the imagery of nineteenth-century picture sheets. Compared with these, the ornamental plaque on the wall of a room in the traditional rural home is a late-comer.

Metals

In view of the fact that the term 'folk art' covers so many different items it is not entirely logical to classify articles according to the material from which they are made. An examination of metal objects other than personal jewellery, however, reveals a number of features which are of importance in the study of the subject as a whole. Since the beginning of the Iron Age iron has become virtually indispensable in even the most simple rural household—from the horseshoe to the three-legged pot or the pot-hook. Hence the particular part played by the village blacksmith in rural life. For a long time, however, there were few implements made exclusively of iron. The blacksmith had to supply a wide variety of additional fittings: bands, clasps, catches, hooks, prongs etc. He supplied the blade for the spade, the share for the plough, the frame for the window and the suspension and overfall for the door. With creative imagination much could be achieved even in such a limited field. The straps of door-hinges might run in curves across the wooden boards, the mounting of a lock be drawn out to a point, or a sheet be cut to the shape of an ornamental figure. Whether it is split, pinched, bent and twisted, beaten flat, pointed or perforated, the malleable hot iron offers great creative possibilities. The appearance of many wooden pieces of equipment was greatly enhanced by metal mounts; this was particularly true of box-type furniture which needed to be effectively secured, such as treasure chests or church collection-boxes. When it came to locking things away people often liked to make a show of security by having the mounting of the lock cut in the shape of a guard.[140] Door mountings could in themselves provide enough material for a whole chapter in the history of civilization. These mountings sometimes took the form of a picturesque representation, but it is the characteristic interplay of the iron bands over the surface, their diverse patterns and fanciful bending into a spiral that gives them their characteristic effect.

224, 228, 229, 226 Even the curves of a simple hook, driven into the wall so that objects can be hung on it, can rise above its merely functional purpose if it is shaped by a sensitive hand. The artistic effect does not necessarily depend on ornamentation. The bell-shaped stove hood makes the same point. The various patterns created by rods across a grid-iron are too numerous to count and makers were only rarely satisfied with mere parallel lines. The interplay of hearts and lily-like shapes is used in a very lively manner. Nearly all German territories contributed such examples of the smith's art. Corresponding forms occur in other implements. Grates in a fire-place set in the wall, where large logs of firewood were placed, developed into impressive figures.

Some regions developed the making of these objects into a notable 225 art. In Westphalia, for instance, the pot-hook, cut from iron plates, became a showpiece of stove equipment, transcending its utilitarian purpose. It might serve as a centre-piece of household equipment and be enriched with pictorial motifs, and even as a testimony to the owner's religious faith. Other utensils had to be made at least partly of metal because of fire hazards. This applied particularly to lighting equipment. The iron parts of these objects often adopted the form of articles made from a more valuable metal. Village blacksmiths 234, managed to shape some very original candelabra from iron sheets or 235 rods. As early as the Middle Ages typical forms of these had been designed for churches.

Only after the end of the Middle Ages could the blacksmith extend his art into the production of more freely formed popular articles. Examples of this are the grave crosses so frequently found in South Germany. In some limited Protestant regions the hat-stand also formed part of church furnishings. Both these objects echo the highly developed art of Renaissance and Baroque blacksmiths who provided palaces and churches with ornamental railings and created the most flexible forms from the rigid material. As in other arts, the smiths followed the example of great artists to the best of his ability. Graveyards in Bavaria preserve many examples of Rococo-style 365 smith's work in the form of grave crosses. They almost give an impression of gaiety where, as is often the case, the rigid shape of the cross is dissolved into a looser form. Next to them we find monuments where iron rods are rolled into spiral patterns, being twined, for instance, around a heart. A shield with an inscription nearly always forms the centre-piece, and dates may be hammered into the cross-pieces. These cross-pieces may be transformed into a star, the sun, a tree or a flowering shrub. In less elaborate pieces the curve of the iron bar alone may be given the expressive force of a pleading ges- 366 ture. People may object to such an interpretation of a plain piece of handcraft. To those sensitive to the idiom of form, however, such a line of reasoning is more than justified. Where blossoms sprout from the bars of the cross they revive the medieval idea of its identification with the 'tree of life' in Paradise. This interpretation is not part of orthodox theology, and is far removed from the symbolic mode of thinking which recognizes mythical 'trees of life' in plant motifs. Nor is it a conceptual designation; it simply exists as a real impression of the senses. The Plates suggest the range of possible variations of 365, form, from a highly-developed pattern to a simple gesture. On the 366 whole, the more elaborate creations occur mainly in South Germany.

Nearly every village had a blacksmith, but specialists in metal-working tended to congregate in towns. They settled near foundries or in places where water-power was available to drive their hammers. The brass-workers of the Maas district have already been mentioned. During the eighteenth century brass articles even found their way
230– into houses in the countryside. They came in the shape of snuff-
233 boxes, mainly from Holland, foot-warmers, warming pans for the
37 bed, covers for the stove and various lighting and kitchen utensils.
216– Numerous vessels, of brass as well as of copper and tin, particularly
223 simple ones, need to be considered as well. In their ordinary form, without decoration, they represent an element which outlived the fashionable style of more pretentious contemporary objects. They have much in common with earthenware crockery in spite of the very different material and mode of production. They demonstrate the same stable relationship to the bulges of the walls, the resilience of the material, the stability and tactile form of the vessel. Their makers had a wide experience of the way spouts were formed, how the vessels were to be handled and how they would wear. All these factors, combined with and related to correct proportions, brought about a number of forms largely independent of the style of the period, which are among the most important items that these craftsmen have left to us. The ornamentation is insignificant by comparison. To deal with the significance of their forms we should have to compare a single example with a large number of others, which is impossible to do here. We can only refer to Walter Dexel's research into ladles, in which he also considers wooden and glass vessels, and shows that the material and the production method create entirely different conditions which strongly influence the result.

Unlike articles made of iron, those of other base metals show fewer regional characteristics. However, the preponderance of brass utensils in North Germany, particularly in the coastal areas, is remarkable. Apart from the Maas territory Holland was the most prolific source of this widespread trade. Dutch brass utensils were generally copied with little variation in local German workshops. In southern Germany the perforated or beaten lids of warming pans were mostly made from copper, and the same applies to a number of other articles. To explain these differences would not only be difficult in the context of this chapter even if we had ample space. Itinerant traders and local markets dispersed light rolled metal goods over great distances.

Pictorial motifs, generally executed in broken lines, often occur on
216– the bottom of brass and copper dishes and on the walls of pewter
219 tankards. They may show a symbol of the trade if the utensil belongs to a guild, or a wedding procession, if it was made for a marriage ceremony, or a target if it constituted a shooting trophy. As in the case of painted window-panes, bentwood boxes or baking moulds, there is a limited, often rigidly circumscribed number of subjects. It would be most enlightening to make a detailed comparison of the range of common motifs with those of other types of objects.

Some materials have their own limited range. For a long period glass vessels were not found in the households of small farmers, at least not in areas a long way from centres of production. Yet painted liquor bottles were often carried in the knapsacks of itinerant pedlars. For a long time wooden utensils, including wooden dishes, were predominant. Too few of them survive to provide an accurate picture of their use. The silverware of upper-class households was replaced lower down the social scale by pewter, which adhered to conventional shapes. Toward the end of the eighteenth century simple faience crockery tended to supersede pewter as the tableware for festive occasions. Guilds and tradesmen's associations, however, continued to favour pewter for drinking vessels which were largely kept for ceremonial use. A considerable store of old vessels and utensils has been preserved, whereas most other articles have been melted down for the metal. The equipment of these associations, from inn signs to shepherd's crooks, comprise a bizarre collection of symbolic and sometimes functional articles. They embody ancient traditions and are also remarkable as examples of objects used by well-defined social groups to demonstrate their status and solidarity.

Compared with utensils, purely pictorial works made of metal play a minor part in folk art. True, votive pictures forged from iron rods and bands provide important evidence of artistic creativity—we shall come back to this later. For the most part, however, metal figures are simply cast, like manes of horses with their *Biedermeier* treatment or banner-bearers on guild goblets. Cast-iron plates make an important contribution to pictorial art in metal. As stove and fire-place plates they were not confined to the houses of the more affluent. Knowledge of their history has increased so much in recent years that it is impossible to give even a brief outline of it here.

Deeper insight into metalwork can be gained only by exhaustive comparative studies of a limited theme. Metalwork could be classified according to the use of the objects (stove-doors, smoothing irons, pudding- and rice-moulds, lighting utensils) or according to production methods in different localities. (A study of the latter type was carried out by F. Fuhse, concentrating on the city of Brunswick.)[141] Existing publications, although numerous, still give an insufficiently complete picture of the changes the crafts went through and their distribution throughout Germany. Watch-making should be included. It was carried out in a number of places from the Black Forest up to north Schleswig as a rural trade or auxiliary occupation.

Ceramics

The development of earthenware goods in the Rhineland in and around Cologne, where extensive dumps of biscuitware have been recovered, is of great significance in the study of what may be called ceramic folk art. It can be followed from Roman times right through to the sixteenth century. During that century it entered the golden age of sintered, i.e. waterproof stoneware, which should really be regarded as a part of the history of fine art rather than of folk art. In the relevant publications[142] different vessels are allocated to the Gothic or the Renaissance period according to the date when they were made. The authors forget to ask how far they show the Gothic or Renaissance spirit that we find in other branches of art. Thus the slim, rising form of the *Schnelle* was allocated to the Renaissance although its real affinities are with the Gothic spirit; only the small impressed reliefs approach the style of the Renaissance. This discrepancy between the shape of the vessel and its decoration stems from the fact that in the second half of the sixteenth century the decorative element was valued more highly than the form, and in the case of implements more than even the overall appearance. In the highly developed stoneware of the early modern era there are specific types which belong to the sphere of folk art. Among them are examples of the traditional technique of modelling the vessel into a human head or even a whole figure. Incising and embossing were still used to depict human features on vessels. This tradition survived well into the eighteenth century in the *Bartmannskrug* (Rhenish salt-glazed bell-armine), particularly at Raeren. There the production of more simple ceramics for general use continued alongside the making of elaborate pieces, and thus the Bartmanns head still appeared on the neck of the vessel.

Even more interesting is the production of stoneware in the Westerwald on the right bank of the Rhine opposite Coblenz, 'the land of the jug bakers'. At Höhr, Grenzau, and Grenzhausen stoneware had been made for local use since the Middle Ages. Around 1600 the craft made a spectacular advance in skill and artistry, no doubt owing to the increasing prosperity of Raeren and Siegburg. We can follow the path of the potters who moved from there to the Westerwald toward the end of the century. Grey biscuitware and cobalt blue painting became characteristic of Westerwald stoneware—and are still the hallmark of these products. A smalt containing manganese, which fires to a mauve colour, was added after the middle of the seventeenth century. Few changes were made in the vessels' shapes, which usually depended on the birth-place of the individual potter. The decorations, however, took an independent direction. The surfaces were not separated into zones and profiles but had patterns spreading over the whole area. This shows a move away from the style of the period toward folk art. In this case it is virtually impossible to draw a strict line of demarcation. In the late eighteenth century forms of decoration occur which are far removed from contemporary styles, and are impressive examples of folk art: for instance, many of the cylindrical tankards which were produced in large quantities in the Westerwald as well as narrow-necked jugs, teapots and especially plates. The leaping horse motif features prominently in this context. It is strongly stylized in outline and its contour is full of abstract lines with strokes reminiscent of calligraphic flourishes and spirals developing from a kind of tendril. The eye is the only detail to be shown. This displacing of realistic representation by a self-contained and self-sufficient system of lines is highly characteristic of the folk-art mentality. The horse fills the centre of the plate and decorates it. The coloured surface representing the horse is regarded as a new background to be filled in and decorated. This kind of manipulation of the representative image is not in tune with the artistic style of the latter half of the century and may even be directly contrary to it. The earthenware plate from the Westerwald constitutes folk art of a high order. Other artistic devices are employed such as strict symmetry and a playful, but austerely deployed combination of (often geometrical) forms into structures which can only with some difficulty be identified as vases. A pair of horses are apparently performing a dance on them. In the same spirit is a larger series of plates painted with stags, birds, garlands of flowers, hearts and a variety of other, completely independent motifs.[143]

The migration of 'jug bakers' from the Westerwald during the seventeenth century increased during the eighteenth. They moved into the Hunsrück, into the Eifel (Speicher) and the Bad Kreuznach area, into the Ahrtal (Adendorf, Meckenheim, Wormersdorf), to the Saar (Krughütte), into the Palatinate, into Alsace (Hagenau) and in particularly large numbers into neighbouring Hesse. Everywhere they went they developed a type of stoneware based more or less on the Westerwald model.

Dreihausen near Marburg was one of the places where stoneware was produced as early as the fourteenth century. Wares from this district are characterized by their silky, matt brown surface, obtained by dipping the ware into a clay mash containing iron. A special form of jug, the *Ringelkrug*, was made here from the sixteenth century until well into the twentieth. It has a slim, sharply constricted body with narrow grooves, provided with several handles with small clay

rings loosely fitted into them. If this form is to be assigned to any period it might perhaps be regarded as late medieval, and as one which preserved a distinct identity for an astonishingly long time. Karl Rumpf[144] is right when he emphasizes the fact that 'Dreihausen stoneware' refers to a category, not just a place of origin. After all, there were many parts of Hesse where the same type of pottery was made; it also occurs in the area around Waldeck, and a similar ware came from Duingen in Hanover. There are a number of Hessian districts where the pottery resembles models from the Westerwald even more closely. It is virtually impossible to localize eighteenth-century Westerwald products more exactly because they were so widely distributed.

Pottery workshops in Thuringia and Saxony, too, were very prolific sources of stoneware. One thinks of such towns as Annaberg, Freiberg, Altenburg, Bürgel, Waldenburg and Zeitz. However, they catered mainly for their own region and lagged far behind the Rhineland centres as far as export was concerned. If we include lower Franconian Kreussen and Silesian wares, particularly those from Muskau und Bunzlau, we can discern a belt of places where stoneware was made which extends right across central Germany. This is not the place to explore further the questions how far particular local products possess a distinct style and can be classed as folk art. Because so much Altenburg pottery has a rather naive decoration consisting of small clay beads, publications on art history tend to classify it as folk art.[145] But the same might be said of the rest. To answer these questions would require a detailed investigation into the extent to which isolated forms and motifs survived as components of the total composition, long after they had been abandoned in the general process of stylistic development. We have not yet assembled nearly enough information to give a convincing answer to these questions. The most obvious examples of forms which do not accord with contemporary style are to be found in pottery that has been imaginatively modelled into animal shapes. But it is seldom possible to differentiate between spontaneous invention and the traditional prescribed form.

The conventional designations of *Bauerntöpferei* and *Hafnerware* include purely linguistic differences: the first is the North German, the second the South German name for pottery. The term 'peasant pottery' is a reminder that the makers of lead-glazed earthenware often lived in the country in farming areas. However, it should not be assumed that the principal buyers of these wares were usually small farmers. Even at the time when Cologne was a Roman colony the potteries were mostly situated on the outskirts of the town. This was a way of minimizing the danger of fire in the settlement. The same is true of medieval towns. From the middle of the fifteenth century onwards there were some pottery kilns inside the city walls but their location in the town was under constant attack. Urban potters also forced up the price of fuel by their heavy consumption of wood and polluted the surroundings with smoke and chlorine gas. They had to wage a surprisingly long struggle to survive in the towns. Their situation was particularly acute in Cologne because the most suitable clay was found in the immediate vicinity and the town was a main trading centre for the export of ceramics. In every city potters were

forced out and driven into the countryside. Building and repairing kilns provided much work for them in the towns, but the pull exerted by the sources of the raw material generally proved stronger. Even from the villages a potter could supply markets of itinerant traders and sell to intermediaries for export. All these considerations resulted in pottery becoming largely a rural industry, and also explain the origin of the term 'peasant pottery'.

Another point is that, when interest in antique pottery revived, many more specimens were found to have survived in farm-houses than in towns. Of course, pottery articles had played a bigger part in rural households than in more affluent ones in towns. In the country various earthenware articles had special functions, for instance on festive occasions such as weddings, childbirth or at harvest time. Collectors are particularly keen on such items. However, we know from old cookery books how many different types of simple earthenware articles were to be found even in the bourgeois kitchen.

There were parts of the countryside where conditions were very favourable for the establishment of pottery kilns and many villages where the inhabitants largely depended on this craft for a living. Paul Stieber conducted research into ways of measuring local demand and the average production of a workshop, and deducing from this the balance of supply and demand, i.e. of exports or imports within a limited area. If these calculations could be expressed graphically they would present a very variegated and dynamic picture. It would not be possible to illustrate the ebb and flow of supply and demand by arrows of different length, thickness and direction throughout the whole of Germany. The sources are now lost. Potters carried out their work in very different conditions, many of them practising agriculture as a main or part-time occupation, and so their living conditions cannot be assessed statistically. If such a map were to be compiled it would be full of gaps, because the findings would relate to different periods of history. The most we can hope for is that the excavation of waste-pits of former workshops may occasionally enable one to assign pottery pieces to their correct origin and date.

This account will be confined to a few groups of the examples that have been preserved. The earliest surviving products indicate that in the mid-sixteenth century coloured glazed pottery was made in a number of places, apparently independent of one another. Potteries operated on the basis of early medieval techniques which were not applied to ceramics for general use until the sixteenth century. The first products, as far as we know, were confined to stove or floor tiles and toys. These articles do not fall within our scope, and we may concentrate on pottery.

In Silesia, Upper Austria and Nuremberg coloured crockery with lead glazing appeared quite unexpectedly around the middle of the sixteenth century. At first it appears to have been rather a luxury article, often covered with raised ornamentation. Showpieces in the form of plates and magnificent jugs started a process of development which finally—not later than the seventeenth century—produced pottery for everyday use. Some dishes made in the Salzburg area in the middle of the sixteenth century exhibit the technique that was to become standard. After pouring a fine clay slip over the crockery

143

to serve as the basic colour, the drawing is incised with a pointed tool and the separated surfaces coloured in with various clay suspensions mixed with metal oxides. Finally, the lead glazing is sprinkled over it in powdered form. This, too, may have added colouring matter. The whole is then fired in a kiln. This technique, probably transmitted to Germany from the Mediterranean area, made it possible to produce pottery on a large scale, and was certainly the technique used by the future rural workers. At a comparatively low temperature, without fusing of the biscuitware, it resulted in an impermeable, easily washable and even decorated crockery. Suitable clay was available almost anywhere. The method of incising and painting with the potter's horn, from which the slip oozes thickly, encourages bold and quick decorative work. A highly skilled hand could even dispense with the preliminary incising. The coloured slip then flowed all the more freely with a broad sweep, and its viscosity helped to shape the outline. In this way many a figure, a fluttering leaf, a leaping stag or a wavy line achieved a freely drawn outline and an effect of effervescent vivacity.

Where pottery is spoken of as 'art', the word may apply equally to the form of the vessel and to its decoration. The pliability of clay is conducive to all kinds of modelled additions and separate parts, which may range from an added spout, handles or feet to the application of raised decoration and free sculpture, perhaps in 'crowning' a vessel with a head-piece. The effect depends partly on established routine and partly on discipline and personal style. A feeling for form can already be discerned in the basic outline of a vessel as the clay is shaped on the potters' wheel. It is not a mere accessory, a luxury added for the benefit of the more affluent, but an essential quality, quite independent of the price. What elevates a wide-rimmed plate from the Kröning or a stoneware jar from the Probstei to the status of folk art is the craftsman's mastery of this idiom of form. It has nothing to do with representation or with ornaments for special occasions, and yet is art in the truest sense of the word.

On the map of Germany many areas stand out as the homes of special kinds of ceramics, although not such elaborate ones as those from the Lower Rhine. The picture is not yet equally clear in all these areas, as can be seen from Paul Stieber's survey.[146] It might, therefore, be useful to draw parallels between a few selected examples.

A suitable representative of North Germany might be the district of Probstei in east Holstein, and in the south, the Kröning, east of Landshut. Probstei ceramics are easily distinguished. This term is obviously not just a label.[147] Some plates are quite outstanding. An early example, dated 1743, shows a bird on flowering branches which fills the whole surface. It is boldly drawn and brightly coloured on a light coloured clay ground. Dates from subsequent decades are found on other plates decorated with painted figures. We see a horseman, a man smoking, a chimaera and a stag. Most characteristic is the motif of large blossoms like rosettes, which may unfold with explosive power to fill the whole surface. A *pièce-de-résistance* of the multifarious output of the district of Probstei is the 'harvest pot', a bulging tureen. Soup was carried in this bellied dish to men in the fields at harvest time. A specimen dated 1799 is still of reasonably

239,
241

262,
263

modest dimensions. Shortly after 1800 the vessel grew in size and a particularly spectacular series was created in the 1830s. Leaping deer, hares, dogs, cockerels and peacocks follow each other in procession all round the pot. The dynamic force of the incising tool and potter's horn is remarkable and follows, so to speak, the turn of the wheel on which the vessel was created. A specimen from 1853 shows eight deer chasing each other along a line drawn round the bulge of the vessel, alternating with large tulips whose fluttering leaves accentuate the movement. Below the line the decoration seems to move in the opposite direction. Later pieces display more static motifs such as opposed birds, Biedermeier flower garlands and rosettes.

263

The other typical form of Probstei vessel in the *Möschenpott* (dish for women in childbed). This ornate vessel for serving food to women in childbed was commonly given as a wedding present. A small spherical tripod pot which originated in the Middle Ages is given added height by a crown-like lid, decorated with such figures as mother and child, a candle, a pelican or even a whole family. One specimen is inscribed 'C. Wiese, 1830'. A potter of this name lived in Schönberg, the main village in the agricultural district of Probstei which fell under the jurisdiction of the prior of the monastery of Preetz. Other potters must have lived there too, although we have no evidence of this from the earlier period. The office which controlled the local pottery industry was located in Preetz; here, too, was the monastery which owned the land. The neighbouring towns of Lütjenburg and Neustadt, which were surrounded by feudal landowners, also were ceramic centres. The pottery made there is similar to that from Schönberg, but the two types of vessels described above do not occur. They were apparently the prerogative of the free farmers of Probstei.

265

A dish signed 'HD 1700' with a picture of the farewell of Tobias can be traced to a potter from Neustadt named Hans Dethlefsen (d. 1743). It may have been his master's or journeyman's piece. Such special compositions with their elaborate details are not dissimilar to the showpieces from the Lower Rhine, but they are in no way characteristic of average products. They tend to indicate stopping-places along the routes taken by itinerant craftsmen during their journeyman years.

All North German pottery regions were fairly limited in extent. Their output was only designed for the needs of places in the vicinity of the workshops. Compared with exporting areas this may have encouraged self-expression in individual local masters or workshops. Looked at as a whole, work from North Germany—between Hamburg and the Danish Hadersleben—presents a distinct contrast to that of the well-researched Danish workshops.[148]

Certain pottery from the Altes Land near Hamburg has a particular *cachet*. The display plates of this group, dated 1694 to 1742, have a circle of bulges all round the rim, echoed on corresponding pieces from Ochtrup in Westphalia. The latter district supplied a fairly wide area including most of Westphalia, and it also exerted the main influence on the rest of Westphalian pottery. A few individual pieces come from the Oldenburg area. We are not yet able to assign them to any of the larger production centres.

254

209△

209 Weaving-comb. Oak. Latter half of 18th century. From the island of Sylt, north Friesland, Schleswig.

210 Weaving-board. Wood. 1856. From the island of Rügen.

211 Weaving-board. Beech, sawn out, notched and painted. Middle of 19th century. Mönchgut, island of Rügen.

211

▽210

MARTIEN·LOCK·18 56

145

212

213▽ 214▽ 215▽

212 Mangle-board with roller. Beech. 1765. From north-eastern Schleswig.

213 Clothes-beater. Beech. Incisions filled in with red and green wax. 1861. From the island of Rügen.

214 Swingle-board. Beech. Middle of 19th century. From the island of Rügen.

215 Clothes-beater. Oak. 1770. Probably from north Friesland, Schleswig.

216 Plate. Pewter, with engraving. 1794. From the Winser Elbmarsch.

217 Tankard. Pewter. 1767. Kiel.

218 Tankard with lid. Pewter. 1776. From Hamdorf, Rendsburg district, Holstein.

219 Jug with lid. Pewter. 1790. From Bohnert, Eckernförde, Schleswig.

216

217

218

219

220 Kettle. Copper. 18th or 19th century. From the Soester Boerde, Westphalia.

221 Coffee-pot. Pewter. *Circa* 1840. From southern Germany.

222 Two tankards. Pewter. 17th and 18th centuries. Unmarked.

223 Dish. Pewter. First half of 19th century. Made in Augsburg (?).

220

221

222

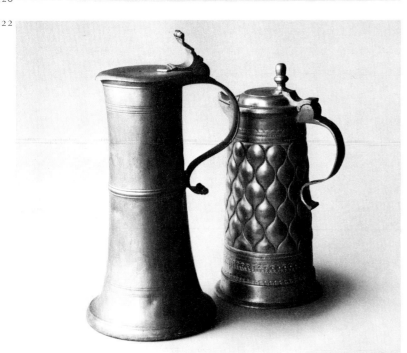

223

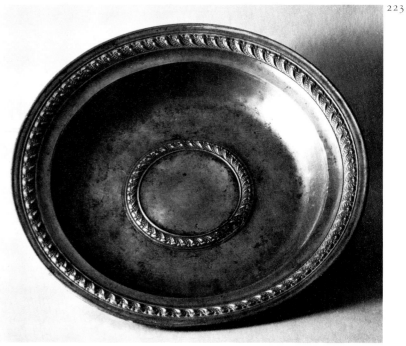

224 Rack for food storage. Wrought iron. 19th century. From Schleswig-Holstein.

225 Pot-hanger. Wrought iron and brass. 1804. From north or east Westphalia.

226 Grill. Wrought iron. 18th century.(?). From Schleswig-Holstein.

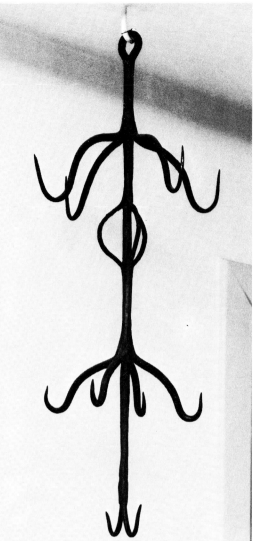

224

225 ▷

226

227 Double grill for fish. Wrought iron. 18th or 19th century. From Nuremberg.

228 Clothes-hook. Wrought iron. 19th (?) century. From north Friesland.

229 Fire-guard. Wrought iron. 18th or 19th century. From Diepholz county. Lower Saxony.

227

228

229

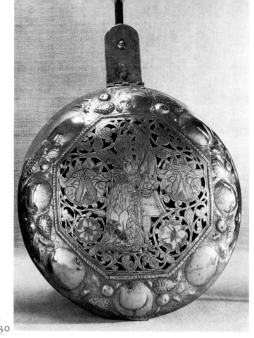

230

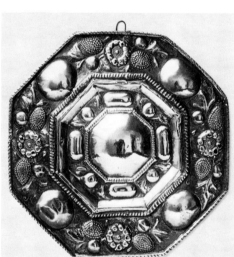

231

232

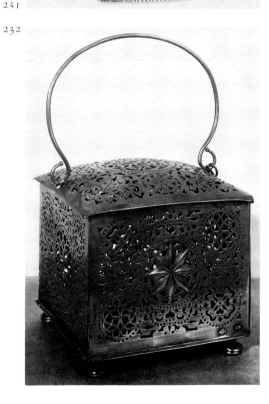

233

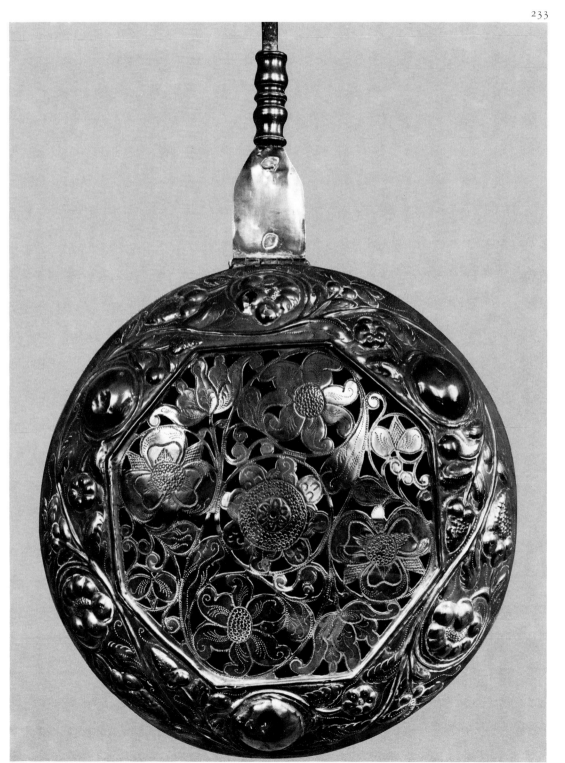

230 Warming-pan. Sheet brass and iron. Middle of 17th century. Acquired in Schleswig.

231 Reflector. Brass sheeting. Latter half of 17th century. Acquired in Schleswig-Holstein.

232 Foot-warmer. Brass. 1762. From Zeven, Lower Saxony.

233 Warming-pan. Brass sheeting and iron. Early 18th century.

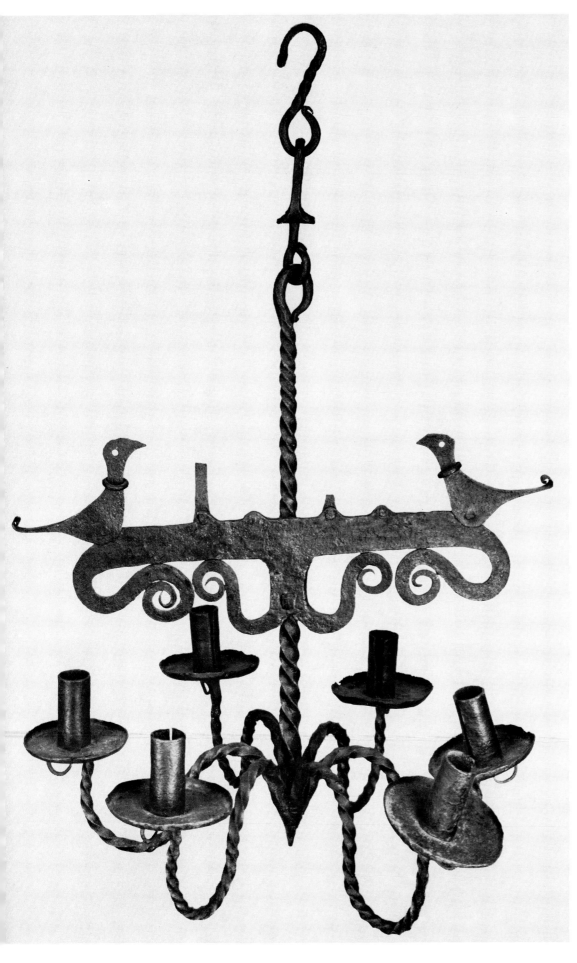

234 Hanging candelabra. Wrought iron. *Circa* 1700. Acquired in Kiel, Holstein.

235 Wax taper-holder. Wrought iron. 18th century. From Schleswig-Holstein.

◁234 ▽235

236 Detail of stove wall in a farm-house in Wimsheim, Leonberg district. Pottery with slip painting and lead glazing. *Circa* the middle of 19th century. Probably made by Johann Georg Dompert (1788–1853) of Simmozheim, Württemberg.

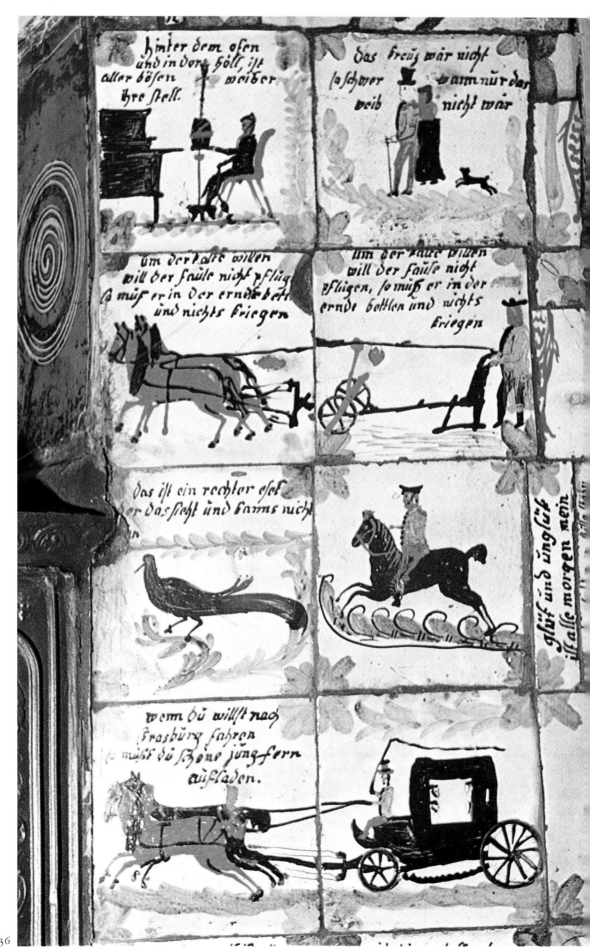

237 Dish. Pottery. 1750. From a workshop at Wick-rath, Lower Rhine valley.

238 Plate with thick rim. Wanfried pottery. 1600 (or 1611). Found in Bremen.

239 Dish. Pottery with slip painting and lead glaze. 1788. From the Probstei, Holstein.

240 Dish. Pottery with slip painting and lead glaze. 17th century. Probably made in Hesse; found in ground in Tönning, Schleswig.

241 Plate. Pottery, with slip painting and lead glaze. 1767. From Raisdorf, Probstei, Holstein.

237

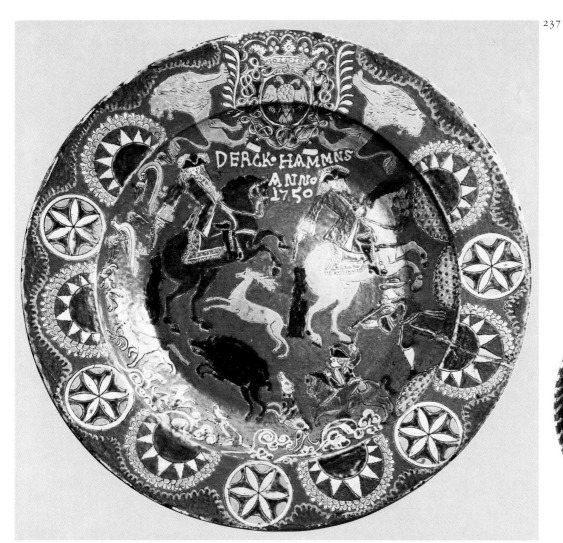

238

239

240▽

241

242 Dish. Pottery. 1796. From a workshop at Frechen, Lower Rhine valley.

243 Dish with handles. Pottery with slip painting and lead glaze. 1799. Made in Marburg.

244 Dish. Pottery with slip painting and lead glaze. Beginning of 19th century. From Heimberg, Baden or the Black Forest.

245 Plate. Pottery. Possibly made in the 1930s in the Blut pottery works in Goslar.

246 Flat dish. Wanfried pottery. 1608.

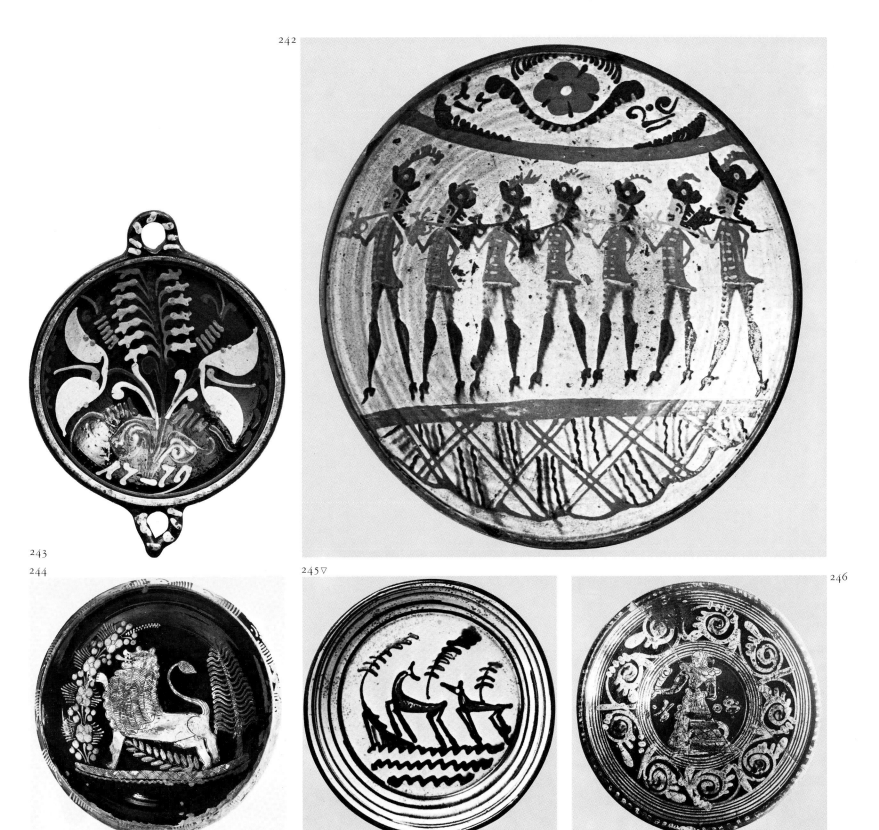

242

243

244

245▽

246

247

248

247 Dish rack. Softwood. 1838. From Tölz. Bad Tölz-Wolfratshausen district.

248 Three strainers (filters). Salt-glazed pottery. 19th century. Origin uncertain.

249 Dish. Pottery with slip painting and lead glaze. *Circa* 1850. From Windsheim, central Franconia, Bavaria.

250 Plate. Pottery with slip painting and lead glaze. 1747. From the Probstei, Holstein.

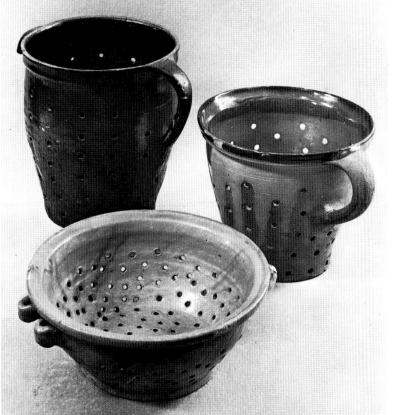

249

250 ▷

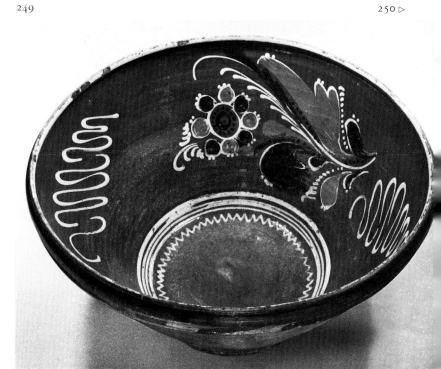

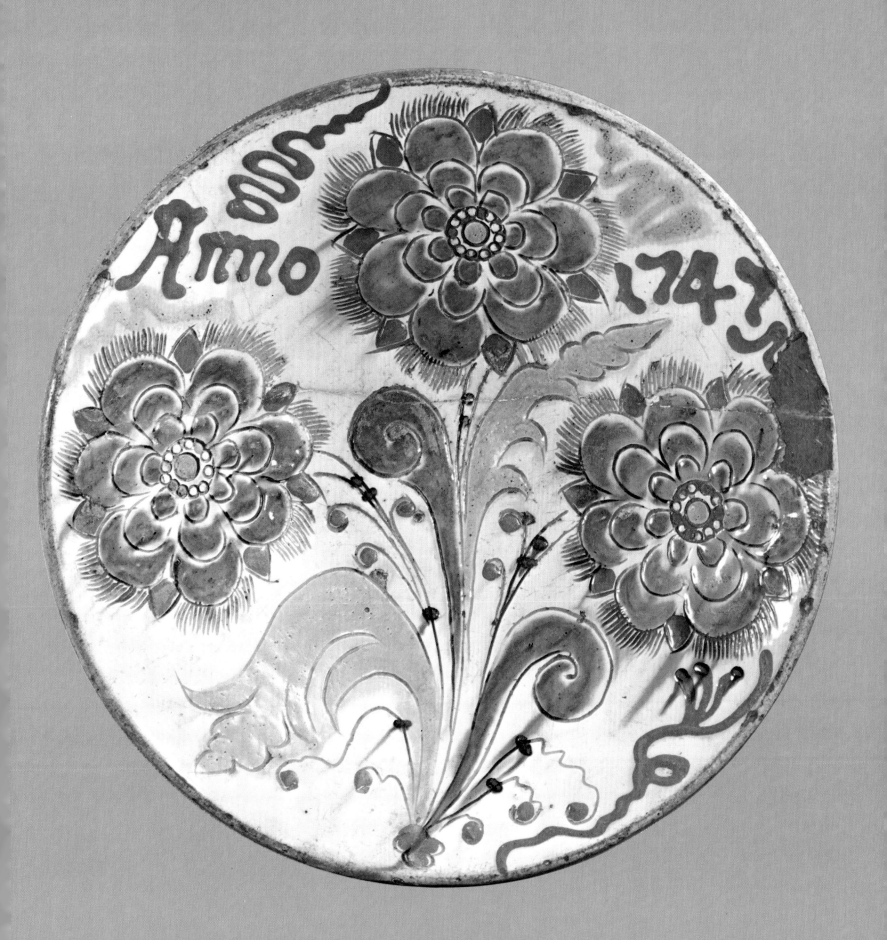

251 Dish. Pottery with slip painting and lead glaze. 1777. From Silesia.

252 Double dish. Pottery with slip painting and lead glaze. 1762. From Steinberg, near Flensburg.

253 Dish. Pottery with slip painting, clay relief, incision drawing and lead glaze. 1804. From the Probstei, Holstein.

254 Dish. Pottery with slip painting and lead glaze. 1694. Made in the Altes Land (?), near Hamburg.

255 Small barrel. Pottery with underglaze and lead glaze. 19th century. From Archsum on Sylt.

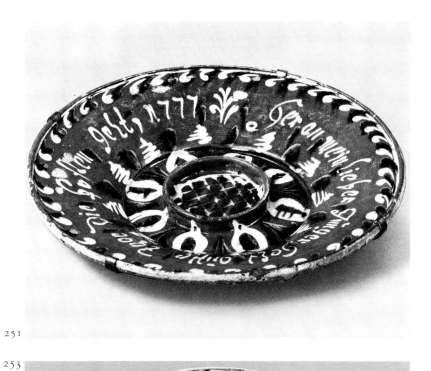

251

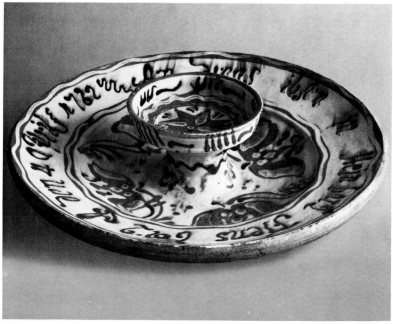

252

253

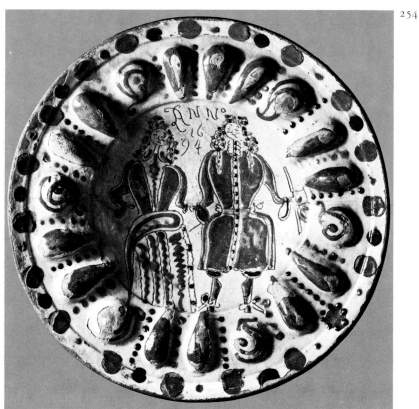

254

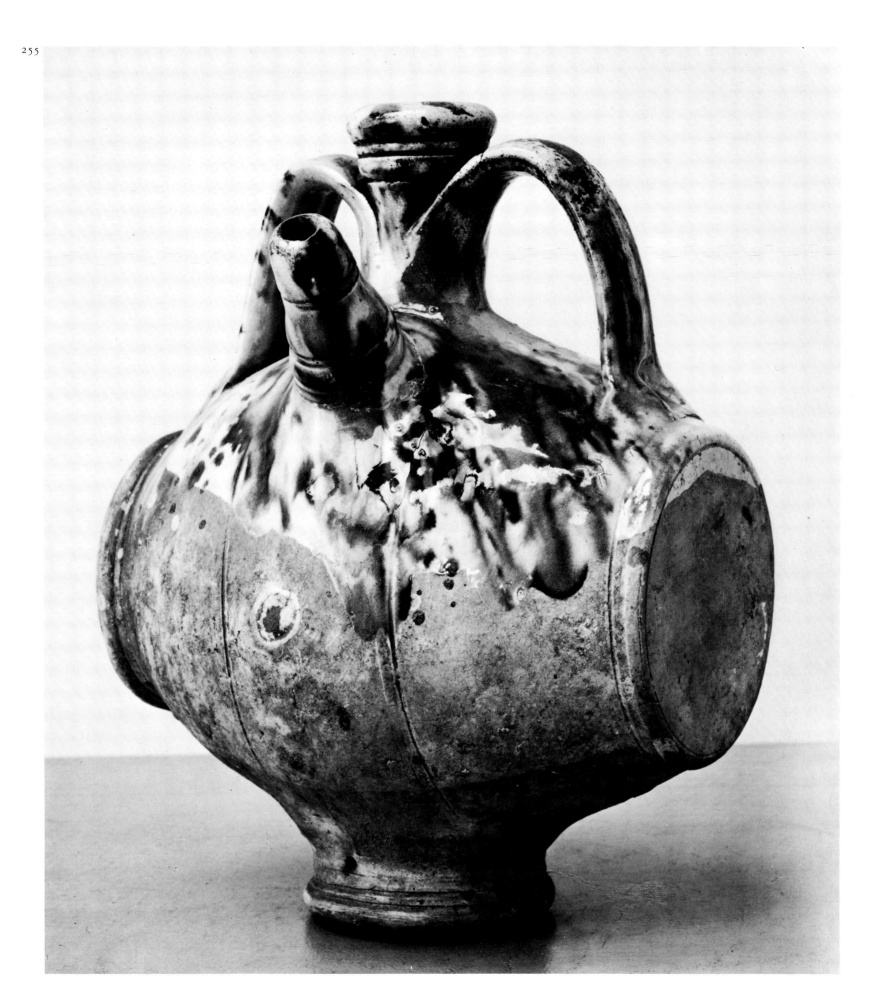

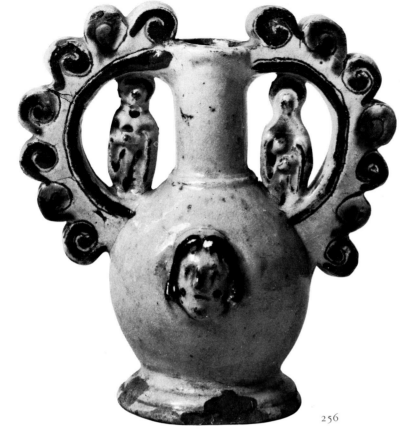

256

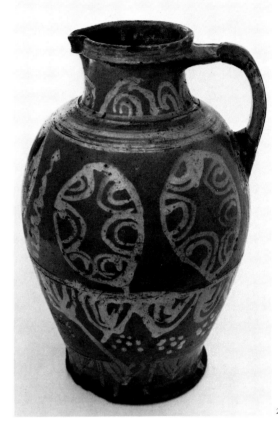

257

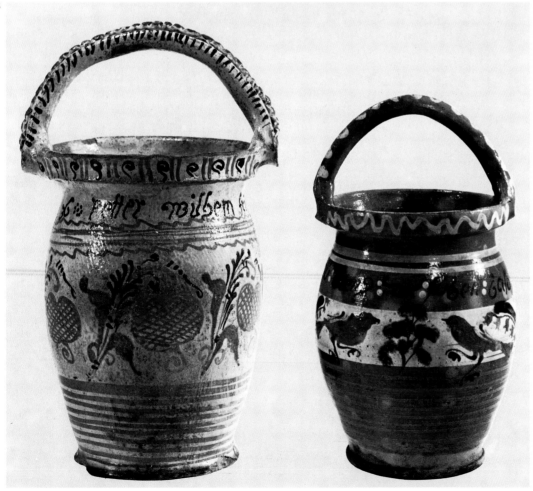

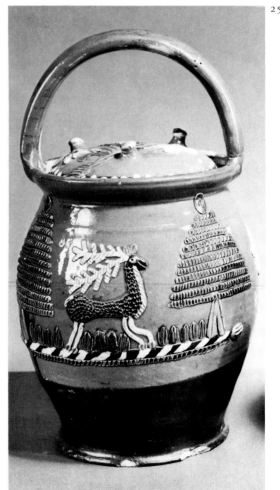

160

256 Jug. Pottery. 19th century. Made at Ochtrup, Westphalia.

257 Jug. Pottery with slip painting and lead glaze. 1749. From Franconia.

258 Two pots with handles. Pottery with slip painting and lead glaze. Left, from Wertheim, 1736; right, from Baden, *circa* 1800.

259 Pot with handle. Pottery with applied decor, painting and lead glaze. *Circa* 1820–1830. Made in Marburg/Lahn or surroundings.

260 Pot with handle. Pottery with slip painting and lead glaze. 1728. Acquired at Rendsburg, Holstein.

261 Coffee-pot. Stoneware. After 1763. Made in Bunzlau, Silesia.

260

261 ▷

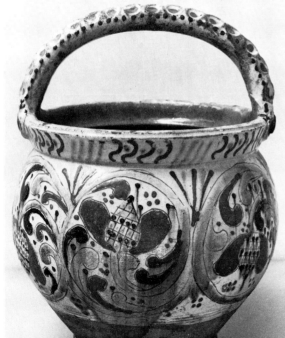

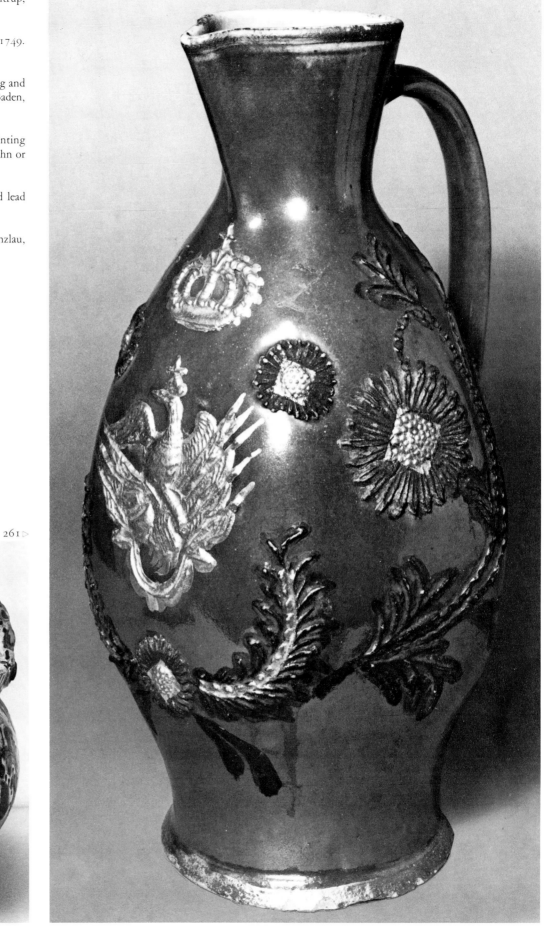

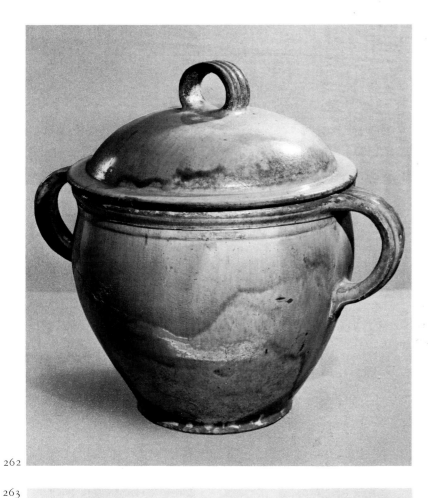

262

262 Tureen with lid. Pottery with lead glaze. 19th century. From Barsbek, Probstei, Holstein.

263 Tureen with lid. Pottery with slip painting and lead glaze. 1833. From the Probstei, Holstein.

264 Preserving pot with underglaze and lead glaze. 19th century. From the Probstei, Holstein.

265 Maternity pot *(Möschenpott)*. Pottery with slip painting and lead glaze. 1787. From the Probstei (?), Holstein.

263

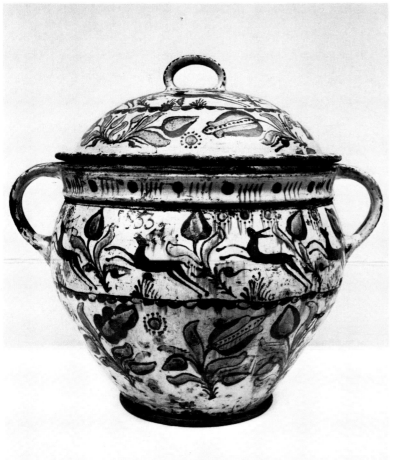

264

266

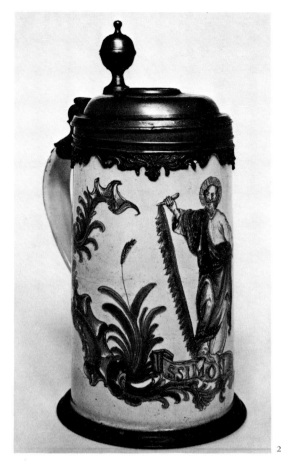

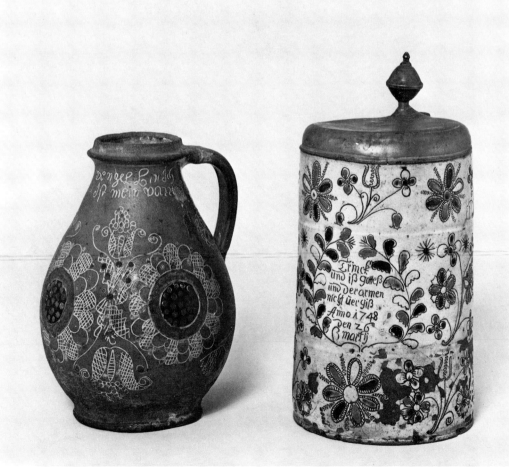

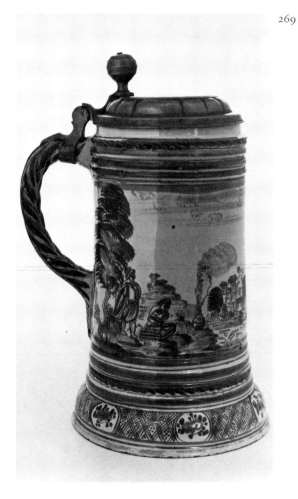

266 Two melon jugs. Pottery with underglaze and lead glaze. 17th or 18th century. Probably made in Nuremberg.

267 Jug. Faience, painted, with pewter lid. Latter half of 18th century.

268 Pear-shaped jug. Pottery with slip painting and lead glaze. 1753. From Oberau, Büdingen district. Cylindrical jug. Pottery with slip painting and lead glaze. 1748. From the Wetterau, Hesse.

269 Cylindrical jug, with pewter lid. Signed on the round knob: IPF. Ansbach. *Circa* 1730.

270 Two drinking mugs. Frosted glass, blue and white, coloured enamel painting, with pewter lids. Early 18th century. Probably South German (Black Forest or Bavarian Forest).

270

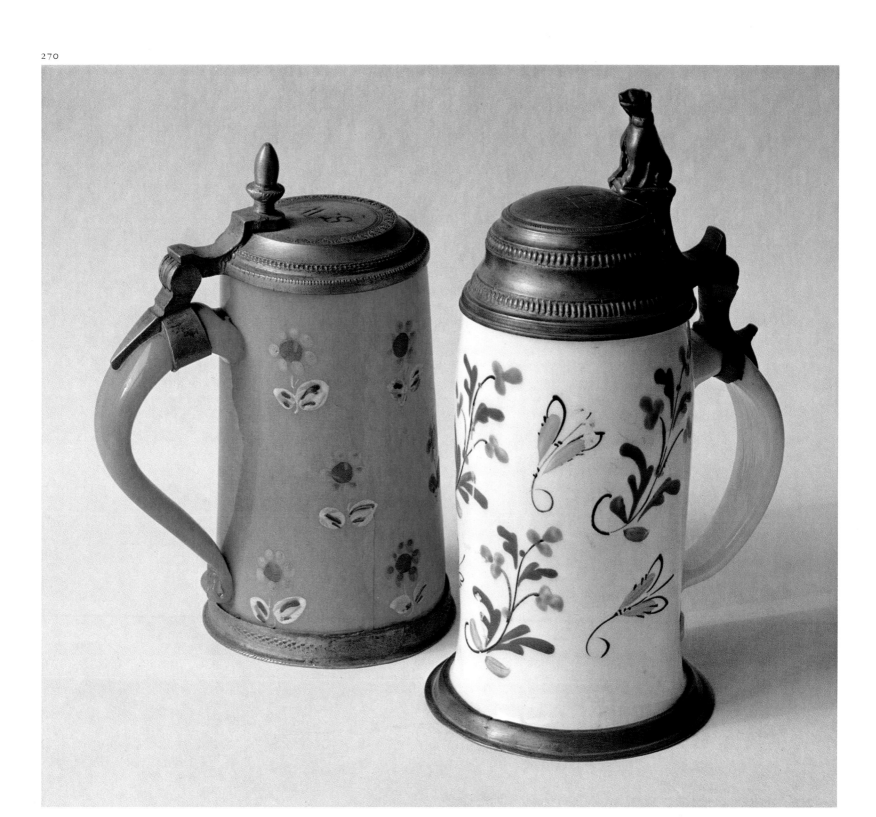

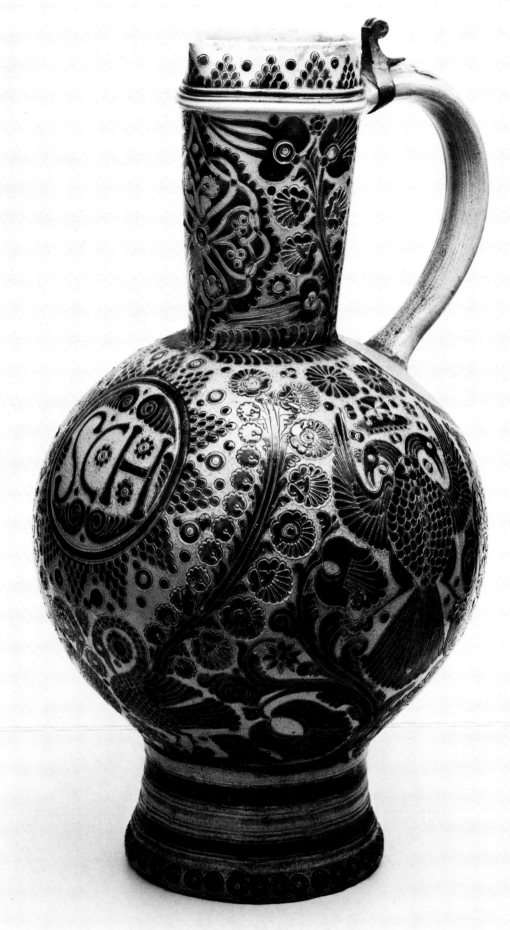

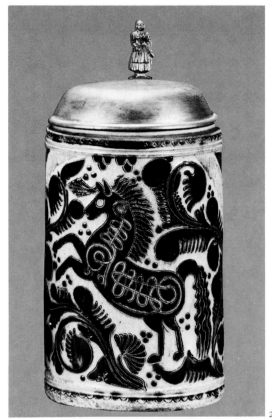

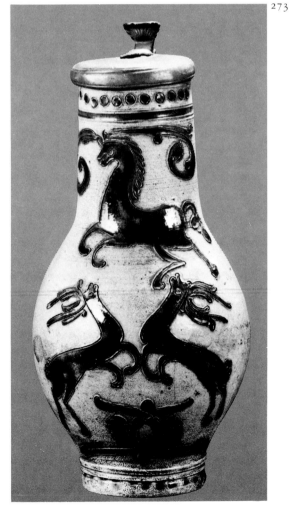

271 Jug. Stoneware with slip painting and salt-glaze. End of 17th century. Made in the Westerwald.

272 Drinking mug. Stoneware. Grey body, blue painting. With pewter lid. Latter half of 18th century. Made in the Westerwald.

273 Pear-shaped jug. Stoneware with painting and salt-glaze. Latter half of 18th century. Made in the Westerwald.

274 Plate. Stoneware with painting and salt-glaze. Middle of 18th century. Made in the Westerwald.

274

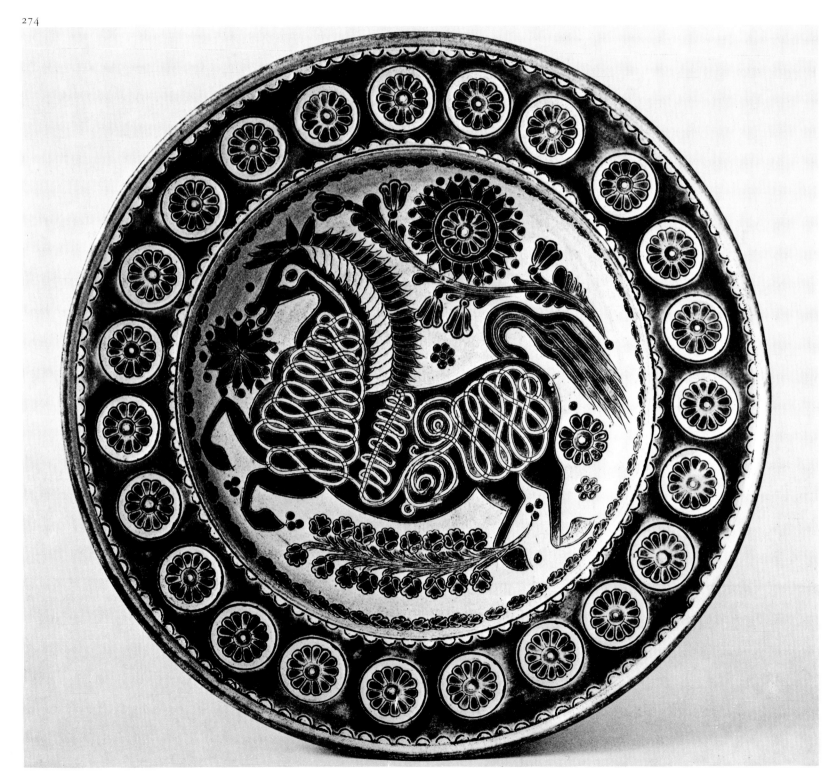

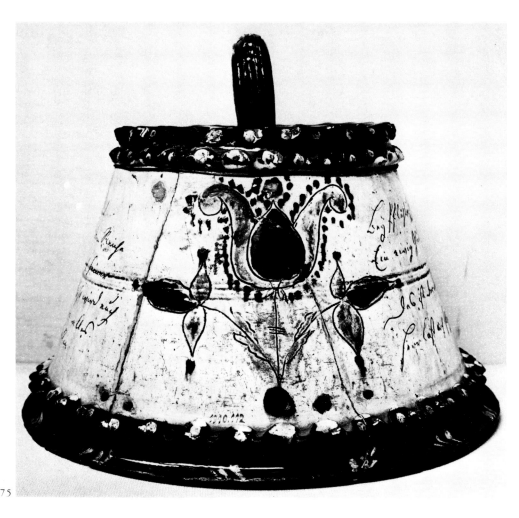

275

277

276

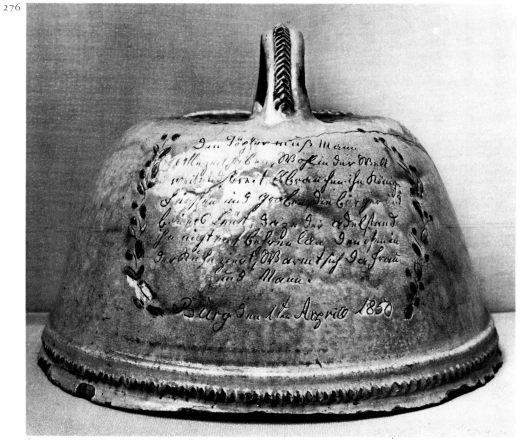

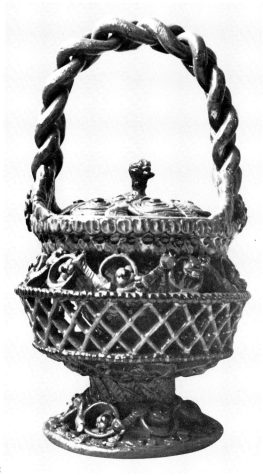

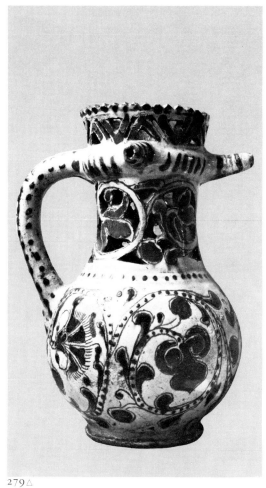

278

279△

▽ 282

280

281

283

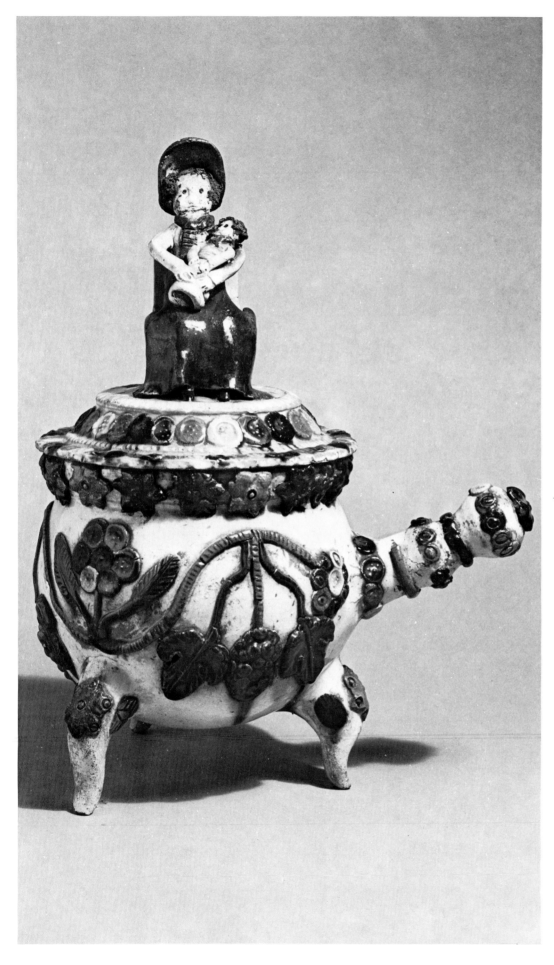

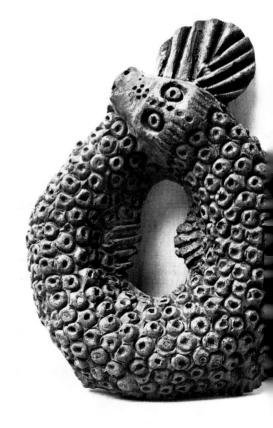

284 'Möschenpott' or porridge pot. Pottery with painting, appliqué decoration and lead glaze. *Circa* 1830. From Schleswig-Holstein.

285 Left: Clay impression of a mould (perhaps for rice or cake?). 1752. From Uetersen, Holstein. Right: Impression of a mould (perhaps for butter?). From Uetersen, Holstein.

286 Mould for cake or rice. Pottery with underglaze and lead glaze. 19th century. Used at Morsum, Sylt.

287 Mould for cake or rice. Pottery with lead glaze. 18th–19th century. Acquired in Kiel, Holstein.

288 Mould for cake or pudding. Pottery with lead glaze. 17th or 18th century. From Kiel, Holstein.

◁284

285

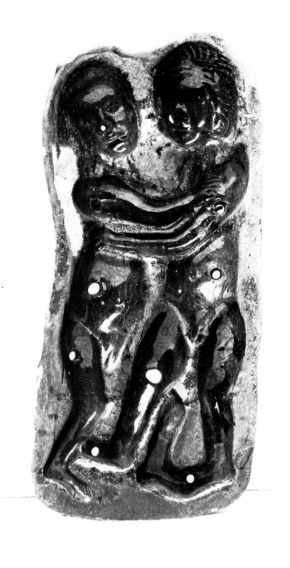

286

287

288

171

289 Fabric with blue print. Linen. 19th century. Made in Silesia (?).

290 Bed curtain. Blue-printed linen. 18th century. Made in Silesia (?).

289

290

It is difficult to ascertain what was actually produced in the ports of Hamburg and Bremen or in their vicinity. Goods coming from distant parts of the interior of Germany obviously dominated the market there. This is well attested by the comment of Pastor Hübbe of Hamburg on Christopher Suhr's picture of a crockery dealer who, at the beginning of the nineteenth century, hawked his wares in the streets of Hamburg by shouting: 'earthenware crockery'. He goes on to say: 'There are few pottery manufacturing centres near Hamburg—too few, at any rate, to meet the demand. Fuel is too expensive and good clay is perhaps too rare. Awareness of this unsatisfied demand encourages importation from many areas, particularly from the country around Hanover. Goods arrive in particularly large quantities for the two markets on Midsummer Day and at St. Martinmas. They are displayed on the Rödingsmarkt, on Messberg and at other places where housewives can replenish their stocks. To save them the journey, pedlars with wicker baskets roam through the streets calling out: 'Buy pots and pans'. A rather superior type of stoneware arrives with the long Saxon fruit barges which anchor near the Reimers and Scheelgangs bridges. They offer articles with a particularly good finish like vessels with 'hare's fur' glaze. Saxony is rich in high-grade and common kinds of clay, and much pottery is made there and distributed far afield along the river Elbe. The products from Pirna and Strahla are well known. The pedlar depicted here may even have come from one of these places. His dialect, though, is anything but Saxon; it sounds more like Brandenburg speech, with phrases like: *'Dresner Steentug koop'* [buy Dresden stoneware].[149]

Compared with the difficulties of sorting out conditions in North Germany, South Germany is easier to classify, because large and productive centres there supplied much larger areas with comparatively simple goods. Transport was mainly overland and the territory to be supplied was circumscribed, though naturally it lay in the main close to the main roads and market centres. This applies particularly to the workshops dotted over more than a hundred localities in the region known as Kröning, which had a very large output. The neighbouring Bina valley also became a major production centre. Decorated crockery did not form a large part of the output. However, the potters of Kröning produced vessels for domestic worship, figures of saints, stoups for holy water, candlesticks and various little baskets etc. The surviving simple Kröning dishes, bulging flasks with handles, big bulging jugs and pear-shaped jars show a high degree of creative skill. The outlines of these vessels are rigid and tense, the parts are well proportioned and composed with a sure touch. These features are all the more noticeable as in most cases the body is covered with a monochrome milky-blue glaze, uninterrupted by incising or painted decoration.

Kröning lies outside the area where the painter's palette was used. A special decoration was applied to some of the pottery by spraying or sprinkling it with a brushwood broom dipped into a pigment. The speckling is kept within bounds and does not disrupt the appearance of the surface. A most impressive view of the art of Kröning potters was provided by an exhibition of crockery from Altbayern, held at the Bayerisches Nationalmuseum in Munich in 1968. It also afforded

an insight into Paul Stieber's systematic research into German ceramics.[150] We cannot but agree with his statement that: 'Our knowledge of medieval pottery is, on the whole, better than that of the present era. What we lack most is an insight into the development between the Middle Ages and the early modern era. We have only a scrappy knowledge of pottery in the sixteenth century, even less of that of the seventeenth. Of the eighteenth century we have a rather better view, and only in the nineteenth does the picture become clearer. Even so the amount of preserved nineteenth-century material is far greater than our understanding of its production.[151] These facts explain why regionally distinct groups only appear as complete units in the eighteenth century at the earliest, and that we are not able to trace their connections with earlier wares. As regards pottery made in Kröning, too, we still lack a proper knowledge of the historical background, although a regulation of 1428 for potters in Kröning shows that it belonged to an old tradition. The craft became increasingly important in the eighteenth century, when it supplied not only the surrounding districts, and perhaps Munich, but much of Upper 12 Bavaria and the Tyrol.

In the south of Germany, too, fluctuations in pottery style are one of the factors which make it difficult to clarify the conditions in which it was produced. It is said that crockery from Bavarian Swabia has softer outlines and colours and more bulging proportions. It appears that this region was mainly supplied with decorated dishes from the Black Forest. North of the areas influenced by Kröning, in central Franconia, quite different forms prevail. They, too, are frequently decorated. We find nineteenth-century bulging and pear-shaped jars with a blackish-brown base decorated with a bunch of flowers, painted with a sure stroke and without previous incising. These features, like similarly decorated deep dishes, are characteristic of crockery made mainly in and around Treuchtlingen. Ingolf Bauer has devoted an exemplary methodical monograph to it.[152] Jars and jugs from Treuchtlingen often have straight vertical downward lines which divide the walls of the vessel into compartments. Each section is garnished with flowers such as lilies of the valley. Decorating a vessel calls for an interpretation of its form. Here the taut outer surface becomes, so to speak, braided and the facets of the outline multiplied. Such an interpretation of the form of the vessel is unthinkable, for instance, in the case of the harvest pots of Probstei which were described earlier. There the dividing line is drawn like a hoop round the vessel as a path for running animals. Other jugs from Treuchtlingen are painted all over without regard for direction or the form of the vessel. There is no relationship between the ornamentation and the body shape. The personal touch is sometimes apparent in articles of this type. Workshops, too, show distinct differences. In what it today the administrative district of central Franconia potters' output was only partially dominated by the concentration of workshops around Treuchtlingen, Ingolf Bauer remarks: 'The large number of workshops spread over the whole territory prevented any single centre from exerting undue influence and provided scope for all the variations found in central Franconia.' This can also be taken to mean that central Franconian pottery was made chiefly for local consump-

tion. Export over wider regions and longer distances requires greater standardization of the products.

Several studies published during the last few decades help to clarify the overall picture of pottery production, mainly in western Germany. Karl Hillenbrand and Gerd Spies examined south-west German wares.[153] After the work of Adolf Spamer and Karl Rumpf on pottery in Hesse, we have recent surveys and specialized investigations by Alfred Höck and Joachim Naumann.[154] Paul Stieber concentrates on ware from Altbayern and Oberthulba, and some less important areas like the Osnabrück district in Lower Saxony have also been studied.[155] The Bayerisches Nationalmuseum has published a complete catalogue of its pottery collection. A number of archives are currently being examined to find reports of potters and potters' guilds, their conditions of life and work, and details of the sale of goods and those who purchased them.

About one outstanding pottery district we are already quite well informed, namely Hesse. The making of stoneware flourished there during the Middle Ages. During the seventeenth century Wanfried style ware had successors in other parts of Hesse. This trend continued during the next century and wares of this type were even produced for export. They occur in Denmark and even at Trondheim in Norway. It is not yet possible to pinpoint the origin of these later products, and there are wide variations in ornamentation. A constant factor appears to be a reddish-brown background. A separate local feature developed in the Wetterau; some plates and jugs are decorated with coloured glazing and others with incised decoration covered with tin instead of lead glazing.

238, 246 240

259 Marburg pottery was popular all over Germany during the nineteenth century. The craft did not develop there on a large scale until relatively late. During the fifteenth and sixteenth centuries there may have been only half a dozen master potters at any one time.[156] They were nothing like so numerous as their colleagues in the nearby villages of Dreihausen, Michelsberg and Giesel. In 1776 Marburg had ten resident potters. In Hesse—as in many other parts of the country—the great boom in pottery started after 1750, and Marburg was no exception. The number of master potters (here often called *Euler*) increased steadily up to 1860; there were fifty-eight in 1858, but thereafter numbers dropped quickly. Around 1850 Marburg potteries employed 140 people, among them many 'painting women'. We know from a report dated 1790 that Marburg ware, made by twenty-three master potters, was collected by carters from the Siegerland and Westphalia and sold in the lands between the rivers Rhine and Weser—a distance of up to forty miles. Since the output was well adapted to fashionable public taste, specializing in coffee pots and cups with added painted and embossed decoration, Marburg had a very extensive market in the first half of the nineteenth century. By 1824 it had won customers not only in Hanover and Hamburg but in the Baltic provinces of Russia, as well as in Denmark.

Embossed decoration, freely applied or formed in moulds and attached to the pots, originated during the Middle Ages and played an important part in stoneware. In Hesse it seems that the practice was adopted in the Werra valley and the Dill area, and that moulds

were used there. Marburg potters developed a different technique at the beginning of the nineteenth century. A lump of clay for the ornament was modelled by hand and pressed on, then carved with a wooden knife. The little lumps had previously been dyed in bulk. The outside surface of Marburg jugs and jars is mostly divided into sections which are blackish-brown at the top and bottom. The wider, light reddish-brown middle section carries the plastic decoration of plants and animals, markedly stylized in the process of manual shaping. The form of the vessels is influenced by early nineteenth-century classicism; they are generally steep, with only slight bulges, or else simply cylindrical.

In this necessarily sketchy survey we must omit the pottery districts of Thuringia, Saxony and Silesia. Of course, names like Bunzlau (in Silesia) and the Lausitz (in eastern Saxony) are widely known and associated with special types of pottery. Bunzlau ware particularly was widely distributed in the nineteenth century and offered powerful competition to distant local potteries. It was fired hard and glazed in brown inside and outside. Part of its success was due to the relief decoration in white clay, later to the simple coloured pattern dabbed on with a sponge. One pottery centre should be singled out because of its outstanding importance. Shortly after 1650 a pottery style appeared along the Lower Rhine which probably started even before the middle of the century. The inspiration for it may have come from France, from the region of Beauvais north of Paris. During the middle of the sixteenth century this was where jugs and dishes with a yellowish background, green painting and ornamentation in an incising technique were produced. Beauvais work often includes inscriptions and embossed details, all features which appear a little later on the Lower Rhine.[157] This French pottery was of a refined type and much in demand at court. It was exported to Holland and to England and must surely have been well known on the Lower Rhine as well, although the exact route by which it arrived there cannot be traced.

The domestic potter's craft had existed in the Lower Rhineland since premedieval times and so the ground was prepared for new techniques. Pottery workshops were established mainly in villages between Krefeld and Xanten. The high ground around Hüls and Tönnisberg provided excellent clay. The craft was rural right from the start here, and was frequently combined with small-scale farming. In this context the villages of Sonsbeck, Issum, Sevelen, Rayen, Wickrath, Rheurdt, Schaephuysen, Kluyn, Tönnisberg and Hüls should also be mentioned. Thanks to recent research we know some potter families who worked there by name. Some remarkable personalities stand out from among the mass of anonymous workers. It must be left open whether pottery was exported via Cologne. We are concerned here with goods made for sale in the immediate vicinity. We know from the inscriptions on them that many articles were made to order and for special occasions. A variegated and lively trade was maintained far into the nineteenth century. Some of the most impressive products are very large plates and dishes. They display a wealth of motifs of imaginative scenes and ornaments which has no parallel anywhere else in Germany. The joint catalogue of pottery

261

from the Lower Rhineland by Mechthild Scholten-Neess and Werner Jüttner has recently given us an almost complete account of the subject.

The earliest dated specimen is a 'wedding dish' of 1664, representing 'Jan den Schmet', i. e. a blacksmith, with his assistants at work on the anvil. On either side of them stands a fiddler. In the sky, beside an angel's head, are the sun, moon and stars (marked only by dots); alongside the year is the date: 20th February. A comparison of this and many other similar scenes and groups, including representations of craftsmen, with motifs on painted windows in North Germany explains the situation. The date indicates the festive day, the musicians tell us that a celebration is taking place. The name is that of a guest who contributes this dish as a gift to the new household in return for the invitation extended to him, and it is he who is portrayed in the picture. The dish would be set up on the ledge of the chimney, to testify to the friendship of the donor. The couples who sometimes appear must be interpreted in the same sense as those on window-panes unless they are accompanied by an inscription containing words of love or wooing. We see farmers ploughing, gentlemen, galloping past firing pistols, courting couples and carriages. The horseman usually raises not a pistol but his sabre in respectful salute. Sometimes two gentlemen stand next to each other, both named. From the analogy of window-panes we may conclude that they are probably both bachelors who had jointly ordered a gift for the occasion. Conversely, a couple who belong together may be depicted on two separate dishes. The numerous religious motifs, too, have parallels in the repertoire of glass painters. The parallel is important, because in the case of the panes their function as a gift presented by a guest in response to an invitation is well documented. The term 'wedding dish' is established, but it is an open question what its function at a wedding might have been and who was depicted on it, except when they are named as prominent people like Maria Theresa or Prince Eugene of Savoy.

From this connection it can be concluded that many such picture dishes and plates were made to order. In any case this is true of examples which refer to specific people or dates. Some dishes without an inscription but with a suitable motif may have been the potter's stock-in-trade. He could not always arrange kiln firing to suit festive occasions, and it was technically impossible to make a single piece to order.

Such pieces must have had other functions in addition to acting as a return for hospitality. Frequent copies of the miracle-working image of the Madonna of Kevelaer suggest that pilgrims to Kevelaer might acquire a dish with this motif either at the place of the pilgrimage or on the way home. At home it then became a devotional picture. In any case this was the idea behind the many dishes with pictures of the Passion and the saints. Strictly speaking this does not apply to other biblical themes such as the Fall or the 'spies' with the large bunch of grapes. However, it was the meaning associated by both Protestants and Catholics with representations of the Last Supper, Christ's Passion, the Crucifixion, the Resurrection and the Old Testament precursor, Abraham's sacrifice of Isaac. A pronouncedly

Protestant spirit is shown in representations of a preacher in the pulpit. The Catholic counterpart is the picture of a bishop standing at the altar lifting up a monstrance to a large congregation. It may be concluded that these painted dishes fulfilled several functions within their area of distribution, including those of the painted cabinet panes in North Germany and of the *verres églomisés* with devotional pictures in the south and east. Themes which North Germans put into their windows and southerners into their domestic shrines, the people of the Lower Rhine assembled in a different form on the ledges of their chimneys. This illustrates the way in which high spirits and deep faith can sometimes be found side by side in these pictures. It makes for a multiplicity of themes, many of which are both joyful and eloquent.

A common feature of all these specimens is the flat form which makes them suitable as showpieces. The rim is generally treated separately as an ornamental frame. We cannot deal here with the many geometrical and plant forms which wind around the rim and bevelled part in double or even quadruple garlands. They include rosettes, curves, stars, tendrils, grapes and blossoms. In some specimens the pictorial representation crowds out into the frames and boldly occupies the bottom as well as the rim. In most pieces the outlines of the drawing have been incised. Some working sketches on paper are preserved which were used by potters to trace the patterns on to the vessels and were, no doubt, also shown to customers to help them choose a pattern. They belonged to a potter in Duisburg called Wolterus Draeck and his son Gerard. Their motifs occur on clay products from the villages of Schaephuysen, Hoerstgen and Rheurdt. They were obviously more or less common property.[158] The figures are often rather naive, more like children's drawings; in many cases they were probably done without a model or are at best a very free copy of one. The Madonna of Kevelaer is represented in a generously simplified cone shape, quite appropriate to the original. It is therefore in tune with the tendency toward simplicity evident in most pottery drawings. A notorious *horror vacui* led to the filling of all the free surfaces left by the main motif with a prolific pattern of tendrils from which masses of tulips and grapes shoot out.

The crowding of motifs is sometimes little short of extravagant. In the case of single figures a favourite device is the use of a large shrub which fills the spaces to the right and left and sends out shoots into the free corners. The motifs in the centre sometimes spread freely and casually into the ornaments of the rim. The latter may be a crown or an angel's head, sometimes a less stately theme such as a meeting of a dog and a bird which seems to help to concentrate the emphasis on the central theme.[159] More often we find the motif strictly confined within a rectangle, a clear reflection of its derivation from a prayer-book or devotional picture. It is adapted to the circular form by adding figures of angels[160] or the ever-popular tulip garlands, or occasionally altar candelabra with candles. Several graphic patterns from which they are taken can be identified, including pages influenced by Lucas Cranach's Madonna of Passau.

Scenes and figures generally require a base on which they can stand. A line is therefore drawn across the bottom which leaves a suitable

space for an inscription. This is frequently wordy and incised in simple script. On a dish dated 1699[161] the base-line is followed by the alphabet, which often appears on objects of folk art. Apparently writing as such commanded respect and indicated education. The lines that follow confirm what has already been said about the function of these dishes: 'A host without beer, a smith without stable, a hunter without kill—these are three poor creatures.' The key word here is 'host'. The two gentlemen depicted are riding on horse-back to a festivity with four fiddlers in a row above to welcome them with music. This is not the place for more details.

The dishes showing the estates of the realm deserve particular attention. The earliest of these dates back to 1696. They represent a member of each of the social classes—nobles and clergy, burghers and peasants—standing next to each other. The example dated 1696 deviates somewhat from this order and shows a bishop, king, knight and peasant, marching behind one another, each carrying his symbol. The motif, familiar from pictorial sheets, undoubtedly had a widely recognized significance. It was an integral part of the world-view which the seventeenth and eighteenth centuries inherited from the Middle Ages. In a country with an absolute régime it was a key to an understanding of the social order as seen and justified from above. Perhaps the not infrequent occurrence of this theme can be explained by reference to North German painted window panes. These frequently feature highly placed persons—dignitaries, noblemen, courtiers, or clergymen—as donors who use their escutcheon as a token of their rank. Possibly such a dignitary thought the presentation of the representatives of the different classes appropriate when he felt obliged to give a present to a farmer in return for hospitality.

Among the dishes preserved those with modelled ornamentation form a considerable group. Scenes with figures are a frequent choice for high relief treatment (the Fall, the Sacrifice of Isaac, Passion scenes, the Madonna with or without attendant figures, also the Nativity, the flight to Egypt and others). Sometimes they used patterns, but most of the figures seem to have been painted freely. The ornamentation was then usually applied in plastic form. The Tree of Paradise grows directly into the framing interlaced decoration.[162] Only the script is always painted on afterwards. An unusual exception is a dish with a modelled group showing the Crucifixion with the instruments of torture engraved into the rim.[163] Sculptured decoration obviously creates a different kind of impression. The surface is covered more sparingly, the background remains more empty. This indicates a dawning understanding of the relationship of three-dimensional figures and space in this type of decoration. Such an impression is not produced by a dish dated 1794 from Sonsbeck,[164] where the figures are modelled but the additional details, a table on which money is spread out, have been drawn with thin strips instead of incised lines. The remaining surface is filled out with tendrils that are plastically drawn rather than modelled and grow from the rim toward the centre. In other cases, too, the technique fluctuates between relief figure work and drawing with plastic lines.[165] A striking example displays the interior of a church with a whole congregation.[166]

Scholten-Neess and Jüttner give much useful information about pottery-making villages and, where possible, their master potters. Fortunately we have a number of points which make it possible to assign certain dishes to definite places. Some masters record their own names in the inscriptions and occasionally portray themselves in the decoration working at the potter's wheel. The finest example of a self-portrait is a dish by Albert Murs the Elder of Rayen, dated 1716. At his side, at the bottom of the dish, we find the ubiquitous fiddler and the potter's wife, whose name is also mentioned in the inscription. She is lifting up a drinking cup, while next to her the jug is floating in the air. All indications point to the fact that the potter himself was a guest at a celebration. The inscription adds after the couple's name: 'Albert makes fine pottery'.[167] This sounds almost like an advertisement, not dissimilar to what we find on firms' signboards. We have an example of these in a clay tablet dated 1721 from the workshop of Jan Spoer at Issum.[168]

The Hamman family at Wickrath, who seem to have been the only potters in the town, occupy a very special place among members of their craft. What are probably the finest display dishes, among them one with two horsemen and a hunting scene signed and dated 1750, 237 are the work of 'Derck Hamman', who was born there in 1705 and died in 1781. The wonderful colours (yellow, blue, greyish green and brown on a reddish-brown base) as well as the bold strokes of the painting and the placing of the figures are most impressive. Hamman's mastery is revealed by the insertion of lions holding coats of arms into the decoration of the rim, and by the sure way in which horses and hunting figures are composed so as to follow the round form in different directions, thus dispensing with a base-line and with zoning.

In the great variety of the pictorial art of this kind some other 242 individual achievements stand out, but it is impossible to discuss them here. However, one dish from Hüls dated 1689 must be mentioned, because of its—there is no other word for it—monumental decoration. A symmetrically expanding mass of flowers—a motif popular in ceramic work in infinite variations—is powerfully worked into the rim. Apart from a wavy line at the very edge, all other framing decoration is crowded out. The flowers maintain their position because of their strict relationship to the axis of the vessel and the lively way in which the drawing of the detail softens the powerful composition. What may originally have been derived from a tulip blossom has been transformed into a forceful motif in its own right. It has become an individual ornament with perforations and framing patterns of a distinctive vitality and regularity. The proud imaginary plant stands before us in yellow slip painting on a deep brown background. Green leaves and dots indicate the connection with its floral origin. The incised drawing only emphasizes the connecting links. The outer contours are determined by the flow of the clay slip as it is poured from the container. This sense of materials indicates a high degree of aesthetic awareness. There is a vast difference between such achievements and many fluently but often naively drawn pieces of pottery from the Lower Rhine.

Other products of this region are not as important as display

dishes, although some pieces may be quite original. However, painted clay tiles deserve to be mentioned. With these the same workshops made another important contribution to German folk art. The earliest of them are from the eighteenth century: this branch of the craft does not seem to have prospered earlier. Many are the same size as Dutch wall tiles and were used, like them, to cover walls. It is remarkable that some figure motifs found on dishes are repeated on tiles. This suggests that they, too, may have been given as presents, specifically as a contribution to the building of a house or for refurbishing the kitchen. There are scenes of handcrafts, dancing couples, and religious themes. They even include some rather suggestive subjects, such as two dogs mating on tiles from Schaephuysen, and names are often added. Larger themes are frequently placed within a frame, like pictures. These are devotional images, as the subjects—Passion scenes and saints—show clearly. The majority of sculptural ceramics were also employed in domestic religious worship. They included figures of Mary, the Lamentation, holy-water stoups, the Crucifix or instruments of the Passion.

Textiles

The raw materials for making textile articles are, like those of wood-work, readily available in most places. Trade in these materials over long distances was already carried on at an early stage. Techniques spread quickly, and it is not surprising to find motifs from the Near or Far East in rural work made entirely in Germany. On the other hand, owing to the large number of different production methods involved in textile work, separate developments took place everywhere. It was easier for craftsmen to break through the barriers of guild restrictions in this field than in any other. Certain difficult operations may have been reserved for highly qualified and privileged experts in the towns, but there was still plenty of scope for the country weaver, particularly for women and girls working at home. Some women who had to earn their own living by doing needlework for people in the neighbourhood had incomes that compared very favourably with those of professional craftsmen. In many regions a loom was an essential piece of farm-house equipment, which served to meet the family's needs for underclothing, bed and table linen. It also had to provide most of their everyday clothing and often clothes for festive occasions too.

Professional weavers were generally regarded as occupying a low place on the social scale. This was partly due to the fact that they could only earn a modest living in competition with those employed in domestic industry, and partly because their calling was often imposed on them by some physical disability which prevented them from working in the fields. They were in a position similar to that of tailors and were regarded as weaklings, though they might be very skilled at their job. In the field of textiles it is particularly difficult to draw the line between craftsmen's work and the domestic industry, and to put the difference in simple terms.

We may start with embroidery because something is known about 301 the teaching and practice of the craft from embroidery pattern cloths which have survived in nearly every part of Germany.[169] In no other branch of folk art is there comparable material to demonstrate traditional techniques and the extent of the stock of motifs. They show how tuition in the craft was organized. Nowadays it is generally taught in schools, but when 'needlework' was first included in the curriculum, teachers were only continuing a practice that had long been carried on by private individuals. Sewing schools, as they were often called, had been run by independent women in town and country who in many cases were the same persons that made sophisticated accessories for women's clothes, such as embroidered bonnets. It is difficult to discover any details about the circumstances, types of

work and social conditions of these mostly anonymous people. They remained in the background, but their trade could command recognition and be passed on to their successors.[170]

Embroidery pattern cloths represent a tradition which started in the sixteenth century and thus goes back to the time when folk art as a general phenomenon as we have defined it first begins to appear. The frequently quoted collection of patterns suitable for cross-stitch, the *New Pattern Book* of Johann Sibmacher, is dated 1604.[171] There may have been similar cloths during the Middle Ages, and it can be assumed that in convents such learning aids were essential. However, during the sixteenth century their influence began to spread far beyond the limits of convents or guilds and a large store of motifs, mainly for cross-stitch, was established which preserved its character well into the nineteenth century.

The numerous copy-books with handwritten descriptions of patterns give us an idea of what the average country weaver could achieve in the eighteenth and nineteenth centuries. These patterns had circulated as printed pamphlets since the seventeenth century. A type of weaving called *Drell* enabled the weaver to achieve rectangular, contoured patterns without any elaborate procedure, simply changing from weft to warp. Their counterpoint breaks up large surfaces like those of curtains or bedspreads in a lively manner. There are rows or groups of trees and towers or arrangements of squares and rectangles. Because of these basic forms these patterns were thought of in Hesse as reminiscent of paving-stones. Simple small patterns were also suitable for clothing. Materials of this type were also made in the domestic industry which were by no means always monotonous and simple. It is impossible at this point to survey the regional forms of such fabrics or their particular names. We must confine ourselves to a few groups of outstanding articles which are representative of popular German art in textiles.

Erich Meyer-Heisig has traced a fifteenth-century linen display towel to a Augsburg weaver named Hans Velmann. It is now in the Germanisches Volksmuseum, Nuremberg.[172] The surface is broken by stripes with animal motifs woven into them; lions, squirrels, large birds and other creatures turn symmetrically toward each other. Craftwork of this type was subsequently much copied and modified both in bourgeois society and in rural circles. It is impressive because the weaving technique gives added strength to the recurring pattern. This applies generally to the towel as a showpiece for festive occasions, originally meant to be used directly and later to cover the functional towel. Where this weaving method originated—and it was a

somewhat complex procedure by means of stencils in which the texture changed—is debatable. Nor do we know the route by which this decoration and technique spread. Early examples are recorded in Tyrol, but their counterparts had already appeared in the north of Germany in the seventeenth century. A comparatively narrow piece of linen, elevated to the status of a display towel by being divided horizontally by decorated strips, was commonly found in the houses of wealthier farmers. In Hesse artefacts in open-work with groups of animals similar to the woven ones can be found.

It would be rewarding to assemble a group of display towels from different parts of Germany. Whereas the prevailing tendency of various techniques was to produce white articles, nineteenth-century 295 examples from north Friesland are an exception. They have coloured wool embroidery but maintain the rigid symmetry of the woven pieces. They look somewhat primitive, with their strict adherence to stereotyped motifs (stars, blossoms, tendrils, crowns, cockerels), and may very probably be the products of a needlework school, i.e. have been worked by children. They nevertheless had an established function at domestic festive occasions. Towels with net insertions were also made in north Friesland. Frieze-like motifs are embroidered or sewn into them, the themes sometimes including ships.

The making of insert pieces provided another outlet for the ener- 297 gies of rural workers. A fancy cushion was traditionally placed on the bed; like the display towel, this was only a representative showpiece. 300, This is another example of the same dichotomy which we have 308 already met in the case of wooden utensils. A particularly productive area in making cushion inserts in filet (network) embroidery was the Vierlande district near Hamburg. The equipment of beds was an obvious focus of attention at the time of a wedding. The bridal couple themselves are shown with a large heart and an enormous crown held by angels and, in addition, a number of pairs of birds inserted in scrolls which extend over the whole surface. Sometimes the embroidery is restricted to the latter motifs. The red cushion cover shows through the network. These cushion inserts remained an essential possession in the Vierlande, a legacy from the eighteenth century which survived right into the middle of the nineteenth. As well as the inserts a broad strip of black cross-stitch embroidery was worked directly on the pillow-case. The centre-piece was formed by one of the imposing rosettes which frequently fill embroidery pattern cloths in the Vierlande; nowhere else are such beautiful and imaginative variations of star and flower forms to be found in such profusion.

Display cushions underwent many modifications and did not 300 remain confined to white embroidery or monochrome cross-stitch. The example shown here, from Buchen, gives a gay, multi-coloured impression and proves that even on showpieces of bedding the decoration no longer consisted solely of stripes. Satin-stitch motifs occupy the whole surface. They may sometimes be laboured and awkward, but have the spontaneity which imparts a lively and fresh effect, even when tied to traditional patterns. It expresses a personal identifi- 297, cation with an impersonal tradition. It is interesting to compare this 308 with the pillow-case which, like the inserts from the Vierlande, comes from the surroundings of Hamburg. It shows what different

solutions can be found for the same problem in neighbouring areas. The date, 1717, indicates an earlier Baroque form of decoration which was later superseded by filet work, itself an achievement of the Baroque. Juxtapositions like this show that more or less sudden changes can occur despite the strength of tradition. Folk art in the field of fabrics is rich in examples of such sudden variations. One must remember that folk art in general arose in the sixteenth century, which was characterized in all aspects of life by revolutions and abrupt changes.

This is not the place to trace all the forms which women embroiderers worked on many fabrics, especially linen. They range from the dainty monogram in red cross-stitch, which was transferred from the embroidery pattern cloth to bed linen, to large bedspreads with prolific embroidery in white, made in Hesse. They include embellishment of the bridegroom's shirt—an example of a female love token—and multi-coloured embroidery on leather gloves from 313 the island of Sylt. They exist in innumerable variations, mainly derived from plant and flower designs which had been shaped by the Renaissance and which blossomed exuberantly under the influence of the Baroque. Here and there regional variants developed, like the calligraphic sweep of lines in the Elbe marshes near Winsen, comparable perhaps with the more forceful show towels from Hesse. One must be careful when making such comparisons—embroidery is a separate category. It is not permissible, for instance, to compare the decoration of bed cushions with that of chair cushions or, worse still, with parts of folk costumes like bonnets, cuffs etc.

The various elements of a folk costume—the examples illustrated 307, are a completely random selection—have to include as many forms 309, as possible on a limited surface, quite apart from the real or apparent 310 value of the material. This is strikingly demonstrated, for instance, on nineteenth-century headscarves from the Laaber valley near Straubing, Lower Bavaria.[173] Even shawls which were already colour- 310 ful and woven in patterns were worked with additional embroidery, and often even bought with this extra ornamentation. Neck-pieces 312 and bonnets are usually completely covered with embroidery. The 314 decoration sometimes has a symbolic meaning, and may indicate the status of the household or the owner's religion. The symbolic mean- 316, ing of all the ornamentation created by needle and thread is a wide 318, field of wordless communication on which we can touch only in pas- 319 sing. It must, however, not be underrated as a factor in acquiring a complete understanding of ornaments in general. On the other hand, abundance, lively colour, joy in movement and variety, and artistic subtlety must be understood for what they are: an expression of vitality and of a sense of beauty. The textiles have mostly preserved the richness of their colours and demonstrate the aesthetic meaning of folk art better than any other category. They should not be attributed merely to an urge for representation, or a show of affluence, status or reputation. Nor is it slavish adherence to custom which has acquired the force of law—that would be an unjustified denigration of its significance. But if, as has happened, an expert goes so far as to see in the cross-stitch a hint at the martyr's cross of St. Andrew he completely misunderstands the true intention of the

embroiderer or owner of this piece. A few decades ago, students of iconography used to be led astray by their imagination in just the same way. They looked for runes and could not see the wood for 'trees of life'. They were unable to recognize the abundance of joy in creativity that flourished around them.

296, 298, 299 A special achievement in the realm of embroidery are the chair cushions in some North German regions, particularly those to the north of the Elbe. The pair of armchairs reserved for the heads of the household (father and mother) required a pair of identical or very similar cushions, correspondingly embroidered. Some such pairs from the second half of the eighteenth century and the first few years of the nineteenth have been preserved. The cover consists of a bright red or deep blue material and the surface is covered with satin-stitch embroidery. Flower arrangements grow in fanciful formation, but in rigid symmetry from the corners toward the middle where an appropriate shrub is embroidered. Initials and year indicate the special function. The satin-stitch rows are placed in adjacent stripes and are obviously derived from Baroque needle painting, but converted into something quite different. Gradual shading turns to contrast, picturesque interplay of shades to strict delineation. Flowers, originally probably meant to be peonies, pile up to flaming mounds and bizarre forms. Oblong cushions made for the seats of carriages bear similar ornamentation.

298 Comparable to these, but more richly varied, are chair cushions from the Probstei, Holstein. A jumping white horse with a large crown above his head, or sometimes two such horses jumping toward each other, are only two of the numerous motifs. There are cushion covers with true needle painting, i. e. with a great variety of different shades in the blossoms and leaves, but with a curiously rigid style of 299 drawing. These basic forms follow contemporary patterns closely and then undergo many transformations as they develop. At the end of the series we find cushion covers to which a heart cut out from cloths of different colours has been added in appliqué work. The example illustrated falls in about the middle of the series. Multi-coloured and piled-up flower patterns expand in a fan shape from the centre, and between them pinnate leaves reach right up to the edges.

302, 305 Further north, in north Friesland, the chair cushion covers consisted of knotted work. This is the southernmost corner of an area comprising Denmark and the Scandinavian peninsula, and stretching into Asia, where fabrics with a knotted pile were still made in post-medieval times. Covers with a close pile can be distinguished from those where figures or motifs are worked in and are formed without 305 cutting the burls. Apart from geometrical or simple floral motifs, biblical themes like the messengers with the cluster of grapes occur. The making of such covers was a favourite domestic activity until the end of the nineteenth century.

The north European region with its long tradition of knotting extended into East Prussia and Poland. Among the most impressive heirlooms of German folk art is a group of knotted pictorial fabrics 304 from Masuria to which Konrad Hahm has devoted a full monograph, published in 1939.[174] Only a few specimens are preserved of what must have been a large total. The oldest is dated 1706, the latest 1837. The average size is 250 cm long and 150 cm wide. A frame surrounds an inner panel and individual motifs are spread in a loose symmetry over all the fields. There are scrolls, honeycombs, crosses, and vases as well as trees, elks, birds and a ship. Then there are bridal couples; at least that is how Hahm interprets the couples, and there is little doubt that these fabrics served as ceremonial carpets at weddings. An architectural motif may have a similar significance: it may be taken to be the gate of a church, and also bears the initials and the year. The magnificent colour effect of the piece is remarkable. Up to nineteen different shades were woven into that single carpet.

The chair cushions of Schleswig-Holstein are also important 303 because they were adopted by tapestry-weavers. The practice of weaving pictures evidently originated in Holland, became established in Hamburg and was also taken up in rural Schleswig-Holstein. The patterns, pictures with biblical motifs framed by flowers, were taken over from the high ranking art-craftwork of the latter half of the sixteenth century. However, the motifs soon deteriorated into a coarser, simplified form. The transformation of the select language of forms and colours into the ossified diction of popular art can be traced step by step, particularly on examples depicting the Queen of Sheba before King Solomon. The illustration with the motif from the story of Tobias shows a definite modification in this respect. These pieces have long ago been compared to the most characteristic and imposing tapestry of Norway. It is quite possible that there are historical connections, but it is not yet possible to establish them more definitely. It has not yet even been ascertained whether the woven tapestry along the Lower Elbe was the work of artisans or of amateurs. Quite lately some completely unexpected light was thrown on this question. The Museum für deutsche Volkskunde in Berlin acquired a unique piece of tapestry dated 1667. It is 350 cm long and 56 cm wide with a 306 bewildering mass of groups of figures and nearly seventy quotations from the Bible. Justus Kutschmann succeeded in identifying the weaver who had incorporated her name, Anna Bump, into the weaving and in deciphering the whole picture.[175] Anna Bump, baptized in 1644, was the daughter of a farmer in Kleve in northern Dithmarschen (Holstein). Although her father was probably one of the wealthier farmers she was a simple country girl. Her brother was pastor in the parish of Hennstedt, of which Kleve was a part. The tapestry was made for the 150th anniversary of the Reformation. It tells very eloquently the whole story of the Passion and Resurrection of Christ in a highly unconventional form, very different from the traditional iconography, and more like an imaginative word picture. The conception may have come from Anna's brother, a trained theologian. The composition and execution of the work was solely that of Anna Bump. She stands apart from the traditional type of artisan, and has no connection with familiar Bible illustrations and contemporary graphics. We have no clue as to the place this hanging was designed to occupy. It may have been made for the church, but could also have been meant as a back-cloth for use in the house on festive occasions. Its strict conformity to the words of the Bible reveals a definitely Protestant spirit, or to be more precise, the outlook of a Lutheran who does not abhor pictures. Indeed, one could hardly find

291 Woollen embroidery on linen. 1717. From the Hamburg district. Reproduced in a water-colour painting to scale by H. Haase.

292 Reversible fabric. Flax and wool. 18th century. From north Friesland.

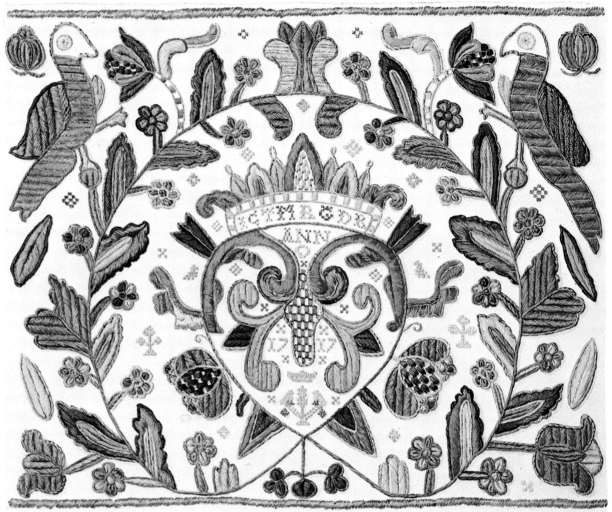

291

292

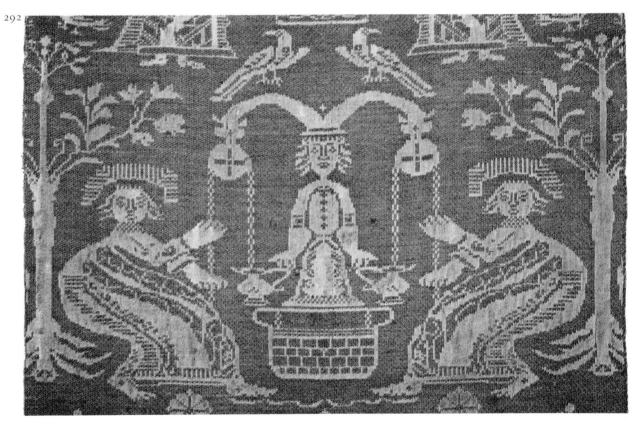

181

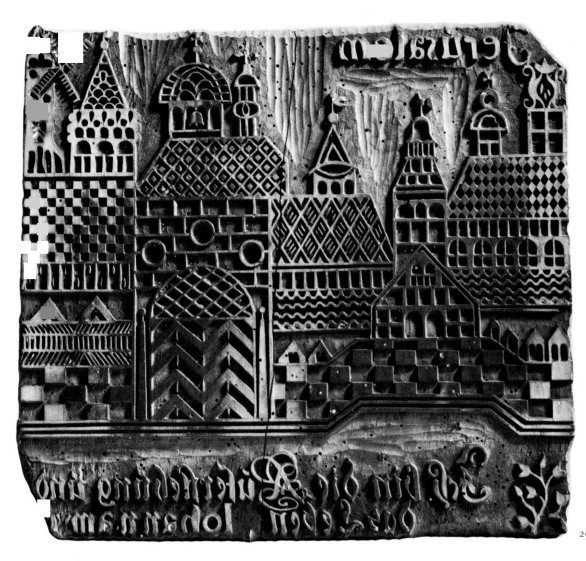

293 Printing block. Wood. *Circa* 1700 (?).
From Hasenpat, Radewig, Herford, Westphalia.

294 Part of a bedspread (perhaps a bed curtain).
Printed linen. 19th century. From Hesse.

295 Part of a display towel. Linen and wool,
embroidered. 18th century (?). From north Fries-
land.

293

294

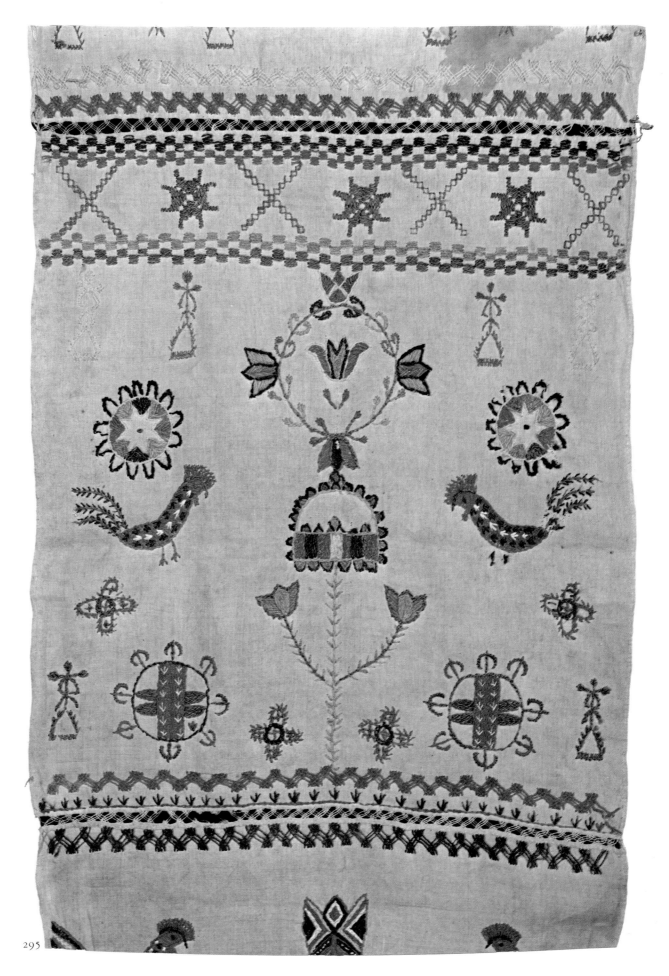

296 Chair cushion. Wool and other materials. 1926. From the Vierlande, near Hamburg.

297 Embroidered cushion cover. Linen and silk thread. 19th century. Made in the Winser Elbmarsch.

298 Chair cushion. Wool. 1769. From the Probstei, Holstein.

299 Chair cushion. Wool with silk embroidery. End of 18th century. From the Probstei, Holstein.

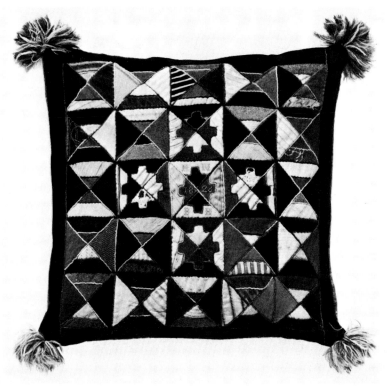

296

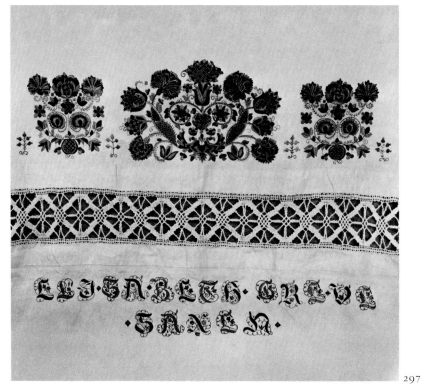

297

298

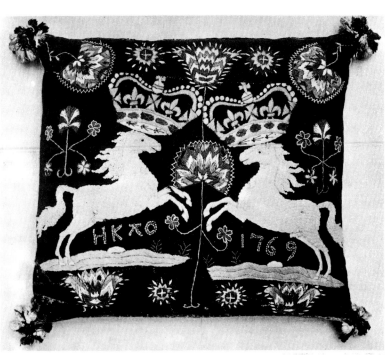

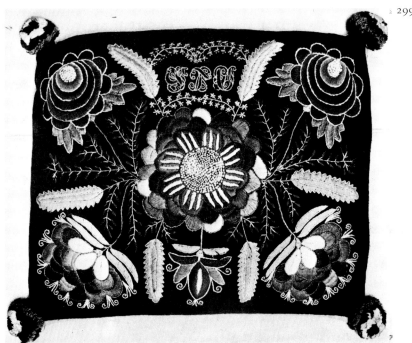

299

300 Cushion cover. Linen, embroidered. Middle of 18th century. From Buchen, Odenwald.

301 Cloth with embroidery pattern. 1831. Woollen embroidery on linen. From the Vierlande, near Hamburg.

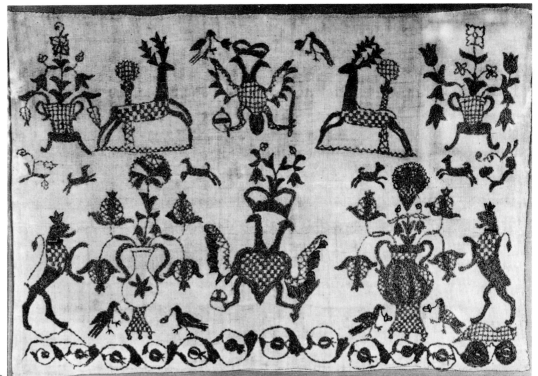

300

301

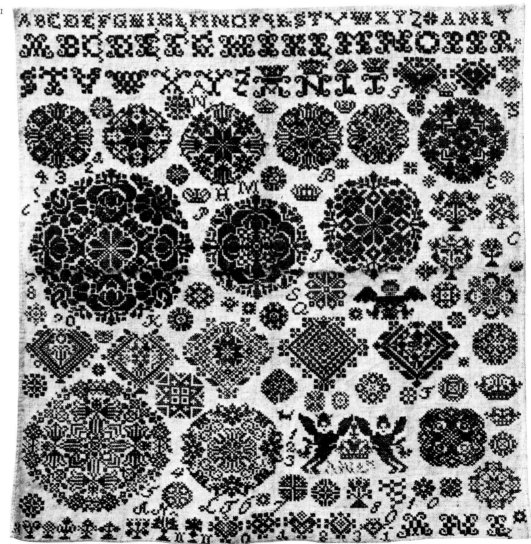

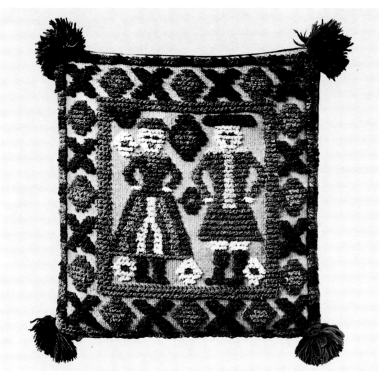

302

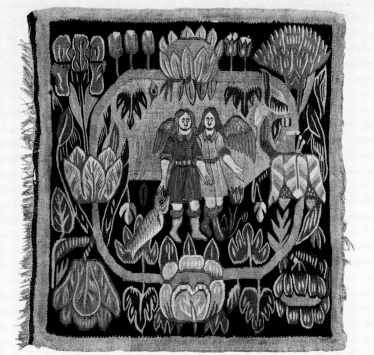

303

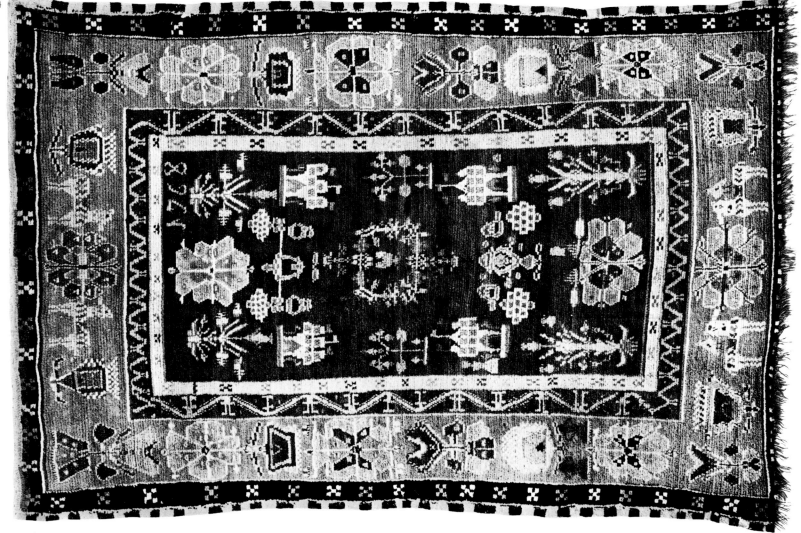

304

186

302 Cushion cover. Burl weaving on woollen mesh. End of 18th or beginning of 19th century. From north Friesland (mainland), Schleswig.

303 Chair cushion cover. Tapestry woven in wool on a linen base. 17th century. From Schleswig-Holstein.

304 Knotted carpet. Wool. 1768. From Masuria, East Prussia.

305 Chair cushion. Knotted fabric, wool on linen mesh. 1769. From north Friesland.

306 Woven tapestry. Linen warp and woof with wool, silk and linen threads. Detail. 1667. Woven by Anna Bump, Kleve in Dithmarschen, Holstein.

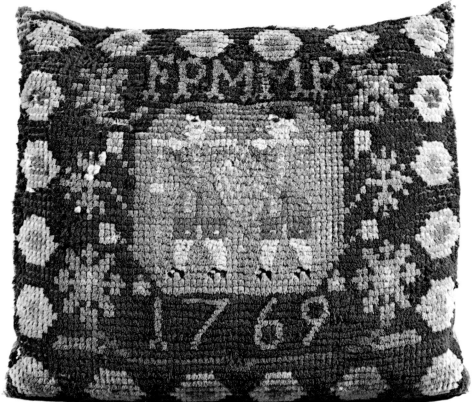

305

306

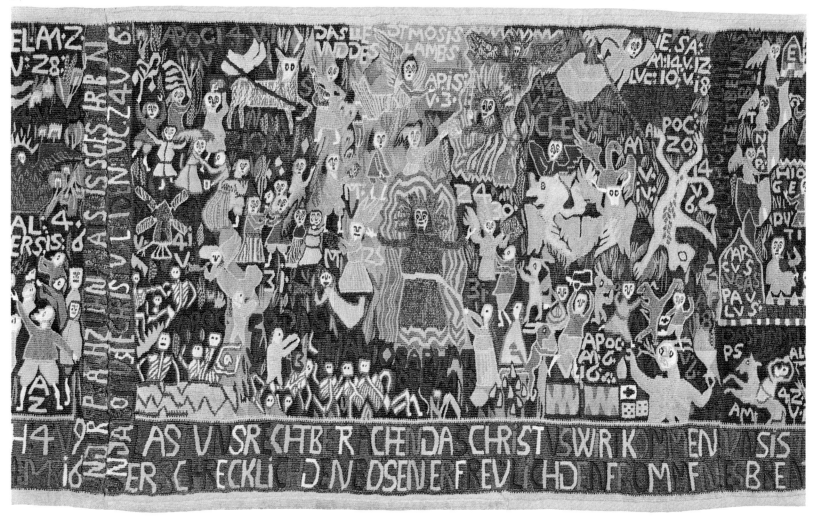

307 Corner of a shawl. Batiste with stitched pattern. 19th century. From Hamdorf, Rendsburg district, Schleswig.

308 Cushion insert. Net needlework. First half of 19th century. Made and used in the Vierlande, near Hamburg.

309 Linen cloth. Silk embroidered. 19th century. Vierlande, near Hamburg.

310 Shawl. Silk, embroidered. 1867. Acquired from Neuengamme, Vierlande, near Hamburg.

◁307

308

309 310

a more convincing manifestation of the joy experienced in creating pictures. They follow, in sequence, the birth of Christ, His baptism and temptation, suffering, death and burial; the descent to hell, Resurrection, the Epiphany, the Ascension at Whitsuntide; the Last Judgement, and the heavenly Jerusalem.

The whole piece is unobtrusively divided into five sections according to these groups of subjects. Many quotations accompany the successive scenes. Words or sayings are given visual expression without inhibitions, in many colours on a dark background, and woven into a single, continuous picture. The figures are reduced to a simple formula but are lively in movement and show individual characteristics. Their faces are either turned toward the spectator or are shown in profile. In the flourishes of the design, which are partly a result of the process of weaving, there is much similarity with the cushion covers already mentioned, which also come from Schleswig-Holstein. The hanging, which has been proved to be the work of an amateur, is certainly an exceptional piece. However, it confirms the existence of a popular tapestry tradition which was quite independent of that of the professionals, a fruitful and artistically separate creation. In the secular field there are comparable examples in medieval backcloths. These woven fabrics had their own tradition in central Europe but were still being made in Scandinavia at this time. In the field of ecclesiastical fabrics there is a similar wealth of scenery on the black cloths ('hunger cloths') preserved in some Catholic churches, and used to cover the altar during Lent. Their pictorial themes always adhere closely to tradition and have a meaning dictated by their function, which is quite different from that of the original woven piece by Anna Bump.

A common factor in embroidery, tapestry and knotted work is the wide-ranging freedom of creative form. There are limitations inherent in the surface and structure of the material, but there are equally strong inducements to arrange, enliven and decorate the given background. The relation of weft and warp has a special influence on the final effect. We have diverged from weaving patterns to the wide field of embroidery. Of course, despite the difference in techniques there are many similarities between them in the way of forming patterns. Let us return from the extreme freedom of composition allowed by tapestry making to woven pictures produced by mechanical means, and examine the limitations imposed by the loom.

The technique of damask weaving led the way in pictures woven straight on to the loom. It was developed into a highly skilled craft during the late Middle Ages and at the beginning of the modern era spread all over north-west Europe. As early as the sixteenth century it was practised in Friesland, Saxony and Silesia; other regions such as Pomerania, Hesse, the Mark of Brandenburg and, in South Germany, Augsburg and Upper Franconia soon followed suit. A very efficient rural linen-weaving industry was established from the end of the eighteenth century onwards around Bielefeld in Westphalia. Here the difficult process of damask weaving became a fully integrated part of folk art.

The subject of the high-class demand for richly decorated tablecloths will be disregarded here. We shall concentrate on fabrics in which the more subtle white-on-white patterns become transformed by the addition of contrasting colours. The most striking examples of this are the so-called 'double wall-hangings'. These originated in the middle of the eighteenth century in Schleswig, mostly on the west coast and possibly in the Dutch settlement of Friedrichstadt on the Eider, founded in 1621. They consist of a woven fabric in two 292 layers which intersect each other. The brightly coloured woollen surfaces appear alternately in front of and behind the monochrome linen surfaces, so that the two sides are interchangeable. Both of them display patterns of equal value: figures and scenes, simple 'stylized' patterns and others—the most charming of all—modelled on oriental silks, which show biblical subjects such as the sacrifice of Isaac, Christ and the Samaritan woman at the well, the story of the Prodigal Son, Christ's entry into Jerusalem, and also secular themes like the four continents or the story of Pyramus and Thisbe. The source of the geometrical motifs has been traced to the eighteenth-century printed pattern books (by Lumscher, Fickinger and Kirschbaum). The patterns for the figures are part of the tradition of damask weaving.[176]

The mechanics of the complicated special loom required for this work cause every picture to appear twice, once as a mirror-image repetition, which imparts a symmetrical effect to these one-metre-wide hangings. The decorative impression of the contrast between the grey tone of the linen and the bright green, blue, ruby, even black woollen weave is striking. These double wall-hangings were used to curtain 31, 32 off wall-bed openings, and also as wall coverings on festive occasions. The significance of the double wall-hangings in Schleswig, apart from their impressive pictorial effect, was that they introduced a handcraft designed to meet local rural demand. It must be assumed that the craft was derived from older and more artistic models. The way in which it was transmitted and the circumstances of local production are not yet properly understood. Dorothea Klein started some new investigations some decades ago,[177] but much more information is required. The whole tradition of comparable picture weaving should be included. There are some peculiar, pure woollen double weavings from Masuria from the period 1799–1818 which may have the same significance as the above-mentioned knotted carpets from East Prussia. Coloured damask weavings from several parts of Germany should also be included. They come mainly from Silesia (Hirschberg, Schmiedeberg, Greiffenberg) and consist of large cloths with illustrations of towns, pictures of rulers, war scenes and monuments to peace treaties. Others show hunting scenes, and there are some with less elaborate motifs which recur symmetrically like those on double wall-hangings from Schleswig. Here, too, the trade was largely a rural one, but it offered a wide range of patterns which could satisfy urban as well as rural demand, and thus includes the transition to true folk art.

Saxony (Gross-Schönau) also had a flourishing damask weaving centre of the same kind. In the churches of the Lausitz altar-cloths still survive in white and green with linen warp and weft; these woven cloths with large figures, made from the first half of the eighteenth century onwards, are especially well suited to their particular purpose. Here, too, illustrated stories and mirror-image repetitions

are worked into the warp and the same subjects occur as in Silesian double wall-hangings, for instance the Samaritan woman at the well. If we could trace this weaving technique through other German territories we would undoubtedly find much more continuity of tradition and distribution among different classes of consumers. The local peculiarities of the various special features would also become clearer in a wider context. Distribution to distant customers was undertaken by both Silesian and Saxon production centres. Most of their work went to distant consumers, and itinerant traders carried their products into other territories. This is in strong contrast to conditions in Schleswig, where production was confined within narrow regional borders and only destined for people living in the immediate surroundings.

Toward the end of the seventeenth century the world of woven pictures encountered competition in the form of printed cotton 289 materials from Asia. This led to a revival of fabric printing. In Germany it was most intensively developed in Augsburg, a city famous for picture printing. In 1690 local craftsmen there succeeded in imitating the process of reverse printing. By this method a colour-rejecting substance is stamped on the material and the untreated spaces are then dyed. As in the foreign models the favourite colour was blue.

These blue printed fabrics soon became popular, largely as an imitation of blue and white damasks. The same stamp was repeatedly pressed on the fabric, one pattern close to the other. It became customary to combine architectural and figure motifs, thus forming 290 a continuous frieze of buildings across the fabric while the scenes were repeated over and over again as independent picture motifs. The Resurrection of Christ is the most frequently recurring subject. The blue-printing trade soon became an independent craft and chose its 293, own motifs and forms from the repertoire of fashionable patterns. It 294 flourished in nearly every part of Germany. Among the main centres of this activity were Westphalia and the Lower Rhine.[178] Blue materials with simple printed patterns remained favourites right into the present century. It was essential to know how to carve the wooden stamp until the introduction of metal figures which were inserted into the wooden blocks, after which they could be printed in the same way as type. Blue printed kerchiefs with picture motifs became important articles in less affluent households both in town and country. They served not only as prestige towels and table-cloths for special occasions, but also, for instance, as pillow-covers for the sick and dying. This may explain the rigid adherence to religious themes and particularly the picture of the Resurrection.

Costume and Ornament

'Costume and ornament' has become an accepted formula in the terminology of folklore. In fact it is not valid to separate metal ornaments from the clothing with which they were worn. Dress ornaments were largely, to begin with at least, accessories for fastening clothes, such as buttons, clips, clasps, chains, hooks and eyes, buckles and pins. In many cases utility items became elaborate articles of only limited practical use, or decorative and display pieces. An ornament may combine many symbolic meanings: it can be an amulet with a magic effect; it can be a religious symbol; or it may demonstrate the status of the wearer in the family or society. At the same time it can also be a capital investment, and may even consist of coins.

The German attitude to popular adornments varies a great deal from region to region. It is not yet possible to trace all the important aspects either in their local distribution or in their historical development. The different trends do not always run in the same direction. Since jewellery demonstrates affluence and social status its total volume tends to increase. But this increase has limits beyond which it becomes unacceptable and these limits are determined by various factors. The author was shown a pectoral with four chains from the island of Föhr. The lower chain had been added subsequently. The traditional explanation was that when the jewellery was first acquired the purchaser was a coxswain, and that the fourth chain was added when he became a captain. This story, however, does not answer all the questions: did that fourth link immediately indicate the owner's status to all and sundry or was it just the result of the prosperity arising from his promotion, which made this addition to an already accepted ornament possible? The Föhr bridal ornament never grew beyond the four-chain stage and this was only reached as a result of the nineteenth century proliferation of forms. Nowadays it is difficult to appreciate how eager even less well-endowed citizens were to participate in this development, even if it meant going without other desirable possessions. We must not forget that people did not necessarily regard the proliferation of adornments as wasteful; rather the contrary. Of course, rulers and their financial advisers took a very different view, as is shown in the strict regulations to limit expenditure on luxuries. Precious metals were disproportionately valued in comparison with other goods. This was a continuation of an earlier attitude that had prevailed in the Middle Ages.

A remnant of old traditions, at least in the choice of material, was the persistent idea of an associated magic effect. This is particularly true of amber jewellery, which was widely worn in certain parts of North Germany in the form of massive necklaces. Amber was widely regarded by women as a healing agent. Magic qualities were also associated with certain special shapes, irrespective of the material.[179] Here we have another area of historical and cultural connections without understanding which we cannot adequately evaluate the significance of personal adornment. This applies, for instance, to ear-rings worn by men, generally sailors. The wearing of a cross as a religious symbol already places it beyond the strict meaning of ornament. Nowadays it has become a manifestation of faith rather than an amulet. Considerations of religion and the confessional divide play quite an important part in the history of ornaments. In Protestant territories the wearing of jewellery was taboo. It therefore could not serve as a status symbol. Borchers writes of women in the regions bordering on the Netherlands: 'All the money they could afford was spent on fitting their Bibles and hymnals with silver clasps and mountings for the covers.'[180] This is particularly true of the hymnal, and can be observed in other regions. In North Germany it was the most important object one took with one to church, along with the silver smelling-bottle which was especially shaped for the purpose. In Catholic areas the prayer-book and rosary had a similar function. This alone shows how impossible it is to confine the concept of ornament within certain limits. In considering the total effect, metal pieces cannot be separated from the ornamental textiles of which the costume is made, or from the woven, embroidered or dyed decorations of the garments. The effect of a piece of jewellery, judged by its material and form on a monochrome background, was rarely considered. What mattered was the principle of accumulating and multiplying one's stock of ornaments.

During the eighteenth century the various forms of decorations developed into 'sets' which differed in style from place to place. As in the case of clothing careful distinction must be made between workday and holiday dress. There were rules for wearing jewellery, like those which governed costume as a whole, for special occasions like Holy Communion, during mourning and particularly for weddings. Bridal ornaments were always the highlight of personal jewellery. In some districts tradition obliged the bride to change her clothes three times in the course of her wedding day and her jewellery too was subject to the same rule. In many cases the menfolk also wore special ornaments, not only buckles on their shoes, belt and hatband, but also ear-rings and watch-chains. In the Vierlande men's waistcoats, coats and trousers were adorned with rows of silver buttons. Similar rows of buttons were the principal decoration of the male folk costume in Franconia, Hesse, Swabia and Bavaria. Some-

times the striking embroidery on waistcoats and trousers was more conspicuous than the metal decoration.

In most parts of Germany the main items of decoration on the female costume were the lace which fastened the opening of the bodice, and then necklaces and collars. Then there are shirt-blouse clasps, brooches, pins for various uses, lockets, finger-rings and earrings. In the case of jewellery made of precious metals the tendency, mentioned above, for folk art objects to get bigger and bigger is particularly evident. There are a few instances of convictions for breach of official regulations prohibiting the wearing of ornaments by various social classes, seven of which were distinguished. On the whole, however, the restriction of gold or silver to the upper classes was largely ignored, as were the provisions about its size and shape. Regional differences caused by the division of the country into petty principalities are among the factors which help to make geographical distribution of decorations so variegated. This diversity was counterbalanced to some extent by the fact that metal ornaments were often produced in specific centres and traded over wide distances. In some towns craftsmen made articles which were worn in very remote areas. Markets and itinerant traders provided the appropriate outlets for their products.

329, 333– 335, 338– 341

328, 329

For example, among the main items of women's jewellery in the Vierlande were shirt-blouse clasps and pectoral chains. The clasp consists of a circular, arched shield with a round opening in the centre, at the edge of which is the pin for fastening it. It is decorated with filigree, garnets and blue or red vitrified glass beads. Small medallions with painted flowers might also be added. This clasp may be as big as the palm of one's hand. It was worn only on holidays; on weekdays a smaller, plain clasp with some engraving served to close the shirt-blouse at the throat.

'As early as the fourteenth and fifteenth centuries the farming population of east and west Friesland had developed a craving for ornamentation unequalled by anything in the rest of Germany or even the whole of central Europe. The ancient chroniclers of the sixteenth and seventeenth centuries report that the women of east Friesland were so heavily decorated with gold that it had become a burden rather than a pleasure. Their clothes were so thickly encrusted from top to bottom with wide strips of gold that they could stand up without the support of the human body.'[181] This kind of ostentation influenced other coastal areas, as Hubert Stierling has proved by reference to contemporary paintings. The tradition of excessive ornamentation among the peasantry, a legacy from medieval times both in form and meaning, came to an end early in the seventeenth century. In the over-all story of rural adornments this was just a prelude, but it clearly reflects the leading part played—then as later—by the forms of personal decoration worn in Friesland and Holland, which influenced all the territories on the North Sea right up to Tønder. Pictorial and written traditions give us a vivid view of the influence of western models on the prosperous farmers of Dithmarschen and Eiderstedt.

It was not until the middle of the eighteenth century that a completely different rural style of ornament developed in east and west Friesland, and this too flourished exceedingly. It shares with the earlier one a predeliction for gold. Dutch influence is discernible in the silver jewellery of the regions around the Lower Elbe: the Vierlande (already mentioned), the Altes Land and particularly the Kremper- and Wilstermarsch. Further north, in north Friesland, women wore the pectoral chain arrangement discussed above, which seems to have originated in Amsterdam but was not worn in the Netherlands. The Dutch remained pre-eminent in the art of working precious metals, but workshops were established in some parts of Germany. They were found at Elmshorn in the Elbmarschen area of Holstein, where twenty-eight master goldsmiths were active between 1750 and 1830. In west Schleswig they were located in Husum and particularly in Tønder.[182] Some silversmiths also settled in the villages.

338

It is not possible to give a detailed description of the various pieces of jewellery here. The most important element of decoration is always filigree work. It often followed Dutch models, as did the cast hook used to fasten a chain worn on the chest and buttons beaten out in hollow forms. Even if one accepts Stierling's findings with some reservations[183] one must appreciate the fact that, thanks to his and Sigurd Schoubye's investigations and the researches into costume by Anna Hoffmann, no other German 'folk costume region' is so well documented as north Friesland.

Chest and neck adornments are often closely related: necklaces can hang down or have pendants attached to them. Excavations have shown that the custom of wearing coins on necklaces or chains has survived uninterruptedly since early times. The chain itself acquired added importance as a piece of jewellery during the Middle Ages, and not only because it contained more metal. Only a few medieval forms were adopted for popular use in local costumes. In the case of necklaces and neck-bands the clasp which fastened them was often worked in a specially elaborate shape. When dresses reached up to the neck, ornaments worn next to the skin were generally reduced to ear- and finger-rings. Pieces of fabric such as neck-pieces, collars and belts had metal ornaments sewn on to them and were then put on as single entities. Stitched-on decoration, even on the main items of dress, played an important part in earlier traditions. An important feature appears to have been the 'bib' (pectoral) worn by the women of Sylt and Föhr up to the end of the eighteenth century. It consisted of gold brocade with little metal discs sewn on to it. The belt with small metal discs sewn on it is part of the same tradition; it could sometimes grow to considerable width. Even today the so-called *Nedderkragen* (low collar), a separate garment with silver buttons sewn on to it, is sometimes found on the island of Föhr.

In South Germany the production of ornaments for the people of the farming areas seems to have been concentrated in a few towns. Schwäbisch-Gmünd, where a very active group of exporters had been established, was the leading centre, at least in the eighteenth century. Since filigree work was dominant in the latter half of that century, jewellery did not remain flat, as it did in North Germany, but grew into three-dimensional Baroque shapes with several layers. The most frequently mentioned example is the Dachau *Florschnalle*, the clasp for the neck-band, which maintained its place as the favourite decora-

311 Lace. Linen thread. 17th or 18th century. Probably made in central Germany.

312 Neck-piece. Cloth, embroidered with silk thread. 19th century. From Neuengamme, Vierlande, near Hamburg.

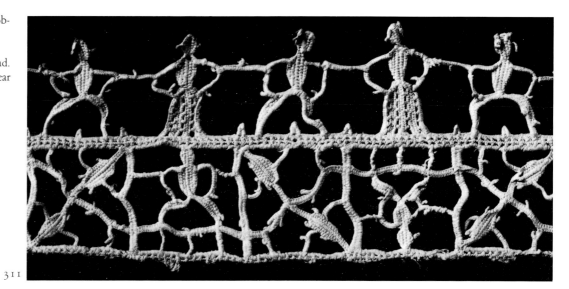

311

312

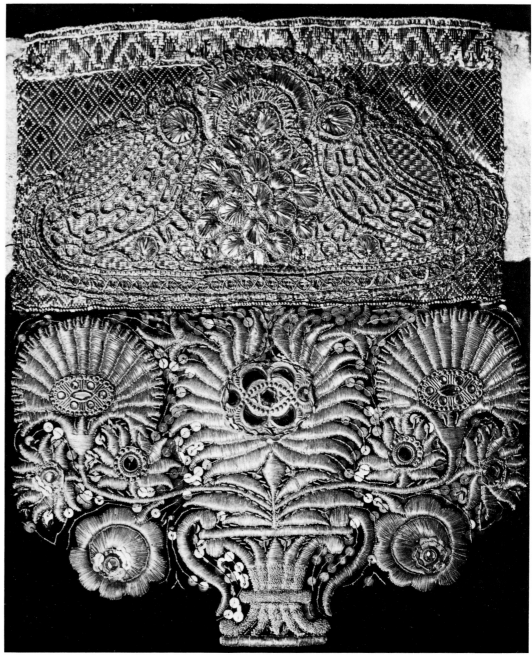

313 Woman's glove. White leather with silk and wool embroidery. 18th century. From the island of Föhr, north Friesland, Schleswig.

314 Plate or flat bonnet. Gold embroidery on dark background, with flowered silk ribbons. 19th century. From the country around Münster, Westphalia.

315 Necklace with large cut and polished beads. From Lindhorst, Westphalia.

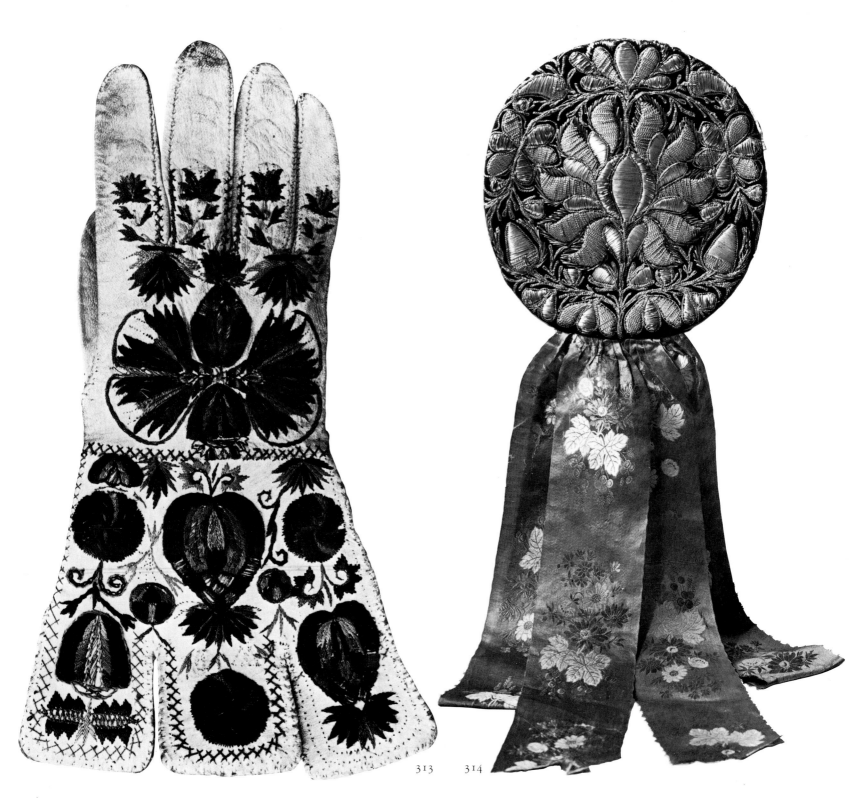

313 314

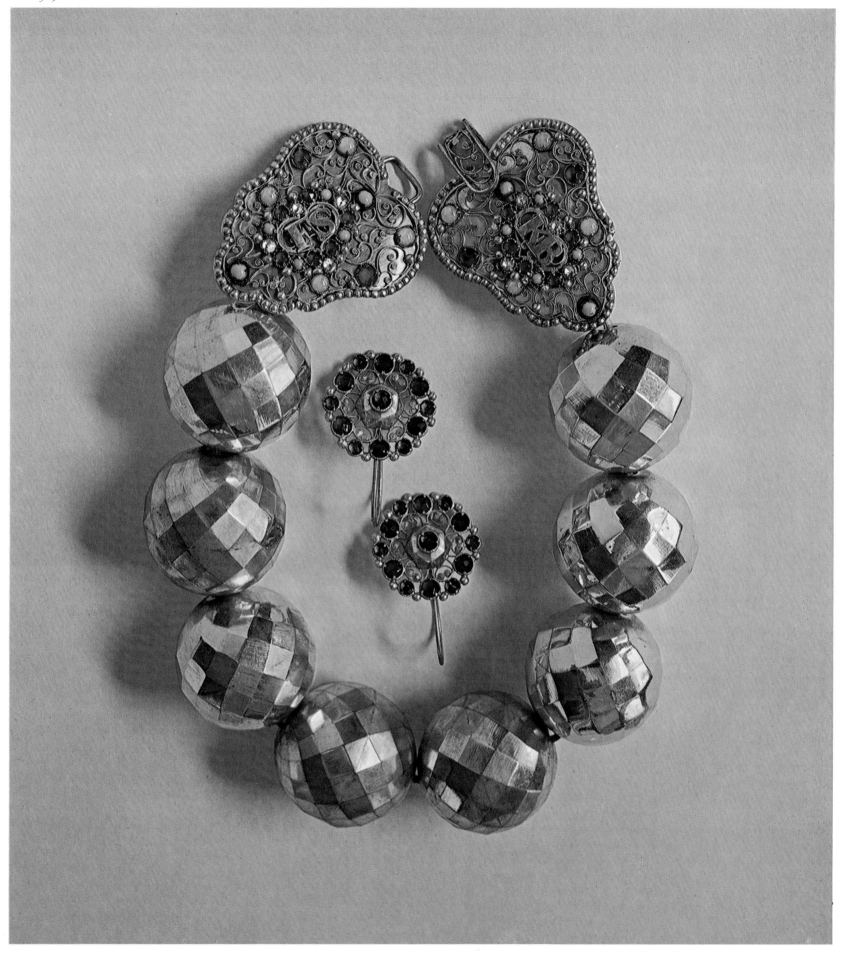

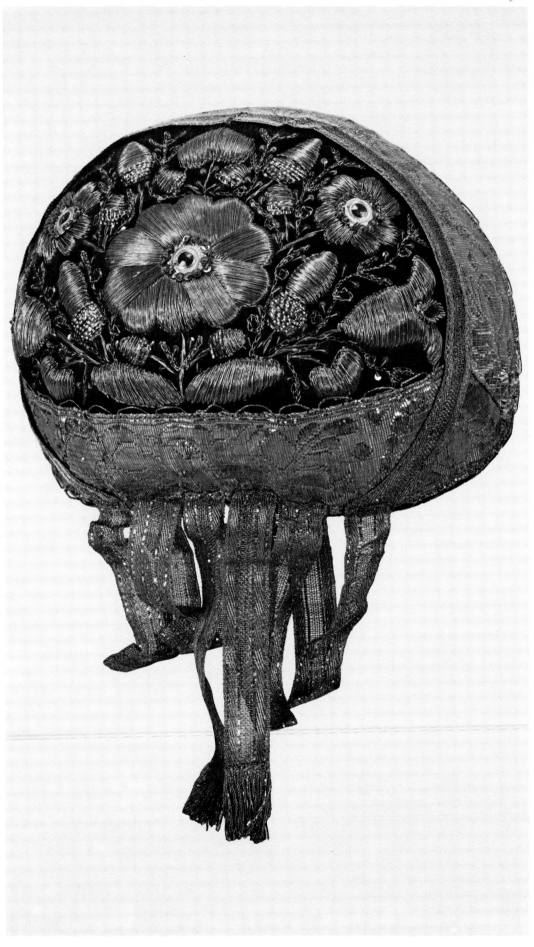

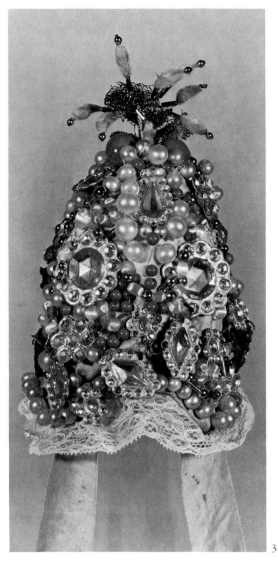

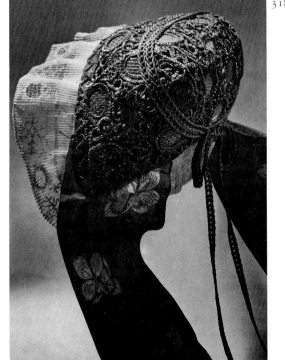

316 Bonnet. Velvet, embroidered with gold thread. 19th century. Worn in Pattensen, Lower Saxony. Acquired in Arnum, near Hanover.

317 Bridal crown. Fabric, with additions of glass and metal. 19th century. From Mecklenburg.

318 So-called golden cap. Tulle and various other fabrics, as well as cardboard. 19th century. From the area around Osnabrück, Lower Saxony.

319 Bonnet with hair-pins. Silver filigree. Middle of 19th century. From Munich or its immediate neighbourhood.

320, 322 Neck collar ('neck harness'). Silver, partly gilded and brass. 19th century. From Minden-Ravensberg, Westphalia.

321 Necklace. Amber and silver. *Circa* 1880. From Lindhorst, Schaumburg.

319

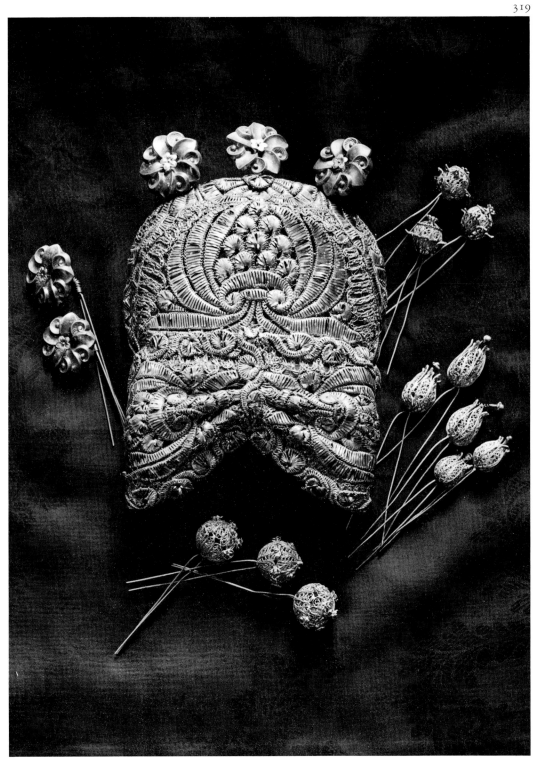

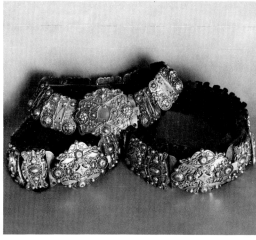

320

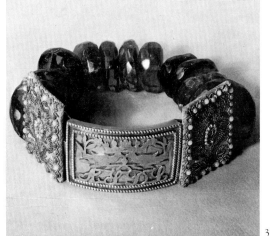

321

322

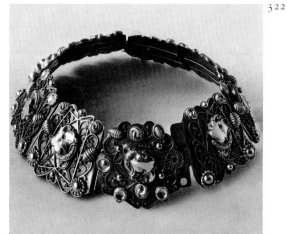

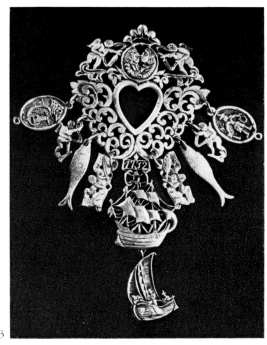

323

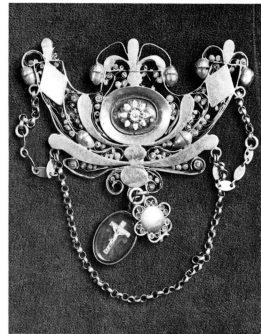

324 △

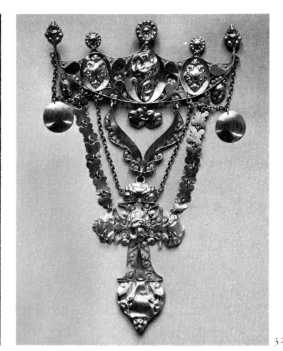

325

326

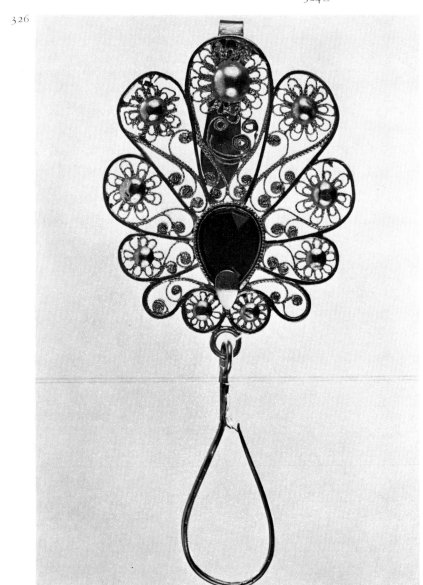

327

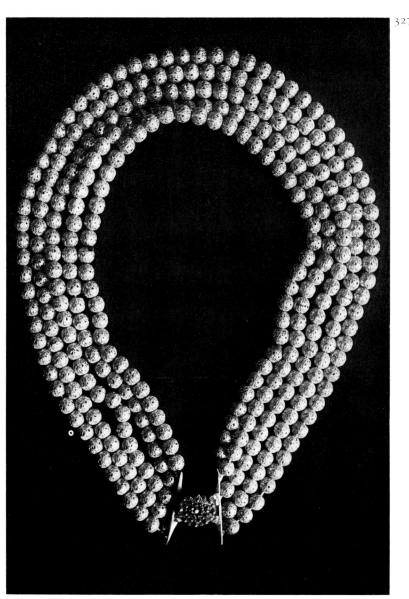

198

323 Shirt buckle ('Hattje'). Silver. 1732. From Heligoland.

324 Brooch with pendant. Gold. Latter half of 19th century. Perhaps from Holland.

325 Pendant. Gold leaf with silver filigree. 19th century. From Emsland, Westphalia.

326 Wool-holder. Silver filigree. From Lower Saxony.

327 Necklace. Silver filigree beads. 18th or 19th century. From the Altes Land, near Hamburg.

328 Shirt clasp. Brass sheeting and silver. 19th century. From the Vierlande, near Hamburg.

329 Pectoral. Silver, partly gilded. First half of 19th century. Worn in the Vierlande, near Hamburg.

328

329

330 Woman's girdle. Leather with quill embroidery. 1807. From Chiem district (?).

331 Man's belt. Leather, mounted with tin studs. 1798. Used at Höglwörth, Upper Bavaria.

332 Man's belt: Leather, mounted with tin studs. Third quarter of 18th century. Made in north Tyrol, used in Upper Bavaria.

333 Woman in festive costume. *Circa* 1840. From the Probstei, Holstein.

334 Woman's costume. Middle of 19th century. From the Bückeburg area.

335 Woman's costume. *Circa* 1800. From the island of Røm, north Schleswig. On one side large filigree buttons made of silver.

330

331

332

333

334 ▽

335

336 Hair-pin with large ornamental filigree head of silver. First half of 19th century. From Schleswig-Holstein.

337 Bodice and belt of a woman's costume. Middle of 19th century. From Neustadt in the Upper Black Forest.

338 Woman's jewellery and folk costume. Silver. Middle of 19th century. From the island of Föhr, north Friesland.

336

337

338

339 Festive folk costume. From the Ochsenfurt district. Gold chains with garnet pendants. Gold brooch with garnets. Ochsenfurt, Franconia, Bavaria.

340 Dress with laced bodice. Stays and fasteners on the bodice in silver. 19th century.

341 Dachau costume with fastener. Lacing and lacing-fastener. Silver. 19th century.

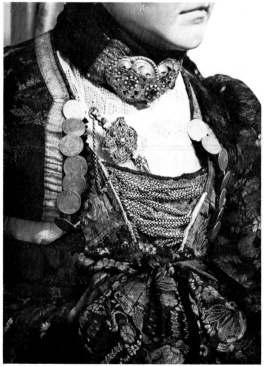

342 Bodice- or lacing-fastener. Unusually rich silver setting: cylindrical band, foil crowned with volutes. Silver, gilded silver, cast-work, glass beads. First half of 19th century. Southern Bavaria.

Necklace, a so-called Kropfkette (goiter chain). The necklace has an extraordinarily elaborate square clasp with large quatrefoil decoration in pattern filigree. It is made of gilded silver, gold filigree and coloured glass beads. *Circa* middle of nineteenth century. Upper or Lower Bavaria, in the style of Schwäbisch Gmünd.

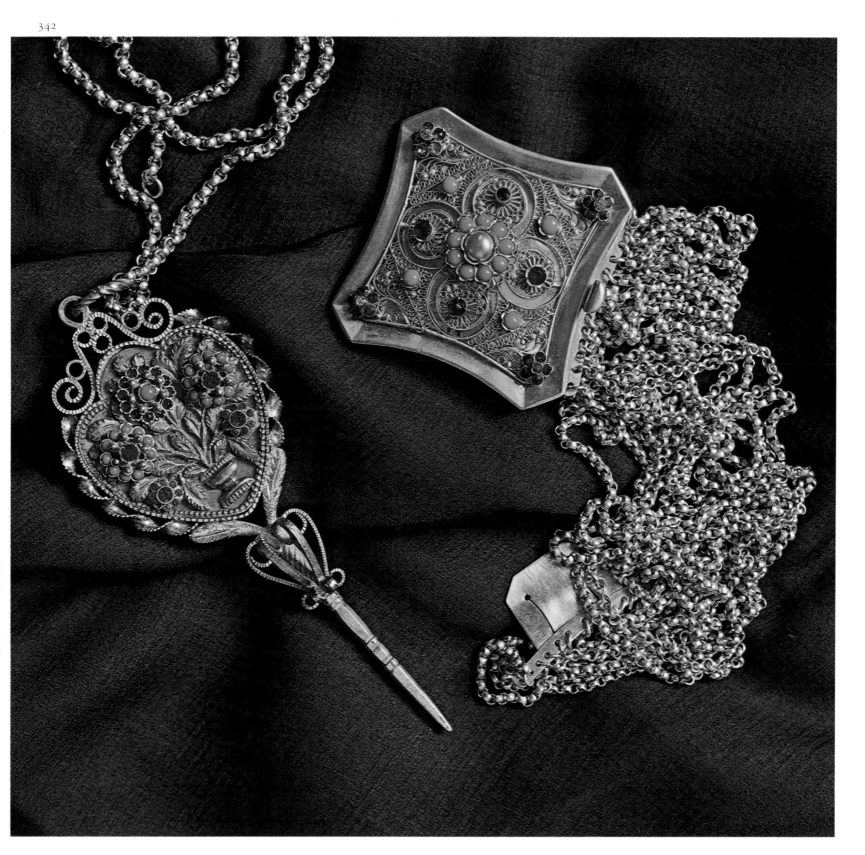

343

344

343–344 Head as ship's decoration. Oak, painted. 18th–19th century. Recovered from a wreck on the island of Sylt, north Frisia, Schleswig.

345 Figure-head. Oak. painted. End of 19th century.

346 Mask of face ('Schwemme') of the 'Hüfingen Hansel'. Wood, painted. After 1945. Hüfingen, near Donaueschingen, Württemberg.

345

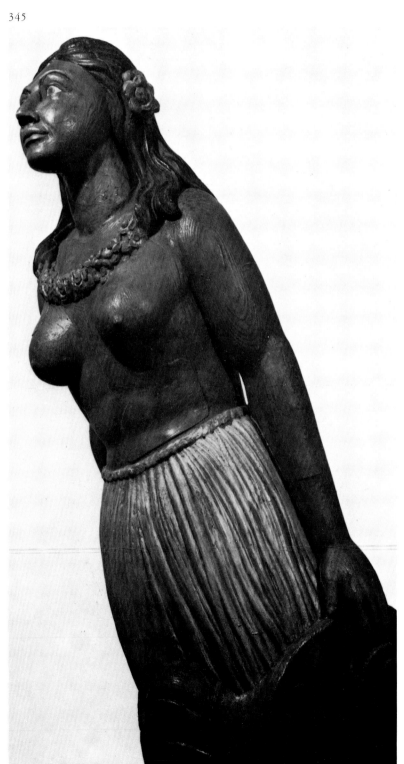

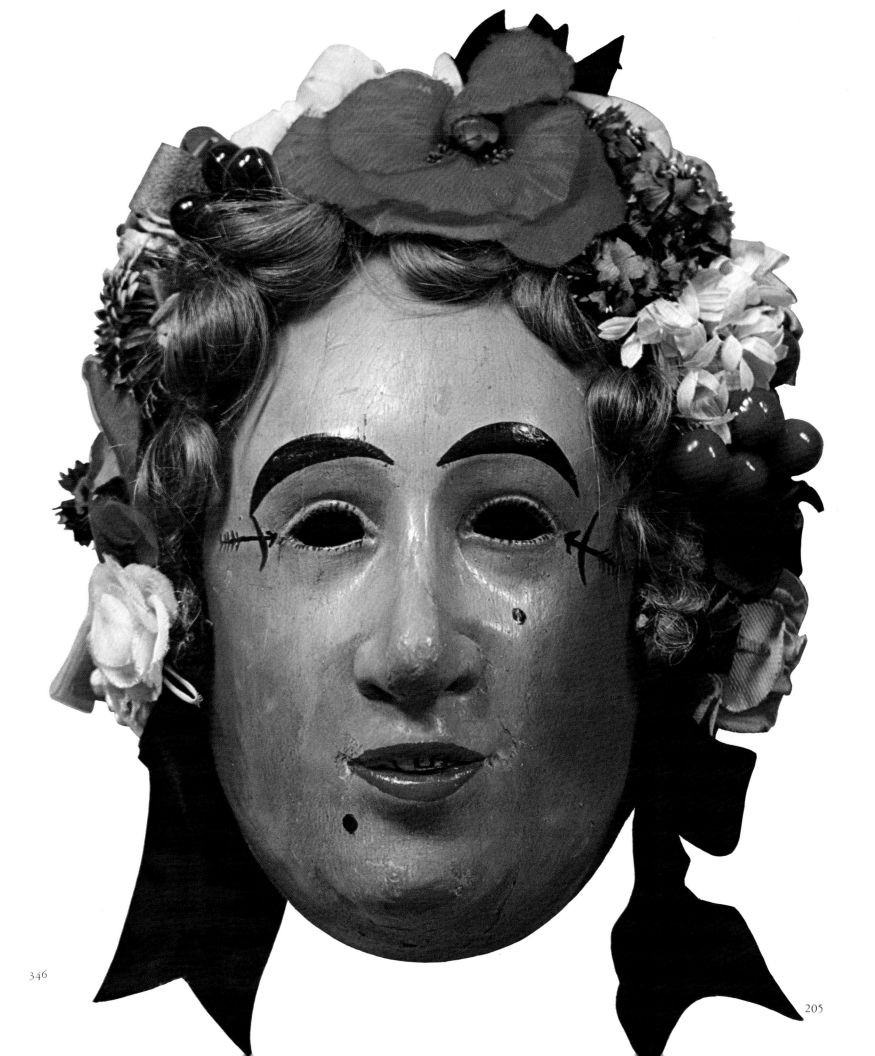

346

205

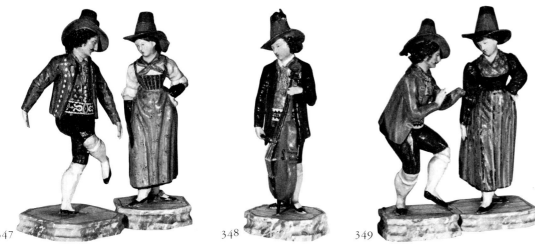

347 348 349

350

351

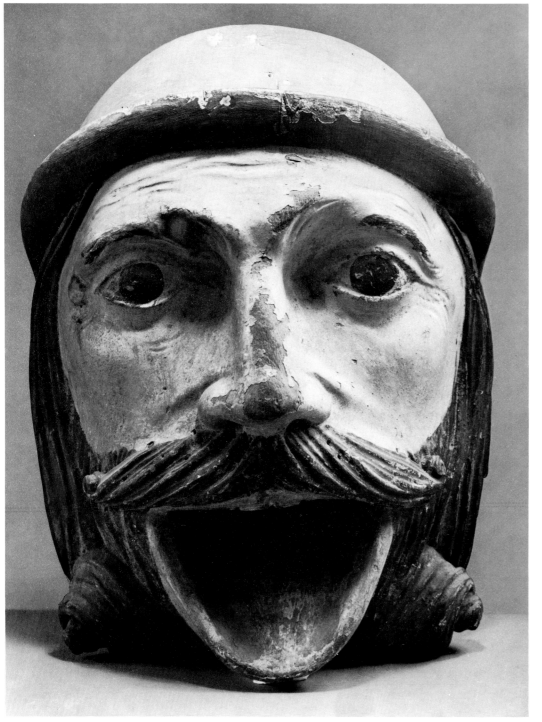

350 'Kleienkotzer' (grotesque mill mask). Wood, painted. 19th century. Central Germany.

351 Flax dolls. Raw flax. 19th century. From the Brunswick region.

352 'Roland' figure. Pine and lime. End of 18th century. From Stördorf, Wilstermarsch, Holstein.

352

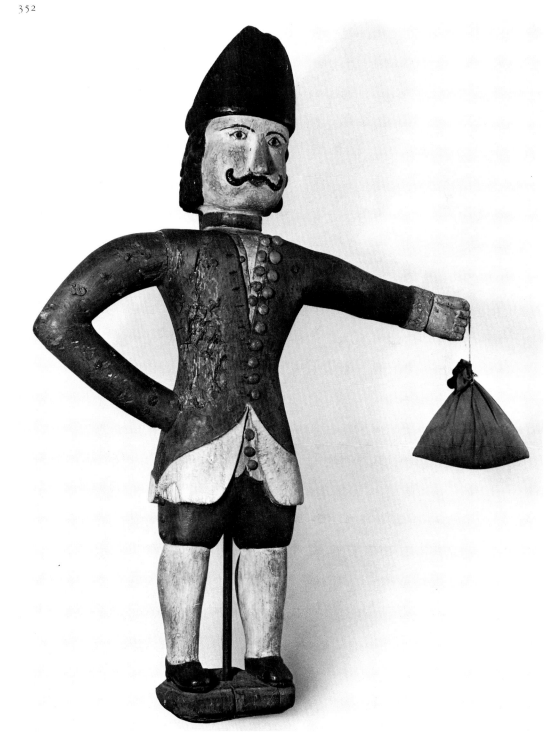

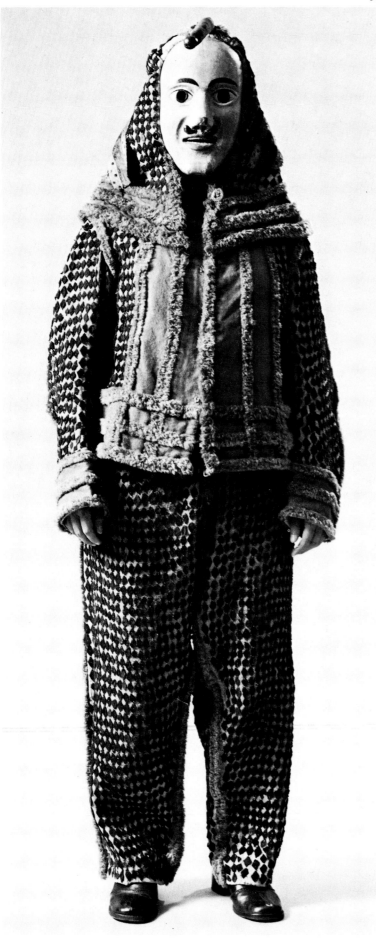

353 Carnival costume. Various materials. 19th century. From the Altmühl valley, central Franconia.

354 Mask of disgrace. Sheet iron, painted. 18th century. Baden.

355 Carnival mask for 'little Hans'. Lime, with painted and artificial flowers. Beginning of 19th century. Villingen, Baden.

354

355

tion for a long time. Belt-clasps, as worn in Bavaria, were also fragile articles consisting of several layers. In such loosely-spun forms the filigree lost its calligraphic quality. Other forms, for example a heraldic double eagle (as a setting for a head of Christ in relief), are more often confined to a single plane. Even as a mounting on the cover 400 of a hymnal Gmünd filigree work curves and buckles in an almost nervous movement.

With the increasing use of metal jewellery in the nineteenth cen-342 tury the bodice pin which held the end of the band or chain of the lacing became very elaborate. It is reminiscent of similar lavishly decorated Baroque articles. However, the filigree was now set flat on the metal plate into which the simple pin-head had been transformed. The pins which the women stuck into their hair echoed this shape. The Upper Bavarian territories differ significantly in the matter of accessories for the hat and hair. Only late—in the nineteenth century—was the single necklace replaced by a silver chain in Upper Bavaria. This quickly multiplied until up to twenty chains might be held together by a single clasp.

315, Necklaces occur in many forms: wide or narrow, uniform all 320– around or with a variety of different links, the central piece or the 322, clasp more or less elaborated. There is no point in describing specific 327, forms unless they can be studied in their overall context, taking into 340– account the total appearance of the costume, the sequence of their 342 modifications or their rôle on ceremonial occasions. They would also have to be compared with cheaper versions made for less affluent customers.

A popular type is the heart-shaped buckle. A simple heart-shaped frame with a pin is found over a vast area extending from north Friesland to the Egerland and from Holland right along the coast of the Baltic. The typology of the heart-shaped fastener or buckle is a chapter of cultural history in itself. Variants with pendants which are confined to a particular area are of outstanding interest. In the Altes Land they are covered with filigree and vitrified glass and topped by an arch, generally decorated with filigree beads. In Blankenese, for instance, cast specimens with little cones and leaves dangling from 323 them are also found. The most elaborate specimens are the *Hatjes* from Heligoland which include a whole armoury of amulet-like silver articles, among them reproductions of the pilot's badge, the

larger prototypes of which were used to select pilots for different jobs.

In the part of West Germany comprising east Friesland and much of Westphalia an arrangement known as a *Gadderken* was worn. It 324, was a pectoral consisting of a crescent-shaped main piece from which 325 hung small shell- or sickle-shaped pieces and occasional hearts or crosses, all joined by chains. Filigree and plain pieces of silver sheeting fill the few remaining spaces. The *Gadderken* looks flexible and mobile, in contrast to the amber chain which was worn with it in some areas. However, the areas where these two pieces were worn do not coincide. More closely akin in form are the two main articles of Schaumburg dress: the fastening of the amber chain is a rectangular 321 shield between two flat beaded pieces with added motifs (a pair of doves, tendrils and the date) matching the clasp worn in front. The latter expanded during the nineteenth century from a small circle to a large plaque with an opening in the centre. Helmuth Plath has studied this development in detail, and by basing his findings on dated pieces has achieved very revealing results.[184] The proliferation of a basic form and its gradual changes of shape can be followed. The front clasp usually worn around Stade underwent a similar process of transformation but with different stages of development. It would be interesting to have the results of more investigations into individual forms—perhaps those of the Westphalian neck collars 322 which occur in a very great variety of types. They may consist of a dark velvet band decorated with two rows of small egg- or barrel-shaped silver pieces, or a wide collar of closely packed or loosely connected discs of gilded silver with filigree and stones added.

Among the forms inherited from the Middle Ages are the audible ornaments by means of which highly placed personages announced their arrival. During the sixteenth and seventeenth centuries wealthy farmers on the coastlands wore, usually on the shoulders, small bells or leaf-shaped pieces of metals which tinkled with every movement. In some parts of Europe the custom persisted even later, but was traditionally confined to the ornaments of a bride. All sorts of old 317 jewellery were assembled in bridal head-dresses together with various kinds of amulets which expanded them to huge, bizarre proportions. There can be no clearer demonstration of the close links between ornament and costume and their many underlying associations with the great days in the lives of those who wore them.

Religious Folk Art

The term 'religious folk art' raises very serious questions which can only be touched on here. For example, if we take one of the main questions, that of the role and importance of images, then a mere list of the motifs which any particular creed accepts, practises or transmits does not lead very far. We shall concentrate on the different forms of worship in order to illustrate the scope it offers for folk art as defined in this book.

If faith is to be given visible expression, in communal or domestic worship or even in private prayer, it must strive for spatial order, obvious concreteness and pictorial form. Many branches of folk art were, and often still are, employed in the service of such demands. Most motifs for religious folk art first took shape during the Middle Ages. The Reformation raised doubts about many motifs or banned them altogether from the concepts and practices of the Protestant service. These items were correspondingly emphasized during the Counter-Reformation in Catholic regions: for example, the whole realm of pictures and symbols which show figures and events from the Scriptures, and represent them in a Protestant or Catholic interpretation; these themes, derived as they are from the imagery of these faiths, may merely suggest them or enable believers to partake in redemption through them. Folk art can only mean objects formed by human hand, and does not apply to relics of any kind. At this point we must confine the field still further in order not to lose all sense of direction. Purely pictorial presentations such as devotional pictures must be passed over, as will the wide field of graphic symbols. Church furnishings, altars and objects or utensils employed in administration of the sacrament are also excluded. These may take shapes which are deeply rooted in simple, unsophisticated conceptions of faith, but they are generally ruled by ecclesiastical regulations based on canon law, and so were even more affected by the demands imposed by contemporary style and standards of craftsmanship and artistic quality.

What we have to consider here is the material object in the hands of the worshipper, the things he handles and uses as an active expression of his membership of the community, as witness of his personal communication with the Deity, and as pledges of his participation in the salvation of God's people. Such articles betray little awareness of learned theological attempts to differentiate between the hundreds of varieties in order to define their degree of nearness to God. The experience of holiness starts in a 'sacred area' centred on churches and chapels and spreading into their neighbourhood, which may have been compared, in regard to their expansion, with the hallowed places associated with the life and suffering of Christ in the Holy Land. The same sanctity may extend to small devotional objects acquired on a visit to a place of pilgrimage, to the crucifix in the family shrine which manifests the divine presence in the domestic sphere, and to the prayer-book which as a ritual object is carried, like the rosary, in a special prescribed manner on the way to church. The tombstone erected for a member of the family also belongs to this category. In the widest sense we must include every object that is drawn into daily life in any way by some symbol or image. It may range from the wayside shrine as part of the sacred setting to the stoup of Holy Water next to the door of the rooms as a token of the Lord's presence in the home. A vast store of significant objects is connected with processions and pilgrimages and tradition allocates a particular place to each one. There was a tendency for such objects, seen as constituting a hierarchy, to be valued for their own sake in a superficial level and external way, which could imperil their real spiritual meaning. This was why the Reformers rejected images and confined themselves to the Word. This raised anew the ancient problem of whether one should represent the image of the Deity. Among the Pietists this question became a source of torment, even for the simple faithful.

All this resulted in a rich treasure of 'religious folk art' in the Catholic territories of Germany and a lack of directly comparable counterparts in Protestant regions. During the Middle Ages people generally undertook pilgrimages to far distant shrines. During the Baroque period—if one may use an art-historical term in this context—places of pilgrimage arose which were mostly visited by local people. They proved a great attraction, encouraged as they were by the revival of popular piety through the Counter-Reformation. The areas they affected might be large or small, and in some cases might overlap. In this connection, too, the phrase 'sacred setting' has been used. The Church's custom of displaying images, the adoration of relics and the increase in the number of saints favoured the new places of pilgrimage. The presence of means of grace in so many localities stimulated the urge to worship, and people expected to see tangible and practical evidence of salvation. This is demonstrated by the rapid growth in the production and spread of votive pictures, mainly as a result of the practice of undertaking pilgrimages or closely connected with it. Copies of the original miraculous images were widely distributed, and these offshoots penetrated as far as the most remote farmsteads. There, in the living-room, these pictures from distant places formed part of the domestic shrine. They are often described

as sacred pictures but are often really material objects, not only because they may represent a figure two- or three-dimensionally but also because they might have been sanctified by contact with the original or by consecration. Of course, glass decorated on the back by painting *(verre églomisé)* is *ipso facto* something material and three-dimensional compared with an altar-tablet or a religious picture on paper, but popular devotional objects, even simple transfers, might also be regarded as sacred and be treated as such, being breathed upon and kissed. *Verres églomisés* were bought ready framed, which is only natural since they were so fragile. However, this was also a result of collaboration between the glass-blowers and frame-makers who produced them. The votive object is essentially a picture, a formal analogy of what it depicts. It reproduces and thereby takes over features of the original, perhaps a part of the body or an animal. But it also transmits part of the nature and meaning of its subject. The act of sacrificing or carrying it round the altar gives it the significance of a prayer for an act of grace or healing as a result of the offering. If this desired effect is achieved, it serves as a continuing witness of divine aid, and may impress other pilgrims who visit the site. This function can also be inherited by other votive pictures which replace it, while existing ones may be used again or be removed without hesitation for lack of space. Wax votives may be melted down, iron votives buried. The very fact that their meaning is therefore ephemeral characterizes them as material objects.

The many articles associated with festival processions or suchlike traditional activities are of entirely temporary and passing value. Divorced from the event which they serve or embellish they have no existence in their own right. This is why so many symbolic objects, whether for a church occasion or a secular festival, become mute and meaningless when exhibited in a museum. This even applies to masks—it is, indeed, especially true of them. They need the active figure of the wearer and the whole context in which their function is fulfilled to give them sense and meaning. Even if the object itself is quite impressive it requires imagination to project it into its proper setting. Even in the case of household utensils we often lack the historical knowledge to appreciate them as part of a historical way of life, and not just as static, isolated pieces. This is even more true of the Baroque festival itself, including those of an ecclesiastical character, whose accessories were designed without any idea of their lasting more than a short time. We still do not know how far court occasions served as models for popular customs. This also applies to some extent to those of a religious or ecclesiastical nature, although in this field Baroque forms certainly proved to be very persistent.

The case of the simple material witnesses of piety which were, and often still are, an essential part of the daily life of the common people, is quite different. They are real objects and remain intelligible if they are visualized in the context of their principal function. For the last few decades the votive pictures which accumulated in large quantities at many places of pilgrimage have been attracting the attention of folklorists and cultural historians as well as a large circle of amateurs, because they clearly reflect a whole mode of expression of pictorial imagination. An unconditional and unquestioning faith testifies the experience of divine help in need and stress by means of a completely direct and naive representation of the circumstances in which the votary put himself or his belongings into the hands of the Almighty or one of the saints. The suppliant's state of mind in the state of dire distress from which he calls on the saint is expressed by a picture of him praying devoutly. Alongside this we may find a portrayal of his external situation at the same moment, perhaps falling from his wagon or into the mill-pond, in a most drastic and dramatic form.

The attitude of the worshipper also expresses his gratitude to his deliverer, who may himself appear in the picture separated from the earth by clouds or set in a separate sphere of celestial light.

An exploration of this world of images would mean embarking on an impossibly long investigation into an area of piety and simple creativity. These two facets are intimately connected, and take their place in a continuous tradition of great antiquity and amazing consistency. Lenz Kriss-Rettenbeck, the curator of the most important collection, in the Bayerisches Nationalmuseum, of such pictorial documents as well as other 'Pictures and symbols of popular religious faith'—that is the title of his comprehensive treatise[185]—has dealt very competently with all the relevant problems. The present account, being concerned with folk art, would have to apply different criteria to this seemingly confused and many-sided world of pictures and objects in order to trace the motives from which they arose. We would have to ascertain where a form arises which transcends the mere conventional symbol, the tangible or visible shape of which speaks louder than words.

Here we can only touch on a few examples, for instance the head- 362 shaped vessels filled with three kinds of grain which occur in Lower Bavaria as offerings. An example dating to the late Middle Ages from Altenkirchen near Frontenhausen has a modelled face surrounded by curls worked on the wall of the vessel in relief.[186] Later specimens equate head and vessel in the same way that vessel and human body are so often seen as connected. In the world of anthropomorphic fantasy the phrase *corpus quasi vas* ('the body is like a vessel') was elevated to a higher meaning as a metaphor for human existence. Here it is given direct and concrete form in literal conformity with the corresponding linguistic terms (cf. English 'cup', Dutch 'kop', etc.). Other parts of the body, too, such as limbs, internal organs, even tongues and sets of teeth are represented according to simple rules which can be very impressive in their simplicity. The directness of the expression in the shaping of the objects makes one feel the real seriousness of the need, the prayer, thanksgiving and act of witness that prompted it. This interpretation may not be acceptable to professional folklorists. It may be rejected as a hypothesis allegedly based on inappropriate premises, but it cannot be entirely ignored, and we shall come back to it in the final chapter. One cannot escape the fascination of the way in which the faithful artlessly reduced their pain and suffering through the simple modelling of a leg, a hand, an eye and so on. If one is prepared to accept that anything depicted and formed belongs to the realm of art in the widest sense and is thereby an aesthetic phenomenon—which is our standpoint here—these votive pictures comprise an extensive range of modes of representa-

tion. They inevitably invite comparison and value-judgements. To look at a model of a leg simply as a leg, or at a hand as a hand, and see both as mere symbols of parts of the body, would be to disregard some significant differences. In the case of the votive picture a simplified representation may indicate a more intensive prayer or may be more generally symbolic of the religious meaning, just as a short fervent prayer may be an expression of intensified feeling. The Kriss collection in the Bayerisches Nationalmuseum contains, for instance, a model tibia, 24 cm long, from Stadeleck near Simbach. It is a simple wood-carving; inscribed on it is a lengthy account of the reason for the offering, an acknowledgement of the grace received by the donor and his gratitude. Apart from the factual aspects—the visual effect and the contents of the inscription—the lack of inhibition in using the surface for the writing must be admired. It thus serves to heighten the effect of religious feeling, which according to Kriss-Rettenbeck's convincing explanation, is the real significance of the votive. Originally the wooden leg must have been a symbolic means of identification, embodying suffering and prayer for healing on behalf of the injured leg. Once this was achieved, it became an acknowledgement of the act of grace. These phases need not have succeeded one another chronologically but may have been concentrated into a single act of sacrifice.

377, 378
The most impressive manifestations of this identification (in more than one sense) can be found in some iron votives which are quite remarkable even in respect of their form. This approach to their conventional, sometimes even primitive shape may be criticized on the grounds that their great expressive power was not created intentionally and that our evaluation is mistaken and owes too much to the imagination. In defence of our approach we maintain that no work made by human hands can fail to evoke such a response as long as it embodies the relevant qualities, which in this case are the forms.

A rod of iron, split and forged by human skill with a hammer into a kneeling human figure with hands raised in supplication can personify fervent prayer in the most intensive manner. No rationalization can argue away the resulting expressive power or shrug off the form as accidental and misunderstood once it is recognized for what it is. The representations of animals, where there is no possibility of misunderstanding a human gesture, are equally moving. In those, too, representations of horses, pigs, cattle or geese are condensed into an irreducible but very vital and meaningful formula. This is achieved without excessive distortion of the basic fabric, the hoop iron and its simple accessories.

Specific local shapes can be observed, for instance, on examples from Aigen-on-the-Inn which may be the work of one particular smithy. Identifiable forms arising from special methods of production may be recognized, as Rudolf Kriss has done,[187] but that does not necessarily indicate a definite historical development. Even attempts to establish which pieces are earliest remain quite unconfirmed. The places where they were found or a written message may give a clue, but not the votive itself. Yet Rudolf Kriss thinks he can see development even in the distribution. According to him the use of iron offerings spread from central Bavaria northward into the Bavarian Forest and established itself there no earlier than the eighteenth century. In Franconia, however, it was already established in the Middle Ages, as mentioned by Josef Maria Ritz.[188] It was not confined to churches dedicated to St. Leonard, as was formerly assumed. However, churches or places dedicated to him obviously had more than their share of iron offerings. Since this saint, before he became the protector of animals, was predominantly the patron saint of human prisoners, the many objects in human shape associated with him must in the main belong to an earlier period, which seems to be confirmed by their shape. This is particularly true of the specimens excavated at Pflaumloch, Württemberg, which Kriss dates back to the High Middle Ages along with similar votives from Bavaria. This confirms that in the field of religion there was a tradition extending from the Middle Ages into the early modern era, but that this was the beginning of the divergence which produced folk art as it is defined in this book. 'Nearly every place of worship later develops its own increasingly individual style in the way of the smith's craft, which reached a peak in the seventeenth and eighteenth centuries and, with it, its most typical form.'[189]

Another tradition which can be traced back to the Middle Ages involves so-called *Gittergüsse,* small flat malleable casts made of lead or tin which pilgrims bought at shrines and brought back as tokens that they had fulfilled their pious mission. A large number of such medieval symbols representing the specific patron saint or place of pilgrimage have been found everywhere in Europe, including Germany. These figures belong to a well-defined tradition, partly dictated by the technique of making them as flat casts in stone moulds. The very large demand resulted in a conventional form. Framing cross-pieces, often indicating a casing, enclose strongly stylized figures of, for instance, the holy Three Kings of Cologne. These fragile specimens which, unlike iron offerings, are not designed to last very long, are flat, perforated metal plaques similar to the mountings for wooden chests which were made in the same way. In the field of this type of metal decoration a kind of product was evolved which, in the total framework of medieval art and craftwork, can be described as folk art. The description is not entirely accurate in modern times because it is not confined in the same social sense to a special group—one can hardly call pilgrims a separate social class.[190]

Pilgrimage symbols are only one form of emblem, though they can be traced back over a long period. Among favourite themes are models of famous miracle-working shrines. It is a particular strength of popular Catholic practice that the powers residing in these shrines could be transmitted into small articles of use which could be carried anywhere. They range from amulets to figures in a procession and, in the form of a small tablet on the living-room wall in the domestic shrine, accompanied the pilgrim through everyday life. The material character is very pronounced in the 'fancy work' which mainly originated in convents. They are products of painstaking industry. They may be small figures made of wax or just painted on paper, clothed and surrounded with a drapery of tinsel consisting of spiral wires which are arranged into tendrils and blossoms. They are interspersed with an endless variety of trimmings like glass beads, stars, shells,

392, 394

hearts, grapes etc. There are tiny metal discs (like sequins) stamped out of thin sheeting, and cardboard pieces wrapped in woven thread and cut to form ornaments or holy symbols. Devotional pictures and weather blessings, reliquaries, canonical tablets and bridal crowns, Christmas cribs and even secular objects such as wedding gifts of figures in bottles play a part in this laborious kind of decorative work. It is intended as an expression of veneration, but is often so excessively ornamented that the essential feature, the picture of the Holy Virgin, is scarcely recognizable among all the embellishments. The Franciscan convent of Reutberg on the Kirchsee, Upper Bavaria, is one of the places where such intricate work was done. Its origins can be traced here, at least in the technical sense, back to the first half of the nineteenth century. However, the practice of making such work is older. Being a decidedly Baroque form of decoration it reached a peak in the eighteenth century. It must have become the main occupation of many of the women in those convents, and some of it must have been done for sale. This particularly includes those pieces of work in which the little image, in its surround of tinsel work, was sewn on a piece of cardboard which was then put into a frame under glass. Some of the preserved specimens can be traced to a specific convent, for instance that of St. Walburg in Eichstädt. Often they were made in collaboration with experts from the glass-working crafts—the part played by the different arts varied considerably. Glass could be the housing for groups of figures or it could, as a flat sheet, be worked into reverse painted, polished or etched frames. The idea of the beauty of something so artifical and detailed in its decoration kept the craft alive throughout the nineteenth century and it remained, except for a few concessions to the style of the Biedermeier period, true to its Baroque tradition.[191]

In reality the taste for pictorial work of such pronounced artificiality originated in late medieval times and had admirers in the academies of the late Renaissance. The eighteenth century then introduced this tradition into the pattern of popular devotional practices.

Two more types of religious image must be taken into consideration: reverse glass paintings *(verres églomisés)* and the Christmas crib. The urge to testify to one's faith visually and materially is common to both categories but is expressed in very different ways. Popular reverse glass paintings with images of divine or saintly figures were produced from the eighteenth century onward on an almost industrial scale from two sources. Starting from the small medieval *verres églomisés* a new art craft arose in the sixteenth century in which large surfaces of sheet glass were painted in reverse with reproductions of famous paintings or with various other motifs as wall decorations for houses of the bourgeoisie and the aristocracy. In the seventeenth century Augsburg, the city of printers and publishers of illustrations, became the home of this type of representational art for daily use. In the following century production spread to Oberammergau and Seehausen where the wood-working flourished as a cottage industry. This move into the country helped to satisfy a vastly increased demand for wall decorations from broad segments of the populace. In the eighteenth century production rose to new peaks and became stereotyped. The key to this output was held by the works which

provided the sheet glass. Thus the glass-making areas—the Bavarian Forest, Bohemia, Silesia and the Black Forest—developed a reverse glass-painting craft which was linked with the glassworks and at the same time encouraged a large manufacture of picture-frames. Developments of this kind often went ahead very rapidly around the middle of the eighteenth century. These changes took place in very much the same way as those in the brass vessel industry along the river Maas which we quoted earlier as an example. The producer of the basic material, the brass sheeting or sheet glass, remained in control in one way or another. Masters controlled the production and wholesale merchants looked after the distribution, even to distant areas. The growing rural population could no longer make a living from the poor soil and had to take up work in this well-organized distribution system.

During recent years *verres églomisés* of the eighteenth and nineteenth centuries have become collector's items and people now regard them as the very essence of folk art. Their history has been adequately researched and very well written up.[192] Experts can trace many typical forms to definite places and times of production. The tell-tale indications are all sorts of characteristic features, including even the hooks for hanging them up; all this helps to establish the reverse glass as a material unit.

Since this is not the place to deal with the wide field of images in the strict sense of the word these few remarks must suffice. Representations on religious themes include pictures of Christ, the saints, even the Trinity, Holy Communion, souls in purgatory, and over and over again the Holy Virgin—suffering, praying, immaculate. The main motif, often copied from a shrine, is framed in an architectural, medallion-like or *passe-partout* mounting which may be either painted or made of polished or etched glass. Tendrils and flowers provide other motifs for the frame or decoration. The glass may be backed not only with resin-varnish colours but also with metal foil, thus creating reflecting areas on the surface of the picture. The combinations of these techniques are very varied and provide clues as to the place and time when they were made—at least during the years between 1750 and 1850, when output was at its height. The most productive regions were the Giant mountains with the glassworks around Hirschberg and the hilly country near Glatz, and, in the Bavarian Forest, Raimundsreut in the district of Grafenau; outside the German lands, in Bohemia, Moravia and adjoining Austrian territories other production centres were established, and a little later similar work was carried on by workshops in the Balkans.

With the large increase in production the forms became routinely superficial. The procedure, consisting of a preliminary linear drawing and then filling in the spaces, was entrusted to different hands, perhaps members of a family including the children. This largely precluded consistent control of the effects while the work was in progress. One can recognize the routine brush-strokes by which different, or even initially simplified models were reduced to a summary formula. Only the most simple means were required to achieve the representation of the personage to be honoured; they would be immediately recognizable by their attributes, their robes, their bear-

389, 391, 395

ing and the typical features of their appearance. It was this transformation of Baroque ideas into rigorously simplified forms which, at the beginning of this century, roused widespread interest in popular reverse-glass painting and inspired modern artists to experiment for themselves.

In the eighteenth century, alongside the cultivation of images which penetrated the homes of all sections of the population in Catholic regions, a fast growing interest arose in Christmas cribs as a three-dimensional representation of the Christian idea of divine salvation. This branch of pious work, too, has its roots in the Middle Ages, both in sculpture and in popular drama. The Counter-Reformation revived a sense of joy in creating such structures with their familiar scenes, to which an ever-increasing number of additions were made. To be always mindful of the accounts of the Christmas story in the Gospels was required by Ignatius Loyola, and after the Counter-Reformation this became a general matter of concern to the Catholic Church. A walk around the oustanding collection of old cribs in the Bayerisches Nationalmuseum, Munich conveys something of the outlay in both materials and imaginative elaboration involved. This effort was characteristic of the Baroque era but persisted for some time afterwards.

397

The enormous displays of scenery and figures in Bavaria enticed members of the community into the churches; only the wealthy bourgeoisie or the aristocracy could afford such elaborate creations for their own homes. However, smaller examples on a more popular scale did exist. The areas where the wood-carvers settled, for instance Oberammergau and Berchtesgaden with their surrounding districts, were kept very busy. Of course, this production was not confined to places close to plentiful supplies of timber but also flourished in urban workshops of all sizes. The craft assumed different forms in different regions; for example, the Saxon Erzgebirge preferred secular additions such as mining and landscape scenes. Like popular dramatic performances in the late Middle Ages, the Christmas crib incorporated various secular aspects. It is, of course, debatable how far the making of these cribs can be classed as folk art. The wide selection of figures often brings them much closer to the great masterpieces than to the stereotypes of reverse glass painting. The fact remains that until quite recently well-known popular carvers were still engaged in carving figures for cribs. Building up the crib scenes with all their accessories was a highlight of the Advent season. The carvers of Oberammergau also prepared display cases for domestic use that could easily be transported. In those, the Christmas crib scene could be seen under glass, embellished all round with the kind of tinsel ornament described above.

399

If one looks for examples of religious folk art in Lutheran areas they are most likely to be found in places where the body of the church is still arranged in the same way as it was during an eighteenth-century service. The fixed pews face the pulpit—rather than the altar—and so express most clearly the social structure of the community. It should be remembered that in the eighteenth century Protestant services lasted several hours, the sermon alone about two. The length of the service was partly due to the fact that after the ser-

mon the minister had to read from the pulpit the laws and regulations issued by the secular authorities, which often ran into many printed pages. The reading of these official announcements was important because it was equivalent to their publication. For the same reason, too, seating in the church was carefully allocated. To quote one example, in the parish of Ostenfeld near Husum in 1726 the 662 available seats had to be distributed among 91 small-holders. The key to the allocation was the size of the holding and the amount of taxes paid. 'Every cottage has seats for one man and one woman. If more than one family live in a cottage they must divide the two seats among them. If several cottagers live together they must not quarrel over church places. Around 1777 there were 15 crofters and 35 cottagers in the whole parish, who required 65 seats. The other 596 seats were divided among the $91\frac{1}{2}$ small-holders (there were holdings ranging from a double down to a half holding). Thus each one got on the average $6\frac{1}{2}$ church seats.'[193]

The right to occupy a certain pew was frequently tied to a house or holding. If the house changed hands through inheritance or sale the pew also changed owners. Like the burghers in the towns, the landowners in the country represented the community in more than secular matters. If pews became scarce, crofters, cottagers, servants and children had to be accommodated on provisional seats or to stand in passages and corners. The building of church galleries which took place nearly everywhere in the eighteenth century indicates the growth of the population, particularly in the country. The presence of at least one member of the family at divine service was not only a religious obligation and a sign of adherence to the congregation of the church, but because of the official announcements that were read out was in the practical interests of the secular authorities and the members of the community. These notifications, couched in bureaucratic language, probably did not rouse much interest, but the pastor also announced local items, such as information about stray animals, offers of things for sale and the like.

A crowded church therefore represented the community, ready to listen to the word of God and its interpretation as well as to the commands of the authorities. Here they were to be seen in their full social order, strictly arrayed according to rank, property and influence and divided according to sex. In the woman's pews the costume added to the demonstration of both the solidarity of the community and at the same time its division by rank and importance. Each displayed his or her status by the position of their seat in the church and by their costume. The total effect must have made a powerful impression. It was a demonstration which in itself can be called a work of folk art.

Those who could afford it enclosed themselves by fitting a door between the ends of each pew. The door or pew-end were favourite spots for displaying the names of the owners, personally chosen pious slogans, and some kind of ornamentation. There was sometimes even a forged iron arch connecting the two pew-ends through which the owners entered their pew. Other accessories were added, perhaps a footstool, a ledge or a decorated drawer for the hymnal. Those whose seats were next to the wall fitted wood-chip mats to protect them-

selves against the cold and moisture, like those on the inside of the wall-bed at home. On the seat lay a cushion, sometimes with an elaborate woven pattern. Every woman brought a warmer, a basin containing embers, called the *Stövchen* ('little stove'), to push under her skirt. In short, one prepared oneself adequately for the lengthy session and transferred something of the character of a private home into the church.

402 The private pew, particularly the parts facing the aisle, were marked with the owner's name, house and symbol of trade, mostly in carving but sometimes on a brass plate. The pew door by which whaler-commander Lödde Rachtsen in 1743 closed off his seat in the church on Hallig Hooge (north Friesland) is well known through many reproductions; it now functions as the door of the pulpit. Apart from the donor and his wife there is a female whale with her calf below the couple carved in bas relief. In Dithmarschen, where the wealthier farmers possessed family crests these are carved into the sides of the pews.

One of the most peculiar features of these almost 'homely' arrangements of the body of the church are the racks for men's hats. In some areas they did not consist simply of hooks but grew into large iron structures. The most remarkable examples are the hat-stands that project from the rows of pews in the churches of the Vierlande. They bear a surprising resemblance to multi-coloured and multiform shrubbery. Oskar Schwindrazheim studied them as early as 1903. As in other examples of Vierlande folk art there is a tendency toward flower patterns. Compared with them hat-stands elsewhere, which hang outward from the church wall, downward from the gallery or stand up from the sides of the pews may be simpler, but are often more original and imaginative; for instance, those in north Friesland, Angeln and north Schleswig. Some churches in Pomerania and Silesia, too, have preserved elaborate hat-stands. They must have satisfied a general demand.

In towns and villages where the social structure was more rigidly developed, churches had to provide not only the town or village council but also the craftsmen's guilds with strictly designated pews. They were very jealous of their exclusive rights. In Saxony, for instance, this applied to the miners, who regarded themselves as particularly faithful guardians of the church as well as the civic community. The exclusion of trespassers sometimes led to bitter altercations. A warning making the privilege crystal clear is carved into the barrier enclosing the seats of the shopkeepers' guild at Stralsund, erected in 1574 in the church of St. Nicholas:

Let no-one shut a shopman out,
Or I shall hit him on the snout.[194]

The words are ascribed to a figure depicted in relief. It is one of those figures of the door-keeper type such as are often encountered on gates. A carving on the door of a pew in the sixteenth-century church at Heide (Holstein) shows David and Goliath. This theme rarely occurs in contemporary picture patterns and could contain an implied threat.

To the best of our knowledge the history of pews in Protestant churches has not yet been written. As a whole they mirror in a most vivid manner the development of social conditions and demonstrate expressively the interplay between private reserve and public order. Each citizen—from the highest dignitary to the despised executioner—is allocated his proper place. Only in this order could there be room for the display of folk art, if we exclude the altar, pulpit, baptismal font and organ as the main items of church furnishing. Going to church should be viewed as a complex ritual which began with the walk there from one's home. In some communities the congregation waited in front of the church door for the pastor to arrive and then followed him inside in procession. After the service a walk to the churchyard frequently followed to visit the family graves. Above all it was an occasion for the exchange of news and opinions. It was also an opportunity to display one's 'Sunday best'. In the villages of Lower Saxony the champion marksman was allowed to appear at church four times a year wearing his marksman's chain and silver bird pendant.[195] Among women's status symbols was the hymnal, often mounted with silver clasps. The richly embroidered ceremonial handkerchief was held in one hand in a prescribed manner, as was the small smelling-bottle; this, too, was usually made of silver and had a place to hold the coin for the collection. In the other hand one carried the warming box, the highly polished brass bowl with its ornamentally perforated wooden casing. Many churches provided 195 anterooms where women could rearrange their dress, particularly in bad weather, and put on their jewellery. It is not surprising that the theme of 'going to church' had a particular fascination for nineteenth-century painters. In the Elbe and North Sea marshes, where the farmsteads were spread out over a broad plain, the wealthier farmers at least drove to church in state; provision was made there for stabling their horses. Their carriages had an elegant design and were 74 carved and painted. The differences in the owners' status were clearly visible in these decorations.

Miscellaneous Folk-Art Objects

In preceding chapters various groups of artefacts have been described—although sometimes only in a sketchy and summary form—according to their characteristics, their origin, the way they were used, their evaluation and more particularly their shape. The author is fully conscious that the subject requires an evaluation of other aspects. If one begins by looking at the clearly defined groups of articles, questions of 'whence' and 'why' soon arise. All our material could have been classified according to its regional peculiarities, as Edwin Redslob did in the series of books started in 1923 under the title 'German Folk Art'. His reason for adopting this division was primarily to have some definite starting point for categorization. There used to be a conception that early tribal differences must be particularly vividly reflected in folk art. It soon became clear that—as in the history of house construction—original ethnic distinctions were soon superseded by those due to historical events.

It might be more valid to draw a differentiation according to occupational groups, since the available material can be related with some degree of accuracy to members of particular social classes. Apart from the craftsmen who actually made these objects, the peasants are the most numerous group and play the most important part, though it is quite wrong to dub folk art 'peasant art'. One would also have to include the art of herdsmen, sailors, fishermen, miners etc. Do-it-yourself workers are found among all groups. The concept of peasant art is very misleading because the rural community was profoundly divided internally, each territory in its own way. This meant that rural artisans fulfilled widely different functions in their relations with the general rural population as well as in their dependence on urban craftsmen, entrepreneurs (of metal- and glassworks, distributors and publishers), public demand, possibilities of export and transport, guilds, journeymen's wanderings etc.

Before people at last began to take an interest in folk art as art, studies had tended to concentrate on social and economic conditions of production. Bernward Deneke has pointed out that in the course of the nineteenth century factors which had originally been seen as a problem of public administration in the cameralist spirit came to be viewed as an object of social and economic policy and led to the enactment of measures to improve organization, education and marketing. Whatever one may think of these efforts, the existence of folk art in the pre-industrial era cannot be understood without taking these social and economic factors into account. This alone does not, of course, necessarily explain the characteristics of these products as works of art.

There have been attempts to classify folk-art regions in wider contexts, for example to counterpose colourful regions against drab ones. During past decades many people travelling from one place to another may have formed the impression that such contrasts existed, but this effect was frequently due only to the fact that the objects concerned stemmed from different periods. This impression was created by the influence of the artistic style of the era, of a passing phase in history which may be reflected in, for instance, period costume. A glance at the historical changes with occurred will usually put the apparent difference into proper perspective. To quote an example: in a very illuminating study Matthias Zender contrasted different areas of pilgrimage. Franconia and the district of Cologne with their festive and much-decorated places of pilgrimage stand out against the region of Trèves (Trier) where private pilgrimages predominated.[196] Or a ship ran aground near the island of Amrum with a cargo of brightly coloured materials, and from that day on the dresses of the local women became colourful.

All folk art can also be classified according to the different materials of which the articles are made, as we have done in some chapters of this book. In every case this involves more than just the material; it also embraces the corresponding craft, its traditional form and its specific possibilities of adaptation. If one breaks the links between these aspects one disrupts important connections such as those of shape and function. More recent literature therefore quite rightly emphasizes such connections: for instance those between religious folk art and pilgrimages in particular, as well as with faith and worship in general. Domestic furnishings must be seen in their practical and social context and in their connection with home life generally. Festive symbols, including masks, must include both the equipment temporarily donned by the person and the setting of the festival as well as all the paraphernalia connected with it. The same applies to a carnival or a shooting competition. All these absolutely essential relationships can only be hinted at in this book, indispensable though they are in understanding the objects that we see in museums.

The relationship of the object to its functional context may be put more precisely in the form of keywords: it might for instance follow the course of an individual life. Oskar Seyffert called his well-known book on Saxon folk art, which appearred as early as 1906, *Von der Wiege bis zum Grabe*. The single word 'death' could conjure up a large complex of images and concrete objects. In the illustrations we show a few examples from the wide field of popular tombstones. True, Leopold Schmidt called stone the 'material of power'[197] and for that

360

356 Handle of a mangle-board. Beech. 1798. From north Friesland (?), Schleswig.

357 Pipe. Wood, carved. 19th century. Acquired in the region of Bückeburg.

358–359 Head-pieces depicting a sitting figure and Samson fighting the lion. Oak, with traces of painting. End of 15th century. From the former organ-loft in the Nicholas church in Kiel, Holstein.

356

357

358

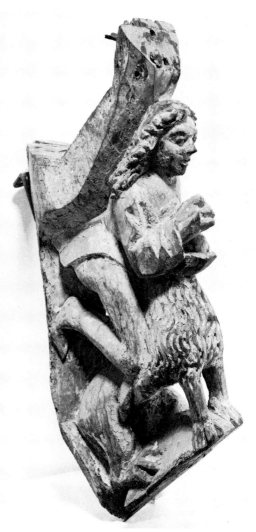

359

360

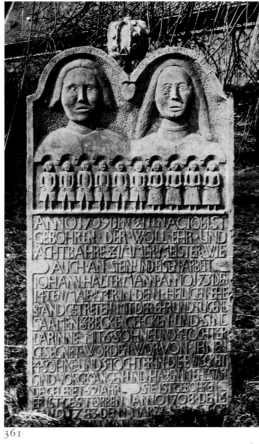

361

362

363

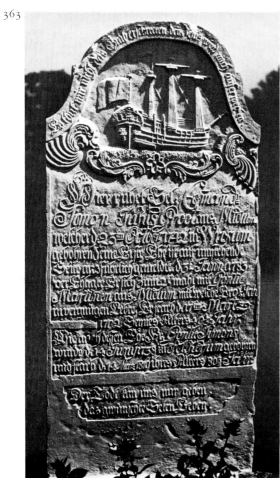

364

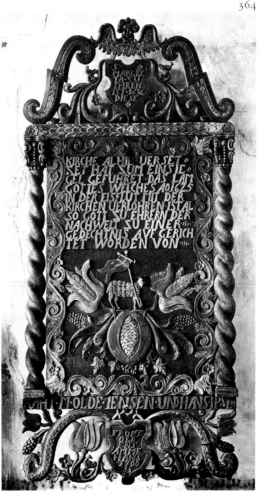

365

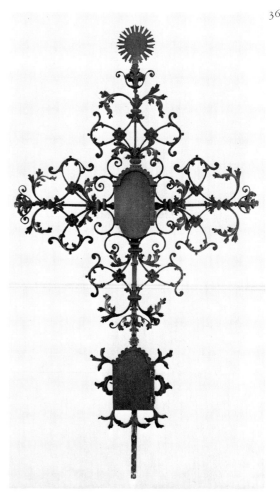

360 Tombstone. Granite boulder. 1640. On a grave in the cemetery at Keitum, Sylt, north Friesland, Schleswig.

361 Grave stela of the family of Johann Haltermann (1709–83) from Seebergen. Sandstone. 1795.

362 Two anthropomorphic urns. Earthenware. 19th century. Lower Bavaria.

363 Grave stela. Sandstone. 1792. In the cemetery of St. Johannis Church, Nieblum, Föhr, north Friesland, Schleswig.

364 Memorial plaque in the church of Hallig Gröde, north Friesland.

365 Cross on grave. Wrought iron, formerly painted. *Circa* 1730. From Bavaria.

366 Cross on grave. Wrought iron. 1840. From Astedt, Brunswick.

367 Epitaph of Clawes Syverdt in the church of Landkirchen, island of Fehmarn, east Holstein. Wood, carved and painted. 1640, renovated 1740.

366

367

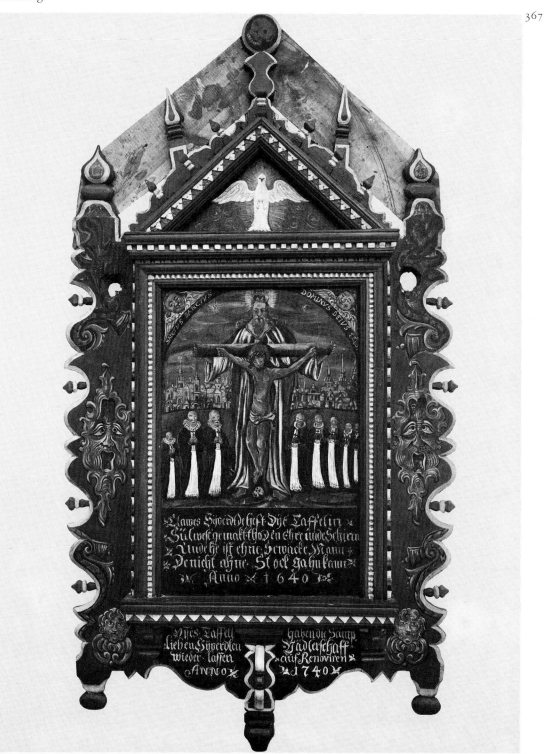

219

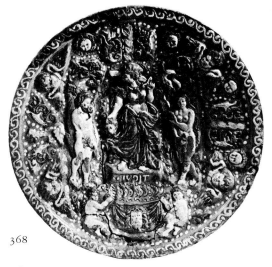

368

369

370

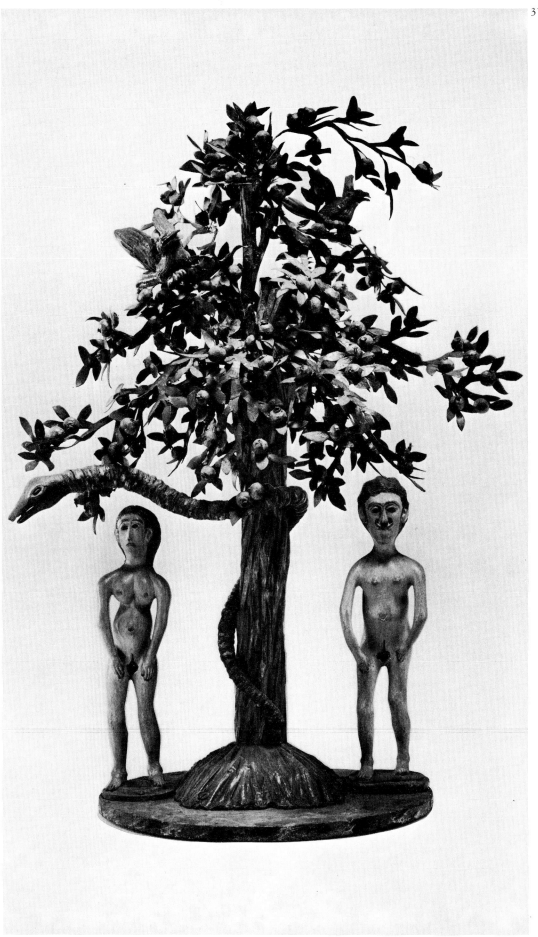

368 Display plate. Pottery with relief, slip painting and lead glaze. Early 18th century (?). From the island of Fehmarn.

369 Dish. Pottery with slip painting and lead glaze. 1710. Made in Tönnisberg, Lower Rhine.

370 Peep-hole in a living-room door, with picture of Adam and Eve. Hardwood. From the house of Christine Carstensen, Wrixum, island of Föhr, north Friesland, Schleswig.

371 Group of figures: Adam and Eve. Wood, sheet iron and hemp, painted. *Circa* 1830. From Upper Bavaria.

372 Letter of Good Wishes. Paper, cut out, pierced, painted in water-colours and inscribed with the initials J. K. and O. J. K. 1842. From Oldsum, island of Föhr, north Friesland.

372

373 Bentwood box with inset. Wood and metal. 18th century. Made in Upper Bavaria.

374 Ship's shrines (or votive offerings). Wood and linen. 1770.

375 Five votive offerings. Wax. 17th–19th century. Denture from Oberhautzenthal. Windpipe and gullet from Dreieichen. Testicles and penis from Oberhautzenthal. Tongue from Günther's wax-chandlery in Bogen, Lower Bavaria.

373

374

375 ▽

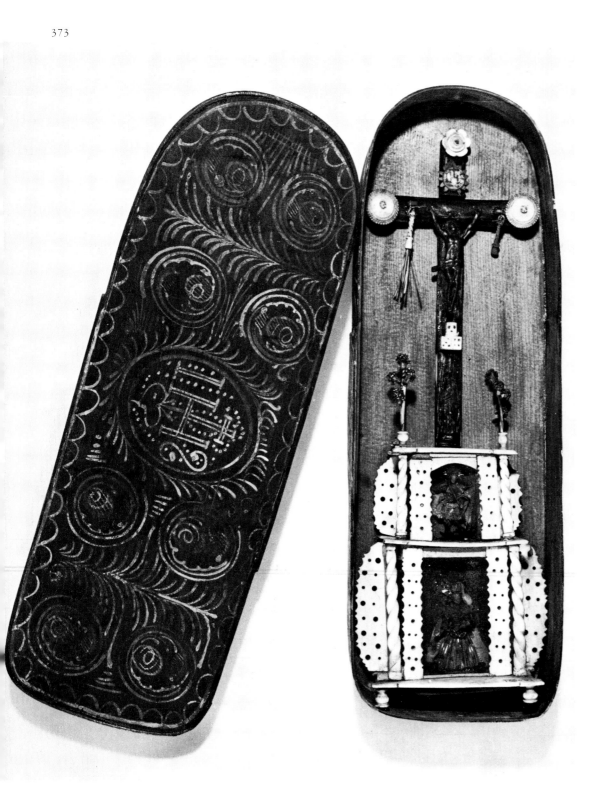

376 Three votive offerings in the shape of toads. Wax. 377 Animal votives: team of cattle. Wrought iron. Date uncertain. From Bad St. Leonhard, Lavant valley. 378 Two animal votives: geese. Wrought iron. Date uncertain. Both from Aigen am Inn.

376

377

378

S.ᵗᵃ Dorodea

S.ᵗ Josephiu:

S.ᵗᵃ Joanna

379 Devotional picture. Paper, cut out and painted in water-colours. Third quarter of 18th century. From north Friesland.

380 Devotional picture. Second quarter of 18th century. Found on Sylt.

381 Devotional picture. Latter half of 18th century.

382 Votive tablet. 1796. Pilgrimage church of St. Leonard, Siegertsbrunn, near Munich.

382

EX VOTO
1857.

383

Am 13 August 1847 fiel der 4 Jahr alte Knabe Anton Maier,
Sohn des Anton und Theresia Maier Bauer von Deißing
in eine Sense welche Ihm die Kniescheibe entzwei
schnitt, und durch die Anrufung des heiligen Sal-
vator wieder geheilt wurde.

384

385

Joseph Zick ist von wegen des S. Salvator von Blut brechen
wieder beschädiget worden und hat dies Tasten, hieher velobt.
Kipfenberg den 21ten May 1830.

Eine gewiße Persohn
verlobte sich in einen
sehr traurigen Zustan-
de zu dem heiligen L
onhard und hat durch
seine Fürbitte Hilf
erfahren 1010.

386

226

383 Votive tablet. Oil on wood. 1857. From Eichelberg (?).

384 Votive tablet. Oil on sheet iron in wooden frame. 1847. From Bettbrunn, Köschnig, Eichstätt district. Upper Bavaria.

385 Votive tablet. Oil on wood. 1830. From Bettbrunn, Köschnig, Eichstätt district, Upper Bavaria.

386 Votive tablet. Oil on wood. 1830 (?). From Siegertsbrunn, near Munich, Upper Bavaria.

387 Votive tablet. Oil on canvas. 1735. In the pilgrimage church at Friedberg, near Augsburg, Bavaria.

388 Votive tablet. Oil on wood. 1753. From Siegertsbrunn, near Munich, Upper Bavaria.

387

388

Erbarmet euch ünser.

389

390

391

392

228

389 Souls in purgatory. Small picture. *Verre églomisé.* 19th century. Made in the Bavarian Forest.

390 Centre-piece. Bone and wood in glass. 18th century. Made in Berchtesgaden.

391 Devotional picture: the Holy Family. *Verre églomisé. Circa* 1800–1820. Made at Raimundsreut, Bavarian Forest.

392 Crucifix. Ivory and braid; framed. 19th century. Made in monastery. From southern Germany (?).

393 Fancy work. Left wing of a small Walburga box. 18th century. From Bavaria (?).

394 Weather charm. Fancy work. 18th century. From the vicinity of Reichenhall.

395 *Verre églomisé:* Anna Selbdritt. Last quarter of 18th century. Painted at Raimundsreut, Bavaria.

393

394

395

396

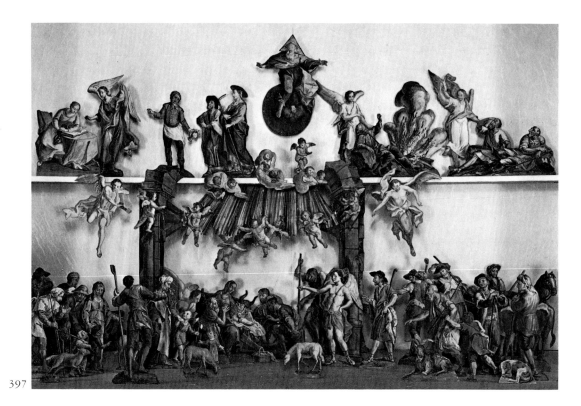

397

398

399

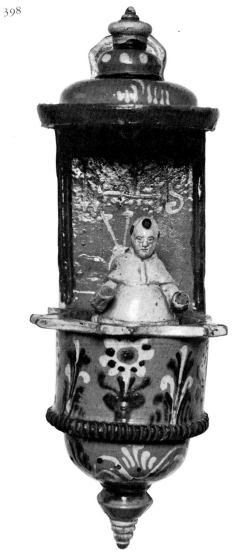

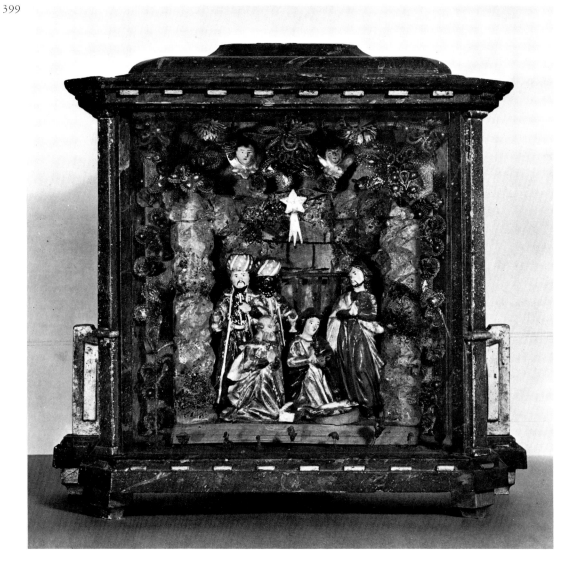

396 Holy-water stoup. Pottery. 18th–19th century. Made in Kröning, Lower Bavaria.

397 Christmas crib. Paper, painted. End of 18th century. From Bavarian Swabia.

398 Holy-water stoup. Pottery, painted and with lead glaze. 1788. From Westphalia.

399 Display case with figures: The Three Kings in adoration before the Christ Child. Wood, framed in colour and other materials. Early 19th century.

400 Prayer-book and rosary. Bound in red velvet with mountings in silver filigree. 18th century.

401 Beam head. Oak. 1699. Church at Keitum, island of Sylt, north Friesland, Schleswig.

402 End of pew. Oak. 1564. Church of Büsum, Dithmarschen.

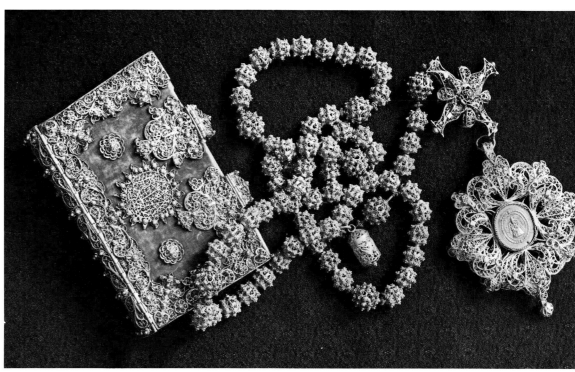

400

401

402▽

403 Cake mould. Beech. Early 18th century. From Kiel, Holstein.

404 Cake mould. Wood. Early 19th century. From Bücken, Lower Saxony.

405 Biscuit-cutter. Sheet iron. 19th century. From the island of Föhr.

406 Cake mould. Copper-beech. 18th century. From the mill at Aarsleben, near Jordkirch, north Schleswig.

407 Biscuit-cutter. Sheet iron. 19th century. From the island of Föhr.

403

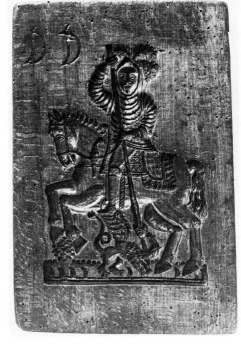

404

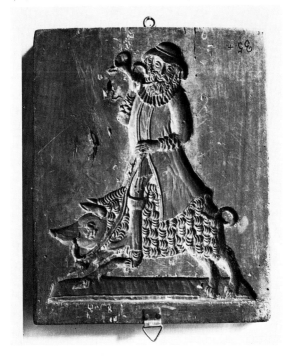

405

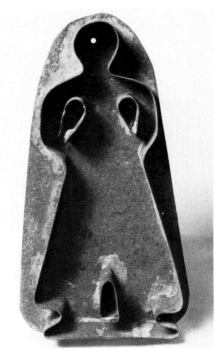

406 ▽

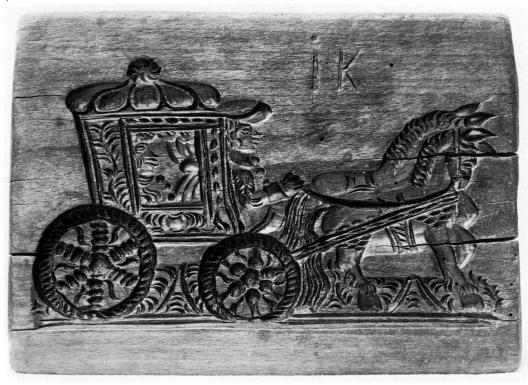

407 ▽

408

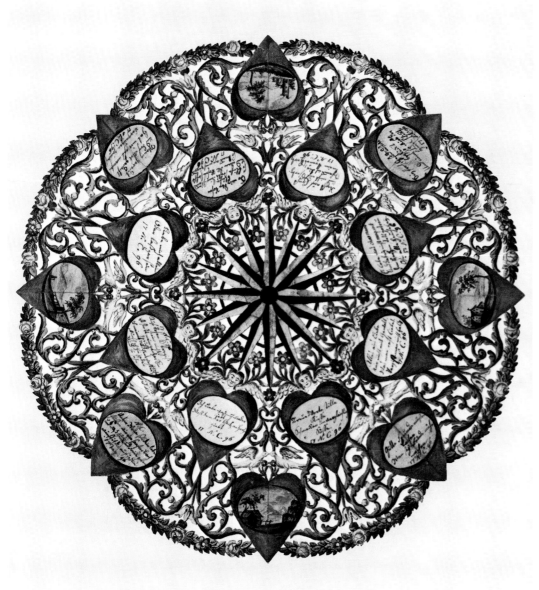

409 Love-letter. Paper, silhouette, painted in water-colours. 1796. From Schleswig-Holstein.

410 Silhouette. Paper. End of 19th century. Originally from Fockbek, near Rendsburg, Holstein.

411–412 Pierced-work pictures. Paper, painted in water-colours. End of 18th century. From the province of Schleswig.

409

410

411

412

413 Nutcracker. Wood (probably spruce), painted. 1912. Made in the Ore mountains (or perhaps in Thuringia).

414 Nutcracker. Softwood, painted. *Circa* 1930. Made in Seiffen, Ore mountains.

413

414 ▷

415

416

415 Toy: wedding coach with span of eight horses. Spruce, painted with casein colours. First half of 19th century. Made in Berchtesgaden.

416 Page from a toy pattern book. Coloured lithograph. 1840.

417 Cut-out figures. Light blue, vermilion, ochre and jet-black coloured woodcut. *Circa* 1700. Augsburg or Nuremberg (?).

418 Two puppets. Wood and fabric. Middle to latter half of 19th century. From North Germany.

419 Jumping Jack. Wood and papier-mâché. Middle of 19th century. From Hamburg-Altona. Made in the Ore mountains.

417

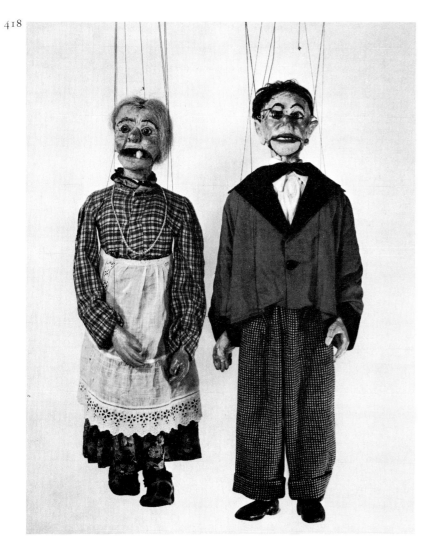

418

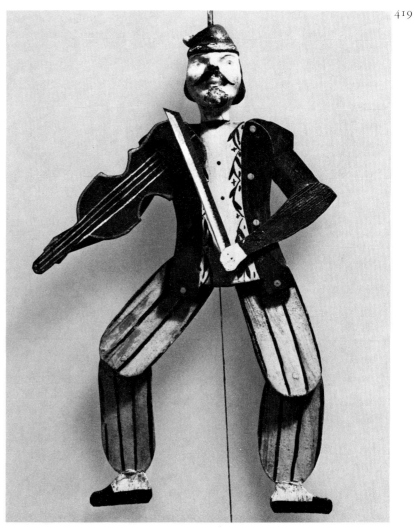

419

237

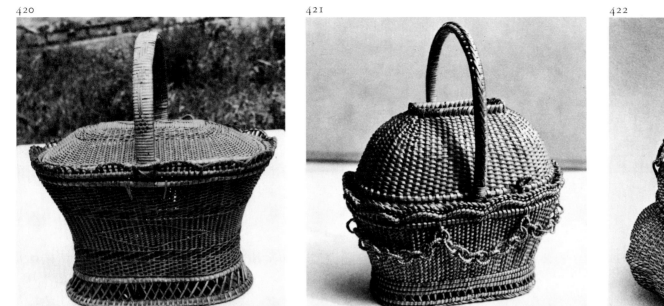

420

421

422

423

420–421 Baskets with handles (market baskets). Wickerwork. *Circa* 1900.

422 Needlework-basket. Wickerwork. Latter half of 19th century.

423 Basket carried on the back. Wickerwork, wood and leather. Middle of 19th century. From Franconia.

424 Bowl-shaped basket. Wickerwork. 19th century. Made in Lichtenfels, Franconia.

425 Shopping-bag. Woven bast, covered with leather. 1831. From Franconia.
Carrier-bag. Woven bast, covered with leather. 1817. From Straubing, Lower Bavaria.

424

425

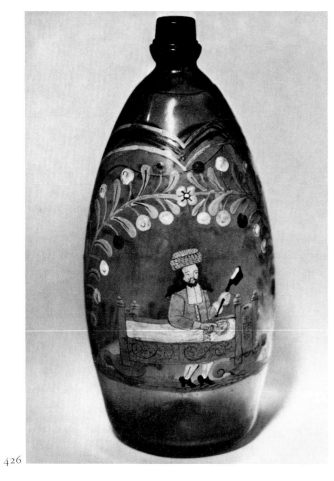

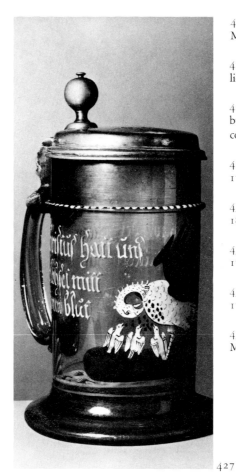

426 Pocket flask. Glass with enamel painting. 1711. Made in central Germany (Upper Franconia?).

427 Mug with handle. Enamel painting and pewter lid. 1699. Made in central Germany.

428 Guild goblet of the journeymen-bakers of Regensburg. Glass with enamel painting. 1679. Made in Franconia or northern Bavaria.

429 Goblet of a joiners' guild, with enamel painting. 1745. Reputedly from Franconia.

430 Mug with handle. Glass with enamel painting. 1808. Originally from central Germany.

431 Goblet with foot. Glass with enamel painting. 1715. Made in Franconia.

432 Screw-top bottle. Glass with enamel painting. 1770. Made in the Black Forest.

433 Pocket flask. Glass with enamel painting. 1721. Made in the Bavarian Forest (or perhaps Austria).

426

427

428

429

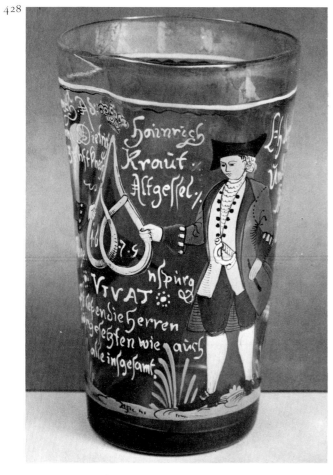

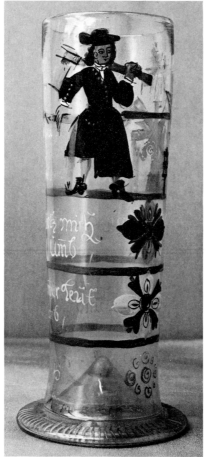

430

431

432

433

434

435

434 Room in a farm-house. Painting by Johann Sperl (1840–1914), oil on canvas. *Circa* 1875.

435 Room *(Dörns)* in Haus Agsen, Lindholm, north Friesland. Oil-painting on canvas by Carl Ludwig Jessen. 1906 (?).

436 Room in a farm-house. Painting by Theodor Schüz, oil on canvas. *Circa* 1860–70.

437 Interior of a house in Blankenese, near Hamburg. Painting by Johann Wilhelm David Bantelmann (1806–77), oil on paper on canvas. *Circa* 1870 (?).

438 Child's cradle. Painting by Peter Philipp Rumpf (1821–96), oil on canvas on cardboard. *Circa* 1860.

436

437

438

243

439 Panel of a wardrobe door. Softwood, painted.
1835. From Schollach, Baden.

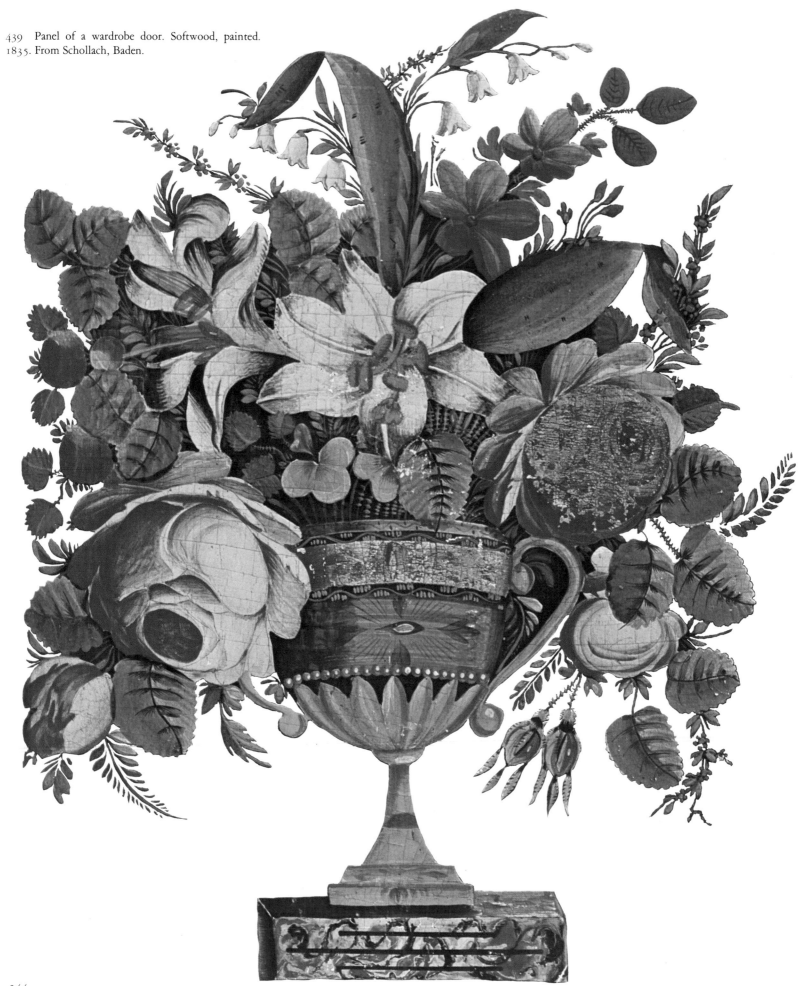

361, reason excluded it from the realm of folk art. But why? Even
363– nowadays we marvel at the expense that many not so affluent, even
367 comparatively poor people consider appropriate (or necessary) when
it comes to the erection of tombstones. But this is surprising only
when regarded from the current bourgeois viewpoint. Yardsticks for
assessing what is 'appropriate' or 'befitting' should only be drawn
from the traditions of a whole range of subjects, not just of one. In
this book grave-stones, which might be informative in this matter,
have been excluded in the belief that the juxtaposition of Plates will
illuminate much of the difference between rich and poor and also
between the old and timeless and the up-to-date. Both monuments
360, are made of stone. The rough granite boulder, difficult to fashion,
361, bears only a year and a monogram; the deceased is now nameless. The
363 sandstone one tells us a lot about a respected family. Yet granite is
more durable than the easily shaped sandstone. The latter had to be
obtained from afar and was expensive. It is impossible to separate the
recognition of art, or the absence of it, in such monuments from the
insistent language of facts which tell not only of piety but also of the
search for prestige.

If the subject of works in stone were to be pursued further, we
should have to include the memorial tablets and wayside shrines
which contribute much to the sacred character of the landscape in
Catholic regions such as Franconia. In other places such as Württem-
berg it was the job of the stone-mason to chisel the supports of stoves
in living-rooms. But tombstones were erected wherever sandstone
could be transported at a reasonable price.

The definition of folk art in this book is non-specific in many other
respects, in some cases because certain branches of it have recently
been expanded into extensive fields of research. Thus, for example,
we could only deal superficially with paper as a basic material. It was
not only the medium for script, symbol and picture but could also
379– be a real object. The nuns in the convents used it, by trimming and
381 cutting-out, to make lace-like pages with pictures which were used
in private worship or as symbols of friendship and love tokens. This
is another wide field of diligent craftwork on a small scale which we
cannot adequately describe here. The only Protestant counterpart of
the 'small devotional image' of the Catholic territories, apart from
410 silhouettes of biblical stories, are secular cut-out sheets. They are
often love letters or so-called *Bindebriefe* (bonds of friendship) with
complicated cut-out loops representing a knot binding the receiver,
372 who had then to ransom himself from this bond. The page with pic-
409, tures of ships illustrated here is simply a token of friendship; these
411, little gifts became very popular during the eighteenth century. About
412 1800 there appeared the popular little picture on which the figures
were executed by perforations with a needle. This was the kind of
thing that served to introduce pictorial secular wall decoration into
households with a lower standard of living. Thus the key-word
'sheet' leads one into different spheres. It applies to artificial flowers
which were made as ephemeral decorations for special occasions on
joyful festive days, but also to the fitting-out of coffins. Finally, the
417 paper theatre must be mentioned. Compared with the puppet
theatre, it had its own possibilities for dramatic representation.

Toys open up a new world of very distinctive forms as regards both 419
craftsmanship and shape. Most articles produced after the Renais-
sance in the toy-making centre of Nuremberg were of wood. The
craft soon turned into a cottage industry in rural areas, marketed
through middlemen. To take another example of classification
according to materials: glass manufacture, always located outside
urban areas, also shares many forms which fall within the general
theme of folk art. No raw material can be excluded—not even whale-
bone, used for the ribs of boxes and baskets, or fish-scales, incor-
porated into embroidery work like sequins. Anything made of horn,
quill, tree-bark or moss could become the basis of an organized
handcraft. At an early date the most flexible of all materials, wax,
achieved a dominant position, not only for wax objects but also
because it was useful in modelling and pre-forming metal casts.

An interesting aspect of the subject is the transmission of shapes
designed for one material, say for a wooden barrel, into another, for
instance clay or metal, always in a size appropriate to the new sub-
stance. The concept that the choice of material should be dictated by
the way one approached the work was as often disregarded, in an
undoctrinaire way, as it was—equally unintentionally—kept to.

There are some specific features in various territories which have
very distinct characteristics. Some objects may be regarded as unmis-
takably representative of their particular area. In Schleswig there were
double-wall hangings, in Holstein a particular form of hymnal-cover,
in the Vierlande an embroidered inset on cushion-covers and hat-
stands in churches, in the Ammerland a wrought iron standing lamp.
Characteristic of the Münsterland in Westphalia are the *Hungertuch*
(black altar-cloth) and the stove hook, of Hesse the bridal chair, of
the Hersbruck district in Franconia the *Schellenbogen* (yoke with
bells), of the Saxon mountain region the display box with mechan-
ically moving figures, of East Prussia knotted carpets, of Courland
in the Baltic fishermen's boats; the list could be continued indefi-
nitely. In each case the creative individuality of the region is evident
from the attention lavished on the form of a certain object over a
definite period, the variations being relatively slight. Each may have
originated with a single inventive genius. From a historical and cul-
tural point of view it is interesting to see how the original idea
developed into a continuing tradition and became obligatory within
a limited area. Bruno Schier has shown that the highly decorative
timber-frame gables of the Egerland go back to the work of one
individual, the well-known Baroque architect Johann Georg
Fischer.[198] Separate developments of this nature do not just occur as
unconnected phenomena, nor can they be shrugged off with a rather
pejorative term like 'sub-culture'. They are the visual manifestation
of a trend in the history of European civilization, a specific form of
individualism which includes even the humblest rural houses. The
high points of this individualism constitute the spiritual heritage of
the West. Some of these phenomena stand out from their surround-
ings. Others fit into a larger material context with a distinct character
in which home, clothing and furnishing all fulfil their function.

Adolf Spamer wrote in 1935: 'Folk art in a system of folklore is
neither a separate style nor a standard of value. It is the whole techni-

cal, ornamental and free creation of things by simple folk to decorate their homes and their environment. Folklore research should not be directed to the creative individual craftsmen but rather to the consumer of all the things he created.'[199]

These views have been accepted during recent decades by several folklore scholars who have contributed the fruits of their own research. On the other hand it should be emphasized that it is not clear what Spamer means by 'separate style', and that it is not justifiable to restrict the subject to 'decoration'. Regional manifestations of a 'separate style', a term not unknown in the history of art, even when they are dissociated from the work of one individual, represent a 'value' in their own right. Folklore as a subject has not yet developed its own categories as a basis for such judgements. Folklore literature is full of vague and unhelpful adjectives. We read of elements which are 'full of character' (Paul Pieper), 'racy' (Hans Karlinger, Josef M. Ritz), 'true' (Werner Lindner) and even 'absolutely genuine' (Adolf Spamer). Nor does it seem valid to describe the recipient, owner and user—or heir—of such articles, or the donor of a votive tablet or a worshipper praying before a devotional image simply as a 'consumer'. This may fit into the terminology of the modern consumer society, but it certainly does not suit the historical approach adopted by modern investigators of articles of many traditional kinds which have been created—but not yet 'consumed'. It is not the primary function of these craft objects to be 'consumed'. Why should not folklore scholars pay due respect to the active and formative element of creativity which affects so many different spheres of life, trades, materials and practices? If this element is ignored, the whole subject is deprived of one of its most valuable sources of knowledge and understanding.

Mass production of consumer goods by industrial methods is quite another theme. This has roots reaching far back into the past, but it began to affect Western civilization as cottage industry, publishing and manufacturing developed in the eighteenth century. Contemporary folklore badly needs research into its origin, development and influence. However, such research need not necessarily detract from a critical appreciation of traditions carried on from pre-industrial periods. This tradition cannot be adequately assessed in terms of modern concepts like specialized mass-production and consumption. It is much more strongly influenced by separate local or regional achievements within a society divided into classes. In this society the productive forces—including those of the intellect—will inevitably make their own impact. They may be receptive, evaluating, applied or perpetuating; but whatever form they assume they will contribute to the total stock of material culture.

Folk Art as Art

The subjects discussed in the foregoing chapters must be understood as an attempt to review the store of surviving material objects as a tangible and visible part of our tradition. It is difficult to define these articles within precise limits. The question of an exact definition of folk art is still unanswered.

Toward the end of the nineteenth century one thing became clear: alongside the arts sponsored by the upper classes, which were subject to fluctuations in style and taste, there had existed in the pre-industrial era a popular type of art. It had diverged from the upper-class form by virtue of its uniform development under varying conditions. It went its own way in different regions, or even more limited localities, and in different branches. This process was termed deterioration; but use of the pejorative words 'upper' and 'lower' classes immediately aroused opposition. The debate has continued ever since, but it will remain futile so long as folk art continues to be seen by some as an imperfect version of fine art while others try to refute their arguments; it should, in fact, be accepted as an art in its own right.

Acceptance of this approach resulted from developments in studies of art during the nineteenth century. The discovery of the 'picturesque' appearance of country folk was first made by creative artists.[200] Ever since the sixteenth century many painters had painstakingly recorded the different costumes of European regions and towns in graphic detail. From the end of the eighteenth century onwards national and local dress aroused increasing interest; it was no longer regarded as strange and peculiar but accepted as a valid artistic subject. This marked the beginning of a new chapter in the history of western art and, in a wider sense, of the history of civilization. At the time when folk art, broadly conceived, began to decline—that is to say, about 1800—artists began to appreciate the aesthetic value of the popular life-style. Two names spring to mind: Wilhelm von Kobell (1766–1855) and Lorenzo Quaglio the Younger (1793–1869), who both worked in Munich. Wilhelm Tischbein (1751–1829), the painter of Goethe, in his own somewhat different way, achieved similar results in Hamburg. These painters inspired their successors to paint scenes from the lives of the people, particularly peasants and fishermen. Soon after 1800, in direct contrast to the prevailing Neo-classical style of the period, we find the first paintings of this kind. Among them is an amazing picture of a wedding performed in a house on the island of Föhr by schoolmaster Oluf Braren (1787–1839).[201] Johann Baptist Pflug of Württemberg (1785–1866) also belongs to this group. A later generation of painters took up the themes in all its aspects. Among them were some young artists from Hamburg who, inspired by Tischbein and others, revived a half-forgotten tradition of seventeenth-century Dutch painting. Following the lead of Kobell in Munich, they produced some large-scale scenes of folk life. This group included Siegfried Bendixen, Johann Jacob Gensler, Hermann Kauffmann, and Heinrich Stuhlmann. In 1825 the book of Plates by Alois Schreiber entitled *Trachten, Volksfeste und charakteristische Beschäftigungen im Grossherzogtum Baden* appeared in Freiburg. Two years later Ludwig Richter wrote of the painter Johann Gottlieb Hantzsch (1794–1848), who was then working in Dresden, that after an 'unsuccessful attempt at Romanticism he happened to light on a theme which suited him much better. He painted very attractive scenes of village life; as he continued along these lines his pictures became extremely popular and achieved widespread recognition'.[202] A distinct category of painting developed which attracted the interest of ordinary people with only modest pretensions to artistic taste. Among the first of its practitioners was Jakob Fürchtegott Dielmann (1809–65), of Frankfurt. They were not leading academicians, but exercised a persistent influence behind the scenes. Accounts of art history hardly mention this school and there is as yet no coherent account of it.[203]

During the first half of the nineteenth century interest in the way people lived was stimulated by several factors. The late Romantic period provided fresh motivation. The contact which many painters had with the lives of ordinary folk in Italy opened their eyes to similar subjects at home. An entirely different way of life came to be seen as fit for adoption into the pictorial repertoire. It included not just folk costumes but many other objects which these artists considered 'picturesque'. The academies taught anatomy, old costumes, uniforms and weaponry with scholarly precision, in order that artists might paint historical subjects correctly; and in the same way the painters felt obliged to depict the trappings of domestic folk life accurately in every detail.

About the middle of the century folk-art objects were beginning to be considered worthy of being depicted for their own sake, although in many cases they were only sketched. Even a simple room in a farmstead came to be seen as an interesting motif. The last Plates in this book show a few examples of this kind. For the same painters this type of work remained a sideline. Among those who took it more seriously was Carl Ludwig Jessen (1833–1917), who painted many rooms in his native north Friesland.[204] His first inspiration came

when he was a pupil of Wilhelm Marstrand in Copenhagen. The description 'painted folklore' could be applied both to Jessen and to Carl Schröder of Brunswick (1802–67),[205] whose work might be regarded as a pictorial stocktaking of 'folk life' in an urban setting, including material objects in rooms, houses and courtyards. If these painters lacked true artistic genius they were soon followed by others who have an indisputable place in the history of art. One of them is Wilhelm Leibl (1844–1900). Bernward Deneke says it is important to ask 'when the aesthetic qualities of pieces of equipment were first recognized'.[206] The most convincing answer may be found in the testimony of painting. The printed word followed long afterwards: German folklorists were particularly tardy in acknowledging insights gained from pictures as opposed to scholarly research; in many cases they do not accept this evidence even today. It was indeed a protracted process which led to the introduction in the 1890s of the still indefinable term 'folk art' into the general vocabulary.

The first attempt to use this new understanding as an inspiration for the contemporary movement came from the ranks of creative artists. This is another chapter in the history of art which we can only mention in passing here. Parallel with it went a discussion in which scientists, economists, promoters of the arts and curators of museums took part. Bernward Deneke has followed up their findings on industrialization, its influence on handcrafts and its potential for encouraging the latter. These scholars also often touched on the question of folk art as an object of public patronage.[207]

By 1900 everybody was talking about folk art. The prevailing aesthetic climate at the turn of the century makes it understandable that patronage should then have been extended far beyond the academic work of Salon und Sezession as cultivated by traditionalists in the established art world. The art nouveau movement also drew inspiration from folk art, and the idea of an art founded on national sources also played its part. It is difficult to define in a few words exactly how far art nouveau is derived from traditional folk art. Publications on the subject certainly tend to overstress its influence. However, some efforts were made to revive old traditional crafts, such as carpet-weaving which, following the Norwegian model, incorporated traditional patterns and developed them further. Examples of this are the designs produced by Otto Eckmann for the 'art-weaving school' at Scherrebek, north Schleswig. In addition to these direct attempts to revive folk art there were numerous efforts to remodel old folk-art patterns. It would require more space to analyse the results of all these ventures.

The shift in taste at the end of the nineteenth century was followed about ten years later by the eruption of Expressionism, which brought much more sensitive understanding of the forms and meaning of folk art. It is common knowledge that the artists of Die Brücke ('The Bridge'), a movement which originated in Dresden in 1905, reacted passionately to the stimulus of so-called 'primitive' art. Suddenly the hitherto neglected artistry in the objects studied by ethnographers was recognized. Parallel with this went the 'discovery' of popular verres églomisés by the Blauer Reiter group of artists which included Vasiliy Kandinsky, Gabriele Münter and Franz Marc.

Between 1908 and 1910 they turned out a considerable amount of verres églomisés based on examples from popular mass production.[208] These artists' work helped to rouse intense public interest in verres églomisés and in folk art generally. Wilhelm Fraenger, an acute and inspired critic, signposted the way to a true understanding of the meaning of folk art and an appreciation of the artistic element in it through the symbolism of the Expressionists. He went on to demonstrate from Russian lubki the special quality of their extremely simplified formal idiom which resulted from a creative transformation of models drawn from upper-class art.[209] His analytical method and conclusions are still valid for the whole subject of folk art as it is defined in this book. Some scholars dealing with the phenomenon of imagery, i. e. the mass production of pictorial matter for the general population, have recently attacked Fraenger's findings.[210] There seems, however, to be some misunderstanding here. Expressionism must undoubtedly now be relegated to history, but this surely does not mean that everything which was recognized as art under its inspiration has automatically become meaningless. If art is no longer topical it does not cease to be art. Applied to folk art, this suggests that when something has played a constructive role in its history, it cannot be disowned afterwards simply because stylistic fashions have changed. Science may correct its findings but art follows a different methodology. Earlier work may be superseded, but not invalidated.

The point is that, when we talk about art we cannot get to the root of things without making value-judgements. Inevitably the question of artistic quality arises, and this can never be defined. Nobody can pursue studies in art history or criticism who has not acquired, through training and aesthetic experience, a yardstick to measure this portentous phenomenon of quality. This should be regarded as an elementary rule. Fraenger has shown that if one compares, say, a woodcut by Albrecht Dürer with a popular pictorial broadsheet in which the same theme is expressed in its own formal idiom, in multiple copies, it is not enough to proceed from a single concept of quality. Only once this rule was recognized could a proper critical treatment of folk art become possible. A history of art which includes folk art needs flexible concepts of quality. The work of genius represents one pole. Copies by artists of lesser rank can lead only to trivial derivatives. A complete transformation into the characteristic mode of expression adopted in a totally different social environment can lead to another pole of quality in its own right.

While Expressionism opened the way to an understanding of folk art as a kind of counterbalance to the art of the educated classes, academies and individual geniuses, it did not exclude a sociological appreciation of folk art: quite the contrary. In any case, it is not justifiable to balance social factors against aesthetic ones, as is so often done. Polemics of this type are generally based on a wrong notion of what art history is all about. Its purpose is to comprehend the origins of art—or preferably, of works of art—in the context of everything that conditioned them, social factors not excluded. Art history certainly does not concentrate exclusively on visual form. There are numerous passages in ethnographical literature where the erroneous opinion is advanced that art historians are not interested

in the 'meaning and significance' of the artistic object.[211] Such remarks are totally irrelevant to the real differences between the various aspects. It surely shows a complete lack of understanding to say that students of folk art and art in general are simply concerned with 'what is beautiful' (a statement which occurs even in some quite recent publications).

Folklorists would be well advised to pay due attention to the aesthetic aspects of people's lives. If they confine themselves to examining the supply of popular pictures and articles of various kinds from the social, economic and technical point of view they are, in fact, dealing with a different (albeit very important) subject. From the beginning folklore as an academic subject has found it difficult to delimit itself sharply, with regard to categories and methods, from other subjects. This is probably the reason for the constant temptation to under-rate or ignore the importance of the aesthetic aspect of folk art and even sometimes to dispute its right to be regarded as an art form. On the other hand professional art historians tend to concern themselves solely with the questions of quality, which they treat as a matter of prestige. Every art form has a historical sphere of influence. It is the legitimate task of the art historian to search for the point at which folk art achieves that second quality which Fraenger emphasized. As long as three generations ago Alois Riegl was pioneering this path. With a few exceptions like Hans Karlinger, it was left to museum custodians to secure for folk art the recognition due to it. Max Sauerlandt (1880–1934), the worthy successor of Justus Brinckmann and supporter of Expressionism, understood folk art, in the spirit of the *Blauer-Reiter* group as an inalienable part of that *ars una* which embraces every artistic expression, whatever its place or date of origin.[212]

There have been many attempts to define precisely the particular character of folk art. Again and again we hear about 'genuine' or 'true' folk art, often to differentiate if from industrial goods or *Kitsch* (trash). We should never describe folk art as 'following its own laws of development'. If we try to enumerate all its features we shall soon come to grief. It has a tendency to be two-dimensional, to symmetry, to serialism etc., but all these formal features are equally present, even combined in this way, in other fields of art, historical as well as contemporary. We shall have to settle for a general designation conditioned by the social circumstances of the time. Folk art always occurs independently of other forms of art but within the same geographical and societal realm as these other forms. It is the result of the fact that society is divided into classes. It breaks away from upper-class art and finds an independent form of its own. Some shapes may recur frequently, but it will never be possible to classify them in accordance with any supposed 'laws of independent development'.

While the style of the turn of the century and Expressionism provided a place for folk art in what one might term 'the museum of the imagination' of European civilization, it certainly did not disappear when those two artistic movements gave way to others. The 'discovery' of folk art could not be reversed. It had given new stimuli to the development of art in general, for instance to the *Werkbund* school of art and craftwork which, from the first decade of this century onwards, has been attempting to go beyond the renewal of artistic forms and to change men's whole way of life. Its members appreciated the 'pure', simple forms they found in traditional folk art. Walter Dexel has tried to find uncomplicated basic forms in wooden, ceramic, glass and metal implements and vessels. He believes these might possibly be connected with specific ethnic units and writes of 'workaday form' and 'folk form'.[213] Connections with ethnic units are certainly not plausible; however, Dexel's collection, systematically ordered as it is, has proved very useful, especially as a stimulus for contemporary work in industrial design. In this way folk art is still topical.

Paul Stieber has studied 'simple form' in the field of popular ceramics with passionate thoroughness and has opened up a field of research which is equally important to an understanding of folklore.[214] Contemporary art crafts demand 'functionalism' in both material and design along with simplified form. These properties can be found in some pieces of traditional folk art, but by no means in all of them; many groups of objects do not meet these demands at all. In brief, a wide interest in the concepts and above all in the practical execution of folk art must always take account of all various functions and aspects. Folklorists do not seem to have grasped this point. They consistently come out with polemics against putting excessive stress on decoration—as if decoration were all that mattered.

While Dexel's work was carried on mainly in the 1920s, a new interest arose after the Second World War, or rather during the last twenty or thirty years, again with an aesthetic bias. The discarded implement from the age of handcrafts, abandoned by our 'civilized', i. e. technology-oriented world, now catches one's eye. It has an appeal of its own which formerly went unrecognized and which cannot be brushed off as mere nostalgia. For instance, a yoke for a pair of draft oxen acquired over the centuries a totally original form with alternating advances and retractions, straight and curved lines. It is carved from hard wood worked with traces of the cutting tool and shows signs of wear: to our modern world of technological gadgets it looks like a puzzling fossil and is fascinating. It seems like a piece of sculpture, completely divorced from the original purpose which determined its shape. This is an exact parallel of the transformation by which, in the course of secularization, church furnishings have become works of art and museum pieces. Some articles illustrated in this book went through this process long ago. The traditional material, isolated from its practical function, acquires a certain aesthetic quality.

Things which often seem merely the result of some playful or snobbish whim sometimes have a very serious background. In 1914 a Frenchman named Marcel Duchamp was the first to put a bottle-dryer, then still a simple article in everyday use, on a pedestal and to proclaim it as a work of art. This act gave rise to a broad new field of fine arts alongside traditional ones. The term *Objektkunst* (the art of objects) signifies a new, living relationship to the objects that surround us in our daily lives.[215] An exhibition which opened in Berlin in 1971 was called 'The Metamorphosis of the Object'. It demonstrated in a most informative way our contemporary manipulation

of the world of real things, and emphasized the role of the object in its relationship to traditional art categories. Anything which artists produce today in this spirit will partake of the same fascination that we described as emanating from the ox-yoke.

This view may be found unconvincing on the grounds that it is based on an interest which is alien to the subject, its origin and its essence. Such an objection may be raised particularly in the case of the last-mentioned example. Obviously no aesthetic considerations shaped the making of the yoke. Surely therefore, any aesthetic judgement on it must be guided by entirely different criteria? Every possession which has outlived its usefulness will one day be considered unacceptable by our descendants. Whoever denies or tries to evade this fact assumes implicitly that any form can be judged adequately only in the context in which it was created. Here opinions will differ. If we are concentrating on art, every form may be seen, understood and interpreted anew; indeed, it must be seen in a new light but without offending in any way against the spirit of history. If we are dealing with an archaeological artefact which we examine solely with an eye to obtaining further data, then our interest will be in the reasons for its creation; we shall not perceive it as having any intrinsic interest, or at least this will be minimal.

The current tendency to take a favourable aesthetic view of traditional folk art does not exclude a historical approach to it. Even when we know that the yoke is thicker at one point because this is where leverage was exerted, and thinner at another point because no mechanical forces were at work there, this knowledge does in no way decrease the fascination we experience. This remains true if we take into consideration the social status of a span of oxen against that of a team of horses. An object retains its material, tangible essence even if we abstract from it all awareness of its functions, and not only the technical ones.

It should by now be obvious that we regard folk art as a historically circumscribed phenomenon. We therefore take the view—already accepted early in the last century—that there is no room for it in a civilization based on machine production. Anyone who thinks he can detect its survival in industrial mass production[216] is talking about something completely different. The apparent controversy is purely a matter of definition. A more serious argument is the objection to the thesis of the 'timelessness' of folk art, which even Hans Karlinger sought to advocate.[217] If this concept has any meaning it can only be in the sense in which all great art is timeless, i.e. valid beyond the conditions that prevailed at the time of its creation.

Notes

1 Annedore Müller-Hofstede, *Der Landschaftsmaler Pascha Joh. Fr. Weitsch 1723–1803,* Brunswick, 1973, pp. 174 ff.

2 H. Biernatzki, 'Die Schnitzkunst', p. 172.

3 Walter Hävernick, 'Volkskunst' und 'temporäre Gruppenkunst', in: *Beiträge zur deutschen Volks- und Altertumskunde,* 9, 1965, pp. 119–25.

4 Adelhart Zippelius, *Volkskunst im Rheinland* (Führer und Schriften des Rheinischen Freilichtmuseums in Kommern, No. 4), Düsseldorf, 1968, pp. 7–14.

5 Lenz Kriss-Rettenbeck, 'Der Hund Greif und die Frage "Was ist Volkskunst?" ', in: *Pantheon,* 1975, pp. 145–52.

6 Cf. Erik Forsman, *Säule und Ornament. Studien zum Problem des Manierismus in den nordischen Säulenbüchern und Vorlageblättern des 16. und 17. Jahrhunderts,* Stockholm, 1956.

7 Joachim Naumann (ed.), *Meisterwerke hessischer Töpferkunst. Wanfrieder Irdenware um 1600* (Kataloge der Staatlichen Kunstsammlungen, Cassel, No. 5, 1974), pp. 7–14: Alfred Höck, 'Wanfried und seine Töpferei um 1600'; Jochen Desel, 'Export und Verbreitung der Wanfrieder Irdenware', in ibid., pp. 15 ff. See also Joachim Naumann, 'Neue Funde Wanfrieder Irdenware in den Niederlanden', in: *Aus hessischen Museen,* 1, n.p., n.d., pp. 157–64.

8 See note 7.

9 In addition to the one mentioned by Naumann, another example, dated 1615, was found at Aalborg, Denmark. Cf. Helge Søgaard, *Lertøj fra nordjyske museet,* Århus, 1958, Fig. 70.

10 On the whole complex see Ernst-Sauermann, 'Eine nordschleswigsche Schnitzschule aus dem Jahr 1600', in: *Bericht über Verwaltung und Ankäufe des städtischen Kunstgewerbemuseums in Flensburg 1901–1905;* C. A. Jensen, *Snedkere og Billesnidere i Danmark,* 1911; Sigurd Schoubye, *Folkekunsten på Tønderegnen,* Tønder, 1955, pp. 11–25; Axel Steensberg, *Danske bondemøbler,* 3rd ed. Copenhagen, 1973, p. 147, Pls. 307, 223; Ellen Redlefsen, *Katalog der Möbelsammlung,* Städtisches Museum, Flensburg, 1976, p. 13, Plates 27 et seq.

11 Rudolf Arthur Peltzer, 'Geschichte der Messingindustrie und der künstlerischen Arbeiten in Messing *(Dinanderies)* in Aachen und den Ländern zwischen Maas und Rhein von der Römerzeit bis zur Gegenwart', in: *Zeitschrift des Aachener Geschichtsvereins,* 30, 1908, pp. 235–463.

12 Peltzer, op. cit., p. 387.

13 See especially Alfred Walcher-Molthein, 'Geschlagene Messingbecken', in: *Altes Kunsthandwerk,* Vienna, 1928, pp. 1–10; H. P. Lockner, 'Das Handwerk der Beckenschläger', in: *Kunst und Antiquitäten,* 1976, pp. 24–30. Cf. also F. Fuhse, *Schmiede und verwandte Gewerke in der Stadt Braunschweig* (Werkstücke aus Museum, Archiv und Bibliothek der Stadt Braunschweig, 5), Brunswick, 1930, esp. pp. 58–76; idem, *Handwerksaltertümer,* pp. 32 ff.; Gerda Bergholz, *Die Beckenwerker-Gilde zu Braunschweig,* (Werkstücke, 17), Brunswick, 1954.

14 Torsten Gebhard, *Alte Bauernhäuser,* Munich, 1977, p. 8.

15 Josef Schepers, *Das Bauernhaus in Nordwestdeutschland* (Schriften der volkskundlichen Kommission im Provinzialinstitut für westfälische Landes- und Volkskunde, 7), Münster, 1943.

16 According to Walter Sage, *Deutsche Fachwerkbauten,* Königstein im Taunus, 1976, p. 7, there are some remarkable examples in northern Hesse.

17 Jost Trier, 'Haus und Wohnen', in: *Zeitschrift Westfalen,* 1939, fasc. 5.

18 Walter Sage, op. cit., p. 8.

19 Oskar Schwindrazheim, 'Vierländer Kratzputz (Sgraffito)', in: Karl Mühlke (ed.), *Von nordischer Volkskunst,* Berlin, 1906, pp. 171–9.

20 Plate: *Hessen-Kunst,* Marburg, 1925, p. 39.

21 For incised plasterwork in Hesse see V. Baumbach, 'Kratzputz in Hesse', in: *Hessen-Kunst,* 1925, pp. 39–47; Karl Rumpf, *Handwerkskunst am hessischen Bauernhaus.* (Beiträge zur hessischen Volks- und Landeskunde, No. 2), Marburg, 1938; also *Deutsche Volkskunst,* new series: *Hessen,* Marburg, 1951, pp. 38–41.

22 Borchers, *Volkskunst in Westfalen,* p. 16.

23 On the whole question see Margarete Baur-Heinhold, *Süddeutsche Fassadenmalerei vom Mittelalter bis zur Gegenwart,* Munich, 1952.

[24] Borchers, *Volkskunst in Westfalen,* p. 17.

[25] Ibid., p. 19.

[26] Josef Schepers (see note 15).

[27] Ernst Schlee, 'Türwächterbilder in Schleswig-Holstein und die Scheunentürmalereien in Eiderstedt', in: *Nordelbingen* (Heide), 17–18, 1942, pp. 1–50.

[28] For the motif of the guardian of the door cf. also Sigurd Erixon, 'Türwächterbilder und Prangerfiguren' in: *Folk-Liv* (Stockholm), 3, 1939, pp. 44 ff.; Robert Wildhaber, 'Diebsschreckfiguren und Türwächterbilder', in: *Zeitschrift für schweizerische Archäologie und Kunstgeschichte,* 22, 1962, pp. 126 ff.; Ernst Schlee, 'Der Wächter am Schlüsselloch', in: *Festschrift für Robert Wildhaber,* Basle and Bonn, 1973, pp. 613–19; also 'Ein Buch aus lauter Türblättern', in: *Flensburger Tageblatt,* 24 December 1977.

[29] W. Pessler, *Deutsche Volkskunst: Niedersachsen.* Munich, n. d., Pl. 42.

[30] Borchers, *Volkskunst in Westfalen,* p. 23.

[31] Wilhelm Schmülling, *Hausinschriften in Westfalen und ihre Abhängigkeit vom Baugefüge* (Schriften der volkskundlichen Kommission im Provinzialinstitut für westfälische Landes- und Volkskunde, 9), Münster, 1951.

[32] Ernst Reventlow-Farve and Adolf von Warnstedt, *Festgabe für die Mitglieder der eilften Versammlung Deutscher Land- und Forstwirthe,* Altona, 1847, p. 186.

[33] Johann Adolfi known as Neocorus, *Chronik des Landes Dithmarschen,* ed. Friedrich Christoph Dahlmann, 2 vols., Kiel, 1827, I, p. 115.

[34] Hans Dunker, 'Werbungs-, Verlobungs- und Hochzeitsgebräuche in Schleswig-Holstein', in: *Sprache und Volkstum,* II, Hamburg, 1930, pp. 79 f.

[35] E. Schlee, 'Über das Wohnen', in: *Kunst in Schleswig-Holstein* (Flensburg), 1958, pp. 9–25.

[36] Professor Gebhard, Munich, is presently investigating this as he kindly informed the author.

[37] Helge Gerndt has already attempted this; cf. 'Möbel als kultureller Wert', in: *Volkstümliche Möbel aus Altbayern,* Bayerisches Nationalmuseum, Munich, 1975, pp. 14–18; he deals with 'problems of functional analysis', 'furniture as utensils', 'furniture as symbols' and 'furniture as an indicator'.

[38] Cf. Jost Trier (see note 17).

[39] On the whole problem see Erich Meyer-Heisig, *Die deutsche Bauernstube,* Nuremberg, 1952; Margarete Baur-Heinhold, *Deutsche Bauernstuben,* Königstein im Taunus, 1967.

[40] Jost Trier, op. cit.; Ernst Schlee, op. cit. (see note 35); idem, 'Die Tischordnung beim Festmahl', in: *Nordelbingen* (Heide, Holstein), 19, 1950, pp. 107–17; idem, 'Sitzordnung beim bäuerlichen Mittagsmahl', in: *Kieler Blätter zur Volkskunde,* 8, 1976, pp. 5–19; Konrad Bedal, 'Gefüge und Struktur', in: *Zeitschrift für Volkskunde,* 72, 1976, pp. 161–76.

[41] The author has only seen illustrations of such interiors.

[42] Josef Schepers, 'Bilder bäuerlichen Wohnens aus Westfalen und der niederländischen Landschaft Twente', in: *Westfälischer Heimatkalender* [Münster], 1951, pp. 68–77.

[43] Ernst Schlee, *Deutsche Volkskunst,* new series: *Schleswig-Holstein,* Weimar, [1939], pp. 18–26; idem, *Schleswig-Holsteinische Volkskunst,* Flensburg, 1964, pp. 12–14; Hildamarie Schwindrazheim, *Die Bauernstube,* Hamburg, 1950; Kai Detlev Sievers, *Schleswig-Holsteinische Bauernstuben,* Heide, 1963.

[44] Ulrich Fliess, *Abteilungskataloge des Historischen Museums am Hohen Ufer, Volkskundliche Abteilung, Hannover,* Hanover, 1972, pp. 36 ff.

[45] On panels in the Vierlande see Ulrich Bauche, *Landtischler, Tischlerwerk, und Intarsienkunst in den Vierlanden,* Hamburg, 1965, pp. 69 ff.

[46] Hubert Stierling, 'Die Wilstermarschstuben', in: *Heimatbuch des Kreises Steinburg,* vol. 2, Glückstadt, 1925.

[47] Ernst Sauermann, 'Aus nordfriesischen Wohnräumen des 16. Jahrhunderts', in: *Schleswig-Holsteinischer Kunstkalender* (Hamburg), 1922, pp. 83–95.

[48] These remarks should serve as a caution against expecting too much for folk art from the innovation statistics published by ethnographers (cf. Günter-Wiegelmann, 'Novationsphasen der ländlichen Sachkultur Nordwestdeutschlands', in: *Zeitschrift für Volkskunde,* 72, 1976, pp. 177–200). Wiegelmann correctly emphasizes the fact that eras of prosperity can, in certain circumstances, result merely in expansion of output rather than genuine innovation.

[49] Bernward Deneke, *Bauernmöbel,* Munich, 1969, pp. 64 f.

[50] *Schleswig-Holsteinische Provinzialberichte* (Kiel), VI, 2, p. 40.

[51] Ernst George, 'Die wirtschaftlichen und kulturellen Beziehungen der Westküste Schleswig-Holsteins zu den Niederlanden', in: *Nordelbingen* (Flensburg), I, 1923, pp. 220 ff., at p. 265; cf. also Ellen Redlefsen, *Katalog der Möbelsammlung,* Städtisches Museum, Flensburg, 1977.

[52] Ellen Redlefsen, op. cit., p. 141.

[53] *Schleswig-Holsteinische Provinzialberichte* (Kiel), X, 1, p. 184.

[54] Ernst Schlee, 'Ein Möbel an der Zeitenwende', in: *Schleswig-Holstein* (Neumünster), 1963, pp. 61–3.

[55] Walter Passarge, 'Zur stilgeschichtlichen Stellung der

Schenkschive', in: *Festschrift des Kunstgewerbemuseums der Stadt Flensburg*, Flensburg, 1928, pp. 83–100.

[56] Bernward Deneke, *Bauernmöbel*, Munich, 1969, p. 115.

[57] *Volkstümliche Möbel aus Altbayern*, ed. Bayerisches National-museum, Munich, 1875, No. 98.

[58] Horst Appuhn and Christian v. Heusinger, *Riesenholzschnitte und Papiertapeten der Renaissance*, exhibition catalogue, Unterschneid-heim, 1976.

[59] Plate: Gislind Ritz, *Alte bemalte Bauernmöbel*, Munich, 1975, Pl. 2.

[60] *Volkstümliche Möbel* (see note 57), pp. 143 f.

[61] Friedrich Sieber, *Bunte Möbel der Oberlausitz*, Berlin, 1955.

[62] Otto Bramm, 'Truhentypen', in: *Volkswerk* (Jena), 1941, pp. 154–86.

[63] Bernward Deneke, op. cit., p. 56.

[64] Otto Bramm, op. cit., p. 166.

[65] Ernst Schlee, 'Bauerntruhen aus der Probstei', in: *Jahrbuch für Heimatkunde im Kreis Plön-Holstein* (Plön), 7, 1977, pp. 108–25.

[66] Ulrich Bauche, *Landtischler* (see note 45). Chests are dealt with particularly on pp. 86–94, 183–94.

[67] Karl Rumpf, 'Frühformen hessischer Truhen', in: *Zeitschrift des Vereins für hessische Geschichte und Landeskunde*, 68, 1957, pp. 185–94.

[68] Plate: Karl Heinz Clasen, *Deutsche Volkskunst*, vol. 10. *Ostpreussen*, Weimar, 1942, Pls. 84 et seq., 87 et seq.

[69] Bernward Deneke, *Bauernmöbel*, p. 69, Pl. 37.

[70] Examples from the Dachau area are illustrated by Hans Karlinger, *Deutsche Volkskunst*, vol. 4. *Bayern*, Munich, [1925], Pls. 34, 38.

[71] Sigurd Erixon, *Folklig möbelkultur i svenska bygder*, Stockholm, 1938, p. 113.

[72] Bernward Deneke, *Bauernmöbel*, p. 72; cf. Karl Rumpf, 'Schlan-gen- und Flechtmusterstühle', in: *Zeitschrift für Volkskunde*, 55, 1959, pp. 259–70.

[73] Bernward Deneke, *Bauernmöbel*, p. 74.

[74] Hans Forrer, *Von alter und ältester Bauernkunst*, Esslingen, 1906; Rudolf Uebe, *Deutsche Bauernmöbel*, Berlin, 1924, p. 210; Heidi Müller, *Volkstümliche Möbel aus Nordschwaben*, Munich, 1975, pp. 102 f.

[75] Cf. Alexander Schöpp, *Alte deutsche Bauernstuben und Hausrat*, Elberfeld, [1921], Pl. 58.

[76] Justus Brinckmann, *Führer durch das Hamburgische Museum für Kunst und Gewerbe*, Hamburg, 1894, p. 663.

[77] Plates: Alexander Schöpp, *Alte deutsche Bauernstuben*, Pls. 49, 61; Gertrud Benker, *Altes bäuerliches Holzgerät*, Munich, 1976, Pls. 105, 107.

[78] Cf. Gertrud Benker, op. cit., Pl. 107; Alexander Schöpp, op. cit., Pls. 55, 61, 62.

[79] O. Schulze, *Bäuerliche Holzschnitzereien und Kleinmöbel aus Norddeutschland*, Elberfeld, [1924], Pl. 30.

[80] Karl Rumpf, *Eine deutsche Bauernkunst*, Marburg, 1943, Pl. XXII.

[81] Karl Rumpf, op. cit., Pl. XXI and Figs. 55–70.

[82] Plates: Gertrud Benker, *Altes bäuerliches Holzgerät*, Munich, 1976, Pl. 14; Alexander Steensberg, *Danske Bondemøbler*, 3rd ed., Copen-hagen, 1973, Pls. 417 et seq.; Rudolf Uebe, *Deutsche Bauernmöbel*, Berlin, 1924, Pl. 228, depicts two pieces from north Friesland which are probably no longer in existence; another one of excep-tional beauty, from about 1702, is in the possession of the St. Annen Museum, Lübeck. Plate: O. Schulze, *Holzschnitzerei und Kleinmöbel*, Elberfeld, [1924], Pl. 3, cf. also Pl. 10.

[83] Walter Borchers, *Volkskunst in Westfalen*, Münster, 1970, Pls. 213–215; O. Schulze, *Holzschnitzereien und Kleinmöbel*, Elber-feld, [1924], Pls. 21, 26 et seq., 31 et seq., 34.

[84] Plate: Ellen Redlefsen, *Katalog der Möbelsammlung*, Städtisches Museum, Flensburg, 1977, No. 791.

[85] Plates: O. Schulze, *Bäuerliche Holzschnitzereien und Kleinmöbel aus Norddeutschland*, Elberfeld, [1924], Pls. 23, 24, 29; Rudolf Uebe, *Deutsche Volkskunst*, vol. 9. *Westfalen*, Weimar, 1942, Pls. 84–8; Walter Borchers, *Volkskunst in Westfalen*, Münster, 1970, Pl. 100; see also *Volkskunst im Weizacker*, Leipzig, 1932, Pl. 29.

[86] Plate: Gertrud Benker, op. cit., Pl. 296.

[87] Karl Rumpf, *Eine deutsche Bauernkunst*, Marburg, 1943, pp. 57 ff.

[88] Horst Appuhn, *Brieflade aus Niedersachsen und Nordrhein-West-falen*, Schloss Cappenberg near Lünen (Westphalia), 1971.

[89] E. g. O. Schulze, op. cit., Pl. 12.

[90] A Norwegian example is illustrated in Justus Brinckmann, *Führer durch das Hamburgische Museum für Kunst und Gewerbe*, Hamburg, 1894, p. 686; another from the Swedish highlands: Sigurd Erixon, *Folklig möbelkultur i svenska bygder*, Stockholm, 1938, Pl. 894.

[91] Gertrud Benker, op. cit., Pls. 178, 182, 183.

[92] Gertrud Benker, op. cit., Pl. 135.

[93] Ernst Schlee, 'Volkstümliche Schnitzereien von der Hallig Hooge' in: *Nordelbingen* (Heide), 26, 1958, pp. 100–15.

[94] See also Gertrud Benker, op. cit., Pls. 160, 162.

[95] Ibid., p. 31.

[96] An example dated 1801 is in the Germanisches Nationalmuseum, Nuremberg; cf. Pl. 202; Gertrud Benker, op. cit., Pl. 36.

[97] In the Museum für Kunst und Gewerbe, Hamburg.

[98] Svein Molaug, in an article published in Norway on mangle-boards with chip carving and horse-shaped handles, details of which are unavailable.

[99] Fritz Adler, *Mönchgut,* Greifswald, 1936, p. 188.

[100] Cf. Rudolf Uebe, *Deutsche Bauernmöbel,* Berlin, 1924, Pl. 100.

[101] Justus Brinckmann, op. cit., p. 692.

[102] Max Hasse, *Zunft und Gewerbe* (Lübecker Museumshefte, 10), Lübeck, 1972, p. 23.

[103] Walter Borchers, *Volkskunst im Weizacker* (see note 85), Pl. XVII.

[104] Cf. also Erich Meyer-Heisig, *Deutsche Volkskunst,* Munich, 1954, Pl. 93.

[105] Karl Rumpf, *Eine deutsche Bauernkunst,* Marburg, 1943, pp. 57 ff.

[106] *Die Gartenlaube,* 1871, p. 619.

[107] Poul Nørlund (ed.), *Nordisk kultur, Drakt,* Oslo, Stockholm and Copenhagen, 1941, p. 8.

[108] Gisland Ritz, *Alte bemalte Bauernmöbel,* Munich, 1975, Pl. 129.

[109] Joachim Naumann, *Haubenschachteln. Schriften zur Volkskunde,* Staatliche Kunstsammlungen, Cassel, 1977, Pl. 7.

[110] Ibid., p. 12.

[111] Museum für Kunst und Kulturgeschichte, Osnabrück.

[112] Johanna Weiser, in: *Die Haubenschachtel,* exhibition catalogue, Schwerin, 1958.

[113] Gertrud Benker, op. cit., Munich, 1976, p. 2.

[114] Johanna Weiser, op. cit.

[115] Schleswig-Holsteinisches Landesmuseum, Schleswig.

[116] Leopold Schmidt, *Volkskunst in Österreich,* Vienna and Hanover, 1966, p. 19.

[117] See examples from Pomerania: Walter Borchers, *Volkskunst im Weizacker,* Leipzig, 1932, pp. 134 ff., esp. p. 136, n. 6; Alfred Höck and Dieter Kramer, *Verzeichnis der volkskundlichen und kulturgeschichtlichen Bestände der hessischen Museen,* Marburg, 1970 (s. v. 'Kappenschachtel').

[118] Walter Borchers, op. cit., p. 136.

[119] J. Heckscher, 'Der Ausruf in Hamburg' in: *Literatur, Kunst und Geschichte, 1808–1908,* new ed. by Prof. [Christopher] Suhr, *Der Ausruf in Hamburg,* Hamburg, 1908, p. 7.

[120] Johanna Weiser, op. cit., cited by Martin Wähler, *Thüringer Volkskunde,* Jena, 1940, p. 80.

[121] Joachim Naumann, *Haubenschachteln* (see note 109), p. 10.

[122] Walter Borchers, op. cit., pp. 137 f.

[123] Joachim Naumann, op. cit., p. 14.

[124] Ibid., p. 4.

[125] On the whole question see Franz Carl Lipp, *Bemalte Gläser, Volkstümliche Bildwelt auf altem Glas,* Munich, 1974.

[126] Ibid., p. 43.

[127] On the whole question see Elisabeth von Witzleben, *Bemalte Glasscheiben,* Munich, 1977.

[128] Werner Kloos, *Die Museen der Böttcherstrasse in Bremen,* Hamburg, 1969, p. 27.

[129] Berthold Hamer in : *Flensburger Tageblatt,* 20 March 1971.

[130] See Walter Borchers, *Volkskunst in Westfalen,* Münster, 1970, p. 119, n. 16, for further details.

[131] Einar Lexow, *Norske glassmalerier fra laugstiden,* Oslo, 1938; on Swedish cabinet panes: Bengt Söderberg, 'Glasmålning från nyere tid på Gotland', in: *Rig* (Stockholm), 1931, pp. 155 ff.

[132] Ernst Schlee in: *Gottorfer Kultur im Jahrhundert der Universitätsgründung,* exhibition catalogue, Kiel, 1965, pp. 416 ff.

[133] *Lauenburgische Heimat* (Ratzeburg), XIV, p. 102.

[134] Otto Lauffer, *Niederdeutsches Bauernleben in Glasbildern der neueren Jahrhunderte,* Berlin and Leipzig, 1936; cf. also: Wilhelm Bomann, *Bäuerliches Hauswesen und Tagewerk im alten Niedersachsen,* Weimar, 1927, pp. 33 ff.

[135] Elisabeth von Witzleben, op. cit., p. 65.

[136] Ibid., Figs. on pp. 62 f.

[137] A good example: Fritz Fuglsang, 'Das Stammbuch des Glasers Cordt Johann Kordes', in: *Die Heimat* (Kiel), 40, 1930, pp. 35–40. Kordes was born in 1701 in the monastery of Bremen at Horneburg and worked as a glassmaker in Neustadt, on the bay of Lübeck, from 1728 onwards.

[138] Bürgermeister Kinder, 'Ein Plöner Glasermeister des 18. Jahrhunderts' in: *Ost-Holstein,* supplement to *Ost-Holsteinisches Tageblatt* (Plön), No. 7, May 1937, sec. 5.

[139] On the whole question see Albert Walzer, *Liebeskutsche, Reitersmann, Nikolaus und Kinderbringer. Volkstümlicher Bilderschatz auf Gebäckmodeln in der Graphik und Keramik,* Constance, 1963.

[140] Ernst Schlee, 'Der Wächter am Schlüsselloch', in: *Festschrift für Robert Wildhaber,* Basle, 1973, pp. 613–19.

[141] F. Fuhse, *Schmiede und verwandte Gewerbe in der Stadt Braunschweig.*

(Werkstücke aus Museum, Archiv und Bibliothek der Stadt Braunschweig, vol. V, Brunswick, 1930); also *Handwerksaltertümer, Werkstücke, etc.,* vol. VII, Brunswick, 1935.

[142] Otto von Falke, *Das rheinische Steinzeug,* 2 vols., Berlin, 1908; Karl Koetschau, *Rheinisches Steinzeug,* Munich, 1923; a more recent summary is given by Gisela Reineking-von Bock, *Steinzeug* (Katalog der Sammlung des Kunstgewerbemuseums der Stadt Köln), Cologne, 1971.

[143] Gisela Reineking-von Bock, op. cit., Nos. 685–707.

[144] Karl Rumpf, *Deutsche Volkskunst,* new series *Hessen,* Marburg, 1951, pp. 63 f.

[145] Gisela Reineking-von Bock, op. cit., pp. 55 f.

[146] Paul Stieber, 'Deutsches Hafnergeschirr', in: *Keysers Kunst- und Antiquitätenbuch,* vol. III, Munich, 1967, pp. 241–92, at pp. 278 ff. Of course new material has appeared in recent years.

[147] Ibid., p. 282.

[148] Louis Ehlers, *Dansk Lertøj,* Copenhagen, 1967.

[149] J. Heckscher, *Der Ausruf in Hamburg* (see note 119), No. LII.

[150] Paul Stieber, *Hafnergeschirr aus Altbaiern,* Bayerisches Nationalmuseum, Munich, 1968.

[151] Paul Stieber, 'Deutsches Hafnergeschirr' (see note 146) pp. 245 f.

[152] Ingolf Bauer, *Treuchtlinger Geschirr,* Munich, 1971.

[153] Gerd Spies, *Hafner und Hafnerhandwerk in Südwestdeutschland.* (Untersuchungen des Ludwig Uhland-Instituts der Universität Tübingen, vol. 2.) Tübingen, 1964.

[154] See Bibliography.

[155] [Ernst Helmut Segschneider], *Irdenware des Osnabrücker Landes, 19. und 20. Jahrhundert,* guide to the exhibition held in Osnabrück and Cloppenburg, 1973. Cf. also Wingolf Lehnemann, *Töpferei in Nordwestdeutschland.* (Beiträge zur Volkskultur in Nordwestdeutschland, ed. Volkskundliche Kommission für Westfalen, Landschaftsverband Westfalen-Lippe, No. 3.) Münster, 1975.

[156] Alfred Höck, *Kurze Geschichte der Marburger Töpferei,* Universitätsmuseum für Kunst- und Kulturgeschichte, Marburg, 1972.

[157] Mechthild Scholten-Neess and Werner Jüttner, *Niederrheinische Bauerntöpferei, 17.–19. Jahrhundert.* (Werken und Wohnen, Volkskundliche Untersuchungen im Rheinland, vol. 7.) Düsseldorf, 1971, p. 28.

[158] For Plates see ibid.

[159] Ibid., No. 658.

[160] Ibid., No. 568.

[161] Ibid., No. 907.

[162] Ibid., No. 945.

[163] Ibid., No. 249.

[164] Ibid., No. 768.

[165] Ibid., No. 760.

[166] Ibid., No. 760.

[167] Ibid., No. 380.

[168] Ibid., No. 313.

[169] Gerhard Kaufmann, *Stickmustertücher aus dem Besitz des Altonaer Museums,* exhibition catalogue, Altonaer Museum, Hamburg, 1975 (with detailed bibliography).

[170] Martha Bringemeier, 'Stickerinnen und Stickereien der Schaumburger Tracht', in: *Volkswerk* (Jena), 1943, pp. 199–212.

[171] Published in Nuremberg, reprinted in Berlin 1874.

[172] Erich Meyer-Heisig, *Weberei, Nadelwerk, Zeugdruck,* Munich, 1956, p. 26.

[173] Plate: Erich Meyer-Heisig, *Deutsche Volkskunst,* Munich, 1954, Pl. 73.

[174] Konrad Hahm, *Ostpreussische Bauernteppiche,* Jena, 1937.

[175] Justus Kutschmann, 'Textilien', in: *Lebendiges Gestern. Erwerbungen von 1959 bis 1974.* Museum für Deutsche Volkskunde, Berlin, 1975, pp. 141–60, especially pp. 146–59.

[176] Ernst Sauermann, *Schleswigsche Beiderwand,* 2nd ed., Frankfurt, 1923.

[177] Dorothea Klein, 'Beiderwand-Studien', in: *Jahrbuch für historische Volkskunde* (Berlin), III–IV, 1934, pp. 221–34.

[178] Wilhelm Schmitz, *Westfälischer Blaudruck in alter und neuer Zeit,* [Münster], n. d.

[179] Cf. especially Liselotte Hansmann and Lenz Kriss-Rettenbeck, *Amulett und Talismann,* Munich, 1966.

[180] Walter Borchers, *Volkskunst in Westfalen,* Münster, 1970, p. 162.

[181] Hubert Stierling, 'Westwind', in: *Festschrift des Kunstgewerbemuseums der Stadt Flensburg,* Flensburg, 1928, pp. 231–53, at p. 232.

[182] Sigurd Schoubye, *Guldsmede-håndvaerket i Tønder og paa Tønderegnen 1550–1900* (Skrifter udgivne af Historisk Samfund for Sønderjylland, vol. 24, 1961).

[183] Ibid., p. 25.

[184] Helmuth Plath, 'Zur Typologie der Schaumburger und Stader Spangen', in: *Heimat und Volkstum. Bremer Beiträge zur niederdeutschen Volkskunde des Vereins für niedersächsisches Volkstum 1959/1960,* pp. 45–61.

[185] Munich, 1963; his monographic treatment of votive pictures is also basic: *Das Votivbild*, Munich, 1958.

[186] Lenz Kriss-Rettenbeck, *Bilder und Zeichen religiösen Volksglaubens*, Munich, 1963.

[187] Rudolf Kriss, *Eisenopfer*, Munich, 1957, pp. 17 ff.

[188] Josef Maria Ritz, 'Mittelalterliche Eisenvotive in Franken', in: *Kultur und Volk*, Vienna, 1954.

[189] Rudolf Kriss, op. cit., p. 20.

[190] Literature about pilgrim's emblems is ample; a few examples are Ernst Grohne, 'Bremische Boden- und Baggerfunde', in: *Jahresschrift des Focke-Museums*, Bremen, 1929, pp. 44 ff.; Monica Rydbeck, 'Ein Detail im Pilgerwesenpuzzle', in: *Festschrift für Erich Meyer*, Hamburg, 1957, pp. 122–5.

[191] Elisabeth and Erwin Schleich, *Frommer Sinn und Lieblichkeit. Vom Zauber der 'Schönen Arbeiten' in Altbayern*, Passau, 1973.

[192] Wolfgang Brückner, 'Hinterglasmalerei', in: *Keysers Kunst- und Antiquitätenbuch*, vol. III, 1967, pp. 69–99; Gislind Ritz, *Hinterglasmalerei. Geschichte, Erscheinung, Technik*, Munich, 1975. Both these books include detailed bibliographies.

[193] Magnus Voss, 'Chronik der Kirchengemeinde Ostenfeld', in: *Veröffentlichungen des Nordfriesischen Vereins*, 2, 1904–5, at p. 54.

[194] *Die Baudenkmäler des Regierungsbezirkes Stralsund*, 1881, p. 508.

[195] Georg Helmer, *Geschichte der privaten Feuerversicherung in den Herzogtümern Schleswig und Holstein*, I, Berlin, 1925, p. 502.

[196] Matthias Zender, 'Volkskultur und Geschichte', in: *Festgabe für Josef Dünninger*, Berlin, 1970.

[197] Leopold Schmidt, *Volkskunst in Österreich* (see note 116), p. 28: 'In Stein gibt es keine Volkskunst, sondern nur Machtkunst.'

[198] Bruno Schier, 'Johann Georg Fischer, ein Meister des Egerländer Fachwerkbaus', in: *Volkswerk* (Jena), 1941, pp. 123–43.

[199] Adolf Spamer, *Deutsche Volkskunde*, vol. II, Berlin, 1935, p. 293.

[200] Torsten Gebhard, 'Das Erlebnis des Pittoresken und die Entdeckung der Volkskunst', in: *Zeitschrift für Volkskunde*, 51, 1954, pp. 153–64.

[201] Wilhelm Niemeyer, *Oluf Braren, der Maler von Föhr*, Berlin, 1920; Ernst Schlee, in the catalogue of the Oluf Braren exhibition (Munich, Hamburg and Flensburg), Husum, 1977.

[202] Ludwig Richter, *Lebenserinnerungen eines deutschen Malers*, 3rd ed., Frankfurt, 1886, p. 298.

[203] There are, however, several publications dealing with limited local areas: Ernst Schlee, *Schleswig-Holsteinisches Volksleben in alten Bildern*, Flensburg, 1963; Gerhard Kaufmann, Catalogue of the exhibition 'Volkslebenbilder aus Norddeutschland'. Altonaer Museum, Hamburg, 1973 (with detailed bibliography); Paul Rattelmüller, *Dirndl, Janker, Lederhose*, Munich, n. d.; on the subject in general: Hans H. Hofstätter, *Der Bauer und sein Kleid*. Introduction to the new edition by: Albert Kretschmer, *Das grosse Buch der Volkstrachten*, Eltville/Rhine 1977, pp. V–XV.

[204] Ernst Schlee and Sigurd Schoubye, *Carl Ludwig Jessen*, Tønder (Denmark), 1976.

[205] Gerd Spiess, *Braunschweiger Volksleben nach Bildern von Carl Schröder*, Brunswick, 1967.

[206] Bernward Deneke, *Volkskunst aus Franken*, Nuremberg, 1975, p. 4.

[207] Bernward Deneke, 'Notizen zum Thema Kunst-Gewerbe 1820–1870', in: *Anzeiger des Germanischen Nationalmuseums*, 1975, pp. 115–27; idem, *Beziehungen zwischen Kunsthandwerk und Volkskunst um 1900*, 1963, pp. 140–61; idem, 'Die Entdeckung der Volkskunst für das Kunstgewerbe', in: *Zeitschrift für Volkskunde*, 60, 1964, pp. 168–201.

[208] A recent publication on the same subject is Ursula Schurr, *Zur Bedeutung der Volkskunst beim Blauen Reiter*, unpublished Ph. D. dissertation, Munich, 1976.

[209] Wilhelm Fraenger, 'Deutsche Vorlagen zu russischen Volksbilderbogen des 18. Jahrhunderts', in: *Jahrbuch für historische Volkskunde*, II: *Vom Wesen der Volkskunst*, Berlin, 1926, pp. 126–73.

[210] Wolfgang Brückner, 'Expression und Formel in Massenkunst. Zum Problem des Umformens in der Volkskunsttheorie', in: *Anzeiger des Germanischen Nationalmuseums*, 1963, pp. 122–39. This is not the place for a detailed analysis of Brückner's arguments; but it must be stated that they cannot be confirmed by the architectural view he has chosen. Fraenger's argument should be countered on the basis of his own examples, or at least from comparable illustrations of landscape or figure work.

[211] E. g., Mathilde Hain in the introduction to the exhibition 'Bildwelt und Glaube', Frankfurt, 1958, p. 5.

[212] Max Sauerlandt, *Reiseberichte 1925–32*, Hamburg, 1971, p. 128. Carl Georg Heise, 'Ars Una', in: *Festschrift für Erich Meyer*, Hamburg, 1957, pp. 331–5.

[213] The most comprehensive publication is Walter Dexel, *Das Hausgerät Mitteleuropas. Wesen und Wandel der Formen in zwei Jahrhunderten*, Brunswick and Berlin, 1962. Dexel's collection is exhibited in Brunswick. Compare Walter Dexel, *30 Jahre Formsammlung der Stadt Braunschweig*. (Arbeitsberichte aus dem Städtischen Museum Braunschweig, No. 20.) Brunswick, 1972.

[214] Paul Stieber, 'Form und Formung. Versuch über das Zustandekommen der keramischen Form', in: *Bayerisches Jahrbuch für Volkskunde 1970/1971*, pp. 7–73. Unfortunately, Stieber's researches suffer from his ideas on quantification of forms.

[215] Willy Rotzler, *Objekt-Kunst. Von Duchamp bis zur Gegenwart,* Cologne, 1975.

[216] Adelhart Zippelius in: *Volkskunst im Rheinland.* (Führer und Schriften des Rheinischen Freilichtmuseums in Kommern, No. 4.) Düsseldorf, 1968, pp. 7–14.

[217] Hans Karlinger, *Deutsche Volkskunst,* Berlin, 1938, p. 15.

Introduction

Explanations of the objects illustrated are principally confined to facts which may not be obvious from the pictures themselves. It has not always been possible to provide full details, such as measurements. Some aspects of the captions are intentionally varied in order to supplement the text. The remarks of other authors are also often quoted intentionally. Objects have been selected for illustration with a view to showing the widest possible range of aspects of the subject. So-called showpieces of folk art have been put alongside simple everyday articles. This does not show lack of consistency. In every case the primary purpose is to demonstrate the expressive visual impact. Where a definite date is given it has been deduced from the object itself.

1 **Peasant house in the Altes Land,** near Hamburg, 18th century.

This photograph was taken many years ago. The surroundings have radically changed since then, and it is difficult to identify the house now. In the linear-type rambling settlements of the Altes Land one house of this type used to be arrayed close to the next, all of them with decorated gables and living-rooms facing the street. The white painted woodwork and the white plaster of the joints, the warm red of the brickwork and the green of door and window frames all combine to give a cheerful, festive impression. An ornamental arrangement of bricks as they come from the kiln can be achieved by laying them in various ways. For patterns on smaller surfaces the builders turned to decorated plaster. The symmetrical distribution of the scheme over the section of the wall contributes to an over-all impression somewhat similar to embroidery. The overhang of the upper floors has been adopted from urban house gables. The beams of the floor rest on half-beams with their heads supported by specially adapted stays. This, too, is only done for show. The non-residential part with the 'great door' faces the property behind the house.

2 **Cross-gable with entrance door of the 'White House'.** Whitewashed brick. 1763. North Friesland, Schleswig.

3 **Fan-light of the 'White House'** (see Pl. 2) with reverse monogram of the owner, F. J. B.

The date 1763 is chiselled into the head stone above the entrance door. The stone bears the following inscription: 'Soli Deo Gloria/Man, think of the end/Then you will never do evil/Blessed is he that shall eat bread in the Kingdom/of God. Luke 14:15/That which is necessary is concern for/eternal bliss. A. D. 1763. F. J. B. C. F. B.' The door panel with older brass fittings (dated 1760) is divided horizontally in the middle, as is customary in north Friesland, so that the upper half alone can be opened. The monogram may be that of a successful ship's captain. He equipped his house lavishly. Even now the floor is laid with black and white marble slabs. A wall panel with pilasters is preserved in the north-east room (the rooms and their contents are located by reference to points of the compass). In the rest of the house Dutch wall tiles are found, among them a tile picture consisting of sixteen individual tablets which represents a large flower vase. (*Die Kunstdenkmäler des Kreises Südtondern,* Berlin, 1939, p. 357.)

4 **Olufshof,** Kathrinenheerd, Eiderstedt peninsula, Schleswig.

Barn in the manner of a woodshed, 'gulf style'. On both big entrance doors are paintings; on the left are two threshers, on the right a black horse. 'The building itself is new, since the old woodshed burned down in 1870. According to oral tradition the painted doors had already been a feature of the old house... As the climate made frequent repainting necessary, these pictures were frequently renewed as a matter of course.' Next to the taller of the two threshers, on the left, we find the rhyme: 'I am the man who right well can thresh.' Next to the smaller one we find: 'I know how/to thresh well/so long as no work is involved.' Various legends are connected with these paintings (cf. E. Schlee, 'Türwächterbilder in Schleswig-Holstein, und die Scheunenturmalereien in Eiderstedt', in: *Nordelbingen,* 17–18, 1942, pp. 1–50). The reason is probably that comparable paintings, which formerly existed in large numbers, have disappeared and the few remaining examples have no reliable explanation. Without doubt, however, the true tradition is enshrined in the pictorial representation, and the tales are secondary.

5–7 **Cramp-irons.** Wrought iron. Middle of 19th century. Various houses at Boldixum, island of Föhr, north Friesland, Schleswig.

The date of the house usually appears on the half-gable wall at the level where the ceiling rafters are clamped. The four digits are distributed evenly over the width of the house for structural reasons. Each serves as a wall anchor, a cramp-iron for the short half-beam running up to the ridge; alternatively all four may connect a roof-beam running inside the brick wall at right angles to the ridge. The seven is part of the date, 1847, and the strength of the iron rod shows the 'style' of the middle of that century. Number clamps of the eighteenth century are slighter. The two corresponding 'lily-shaped' irons are placed at the side of the entrance door where they occur in pairs and anchor the cross walls of the passage of the house to the outer wall. A small ring to tether horses is often added. It has been established that such iron wall anchors were not used after 1877 on the mainland and the same applies, no doubt, to the islands. (Cf. S. Sinding, 'På Opmåling i Sønderjylland', in: *Architekten,* Copenhagen, XI, 1908–9, p. 440.)

8 **Stone tablet.** Sandstone slab. 1750. From Nieblum, island of Föhr, north Friesland, Schleswig. Height 58 cm, width 58 cm. Schleswig-Holsteinisches Landesmuseum, Schleswig.

Stone slabs of this type, sometimes simpler, occasionally in the form of a sundial, were frequently let into the brickwork over the entrance door in houses owned by the more affluent inhabitants of the island (cf. Pl. 2). As a rule they give information about the owner of the house and the year it was built, and commend it to the protection of Almighty God. They were made by the stonemasons of the island, who also carved tombstones. The words *Welt Gebau* in the text refer to the transient glory of this world. Perhaps the master of the house also had in mind the two big buildings within his field of vision: the mill on the left—he was surely the miller—and the parish church on the right.

9 **Lintel.** Oak, painted 1775. From Bremen. Height 30 cm, length 120 cm. Focke-Museum, Bremen.

This isolated fragment provides an unassuming example of the custom, followed widely in town and country, of proclaiming one's faith by a token above the entrance to the house and at the same time announcing the names of the couple who owned or built it. This particular design, a garland of laurel(?), garnished with four flowers, became very popular in folk art along the North Sea coast from about 1750 (see Pl. 156). Painted red, green, yellow and brown.

10 Bay on the upper floors of a Burgher's House, the 'Haus zur Sonne', Wetzlar, dated 14 June 1607.

This section of a gable front, comparatively modest in its decoration, is an example of fully developed half-timbering of the central German type. It can be clearly seen that the floors are superimposed on each other as detached units. The two upper floors project only slightly, so that stays and brackets can be dispensed with. This serves to emphasize the protruding bay in the centre which is distinguished by carved decoration on the corner stays. Motifs dating back as far as the early sixteenth century are perpetuated. The crossed struts below the window of the first floor make clear what the text means when it refers to 'noses': these are the small protruding spikes with four incised hearts added to them at the intersections. On the second floor the original shape, the simple diagonal cross, is retained. The decorated cross in the neighbouring section has a counterpart in the shape of a wooden panel with the inscription:

This house rests in the Good Lord's hand.
Good God, preserve us from firebrand.
Zur Sonnen be it called throughout the land.

The sign of the house, the sun, is carved between the lines. It is not clear how it fits in with the globe with a cross, the imperial orb, carved on top of the middle wall stay. From traces of chipping on the timber it appears that the whole wall was later plastered over and has only recently been exposed again.

11 Detail of gutter wall of a house at Goslar (first floor). Half-timber. Harz mountains.

A half-timber storey has been laid on a sixteenth-century Gothic ground floor of solid masonry. An oak sleeper rests on a bulging cornice. On the sleeper are the wall posts, fixed with stub tenons, the heads of which carry the cross-beam. They are braced with small cross-bolts which are let into the posts and are reinforced against the sleeper with foot stays. These fill out the angles between sleeper and posts to form triangles, and provide a surface for carved decorations. The first-floor windows are recent. The stays below the guttering show the Magi in adoration of the Christ Child, the posts below them personifications of the planets. The grotesque animal figures on the cross-bars still show Gothic characteristics, while the triangles around the feet of the posts are examples of Renaissance ornament. They terminate in grotesque human and animal figures and feature small scenes. On the right-hand panel a donkey and a fox are making music together.

12 Gable of a house in Rissbach, near Traben-Trarbach on the Moselle.

The mature form of the central German timber-frame house is characterized by a wooden structure on the massive stonework of the lower floor. The diagonal struts are developed into ornamental forms, but their distribution over the gable wall follows the rules of symmetry only so far as the placing of windows and skylights permits. The curved wooden struts are dovetailed into uprights and cross-bars and have cut-out extrusions which animate the total effect. Doubling the stays creates crosses, stars and reticulations. Their variations add to the attractively asymmetrical impression; they have no structural function. Apart from the placing of the dormer-window, the gable itself is symmetrical. The asymmetrical effect of the windows on the upper floor is made even more pronounced by the different struts below the windows.

13 Gable of a peasant house at Kölbe, near Marburg an der Lahn, Hesse, with incised plaster motifs in framed panels. 19th century.

The two rows of partitioned areas on the ground floor are built on a brickwork base and are topped by the wooden beams. On this rest the heads of half-beams which support the long beams for the mighty loft which obviously could only be used as a store-room. The loft is extended by interposing a kind of mansard roof. The load of the templets in the buckling line is taken up by a series of struts strictly arranged in a line running down to the brick base. Its alignment corresponds exactly to the symmetric support of the roof ridge, which roughly resembles the type of struts which are found in later timber-frame work in Franconia. The incised plaster designs change from one panel to another and result in an even, self-contained pattern. It might be compared to a sheet of paper as used in pastry decoration. As well as plant motifs, animals, such as stags, birds and sometimes a man next to a pine-tree are found.

14 Weather-vane. Wrought iron. 1717. From the Winser Elbmarsch. Height *circa* 150 cm. Photograph in the Historisches Museum am Hohen Ufer, Hanover.

This is the earliest specimen in the collection of splendid weather-vanes from Lower Saxony in the Museum in Hanover. It comes from a peasant house and demonstrates that the old motif of the weather-cock was not confined to church steeples.

15 Weather-vane. Wrought iron. 1894. From Nordsehl, Schaumburg-Lippe district. Height 253 cm, width 139 cm. Historisches Museum am Hohen Ufer, Hanover.

An example of a type which is not uncommon in this district. Inscribed: F SCH: E M SCH 1894. The number of horses may indicate the size of the farm. It is difficult to make out what type of conveyance it is meant to represent—perhaps a wedding carriage. This may be confirmed, to some extent, by the monogram of the peasant and his wife who were married in 1894. The Historisches Museum am Hohen Ufer in Hanover possesses a similar example from Bergkirchen, also in the district of Schaumburg-Lippe, from 1883, on which the carriage is pulled by four horses. Instead of a plough the farmer and his wife appear in person with their implements. (Ulrich Fliess, *Volkskundliche Abteilung, Abteilungskataloge des Historischen Museums am Hohen Ufer,* II, Hanover, 1972, p. 57, No. 85.)

16 Dinner bell. Wrought iron. 1869. On the house 'Beim Hutterer' in Irlach, parish of Pleiskirchen, Altötting district, Bavaria.

With the coat of arms of Bavaria, supported by crowned lions, are the initials M P and the year. The larger farms required bells that could be heard far out in the field to regulate the daily routine, particularly to mark the working hours and meal times. Such bells were widespread in peasant holdings all over northern and eastern Germany before pocket watches came into general use. They were as a rule mounted on the entrance gate of the farmhouse. These bells' function is broadly similar to that of bells on town-hall clocks and other civic buildings which, together with the call to prayer of the church bells, regulated daily life in the towns. Not so long ago these were still rung by hand and clockwork mechanism is relatively recent.

17 Gable decoration and weather-vane. Wood and iron. Forged, 19th century. Altes Land, near Hamburg. Water-colour by Ursula Becker, painted 1935. Height 32.5 cm, width 25 cm. Historisches Museum am Hohen Ufer, Hanover.

The gable decorations of the Altes Land, cut out with the help of stencils from oak planks and painted green, belong to the so-called *Esteschwan* type. This style is common along the river Este, a tributary of the Elbe. The delicate, almost filigree-like and playful fretwork is characteristic. The water-colour painting makes it clear that the gable boards and weather-vane should be seen as a unit. The latter bears the figure of a mermaid with a fish-tail.

18–19 Gable planks from peasant houses in Lower Saxony. Wood. 19th century. Pl. 18: Historisches Museum am Hohen Ufer, Hanover, Pl. 19: T. Gebhard, *Alte Bauernhäuser,* Munich, 1977, Pl. 66.

Plate 18: This frequently-published specimen, now in a museum, gives the impression of being very early, probably because it is weather-worn. This tempted nineteenth-century scholars to attribute greater antiquity than was warranted to the horse's head as a gable decoration and to make sweeping deductions in regard to religious history. Plate 19: This example from the Lüneburg Heath makes it clear that the pair of boards prevented damage to the roof (of thatch or reeds) by covering the small gap *(Ulenflucht)* in the gable, which was exposed to the elements.

20–21 Sections of planks on barns. Softwood. *Circa* 1800. Miesbach district, Upper Bavaria.

All barns require smaller or larger openings to let in air for proper ventilation of the grain. In practically every part of Germany the timbering was decorated with ornamental carvings, but especially notable are the gable boards of the northern German long-house. The ornaments are predominantly simple ones, such as hearts,

stars, crosses and lozenges. These two examples, chosen more or less at random, show that more meaningful and descriptive motifs were also developed such as the cross with two hearts, referring to the Sacred Hearts of Mary and Christ or else to those of the couple who owned the place. The peasant himself appears with his rake and spade. An earlier generation of folklore scholars saw these simple carved motifs as a series of 'symbolic pictures' of ancient origin.

22 Gable wall of a barn with criss-crossing wood-work, section. Miesbach district, Upper Bavaria.

The timbering looks old-fashioned because the struts are not dovetailed into the horizontal planks but affixed. This type of construction is technically easier to master because the stays can be added after erecting the horizontal and vertical timbers. When dovetailing with plugs the whole framework must be erected and joined in one piece. The doubling of the horizontal beams at the gutter level is characteristic. The gable planks are laid directly on the cross beams because there is no upper floor. As the boards are laid down without notching, the wood warps and thus creates a rift which assists in the ventilation. If additional openings are required they are sawn out as small ornamental patterns.

23 Entrance-door fan-light. Oak. *Circa* 1790–1800. From the Wilstermarsch, Holstein. Height 58 cm, width 110 cm. Schleswig-Holsteinisches Museum, Schleswig.

In peasant houses in the Wilstermarsch, unlike other regions where the North German long-house predominates, the living quarters face the street and have a certain dignity. This is partially due to the design of the entrance door. A number of open-work fan-lights illustrate the occupation of the inhabitants, for instance. One shows a peasant ploughing with more than one horse (the heavy soil of the marsh is particularly difficult to break). Landscapes and flower decorations are executed in colour. This example is not as rich in scenic and flower decorations as some in private collections. A similar piece is in the Museum of Arts and Crafts, Hamburg. (Justus Brinckmann, *Führer durch das Hamburgische Museum für Kunst und Gewerbe,* Hamburg, 1894, p.668. Cf. E. Schlee, *Schleswig-Holsteinische Volkskunst,* Flensburg, 1964, Pl. 57.)

24 Part of the façade of the inn 'Zum Husaren', Garmisch, Upper Bavaria. Painted about 1800.

This greyish monochrome painting by an unknown painter fits with astonishing facility into the structure of the façade. It does not even clash with the shutters, which might have proved a problem in such an attempt at Baroque illusion. These two sculptured half-length figures looking out of a painted 'window' have three-dimensional forerunners in the Netherlands as early as the fifteenth century (cf. remarks on 'guardians of the door', Pl. 4, and relevant references). Figures at a window occur elsewhere on house walls in the Alpine region, sometimes in a form which suggests that they represent

the occupants or the builders. From the stylistic point of view, this kind of façade painting marks a decline of the genre. The nineteenth century remained productive in this field only in so far as it repeated Baroque techniques.

25 Façade (overlooking the garden) of the so-called 'Pilate House', Oberammergau, Upper Bavaria. Painted by Franz Zwinck, 1784. Detail.

This is the principal example on German soil of illusionistic Baroque façade painting on a rural house. The gutter-pipe and the enlargement of the ground-floor window on the left are the result of later modifications. However, in other places such painting found itself in direct conflict with the basic structure of a rural house; for example the proportion of the galleries on both sides, and most certainly at the roof-guttering and the roof, immediately destroys any illusion. It says much for the aesthetic feeling of those who conceived such a work that the architectural features did not prove to be a deterrent. Their artistry transcends them and achieves an effect which from a strictly conventional point of view may seem incongruous. Reality and illusion are merged, and are as equally acceptable as in the popular theatre. Indeed a certain theatrical effect pervades the whole work. The single figure on the lowest step lends credence to the comparison.

26 Room panelling. Softwood, painted. End of 18th century. From Viöl, Schleswig. Altonaer Museum, Hamburg.

The interior walls of north Frisian houses frequently consist of tongued and grooved planks. The boards are fitted into the slots of rabbeted moulding. This form of wall construction is probably a heritage from the late Middle Ages. It produces a Gothic impression, because most of the mouldings terminate abruptly at the horizontal end boards. The decoration, mostly painted on a blue background, consists of alternate linear and wavy tendrils, and is frequently met with. The Schleswig-Holsteinisches Landesmuseum in Schleswig has a wall section very similar to the one illustrated here which comes from a small island. (Cf. J. M. and G. Ritz, *Alte bemalte Bauernmöbel,* Munich, 1975, Pl. 278, section.)

27 Wall panel from a room. Pine, painted. *Circa* 1772. From the 'Haus Robert Rave'. Moorhusen, Steinburg district, Holstein. Height 296 cm, width *circa* 900 cm. Schleswig-Holsteinisches Landesmuseum, Schleswig.

In the middle of the wall, which consists of vertical boards, is a door without a frame leading to another room. Painted frames outline square spaces on either side. In these spaces scenes are painted: on the left is the owner of the farm, Claus Piening, his wife Christine, with a horse dealer and a farm-hand holding a horse (which is apparently for sale). On the right the same Claus Piening is shown at a stag hunt, riding a white horse and accompanied by a hunting dog. In the foreground is a pond with two swans. The rest of the wall

surface is covered with curved Rococo scrolls swaying in the wind against a light background. The door has an imitation marble base on which is a vase of flowers. While these panels were being removed from the 'Haus Rave' it was found that the wall was no longer in the original position. The original state cannot be accurately reconstructed. According to tradition the decoration was done by a painter named Drawer. (*Katalog Volkskunst aus Deutschland, Österreich und der Schweiz,* Cologne, 1969, No. 24.)

28 Detail of a painted ceiling in the room of a peasant house on the island of Fehmarn. *Circa* 1780. Measurements of the detail *circa* 203 × 407 cm. Schleswig-Holsteinisches Landesmuseum, Schleswig.

The total size of the boarded ceiling is *circa* 670 × 620 cm. It is divided into three sections by four ceiling beams. On Fehmarn the room to which it belonged, a hall rather like a *Pesel,* was always situated at the rear of the house between two rows of supports. It adjoined the huge vestibule and was of the same width. The great farmers of Fehmarn (the granary of Lübeck) commissioned very lavish fittings. The ceiling boards had already been ripped out and dispersed, but it was possible to carry out a complete reconstruction in the museum. Each of the three panels between the beams presents a biblical story in a cartouche. The section illustrated here shows the parable of the Good Samaritan.

29 Corner of a summer room ('summer house') from Honigfleth, Wilstermarsch, Holstein. First painted during the middle of the 18th century. Altonaer Museum, Hamburg.

'Our summer room from Honigfleth ... has no stove because it was only used during the warm season. The walls, except for the tiled wall on the window side, are covered with wooden panels from the top down and painted in bright colours. There are twisted columns entwined with roses, heavy foliage and imaginary landscapes, almost Chinese in style, surrounded by cartouches. Together with the carved twisted half-columns between the windows they show that this arrangement may have been created *circa* 1750. Although the room was designed purely for show, we still find on the left two alcoves, the doors of which were clearly not painted until after 1800. A fine great tent, which might have belonged to an imperial general, here serves as a motif in the 'Empire' style.' (Hildamarie Schwindrazheim, *Führer durch das Altonaer Museum,* 1. *Die Bauernstuben,* Hamburg, 1950, pp. 15 ff.)

30 Pesel (summer parlour) in a peasant house from Ostenfeld, near Husum, Schleswig. 1673. Built on to an older house. Now in the Ostenfelder House Open-Air Museum, Husum, Schleswig.

This house, which was moved from Ostenfeld to Husum in 1899, was erected in the sixteenth century. The living quarters were added in 1673, perhaps as a replacement for earlier ones. They contain an unheated *Pesel* and a small

room. The *Pesel* retains features common to such living-rooms, which are mainly used on festive occasions: the bench fixed against the wall below the window, the brick floor, the predominant place occupied by an opulent sideboard, at least one chest, and a display of crockery. While not all the fittings come from the same house the ensemble can be accepted as authentic. Sideboards like this are more commonly associated with the urban upper classes. This one is the work of Berend Cornelissen, who was active in Husum during the mid-seventeenth century. The representation of the 'Last Supper' on the flap refers to the festive dinners held in the room. The chairs are magnificent specimens of the type characteristic of Ostenfeld. For purposes of heating another room *(Dörns)* was added in 1789 in lieu of one of the two inglenooks beside the stove.

31 **Room** *(Dörns)* from Hallig Hooge, Schleswig. 1669. Municipal Museum, Flensburg.

This room, in a house on the Hallig-Wharf facing south, is almost square in plan. The walls were made of tongued and grooved planks; they extended from a smooth floor to a carved ledge. The bed projects into the room like a box, closed off by a double curtain. The door shown in the photograph has panels painted in colours with circular patterns, stars and little blossoms. Below the window the bench is still fixed to the wall. The table is more elaborate than any other example from the islands. (Heinrich Sauermann, *Führer durch das Kunstgewerbe-Museum der Stadt Flensburg,* Flensburg, 1906, pp. 18 ff.)

32 **Room** *(Dörns)* from the Boie Lau House at Wester-büttel, Dithmarschen. 1792. Municipal Museum, Flensburg.

Compared with the highly-segmented panels of the Wilstermarsch, the fittings of this Baroque room in nearby southern Dithmarschen are more modern. Like the rest of this house they are the work of the joiner Jürgen Johannsen of Eddelak, Dithmarschen. (Wilhelm Johnson, 'Die Johannsen in Eddelak, ein ländliches Baumeistergeschlecht', in: *Sippe der Nordmark* (Kiel), IV, 1940, pp. 29 ff.) The survival of the fixed bench under the window and the floor of Swedish limestone tiles may give an old-fashioned impression. In contrast, the architectural framing of the wall-bed opening, which resembles an elaborate wardrobe front, and the small built-in glass cupboard like a dresser, as well as the decoration on all the woodwork, including that of the ceiling and the beams, give quite a modern effect. The other three walls are covered with tiles. In a certain sense the big farmers of Dithmarschen were more men of the world than their southern neighbours. The room was planned as a home for the owner's aged parents. The treatment of fashionable decorative elements strikes us as unsophisticated: for example, the grating pattern around the ledge over the bed opening. On the left-hand wall is a rack with long clay pipes. To the right, between the windows, hangs a mirror; this accords with the usual practice. The table consists of a flat top with two semi-circular pieces which can be raised and supported on movable legs. The column-like stove was added when the room was placed

in the museum—the original one probably looked more like a box. (Heinrich Sauermann, *Führer durch das Kunstgewerbe-Museum der Stadt Flensburg,* Flensburg, 1906, pp. 23 ff.; on the house and the first inhabitants of the *Dörns:* Wilhelm Johnsen, *Aus dem Flensburger Museum,* Flensburg, 1953, p. 90.)

33 **Room** *(Dörns)* from the Albert Reimers House, Grosswisch, near Wewelsfleth, Wilstermarsch, Holstein, Oak panelling. 1759 (or a little later). Altonaer Museum, Hamburg.

The fittings of this room are magnificent testimony to the life-style of the large farmers in the Wilstermarsch. The left half of the wall panelling contains the openings for the wall bed, where the parents slept, the right one a bay window to the vestibule which allows constant observation of the working quarters of the household. It is uncertain whether the hanging corner cupboard and the chest are in the right place. We do not think that the painted wooden ceiling belongs here. It is more likely to come from a 'summer room' used as a banqueting room, possibly in the same house. To fit in with the larger scale required, the room was extended when it was taken to the museum. As a result, it is now too big for a room of the *Dörns* type. The ceiling of a *Dörns* was not usually painted. This may also explain the otherwise puzzling fact that there are two doors, one next to the other. The one on the left may come from another room, but this only shows how uniform the style of this particular region was in regard to room arrangement. (Gerhard Kaufmann, 'Zur Möbeltischlerei in der Wilstermarsch', in: *Volkskunst* 1, 1978, pp. 42–52.)

35 **Inglenook in a room** *(Dörns)* from Bendfeld, Probstei, Holstein. *Circa* 1720. Schleswig-Holsteinisches Landesmuseum, Schleswig.

Gustav Brandt, who originally acquired the contents of this room for the museum, was probably correct in stat-

ing that the inscription 'P.M. 1751' on one of the doors was not conclusive evidence for dating the panelling. The intarsia woodwork clearly indicates an earlier origin. 'Peter Muss, the name represented by the initials, doubtless introduced the cupboard and the little tablet which bears his initials into the room which he inherited from his father... The whole arrangement results naturally from the traditional building methods used to construct the whole house. The stove corner with its Kellinghusen tiles, the wall beds closed off with sliding doors,... the doors to the side-chambers and the particularly ornate wardrobe door—everything has its traditional place, fixed by the style in which Probstei houses were built.' (Gustav Brandt, *Führer durch die Sammlungen des Thaulow-Museums in Kiel,* Kiel, 1911, p. 107.) (The former Thaulow-Museum is now the Schleswig-Holstein Landesmuseum in Schleswig.)

36 **Room** from Kirchwerder, Vierlande, near Hamburg. 1812. Altonaer Museum, Hamburg.

This room was situated in a corner of the house overlooking both the street and the dam and therefore has two window walls. The illustration shows on the right the wall with the stove, covered with Dutch tiles. The tiled stove, painted blue, is in the style of Hamburg faience stoves. It was fuelled from the vestibule outside, to the right of the room. The Vierlande rooms developed their particular character after the middle of the eighteenth century and were still built in the same way in the nineteenth century; this is apparent in the intarsia decoration of one of the panelled walls. On the surfaces, which are mostly small, one finds the same stock patterns as on the furniture. An inscription on the panel of this room states that it was furnished for Claus and Becke Harden. The chairs, too, bear the family name of Harden. In rooms of this region there is often a niche of this kind, the access to the wall bed with its sliding doors being barely visible in the panelling. The door on the left usually leads to a small room. Whether the chest (a woman's chest) is in the correct place here remains doubtful. The cross boards between the ceiling planks are typical of Vierlande rooms. Shallow baskets with seed were stored on top of them. (Cf. Hildamarie Schwindrazheim: *Führer durch das Altonaer Museum,* 1. *Die Bauernstuben,* Hamburg, 1950, pp. 35–7.)

34 **Room** from Nieblum, island of Föhr, north Friesland, Schleswig. 1637. Municipal Museum, Flensburg.

In this example the construction of the framework which supports the whole house is clearly visible. About a metre from the outer wall one of the posts which carry the heavy cantilever beams stands in the side wall; the ceiling beams are set on top of them. The space between the cantilever and the roof guttering (or lintel) is covered by a sloping sheet, the so-called *Kattschurf*. Between posts and wall is a small wall cupboard, corresponding to the *Hörnschapp*. A long table stands in front of the bench along the wall, and with the armchair of the master of the house at its head. The wall opposite the window is occupied by two wall beds and a wardrobe. At the time it was made this room must have been one of the finest on the island. The fittings were ordered by Peter Hansen. It is said that there was no stove in the room—in other words it was a *Pesel*. (Cf. Heinrich Sauermann, *Führer durch das Kunstgewerbe-Museum der Stadt Flensburg,* 2nd ed., Flensburg, 1906, pp. 54–6.)

37 **Room** *(Dörns)* from Schönberg, Probstei, Holstein. 1723. Altonaer Museum, Hamburg.

'The inscription on the ceiling beam reads: "Anno 1723, May 1st, these back premises were erected. Claus Wiese, Wiebke Wiesen." Of the original fittings of these rear premises (i.e. the living quarters) there survive only the ceiling beams and the front wall of the sideboard in front of the small window outside the room. The inlaid patterns are similar to those in the room from Bendfeld (Pl. 35). It can be assumed that Wiese's room was similarly decorated. The present fine panelling, simple and well-conceived, dates from the late eighteenth century. A particularly pleasant feature is the ceiling, divided into several surfaces by cross-beading. This type is often seen in the Probstei region and, like the panelling, shows what

excellent effects can be achieved with simple means.' (Gustav Brandt, *Führer durch die Sammlungen des Thaulow-Museums in Kiel,* 1911, p. 108; cf. text to Pl. 35.)

38 Room of the main house from Kleinenheerse, Mindener Land, 1780. Westfälisches Freilichtmuseum Bäuerlicher Kulturdenkmale, Detmold.

This imposing long-house of the classical Westphalian type was erected in 1673. In 1780 the living quarters at the rear were re-built. The room was then fitted with a wooden facing in front of the beds, a feature often found in Westphalia and other North German regions. If the room is large enough a built-in wall cupboard may be fitted between the bed chambers. This picture demonstrates clearly that the night's sleep and the day's activities were closely connected. The bedstead on the right is also accessible from the neighbouring room. The Renaissance heritage survives in the carved decorations on the front of the bedstead; the tress pattern and rosettes remained popular on North German furniture up to the end of the eighteenth century. The slender scrolling above the openings seems to be influenced by Rococo style. The painting was carried out in contrasting colours of red and green. The huge clock-casing seems to have partly served as a place to keep small objects which needed careful handling—a usual practice. The stove, fuelled from the rear, was erected in 1745; the date 1830 refers only to its brass door.

39 Room at Grossenohe, near Kappel, Forchheim district, Upper Franconia.

This room belongs to a house which was probably built during the eighteenth century. It remains remarkably untouched even though it was inhabited until recently. The character of the room is emphasized by the bench that runs all around the wall and by the nature of the lighting. The comparatively recent curtain between the large stove and the outer wall conceals the resting-place, a favourite retreat for a short break. The fired clay underneath the stove is authentic; it served to protect the floor boards. The metal railing around the stove, precariously fixed to the ceiling with iron hooks, replaces the former guard of wooden slats; the latter could sometimes be artistically decorated but was usually left plain. The flooring too, has obviously been renewed. This example shows both the permanent features which combine to produce the spatial effect, but also how individual fittings can influence the atmosphere of a room. As it appears now, it gives the impression of being lived in by people socially inferior to the original occupants.

40 Room in the Rambart-Hof(?), Dreisam valley, near Freiburg, Breisgau, Baden.

This room was still occupied when this photograph was taken and clearly demonstrates the traditional arrangement. Like the other examples shown, it makes it clear that the middle-class dining-room pattern, with a dining-table surrounded by chairs in the centre of the room,

could not be introduced here. In this room, whatever the occasion, people had to sit down against one of the walls. They sat 'alongside' the room rather than 'inside' it, with the whole extent of the room in full view. This is an important feature in the traditional life-style, more characteristic than any ornaments or ostentatious fittings. Decorations are confined to a few fancy fretwork shapes at the ends of the slats of the drying frame, bench supports and chair-backs. Even planed profiles do not occur. The main impression is that of the shape of the room itself and the massive body of the stove.

41 So-called 'Upper Room' of a peasant house in Unterhasel, Thuringia. 1667. Now in the Rudolstadt Museum, Thuringia.

In southern and central Germany, where at an early stage houses were built with an upper floor, the occupants soon came to carry on different activities in different rooms. One of these was the bedroom, located on the ground-floor; another was the upper room, often heated from the living-room directly underneath by means of an opening (which could be closed) in a corner of the room. As it was the 'best room' it might also be fitted with a stove of its own. It is not possible to verify how far the museum reconstruction of this room is authentic in regard to the fittings. The stove, constructed entirely of pottery tiles, has an antique appearance. To put the clock near the stove was the general rule, because this was the best way to protect the wheels of the machinery from rust. The folding-table near the stove is in keeping, because it was useful for anyone sitting on the bench. The display of plates on the shelf is to be expected in a 'best room'. Other features could be interpreted only accurately if the particular habits of the household were fully known. The door on the right leads to a bedchamber.

42 Room from Thurgau, Switzerland. 1666. Germanisches Nationalmuseum, Nuremberg.

This example from a German-speaking Swiss canton illustrates the Alpine background of living conditions in southern Germany. 'During the seventeenth century the formerly simple wooden panelling of rooms in the Alpine regions became more elaborate. The ceilings were coffered in the Italian manner and the wall panels were architecturally arranged with arches and pilasters. The wall was concealed by a sideboard, a feature of Swiss internal fittings since the sixteenth century, together with a slightly recessed washstand with a niche for a pewter water-container. The sideboard consists of three tiers and there is a display of crockery on the middle shelf. It is sometimes decorated with scrolls in the style of the time. Next to the stove is a tiled seat, known as a *Kunst.*'(Bernward Deneke in: *Germanisches National-museum, Nuremberg: Führer durch die Sammlungen,* Munich, 1977, p. 262.)

43 Room in the so-called 'King's House' on the Hans Wharf, Hallig Hooge, north Friesland, Schleswig. After 1776.

One of the last old-style Hallig living-rooms on the original site. Although called a *Pesel* it is really a *Dörns,* because it contains an auxiliary stove. The house was built in 1776 by Captain Tade Hans Bandix. A projection extending the room at the front of the house is unusual, and makes this room larger than others. This may have been the reason why King Frederick VI of Denmark spent the night here when he inspected the vast destruction caused by the tidal wave in the previous year; since that time it has been called the 'King's *Pesel'*. The room has now become very well-known and is much frequented by visitors, but as an example of the equipment of rooms in Hallig houses it is only partly authentic. However, the opening to the beds, covered with double curtains (not shown in the illustration), the tiles covering the walls all around, the paintings on the door and ceiling, and the grandfather clock with Chinese lacquer painting, do recall the atmosphere of daily life on Hallig in former days. The Dutch wall tiles, medallions painted in blue, mostly depict biblical scenes. The stove and doors form a framework for designs of twisted columns. The base next to the door bears allegorical female figures (Hope and Love); while next to the stove are a cat and a dog. The lintel above the door has been turned into a decorative strip and by the stove is a larger representation consisting of twenty tiles. It depicts three large ships under sail, executed in manganese brown, surrounded by a blue shell pattern, with a few smaller ships on the horizon. The three-master in the centre carries on her Dutch flag the name: 'Hanna Maria Dianna'. On the frame on the upper corners are the words: 'Tade Hans Bandix/Stienke Tadens', and in the centre is a garland of flowers with the text: 'Tot hierto heft ons den Heer geholpen, Anno 1776' (Until now the Lord has helped us). Below left is the inscription: 'Verloren op Sweeden 1760' and right: 'Anno 1766'. (This refers to the largest of the ships in the painting.) The cast-iron stove plates show, as usual, biblical scenes. The wooden parts are mostly painted with oil colours in the early style. At the entrance door an inscription reads: 'Tade Hans Bandix, Anno 1780' in Gothic letters on the cross panel in the middle; below and above are paintings of fruit and flowers. The door opposite has the same divisions and the inscription: 'Sel. Stienke Tadens/Sel. Eicke Tadens'. The ceiling is painted on both sides of the centre beam with a large field intersected at the corners by quarter circles, on a green ground. These segments have golden shell ornaments on a red background. They surround areas of bright red and dark green with naturalistic flowers. The beam shows large acanthus-like leaves in red, blue and mauve on a brown ground. Above the wall-bed ledge is a painted line bearing in Gothic letters: 'What God may decree/that will be right for me. Now I only wish to strive/for bliss in after-life'. *(Die Kunstdenkmäler des Kreises Husum,* Berlin, 1939, pp. 96–8; cf. also: Gerhard Kaufmann, *Bemalte Wandfliessen,* Munich, 1973, Pl. XX.)

44 Room from the Inn valley, Tyrol, 1702, Germanisches Nationalmuseum, Nuremberg.

The room, or rather its cembra-pine panelling, is dated by an inscription carved into the door lintel which can be seen on the right of the illustration. The guide issued

in 1930 by the Germanisches Nationalmuseum says of this arrangement: 'Inside [is] a primitive stove with a round base of plastered masonry and a head-piece of hollow green tiles' (p. 330). The general effect of the room is largely determined by the wooden wainscoting which, as in many earlier South German living-rooms, is divided into fairly large compartments by vertical beading and a wide protruding ledge. North German room panels, in contrast, are arranged like the fronts of box-type furniture to form frames and framed panels (see Pls. 33 ff.). Even in the north the practice of dividing the wall into large surfaces persisted for a long time, but here it was usually made of groove-and-tongue woodwork. It must be regarded as carpenter's work, more closely akin to the builder's than the joiner's craft. It is difficult to draw a demarcation line. Where does building stop and fitting start? This question would not have been of so much importance in country areas where the distinction between the trades was not so clear as it was in towns. The kitchen must have been situated behind the left wall of the room, as the stove was heated from there. The presence of the serving hatch leads to the conclusion that meals were usually eaten in the room. It is an open question whether the table and the chairs placed around it convey an authentic impression. It is obviously a typical museum arrangement.

45 **Inglenook** in a room from Sonthofen, Allgäu. Beginning of 19th century. Now in the 'Heimathaus', Sonthofen.

Many years ago this peasant house in Sonthofen, which has remained *in situ*, was declared a 'Heimathaus'. In 1970 it was extended by an annex so that it could be used as a museum. 'According to the usual practice in old peasant houses in the Allgäu, the kitchen is situated in the vestibule and the living-room as well as the bedroom were heated from there.' (Sayn-Wittgenstein, '*Weiss-blaue Museumsfahrten*', Munich, 1975, p. 250.) The illustration shows a stove from the same area. The customary stove bench here has been moved to the front and transformed into a comfortable couch, a so-called *Gautsche*. Like the *Kunst* in the Swabian house it enabled the inhabitants to have a siesta during the day. As the drawers indicate, this piece of furniture served more than one purpose.

46 **Room** in Schliersee. 1842. Heimatmuseum, Schliersee, Upper Bavaria.

This is another example dating from 1842 which preserves characteristic features of the traditional fittings. The photograph is taken across the main axis of the room, from the stove to the domestic shrine. Late Baroque features occur in the form of shallow painted grooves in the wide beam which serves as a back-rest for the bench fixed to the wall all around the room. These painted grooves also appear on the door panels of the two built-in wardrobes recessed in the wide areas of masonry between the windows. While the North German wall insets can only be built into the inside walls, those in South Germany are generally smaller and may sometimes be put into the outside walls. An impression of old-

fashioned elegance is conveyed by the large panels of the ceiling outlined with small cross-pieces. The grooves on the underside of the ceiling beams correspond to those on the back-rest of the bench. The movable benches at both free sides of the table conform to an old-fashioned way of setting the table. They probably were originally the seats of the women and girls. (Cf. Josef M. Ritz and Gislind Ritz, *Alte bemalte Bauernmöbel*, vol. I, Munich, 1975; Alois Wolf, *Aus alten Stuben und Kammern*, Munich, 1977.)

47 **Room** from the Eggental, Allgäu. 1806. Heimatmuseum, Kaufbeuren, Bavaria.

The Eggental room reproduces the prevailing South German form with very little variation. A bench is fixed all around the walls, above it is a wall cupboard, and there is a panelled ceiling with large surfaces. The grooving in the boards of the back-rest indicates that it was erected at the beginning of the nineteenth century. The suggestion of Baroque taste in the curved frame of the wall cupboard does not fit in easily with such a date; it is probably earlier. A very striking feature is the typical domestic shrine: a comparatively large crucifix on a small shelf in a corner of the room, surrounded with sacred pictures and entwined in the tendrils of an ivy pot-plant. It is no accident that the domestic shrine receives special care in this particular museum, which contains a very large number of crucifixes from the twelfth to the nineteenth century, among them many which once formed the sacred focal-point of a household, like this one.

48 **Door of a room** *(Dörns)* from the Peterswarf on Hallig Nordmarsch, north Friesland. Oak, painted in colours. 1774. Height 200 cm, width 108 cm. Germanisches Nationalmuseum, Nuremberg.

The framed door panel is one of two corresponding pieces in the same room. The two Evangelists (St. Luke and St. John) in the upper panel are paralleled on the lower one by St. Matthew and St. Mark. On the upper part of the frame of the counterpart we read the beginning of the verse: 'Whale catching and God's hand', which is continued on the illustrated section with: 'Gave me my house and land'. On the lower part of the latter piece we see in bas-relief a three-masted whaler, while the middle piece, now faded, probably bore the names of the owners. On the specimen shown in the picture is the saying: 'To you, Lord, I commend my coming and my end.' This pair of doors has frequently been described, since it is the outstanding achievement of a group of wood-carvers, mainly from the Hallig Hooge, perhaps also from the island of Föhr. The frame mouldings around the panels, shaped as blossoms and foliage, are unmistakable. (Cf. Gislind Ritz, *Alte geschnitzte Bauernmöbel*, Munich, 1974, Pl. 4, Fig. 35; Eugen Traeger in: *Mitteilungen aus dem Germanischen Nationalmuseum*, Nuremberg, 1896, pp. 130–4).

49 **Door of a room.** Frame and panel. Softwood, painted *circa* 1800. From the island of Föhr, north Fries-

land, Schleswig. Height 195.5 cm, width 96.5 cm. Schleswig-Holsteinisches Landesmuseum, Schleswig.

A particularly colourful example of landscape painting in north Friesland, where it occurs not only on doors, but also as room decoration. Such paintings comprise schematic views. Although the subjects are much the same as those on wall tiles, they produce a powerful decorative impact, which harmonizes well with the wood of the panel frames and marbled door posts. The astonishing variety in the decoration of door panels in north Friesland may be due to the fact that neighbours share in the expense of purchasing such articles of domestic equipment; or else they may have been popular items as gifts. This was the case in other regions, e. g. in the Vierlande and in Switzerland (see Pl. 57).

50–51 **Wall paintings on lime-washed wooden wall.** Detail. 17th century. From a farm-house at Tyrlbrunn, parish of Freutmoos, Traunstein district. Now in the Open-Air Museum, Glentleiten, near Grosswil (near Murnau), Upper Bavaria.

This type of painted mural decoration in farm-houses rarely survives. It is therefore difficult to assess how far the illustrated example can be regarded as typical. The overall effect of the wall is inherited from the burghers of the late Middle Ages, while the detailed forms of decoration correspond to the style of the sixteenth century. The panels depict a hunting scene grouped around a central vase and the killing of the dragon by St. George with the princess praying as she looks on. A small window in an ornamental frame next to the princess becomes part of the wall decoration. A frieze of interlacing double scrolls at the level of the window-sill separates the picture from the base, which is decorated with more volutes. The main colours are red, yellow and blue.

52 **Domestic shrine** in the 'Raftsman's Room', Tölz. Heimatmuseum, Bad Tölz, Upper Bavaria.

The Heimatmuseum in Bad Tölz is devoted to preservation of the folk culture of the surrounding area. Tölz was an important centre for the manufacture of furniture and boasted many joiners and carpenters. The museum contains an almost uninterrupted sequence of representative examples of Tölz wardrobes from the period 1632 to 1850, which illustrate the gradual changes of form. There are also pictures under glass, votive tablets and items produced in monasteries—a selection of the most brilliant achievements of Bavarian folk art. This well-stocked 'home museum' also illustrates local people's life-style in so far as this can be done by an arrangement utilizing the space and objects available—by reproducing complete living-rooms, urban as well as rural. It may well be doubted whether the raftsmen of Tölz, important as they were in the transport of the goods produced in the town, had really developed their own separate life-style. However, this room certainly belonged to a raftsman. The domestic shrine follows the general rules. Among the pictures of saints we naturally find one of St. Nepomuk, patron saint of raftsmen.

263

53 Room from the Egerland. Czechoslovakia. First half of 19th century. Germanisches Nationalmuseum, Nuremberg.

This is an example of the type of living-room considered characteristic of the varying ways of life in different territories which have been displayed in this museum since 1902. It was reconstructed more or less faithfully, on the advice of collectors and scholars with expert knowledge of Egerland folk art of the first half of the nineteenth century, and equipped mainly with genuine furniture. Bernward Deneke has shown, in a subtle study, some of the questions and difficulties which might arise even at this date when a major museum attempted to reconstruct a composite work of art of this type and to make it authentic and comparable to rooms from other territories. The outer wall *(left)* consists of large vertical beams like those of a log house. Typical of the region are two large cast iron water-containers built into the wall near the stove. Hooks hanging from the ceiling, now without purpose, once supported the *Lienhut,* a cone-shaped hood of fired clay. This device was destroyed during the war. It diverted the smoke of the pine torch, the means of illumination, through the ceiling into the loft. It is somewhat doubtful whether the painted table of 1813 really belongs in the ensemble. However, the child's bed from Roding from about 1820–30 is characteristic of the Egerland and conveys an impression of the furniture painting of the region. The board chair with the rounded back-rest supported by seven rods is also notable because this type is not represented in any pictures of chairs in this book. (Bernward Deneke, 'Die Egerländer Stube im Germanischen Nationalmuseum in Nürnberg', in: *Jahrbuch für ostdeutsche Volkskunde,* 16, 1973, pp. 254–69.)

54 Door of a room. Pine. End of 18th century. From the island of Föhr, north Friesland, Schleswig. Height 175.5 cm, width 75 cm. Schleswig-Holsteinisches Landesmuseum, Schleswig.

The upper panel shows a husband and wife, evidently in their finery. She is carrying a basket with a handle, while he has a walking-stick and a flower. In the middle panel are a pair of pigeons and a flowering tulip. On the lower left panel is a three legged table covered with a tablecloth, on which is a vase-shaped candlestick with a lighted candle; two birds are flying toward the light. On the right we see the trunk of a man who has been beheaded, and in front of this his head stuck on a sword, with a raven diving down towards it. The lower motifs must have been taken from the repertoire of emblems (as indeed was often the case in north Friesland). This presents something of a problem, in that the wife's costume does not accord with that on Föhr, nor do the husband's clothes have a real local parallel either. Could it be that the foreign connections of seafaring people encouraged such forays into the world of fashion?

55 Entrance door to the Jehlhof, near Gotzing, Miesbach district, Bavaria. 18th century.

This door is made up of frame and panel boards like a mosaic, or even a piece of intarsia art. It is faced with pinewood boards which create the pattern of two stars,

one above the other. The change of directions of the radii marking the ends of the sections together with the grain and the carving of the edges of the boards create a vividly decorative effect. The diamond in the centre seems enclosed by struts pressing inward. The effect of the material is enhanced by the technique but was obviously deliberate.

56 Door of a room. Oak. Latter half of 18th century. From Wertingen, Swabia, Bavaria. Height 181.5 cm, width 92 cm. Bayerisches Nationalmuseum, Munich.

The door panels of living-rooms were, as many examples from various German regions demonstrate, to a large degree both subjects for decoration and expressions of the religious belief and calling of the inhabitants. This becomes clear if one compares this Plate, which shows part of a room from a Catholic part of the country, decorated with the flaming heart of the Virgin (with sword) and of Christ (with the Cross) carved in bas-relief, with a pair of doors from the Hallig in Protestant north Friesland (Pl. 48). There the four Evangelists appear on the corresponding panels. On the lower panel here the farmer is shown on horseback with his scythe, while the north Friesland example depicts the three-master of the seafarer. The Bavarian National Museum collection includes a wall cupboard with the same type of Rococo decoration on the door panelling which is part of this room's fittings. (Plate: Gislind Ritz, *Alte geschnitzte Bauernmöbel,* Munich, 1974, Pl. 163.)

57 Door of a room. Oak with intarsia decoration. 1787. From Handorf, Winser Elbmarsch, Lower Saxony. Height 179 cm, width 85 cm. Historisches Museum am Hohen Ufer, Hanover.

This door panel must come from a room fitted in Vierlande style (cf. Pl. 36) and may have originated there. It has two recessed areas with an octagonal, strongly profiled inner frame. Inlaid into the two surfaces are representations of galloping riders, carried out in intarsia technique. Each picture corresponds to the other in the shading of the wood. In the centre of the cross-bar are two garlands with the crowned reverse monograms I. W. and C. W. and between them a star and the year. In the upper part of the frame is a bas-relief inscription telling us that: 'This door of the room was presented by the young girls of Handorf'. This suggests that when buildings were erected or refurbished not only painted window-panes but at times even door panels were received as presents from neighbours.

58 Tablet with four painted window-panes. Glass with colourful painting and *Schwarzlotmalerei.* Latter half of 17th century. From Lower Saxony. Height 39 cm, width 27 cm. Bomann-Museum, Celle.

Above is a rider, raising his pistol. Beneath is the designation: 'Iochim · Friedrich · Naries · Soldier and Trader', and below that a soldier with musket and sword. The inscription reads: 'Niclaus Macken of . . .'. (Elisabeth von Witzleben, *Bemalte Glasscheiben,* Munich, 1977, Pl. 271.)

59 Painted oval window-panes. Glass with *Schwarzlotmalerei. Circa* 1593. From Schleswig-Holstein. Height *circa* 15.2 cm, width 11.5 cm. Schleswig-Holsteinisches Landesmuseum, Schleswig.

This pane depicts a rigged three-master. Jacob Wessel, the donor, was probably a sailor. Pictures of ships frequently occur on painted window-panes in the coastal region. They indicate that the local farmers engaged in extensive coastal shipping as well as in agriculture.

60 Painted window-pane. Glass with *Schwarzlotmalerei.* 1690. From Dithmarschen. Height *circa* 12 cm, width 8 cm. Dithmarscher Landesmuseum, Meldorf, Holstein.

A standard motif is a woman (probably the lady of the house) bidding welcome with a drink. This subject was perhaps often chosen because this was the ritual on receiving a guest. We have no precise written description of this practice. (Elisabeth von Witzleben, *Bemalte Glasscheiben,* Munich, 1977, Pl. 245.)

61 Painted window-pane. 18th century. From Sehestedt, Holstein. Height 12.5 cm, width 10.5 cm. Schleswig-Holsteinisches Landesmuseum, Schleswig.

This motif—guests arriving for a wedding or a 'window' celebration—is repeated almost identically on other panes in the same museum. Jochim Todt must have been one of the dignitaries: he is distinguished by being depicted on a larger scale, riding in a carriage, and is firing off a giant pistol. His social status may have been revealed in the second line of the inscription which is now illegible.

62 Painted window-pane. Glass with *Schwarzlotmalerei.* End of 17th century. St. Annen-Museum, Lübeck.

The motif of the host welcoming his guests and shepherding them politely to an open door is the counterpart to the watchman at the door who frightens people (cf. Pl. 24). Both figures, in the most diverse forms, have entered into the rich store of folk-art themes. The tankard in the host's hand does not necessarily mean that he is dispensing his hospitality professionally. The pane may simply signify that this is a hospitable home. (Elisabeth von Witzleben, *Bemalte Glasscheiben,* Munich, 1977, Pl. 256.)

63 Painted window-pane. 1767. From Schleswig-Holstein (Wilstermarsch?). Height 17 cm, width 13 cm. Altonaer Museum, Hamburg.

'Thomas Lehmberg, 1767', reads the inscription. Here the woman presenting the drink seems to have arrived at the wrong moment, for Thomas Lehmberg would hardly want a drink when he is just about to collect a swarm of bees. There are two possible explanations: either the woman is demonstrating her general role in ministering

to all her husband's needs, or else he is showing, regardless of the particular situation, that he is a bee-keeper who owns many swarms. (Elisabeth von Witzleben, *Bemalte Glasscheiben,* Munich, 1977, Pl. 277.)

64　**Painted window-pane.** *Circa* 1640. From Südfelde, Oldenburg. Landesmuseum für Kunst- und Kulturgeschichte, Oldenburg i. O.

The scene shown in Plate 60 appears here in a somewhat earlier version. The pious inscription, 'Heinrich Gewen. O Lord, help me to spend an honest life and find a peaceful end', provides the key to the meaning of the incident. It appears that in order to fit the picture into the limited space of the pane the motifs had to be placed close together. The pane was displaced slightly towards the base with the preliminary sketch. In the process an important part of the tall glass was found to be behind the horse's head and the rear hooves, among the lettering. It can be seen that the painters worked over a previous sketch, as one would expect. These sketches constituted the repertoire of motifs from which the customers made their choice. (Elisabeth von Witzleben, *Bemalte Glasscheiben,* Munich, 1977, Pl. 224.)

65　**Painted window-pane.** First half of 18th century. From Schleswig-Holstein (Eiderstedt?). Height 10 cm, width 8.7 cm, Altonaer Museum, Hamburg.

This pane, commissioned by Jochim Brandt, was probably originally placed in a church window as a pious contribution to the renovation of the house of God. However, it is surprising how frequently religious themes occur in the most profane surroundings. Hints at occupation, locality or other circumstances were often more important than we can appreciate nowadays. They cannot be identified in default of specific information. (Elisabeth von Witzleben, *Bemalte Glasscheiben,* Munich, 1977, Pl. 234.)

66　**Painted window-pane.** Middle of 17th century. From Schleswig-Holstein (Kiel?). Height *circa* 11.5 cm, width *circa* 8.5 cm. Schleswig-Holsteinisches Landesmuseum, Schleswig.

This pane, depicting the month of April, belongs to a series from which several other pieces are preserved in the same museum. We do not offer any interpretation of the figure in the picture, a man bearing on his back a large basket containing a second figure (with winged headdress, perhaps a fool?).

67　**Fragment of painted window-pane.** Middle of 17th century. From Lower Saxony. Height 12 cm, width 10 cm. Bomann-Museum, Celle.

This fragment is no larger than the palm of one's hand, but the reproduction, which is much enlarged, brings out the amazing craftsmanship. Though every line may have been practised a hundred times, yet time and again the bold horseman arises afresh, built up from dabs,

whisps and lightly sketched lines. The style and technique of the picture as a whole might be described as bold, too. (Elisabeth von Witzleben, *Bemalte Glasscheiben,* Munich, 1977, Pl. XIX.)

68　**Back-rest of a wooden board chair.** Walnut. *Circa* 1820. From Kippenheim, near Lahr, Baden. Height 92 cm, width 40 cm. Augustinermuseum, Freiburg i. Br.

This back-rest of a wooden chair is an example of the popularity of the motif of intertwining straps in openwork. The question whether such abstract forms arose from the motif of intertwined snakes, or conversely whether the interlaced pattern came first and was then applied to snakes' bodies, can be left open. Knots have played an important part in the graphic arts over several centuries and cannot easily be identified with the style of any single period.

69　**Back-rest of a wooden board chair.** Walnut. Middle of 18th century. From the Black Forest. Baden-Württemberg. Height (of rest) 90 cm, width 38 cm. Augustinermuseum, Freiburg i. Br.

In this example the bodies of the pair of snakes are shown clearly. They are still flat, with only the heads modelled in the round. The essential opening for the grip in the middle at the top is provided by adding a little wooden bow. Like the base, the bow is set off from the snakes.

70　**Back-rest of a wooden board chair.** Softwood. *Circa* 1830. From Steincke, Gifhorn district, Lower Saxony. Height 92 cm, width 47 cm, depth (of seat) 44 cm. Historisches Museum am Hohen Ufer, Hanover.

In northern Germany there is a variant on the snake back-rest in which, unlike so many South German examples where two creatures wind symmetrically around each other, there is only one animal biting its own tail. In the upper part this takes the form of a *pretzel* and the hole for the grip shrinks to make room for other openings. By the addition of a little crown the snake becomes a fairy-tale creature. (Bernward Deneke, *Bauernmöbel,* Pl. 23; Gislind Ritz, *Alte geschnitzte Bauernmöbel,* Munich, 1974, Pl. 101.)

71　**Bridal chair.** Beech. 1843. From the Schwalm, Hesse. Height *circa* 100 cm. Universitätsmuseum für Kunst- und Kulturgeschichte, Marburg an der Lahn.

According to the inscription this chair was part of the dowry of Anna Catharina Susmann from Leimbach. The ornaments on the back-rest and the surrounds below the seat are mostly cut out, the rest chiselled or grooved. All the woodwork is painted. The background colour is a deep blue. The ornaments are painted partly in a bright vermilion, partly in dark green. The red highlights details such as the spherical parts of the turned front legs and the crowning row of little arches on the upper part of the back-rest. The painting is strictly confined to filling in the existing forms.

72　**Armchair.** Oak. 1807. From Kirchbaitzen, Fallingbostel district, Lower Saxony. Height 121 cm, width 55 cm, depth 51 cm. Historisches Museum am Hohen Ufer, Hanover.

The small frame, consisting of four angular posts, thinner cross bars and back- and arm-rest boards looks curiously archaic, almost Gothic in its vertical forms. It has a caned seat like those made in Lower Saxony and in north German regions from straw, rushes or hemp fibre. The occupier usually sat on a cushion. It was probably a man's chair. The fact that it has arms, and the shape of the cut-out section of the back-rest, suggest that it was acquired as the seat of the master of the house when he took over as heir to the farm, or for his wedding. Post and board chairs existed alongside each other since the beginning of the nineteenth century at the latest. (Wilhelm Pessler, *Deutsche Volkskunst,* vol. *Lower Saxony,* p. 30, Pl. 31.)

73　**Box seat.** Oak and softwood, painted. 1796. From Daun, Rhineland-Palatinate. Height 111 cm, width 55 cm, depth 48 cm. Museum für Deutsche Volkskunde, Staatliche Museen Preussischer Kulturbesitz, Berlin.

The box seat as a type perpetuates an old tradition, mainly in so far as the seat forms the hinged lid of the box and can be raised. Even the ancient Scandinavian *Kubb* chairs, which were carved out of a single tree-trunk, contained a hollow space under the seat. It was sometimes considered to be a particularly safe place to keep valuables. Servants brought a chair of this type with them to their place of service, and kept all their possessions inside it. This piece of furniture and its contents constituted the minimum space that they could claim for themselves in the household. Certain concepts of legal rights may also once have been connected with the post-type armchair of the Palatinate. Not enough is known to make a precise statement about this tradition. The colours are light blue with red.

74　**Back of a coach-seat.** Soft- and hardwood. End of 18th century. From Moorrege, near Uetersen, Krempermarsch, Holstein. Height 70 cm. Schleswig-Holsteinisches Landesmuseum, Schleswig.

Since the country roads were impassable for months on end, the farmers of the marshlands travelled to church or to celebrations in lightly built carriages with two high wheels, pulled by one horse. The two- or three-seater body with its elegantly curved shape was made by the wheelwright. The board at the back of the seat, on which the decoration is concentrated, was contributed by the joiner or sculptor, such as one Hans Holtmeyer who worked in Wewelsfleth, Wilstermarsch. In this area we find a relief decoration consisting of a mixture of human figures, animals and plant motifs very similar to those on the mangle-boards of the same area and on the ornamental bands of chests and panels, although these are executed with rather more restraint. The origin of such patterns can be found in the early eighteenth-century reliefs mounted on the cornices of Hamburg wardrobes. With their paintings, which were sometimes even

gilded, these coach-seats became a status symbol. In the country west of the Elbe and far into Lower Saxony similar back-boards, although narrower and less elaborate, are found on coaches. Because they were not made as part of the coach, they survived whereas the coaches themselves perished. They are highly-prized museum pieces, but their appearance in the exhibition room gives no reliable idea as to what they once signified and in what connection they displayed their owner's importance. Both the Schleswig-Holsteinisches Landesmuseum, Schleswig, and the Dithmarscher Landesmuseum, Meldorf, Holstein, possess a complete light coach of this type.

75 **Back-rest of a board chair.** Beech. 1756. From Lower Franconia (?). Height 86 cm. Mainfränkisches Museum, Würzburg.

Two bird-like heads grow out of this chair back-rest. The outline of this chair-back could, no doubt, be classified with a number of similar ones from which it appears to differ only slightly (as. R. Forrer has done with other examples in his *Von alter und ältester Bauernkunst*, Esslingen, 1906). However, it is questionable whether this interpretation would reflect the actual historical development accurately. The spikes on the sides may be all that remains of the outlines of the body and the plumage of a bird. However, other basic shapes can be discerned in the process of seeking an original motif, now stylized and transformed. The shell on top, which often replaces a crown (see Pl. 44), and the carved spirals on the sides certainly do not derive from a representational double eagle or some such motif. The maker of this piece sawed out a heart shape at the point where it provided a practical hand-grip for carrying. He readily adopted the board type as the basis for the carving of two bunches of grapes which support the beaks of the birds' heads on their stalks. Chairs with these grape motifs are also known as 'vine-growers' chairs.

76 **Armchair.** Ash and pine. 1829. From the Altes Land, near Hamburg. Height 110 cm, width 61 cm, depth 41 cm. Altonaer Museum, Hamburg.

Although armchairs in other areas, for example north Friesland, are also composed almost entirely of turned pieces, those of the Altes Land exhibit certain Baroque trends. This effect is produced by the soft form of the turners' work on the lathe; the upper board of the back-rest, much perforated and shaded, also contributes to this impression. The main motifs are animal and plant forms carved in low relief—and the name of the owner which gives the piece an individual touch. One little feature is characteristic of wooden pieces from the Altes Land: the pair of turned knobs on the edge of the back-rest are placed diagonally, whereas head-pieces of this type are usually placed radially. (Bernward Deneke, *Bauernmöbel*, Pl. 13 and our Pl. 188.) This example is an exception in this respect.

77 **Four-poster chair.** Wood. 19th century. From Werther, Halle district, Westphalia. Museum für Kunst- und Kulturgeschichte, Dortmund; now in Cappenberg Castle, near Lünen, Westphalia.

The spirit of the early nineteenth century is perceptible in the fretwork on the back-rest, but the small 'leaves' are additions that do not belong to the style of that era. The placing of the chair was largely influenced by the widening of the front of the seat. The raised mouldings on the seat frame are an unusual feature.

78 **Bench.** Softwood. 1836. Probably from Lower Franconia. Height 86.5 cm, length 151 cm. Mainfränkisches Museum, Würzburg.

Lightly constructed benches of this type, with curved back-rest boards, are common in central and southern Germany. The upper edge of the back-rest is usually straight. Like corresponding pieces without back-rest, this article of furniture served as a movable seat, i.e., at meal-time it was pushed to the free ends of the dinner table. (Cf. a similar piece from Saxony in Konrad Hahm, *Deutsche Volkskunst*, Berlin, 1928, Pl. 32; and from Alsace in Konrad Hahm, *Deutsche Bauernmöbel*, Jena, 1939, Pl. 21.)

79 **Chest bench.** Oak. 1812. From Friedewalde, Minden district, Westphalia. Height 93 cm, width 189 cm. Museum für Kunst und Kulturgeschichte der Stadt Dortmund; now in Cappenberg Castle, near Lünen, Westphalia.

The chief impression conveyed by this piece is the red and white colour used. In contrast to similar chest benches in the country around the Lower Elbe, those from Westphalia have carved and painted decorations not only on the back-rest but also on the front of the chest. The low back-rest on this specimen should be noted.

80 **Chest bench.** Oak. 1796. From Grünendeich, Stade district. Height 101 cm, width 147 cm, depth 41 cm. Germanisches Nationalmuseum, Nuremberg.

The chest bench is a piece of furniture found over an area stretching from the Wilstermarsch in the north to Westphalia in the south-west. Around Hamburg its specific local characteristics can be used to differentiate between the various marsh regions, but as a general rule carved decorations are confined to the back-rest. In Westphalia, however, the front of the chest, too, may have its full share of ornamentation. This specimen is painted a reddish brown.

81 **Wooden board chair.** Softwood. First half of 19th century. From the church at Neudorf, Ore mountains, Saxony. Formerly in the Oskar-Seyffert-Museum, Dresden.

This chair is one of a group from Saxony and Hesse in which the back-rest is cut out to form two curved fields. A leaping animal, in this case a hunting dog, bridges the two openings. On other specimens animals of the chase occur. The hunting horn added in the horizontal section also conveys this association. (Cf. Konrad Hahm, *Deutsche Volkskunst*, Berlin, 1928, Pl. 30.)

82 **Table.** Softwood. 18th or 19th century. From the neighbourhood of Wasserburg, Bavaria. Height 76 cm, width 115 cm, depth 100 cm. Städtisches Heimatmuseum, Wasserburg am Inn.

The catalogue text reads: 'Table with crossed framework, with turned rods at the intersection of the arched legs. There is a foot-rest all around, and on top of the legs are two guide mouldings for a drawer (not preserved). The top is a flat rectangle with two strong edge pieces but no firm connection to the framework. Below the edge of the top are leather strips fixed with nails (to hold eating utensils).' (Cited from *Volkstümliche Möbel aus Altbayern*, Munich, 1975, p. 160.) Stability is thus achieved by clamping of the angular supports in the basic structure. The turned rods play no part in this. The supports are set into a round pole. This type of construction is found in smaller household implements from various regions, such as Pomeranian chandeliers.

83 **Table.** Apple and oak. 1832. From the Rhön mountains. Height 76.5 cm, top 107×84.5 cm. Germanisches Nationalmuseum, Nuremberg.

'Even as early as the late Middle Ages a box, sometimes a second container with slanting sides, was added to the basic parts, the frame and the top. This established a form which occurs in Hesse and in Franconia well into the nineteenth century. Museum catalogues often used to associate this type with the Rhön mountains, assuming that this region also supplies the materials' (Bernward Deneke, *Bauernmöbel*, p. 76). Accepted opinions of this kind are often reinforced by the terminology used by antique dealers. In the case of the table in this illustration access to the upper drawers of the box attachment was gained by pushing the top aside. (In this case the top is not original.) The upper section once had several more small drawers which are now lost. The intarsia decoration is of plum-tree and maple.

84 **Table with surround.** Softwood, painted. From Degerndorf. Height 77 cm, width 108 cm, depth 73 cm. Signed on the drawer AP (Perthaler) and dated 1793. Bayerisches Nationalmuseum, Munich.

This table very clearly reflects a number of aspects of popular farm-house furniture. On one hand it adopts the fashionable form, not unlike that of the contemporary card-table, particularly in the curved legs, though they were perhaps somewhat heavy with only a short surround at the top. The idea of these springy supports with turned-in feet, their outline already indicated at the upper edge, is to ensure that the table stands firmly. This example had to withstand hard use and the form is therefore singularly inappropriate; it would soon have fallen to pieces. The feet are therefore fitted into a stable frame and are shaped as concave spheres which had to withstand heavy wear. The company around the table could rest their feet on the frame, which would have been considered ill-bred in upper-class society. The table could, no doubt, also serve as a dining table for the household. This is indicated by the painting of the table top, as well as by the frame. The monogram of Christ framed by ten-

drils appears (see also Pl. 86). The family dining table could assume an almost sacred significance. The drawer also bears a monogram. It was probably part of a bride's dowry.

85 **Table.** Softwood. 19th century. From the Rhön mountains. Bavaria. Height 72 cm, top 77.5 × 117.5 cm. Rhönmuseum, Fladungen.

Tables in regular use have not survived to the present day to the same extent as chests or even chairs. This is mainly, of course, because the table-top suffered such hard wear. The Rhön occupies a special place among furniture regions, especially because of its large chests on supports with their curiously old-fashioned design, but also because of its attractive smaller box chests with three curved areas on the front. This table cannot claim regional individuality, but it impressively embodies a type that in its simplest form was once very popular in central Germany. All the visible parts make for stability. The angle of the legs itself suggests steadiness. There are no drawers beneath the top, and it can be moved much more easily than the table in Pl. 83. Yet in the early farmhouse a movable table was not really regarded as an advantage, for the table around which the family gathered for meals was in an almost sacred sense immovable. Well-scrubbed floor-boards provided a solid surface for it to stand on.

86 **Table-top.** Maple with intarsia decoration. 1743. From Wiechs, Heimatmuseum Bad Aibling, Upper Bavaria.

Examples of intarsia art adopted from Italy into the central European folk-art repertoire occur around Rosenheim in the Inn valley. In this example the motif—a table laid for a meal—follows the model of painted table-tops from the late Middle Ages; they occur quite frequently in southern Germany. (F. R. Uebe, *Deutsche Bauernmöbel*, Berlin, 1924, p. 92.) It is debatable whether the round plates were put into the rounded-off corners of the table for the sake of the composition, or whether four people sat down at the four sides of the table, as was probably the case. The variety of food on the plates alone indicates that one cannot draw any conclusion from this about what people actually ate. The artists evidently preferred to indulge in playful visual deception rather than to indicate the actual order of seating or the kind of menu. (Leopold Schmidt, *Bauernmöbel aus Süddeutschland, Österreich und der Schweiz*, Vienna and Hanover, 1967, Pl. 86.)

87 **Furniture from Hesse.** Various kinds of wood. 18th century. Universitätsmuseum für Kunst- und Kulturgeschichte, Marburg an der Lahn.

In many museums 'peasant rooms' are exhibited which contain arrangements of furniture that originally did not belong together at all. As a collection of odd pieces they do not give an authentic picture and certainly do not illustrate the way of life of the time. This group of furnishings from the Marburg University Museum does not pretend to be authentic: it is simply an arrangement for display in the museum. Placing the dining-table in the centre of the room is a middle-class custom dating from the nineteenth century. Hessian popular furniture has an extraordinary variety of vigorous surfaces, and cleverly combines heterogeneous ornamental elements. The examples shown here can give only a scanty idea of its richness. Obviously, in certain circumstances the effect of lavish ornamentation may to some degree be created by the lack of decoration on the white lime-washed walls and by mobility of the furniture. The phrase 'peasant style', as denoting a more or less standard way of equipping a living-room with a precise regional character, means different things in different parts of Germany.

88 **Bedroom furniture,** with four-poster bed and chest, both painted. From Oberhasel, Thuringia. Museum Rudolstadt, Thuringia.

'In no other respect is the folk art of Thuringia so deficient as in interior fittings and household goods. The dominant feature of the equipment in Thuringian peasant houses is its simplicity, even austerity. Benches under the windows and at the stove, a fixed table with a large drawer in the corner near the window, simple chairs with carved back-rests, a little treasure chest next to the door, carved drying racks near the stove: these are the main features of the living-room. Add to these the bedstead with piled-up featherbeds and the canopy over the bed in the bedroom... The wood is mostly spruce; more elaborate pieces are painted; and in the simple huts of the Thuringian Forest dates and names are simply burned in.' (Edwin Redslob, *Deutsche Volkskunst,* vol. *Thuringia,* Munich, 1926, pp. 20 ff.)

89 **Head- and foot-end of a bed.** Spruce, painted. 1781. From Degerndorf, near Blannenburg, Rosenheim district. Height 186 cm, width 130 cm. Germanisches Nationalmuseum, Nuremberg.

The painting was executed by Anton Perthaler (1740–1806). On a blue ground are light blue areas and tendrils in golden yellow; the blossoms are mostly red, mauve, blue and yellow, but always with some white. At the head of the bed the infant Jesus, with a cross in His left hand, is lying in a basket filled with blossoms standing in a meadow. The canopy shown in Pl. 95 is part of this bed.

90 **Four-poster bed.** Oak. 18th century. From Ravensberg, Westphalia. Height 199 cm, width 161 cm, length 187 cm. Historisches Museum am Hohen Ufer, Hanover.

The inscription on the head-board reads: 'Anna Ilsabein Sewings zu Lensinghaus.'
'The combination of Baroque arrangement of panels on the footboard, of Baroque columns and lace-like openwork carvings on the boards at the edges of the canopy is characteristic.' (Gislind Ritz, *Alte geschnitzte Bauernmöbel,* Munich, 1974, Pl. 52.)

91 **Four-poster bed.** Softwood. Latter half of 18th century. From the Waldshut district. Height 192 cm, width 141.5 cm, length 192 cm. Badisches Landesmuseum, Karlsruhe.

'The canopy with its curved edges and its slender frame seems light. It is supported only at the foot end of the bed, the top ends with the canopy and appears to be divided in the middle by a small column. In both parts the two saints and martyrs are shown in a frame of shell patterns. On the ceiling of the canopy is a portrait of St. Blasius with candles. The footboard is decorated with two angels' heads. Flower and leaf ornaments depicting tulips decorate the sideboards and small intermediate surfaces between foot and head.' (H. E. Busse, *Deutsche Volkskunst,* Baden, Weimar, n. d., p. 17.)

92 **Board surmounting a wall-bed opening.** Wood, painted fretwork. Late 18th century. From Humptrup, north Friesland, Schleswig. Height 68 cm, width 115 cm. Schleswig-Holsteinisches Landesmuseum, Schleswig.

In cases where wall-bed openings were not closed off with wooden flaps but with curtains some sort of ornament was often added, frequently no more than simple decorative fretwork. This specimen is more ambitious. On the cartouche below the crown is the following painted inscription (white on red ground):
 Jesu, thou my beloved art,
 Find a soft bed right in my heart.
 Thy rest in my heart's shrine shall be
 That I may always think of thee.

93 **Box bed.** Softwood, painted. *Circa* 1800. From Kamm, near Passau, Lower Bavaria. Height 170 cm, length 173 cm, width 85 cm. Oberhausmuseum, Passau.

This type of box bed, an example of movable furniture, is found in Lower Bavaria and Upper Austria. The end facing the room is closed off with woodwork and the other by the wall. The doors are placed on one of the long sides. Complete enclosure of the bedstead may be regarded as a logical late development of the practice of sealing off the bed with draperies. Such box beds are not directly comparable with the built-in wall beds of North Germany. Heat-saving was hardly an important factor by the time they came into being, but rather a desire to conceal the sleeping-place during day-time. This specimen bears simple, but quite impressive painting which includes simulations of different kinds of wood and uses the artificial graining to form a regular pattern. The main colour is brown, slightly shaded. The frames of the door wings pick up some blackish-green tones, and their panels are a brighter red. The frames of the cartouche simulate light yellow wood, while their panels have a light blue base on which red blossom arrangements are painted. The total effect is somewhat meagre and subdued.

94 **Bedstead.** Softwood. Middle of 19th century. From Obstätt, Ebersberg district, Upper Bavaria. Height

188 cm, length 175 cm, width 95 cm. Heimatmuseum Wasserburg am Inn.

Bedsteads of this type came into general use in rural houses only during the latter half of the eighteenth century. Apart from the raised head-piece the same basic shape has persisted until the present day. Before that time the sleeping-place was either a bench, a pallet or something similar, or a more or less enclosed box, the walls of which might consist of fabric curtains. It used to be assumed that the change was brought about by the growing demand for something more hygienic. However, progress in heat economy may have played a part. Better bedroom equipment and perhaps improved window insulation enabled people to dispense with enclosed sleeping-places. The raised head of the bed may be a relic of earlier styles, but may partly be due to the fact that the head and upper part of the body rested on thick pillows. It may therefore be a parallel to the contemporary form of seating. The head-board is accordingly heightened and given a gable shape. The footboard remained rather flat and was less subject to variations. The head-board thus bore the principal decoration, often in the form of religious pictures and symbols designed to guard one's nocturnal rest, as we already saw in the case of the four-poster bed (see Pl. 91). The main colours are green and red; the leaf ornaments are covered with gold-dust and a coat of bronze.

95 **Canopy above the bed** in Pl. 89. Length 19.4 cm, width 137 cm. Germanisches Nationalmuseum, Nuremberg.

The canopy harmonizes with the bed's head- and footboards as far as colouring is concerned. Depicted in the centre panel are the hearts of Jesus, Mary and Joseph— 'a trinity which, compared for instance with the Tölz picture of the hearts of Jesus and Mary, is rarely found in furniture painting. The festoons of leaves and blossoms on the posters are painted white.' (Bernward Deneke, *Bauernmöbel*, p. 246.) The rather 'refined', almost sickly colour range is not really in tune with the gaunt style of German furniture decoration. It is probably explained by the fact that Anton Perthaler was an immigrant from Austria.

96 **Cradle.** Oak. *Circa* 1800. From Mausbach, Aix-la-Chapelle district, North Rhine-Westphalia. Height 60 cm, length 103.5 cm, width 56 cm. Municipal Museum, Cologne.

This type of box cradle with swinging runners placed crosswise, half sheltered by a cover, can frequently be seen in the Lower Rhine region and in the Netherlands. It may seem obvious to find the six-pointed star, a symbol of protection, carved on the long side of a child's cradle, but one should not draw far-reaching conclusions from what is no more than a possibility. This type of cradle may be made of either wood or iron (!). (Cf. Gislind Ritz, *Alte geschnitzte Bauernmöbel*, Munich, 1974, Pl. 127. A similar specimen from the Eifel region is in Bernward Deneke, *Bauernmöbel*, Pl. 117.)

97 **Cradle.** Oak and pine, painted. Middle of 18th century. From north Friesland. Height 72 cm, length 97.5 cm, width 56 cm. Altonaer Museum, Hamburg.

We know of quite a number of 18th-century cradles from north Friesland. One similar example to this is in the Schleswig-Holsteinisches Landesmuseum. The combination of carved ornament and brightly-painted landscape themes on the panelling is typical.

98 **Corner of bedroom with four-poster.** 1793; cradle and wardrobe 1835. From the Feuchtwangen area. Heimatmuseum, Feuchtwangen, Franconia.

On this multi-coloured four-poster the head-piece is decorated with fretwork, the surfaces of the canopy are hollowed out or raised, and the side parts have an undulating pattern. At the foot-end, too, is a curved board terminating in a pronounced bulge. The body of the bed is ornamented with dark-green mottling, while the coffered parts have flowers painted on a white background; it is signed and dated 'Margarethe Barbara Hesslerin, 1793'. The single-door wardrobe has a deep blue background with coloured flowers on a white ground on the door-panels and frame. The cradle is also painted in colours, and has a retractable railing at the head-piece to support the protective cloth. On the wall are pictures of saints. (H. Guthlein and J. M. Ritz, *Das Feuchtwanger Heimatmuseum*, 2nd ed., revised by Prinz Franz of Sayn-Wittgenstein, p. 37.)

99 **Cradle.** Softwood, painted, 19th century. From the Feuchtwangen area. Height 78 cm, length 90 cm. Heimatmuseum, Feuchtwangen, Franconia.

Unlike Upper Bavarian cradles, which were low with their corner posts turned outward, this Franconian example represents an advanced type with vertical posts, as was the custom in most parts of Germany. The ribbons that held the pillows in place were tied to the knobs on the long sides, which thus fulfilled the same function as the perforations on the cradle of Plate 100. The cradle in this illustration is painted all round with flowering pot plants on an alternating white and brownish background.

100 **Cradle.** Softwood, painted. 19th century. From Lower Franconia or Württemberg-Franconia. Height 75 cm, length 92 cm. Heimatmuseum, Feuchtwangen, Franconia.

Cradles become progressively lower in height from the north to the south of Germany. In Upper Bavaria they are only about half the height of those in the Vierlande. The height of this one, in Feuchtwangen, may be about mid-point in the range. The overhead rack, which could be horizontal as here or hinged back, is not known in the north but is quite common in the south. A cloth was laid across it to protect the child from the sun or from insects. The openings near the edge of the long sides enabled the mother to draw a strap across to prevent the child from falling out. Elsewhere knobs or posts served the same purpose.

101 **Cradle.** Oak. 1810. From the Vierlande, near Hamburg. Height 103 cm, length 93 cm, width 62 cm. Schleswig-Holsteinisches Landesmuseum, Schleswig.

In the frames and on the boards between them are motifs which in the Vierlande are commonly inset as intarsia decoration in beech and lime. They mainly represent flower tendrils and birds. This inscription reads: 'Hans Buhk/Anke Buhks Anno 1810'. It may be typical of the increasingly middle-class style of living in the Vierlande that the cradle is provided with guide boards on which the runners can swing without moving out of position. The cradle can thus be rocked much more easily on an uneven floor. In this case the guide boards were lost during the war.

102 **Bench cupboard.** Oak. Latter half of 16th century. From Lindholm, north Friesland, Schleswig. Height 124 cm, width 97 cm, depth *circa* 40 cm. Schleswig-Holsteinisches Landesmuseum, Schleswig.

This crudely made fixture belongs to the type of wall or bench cupboard that in north Friesland was located next to the seat of the master of the house, either in the wall between the frame posts and the outer wall (Pl. 34) or on the bench fixed to the wall. Remarkable attempts have been made to fill in the plank panels with creepers. Remarkable, too, is the variety of effects achieved on the three panels, suggesting that several hands were at work. The inscription around the medallion is illegible.

103 **Wall cupboard** (Schenkschiewe). Oak. First half of 17th century. From the Schleswig region. Height 200 cm, width 143 cm, depth 48 cm. Schleswig-Holsteinisches Landesmuseum, Schleswig.

This sideboard, too, must originally have been set into a wall. The ledge and the framework for the runners were presumably added when it was altered to stand in front of the wall. The scroll-work decoration, echoing Renaissance forms, is mostly carried out in bas-relief, and may indicate that the piece came from Husum.

104 **Wall cupboard** (Schenkschiewe). Oak. First half of 16th century. From Angeln (?), Schleswig. Height (without runners) 186 cm, width 102 cm, depth 42 cm. Schleswig-Holsteinisches Landesmuseum, Schleswig.

This cupboard (originally built into the wall) can be described as a *Schenkschiewe* even though the middle compartment is no longer fitted with a flap that closes down but rather with one that swivels. The decisive factor is that this feature determines the layout of the cupboard's interior and the overall make-up of the façade. Because it is so slender, the upper and lower sections, too, are accessible only through the centre door. The runners and filling-in board, dated 1690, were probably added after the body of the cupboard had been detached from the wall for use as an independent piece of furniture.

105 **Bench cupboard.** Oak. 1593. From Nord-Lind-

holm, north Friesland. Height 133 cm, width 88 cm, depth 41 cm. Municipal Museum, Flensburg.

It can be seen at a glance that this cupboard was originally part of the bench fixed to the wall in a corner of the room. The ornamental head-board is broken off vertically on the left because, although it is fairly low, this was the point where it came up against the beam closing off the outer wall. The planks on both sides of the cupboard are fixed and are the principal focus of the ornamentation. They are also inscribed with the year and a (badly worn) monogram of Christ. A Gothic impression is conveyed by the whole construction, the carved fluting of the head-board and, last but not least, the abrupt way the edges of the planks are terminated. The Municipal Museum in Flensburg owns a second, very similar piece from the year 1588 which undoubtedly comes from the same workshop. (Ellen Redlefsen, *Katalog der Möbelsammlung,* Municipal Museum Flensburg; Flensburg, 1976, No. 85 f.)

106 **Panel of a wardrobe door.** Oak. 1824. From Hof Redeker (called Strunk). Isingsdorf, Halle district, Westphalia. Measurements of panel board: height 36 cm, width 33 cm. Museum für Kunst- und Kulturgeschichte, Dortmund; now Cappenberg Castle, near Lünen, Westphalia.

This wardrobe is opened by two identical doors. We see here one of the upper panels, a stylized angel's head, which 'looks as if it had been baked with a gingerbread cutter', is set into the grooved surface. It looks to me more like a piece of hand-modelled pastry! (Cf., on this whole piece, Walter Borchers, *Volkskunst in Westfalen,* Münster, 1970, p. 59, Pl. 155.)

107 **Panel board of a piece of furniture.** Oak. Latter half of 18th century. From Hof Mönk, Bardüttingdorf, Herford district, Westphalia. Measurements of panel board: height 48 cm, width 37 cm. Museum für Kunst und Kulturgeschichte, Dortmund; now Cappenberg Castle, near Lünen, Westphalia.

The symmetrical composition of two S-shaped groups of tendrils or runners has been part of the folk-art repertoire at least since the sixteenth century. It went through an infinite number of far-reaching variations, during the course of which the original plant form underwent radical deformation, as in this example. The panel below the one illustrated here shows in bas-relief a couple riding on a horse. (Plate: Walter Borchers, *Volkskunst in Westfalen,* Münster, 1970, Pl. 20.)

108–110 **Sideboard** *(Schenkschiewe).* Oak. 1550. From Dithmarschen. Height 316 cm, width 157 cm, depth 58 cm. Germanisches Nationalmuseum, Nuremberg.

This is one of the important early fixtures found in the houses of large early capitalist farmers in Dithmarschen. The main body of the cupboard was inside the wall and the façade was flush with it, but the ledge and head decoration projected. The latter displays emblems of the

farming families Woldersmannen and Vogdemannen and traces the couple's ancestry. The façade proper consists of four tiers. On top are three single drawers about equal in size; below them one that extends right across and is opened or closed by means of the *Schenkschiewe* proper, the flap which can be closed down; below this are two more drawers, and further down two larger compartments, each with its own door. On top the story of Samson is shown in three scenes: on the left the struggle with the lion (next to it, the jawbone of an ass, Samson's distinctive mark); on the right Samson is carrying off the gates of Gaza, and in the middle Delilah is shown cutting off the curls of the sleeping Samson. The *Schenkschiewe* itself relates the story of the Fall and the expulsion of Adam and Eve from the Garden of Eden. On the drawers appears the saying, so frequently seen on North German Renaissance furniture: 'If God is with us/who can be against us.' The tendrils on the other surfaces are of unusual elegance in tune with the style of the period. The pair of heads at the bottom represent the owners, in spite of the head-dress costume. The heads in the equally elegantly carved half-rosettes at the very top may be purely decorative. The nearest comparable *Schenkschiewen* from Dithmarschen are that from Meldorf of 1546 in the Schleswig-Holsteinisches Landesmuseum, and one (lost in the Second World War) of 1568 in the *Pesel* of Markus Swin, Lehe near Lunden, Dithmarschen (later in the Dithmarscher Landesmuseum, Meldorf). Neocorus, the chronicler of Dithmarschen, wrote about 1600: 'The housewife, whenever she likes or whenever guests arrive, goes to her *Schenkschiewe,* where she keeps her best glasses and silver plate, takes one out, toasts her guests and drinks to them.' (Ed. Dahlmann, Heide, 1904, p. 125.)

111 **Wardrobe.** Pine. Middle of 18th century. From Freesmark, north Friesland, Schleswig. Height 226.5 cm, width 236 cm. Schleswig-Holsteinisches Landesmuseum, Schleswig.

This piece of furniture is a rural version of the Hamburger *Schapps,* or large wardrobe with two doors. What it lacks in valuable timber it makes up for in colour. The basic tone is a dull olive-green, the slightly protruding vertical strips being in a mottled white and red. In the mirror centre are biblical scenes: on the left Jacob and Rachel at the well (he is putting a pearl bracelet around her wrist, and an accompanying inscription explains what is happening), on the right Abigail, kneeling, is handing David loaves of bread. In north Friesland wardrobes of this type could only be found in the largest farmsteads of the mainland. They are exemplars of the 'old painted farm furniture' of that region.

112 **Wardrobe.** Oak, painted. 1732. From Eiderstedt, Schleswig-Holstein. Height 225 cm, width 224 cm, depth 84 cm. Lyngby Open-Air Museum, near Copenhagen.

The painting—red, yellow and black—strikes a sonorous, solemn note. The structure shows that it is a direct descendant of the Hamburg wardrobe type from around 1700, even to the carved 'clasp' on the ledge. The twisted

half-columns in front of the framing partition strips are skilfully modelled and not, as is often the case, simply cut out of a plank—a clear sign of the costly work that went into such an item of furniture. It would have stood in a large vestibule of the type frequently found in the huge farm-houses of Eiderstedt (where they were called *Haubarg*). The region was in direct contact with Hamburg through the grain trade.

113 **Wardrobe.** Pine, painted. 1778. From the island of Föhr. Height 153 cm, width 131 cm, depth 33 cm. Schleswig-Holsteinisches Landesmuseum, Schleswig.

This one-door specimen from the north Frisian islands is quite unique—no comparable piece is known. The placing of raised, outlined boards over the front and cross areas is an original feature. The projecting ledge on the straight front points into empty space on both sides. The bevels, on the other hand, are finished off with a superimposed layer shaped like clasps. All these details emphasize that making a wardrobe was rarely something undertaken by an amateur, for in this area wall cupboards were the general rule. The carvings on the door panels are among the finest examples in north Frisian folk art of this type of wood-carving. Perhaps the work has some connection with the group of people around the Greenland explorer Commander Lödde Rachtsen, who lived in the neighbouring Hallig Hooge. The clasps on the frame have a parallel in some watch cases. The Municipal Museum, Flensburg possesses the largest and finest case of this type.

114 **Wardrobe.** Oak, painted. 1824. Gütersloh district, Westphalia. Height 171 cm, width 140 cm, depth 43.5 cm. Museum für Kunst und Kulturgeschichte, Dortmund; now Cappenberg Castle, near Lünen, Westphalia.

'This one-door wardrobe has wide, solid wall sections in front, each with two fluted panels. Between these panels, which occur again on the base, are flower patterns. Painted on the door is an angel blowing a trumpet and a bunch of flowers. Only the front is painted. The dominant colour is reddish-brown, the surface areas are dark bluish green, and in addition white, yellow, cream, pink-orange and black shades are used.' (Bernward Deneke, *Bauernmöbel,* Pl. 229.) The inscription reads: 'Margreta Ilsabein Brinckmanns in the year 1824.'

115 **Dresser.** Oak, painted. 1767. From the Aurich district, east Friesland, Lower Saxony. Height 200 cm, width 172 cm, depth 57 cm. Historisches Museum am Hohen Ufer, Hanover.

The general appearance of this dresser with its open top is typical of such furniture in north-western Germany. It shares its square shape (about 2 × 2 m) with wardrobes from the same area. Pieces like this are frequently inscribed with the saying 'What God has blest, that is best.' The shelf on the open part often has notches in front where tin spoons could be hung. Unmistakably east

Frisian is the tulip-tree, repeated no less than twelve times on this single piece in low relief decoration. It can also be seen on the front of chests and is typical of an entire 'furniture region'. The colours are black on the base, with flowers in green and red, and the inscription in red. (Cf. Albert Schröder, *Bemalter Hausrat in Nieder- und Ostdeutschland,* Leipzig, 1939, Pl. 18.) A very similar sideboard used to be in the Museum für Deutsche Volkskunde, Berlin. (Cf. Hans Karlinger, *Deutsche Volkskunst,* Berlin, p. 310.)

116 **Dresser.** Oak, painted. 1827. From Rumohr, Holstein. Height 231 cm, width 133 cm, depth 50.5 cm. Schleswig-Holsteinisches Landesmuseum, Schleswig.

This type of furniture, which corresponds to the broader, more elaborately constructed sideboards of Westphalia, is not often found in Holstein and hardly ever in Schleswig. It belonged in the kitchen which, in Westphalia, was freed of smoke from the stove and so made more habitable at an earlier date, and was matched by open shelves on which a number of attractive dishes and plates were generally displayed. The panels of this piece bear rather feeble flower patterns, a sure sign that painting was not regarded as essential in this furniture, but as a more or less optional addition.

117 **Wardrobe.** Softwood, painted. 1836. From the neighbourhood of Aichach, Swabia, Bavaria. Height 193 cm, width 135 cm, depth 50 cm. Heimatmuseum, Aichach, Bavaria.

Four ornamented areas in vivid colours are set off against a rather dull light blue background. They have frames which are sawn out, carved and turned. The frames are painted red, green and yellow, as are the central moulding and the decorative beading on the cross planks and the ledge. The colour of the base within the frame is yellow, that of the vases white and red. The bunches of flowers are gaily coloured. (Colour Plate in Gislind Ritz, *Alte geschnitzte Bauernmöbel,* Pl. VIII.)

118 **Wardrobe.** Softwood. 1845. From the Beilngries district, Upper Palatinate. Height 173 cm, width 144 cm, depth 34 cm. Municipal Museum, Regensburg.

This single-door type of wardrobe, also known as the Upper Palatinate cupboard, excels in its very vivid ornamentation. This example has a general background of a brilliant blue, while the base colour of the panels is bright red. The flower garlands are pink and green, the enclosing beading a basic red, while the small ledge is painted in three colours: white, green and red.

119 **Wardrobe.** Softwood. *Circa* 1830. From Upper Swabia, Bavaria. Height *circa* 200 cm, width 130 cm, depth 45.5 cm. Weissenborn Museum.

The style of this wardrobe is typical of Upper Swabia, with its particular combination of carved and painted decoration. This point is evident from a very similar

wardrobe in the Germanisches Nationalmuseum, Nuremberg, from the country around Günzburg (B. Deneke, *Bauernmöbel,* Pl. 272). In the Günzburg example the round medallions on the upper door panels bear half-length portraits of Mary and Christ, while in the one illustrated here they contain carved hearts with flames and an aureole. The two pieces are very similar in general decoration and even in details such as the marbling of the base and the gilding of the carved parts. At the top of the centre moulding a small carved urn was added. It is obvious that the numerous similar wardrobes must have been modelled on an influential exemplar from the furniture workshops in Ulm.

120 **Detail of a wardrobe.** Softwood, painted. 1821. From Ulbering, near Pfarrkirchen, Lower Bavaria; made in the Rot valley, Lower Bavaria. Height 182 cm, width 107 cm, depth 56 cm. Measurement of section: height 76 cm. Municipal Museum, Regensburg.

The doors of this two-door wardrobe are painted with two saints in each of the panels. The upper one is separated from the one below by landscapes. The basic colours of the wardrobe are shades of ochre and brown. The head-piece, central beading and base are painted in alternating shades of brown, yellow and blue, while the corner supports are decorated with tendrils and flower motifs, filled in with red; the saint's garb is red on a light blue ground.

121 **Wardrobe.** Fir, painted. *Circa* 1810. From the area around Langenburg, Crailsheim district. Height 180 cm. Museum für Deutsche Volkskunde, Staatliche Museen Preussischer Kulturbesitz, Berlin.

This wardrobe has yellow areas painted on a blue background. The frames of the door-panel are red. On the panel is a Württemberger infantryman in uniform, standing with rifle shouldered. The frame and the two side-panels are embellished with coils of flowers above a pair of doves. It is a curious fact that pictures of soldiers are popular on wardrobe doors in other European countries. It is sometimes tempting to interpret them as guardians, but they may express nothing more significant than the pleasure in a colourful uniform.

122 **Wardrobe.** Spruce, painted. Beginning of 19th century. From the Giant mountains, Silesia. Height 193 cm, width 115.5 cm, depth 49 cm. Germanisches Nationalmuseum, Nuremberg.

'Outside the panels the dark and light blue colouring is traversed by wavy bands. There are white areas on the doors and beside them, as well as on the beams, red painting. Among the bunches of flowers in vases, red and blue predominate. On the ledge, the base and the side-walls are patterns in yellowish and reddish-brown, as on the background.' (Bernward Deneke, *Bauernmöbel,* p. 323.)

123 **Wardrobe.** Spruce, painted. 1749. Vicinity of Miesbach, Upper Bavaria. Height 176 cm, width

121 cm, depth 50 cm. Germanisches Nationalmuseum, Nuremberg.

The basic colour of the painted parts is green, the decoration multi-coloured with many shades of red, and the contours are clearly defined. 'The painting leaves part of the surface plain. It forms larger or smaller panels, each with a frame of plain wood. On the top ones are monograms of Jesus and Mary. The areas on either side of the doors of this specimen—like similar furniture elsewhere—feature painted pillars. More elaborate furniture from the Renaissance often displays carved pillars.' (Bernward Deneke, *Bauernmöbel,* Pl. IX.) Light green and red-dotted strips alternate on the pillars.

124 **Pair of wardrobe doors.** Softwood, painted. Beginning of 17th century. Probably made in Tölz, Upper Bavaria. Heimatmuseum, Bad Tölz.

Although these two doors are all that is left of a wardrobe, they are the chief evidence of a certain phase in the development of South German furniture painting, the transition from intarsia imitation to real painting. 'Contrary to intarsia work, stencil painting lacks vivid outlines and specifically avoids overlapping. The IHS motif with the aureole is not directly derived from inlaid work, so there must have been some connection with sacred pictures and other woodcuts.' (Torsten Gebhard, 'Die volkstümliche Möbelmalerei in Altbayern mit besonderer Berücksichtigung des Tölzer Kistlerhandwerks', in: *Bayerischer Heimatschutz,* 32, 1936, p. 24.)

125 **Wardrobe.** Spruce, painted. 1825. From central Franconia. Height 179.5 cm, width 139.5 cm, depth 50 cm. Germanisches Nationalmuseum, Nuremberg.

'The main colour of this piece is green. The white areas on the doors are enclosed by projecting red beading. Below the painted flowers in white appear the owner's name and the year. The base has vine tendrils on a lighter green ground. The joints and sides bear lozenge-shaped fields with flowers, turned into rectangles by the addition of a different colour. Above the door in the fluting is a festoon with red tassels and also a multi-coloured wavy ribbon. At the edge of the doors is a marbled frame. On the ledge of the base is a striped pattern in a different colour.' (Bernward Deneke, *Bauernmöbel,* p. 316.)

126 **Wardrobe.** Softwood, painted. 1778. From Leitzachtal-Aibling, Rosenheim district, Upper Bavaria. Height 178 cm, width 127 cm, depth 58 cm. Bayerisches Nationalmuseum, Munich.

127–128 **Details of the front of a wardrobe.** Softwood, painted. 1831. Made at Tölz, Upper Bavaria. Measurements of sections: height 61 cm, width 37 cm (35 cm). Municipal Museum, Regensburg.

Portraits of St. Notburga and of St. Isidore appear in the upper panels of the two wardrobe doors. The colours are blue, green and red. St. Notburga is wearing a green hat,

a blue bodice with a red front, a red shirt and a white apron. St. Isidore has a black hat, dark olive-green tunic, black trousers and white stockings.

129 **Wardrobe.** Softwood, painted. 1786. Formerly in the Jodlbauernhof, Hagnberg, parish of Fischbach, Miesbach district, Upper Bavaria. Private collection.

The name of the maker of these wardrobes Johann Böheim is recorded. They are highly typical specimens of their kind, belonging to the best period of South German furniture painting.
Two basic parallel types of this furniture can be distinguished, which have equal potential: one with a straight and the other with a wavy upper ledge, the latter crowned with a top piece in Rococo style. Both have the sloping front ends that became almost compulsory during the latter half of the century. The elaborate structure of the piece calls for trimming with cross-pieces to match the 'crown'. There are volutes below and above the clasp in the centre. The outlines of the door panels follow the sweep of the upper line. Common to both types are the pictorial themes: the four seasons, represented on one by men at work and on the other by allegorical women with *putti*. This motif—the seasons of the year were a very popular subject—was derived from the copper engravings that were distributed in large numbers, chiefly by printer's firms in Augsburg. Plate 126: see Joseph M. Ritz/Gislind Ritz, *Alte bemalte Bauernmöbel*, Col. Pl. 39. Plate 129: Main colour golden yellow to brown, blossoms red, pictures in bright colours, carved parts gilt.

130 **Treasure chest**, a so called 'Landesblock'. Oak. Medieval. In the church at Landkirchen, island of Fehmarn, Holstein. Height 104 cm, length 213 cm, depth 65 cm.

This is a very ancient form of chest. The long sides, top and bottom consist of hewn planks about 10 cm thick. They are held in place by pieces of tree-trunk, fully round below and flattened above the foot; these also form the ends of the short sides. The several parts are joined together with wooden pegs, above which (perhaps as a decoration) are iron nails. Strong iron bands have been added to bind the parts together more firmly like the hoops of a barrel, and these provide a place for the overlapping parts of the three locks. The round legs (partly restored) are set back. A box of planed oakwood which can also be locked was added later. The original piece contained the legal documents of the island of Fehmarn (Horst Appuhn, 'Der Landesblock von Fehmarn', in: *Nordelbingen* (Heide, Holstein), 28–29, 1960, pp. 46– 52; idem, *Brieflanden aus Niedersachsen und Nordrhein-Westfalen, Ausstellungskatalog,* Cappenberg Castle, 1971, pp. 9 f.)

131 **Chest on supports.** Softwood; supports: oak. Ornaments painted in black and red. 15th or 16th century(?). From the country around Wasserburg am Inn, Rosenheim district, Upper Bavaria. Height 75 cm, width 156 cm, depth 62 cm. Heimatmuseum, Wasserburg am Inn.

The construction and decoration of this chest with its frontal supports exemplifies the medieval tradition behind the later development of such chests. The patterns carved into the planks are coloured black and red. The modestly embossed supports below the chest convey a Gothic impression. Numerous types of curved and bevelled work later evolved from these origins.

132 **Chest on supports.** Oak. *Circa* 1400. From Holzacker, north Friesland district. Height 89 cm, width 143 cm, depth 74 cm. Municipal Museum, Flensburg.

This specimen belongs to the class of chests supported at the front on planks. These planks indicate the points where the whole front was divided into six areas filled with carvings resembling decorative gables. It is generally accepted that this system of decoration originated in Lüneburg. During the late Middle Ages Lüneburg was, thanks to its production of salt, a wealthy town with strong connections to the north. It provided many models for 'box-makers' *(Kistenmaker:* this was the term for joiners and carpenters; in Schleswig they were often called 'carvers' or *Schnitker).* Decorations originally based on architectural forms were transformed so that crowns of lilies became leaves hanging down loosely, and gable shapes became something like a ship's figure-head in the form of a dragon. The scaly forms and carved crosses are derived from earlier models. (Cf. Hans Schröder, *Gotische Truhen. Festblätter des Museumsvereins für das Fürstentum Lüneburg,* No. 4, Lüneburg, 1932.)

133 **Grain storage chest.** Oak. 1752. From the Artland. Height 144 cm, width 165 cm, depth 106 cm. Municipal Museum, Osnabrück.

Large chest-shaped containers for grain, of a type made by carpenters, were still used in northern Germany until recent times. Basically similar in construction to the chest supported on planks, the horizontal planks are tongued and grooved and jointed into the vaulted top. They preserved the 'Gothic' tradition into the latter half of the eighteenth century or even beyond. (Cf. Walter Borchers, *Volkskunst in Westfalen,* Münster, 1970, Pl. 54.)

134 **Front of a chest.** Oak. 16th century. Acquired at Lunden, Dithmarschen. Height 44 cm, width 102 cm. Schleswig-Holsteinisches Landesmuseum, Schleswig.

The front of this chest shows how Gothic architectural motifs were transformed into a local two-dimensional style. Clearly, the wall, which consists of two planks, was properly dovetailed into the shorter sides of the box of the chest; this type was therefore technically more advanced than the 'Gothic' type of chest on planks. Details make it clear that the motifs of the carving are derived from the Lüneburg chests with some decorative gables (see Pl. 132). This is particularly apparent on the notched strips between the panels and on the crossed leaves below the pointed arches. The rest of the ornamentation is greatly simplified. Chests with such frontal decoration were apparently made and traded on a fairly large

scale. Examples can be found in the area from Lüneburg to Denmark, as well as in the latter country. We still do not know exactly where they were made. A variant of this adoption of an architectural motif as a pattern for surface decoration occurs in Pomerania about 1600. (Cf. a specimen from Jamund, Köslin district, reproduced in Pommersches Landesmuseum, Stettin, *Erwerbungs- und Forschungsbericht,* 1937, in: *Baltische Studien,* new series, vol. XXXIX, 1937.)

135 **Chest.** Oak. *Circa* 1600. From Sillerupsgaard, Hadersleben (Haderslev) district, north Schleswig (now Danish). Height (without base) 68 cm, width 139.5 cm, depth 73.5 cm; base restored. Municipal Museum, Flensburg.

This chest belongs to the western Jutland school of carving. It is characterized by a combination of different-sized panels and playful variations on fluting carried over from the late Gothic. The lower terminals are combined with Renaissance-type forms, while the upper ones occur in several gradations. The panel on this chest, like other furniture from the same group, displays the original motif of a baluster ending in a man's head. It is also found, for instance, on the front of a wardrobe dated 1577 from Bröns near Ribe. (Plate: Axel Steensberg, *Danske Bondemøbler,* 3rd ed., Copenhagen, 1973, Pl. 307.)

136–137 **Panels from the façade of a chest.** Oak. Latter half of 18th century. From the Probstei, Holstein. Measurements of details: Plate 136: height 44.2 cm, width 32 cm; Plate 137: 44.3 cm, width 32.4 cm. Schleswig-Holsteinisches Landesmuseum, Schleswig.

The overall design of this piece and its façade conforms to that in Plate 138, but intarsia decoration has been inserted into the arched areas. Two of these surfaces show a dish, a bird and a head of cabbage, the two others human figures. This Plate depicts a soldier with Chinese features. This is the form in which chinoiserie found its way into popular furniture decoration. It was spread by the very productive workshop in Kiel of a craftsman in ebony, Anton Gottfried Lindemann (1706–87), who trained joiners from a wide area of the country around Kiel. (Cf. E. Schlee, 'Bauerntruhen aus der Probstei', in: *Jahrbuch für Heimatkunde im Kreis Plön-Holstein,* 7, 1977, pp. 108–25.)

138 **Chest.** Oak, painted. Beginning of 18th century. From the Probstei, Holstein. Height 95 cm, width 178 cm, depth 77 cm. Schleswig-Holsteinisches Landesmuseum, Schleswig.

Chests with this type of façade are the ancestors of a line of autonomous development in a small area near Kiel which lasted for about a century. The four panels in architectonic form are of seventeenth-century origin and the metalwork is of Renaissance design. The painting of the arched areas is not a later addition but an integral part of the overall decoration. In contrast to the country around Hamburg, the Probstei adopted the chest on a

stand at an early stage. In other words, the actual box of the chest, dovetailed according to best joiners' techniques, rests on a support.

139 **Chest.** Oak. 1813. Made in the Vierlande, acquired from Bergedorf, near Hamburg. Height 85 cm, width 134.5 cm, depth 67 cm. Museum für Deutsche Volkskunde, Staatliche Museen Preussischer Kulturbesitz, Berlin.

Owing to its inscription this has been termed a 'man's chest'. The division of the front by beadings, formerly the rule in the Vierlande, has been abandoned and the inlay patterns are freely set into the surface. This indicates that it is a much later type; this is also suggested by the restraint in the ornamentation compared with specimens from the latter half of the eighteenth century. This example shows that in the Vierlande 'man's chests' were not always built with supports. (Cf. Ulrich Bauche, *Landtischler, Tischlerwerk und Intarsienkunst in den Vierlanden,* Hamburg, 1965.) The inlay is composed of maple, walnut, mahogany and oak.

140 **Chest.** Oak. 1964. From Dithmarschen or northern Lower Saxony. Private collection.

The subdivision of each of the four front panels into two blind arcades and the spread of bas-relief scroll motifs over all the other surfaces is characteristic of a type of chest commonly found in and around the Lower Elbe valley. It is difficult to identify the area where it first originated. The even scrolls preserve a Renaissance tradition. The style of seventeenth-century scrolls called for additional eccentric spirals which contribute a playful note, the patterns often being duplicated. Note how the rows of tendrils are repeated in a number of modifications. Here and there the winding tendrils cross, but the tendency toward a unified smooth ornamental plane has triumphed over the rather rough style of the base, which emphasizes the profiles of the head-pieces and the moulded beadings. This means that the scale of the three-dimensional effects is reduced and the repetition of the basic motifs in a number of variations helps to increase their potential.

141 **Chest.** Softwood, painted. 1811. From Franconia. Height 62 cm, width 135 cm, depth 66 cm. Mainfränkisches Museum, Würzburg.

Projecting, turned astragals, as a separating or framing pattern on wardrobes and particularly on chest fronts, are a frequent feature in Franconia and Thuringia – in fact, they occur right across Germany.

142 **Chest.** Softwood, painted. End of the 18th century. From the Bavarian Forest, probably north-east of Passau. Height 69 cm, width 134 cm, depth 63 cm. Municipal Museum, Regensburg.

This chest with panels is coloured light brown on dark brown, and the plain wood is only lightly painted over. The two panels are decorated with a row of trees of different sizes. The chest as a whole conveys the impression that it is a very robust, stable piece.

143 **Chest.** Softwood (?). *Circa* 1800. From the Giant mountains, Silesia. Germanisches Nationalmuseum, Nuremberg.

Typical of Silesian painted furniture is the peculiar blue 'veined' background, which probably originated in imitation of the graining of wood and later developed into a linear pattern. Vases of flowers in many colours are set on a light background in the panels. A very similar chest in the museum in Pardubice (Czechoslovakia) is illustrated by Josef M. Ritz and Gislind Ritz, *Alte bemalte Bauernmöbel,* Munich, 1975, Pl. 254, with the ascription 'Nordböhmen/Czechoslovakia, 1837'; for a similarly painted wardrobe see Günther Grundmann and Konrad Hahm, *Deutsche Volkskunst,* vol. *Schlesien,* Munich, n.d., Pl. 103. Cf. also Pl. 122.

144 **Chest.** Softwood, painted. 1782. From the Rosenheim district (?), Upper Bavaria. Height 55 cm, width 113 cm, depth 59 cm. Heimatmuseum, Rosenheim.

The catalogue description reads: 'Chest with edges mounted with iron and additional iron bands. Slightly curved lid, two strips along its edges, suspended on two bands. Handles on the sides. Fittings: a side-chest with lid on the left side-wall. Blue background (the lid has been repainted). The metal mountings are painted over with white and blue Rococo scrolls. In the centre of the front wall, below the Eye of the Lord, is a covered riverboat in the water. In the boat stand Sts. John of Nepomuk and Nicholas. Inside the lid is an ochre-yellow cartouche with an oar, a hook and the Evangelist St. John.' (*Katalog Volkstümliche Möbel aus Altbayern,* Munich, 1975, pp. 170ff.) The painting indicates that it was the chest of a boatman. Other sailors' chests can be seen in museums in Rosenheim, Wasserburg, Passau and Vienna. May this have been a particular custom of boatmen on the Danube?

145 **Chest.** Fir, painted. 1833. In den Kaupen, Burg, Spreewald. Width 95 cm. Museum für Deutsche Volkskunde, Staatliche Museen Preussischer Kulturbesitz, Berlin.

In the two panels of the front are vases full of flowers on a red-marbled background. The inside of the lid is white with coloured dots at the corners. The inscription in the garland of leaves reads 'dated 31st May 1833.' (Lothar Pretzell, *Katalog der Ausstellung Kostbares Volksgut aus dem Museum für Deutsche Volkskunde,* Berlin, 1967, No. 25.)

146 **Detail of a chest.** Spruce. End of 18th century. From a parson's house near Eberswalde, Mark Brandenburg. Width 145 cm. Museum für Deutsche Volkskunde, Staatliche Museen Preussischer Kulturbesitz, Berlin.

The frames of the three panels on the front are painted with blossoms and columns on a blue ground, the panels themselves with a dancing couple, flowers (in the small centre panel) and two musicians. (*Katalog Volkskunst und Volkshandwerk,* Berlin, 1964, No. 353, shows the whole front.)

147 **Chest.** Oak. 1794. From Klein-Sonnendeich, Pinneberg district, Holstein. Height *circa* 62 cm. Private collection.

The inscription: 'Claus Hasemann 1794' indicates that this was a man's chest. The structure and decoration are the same as on women's or bridal chests of this district. It must have been brought by a bridegroom marrying into a local family. Arnold Lühning has shown that until a decade or two ago the Pinneberg district had a large number of old chests. There were two types of chest on the Lower Elbe. One, the *Stollentruhe,* had planks and an ornament carved in bas-relief. The other was a low box-like chest on runners; the front was divided into two parts and had carving around the centre-piece with its sharp angles. The two types of chest were passed on from one generation to another and developed independently. This piece differs from the more distinctive type found in northern Wilstermarsch (Pl. 149) in that it does not have decorative strips at the two corners.

148 **Chest.** Oak. Latter half of 18th century. From south Dithmarschen. Height 55 cm, width 150 cm, depth 62 cm. Altonaer Museum, Hamburg.

This chest is one of the few specimens of traditional peasant furniture which illustrates the efforts of a south Dithmarschen joiner, in the immediate neighbourhood of Wilstermarsch, to rival or even surpass his colleagues to the south. He adopted the general scheme of division, simplified the panel arrangement and covered the chest all over with rather rough relief carving. On other specimens (one is dated 1757) the angels' heads on the main panels are replaced by trees with birds facing each other; on the frame boards are lions and horses. The whole front is painted in dark colours. On this piece the layer of paint has apparently been removed. (Cf. E. Schlee, *Schleswig-Holsteinische Volkskunst,* Flensburg, 1964, Pl. 29.) An exact counterpart of the chest illustrated here could formerly be seen in the Museum für Deutsche Volkskunde, Berlin (cf. F. R. Uebe, *Deutsche Bauernmöbel,* Berlin, 1924, Pl. 61).

149 **Bridal chest of Margretha Thumann.** Oak. 1805. From the Wilstermarsch. Height 65 cm, width 164.5 cm, depth 59 cm. Municipal Museum, Flensburg.

This early nineteenth-century chest belonging to Margretha Thumann perpetuates the manner of constructing the side on which the ornament was concentrated which had been introduced in Elbmarschen in the mid-eighteenth century. The carving was done in Hans Holtmeyer's workshop at Wewelsfleth, who noted items of income in 1805 as follows: '3 vertical strips with figures; 8 corners with birds and flowers; 4 strips in antique

design; 8 corners on the short sides; 2 flowers on the panels ... name and year.' His total remuneration for this was 35 marks and 2 schillings. The box part of the chest, apparently made by his brother Johann Holtmeyer, is not included in the accounts. (E. Schlee, 'Zur Volkskunst der holsteinischen Elbmarschen', in: *Steinburger Jahrbuch,* 1960, published by the Heimatverband für den Kreis Steinburg, Itzehoe, pp. 7–20; Ellen Redlefsen, *Katalog der Möbelsammlung,* Municipal Museum Flensburg, Flensburg, 1976, No. 305.)

150 **Coffer chest.** Oak. Iron mountings, painted. 1823. From Blankenese, near Hamburg. Height 95 cm, width 137 cm, depth 65 cm. Altonaer Museum, Hamburg.

Iron mountings, probably hammered over a mould, are a common feature of Baroque coffers, but this example shows them at their most unrestrained. Cut into the chest is an earlier inscription: 'Spinster/Gesche/Kostern/1823'. When the chest was refurbished about 1840 the wood was painted with the additional words: 'A. El. Brenners'. The colours are green, white and red.

151 **Trunk (with wheels).** Oak, with brass fittings, painted. 1723. From Seesen am Harz. Height 80 cm, width 115 cm, depth 60 cm. Municipal Museum, Brunswick.

Large eighteenth-century trunks were quite frequently equipped with wheels so that they could be removed quickly in case of danger. 'In 1764 a special publication appeared which gives advice on "How, in a fierce and rapidly spreading fire, to safeguard houses and their contents".' (Bernward Deneke, *Bauernmöbel,* p. 109 and Pl. 206.) The practice is even earlier: in Holstein there were storage chests for grain which were almost as large as small huts. They usually stood on the floor of the house but could be moved on gliding runners.

152 **Chest of the Guild of Shoemakers and Saddlers of Rottweil.** Spruce, painted. 1642. Height 81 cm; width (closed) 61 cm, (open) 82.7 cm; depth 10.3 cm. Württembergisches Landesmuseum, Stuttgart.

In South Germany shrine-like guild chests, which could be hung up in the guildhall like a wall cupboard, are sometimes found. Perhaps the most impressive examples are in the museum in Ulm. When both doors were opened the emblems of the trade concerned, or rows of small portraits of the masters, could be seen. In this example the doors could be secured against unauthorized opening by a padlock. The opening of the chest in front of the assembled guild members was a special ceremony, never undertaken frivolously. The painting introduces two saints, Crispinus and Crispinian, who were the patrons of the leather-working crafts, in particular. A shoe and a shoemaker's awl on one side and a saddle on the other indicate the principal products and an important tool used to make them.

153 **Hanging cupboard.** Scots pine with glass front. 18th century. From Kellinghusen, Holstein. Height 109 cm, width 84 cm, depth 24 cm. Schleswig-Holsteinisches Landesmuseum, Schleswig.

On farms—as in town houses—hanging cupboards of this type were used to display the owner's store of precious pottery (especially cups, tea caddies, cream jugs, etc.) and also silver and knick-knacks. In north Friesland unglazed triangular shelves were popular. On the curved front part of the bottom of the cupboard notches are cut out to take silver spoons. Little cupboards of this kind correspond to what are known as *Prahlhänsen* ('boastful chaps') in the Elbmarschen and in east Friesland, where they are built in above the doors.

154 **Hanging cupboard.** Oak. 17th century. Probably from Angeln, Schleswig. Height 60.7 cm, width 54.5 cm, depth 23.5 cm. Schleswig-Holsteinisches Landesmuseum, Schleswig.

Small cupboards which could be hung on a wall developed in a remarkable variety of forms in Schleswig-Holstein. It is characteristic of this kind of ornament that Renaissance motifs on the metal fittings are confined to friezes or bands, and are used only as surface patterns. Whether such furniture was originally painted must remain an open question. It seems that, like that standard piece of furniture, the chest, they generally left the joiner's workshop unpainted.

155 **Hanging cupboard.** Hard and softwood. Latter half of 18th century. From Eiderstedt, Schleswig. Height *circa* 90 cm, width 55 cm. Schleswig-Holsteinisches Landesmuseum, Schleswig.

The body is painted in dark blue and green. The scalloped shell pattern on the glazed door is coloured white, red and green. Cupboards of this type are characterized by Rococo lattice-work on the doors, and seem to be particularly associated with the Eiderstedt peninsula. They were used for storing valuable crockery, mainly cups and glasses. The interior shelf is cut out in front so that silver spoons could be hung in the openings.

156 **Trough-shaped tray.** Hardwood, painted. Middle of 18th century. Painted in water-colours by H. Haase. Measurements of water-colour: Height 20.1 cm, width 25.5 cm. Schleswig-Holsteinisches Landesmuseum, Schleswig. (The object itself is in the Museum für Kunst und Gewerbe, Hamburg.)

This tray, decorated with bas-relief carving and painted in colours, is one of the most ornate of its kind and also one of the best preserved. As only light and delicate textiles were put on it and it was kept in a chest most of the time it did not suffer hard wear. This is one of the pieces in a distinct local group of carvings found in the Hallig Hooge and the island of Föhr. Justus Brinckmann acquired it at an early date (before 1900) for the Hamburg museum. He arranged for the Hamburg painter H. Haase to record objects of folk art in water-colours. With

painstaking accuracy he created a whole archive of pictorial documents for the investigation of folk art and its practical uses. The Schleswig-Holsteinisches Landesmuseum also possesses a fine collection of water-colours by Haase.

157 **Bentwood box.** Fir, painted. First half of 19th century. From Silesia. Length 24 cm, width 13 cm. Private collection, Munich.

On a black background, overpainted with green, are three men, armed with lances, in red coats and white stockings. The proprietor of the box describes them as 'wedding guests' *(Hochzeitslader).* The surrounds are decorated with red and white patterns, in addition to coloured tulips on a dark ground. (Cf. Gertrud Benker, *Altes bäuerliches Holzgerät,* Munich, 1976, Pl. 205; Josef M. Ritz, *Bauernmalerei,* Leipzig, 1935, p. 53.)

158 **Bentwood box.** Softwood, painted. Beginning of 19th century. Acquired from Klein-Ecklingen, near Celle, Lower Saxony. Height 20.5 cm, width 30 cm, length 47 cm. Historisches Museum am Hohen Ufer, Hanover.

The sides of this box, like those of most similar boxes, are decorated with large flowers. The motif on the lid, however, is unusual: a woman with coloured feathers in her hair is shown riding on a cockerel. A *Hahnrei* ('cockerel rider') is the German expression for a cuckold, which apparently applies in this case to the woman, instead of to the man as is usual. The inscription plainly confirms the meaning: 'My cockerel is just too bad, he only makes the strange hens glad.' Such a box must have been the exact opposite of a love token. It would only be given as an expression of sarcastic insult.

159 **Bentwood box.** Fir. Latter half of 18th century. Length *circa* 45 cm, width *circa* 30 cm. Historisches Museum am Hohen Ufer, Hanover.

This is an example of extreme stylization of the familiar motif of a couple. The original flexibly executed drawing has been distorted into an absurdly rigid and angular composition, the nature of which is barely recognizable. It is therefore an excellent illustration of the spirit of this type of mass production. The lid is a very striking example of the search for form, which is so common in folk art. Well-defined flat contrasting patterns are assembled to form a human couple, one figure balancing the other. For instance, the contrast of the angular coat-tails of the gentleman with the well-rounded skirt of the lady is no mere aesthetic accident. In such a case the structured forms which compose the picture as a whole are not the result of a standard routine way of painting, in which each brush-stroke is repeated hundreds or even thousands of times, but rather are clear evidence of creative ability. (Cf. also the description of a comparable example in the text.)

160 **Bentwood box.** Fir, painted. *Circa* 1840. Used in

eastern Lower Saxony. Height 29 cm, width 47 cm, depth 15 cm. Germanisches Nationalmuseum, Nuremberg.

The background is in cinnabar red and the landscape in shades of blue as are the girl's skirt and the man's jacket. He is wearing yellow trousers, a pink vest and a black hat; she a dark red bodice, yellowish neckcloth, white sleeves and a white shawl. The surrounding lines are white and yellow. There is no indication of its place of origin. It may have come from Thuringia.

161 **Bentwood box.** Fir, painted. 19th century. Museum für Deutsche Volkskunde, Staatliche Museen Preussischer Kulturbesitz, Berlin.

The inscription reads:

'He, she and you are all remiss;
Just thou and love live in the kiss.'

162 **Box for sailmaker's needles.** Wood. 19th century (?). Acquired at Husum, Schleswig. Height 7.1 cm. Schleswig-Holsteinisches Landesmuseum.

The hollow space for a sailmaker's coarse needles is in the 'foot' of the box. It is closed by means of a sliding cover (this can be seen below right), which also forms the stand. The lid, formed by the tail fin of the fish-like hoop, is perforated so that it can be tied down. The form of this box is most unusual. It displays the sense of humour, often original and especially evident in Holland, which distinguished the amateur work of sailors. (Cf. E. Schlee, *Schleswig-Holsteinische Volkskunst*, Flensburg, 1964, Pl. 51.)

163 **Box.** Oak. 1735. From north Friesland. Height 14 cm, width 33.5 cm, depth 18.3 cm. Schleswig-Holsteinisches Landesmuseum, Schleswig.

This is a particularly fine specimen of its kind, with a carved and contoured surround to the lid. The lid is slightly arched. All the surfaces are criss-crossed with small areas of chip carving in a great variety of patterns. The engraved brass mountings, too, with their lively outline contribute to the decoration. The hinges are placed inside and bear the inscription: 'Anno 1755, 9th Dec.' and 'WMI JCM (?)/IWMPL.'

164 **Box.** Oak. Early 19th century. From the island of Föhr, north Friesland, Schleswig. Length *circa* 25 cm, width *circa* 11 cm. Heimatmuseum, Wyk, Föhr.

This box bears the name of Hans Peder and was most likely made, or at least decorated in bas-relief carving, by this individual. It has a sliding lid and is one of a wide range of such containers known as shaving boxes. They may have contained other small belongings which sailors wanted to protect in the almost unbelievably cramped and meagre life on a ship. One of the two figures probably represents the man himself (with the long pipe) and the other may be his son (with glass and bottle). Often

a father would take his son—from the age of twelve boys were regarded as old enough to go to sea—into the Arctic seas. That the object of the journey was whaling appears from the picture on one of the long sides: two sloops, i.e. long rowing boats, are shown, each in pursuit of a fleeing whale. The other long side shows the Tree of Knowledge with Adam and Eve. To the left are two trees, and on the right one tree, a church-like building with birds, and a flying creature resembling a human being. On the two small sides are rosettes in chip carving.

165 **Box for clay pipes** (detail of the front wall). Pine, painted. Late 18th century. From the island of Föhr, north Friesland, Schleswig. Measurements of box: height 15 cm, width 71 cm, depth 17 cm. Schleswig-Holsteinisches Landesmuseum, Schleswig.

This box seems to have been the work of an amateur. Figures of Negroes with bananas, snuff-box and brazier leave no doubt as to its function. The lid shows in equally primitive painting four buildings in a landscape, among them a church and a round structure with a dome. The reverse side has what appear to be fishes and shells. The main colour of the frame is blue.

166 **Box.** Oak. 18th century. From the island of Sylt, north Friesland, Schleswig. Height 7.5 cm, length 29 cm, depth 14 cm. Heimatmuseum, Keitum, Sylt.

Boxes of this kind seem on the whole to have been regarded as an essential part of a man's equipment. In north Friesland particularly they follow a stable tradition even in the way they close. The sliding lid, still in use on the schoolchildren's pencil cases, must have been old-fashioned even in the eighteenth century. The decorative carving of this specimen, which includes a figure of Hope with an anchor on the short side, indicates that it belongs to a category developed on the islands of Föhr and Hooge after the mid-eighteenth century. It has the pronounced volutes so typical of this area.

167 **Box.** Oak. *Circa* 1580. From North Germany. Height 17.8 cm, length 28 cm, depth 16.3 cm. Altonaer Museum, Hamburg.

This box is traditionally described as a wedding box. It may be true that the figures in bas-relief in front, a woman and a man, are meant to represent a bride and groom. While the traditional medieval love boxes were gifts from the man to his sweetheart and bore appropriate picture motifs, in this case the woman seems to have been the donor. This theme frequently recurs on painted window-panes in North Germany, where the married woman pours out and presents a drink to her husband. If the description 'wedding box' is correct, then the carved scene, despite the interruption of the keyhole, depicts the coming marital state rather than the marriage ceremony or the preceding courtship. The author knows no other roughly contemporary counterpart to this object. It is quite different from the popular type of box carved in North Germany from the seventeenth to the nineteenth century.

168 **Box for shaving kit.** Wood. 18th–19th century. From Archsum on Sylt, north Friesland. Height 5.4 cm, length 20 cm, width 8.7 cm. Schleswig-Holsteinisches Landesmuseum, Schleswig.

This box has been carved to look like three books lying on top of each other. On the two outside book-covers are incised patterns and in the middle entwined knots. The corners are decorated with chip carving. The edges of the three 'volumes' are painted red. One of the sides has the sliding lid.

169 **Small box,** carved from wood. 17th–18th century. From Bavaria (or Tyrol?). Height 19.5 cm. Germanisches Nationalmuseum, Nuremberg.

This little box was probably designed to contain consecrated salt (cf. Erich Meyer-Heisig, *Deutsche Volkskunst*, Munich, 1954, Pl. 102). That it served a sacred purpose is suggested by the relief covering the whole side: the creation of Eve, the Fall, Christ carrying the Cross, and the interment of Christ. The last scene is shown in this illustration. There is no evidence to permit more accurate dating of the style. This specimen is quite exceptional. There seems to be no obvious practical reason for the perforations in the serrated crown.

170 **Bentwood box.** Softwood. From the island of Sylt, north Friesland, Schleswig. Height *circa* 12 cm, length *circa* 20 cm. Heimatmuseum, Keitum, Sylt.

North Friesland belongs to the area, stretching from Scandinavia into Germany, where this type of bentwood box is found; the form stems from an early historical period. It is distinguished from the South and central German type by making use of the tension of the sides to hold the flat lid. This lid is held by two pegs fixed on the side, rather like clothes-pegs. When the knobs are pressed apart they release the indented ends of the lid, which can then be taken off. To close it, the ends are pressed back under the knobs till they snap into place. From this audible sound the box is known in Schleswig as a *Klobb*. Larger specimens served as containers for bread and other provisions. Women kept their small personal accessories in the smaller ones. (Cf. E. Schlee, 'Der Klobb', in: *Die Heimat*, Kiel, 51, 1941, pp. 1-7, 87-9.)

171 **Box for sewing-needles in the form of a miniature warming oven.** Beech and oak. 1802. From north Friesland, Schleswig. Height 11 cm, width 11.2 cm, depth 4.8 cm. Schleswig-Holsteinisches Landesmuseum, Schleswig.

This little box is carved out of a block of beechwood; the cover plate of the 'oven' forms a sliding lid made of oak. Holes are bored into the solid block as containers for needles. The grooved part corresponds to the iron stove plates which we may imagine as built into the wall. The four legs are a definite error; there should really only be two. Vases of flowers were not used as decoration on real stoves. The form suggests that other needle-boxes from

north Friesland were made by the same carver. He obviously specialized in this type of container.

172 **Small box.** Oak, coopered. 18th–19th century. From the island of Sylt, north Friesland, Schleswig. Height 12 cm, diameter 12–15 cm. Heimatmuseum, Keitum, Sylt.

Containers of this kind were usually the work of self-taught amateurs, often sailors who could not go to sea. They were used by women to hold their needlework and similar things. In this one all the staves are cut out to make a perforated pattern. The lid has an incised scroll ornament.

173 **Wall clock.** Wooden dial with lacquer painting. *Circa* 1840. Black Forest. Municipal Museum, Villingen-Schwenningen.

A glance at the clock face leaves no doubt that it comes from the Black Forest. There was, in fact, a special category of 'dial-painters', one of whom supplied the decorations for the almost square wooden face with its semicircular head-piece. The main colour was usually white. During the eighteenth century the areas outside the dial were filled with compact flower arrangements. In the nineteenth century these gave way to smaller, dainty motifs which look rather lost. The head-piece opens up like a miniature peep-show stage to show a four-man brass band wearing uniforms resembling those of hussars, which announces the hours and perhaps the half-hours as well. That the clock also piped is clear from the wooden parts of the mechanism visible on the right. During the nineteenth century sound mechanism, which until then had been confined to noble and very wealthy houses, invaded the homes of townsfolk, and farmers.

174 **Box with sliding lid.** Oak. Dated 1749. From the Hallig Hooge, north Friesland, Schleswig. Height 19 cm, width 23.3 cm, depth 14.5 cm. Germanisches Nationalmuseum, Nuremberg.

The overall impression made by this box is reminiscent of the older, perhaps medieval form, although the construction does not exactly correspond. In the older type the raised short sides enclose all the other parts between them. Here they are inset and only the 'gable' is somewhat wider. The box is opened by sliding the horizontal piece of the 'roof' through a slit in one of the gables. The exposed short side shows a man in a long coat, smoking a clay pipe and holding a goblet in his right hand. The other short side displays his female counterpart, but the lady carries a pair of scales in her right hand and a dove in her left. She thus embodies both justice and hope. Stinke Löddens, the young girl whose name appears on the lid, is well known. Her father, Lödde Rachtsen, was a whaling-ship captain and probably carved several objects in the same style for her with his own hands; (they include a chest, mangle-board and sewing-box). (See E. Schlee, 'Volkstümliche Schnitzereien von der Hallig Hooge', in: *Nordelbingen,* 26, 1958, pp. 100–15.)

175 **Sextant-case.** Oak, painted. 1750. From the Hallig Hooge, north Friesland, Schleswig. Height 15.5 cm, width 43 cm, depth 5 cm. Schleswig-Holsteinisches Landesmuseum, Schleswig.

This container for a sextant (a brass instrument to measure the elevation of stars at sea), was made for the Greenland sailor Commander Lödde Rachtsen on the Hallig Hooge, north Friesland, and possibly carved by the owner himself. It belongs among the extensive group of carvings associated with his name (cf. Pl. 174). The sailors took great care of their measuring and sighting instruments which were very precious. Unfortunately few such casings have been preserved. For a comparable Dutch specimen of 1786 with rich chip carving, see Gislind Ritz, *Alte geschnitzte Bauernmöbel,* Munich, 1974, Pl. 135, there mistakenly described as a bonnet box. Such a case, made by a man for a man, cannot be interpreted as a love gift. The case from Hooge is painted green; the lid can be raised and inside are fittings to hold the instrument.

176 **Small box.** Softwood, painted. Latter half of 17th century. Height 26.5 cm, width 34.8 cm, depth 23 cm. Badisches Landesmuseum, Karlsruhe.

Bismuth painting, covering all kind of surfaces with very bright colours, is often regarded as 'bourgeois' art, because it calls for very painstaking, accurate and technically correct execution. It also pays detailed attention to form. One should not forget, however, that this type of painted decoration marks the beginning of a movement away from the conventional art of the period and that a few more steps in the same direction will result in folk art. Decorative painting which truly represents the art of the period, such as can be seen on seventeenth-century wall cabinets, is very different. It attempts a three-dimensional or at least sculptural effect, takes careful note of light and shade and avoids such drastic measures as we see here, for instance, in the interchange of contrasting shades of red and blue in the vases and blossoms on the front. Such typical examples are rare. (J. M. and G. Ritz, *Alte bemalte Bauernmöbel,* Munich, 1975, Pl. 139.)

177 **Standing clock.** Casing of softwood. *Circa* 1840. Mechanism by Diedrich Wilhelm Färber, Neukirchen, Rhineland. Owner unknown.

In some parts of Germany clock-making was carried out in rural areas and in many ways helped to stimulate rural crafts. This art was a medium for introducing all manner of innovations; it could establish connections with distant customers, encourage technical understanding and skill, and force craftsmen to turn out precision work. More exact time measurement imparted an increasingly rigorous rhythm to life in town and country. Even joiners, who were responsible for the tall casings of these vestibule clocks, had to keep in step. This is why the casings mostly show conventional bourgeois forms. To its credit this piece has close affinities in design with other rural furniture from mountainous regions. This applies to the overall proportions as well as the slightly embossed decor, which fills the surfaces with plant forms—mostly grapes, a motif also seen on chests and wardrobes in this region.

178 **Standing clock.** Casing of pine, painted. 1783 (mechanism 1765). From north Friesland. Height 226 cm, width 51 cm, depth 29.5 cm. Altonaer Museum, Hamburg.

The clockmaker engraved his name on the clock-face: Jens Ewaldt Hans/Ballum/1765. The escutcheon above the clock-face reveals the name of the owners: Knud Mi/chelsen Christina/Knudes. These inscriptions coincide with the reverse monograms painted on the casing in 1783. Ballum is situated on the north Frisian coast, opposite the island of Sylt. The clock comes from the very active rural workshops of northern Schleswig, which catered largely to local demand. It was acquired by the museum on Sylt in 1910. The unpretentious housing largely confirms the remarks made in the caption to Plate 177. Clockmakers' and joiners' work, as well as painting, were done in the same rural area.

179 **Wall clock.** Wooden clock-face with lacquer painting. *Circa* 1830. Black Forest. Badisches Landesmuseum, Karlsruhe.

Männleuhr ('little man clock') is the name given to this type of Black Forest wall clock. It has an opening above the clock-face with figures that sounded full, half- and sometimes quarter-hours by striking bells with small hammers. These 'little men' are very late successors of the figures known as *Jacquemart* which served the same purpose during the Middle Ages on public clocks, and reached their peak of popularity during the Baroque period. The painting, usually the principal decoration of Black Forest clocks, is less important here than the mechanical chimes. It may be assumed that a clock of this type was always placed on the wall as shown here; only the pendulum is lacking here. The simpler clocks from this classic clockmakers' country were often mounted in tall housings manufactured in the region where the customer lived.

180 **Face of a wall clock.** Oak. 1740. From the mainland of north Friesland. Height 42 cm. Heimatmuseum, Deezbüll, north Friesland.

This clock-face is unique in the rich tradition of north Frisian carved furnishings, but the style of decoration proves that it is a local product, not an import. Before the middle of the eighteenth century Dutch console-clocks were often made with an iron face, and later clockmakers working in north Friesland often used brass sheeting. The C. T. whose reverse monogram is placed on top of the frame, and who does not hesitate to crown it like a king, must have been the owner as well as the maker of this typical north Frisian specimen. The clockwork may well have been supplied by a rural craftsman from this area.

181 **Portable barrel.** Beech (?). 19th century. From Oberaudorf am Inn, Bavaria. Diameter 21 cm. Germanisches Nationalmuseum, Nuremberg.

Little barrels of this type, known by a variety of names

(e.g. *Lechel*), were used for carrying beverages to men working in the fields. This example must stand for the barrels, large and small and of every kind, in our collection. In some areas—particularly in wine-growing districts, as one would expect—the shaping of barrels produced remarkable results. The head of the barrel offered the best opportunity for carved ornaments. The spigots, too, were often made in a special way. (Erich Meyer-Heisig, *Deutsche Volkskunst*, Munich, 1954, Pl. 29.)

182 **Basket for spoons.** Wood. 19th century. From the Schwalm, Hesse. Height 22.5 cm. Museum für Deutsche Volkskunde, Staatliche Museen Preussischer Kulturbesitz, Berlin.

The cross-bars are dovetailed into the corner posts and enclose filling-in boards with serrated edges. The painted red and black decoration is engraved and grooved, and the raised back ornamented with fretwork. The inscription reads 'Marileis Schaefer'. This piece was probably made in the 1840s. The fact that its construction and ornamentation are very like those of Hessian chairs is remarkable. (Karl Rumpf, *Eine deutsche Bauernkunst*, Marburg, 1943; Gislind Ritz, *Alte geschnitzte Bauernmöbel*, Munich, 1974, Pl. 96.)

183 **Jug.** Wood, coopered and painted. 19th century. From Mistelgau, Franconia. Height 36 cm. Germanisches Nationalmuseum, Nuremberg.

Characteristic of the wooden jug known in Franconia as a *Kirchweihbitsche* ('parish fair vessel') are the spout, which consists of a bent sheet-iron tube held by iron stays, and the carefully sawn-out handle with its angular outline. The staves are painted alternately in a dark colour and with plants in bloom. (Cf. Josef Ritz, *Deutsche Volkskunst*, vol. *Franken*, Munich, n.d., Pl. 117.)

184 **Stove-surround.** Oak. Dated 1806. Wilstermarsch, Holstein. Height 74.5 cm, width 60 cm, depth 60.5 cm. Altonaer Museum, Hamburg.

This specimen is more elaborately fitted than most comparable surrounds that have survived. The front board is usually topped by no more than a turned cone. The central area is framed by scrolls and bears two reverse monograms: ML and TNL, the initials of the farm owners. The front board must be exactly the right size so that a broad peg can be fitted into the post and, set on the edges of the stove, lend the frame the necessary stability. A cross support could not be used here because it would have prevented one from putting food or other articles on the tiles over the stove to keep them warm.

185 **Salt-box.** Oak. 1787. From Langeberge, near Osterkappeln, Osnabrück. Height 52 cm, width 35 cm. Historisches Museum am Hohen Ufer, Hannover.

In Lower Saxony the two principal forms of salt-boxes are both found: the desk-shaped type with a raised back

like this one and the type like a house with a hole in the gable façade. The inscription reads: 'If you just come to me/a better meal you'll see, 1787'. The use of the first person here refers to the contents, as is often the case with inscriptions on ceramic and brass vessels.

186 **Salt-box.** Oak. 18th or 19th century. From Achim, Verden district, Lower Saxony. Height 63 cm, width 39 cm, depth 28 cm. Historisches Museum am Hohen Ufer, Hanover.

'In the early peasant home the salt-container was always placed near the hot stove. It was pegged on four sides with wooden nails and had a dovetailed saddle lid. Characteristic is the hole in front through which one could put one's hand into the box; this is normally closed with a wooden disc. On this specimen the disc has a tendril carved in bas-relief. The owner must have been very proud of the decorated gable with its two opposing sawn-out volutes terminating in an animal head. At the bottom is a drawer with a knob to pull it out.' (Ulrich Fliess, in: *Abteilungskataloge des Historischen Museums am Hohen Ufer, Hannover*, pt. II. *Volkskundliche Abteilung*, Hanover, 1972, p. 181.)

187 **Spoon-board.** Oak, painted. 19th century. From the Osnabrück region, Lower Saxony. Height 76 cm, width 23 cm. Focke-Museum, Bremen.

Between the ledges which hold the spoons there are five fields on the perforated wall at the back. Three of these fields feature a cross, invoking a blessing, while one is star-shaped. This elongated spoon-board with several rows of spoons above each other is found mainly between the mouths of the Elbe and Rhine.

188 **Plate-rack.** Lime, painted. 1787. From the Altes Land, near Hamburg. Height 103 cm, width 34 cm, depth 18 cm. Altonaer Museum, Hamburg.

The colours are gold for the inscription on reddish-brown, and for the flowers dark blue on a green background. Somewhat smaller plate-racks bearing the year and names of girls or women are also found in other parts of northern Germany. The wooden plates that were stacked on them are often called ham-boards (*Schinkenbretter*). They were originally simply plates used at meal times, but were principally employed for carving meat or fish, while vegetables, dumplings and porridge were eaten from the dish. No doubt pewter plates were also placed in this rack at a later date. The lower board has holes into which (pewter) spoons could be inserted. (Cf. Gislind Ritz, *Alte geschnitzte Bauernmöbel*, Munich, 1974, Pl. 100.)

189 **Spoon-board.** Softwood, painted, with pewter spoons. Colours: dark green ground; yellow stripes with black dots. 19th century. From Bentheim, Lower Saxony. Height 44 cm, width 29 cm. Historisches Museum am Hohen Ufer, Hanover.

A description of a very similar specimen in the Historisches Museum am Hohen Ufer, Hanover (only the position of the birds is reversed) reads: 'Colours: brown-green background, vertical stripes with yellowish-red dots. Between them: above, a stork in light yellow colour; below, a yellow cock with red feathers.' (Albert Schröder, *Bemalter Hausrat in Nieder- und Ostdeutschland*, Leipzig, caption to Pl. 22.) 'The cheerful multi-coloured painting of spoon-boards from Bentheim no doubt owes a great deal to influences from Frisia and Holland.' (Ulrich Fliess, in: *Abteilungskataloge des Historischen Museums am Hohen Ufer, Hannover*, pt. II. *Volkskundliche Abteilung*, Hanover, 1972, p. 76.)

190 **Weaving-frame** (cloth-holder). Wood. 1858. From Mohrungen district, East Prussia. Length 55 cm. Museum für deutsche Volkskunde, Staatliche Museen Preussischer Kulturbesitz, Berlin.

This implement consists of two pieces of wood which can be interlocked and held in place by an iron hoop and wooden sliding bars. It serves to hold the cloth in the loom at an even width and thus to ensure a straight selvage. At the iron-covered ends the points of the nails are pressed into the selvage and the wooden pieces then pushed apart and fixed. (Lothar Pretzell, *Katalog Kostbares Volksgut aus dem Museum für Deutsche Volkskunde*, Berlin, 1967, No. 711.)

191 **Measuring-rod.** Fruit wood. 1718. Origin unknown. Length 87 cm. Deutsches Museum, Munich.

This rod for measuring one ell cannot be traced to a definite locality. It seems to have been primarily intended for use by a craftsman. It not only shows the measuring marks (1 foot = 30 cm), but also, scratched or finely incised, the year, the figure of a saint holding a flower, builders' tools and a flower vase. In addition there is a crucifix and below that a flaming heart entwined with volutes and a blossom tendril. (Cf. Gertrud Benker, *Altes bäuerliches Holzgerät*, Munich, 1976, Pl. 427.)

192 **Container for a 'Jakobstab'.** Oak. 1736. From the island of Sylt, north Friesland, Schleswig. Length 105 cm, width 15.5 cm. Heimatmuseum, Keitum, Sylt.

'The *Jakobstab* is one of the oldest instruments for measuring angles in land surveying, and also served to determine one's geographical position on the high seas. It is the forerunner of the Davis quadrant and the subsequent octants and sextants.' It consists of a four-sided stick with graduations in the centre of the container. Four different cross-bars can be attached to it corresponding to one of the measurement scales. Two of these are preserved, on the left and right in the container. To take a sight the cross-bar is pushed into a suitable notch and a value is read off—e.g., the height of a star above the horizon. Below on the right is a place for a divider (to mark the course on a sea chart). Cases of this type were made by sailors as a hobby. (Cf. Hildamarie Schwindrazheim, 'Der Jakobstab', in: *Festschrift Otto Lehmann zum siebzigsten Geburtstag*, Altona, 1935, pp. 107–11; illus-

tration of a *Jakobstab:* Gerhard Wietek, *Das Altonaer Museum in Hamburg,* Hamburg, 1963, Pl. 30.)

193–194 **Ell measure.** Oak. 18th century. From north Friesland (?). Length 48 cm. On the Hamburg art market (1955).

Measuring rods of this type were used mainly by women to measure their home-woven piece goods. They were therefore, like other weaving utensils, popular love-tokens, and were among the articles to which decorative motifs were applied, particularly in chip carving. The handle consists of two groups of four human heads in the manner of Roman column capitals. Between them the rod is perforated into four thin twisted stems enclosing loose spheres which move and rattle, all cut out of the solid wood. To finish off there is a fist—altogether a wealth of forms gathered from far and wide, although certainly not from a pre-medieval tradition. Perforations with rattling spheres are very often found on winding frames, that is, slightly conical wooden staves with a grip used to wind up balls of yarn.

195 **Foot-warmer.** Oak. 18th century. From north Friesland. Height 20 cm, width 25 cm, depth 21 cm. Schleswig-Holsteinisches Landesmuseum, Schleswig.

The wooden casing, carried by means of a brass ring and with a kind of door in one of the long sides, contained an earthenware or metal basin with glowing charcoal. The top is perforated to allow the heat to escape. Women pushed the warmer under their skirts, but we know from the state of preservation of nearly all existing pieces that they did not put their feet on top of it. The decoration with chip-carved patterns conforms to popular convention.

196 **Pipe-rack.** Lime and oak, painted. *Circa* 1800. From Dithmarschen. Height 30 cm, width 39 cm, depth 4.7 cm. Altonaer Museum, Hamburg.

This is a typical example of wall decoration, very popular in the Wilstermarsch, which also has a practical use: the overlapping ledges are notched to hold long-stemmed clay pipes. Since many women also smoked, the monogram PN does not necessarily denote a male owner. Of the same type, but far more elaborate and elegant, is the perforated carving on a pipe-rack of 1800, perhaps the most lavish example from the Wilstermarsch to reach the Nordic Museum in Stockholm. (Cf. Hans Karlinger, *Deutsche Volkskunst,* Berlin, 1938, p. 336.) According to Schöpp (*Bäuerliche Holzschnitzereien und Kleinmöbel aus Norddeutschland,* Elberfeld, 1924, Pls. 5, 6) both these specimens came from the Wilstermarsch. This conjecture about their origin appears to be borne out by the evidence.

197 **Bird-cage.** Apple-wood, oak and wire. First half of 19th century. From central Franconia. Height 30.5 cm, width 39.5 cm, depth 24.5 cm. Germanisches Nationalmuseum, Nuremberg.

The patient work of a self-taught amateur. There seem to have been some generally accepted conventions of what a bird-cage should look like. This one has strong affinities with cages that occur in several different regions and bear different attributions (sometimes very doubtful, such as 'bread box'). (A very similar piece is illustrated in the *Jahrbuch des Bayerischen Landesvereins für Heimatschutz* for 1937, Pl. 79. On this illustration see Bernward Deneke, *Volkskunst aus Franken,* Nuremberg, 1975, p. 11.)

198 **Three-bell collar for cattle.** Beech, multi-coloured. 19th century. From Franconia. Germanisches Nationalmuseum, Nuremberg.

The small group of three-bell collars testifies to a widespread and important tradition among herdsmen of the Upper Palatinate and Franconia. In the Hirtenmuseum at Hersbruck, Franconia one may see how such a collar was made, i.e., the cutting and bending of the wooden sheet (generally walnut) and the grinding and mixing of the colours—work in which, according to tradition, the herdsman's whole family took part during the winter (see: *Führer durch das Hirtenmuseum*). The bright colours and wide variety of motifs in the large Hersbruck collection, which includes more than 400 specimens, are most impressive. There are certain constant factors in the painting: among them the divisions of the tongue-shaped ends at the place where the cordage is attached on the side, and the holes for the toggle holding the leather strap. There seems to be a large store of motifs that have persisted from the eighteenth century right down to the present day.

199 **Pair of bucket crosses.** Oak, painted in colours. 1851, Blankenese, Hamburg. Length of bar 28.5 cm, thickness 4.2 cm. Altonaer Museum, Hamburg.

Floats of this kind were a necessary item of equipment for maidservants on farms. Since this pair is inscribed with the name of S. Stehr, they must have been a love token. The carving, with its vases and baskets, reproduces popular subjects from the beginning of the century in classicist style. The motifs in the medallions of one cross seem to represent the seasons of the year; those in the other remain uncertain. Milk-pail floats of this kind were always needed in pairs because milk was carried in a pair of pails so as to distribute the weight equally between them. The buckets were coopered from wooden staves and bound with metal bands. In Holstein they were usually painted bright red inside and green outside. For that reason alone it seemed necessary to give the floats, too, a decoration in bright colours. (Cf. G. Benker, *Altes bäuerliches Holzgerät,* Munich, 1976, Pls. 376 f.)

200–201 **Milk-pail float.** Open-work wooden plate, oak. Plate 200: from Gravenstein, Alsen (Als) island, Schleswig. Diameter 18.3 cm. Plate 201: from Alsen (Als) island, Schleswig. Dated 1785. Diameter 17.5 cm. Municipal Museum, Flensburg.

Ordinary wooden plates, like the ones used as eating

utensils, were often put in milk-pails to prevent the milk from splashing when it was being carried. The decoration elevates these specimens to a special class of utensils no longer suitable for table use. There is no doubt that they were really given as love tokens, rather than being used for practical purposes. A pair of them might hang on the wall of the living-room or be displayed on a shelf. The mere object, as we know it today, cannot provide the answer. The inscription on the piece in Plate 201 is only scratched in. This suggests that the float was bought ready carved and was only inscribed afterwards.

202 **Cake-board.** Softwood, painted. 1865. From Thuringia (?). Diameter 63 cm. Museum für Deutsche Volkskunde, Staatliche Museen Preussischer Kulturbesitz, Berlin.

During the nineteenth century a standard form of cake-board was developed; it was round with one or two sunk mouldings to prevent warping. The handle was worked from the same piece and the whole surface generously painted. Large flat cakes were served on them, but we have no reliable information about the conventions governing their use. The underside was usually painted and often bore a female name and a date. It was therefore very probably one of the showpieces in the dowry or perhaps given as a wedding present. Pieces like this one are known not only from Thuringia but also from Lower Franconia, the Palatinate and Alsace. (Gertrud Benker, *Altes bäuerliches Holzgerät,* p. 17; cf. the Thuringian example in Pl. 36).

203 **Flax swingle.** Beech. 19th century. From the Marburg region, Hesse. Height 93 cm. Museum für Deutsche Volkskunde, Staatliche Museen Preussischer Kulturbesitz, Berlin.

A bundle of dried and scutched flax was placed on the horizontal end of the upright board, and the woody particles beaten out with the swingle wood or swingle-board (Pl. 214). During the process one foot was placed on the baluster so that the implement did not wobble. In North Germany decoration was usually applied at least to the hoop, which was designed to prevent the flax from sliding off and which closes off the upper board. In this example the incised drawing, which is coloured, features tendrils growing out of a pot or basket and winding up the neck, ending in an open-work tulip. In other specimens the hoop is often transformed into the neck and head of an animal, horses being as popular as snakes. (Cf. *Ausstellungskatalog 'Kostbares Volksgut',* Berlin, 1967, No. 684.)

204 **Pair of wool-combs.** Oak, with shallow incision and chip carving. Dated 1815. From Blankenese, near Hamburg, Length 23.5 cm, width 22 cm, thickness of boards 1 cm. Altonaer Museum, Hamburg.

Wool-combs, used in pairs, were needed to draw out the wool fibres so that they lay in the same direction ready for spinning. The same process cleared the wool of tangles and foreign matter. 'The implement consists of

a pair of small boards with handles. Underneath they are generally covered with leather and wire bristles, while the upper side offers an inviting surface for decoration' (G. Benker, *Altes bäuerliches Holzgerät,* p. 94). This pair from Blankenese is an unusual specimen. Instead of wire bristles distributed over the whole surface each comb has one row of nail-like prongs. This strongly suggests that they were not really intended for practical use but purely for show. The inscription reads '*Jungfer* Margreta Brekwolts/Peter Brekwolt, anno 1815', and is the same on both combs, which seems to confirm this assumption. Unless the girl's maiden and married name happened to be the same, the word used here, *Jungfer,* indicates that she was a bride; if she did not change her name on marriage, it may mean that she was a married woman.

205 **Swingle.** Beech. 1816. From Schleswig-Holstein. Height 102 cm, length 35 cm, width 29 cm. Schleswig-Holsteinisches Landesmuseum, Schleswig.

The inscription reads 'DNG/WR'. In Schleswig-Holstein this implement was often called a 'swingle-foot'. Its efficient use depended very much on its standing firmly in its place. This explains why it is provided with heavy feet, rather like runners. This specimen is one where the main decoration is on the lower board, which exists primarily to improve the stability. The tulip sends out shoots which continue in the shoddy open-work cross-support. The top board preserves the horse's head, further adorned with a flowing mane, only part of which has survived.

206 **Three mangle-boards.** Oak and beech, painted. Undated, but before 1756 and 1781. From north Friesland, Schleswig. Length 66, 67 and 64.5 cm respectively; width 16, 15 and 14.5 cm. Schleswig-Holsteinisches Landesmuseum, Schleswig.

Left: A typical example with no inscription on the cross stripe. This suggests that pieces of this kind were regarded as articles of commerce. The conventional carving supports such an interpretation. The painting was obviously done before the inscription (a dedication) was finally added, in a manner often found in earlier chip carvings, namely compartments of various sizes with the patterns alternating between white, red and black.

Centre: Shallow-section volutes, perhaps tendrils, painted in colours on a base that was originally white. Thus the colours white, red and black recur here. The medallion with the crown was formerly also filled in with low-relief carving of which traces remain visible. It probably featured the initials of the recipient of the gift and a date—around 1750. The present inscription reads 'A TS (the letters T and S linked together) B 1786'; it is only painted on and probably refers to a second owner. The asymmetrically arranged volutes or tendrils have the freshness of an earlier generation (i. e. earlier than 1786). The rest of the painting belongs to the period when it was done.

Right: The areas with chip carving do not leave any plain surfaces for the later addition of a name or dedication.

The script just consists of initials surrounding the whirling rosette and the handle. It is virtually impossible to decipher it. Only the letters and figures carved into the margin between the ornament and the edge are legible: Anno 1781. It must be assumed that a special understanding existed between the donor (was he also the maker?) and the unnamed recipient of the gift. One original feature is the chip-carving motif below the smaller whirling rosette which looks like a kind of tree. Common to all three mangle-boards is the horse-shaped handle, which seems to have become almost obligatory during the eighteenth century in the area where these pieces originated. Lions and sirens occur more rarely. Older boards, particularly those under Dutch influence in the seventeenth century, but also some specimens from the nineteenth century, had no handle. The board was not heavy and was held in place by hand. Simple bow-shaped handles are rarely found on decorated mangle-boards from this area. (Cf. the double-headed horse in Pl. 356.)

207 **Yarn-winder.** Various kinds of wood, turned. Latter half of 18th century. Acquired from Uetersen, Holstein. Height 113 cm, depth 40 cm, diameter 86 cm. Altonaer Museum, Hamburg.

The counting mechanism of a yarn-winder, which from a distance is not unlike clockwork, can easily be combined with moving figures after the manner of those on a musical box. This often results in elaborate works of art like this. When the reel is turned it moves a circular tray on which stand three figures. Another figure is apparently manipulating the axle, but is really moved by it; yet another is beating a little bell with a hammer. Such toys and turnery were always closely related, and occur together in many combinations.

208 **Spinning-wheel.** Beech. 18th or 19th century. Height 123 cm, width 70 cm, depth 36 cm. Universitätsmuseum für Kunst- und Kulturgeschichte, Marburg.

The type of spinning-wheel known in Hesse as a *Geiss* (goat) is usually called a bench spinning-wheel, as opposed to a stock- or buck-wheel. 'The bench form ('lying' or 'long' spinning-wheel) appears to be the earlier type. It was very popular in the north, particularly in Lower Saxony. The wheel is placed on top of three or four slanting supports with the treadle between them. Between the wheel and the spindle-holder runs a sloping bench; the spinning mechanism is approximately on the same level as the wheel.' (Gertrud Benker, *Altes bäuerliches Holzgerät,* Munich, 1976, p. 95.) Until very recently the spinning-wheel was the classic product of the wood turner. What might be termed the art-work is mostly confined to elaborating the baluster. At the most some modest carving of the bench, perhaps along the edges, was added. The head-pieces of the distaff and the leather or oil-cloth distaff wraps were quite another matter. They made popular wedding-gifts, and were painted or printed with flowers or sayings.

209 **Weaving-comb.** Oak. Latter half of 18th cen-

tury. From the island of Sylt, north Friesland, Schleswig. Height 27 cm, width *circa* 20 cm. Heimatmuseum, Keitum, Sylt.

The folk art of north Friesland finds one of its most fanciful expressions in the varied decoration of this implement, used in a craft carried on mainly by women. There is no other example of the motif of two crowing cocks in juxtaposition, and the effect is decidedly original. The cut-out portion is presumably meant to represent a heart. It was used to hold the implement when weaving but also served to hang it up on the wall of the room. It was obviously given as a love token. The reverse side is treated in the same way.

210 **Weaving-board.** Wood. 1856. From the island of Rügen. Museum für Deutsche Volkskunde, Staatliche Museen Preussischer Kulturbesitz, Berlin.

This specimen is narrower than most other weaving boards from Rügen. The overall format is rectangular and the upper perforated part is decorated with a rare interplay of forms. They signify alternating negative and positive motifs: hearts and tulips. The remarks in the caption to Plate 211 are equally applicable here. The ship motif in the incised drawing below (cf. also Pl. 214) sometimes occurs in fretwork, where small cross-pieces take the place of lines.

211 **Weaving-board.** Beech, sawn out, notched and painted. Middle of 19th century. Mönchgut, island of Rügen. Height 39.5 cm, width 36 cm. Museum für Deutsche Volkskunde, Staatliche Museen Preussischer Kulturbesitz, Berlin.

This specimen represents vividly a very characteristic item from Mönchgut. This weavers' implement occurs all over North Germany in many variations. Typical is the frieze-like development of the opposed horses' heads across the whole width of the board, surmounted by enlarged variants of the same theme. Characteristic, too, is the combination on the lower part of incised drawing with chip and pierced engraving. The decorations may to some extent have impaired the practical usefulness of the utensil. A considerable number of weaving-boards made in Mönchgut are preserved in various collections.

212 **Mangle-board with roller.** Beech. 1765. From north-eastern Schleswig. Length of board 65.5 cm, width 15 cm. Schleswig-Holsteinisches Landesmuseum, Schleswig.

The piece of washing, folded, was wound around the roller and rolled to and fro on a table top under pressure of the mangle-board. The handle is often shaped like a horse. The surface of the board is covered with chip carvings and the smooth cross-sections bear the incised inscription 'MPHL 1765'.

213 **Clothes-beater.** Beech. Incisions filled in with red and green wax. 1861. From the island of Rügen. Height

29.5 cm, width 17.5 cm. Museum für Deutsche Volkskunde, Staatliche Museen Preussischer Kulturbesitz, Berlin.

After a thorough boiling, the soap suds were beaten out of the washing with a clothes-beater like this. As with weaving utensils, those for the care of laundry, particularly linen, were popular as love tokens. The clothes-beater occurs all over Europe and generally has the same shovel-like shape as the illustrated piece. The slanting handle is common to utensils used for beating on a flat surface. Similar handles are found on beaters used to level and harden the clay floors of barns. The clothes-beater, like other wooden implements from the island of Rügen, shows loosely arranged incised and chip-carved decoration. The incisions were often filled in with coloured wax or simply painted.

214 **Swingle-board.** Beech. Middle of 19th century. From the island of Rügen. Length *circa* 44 cm. Museum für Deutsche Volkskunde, Staatliche Museen Preussischer Kulturbesitz, Berlin.

The swingle-board was used, along with the swingle (Pl. 203), for beating the woody particles out of dried flax. It was a popular love token all over northern Germany, as suggested by the heart shapes depicted here. Especially characteristic of Rügen is the incised representation of a sailing boat; it can be seen on earlier specimens (for instance one of 1814). The incised notches and lines were often filled with coloured (green and red) wax.

215 **Clothes-beater.** Oak. 1770. Probably from north Friesland, Schleswig. Length 45 cm, width 19 cm. Schleswig-Holsteinisches Landesmuseum, Schleswig.

In the region where it originated this utensil was known as a *Bükholz*. It was used to beat out the wet laundry after it had been boiled in beech-ash, and became very popular as a love token; hence the numerous modifications. Variations occur in the position of board and handle (which may be in one plane or inclined) in the shape of the beating surface, and particularly in the ornamentation. Chip carving was superseded around the mid-eighteenth century by plant and animal themes.

216 **Plate.** Pewter, with engraving. 1794. From the Winser Elbmarsch. Height 2.5 cm, diameter 33.5 cm. Historisches Museum am Hohen Ufer, Hanover.

On the rim is a wavy line enclosing stylized blossoms engraved with a quaver stroke. On top is the inscription 'A. M. K. 1794'. In the centre are the two emissaries, Joshua and Caleb, with a large bunch of grapes. These are executed partly in the quaver stroke, as is the surrounding garland. Such plates were probably only for display on shelves or on a dresser. Perhaps they were used on special occasions, and may also have functioned as a baptismal basin. (Cf. Ulrich Fliess, in: *Abteilungskatalog des Historischen Museums am Hohen Ufer, Hannover*, II. *Volkskundliche Abteilung*, Hanover, 1972, p. 130.)

217 **Tankard.** Pewter. 1767. Kiel. Height 32.5 cm, maximum diameter 11.6 cm. Schleswig-Holsteinisches Landesmuseum.

Engraved on the cylindrical body of this tankard is a picture of a couple, Hartwig Bruhn and his wife. His name is engraved on the lid. Husband and wife are shown standing, holding hands and offering each other an immensely large blossom. This kind of presentation obviously symbolizes marriage or married life, and is well known in other connections. A simple representation of a standing couple naturally requires them to be bare-headed, so Bruhn is holding his cap under his left arm. The couple is flanked on both sides by waving long-stemmed flowers—a form often used on pewter pieces to adapt figurative subjects to the decoration of curved surfaces.

218 **Tankard with lid.** Pewter. 1776. From Hamdorf, Rendsburg district, Holstein. Height 36 cm. Schleswig-Holsteinisches Landesmuseum, Schleswig.

From this picture one can barely see that a round practice target is engraved on the side. It is surrounded symmetrically by plant forms with tulip blossoms. The inscription reads: 'Hamendurfer/Scheiben (i. e. Guild) Gewin 17–76'. The hallmark names Master Gottlieb Geisler, Rendsburg, as maker (Erwin Hintze, *Norddeutsche Zinngiesser*, No. 1842, Leipzig, 1923, but with the year 1763). Inside the lid, which may be a later addition, are three equal stamps arranged in the shape of a clover-leaf; they read 'Engelmarke' (Justitia with sword and balance), above 'C. A. K.', and below '1708' (not mentioned by Hintze).

219 **Jug with lid.** Pewter. 1790. From Bohnert, Eckernförde district, Schleswig. Height 22.2 cm. Schleswig-Holsteinisches Landesmuseum, Schleswig.

This cylindrical jug, like the comparable item in Plate 218, shows a circular practice target engraved in quaver-stroke technique. This time it is framed by star blossoms with large leaves. The inscription reads 'Bonerte Schiben Giell (i. e. Guild), 1790.' The stamps name Master P. C. Petersen of Eckernförde as maker. (Erwin Hintze, *Norddeutsche Zinngiesser*, Leipzig, 1923, N. 407.)

220 **Kettle.** Copper. 18th or 19th century. From the Soester Boerde, Westphalia. Height 25.5 cm. Westfälisches Landesmuseum, Münster, Westphalia.

The shape of this kettle, the lower part indented on four sides to give it a waistline, is most unusual. Even the handle with its pinched-in 'nose' departs from the conventional form. This is perhaps why Walter Dexel has not included it in his extensive *Das Hausgerät Mitteleuropas* (Berlin, 1962). It does not conform to the puristic, strict form considered ideal at the time it was made. Nevertheless, the basic idea governing its shape is followed through clearly and consistently, and the transfer from the bulging part below to the rounded part above is successful. It might be said that the kettle sits, almost

in a human sense, rather than stands. (Walter Borchers, *Volkskunst in Westfalen*, Münster, 1970, Pl. 290.) Woven baskets, such as were made in Franconia, may have been the inspiration. (Cf. Josef Ritz, *Deutsche Volkskunst*, vol. *Franconia*, Munich, n. d., Pl. 162, and our Pl. 422.)

221 **Coffee-pot.** Pewter. *Circa* 1840. From southern Germany. Height 29 cm. Private collection, Munich.

The basic form of this coffee-pot may have been developed during the eighteenth century. The lack of any curvature in the outline of the vessel prompts such an attribution.

222 **Two tankards.** Pewter. 17th and 18th centuries. Unmarked. Height of tankard on left 29 cm. Private collection.

Both vessels have typical shapes which were frequently used for popular pewter vessels during the seventeenth century and continued to be in demand long afterwards. Both examples still bear features from the latter half of the sixteenth century, originally developed for silverware and then taken over for pewter ware. The bulge in the piece on the right, originally a feature of goblets and similar vessels, can be traced back to sixteenth-century Nuremberg (the workshop of Ludwig Krug).

223 **Dish.** Pewter. First half of 19th century. Made in Augsburg (?). Diameter 32 cm. Private collection, Munich.

This dish exemplifies a more 'bourgeois' type. The undecorated circle and the repeated comma-shaped bulges derive from the Biedermeier style, which was influenced by classicist taste. Forms like this will hardly have penetrated into the world of peasant art.

224 **Rack for food storage.** Wrought iron. 19th century. From Schleswig-Holstein. Height 78 cm. Schleswig-Holsteinisches Landesmuseum, Schleswig.

This is a simple utensil on which pieces of meat were hung in the pantry. It has been included to show that a purely practical article can possess a certain brittle grace and even, up to a point, become a work of art with its own aesthetic charm.

225 **Pot-hanger.** Wrought iron and brass. 1804. From north or east Westphalia. Length 100 cm. Westfälisches Landesmuseum, Münster, Westphalia.

The hooks on which pots and kettles were suspended over a fire in the open hearth were particularly handsome in Westphalia (where they were known as *Hahl*). 'The pot-hook is a flat piece of iron with cogs on one side, ending below in a short hook and hanging from a ring above; it is connected to a longitudinal rail which is gripped by cogs. It can thus be made longer or shorter as required . . . The three most important shapes from the

country around Münster are the *Sagehaol, Dräihaol* and *Keddenhaol* … The number of variations on these pot-hooks in the Münster region is very large indeed.' (Walter Borchers, *Volkskunst in Westfalen,* Münster, 1970, pp. 93 f.) Engraved drawings depict hearts, tulips and other plant motifs, coats of arms, horsemen and even the Madonna of Kevelaer. Particularly elaborate pieces like this one have additional figures cut out of the iron plate as a decoration on top.

226 **Grill.** Wrought iron. 18th century (?). From Schleswig-Holstein. Height 11 cm, length 85 cm, diameter 40.5 cm. Altonaer Museum, Hamburg.

According to Gertrud Benker grills are not known until recent times, when rectangular and round shapes occur. 'Iron rods', she writes, 'are set into a ring which rests on three legs. A special form is the circular grill with a revolving disc. This rests on a tripod and is reinforced by a centre bar which often extends upward into a handle … The grill bars run radially or of a slant … The round grill is said to have been developed in the late Middle Ages (…); owing to lack of evidence it is impossible to be definite about the date. From the fifteenth century onward both types—the rectangular and the round—appear simultaneously, the round one being less common.' (Gertrud Benker, *Altes Küchengerät und Kochpraxis,* in: *Bayerisches Jahrbuch für Volkskunde,* 1975, pp. 136–79, reproduced on p. 170.) If round specimens are more frequent in north German collections, this is probably due to the many variants; rods are fancifully worked to produce an interplay between those that start at the periphery and those that start at the centre. Hearts and fleurs-de-lis play an important part.

227 **Double grill for fish.** Wrought iron. 18th or 19th century. From Nuremberg. Germanisches Nationalmuseum, Nuremberg.

The hollow part consists of iron bands rivetted together and can be opened. The head and tail pieces, executed in sheet iron, give an abstract impression of a fish. When the grill was opened, the two halves of the projecting pieces served as supports. Vessels in ceramic or wood for serving fish, and shaped in the form of a fish, play an important rôle in folk art, as do fish-shaped baskets (illustrated in Hans Karlinger, *Deutsche Volkskunst,* Berlin, 1938, p. 348); there are also fish-shaped silver snuff-boxes etc. They are always an interpretation of the natural form. Since they incorporate a hollow for the fish, they are different from ceramic table decorations or reproductions of model meals in china. They are sometimes amazingly abstract. (A similar piece is discussed by Gertrud Benker, 'Altes Küchengerät und Kochpraxis', in: *Bayerisches Jahrbuch für Volkskunde,* 1975, pp. 136–79.)

228 **Clothes-hook.** Wrought iron. 19th century (?). From north Friesland. Length *circa* 60 cm. Municipal Museum, Flensburg.

The village blacksmiths of north Friesland developed an amazing number of ways of splitting up square pieces of iron to make clothes-hooks with arms projecting in all directions like chandeliers, or with serpentine undulations. At the top the rod had a spike or a point like a nail by means of which it could be fixed to the lower side of the roof beam above or near the stove. This contraption was used to hang up damp articles of clothing. The Municipal Museum, Flensburg, and the Schleswig-Holsteinisches Landesmuseum, Schleswig, each possess a collection of these hooks.

229 **Fire-guard.** Wrought iron. 18th or 19th century. From Diepholz county, Lower Saxony. Height 50 cm, diameter 54 cm. Historisches Museum am Hohen Ufer, Hanover.

'At night this gadget was put over the raked-up embers to prevent domestic animals from getting near them and perhaps causing a fire. The bell-shaped guard with a handgrip consists of iron bands terminating in small twisted rods.' (Ulrich Fliess, in: *Abteilungskataloge des Historischen Museums am Hohen Ufer, Hannover,* II. *Volkskundliche Abteilung,* Hanover, 1972, p. 182.)

230 **Warming-pan.** Sheet brass and iron. Middle of 17th century. Acquired in Schleswig. Diameter 32.5 cm. Schleswig-Holsteinisches Landesmuseum, Schleswig.

Figure motifs like the one shown here, a couple standing close to each other, are less frequently found on warming-pan covers than simple patterns such as stars, birds on leafy branches or just plants of various kind. The latter generally cover the entire surface, leaving small openings to allow the heat to percolate. The decoration of the surround is quite conventional, the bulges mostly bearing fruit with interlaced leaves and berries. Embossing, punching and engraving sometimes occur on a single piece. In this photograph the raised brass lid hides the pan, which was often made of iron. Glowing charcoal was placed inside and it was pushed into the bed by means of a long iron handle. It was then moved to and fro between sheet and cover to warm the bed before the occupants retired for the night. During the day the warming-pan hung on the wall as an item of display and decoration.

231 **Reflector.** Brass sheeting. Latter half of 17th century. Acquired in Schleswig-Holstein. Height 59 cm, width 55 cm. Schleswig-Holsteinisches Landesmuseum, Schleswig.

This octagonal brass shield is designed to serve as a reflector behind a wall candlestick. It probably came originally from somewhere near Aix-la-Chapelle, but in North Germany there were many other centres where articles of this type were produced, which regularly followed the patterns established by the workshops of the Rhine-Maas area. The brass sheeting was hammered over a mould made of a harder material.

232 **Foot-warmer.** Brass. 1762. From Zeven, Lower Saxony. Width 20 cm, length 20 cm. Historisches Museum am Hohen Ufer, Hanover.

The perforations on all sides of the thick brass sheeting are abnormally small. Unusual, too, is the arched lid. It indicates clearly that the proprietress did not put her feet on the 'little stove'—as they call this piece of equipment in Lower Saxony—but that it was simply pushed under her skirt.

233 **Warming-pan.** Brass sheeting and iron. Early 18th century. Owner unknown. Photograph in Municipal Museum, Flensburg.

See caption to Plate 230.

234 **Hanging candelabra.** Wrought iron. *Circa* 1700. Acquired in Kiel, Holstein. Height (with hook) 61.5 cm. Schleswig-Holsteinisches Landesmuseum, Schleswig.

Candelabra of this kind would have been found in rooms used on festive occasions, even in peasant houses. In the *Pesels* (large rooms) of wealthy farmers in the marshlands along the North Sea coast brass chandeliers begin to appear as early as the sixteenth century; they were smaller but quite elegant versions of the larger ones in churches, town halls and palaces. This piece shows how attempts were made to emulate these examples with greater economy of material and design. The blacksmith could still find room for his individual skill in the design of the cross-sheet with drawn, wavy and rolled ends and a row of patterns welded on it. The part once placed between the two birds has broken off and is irretrievably lost.

235 **Wax taper-holder.** Wrought iron. 18th century. From Schleswig-Holstein. Height 18.5 cm. Schleswig-Holsteinisches Landesmuseum, Schleswig.

A rosette-shaped metal base on three legs carries a wax taper, consisting of a cotton or flax thread that has been drawn through liquid wax a number of times. As wick and wax burn down the next length is pulled up, like yarn from a ball of wool, and pinched tightly with a scissor-shaped clip. The idea of crowning the utensil with a cock cut out of a flat sheet of forged iron must be derived from the cock on the church steeple who welcomes the rising dawn with his crowing. (Cf. E. Schlee, *Schleswig-Holsteinische Volkskunst,* Flensburg, 1964, Pl. 61.)

236 **Detail, stove wall, farm-house in Wimsheim,** Leonberg district. Pottery with slip painting and lead glaze. *Circa* middle of 19th century. Probably made by Johann Georg Dompert (1788–1853) of Simmozheim, Württemberg. Individual tiles 19 × 19 cm. Württembergisches Landesmuseum, Stuttgart.

A number of potters making painted wall tiles established workshops in small communities between the rivers Enz and Neckar, or rather between the towns of

Pforzheim, Nagold, Tübingen and Stuttgart. These tiles were used to cover the walls of the living-room near the iron stove, not, as is often claimed, as a protection against fire but to conserve heat. A large number of potters, many of whom are known by name, produced these wall covers to order, mostly for use in the immediate surroundings. The varying sizes of the tiles alone indicate that trade to distant areas did not take place. They created a whole series of amusing pictures without properly connected sequences. They were simply a random selection of scenes of farm life, hunting motifs, different animals, flowers, sometimes groups of soldiers etc. There were occasionally religious themes but on the whole, a light-hearted spirit prevails. Inscriptions are frequently added, a varied mixture of more or less meaningful sayings, some of them rather suggestive. The tiles by Johann Georg Dompert were characterized by free and fluent handling of the painting horn; he belonged to a family of potters that can be traced over three generations in the same place. The creator of the group illustrated here can also be identified by the green stars formed where the corners meet.

This single example must do duty for similar work from Hesse, the Lower Rhine valley and perhaps Thuringia. (Cf. Karl Hillenbrand, *Schwäbische Ofenwandplättchen,* Stuttgart, 1971; Gerhart Kaufmann, *Bemalte Wandfliessen,* Munich, 1973, pp. 81 ff.)

237 **Dish.** Pottery. 1750. From a workshop at Wickrath, Lower Rhine valley. Diameter 66 cm. Museum für Kunst und Gewerbe, Hamburg.

The base of this dish is completely covered by a hunting scene: three elegantly dressed horsemen and a huntsman on foot are pursuing a stag and a wild boar; dogs are giving chase. On the rim we find the name 'Derck Hammns, Anno 1750' and the crest, supported by a pair of lions whose hindquarters project into the moulding. The background is reddish-brown; the painting is light yellow, ochre, grey-green blue, red-medium brown, and manganese bistre. The contours of the drawing are incised contours. This is a major example of Lower Rhine pottery. A unique feature is the natural manner in which the figures of the hunting scene are fitted into the moulding. They seem to circle the centre even though they do not move in common direction. The motifs, even the outer circles, contrast strongly in their colouring with the dark background. (Described in M. Scholten-Neess and W. Jüttner, *Niederrheinische Bauerntöpferei,* Düsseldorf, 1971, No. 886.)

238 **Plate with thick rim.** Wanfried pottery. 1600 (or 1611). Found in Bremen. Diameter 21 cm. Focke-Museum, Bremen.

The body of the plate is red-brown biscuitware with brown-red slip. It is painted in white, brown and yellow; the drawing is incised and the glaze is light green. The catalogue description reads: 'On the rim, longitudinal stripes and short cross-strokes. A wide band of concentric circles. In the centre a picture of a gentleman with a large hat with a long feather, holding a stemmed glass in his right hand. To the left and right of the figure stylized

flowers. Above the outstretched right arm, the number 16. Correspondingly, on the left of the figure, two dots which might be interpreted as the number 00 or 11.' (Catalogue: *Meisterwerke hessischer Töpferware,* Staatliche Kunstsammlungen, Cassel, 1974, No. 51, where further references to other writings on the subject will be found.)

239 **Dish.** Pottery with slip painting and lead glaze. 1788. From the Probstei, Holstein. Height 9 cm, diameter 32.5 cm. Schleswig-Holsteinisches Landesmuseum, Schleswig.

The background is light, with painting in green, brown and yellow. The fabulous animal with a human face and horns or huge ears is a surprising feature, and has no counterparts in contemporary ceramic art in this part of the country. The rest of the decoration accords closely with other pieces from the Probstei, such as a two-handled dish with a painting of a stag, its legs similarly extended. Another closely comparable piece in the same museum is dated to the year 1783.

240 **Dish.** Pottery with slip painting and lead glaze. 17th century. Probably made in Hesse; found in ground in Tönning, Schleswig. Height 6 cm, diameter 23 cm. Schleswig-Holsteinisches Landesmuseum, Schleswig.

The background is light brown, painted with a yellow-white mixed into which some green has run. The glazing has peeled off in parts. A trade mark is incised on the bottom of the dish. Pieces of the same type, but with different patterns, have been found in other parts of north Friesland and also in the Wadden Zee.

241 **Plate.** Pottery with slip painting and lead glaze. 1767. From Raisdorf, Probstei, Holstein. Diameter 34.5 cm. Schleswig-Holsteinisches Landesmuseum, Schleswig.

This plate—characteristically without a rim—belongs to a type of pottery which originated in 1743 in the Probstei but may also have been made in some nearby place such as Preetz. It is outstanding for the very precise and generous drawing which completely covers the circular part. The outlines of the drawing were first incised. The picture, in this case a nobleman wielding a sword, does not necessarily prove that the plate was not designed for the farming community. The colours are a light yellow background with painting in brown, green and yellow.

242 **Dish.** Pottery. 1796. From a workshop at Frechen, Lower Rhine valley. Diameter 42 cm. Museum für Kunst und Gewerbe, Hamburg.

In an area marked out into two sections are seven riflemen marching, with rifles shouldered, and wearing hats with long feathers. The remaining surfaces are also decorated. The background is cream-coloured, painted in ochre, green and manganese brown. The figures are

drawn without previous incision, boldly and gaily, straight from the paint-box. In their fluency and ease they resemble motifs on wall tiles from Württemberg. The dish was probably made to commemorate a shooting contest: perhaps it was one of the prizes? (Described by M. Scholten-Neess and W. Jüttner, *Niederrheinische Bauerntöpferei,* Düsseldorf, 1971, No. 63.)

243 **Dish with handles.** Pottery with slip painting and lead glaze. 1799. Made in Marburg. Height 6 cm, diameter 19 cm. Museum für Kunst und Gewerbe, Hamburg.

This dish is of red biscuitware with underglaze in black-brown, and is painted in bright yellow, green, ochre and reddish-brown. 'Round dish with flat bottom, moulded wall and bulging rim. On the edge, two opposed loops as handles, the lower one at an acute angle. Bottom and sides covered by a picture of a shrub with a central panicle and a blossom on either side. Below is the date 1779. On the black-brown rim a red wavy band. The handles have bright yellow stripes. Reverse side unglazed. Such double-handled dishes were used to drink coffee and are called *Kaffeedibbe* in Hesse. They were used by placing the thumb in the lower handle. The upper one serves to hang the bowl up on a wooden plug. A similar dish is depicted by Konrad Strauss, *Die Töpferkunst in Hessen,* Strasbourg, 1925, Pl. 35.' (Hermann Jedding, in: Bilderhefte des Museums für Kunst und Gewerbe, Hamburg, No. 13: *Volkstümliche Keramik aus deutschsprachigen Ländern,* Hamburg, 1976, p. 105.)

244 **Dish.** Pottery with slip painting and lead glaze. Beginning of 19th century. From Heimberg, Baden or the Black Forest. Diameter 33.5 cm. Badisches Landesmuseum, Karlsruhe.

This dish, which was shaped on a mould, has a sloping rim and a black base. It is painted in white, yellow, brick-red and blue. The contours are incised. There are differences of opinion about its origin and date. Erich Meyer-Heisig believes it came from Heimberg or Bariswil, and dates it to the middle of the eighteenth century. (Catalogue: *Mit Drehscheibe und Malhorn,* Germanisches Nationalmuseum, Nuremberg, 1954, No. 277.)

245 **Plate.** Pottery. Possibly made in the 1930s in the Blut pottery works in Goslar. Diameter *circa* 20 cm. Historisches Museum am Hohen Ufer, Hanover.

The circumstances under which this plate reached the museum are not quite clear. It may therefore be a product of artistic craftsmanship in the modern sense, a case of the craftsman consciously adopting a sensitive affinity with folk art. The Municipal Museum in Brunswick possesses a plate dated 1742 from an artisan's workshop. It has an architectural motif but in spite of this it offers a remarkable comparison. (Illustrated in Gerd Spiess, *Führer durch die Schausammlung Keramik,* Arbeitsberichte aus dem Städtischen Museum, Brunswick, No. 11, n. d.) In the field of twentieth-century ceramics traditional

forms often merge into new ones and it is impossible to draw a clear dividing-line.

246 Flat dish, Wanfried pottery, 1608. Diameter 26 cm. Formerly in the Schleswig-Holsteinisches Landesmuseum, Schleswig; acquired in Holland. Now in the J. Beestra collection, Dokkum, Netherlands.

This dish is of red-brown biscuitware with an orange underglaze. It has incised drawing, brown painting, and lead glazing with a green admixture. There is dark green glazing on the figure and the volutes. 'On the rim between concentric circles, a band of volutes of intermittent spirals. In the centre, a picture of a lady in fashionable dress with a split skirt, or *Vertugadin*. In her right hand she holds a glass with a stem. To the right and the left of the figure, the number 16/08.' (Catalogue: *Meisterwerke hessischer Töpferware*, Staatliche Kunstsammlung, Cassel, 1974, No. 56.)

247 Dish rack. Softwood. 1838. From Tölz, Bad Tölz-Wolfratshausen district, Upper Bavaria. Height *circa* 85 cm, width 120 cm, depth *circa* 15 cm. Heimatmuseum, Bad Tölz.

Fittings of this kind, also known as *Schüsselreck* in northern Germany, were used in all parts of the country. They were often displayed purely as showpieces. (J. M. and G. Ritz, *Alte bemalte Bauernmöbel*, Munich, 1975. Pl. 24.) Painted in various shades of blue with a reddish ornament.

248 Three strainers (filters). Salt-glazed pottery. 19th century. Origin uncertain. Height 20 cm, diameter 16.5 cm; height 9.5 cm, diameter 20 cm; height 16.5 cm, diameter 18 cm respectively. Private collection.

In the kitchen of old a variety of specialized vessels were required for separating liquids from solids. Capacity and shape depended on the style of the household and its other equipment. They also had to be handy: that is to say the size and shape of the handles had to be adapted to the weight of the vessel and its contents. In such matters even the most simple utensil is a reflection of a broader pattern. In certain cases they had a very specialized function. The interesting feature here is the confidence with which the makers evolved a simple, clear and appropriate form.

249 Dish. Pottery with slip painting and lead glaze. *Circa* 1850. From Windsheim, central Franconia, Bavaria. Diameter 46.5 cm. Bayerisches Nationalmuseum, Munich.

'Of unusually deep form with straight walls and an inverted rim. Painted on a bright reddish-brown base in white, green, yellow and manganese brown. On the wall, two large branches with blossoms alternating with two florid scrolls.' (Erich Meyer-Heisig, *Deutsche Bauerntöpferei*, Munich, 1955, p. 158, Pl. 55; Catalogue: *Mit Drehscheibe und Malhorn*, Germanisches National-

museum, Nuremberg, 1954, No. 358; cf. also: Ingolf Bauer, *Treuchtlinger Geschirr*, Munich, 1971.)

250 Plate. Pottery with slip painting and lead glaze. 1747. From the Probstei, Holstein. Diameter 30 cm. Schleswig-Holsteinisches Landesmuseum, Schleswig.

The outline of the drawing, which fills the whole of the rimless flat plate, is pre-incised except for the ribs of the flowers, the script and the flourish. This is the earliest example of a type of pottery which was used for decades in the Probstei, but not actually made there. It has an unmistakable character. The painting of the three blossoms is so forceful that it could never be classed as a 'pretty little flower painting'. The same museum possesses another plate with the same motif dated 1761, and the Germanisches Nationalmuseum, Nuremberg, has one dated 1735 with a single flower of exactly the same kind (illustrated in Erich Meyer-Heisig, *Deutsche Volkskunst*, Munich, 1954, Pl. 42). If these pieces are compared, it becomes apparent that the style is becoming increasingly rigid and impoverished. The lines have lost their vitality, the blossoms have become stiff and stylized, and the symmetry makes the drawing look stereotyped. By the middle of the century, despite the routine production method, the freshness and power can still be felt. This marks the high point in the development of this workshop.

251 Dish. Pottery with slip painting and lead glaze. 1777. From Silesia. Diameter 36 cm. Germanisches Nationalmuseum, Nuremberg.

The underglaze is bright reddish-brown, the painting white and green (tulip blooms). The inscription reads: 'Come on, young friend, you might do worse: For jolly days open your purse.' 1777. Erich Meyer-Heisig describes this item as a 'double dish' (*Deutsche Bauerntöpferei*, Munich, 1955, Pl. 44), but this term is usually reserved for dishes with a small bowl firmly fixed in the middle. This little bowl projects above the food (fish or broth) which filled the dish all around, and contained the sauce into which the food was dipped. The piece in this illustration only has a low, round cross-piece with some holes in it, which would be quite useless for such a purpose. It is designed to provide a hollow below the food (perhaps a pancake) in which any liquid that dripped off could collect. The example demonstrates how little we know nowadays about the formerly well-known functions of simple utensils.

252 Double dish. Pottery with slip painting and lead glaze. 1762. From Steinberg, near Flensburg. Height 7 cm, diameter 29.5 cm. Museum für Kunst und Gewerbe, Hamburg.

This dish is in yellow biscuitware with white-yellow underglaze, and is painted in reddish-brown, blue and green. 'Mould-shaped dish with a broad brim, the edges thickened. In the centre on a round stem, a round bowl with steep sides. On the bottom of the dish, four tulip blossoms in juxtaposition. In the bowl, a star-shaped

rosette. The rim is framed with wavy lines. In a faded blue the inscription: 'Andreas ibsen in Steinbarg/Flensburg, den 4. April 1762.' The underside is not glazed. This double dish was acquired in Flensburg. The inscription obviously names the potter, who ran his workshop in a small place called Steinberg, east of Flensburg. The drawing on this dish, unlike other pottery pieces usually ascribed to Flensburg, was not executed over previous incision. Flowers and script were freely applied with the *Malhorn*.' (Hermann Jedding, in: Bilderhefte des Museums für Kunst und Gewerbe, Hamburg, fasc. 13: *Volkstümliche Keramik aus deutschsprachigen Ländern*, Hamburg, 1976, pp. 89 ff.)

253 Dish. Pottery with slip painting, clay relief, incision drawing and lead glaze. 1804. From the Probstei, Holstein, Diameter 60 cm. Schleswig-Holsteinisches Landesmuseum, Schleswig.

This comparatively deep dish was obviously designed as a showpiece. The body is brown biscuitware, with whitish-yellow underglaze. Above the cross is an angel's head, and below it skulls. To the left and right are kneeling worshippers. The whole of the moulded area is occupied by the incised text of a hymn (No. 235 of the hymn-book current in Schleswig-Holstein in 1804, verses 1 to 8, beginning: 'Jesus, whose faith in heaven and on earth...'). The rim decoration is in brown and green. The reverse side is provided with loops cut into the clay by means of which the dish can be hung up. (Cf. *Zeitschrift Niedersachsen*, 1901.)

254 Dish. Pottery with slip painting and lead glaze. 1694. Made in the Altes Land(?), near Hamburg. Diameter 31.8 cm. Museum für Kunst und Gewerbe, Hamburg.

This dish in red-brown biscuitware has whitish-yellow glazing and shows traces of a faded green. The drawing is incised, the painting executed in light and dark brown, with a little green. 'The dish deeply moulded with a wide, slanting rim raised by alternating oval and round bulges. The thickened edge has double fluting. On the bottom is a bridal couple standing next to each other with hands clasped. Both wear long wigs. The bride has on a dress with an accentuated waistline and a wide skirt with vertical stripes. The bridegroom is dressed in a long garment reaching down to his knees, buttoned in front, with a belt. In his left hand he holds a rod(?). On the left side of the belt a sword hangs dangling. Inscription: 'Anno 16/94'. Reverse side unglazed. According to the previous owner this platter comes from the Altes Land. It is one of the earliest known pieces of pottery from this district. Only one platter with bulges of this type in the Municipal Museum in Göttingen shows an even earlier date, 1691. The young couple, drawn in this lively, carefree manner, was obviously of noble descent, as their clothes, wig and sword indicate. It is therefore quite possible that it was made especially for the wedding of a substantial farm owner or of a landed gentleman.' (Hermann Jedding, in Bilderhefte des Museums für Kunst und Gewerbe, Hamburg, fasc. 13: *Volkstümliche Keramik*

aus deutschsprachigen Ländern, Hamburg, 1976, p. 87.) I would like to add that the object in the man's left hand is without doubt his wide-brimmed hat. It is not uncommon for simple farmers to appear as noblemen, for instance on painted windows. (Cf. Pl. 61.)

255 **Small barrel.** Pottery with underglaze and lead glaze. 19th century. From Archsum on Sylt. Height 24.7 cm, width 20 cm. Schleswig-Holsteinisches Landesmuseum, Schleswig.

The barrel is in light biscuitware, with a whitish-yellow underglaze, sprinkled with manganese-brown and green, all confined to the upper half. The vessel is of an unusual specialized form, and was probably used to carry a beverage to the owner's place of work. On the other hand it looks so graceful and has such a carefully turned stand that it may have had only an ostensible practical use. According to the previous owner it was excavated in or near Archsum.

256 **Jug.** Pottery. 19th century. Made at Ochtrup, Westphalia. Height 16.5 cm. Bischöfliches Museum, Münster, Westphalia.

Pottery made at Ochtrup is frequently characterized by modelled embellishment on the body of the vessels. This is sometimes achieved by embossing the rim of the dish with reliefs from devotional plaques or garlands of small handles around the edge of vessels. The form of this jug conforms to the type. Figures of saints are set in the two handles, the body is decorated with a modelled mask, and each handle bears seven scrolls.

257 **Jug.** Pottery with slip painting and lead glaze. 1749. From Franconia. Height 35 cm. Heimatmuseum, Feuchtwangen, Lower Franconia.

The base is reddish-yellow with painting in white. Jugs of this shape are referred to in Franconia as *Mostkrug* (new-wine jug).

258 **Two pots with handles.** Pottery with slip painting and lead glaze. Left, from Wertheim, 1736; right, from Baden, *circa* 1800. Height: left, 45 cm; right 32.5 cm; diameter (taken at standing rim) 16.7 cm and 12.4 cm respectively. Badisches Landesmuseum, Karlsruhe.

The inscription on the left reads 'petter wilhelm frischmudt, becker in Wertheim 1736'. *Becker* means *Kannenbäcker,* i.e. potter.
The inscription on the right reads 'frau: brenn: die: suben: bald: sonst: wird: mir: mein: magen: kald:.' ('Wife, boil up soup in the pot, my tummy needs something hot.')
Such pots with handles are often called 'food carriers', though it is difficult to imagine that food was commonly carried in such quantities as the number of these pots indicates. Presumably they were used for carrying not only soup but also other beverages such as milk.

259 **Pot with handle.** Pottery with applied decor, painting and lead glaze. *Circa* 1820–30. Made in Marburg an der Lahn or surroundings. Height 30 cm. Germanisches Nationalmuseum, Nuremberg.

Characteristic of 19th-century Marburg ware is a type of ornamentation which consists of applying ready-shaped clay in a variety of shapes dyed *en masse.* Grooves and fluting were pressed in with a modelling stick after the clay was applied to the pot.
Marburg ware looks stiff and primitive compared with slip painting. Precisely because of this it achieves an individual expressiveness and develops specific conventions for plant and animal motifs. The main parts of Marburg ware are light brown, while the lower portion is dark brown. The applied parts are white, green, yellow and dark brown. The lid has three knobs. They could function as feet if the lid was inverted and used as a plate. One group of west German pots with handles has an unusually long spout. (Cf. Erich Meyer-Heisig, *Deutsche Bauerntöpferei,* Munich, 1955, Pl. 36.)

260 **Pot with handle.** Pottery with slip painting and lead glaze. 1728. Acquired at Rendsburg, Holstein. Height 30 cm, diameter 23 cm. Schleswig-Holsteinisches Landesmuseum, Schleswig.

All the numerous examples of this type of Holstein pot have a portly, rounded, sedate shape, very different from the more slender form which prevails in central Germany and also in Hesse. The decoration of this piece (the incision was executed before the painting) suggests some special (ritual?) significance. In Denmark this type of vessel was commonly called a *Barselpott,* which hints at a particular function associated with childbirth. This may however be overstating the matter, for the simpler pieces will not have had such a purpose but only the more ornate and elaborate pieces like the one, and especially the so-called 'maternity pots' (*Möschenpötte:* see Pl. 265). (Catalogue: *Mit Drehscheibe und Malhorn,* Germanisches Nationalmuseum, Nuremberg, 1954, No. 63.)

261 **Coffee-pot.** Stoneware. After 1763. Made in Bunzlau, Silesia. Height 23.5 cm, diameter 12 cm. Museum für Kunst und Gewerbe, Hamburg.

This pot, in white biscuitware, has brown clay glazing and relief decoration gilded and painted in green, black and brown. 'Pear-shaped coffee-pot, with five facets and round, gilded foot. The funnel-shaped neck has a markedly protruding spout. Flat, wide handle. Body decorated with embossed relief. In front the Prussian eagle, gilded, with trophies of victory (flags, cannon-barrel, kettledrum). Above this the royal crown of Prussia. Below it on each side, in unfired pigment, a flower-pot with two rosette blossoms, encircling laurel twigs. On top the initials J. E. Z. The pot is glazed a light brown inside, but unglazed underneath. The lid is missing. The victory trophy is probably a symbol of the Prussian victory after the Seven Years' War (1756–63).' (Hermann Jedding, in: *Bilderhefte des Museums für Kunst und Gewerbe,* Hamburg, fasc. 13: *Volkstümliche Keramik aus deutschsprachigen Ländern,* Hamburg, 1976, p. 110; also Konrad

Strauss, 'Bunzlauer Töpfereien, ihre Geschichte und Erzeugnisse', in: *Keramik-Freunde der Schweiz,* 82, 1972, Pl. IV.)

262 **Tureen with lid.** Pottery with lead glaze. 19th century. From Barsbek, Probstei, Holstein. Height (with lid) 33 cm. Schleswig-Holsteinisches Landesmuseum, Schleswig.

The underglaze and glaze are brilliant yellow, and the inside brown-yellow; the lid is lighter. This form of vessel was very popular in the Probstei (see Pl. 263) and there are many variations on the decoration. It is known in this area as a 'harvest pot'. Tradition has it that such tureens were used to carry the soup for the mid-day meal into the fields. Ropes were probably threaded through the grooved handle-loops for this purpose.

263 **Tureen with lid.** Pottery with slip painting and lead glaze. 1833. From the Probstei, Holstein. Height (with lid) 44 cm, diameter (at the upper rim) 35 cm. Schleswig-Holsteinisches Landesmuseum, Schleswig.

One of the many surviving examples of the Probstei 'harvest pot' (cf. caption to Pl. 262). This is one of the more elaborate examples, but even larger ones are known, some of them with figure motifs in the painting (for instance, harvesters and maidservants going into the fields). The motif in Plate 239, leaping red deer, however well known it may be in the decoration of ceramics generally, reappears in a highly original form as a frieze running all round this vessel, the animals alternating with the bending tulips so characteristic of Probstei pottery. The animals' bodies are placed on the widest part of the vessel. The decor follows the shape of the vessel very sensitively. The painting is applied with the painting cone *(Malhorn).*

264 **Preserving pot with underglaze and lead glaze.** 19th century. From the Probstei, Holstein. Height 31.5 cm, upper diameter 28.5 cm. Schleswig-Holsteinisches Landesmuseum, Schleswig.

Two-handled pots known as *Kruken* were made in the Probstei (or for use there) in large numbers. They are usually identified as vessels for making preserves. Unlike the harvest pots, they display a strict tautness. The contours swell like a stretched bow and are strictly restrained by the standing ring and the rim. The colours are lemon-yellow glaze on the outside and brown with a slight admixture of green on the inside.

265 **Maternity pot** *(Möschenpott).* Pottery with slip painting and lead glaze. 1787. From the Probstei (?), Holstein. Height 24 cm. Schleswig-Holsteinisches Landesmuseum, Schleswig.

This example, like the one in Plate 285, is typical of the 'maternity pot' so characteristic of Schleswig-Holstein pottery. It is a comparatively simple specimen since the lid has only a slightly raised 'crown'. An unmistakable

mark of the Holstein maternity pot is the spherical form inherited from the medieval *Stertpot* (i.e. 'tail pot'), which continued to be used for cooking small quantities of food such as fat and sauces well into, and even beyond, the seventeenth century in North Germany. In this example the outlines of the painting are largely pre-incised. Shapes of plants are embossed and coloured afterwards. They correspond to the peculiar embossing on the 'knees' of the short legs.

266 **Two melon jugs.** Pottery with underglaze and lead glaze. 17th or 18th century. Probably made in Nuremberg. Maximum height 21 cm. Germanisches Nationalmuseum, Nuremberg.

It is not certain that these monochrome jugs in brilliant deep blue originally came from Nuremberg. Erich Meyer-Heisig suggests Lower Bavaria or Franconia, about 1700. (Catalogue: *Mit Drehscheibe und Malhorn,* Germanisches Nationalmuseum, Nuremberg, 1954, No. 324.)

267 **Jug.** Faience, painted, with pewter lid. Latter half of 18th century. Height *circa* 20 cm. Heimatmuseum Feuchtwangen, Lower Franconia.

This piece from the impressive collection of ceramics in the Feuchtwangen Heimatmuseum is comparable, in respect to the correct interpretation of its motif, with Plate 269. The representation of St. Simon with the large saw is obviously copied from a copper engraving of a whole Apostle series. Such engravings were produced in large numbers by engravers in Augsburg for the craftsmen of half Europe. It is quite likely that the picture of this saint on the jug means that it was the property of a guild of craftsmen.

268 **Pear-shaped jug.** Pottery with slip painting and lead glaze. 1753. From Oberau, Büdingen district. Height 18.1 cm. **Cylindrical jug.** Pottery with slip painting and lead glaze. 1748. From the Wetterau, Hesse, Height 17.1 cm. Hessisches Landesmuseum, Cassel.

This pear-shaped jug is painted in green, black and yellow on a reddish-brown background. The pattern is only partially incised and is filled out in white. On the wall is a large triple branch and below the handle a man and the date 1753. Below the spout, in incised and white painted script, are the words 'Johann Wilhelm Wentzel I am called and Oberau is my fatherland.' (Erich Meyer-Heisig, *Deutsche Bauerntöpferei,* Munich, 1955, p. 156, Pl. 35.)
The cylindrical jug is painted in green, yellow, manganese-brown and red-brown, with outline drawings. On the side are bunches of blossoms and rosettes, very gracefully executed. The inscription reads: 'While you eat and drink, of God and the poor do think. Anno 1748 on the 26th of March.' (Erich Meyer-Heisig, as above. Catalogue: *Mit Drehscheibe und Malhorn,* Germanisches Nationalmuseum, Nuremberg, 1954, No. 200.)

269 **Cylindrical jug, with pewter lid.** Signed on the round knob: I P F. Ansbach. *Circa* 1730. Heimatmuseum Feuchtwangen, Lower Franconia.

This cylindrical jug has a round base with lattice painting and stippled roses. The motifs of the painting are the Old Testament themes of the sacrifice of Isaac and Isaac with the Angel. A palm-tree is shown rising in tiers. The handle is twisted. On the top and bottom of the jug are five surrounding wavy bands.

270 **Two drinking mugs.** Frosted glass, blue and white, coloured enamel painting, with pewter lids. Early 18th century. Probably from South Germany (Black Forest or Bavarian Forest). Private collection.

Opaque glass vessels, when painted over or dyed in bulk, can look like faience. This effect may have been deliberately produced. Enamel paint on a background of glass, however, behaves quite differently, and this is apparent in the technique of painting and the corresponding handling of the pointed and the wider brush. This becomes even clearer when frosted glass is compared with other painted glass vessels (Pls. 426–33).

271 **Jug.** Stoneware with slip painting and salt-glaze. End of 17th century. Made in the Westerwald. Height (up to the knob on the lid) 34 cm, diameter 14.5 cm. Museum für Kunst und Gewerbe, Hamburg.

This jug is in grey biscuitware with blue painting. 'On a cylindrical foot, sloping slightly upward, a spherical body with a tall cylindrical neck. The foot and the end of the neck are grooved. The rim has a pointed spout. Bulging handle. The blue body walls completely covered with embossed, symmetrically arranged bands of beads and rosettes. A flat pewter lid with a little bowl under the spout and a thumb-rest.' (Hermann Jedding, in: Bilderhefte des Museums für Kunst und Gewerbe, Hamburg, fasc. 13: *Volkstümliche Keramik aus deutschsprachigen Ländern,* Hamburg, 1976, pp. 102 ff.)

272 **Drinking mug.** Stoneware. Grey body, blue painting. Pewter lid. Latter half of 18th century. Made in the Westerwald. Height *circa* 20 cm. Germanisches Nationalmuseum, Nuremberg.

The decoration of this mug, compared with that in Plate 274 opposite, appears to be a small-scale version of the jumping horse in full harness, a common motif in stoneware from the Westerwald. All the details as well as the proportions of the animal's body have been stylized, as has the movement and the outline. The position of the hooves alone makes a considerable difference. Special attention should be paid to the proportion of the associated forms—meant to be plants—which stress the animal and its movement. The craftsman has not yielded to the temptation merely to fill up the empty spaces. The corresponding forms do not just avoid overlapping; they display considerable sensitivity in the interplay of uniting and opposing positions.

273 **Pear-shaped jug.** Stoneware with painting and salt-glaze. Latter half of 18th century. Made in the Westerwald. Height 30 cm. Germanisches Nationalmuseum, Nuremberg.

Jumping animals are drawn on the bulging wall of this vessel. They form a kind of symmetrical pyramid, but nevertheless emphasize the vessel's lively form. The stag was always a popular theme of pictorial decoration in all branches of folk art. It appears here in the kind of movement that may echo hunting scenes as portrayed in the fine arts. The reverse image repetition of the motif belongs to the sphere of folk art carried out by craftsmen, and has nothing to do with landscape painting. The draughtsman selected just the right place for the main motif. The curve of the outline of the stag's chest which determines the force of the movement coincides with the widest circumference of the vessel. The unison of the three animal figures and the way they harmonize with the form of the vessel is quite remarkable.

274 **Plate.** Stoneware with painting and salt-glaze. Middle of 18th century. Made in the Westerwald. Diameter 31.2 cm. Museum für Kunst und Gewerbe, Hamburg.

This plate is in grey biscuit with blue painting. The drawing is partly incised, partly impressed, 'Round plate, mould-shaped, with a flat rim and an off-set edge. On the main surface a horse jumping to the left. Around its body ornamentally twisted ribbons; below and above twigs with blossoms, above and on the side flower rosettes. On the rim 23 flower rosettes on a blue background. A garland of smaller ones decorates the edges. A similar plate with the horse jumping to the right is illustrated by Gisela Reineking-von Bock, *Steinzeug,* Kunstgewerbemuseum der Stadt Köln, Cologne, 1971, No. 685.' (Hermann Jedding, in: Bilderhefte des Museums für Kunst und Gewerbe, Hamburg, fasc. 13: *Volkstümliche Keramik aus deutschsprachigen Ländern,* Hamburg, 1976, p. 102.)

275 **Stove-cover.** Pottery with slip painting and lead glaze. 1841. From Gädendorf, east Holstein district. Height (without handle) 21 cm. Schleswig-Holsteinisches Landesmuseum, Schleswig.

Like the covers in Plates 276 and 277, this one was originally thrown on the wheel as a vessel. The rear portion was cut off vertically, the edges strengthened and decorated by pinching them between the potter's fingers. The inscription incised to the left of the tulip reads 'Strive first after the kingdom of God etc.'. To the right are the words 'With duty and diligence devote yourselves to God…' On the top cover, where the handle is fixed, we read: 'Paul Elsner 1841 Gädendorf.' This must be the name of the customer who ordered it.

276 **Stove-cover.** Pottery with incision and lead glaze. 1850. Made at Burg in Dithmarschen. Height (with handle) 25 cm, width 32 cm. Schleswig-Holsteinisches Landesmuseum, Schleswig.

The cover has a light underglaze. The incised script reads:

Everyone needs the potter's craft;
King, prince and nobleman.
In manor and town house it plays a part,
And finds its place in the humblest home
Of the countryman on his farm.
It graces the stove-box in their room
And keeps both man and woman warm.

Burg, this 1st April 1850.

277 Stove-cover with slip painting and lead glaze.
1838. Made at Windbergen, Dithmarschen. Height
27 cm, width 31.7 cm, depth 25 cm. Museum für Kunst
und Gewerbe, Hamburg.

Clay hoods of this type are produced by cutting off part
of a large pot thrown on the wheel. Like comparable pie-
ces made of brass they were put over a box-shaped warm-
ing oven in order to keep food or drink hot. They occur
chiefly in Dithmarschen. For a long period Windbergen
was a very active centre of village pottery-making. There
are long incised inscriptions referring to the decoration
on the cover. They read:

Whatever the wise old bird has uttered,
He knows which side his bread is buttered.

To God you must heed/He'll help you in need/
Windbergen.

How can a young man walk the proper road?
If he will follow step for step the word of God/
Anno 1838.

My fortune shall be built on God's word, not
on my own counsel/Karsten Kloppenborg 1838.

On the cover:

If in distress I sing and pray
My heart rejoices and feels gay
And to my mind such prayer brings home
The certainty of life to come.

(Hermann Jedding, in: Bilderhefte des Museums für
Kunst und Gewerbe, Hamburg, fasc. 13: *Volkstümliche
Keramik,* Hamburg, 1976, pp. 94 ff.)

278 Vessel in the shape of a basket. Pottery with lead
glaze. Latter half of 19th century. Height 20 cm, diame-
ter 11 cm. Museum für Kunst und Gewerbe, Hamburg.

This vessel is listed as a 'hand warmer'. In 1886 Justus
Brinckmann acquired it for his collection of works of
folk art. Its origin is uncertain; it may not even be Ger-
man. Similar playful forms, suggested by the flexibility
of the potter's clay, were also produced in Germany.
They came, for instance, from the potteries of Kröning,
Lower Bavaria, along with quite different large, simple,
unadorned vessels. The description of this piece as a
'hand warmer' is not entirely convincing. It is more
likely to be a showpiece, almost a piece of bric-à-brac.

279 Trick jug. Pottery with slip painting and lead

glaze. Latter half of 18th century. Made in the Probstei,
Holstein (?). Height 17.5 cm, diameter 11 cm. Museum
für Kunst und Gewerbe, Hamburg.

This jug is in red biscuitware, with whitish-yellow
underglaze; the drawing is incised and painted in
reddish-brown and green. 'Pear-shaped jug. The belly
painted with spirally curved flower tendrils all around.
Similar tendrils on the perforated neck. On the shoulder
and the arched handle, rows of brown dots. Above the
neck, a hollow bulge with three extended outflow tubes.
Above that an upright collar with serrated edge. The
inside is glazed light brown. The jug was acquired in
Flensburg. On festive occasions such trick jugs were used
to play practical jokes. An inside tube takes the liquid
through the hollow handle into the round bulge, to flow
out through one of the three tubes. The drinker could
therefore only get the liquid by sucking and also had to
take care that it did not run out of the perforated neck
of the vessel or through all three tubes at once.' (Her-
mann Jedding, in: Bilderhefte des Museums für Kunst
und Gewerbe, Hamburg, fasc. 13: *Volkstümliche Keramik
aus deutschsprachigen Ländern,* Hamburg, 1976, p. 90.)

280 Circular (ring) bottle. Pottery with appliqué
decoration and lead glaze. 18th century. From North
Germany (?). Height 25.2 cm, diameter 17 cm. Museum
für Kunst und Gewerbe, Hamburg.

The circular or ring bottle is a very ancient type of vessel.
Ring bottles made of glass which date back to Roman
times have been found in the Rhine valley. Correspond-
ing glass specimens were made in Germany in the seven-
teenth century; the museum in Hamburg possesses sev-
eral examples. It was therefore no surprise when similarly
shaped pieces of Japanese porcelain turned up in Europe.
In the same collection there is also a specimen, described
as 'German peasant ceramic', which is flattened on both
sides and covered with an incised inscription in Danish
which leaves no doubt about the purpose of the vessel:
'Oh brandy, how sweet you are...'. (Hamburgisches
Museum für Kunst und Gewerbe, *Bildführer,* Hamburg,
1938, p. 226.)

281–283 Clay figures: Monkeys playing music.
Pottery, painted, with lead glaze. 20th century. Made in
Marburg an der Lahn, Hesse. Height 11–13 cm. Univer-
sitätsmuseum für Kunst- und Kulturgeschichte, Mar-
burg an der Lahn.

Groups of several small figurines forming a monkey band
are characteristically playful creations of pottery work-
shops in Hesse, and especially Marburg. Bands of frogs
are also known. The idea of making such knick-knacks
stems from the traditional figures in faience, later also in
porcelain. They have a humorous intent and are designed
only for show. More recent products of this kind are usu-
ally aimed at the tourist industry. The colours are brown,
yellow and green.

284 'Möschenpott' or porridge pot. Pottery with
painting, appliqué decoration and lead glaze. *Circa* 1830.

From Schleswig-Holstein. Height 25.5 cm, diameter
12.5 cm. Museum für Kunst und Gewerbe, Hamburg.

This pot is in white biscuitware, with cream underglaze,
and is painted in green, brown, manganese black and
orange. 'On three legs which taper towards the bottom,
a hemispherical bowl with a mounted border. The outer
surfaces are decorated with applied leaves, fruit and
ornamental patterns. On the belly of the vessel, a wavy
brown ribbon from which grapes, vine-leaves and bun-
ches of fruit with spear-shaped leaves are suspended. On
the handle, rings with discs. At the end of the handle,
a rose. The round, inset lid is raised in steps. The
individual steps again are covered with rows of discs; the
edge is grooved. The lid is crowned with a figure of a
young woman in a wide green apron, sitting on a chair,
a green bonnet on her head. She holds an infant with
both arms on her lap. The bowl is glazed in cream inside
as well as outside; the inside of the lid is also glazed.
According to the previous owner the bowl comes from
somewhere near Elmshorn. No comparable examples are
known so far. The technique of firing ready-moulded
ornaments on to the surface of a vessel is reminiscent of
Marburg pottery from the 1820s and 1830s, specimens
of which were also widely known in Schleswig-Holstein.
They could have been the models for the decoration of
this porridge pot.' (Hermann Jedding, in: Bilderhefte
des Museums für Kunst und Gewerbe, Hamburg, fasc.
13: *Volkstümliche Keramik aus deutschsprachigen Ländern,*
Hamburg, 1976, p. 97.)

285 Left: Clay impression of a mould (perhaps for
rice or cake). 1752. From Uetersen, Holstein. Length
20 cm, width 15 cm. Schleswig-Holsteinisches Landes-
museum, Schleswig. Mould in the Museum für Kunst
und Gewerbe, Hamburg.

These fish-shaped moulds for pudding, or more probably
for rice, are frequently found in Schleswig-Holstein.
Rice, richly mixed with raisins, was served separately
with 'fresh soup', a broth, on festive occasions. The clay
moulds used for the purpose have many different shapes
besides that of a fish.

Right: Impression of a mould (perhaps for butter).
From Uetersen, Holstein. Height 15 cm, width 17 cm.
Schleswig-Holsteinisches Landesmuseum, Schleswig.
Whereabouts of original mould not known.

The Landesmuseum also has in its collection the
impression of a very similar bird-shaped mould from the
same locality.

286 Mould for cake or rice. Pottery with underglaze
and lead glaze. 19th century. Used at Morsum, Sylt.
Height 5.5 cm, length 21.5 cm, width 10 cm. Schles-
wig-Holsteinisches Landesmuseum, Schleswig.

The hollow form represents a nude couple. It stands on
three short legs. Ten apertures allow moisture to escape.
The inside has a yellow glaze.

287 Mould for cake or rice. Pottery with lead glaze. 18th–19th century. Acquired in Kiel, Holstein. Height 23 cm, width 22.5 cm. Schleswig-Holsteinisches Landesmuseum, Schleswig.

The hollow form stands on three legs and is glazed a greenish yellow inside. An impressed figure represents Samson pulling open the lion's jaws.

288 Mould for cake or pudding. Pottery with lead glaze. 17th or 18th century. From Kiel, Holstein. Diameter 19.5 cm. Schleswig-Holsteinisches Landesmuseum, Schleswig.

The hollow form stands on four legs and depicts in sunken relief the half-length figure of the Lord with the globe, making a gesture of blessing. It is in grey-brown biscuitware, with the interior glazed in yellow. The inside and outside are spotted with green glaze.

289 Fabric with blue print. Linen. 19th century. Made in Silesia (?). Museum für Deutsche Volkskunde, Staatliche Museen Preussischer Kulturbesitz, Berlin.

Large pieces of linen were printed with blue patterns, particularly in Silesia. They were used primarily as bed curtains, bedspreads and bed linen. The most popular motifs were hunting themes; the whole area could be filled with these forms without attempting unified scenes. Only occasionally are a few individual figures shown in relation to one another. The arrangement generally followed the rules of strict symmetry and in this respect, too, echoed the style of damask weaving. This piece may have served as a bedspread, judging by the arrangement of the border motifs.

290 Bed curtain. Blue-printed linen. 18th century. Made in Silesia. Museum für Deutsche Volkskunde, Staatliche Museen Preussischer Kulturbesitz, Berlin.

The theme of the emissaries Joshua and Caleb with the large cluster of grapes (Numbers, 13: cf. also Pls. 216, 305), so popular in all branches of folk art, was naturally also adopted in fabric printing. There is a picture of Hebron (one of the stations of the exploratory trip) composed like a frieze. It is similar to the pictures of Jerusalem which are frequently seen in connection with the Resurrection of Christ, arranged like a frieze and occupying a whole section of the pattern. (Cf. Pl. 294.)

291 Woollen embroidery on linen. 1717. From the Hamburg district. Reproduced in a water-colour painting to scale by H. Haase. Height 26 cm, width 31 cm. Schleswig-Holsteinisches Landesmuseum, Schleswig. Original embroidery in the Museum für Kunst und Gewerbe, Hamburg.

The illustration shows part of a roller-towel, i.e. the part which was hung in front on special occasions. The filling-in is executed in satin-stitch, arranged in a herringbone pattern, separated by threads of a different

colour. Note the manner in which broad flowers and leaves grow out of the original linear tendril or stem. The hearts and crowns are integrated into the overall pattern and become wholly decorative. Below the main motifs with their taut and sculptural effect is a mixture of script (the abbreviations have never been explained) and small, rigid scattered patterns from the stock repertoire of embroidery designs. Here and there the woollen threads are interwoven with metal filaments.

292 Reversible fabric. Flax and wool. 18th century. From north Friesland. Size of detail: height 49 cm, width 77 cm. Schleswig-Holsteinisches Landesmuseum, Schleswig.

The section shown can only convey a faint impression of this cloth, in which motifs from damask weaves are adapted to a fabric of contrasting coloured wool and undyed flax. The main motif is Christ at the well, repeated in reverse as a result of the method of weaving. The suggestion of another human being above the well may be a stone fountain figure. In the layer above (not shown here) is the Samaritan woman with her jugs, whom Christ is engaging in conversation; above this is a picture of the town of Sychar; and above this a star; the fountain motif is then repeated. This produces, through the use of reflected images, an endless sequence made possible by the simple action of the loom. A remarkable feature is the transformation of the representational as well as the material designs which fill the entire field, and the careful integration of the patterns. (Cf. Ernst Sauermann, *Schleswigsche Beiderwand,* 2nd ed., Frankfurt, 1923, Pl. 44, where it is shown in a green version. In addition, on p. 18 he gives a different, surely erroneous interpretation. He believes the fountain figure to be the Samaritan woman and takes her for one of the disciples.)

293 Printing block. Wood. *Circa* 1700 (?). From Hasenpat, Radewig, Herford, Westphalia. Height 33 cm, width 29 cm. Municipal Museum, Herford, Westphalia.

Among the most popular subjects for prints were the Resurrection and the Heavenly City of Jerusalem. Jerusalem was depicted as a conglomeration of surface patterns crowned with towers: these patterns represent masonry, guttering, slate, panelling, windows, doors etc. and combine to form a pleasing two-dimensional linear picture. The inscription carved into the mould: 'I am the Resurrection . . .' indicates that it was the custom to print the heavenly Jerusalem together with a representation of the Resurrection of Christ. (Cf. Walter Borchers, *Volkskunst in Westfalen,* Münster, 1970, Pl. 226; Wilhelm Schmitz, *Westfälischer Blaudruck in alter und neuer Zeit. Aus Westfalens Museum,* ed. Vereinigung Westfälischer Museen, Münster, n. d., Pl. VIII.) In one case the Resurrection and Jerusalem are both shown on a single block (cf. Konrad Hahm, *Deutsche Volkskunst,* Berlin, 1928, Pl. 70.)

294 Part of a bedspread (perhaps a bed curtain). Printed linen. 19th century. From Hesse. Deutsche

Volkskunde, Staatliche Museen Preussischer Kulturbesitz, Berlin.

The theme of the Resurrection of Christ recurs with amazing consistency in prints from different parts of Germany. It is paralleled by representations of Jerusalem, which is used both as a scenic background and as a reminder of the longed-for hereafter. There may have been a connection with the use of linen sheets, expressing the hope of a joyous awakening. The parallel between sleep and death was never far from the mind.

295 Part of a display towel. Linen and wool, embroidered. 18th century (?). From north Friesland. Width *circa* 45 cm. Schleswig-Holsteinisches Landesmuseum, Schleswig.

This towel should be compared with the one shown in Plate 291. As such display towels became an essential feature of domestic celebrations, a variety of local standard patterns emerged. These may have been created by a particularly able or active teacher of embroidery, and remained in vogue for several decades. It is difficult to narrow down the particular part of north Friesland where long hanging towels with sections like the one originated, but a distinct local school is clearly discernible. There is only a small repertoire of motifs, frequently repeated, but their arrangement and selection offer a wide variety of choice. A certain naive awkwardness is even more apparent on this example than on the fabric illustrated in Plate 291. The colours, too, are varied and bright.

296 Chair cushion. Wool and other materials. 1826. From the Vierlande, near Hamburg. Length 50 cm, width 50 cm. Focke-Museum, Bremen.

Triangles and other geometrical figures made of various coloured materials are here arranged in mosaic fashion on a piece of cloth. The tassels on the corners consist of woollen threads. The initials HM and BK and the year are embroidered. Patchwork cushions of this type are seen frequently in the Vierlande but apparently nowhere else.

297 Embroidered cushion cover. Linen and silk thread. 19th century. Made in the Winser Elbmarsch.

The combination of hem-stitching (or lacework) and frieze-like coloured silk embroidery above and below it is typical of cushion decoration in the Winser Elbmarsch. 'The original size of the square cushion covers can be deduced from the cloth width of 70–90 cm, which determines their measurements. The decoration was very similar to that on towels. Apart from the embroidery in front, cushions often had lace trimmings at the lower end. They were bound with linen ribbons. Between the bound ends were a few openings through which the coloured ticking could be seen.' (Annemarie Zieting, *Bäuerliche Stickereien aus der Winser Elbmarsch,* Berlin, 1942, p. 11.)

298 **Chair cushion.** Wool. 1769. From the Probstei, Holstein. Height 42.5 cm, width 48.5 cm. Schleswig-Holsteinisches Landesmuseum, Schleswig.

This cushion cover is made of red cloth. In the centre are two juxtaposed white horses in darning stitch below two large crowns. Below them are the initials HK – AO and the date 1769. These motifs are surrounded by flower patterns in satin-stitch (light and dark blue, red, brownish red, yellow and white). At corners are red and white tassels. (Catalogue: *Volkskunst aus Deutschland, Österreich und der Schweiz,* Cologne, 1969, No. 1086, Pl. 84.)

299 **Chair cushion.** Wool with silk embroidery. End of 18th century. From the Probstei, Holstein. Height 41 cm, width 50 cm. Municipal Museum, Flensburg.

Blossoms, twigs and leaves radiate across the rectangle on a black background and make an impressively forceful arrangement. Among the colours various shades of red and green (several olive shades) predominate; there is no blue. The basket of flowers in the centre is filled in with little dots. It therefore looks more three-dimensional than the satin-stitch areas, which are framed with chain-stitch in bright colours and comprise the compact parts of the composition. Differentiation of the blossoms by colours derives from the needle painting of the contemporary Baroque era. It is clear that this is a chair cushion and not intended for a bench, because an almost identical specimen is known. They therefore belong to the pair of chairs of heads of the household. The matching cushion only differs in details of the tendrils.

300 **Cushion cover.** Linen, embroidered. Middle of 18th century. From Buchen, Odenwald. Length 49.5 cm, width 74.8 cm. Badisches Landesmuseum, Karlsruhe.

The white linen is embroidered with red and a little yellow linen thread in satin-, feather- and stem-stitch. The pattern features flower vases, a heraldic double eagle, stags, rampant lions and birds. This particular cover once graced a show cushion. In Lower Franconia people preferred red linen and subsequently cotton thread for embroidering it. In that predominantly Catholic part of the country—in contrast to the piece in this illustration—religious motifs are mainly favoured: the Lamb of God, the Virgin Mary (copied from one of the shrines), the monogram of Christ; more worldly themes are knights, ladies etc. 'These examples from Lower Franconia can be seen to be related to the red embroidery on cushion covers and luxury towels from the Badische Landessammlung in Karlsruhe, both in respect of their technique and of their subjects.' (Erich Meyer-Heisig, *Weberei, Nadelwerk, Zeugdruck,* Munich, 1956, p. 51, Pl. 50.)

301 **Cloth with embroidery pattern.** Woollen embroidery on linen. 1831. From the Vierlande, near Hamburg. Height 40 cm, width 40 cm. Schleswig-Holsteinisches Landesmuseum, Schleswig.

The Vierlande developed its own particular form of

embroidery pattern for cloths. Roughly square in shape, they are almost always embroidered with black woollen threads. Apart from letters of the alphabet and small decorations the main motifs are large rosettes and stars, similar to those on cushion covers. The example illustrated here has only one small spot of colour: the flesh-coloured face of the angel in the centre of the right half.

302 **Cushion cover.** Burl weaving on woollen mesh. End of 18th or beginning of 19th century. From north Friesland (mainland), Schleswig. Length 50 cm, width 47.5 cm. Municipal Museum, Flensburg.

The basic fabric is light ochre-yellow with figures in different shades of red, pale yellow, green and white. The legs and the man's hat are dark blue. The frame is red, dark blue and pale green. The subject of the couple, which stand out beautifully on the monochrome base, was probably repeated on a similar piece and would thus make the meaning of the cushion doubly clear. The armchairs of the house-owners' parents have been supplied with identical cushions (cf. caption to Pl. 303). The Schleswig-Holsteinisches Landesmuseum in Schleswig possesses a similar cushion, but it is not really comparable to the one illustrated here. (Cf. Hans Karlinger, *Deutsche Volkskunst,* Berlin, 1938, p. 414.)

303 **Chair cushion cover.** Tapestry woven in wool on a linen base. 17th century. From Schleswig-Holstein. Height *circa* 57 cm, width *circa* 57 cm. Schnütgen-Museum, Cologne.

There is a cushion cover in the Schleswig-Holsteinisches Landesmuseum which is almost identical, thread for thread, with the one depicted here. Cushions of this type were made in matching pairs. They were designed for the armchairs of the house-owners' parents and were often described as 'wedding cushions'. The figure depicted is Tobias, carrying a fish, with the angel (*Tobias,* chapter 6).

304 **Knotted carpet.** Wool. 1768. From Masuria, East Prussia. Length 237 cm, width 147 cm. Germanisches Nationalmuseum, Nuremberg.

On the dark blue background of the central area are gate-towers, rosettes and cyprus trees in white, light green, red and yellow. On the surround, on a red base, are perennials, single blossoms, rosettes, pairs of female figures and elks in white, green, yellow and dark blue. This is one of the most impressive examples of traditional East Prussian knotted carpets, only few specimens of which can still be traced. (Erich Meyer-Heisig, *Weberei, Nadelwerk, Zeugdruck,* Munich, 1956, Pl. 25; Konrad Hahm, *Ostpreussische Bauernteppiche,* Jena, 1937.)

305 **Chair cushion.** Knotted fabric, wool on linen mesh. 1769. From north Friesland. Height *circa* 47 cm, width *circa* 52 cm. Schleswig-Holsteinisches Landesmuseum, Schleswig.

This cushion is one of a pair; the other probably bore the

same pattern, the 'spies' with the large bunch of grapes. In knotted work chair cushions, which usually came in pairs, must be distinguished from wagon cushions, two or three times as wide, and bench cushions, which in some cases could be five or six times as long. Figure motifs are only seen on chair cushions. The basic colour is dark blue, with white (?), red and green (or light blue) hexagons, stars and flowers, and in red the initials FDMMP and the date 1769. The figures on the light blue background of the octagonal area have red coats and blue trousers. The bunch of grapes almost covers the space in between them. All the colours are somewhat faded.

306 **Woven tapestry.** Linen warp and woof with wool, silk and linen threads, detail. 1667. Woven by Anna Bump, Kleve in Dithmarschen, Holstein. Height 56 cm (total length: 350 cm). Museum für Deutsche Volkskunde, Staatliche Museen Preussischer Kulturbesitz, Berlin.

This detail includes the fourth of the five groups of pictures into which the tapestry is divided. This is how Justus Kutschmann describes them: 'In the centre of the fourth picture the Son of Man radiates all His glory, in a blue halo, a long red gown, His arms spread open in compassion. Grouped around this principal figure are a large number of persons and biblical quotations. I shall have to look at this picture many more times and read the relevant texts before I can find order in this seemingly confused jumble. But in this section, too, some words have been so naively transferred into the visual presentation that they should be mentioned. There are echoes of 'the song of Moses and the Lamb'. The lamb with the banner of the cross stands on the word 'Zion'; in front of him is a lute player and behind him someone beating a tambourine. Next to a windmill the Saviour takes a woman's hand, because it says in Matthew 24, verse 41: "Two women shall be grinding at the mill: one is taken and one is left." Below sound the trumpets of Judgement Day. Dry bones rise out of the ground and from the waves a skeleton regains its former body. Opposite, Christ on His throne graciously holds out His hand to a man. Below we see the four horsemen of the apocalypse. Finally an angel with a spear pushes the devil down head over heels. With it are the text of Isaiah 14, verse 12: "How art thou fallen from heaven..." and Luke 10, verse 18: "I beheld Satan fallen as lightening from heaven...". On the lower edge precious cloths and other valuables are spread out for sale: "And the merchants of the earth shall weep and mourn over her, for no man buyeth their merchandise any more" (Revelation 18, verse 11). Next to it we see the upper part of a person with the bluish, weird complexion of a corpse, holding a large goblet in one hand while waving a bottle in the other. With it is the text of Revelation 18, verse 6: "In the cup she mingled, mingle into her double".' (Justus Kutschmann, in: *Lebendiges Gestern. Erwerbungen von 1959 bis 1974,* Museum für Deutsche Volkskunde, Berlin, 1975, p. 157.)

307 **Corner of a shawl.** Batiste with stitched pattern. 19th century. From Hamdorf, Rendsburrg district,

Schleswig. Schleswig-Holsteinisches Landesmuseum, Schleswig.

An example of an early Victorian (German *Biedermeier*) fashion as worn by countrywomen to replace their earlier folk costume. The corner displayed here was presumably meant to hang down the wearer's back. The form of the blossoms is reminiscent of motifs transmitted by woven silk fabrics from distant parts. They create their own vivid effect, with whirls of threads on the delicate fabric.

308 **Cushion insert.** Net needlework. First half of 19th century. Made and used in the Vierlande, near Hamburg. Height 47 cm, width 64 cm. Museum für Kunst und Gewerbe, Hamburg.

Net embroidery of this kind, worked with linen thread on a diagonal net, has survived in considerable quantities, but with rather a limited repertoire of motifs. These inserts were part of the plump feather pillows of a bride's dowry that were so characteristic of the Vierlande. The coloured ticking of the pillow shows through. The piece of linen connected to the insert had a wide strip of black cross-stitching and included (like the embroidered cloths in Pl. 301) ornamental strips, rosettes, a name and a date. A specimen in the Germanisches Nationalmuseum, Nuremberg, very similar to this one, bears the year 1841. This has been described as a 'bachelor pattern'. (Erich Meyer-Heisig, *Weberei, Nadelwerk, Zeugdruck,* Munich, 1956, Pl. 69.) Justus Brinckmann, who could still draw on ancient oral tradition, reported in 1894 that on festive occasions, particularly weddings, such decorated cushions were put on top of the high-piled pillows on the wall beds behind the panel. (J. Brinckmann, *Führer durch das Hamburgische Museum für Kunst und Gewerbe,* Hamburg, 1894, pp. 52 ff.)

309 **Linen cloth.** Silk, embroidered. 19th century. Vierlande, near Hamburg. Width of detail *circa* 40 cm. Owner unknown.

The style of the flower embroidery corresponds to that of embroidery pattern cloths from the same area. The forms, complete in themselves, are placed alongside each other. The colours are mostly dark and strong.

310 **Shawl.** Silk, embroidered. 1867. Acquired from Neuengamme, Vierlande, near Hamburg. Length of side (detail) *circa* 55 cm. Historisches Museum am Hohen Ufer, Hanover.

The shawl is red, with black and white stripes at the sides. The coloured satin-stitch in silk in one corner names the owner: 'Anna Wulf, anno 1867'. Comparison between the playfully arranged garlands of flower motifs on the woven pattern and the contemporary inlaid work of Vierlande joiners are misleading. Yet there is a certain similarity of form and the script, too, reminds us of some of the names inscribed on chests of the period. This specimen—and many others in museum collections—is a good example of the striking unity of style in the folk

art of this area. Justus Brinckmann's work was already making this point as early as the 1880s, and drawing this region to the attention of students of all forms of folk art.

311 **Lace.** Linen thread. 17th or 18th century. Probably made in central Germany. Municipal Museum, Flensburg.

Little is known about the origin of this type of lace. It may illustrate the tendency towards figuration expressed by a great deal of imagination.

312 **Neck-piece.** Cloth, embroidered with silk thread. 19th century. From Neuengamme, Vierlande, near Hamburg. Width *circa* 18 cm. Altonaer Museum, Hamburg.

The black flap is very densely covered with embroidery. It is rounded off at the bottom to correspond to the curved neckline of a dress. Tinsel is sewn into the narrow spaces left. The materials include vitrified glass, metal threads and various braids. The motif of the upper border is not easy to identify; it consists of two birds facing each other, and between them a rosette-like shape which apparently derives from a plant. The lower part repeats the theme, so popular and frequently seen in the Vierlande, of the basket or the vase with flowers—apparently roses and carnations—sprouting from it.

313 **Woman's glove.** White leather with silk and wool embroidery. 18th century. From the island of Föhr, north Friesland, Schleswig. Length 29 cm. Municipal Museum, Flensburg.

Gloves, embroidered in bright colours with flower patterns, were an indispensable part of a woman's clothing on the island of Sylt, and were worn up to the end of the eighteenth century, at least on festive occasions, by brides and older women. The skirt, too, consisted of white leather, or rather of sheepskin, which was worn with the fur inside.

314 **Plate or flat bonnet.** Gold embroidery on dark background, with flowered silk ribbons. 19th century. From the country around Münster. Westfälisches Landesmuseum, Münster, Westphalia.

This specimen is an example of the type worn in the heart of the Münster country and occasionally in the vicinity of Osnabrück. The plate-shaped bases of the bonnets, which in the Münster district stiffened with cardboard, were particularly rich in gold embroidery. The farmers with larger holdings set the pace in this area. The base rose vertically at the back of the head and the front brim was garnished with lace to which the ribbons were fixed; these were then tied together under the chin. The ribbons in this example hung down the wearer's back.

315 **Necklace with large cut and polished beads.**

From Lindhorst, Westphalia. Eight spheres, diameter 4.5 cm; gold clasp, 13.5 cm, with the initials FS and KB. Coloured stones: turquoise, brilliants, opaque glass. Ear-rings: round, with coloured stones, red and green. Gold filigree. Museum für Kunst und Gewerbe, Hamburg.

Necklaces of large, slightly cut and polished amber beads (see Pl. 321), very popular in North German regions, were characteristically transformed into metal in Westphalia. The cut and polished brass foil spheres improve on the effect of the amber by shining and glittering brightly.

316 **Bonnet.** Velvet, embroidered with gold thread. 19th century. Worn in Pattensen, Lower Saxony. Acquired in Arnum, near Hanover. Width 16 cm. Historisches Museum am Hohen Ufer, Hanover.

The green velvet of the top of the bonnet is embroidered with exceptionally fine gold thread. Five pieces of red vitrified glass are set into the flowers. The rim of the bonnet is formed by a woven gold band, 5 cm wide. This in turn is bordered by a small gold band which is tied at the back in four bows. The ends, with fringes, hang down in the middle. A comparison with Plate 314 shows how closely the embroideries on the crowns of bonnets from different regions resemble each other. Glittering decoration of this type calls for massed ornaments, and the rounded-off form of the embroidered surface makes for a centralized arrangement of the motifs.

317 **Bridal crown.** Fabric, with additions of glass and metal. 19th century. From Mecklenburg. Museum für Deutsche Volkskunde, Staatliche Museen Preussischer Kulturbesitz, Berlin.

This bride's headgear, shaped like a sugar-loaf or beehive, is a development of the original crown, which was much smaller. The initial form, from which this Mecklenburgian one evolved, was quite possibly bow-shaped, like the head-covering of the Virgin in late medieval paintings. The bow-shaped crowns of secular rulers had an additional piece rather like a cross at the top, where the bows come together. One can imagine how such a form of headgear developed by heaping tinsel on to the kind of head-piece illustrated here. (Otto Bramm, 'Deutsche Brautkränze und Brautkronen', in: *Jahrbuch für historische Volkskunde,* vol. III-IV, Berlin, 1934, pp. 163–85, esp. p. 176, Pls. 31, 37.)

318 **So-called golden cap.** Tulle and various other fabrics, as well as cardboard. 19th century. From the area around Osnabrück, Lower Saxony. Westfälisches Landesmuseum für Kunst und Kulturgeschichte, Münster, Westphalia.

The so-called Osnabrück gold cap falls into the category of three-piece caps *(Drigpandsmütze)*. 'These caps, with their three parts, are made from fabric stitched over cut-out cardboard or ruled school exercise-paper (sometimes with pious sayings), and sewn together. They are

decorated with gold and silver paper lace, so-called buckle patterns, sun motifs, roses, hearts in coloured velvet, gold tinsel and shining coloured stones, and trimmed with a wide, starched tulle cone. These bonnets occur in both gold and silver. In the case of the Osnabrück gold one, the head portion is strictly marked off by a plaited gold ribbon wound around the crown several times. It includes rhythmically arranged double-contoured hearts as well as half-circles, bow patterns in rectangles and undulating bands.' (Walter Borchers, *Volkskunst in Westfalen*, Münster, 1970, p. 149.)

319 **Bonnet with hair-pins.** Silver filigree. Middle of 19th century. From Munich or its immediate neighbourhood. Schatzkammer, Altötting, Upper Bavaria.

Headgear of this type was worn by middle-class women, servant girls, and also by farmers' wives in the Munich district.

320, 322 **Neck collar** ('neck harness'). Silver, partly gilded and brass. 19th century. From Minden-Ravensberg, Westphalia. Diameter at top 13 cm. Westfälisches Landesmuseum, Münster, Westphalia.

The 'harness' consists of eight plates and a clasp. The plates bear filigree patterns and ornamental forms beaten over a mould. 'These Westphalian neck collars or harnesses, whose forms vary widely, all come from eastern Westphalia and Lower Saxony: from the vicinity of Ravensberg, Minden and Lübeck, the districts around Paderborn and Osnabrück, and particularly the Grönegau... Similar neck collars with alternating chain links and shields of different kinds are also found in Lower Saxony, Friesland and Holland.' (Walter Borchers, *Volkskunst in Westfalen*, Münster, 1970, p. 163.)

321 **Necklace.** Amber and silver. *Circa* 1880. From Lindhorst, Schaumburg. Length of clasp 8.5 cm, diameter *circa* 34 cm. Westfälisches Landesmuseum für Kunst- und Kulturgeschichte, Münster, Westphalia.

In various parts of North Germany, especially in Bückeburg and Minden-Ravensberg, chains of thick, clumsy amber beads with roughly cut facets were greatly esteemed. In the specimens from Westphalia an intermediate piece consisting of a small plaque embroidered with glass beads is always inserted between the beads and the clasp. The brass clasp features a pair of birds, cut from sheet silver. The initials of the wearer often appear. (Cf. Erich Meyer-Heisig, *Deutsche Volkskunst*, Munich, 1954, Pl. 62; Paul Pieper, *Volkskunst in Westfalen*, Münster, n.d.)

323 **Shirt buckle** ('Hattje'). Silver. 1732. From Heligoland. Height 43 cm. Schleswig-Holsteinisches Landesmuseum, Schleswig.

The Heligoland *hattjes* (meaning hearts) have long been favourite collectors' items and for that reason are often forged or marked with spurious earlier dates. The earliest genuine pieces were made about 1660. It is not known where they originated, but they may first have been made in the Netherlands. The forms, especially the flourishes around the heart, remained unchanged for a long period, as did the pendants. The only changes are in their selection and sequence: boats, angels, fishes and pilot badges may be used. The latter are copies of larger, originally oval medallions made of polished brass, of which every pilot in Heligoland had his own personal specimen. They were used to decide by lot who should pilot a passing ship. One side of the medallion shows a pilot, the other the monogram of the reigning Danish king. This helps to date the badge where no year is indicated. 'On the upper part the *hattjes* always pictured the profiles of a couple facing each other, which surely indicated bride and groom. (The *hattjes* from east Friesland and Jeverland in the museum at Oldenburg bear only one head.) The double figures may have been inspired by related pictures on coins, like Albertus and Isabella on the seventeenth-century guilders of Brabant'—which were frequently given as a marriage fee. (Hubert Stierling, *Der Silberschmuck der Nordseeküste*, Neumünster, 1935, pp. 210–12.) On the specimen illustrated here the monogram of King Christian VI appears on the pilot badge on the left. Christian VI ruled from 1699 to 1746, which accords with the year given, 1732.

324 **Brooch with pendant.** Gold. Latter half of 19th century. Perhaps from Holland. Owner unknown.

This piece of jewellery worn in the Lower Rhine valley is known there as a *Schuwe*. It corresponds to the 'little gratings' widely worn in many parts of North Germany. The main rosette is made of coloured enamel. Being of gold it is rather smaller than the silver examples found, for instance, in Westphalia. These brooches, the property of peasant farmers, show how wealthy peasants could break through the barriers of official regulations forbidding luxury clothing. However, this is only meaningful if such pieces of gold jewellery were owned by earlier generations as well. German farmers of adjoining coastal areas acquired gold ornaments during the eighteenth century and before, often from Holland.

325 **Pendant.** Gold leaf with silver filigree. 19th century. From the Emsland, Westphalia. Museum für Kunst und Kulturgeschichte der Stadt Dortmund, Cappen Castle, near Lünen, Westphalia.

'The centre-piece of this pendant is a horizontal, perforated half-moon-shaped sickle, the upper edge decorated with four coils and set with spheres, rosettes, and shells at the intersections. The lower part is gently curved and fitted with loops for double and simple chains of different lengths. These meet at a central point where there are two hanging crossed leaf patterns, partly worked in filigree, with added decorations, forming a cross. Smaller hearts, acorns, stars, and shells also hang from the sickle. As far as the sickle itself is concerned, its surface is broken by foliage, cut out and placed in juxtaposition to coiled filigree spirals. Added ornaments in the shape of shells and ovals enrich the surface of the sickle.' (Walter Borchers, *Volkskunst in Westfalen*, Münster, 1970, p. 164, Pls. 410–13.)

326 **Wool-holder.** Silver filigree. From Lower Saxony. Length of holder *circa* 15 cm. Historisches Museum am Hohen Ufer, Hanover.

The holder was hooked into the belt of the woman so that she could knit from the hank of wool stuck through the loop whatever she was doing, even walking along, without the wool trailing behind her and unrolling. The implement was of middle-class origin but found its way into peasant homes. On the island of Sylt the women and girls knitted incessantly, almost ostentatiously, whenever there was nothing else to do, even when they were on their way to work in the fields.

327 **Necklace.** Silver filigree beads. 18th or 19th century. From the Altes Land, near Hamburg. Altonaer Museum, Hamburg.

Necklaces worn by women on nineteenth-century farms of the Altes Land near Hamburg occur in various forms. 'Sometimes there are from three to seven rows of smooth, pea-sized hollow silver beads, sometimes massive beads the size of millet seeds made by bending thin wire, then again daintily perforated wire-work beads as big as a small cherry.' (Justus Brinckmann, *Führer durch das Hamburgische Museum für Kunst und Gewerbe*, Hamburg, 1894, p. 212.) This specimen consists of beads the size of peas.

328 **Shirt clasp.** Brass sheeting and silver. 19th century. From the Vierlande, near Hamburg. Altonaer Museum, Hamburg.

Vierlande shirt clasps are characteristically decorated with small glazed metal frames. In this example the frames contain tiny baskets of flowers painted in watercolour. The added filigree work is partly gilded.

329 **Pectoral.** Silver, partly gilded. First half of 19th century. Worn in the Vierlande, near Hamburg. Height 8 cm, length 13.5 cm. Historisches Museum am Hohen Ufer, Hanover.

'This type of pectoral was known in the Vierlande as a *strängekeed*. Two segment-shaped decorated pieces enclose varying numbers of simple chain-links, each about 6 to 7 cm long. A more ambitious form of chain is known as the *schillerkeed* (picture chain)... The two outer segments of this 'picture chain' enclose a central plate held in place by the links. These outer ornamented segments consist of gilded cast silverwork which was afterwards engraved. The dove and crown motif appears in perforated work in two versions: with vase and foliage and with heart and ribbons... The main part of the central plate of the 'picture chain' is made up of groups of filigree spirals. These enclose three medallions framing paintings of bunches of flowers in water-colours... Pectoral chains always have a loop at one end and a hook at the other. They can thus be sewn to the bodice by means

of the loop, or just hooked in loosely.' (Ulrich Fliess, in: *Abteilungskataloge des Historischen Museums am Hohen Ufer, Hannover*, II. *Volkskundliche Abteilung*, Hanover, 1972, pp. 173 ff.)

330 **Womans's girdle.** Leather with quill embroidery. 1807. From Chiem district (?). Length 107 cm, width 15 cm. Bayerisches Nationalmuseum, Munich.

Within the heart in the centre of the girdle is Christ's monogram with a heart and three nails of the Cross (or perhaps a triple sprig).
(Lenz Kriss-Rettenbeck, *Bilder und Zeichen religiösen Volksglaubens*, Munich, 1963, Pl. 42.)

331 **Man's belt.** Leather, mounted with tin studs. 1798. Used at Höglwörth, Upper Bavaria. Length 101 cm, width 14 cm.

The motifs are ibexes, lions and a flower vase with five blossoms. On top is the inscription: 'Jesus—Maria—Joseph'. Below is the symbol 'INRI', the inscription on the Cross.
(Lenz Kriss-Rettenbeck, *Bilder und Zeichen religiösen Volksglaubens*, Munich, 1963, Pl. 44.)

332 **Man's belt.** Leather, mounted with tin studs. Third quarter of the 18th century. Made in north Tyrol, used in Upper Bavaria. Length 100 cm, width 17.5 cm. Bayerisches Nationalmuseum, Munich.

The motifs are two pairs of lions, each supporting a crown between them with the words: 'Help us, Mary.' In the centre are large flowers. (Lenz Kriss-Rettenbeck, *Bilder und Zeichen religiösen Volksglaubens*, Munich, 1963, Pl. 43.) Arthur Haberlandt, 'Gürtel als Heiltum', in: *Volkskunde-Arbeit. Festschrift für Otto Lauffer zum 60. Geburtstag*, Berlin, 1934, pp. 83–96, writes: 'Ornamental money bags, pouches or satchels, with metal mountings or quill embroidery, are very important in the lives of the people, by giving added strength and enabling the body to withstand rupture or strains. Their ornamentation shows that they were commonly worn by hunters, butchers, coachmen and peasant cattle-dealers. They are also part of the equipment of ploughmen and marksmen. All these activities are depicted in the metal mountings or brass as well as in the quill-stitch embroidery. At the beginning of the eighteenth century the prevailing style was a rigid arrangement of mounted studs. Thus we see hunting scenes with stags and deer and even ibexes in the Tyrol, in addition to heraldic eagles, heraldic animals or flower garlands. Only much later, around 1800, does quill embroidery emphasize jumping stags, chamois on the look-out, leaping, or sometimes resting. They are shown heraldically opposed or singly. The Pascal lamb and the monogram of Christ occur along with symbolic pictures of the crafts or the peasantry.'

333 **Woman in festive costume.** *Circa* 1846. From the Probstei, Holstein. Altonaer Museum, Hamburg.

This illustration shows the section of the bodice called the 'rump'. The dark, single-coloured upper part is enlarged to the width of the inset piece, the rump proper. It is made of a light silk and decorated with satin-stitch embroidery and beads. The series of eight buttons no longer has a practical use and has just become part of the decoration. (Anna Hoffmann, *Die Probsteier Volkstracht*, Heide, Holstein, [1939], pp. 16, 71.)

334 **Woman's costume.** Middle of 19th century. From the Bückeburg area.

The so-called 'Österken costume' as worn by women around Bückeburg ties in with the 'Westerken costume' as part of the folk costume of a single county, namely Schauenburg. This territory includes most parishes of the former county of Schauenburg which was split up after the Thirty Years' War. The sovereign county Schaumburg-Lippe, later the principality of Schaumburg-Lippe, was of particular importance in the matter of folk costumes. The fact that until 1945 it enjoyed continuous independence as a county and that the princes took a lively interest in peasant customs and ways was certainly important. These factors helped to preserve and later to maintain its traditions, and were partly responsible for the survival of the Schaumburg folk dress till long after 1900' (Ulrich Fliess, *Abteilungskataloge des Historischen Museums am Hohen Ufer, Hannover, Volkskundliche Abteilung*, II, 1972, p. 158). Two pieces of jewellery can be seen in this detail; they are characteristic of this unique costume with its wing—or bow—bonnet. One is the clasp of the necklace on top of the wide-pleated neck collar, a rectangular silver plate between two smaller plates with pearl embroidery (cf. Pl. 321), the other the large octagonal brooch in front. The latter has, in this picture, reached its maximum development. On the round shield a pair of doves are depicted and another is placed below the circular opening in the centre; the monogram and the date are added. While the black and white reproduction appears to be overcrowded with decoration, the effect of the real article is much better, thanks to the contrasting impressions of colour and material. As the wearer moved about, the metal ornaments must have formed the centre of a well-proportioned total impression, with vivid outlines. Another aspect of the cotume, which cannot be illustrated, must be taken into consideration: the traditional workaday clothing was also heavy and forced the wearer to proceed in measured movements, even when simply walking. The effect could only be imitated by cultivating it deliberately for a special performance. (On Schaumburg costumes: Wolf Lücking *Trachtenleben in Deutschland*, vol. I. *Schaumburg-Lippe*, Berlin 1958. Also a review of costumes in Lower Saxony, loc. cit., pp. 144 ff.)

335 **Woman's costume.** On one side large filigree buttons made of silver. *Circa* 1800. From the island of Røm, north Schleswig. Height of detail *circa* 80 cm. Altonaer Museum, Hamburg.

The bodice consists of bright red cloth and the garment underneath is dark blue with white stripes.

336 **Hair-pin with large ornamental filigree head of silver.** First half of 19th century. From Schleswig-Holstein. Museum für Deutsche Volkskunde, Staatliche Museen Preussischer Kulturbesitz, Berlin.

337 **Bodice and belt of a woman's costume.** Middle of 19th century. From Neustadt in the Upper Black Forest. Length 85 cm. Badisches Landesmuseum, Karlsruhe.

The length refers to the band of black velvet with simple shiny buttons which serves as a belt. The practice of sewing little metal plates on to a belt was medieval in origin. However, in this case we are not necessarily dealing with a medieval tradition which persisted continuously right through into the nineteenth century. Wedge-shaped sections of embroidery appear not only in front of the body where the shaping of the bodice seems to call for it, but also at the back. Eighteenth-century fashion required a bodice which tapered toward the line of the belt (cf. Pl. 159). It is therefore a graphic expression of the function of clothing.

338 **Woman's jewellery and folk costume.** Silver. Middle of 19th century. From the island of Föhr, north Friesland. Length of chain 32.5 cm. Altonaer Museum, Hamburg.

In the early nineteenth century the chain which women on the island of Föhr wore across the chest consisted of a single row of links. About 1830 two rows appeared with a centre-piece inserted. Then followed a third row, but among wealthier people this seems to have been worn even earlier. In the latter half of the nineteenth century a fourth chain was added and the hook-like end-pieces in filigree, as well as the centre-piece, achieved greater importance. The usual motifs for the centre-piece were the symbols of faith, love and hope with a crown. These centres could be worn as pendants, as in this case. Chains covering the whole chest, too, were popular. The border of the jacket is decorated on both sides with rows of large spherical filigree buttons joined together in an arc. (Cf. Hubert Stierling, *Der Silberschmuck der Nordseeküste*, Neumünster, 1935, pp. 93 ff.; Anna Hoffmann, *Die Landestrachten von Nordfriesland*, Heide, 1940, pp. 88 ff.)

339 **Festive folk costume.** From the Ochsenfurt district. Gold chains with garnet pendants. Gold brooch with garnets. Ochsenfurt, Franconia, Bavaria. Private collection.

This is one of the most elaborate German national costumes and is still worn today. The colourful effect of the harmony of beads and tinsel (on the upper part and sleeves) with the bead-embroidered gloves, magnificent pectoral and dress material is particularly attractive. The closely pleated skirt is also unique.

340 **Dress with laced bodice.** Stays and fasteners on the bodice in silver. 19th century. Bayerisches Nationalmuseum, Munich.

An early description of folk costume says: 'The bodice, which covers the jacket like a cuirass, is made of shiny black Orleans (a cotton and worsted fabric) and is stiffened with whalebone stays. It is hooked on one side and fastened on the shoulders with small clasps which are, however, always covered with a kerchief. On either side of the front are six silver loops with hooks through which the rich ornament of silver chains is laced. They also carry various pendants in the form of round or rectangular medallions, made of teeth or birds' claws, amulets and suchlike set in silver. Equally valuable is the silver chain necklace with the gold clasp embossed with coloured stones.' (Albert Kretschmer, *Deutsche Volkstrachten*, Leipzig, 18887–90, reprinted under the title *Das grosse Buch der Volkstrachten*, Eltville am Rhein, 1977, p. 116.) The description applies to the Miesbach district.

341 **Dachau costume with fastener.** Lacing and lacing-fastener. Silver. 19th century. Bayerisches Nationalmuseum, Munich.

In this case the chain which closes the opening of the bodice is sewn directly on to the seams, without rows of hooks. It terminates in a fastener *(Stecker),* a kind of expensive pin which allows a small piece of chain to hang down loosely. Tucked behind the lacing, the pin becomes a piece of jewellery in its own right. Some distance from the seam are two rows of buttons aligned on both sides of the bodice, which look like coins and serve only as ornaments. The neck-band with the clasp has also turned into a separate article of decoration.

342 **Bodice- or lacing-fastener.** Unusually rich silver setting: cylindrical band, foil crowned with volutes. Silver, gilded silver, cast-work, glass beads. First half of 19th century. Southern Bavaria.

Necklace, a so-called *Kropfkette* (goiter chain). The necklace has an extraordinarily elaborate square clasp with large quatrefoil decoration in pattern filigree. It is made of gilded silver, gold filigree and coloured glass beads. Upper or Lower Bavaria, in the style of Schwäbisch-Gmünd. About the middle of the nineteenth century it was in a private collection.

343–344 **Head as ship's decoration.** Oak, painted. 18th–19th century. Recovered from a wreck on the island of Sylt, north Friesland, Schleswig. Height 27 cm and *circa* 30 cm respectively. Heimatmuseum, Keitum, Sylt.

Smaller sailing vessels often had a carved head, generally of a martial aspect, on top of the rudder. It may be regarded as the counterpart of the figure-head on a galleon.

345 **Figure-head.** Oak, painted. End of 19th century. Length 158 cm. Altonaer Museum, Hamburg.

'A native girl (Hawaiian) with long dark hair, looking straight ahead. She has a flower in her hair and wears a garland of flowers around her neck. The upper part of her body is nude. A grass skirt swings from her hips, her arms are stretched out full-length along her body. The hands rest with the palms turned inward on the volutes from which the body seems to emerge.' (Altonaer Museum, Hamburg, *Jahrbuch* for 1966, p. 225) As is the case with most ship's figure-heads, it is not possible to ascertain the origin of this piece.

346 **Mask or face** ('Schemme') **of the 'Hüfingen Hansel'.** Wood, painted. After 1945. Hüfingen, near Donaueschingen, Württemberg. Württembergisches Landesmuseum, Stuttgart.

The outfit of 'Hüfingen Hansel' belongs to the category of 'white clothes', like several other carnival costumes typical of parts of Württemberg, such as the Rottweil *Biss* and the Villingen *Stachi.* The smock and trousers were made of white material and were painted with rose tendrils. Like the Villingen Hansel masks, those of the Hüfingen Hansel are evenly smoothed out and display friendly rather than frightening expressions. The decoration of the hair with artificial flowers corresponds to the painting of the costume. (Cf. Herbert and Elke Schwedt, 'Malerei auf Narrenkleidern. Die Häs- und Hanselmaler in Südwestdeutschland', in: *Forschungen und Berichte zur Volkskunde in Baden-Württemberg,* vol. 2, Stuttgart, 1975.)

347–349 **Figurines** (male and female) wearing Upper Bavarian costume. Wood, painted. Made in Berchtesgaden. Bayerisches Nationalmuseum, Munich.

These figurines from Berchtesgaden follow the style of the porcelain figures which had their heyday in the eighteenth century. The tradition developed logically: it started early in the eighteenth century (in some places even earlier), when the ruler erected in parks stone statues of his subjects in national garb. In the eighteenth century these were transformed into groups and scenes on a smaller scale, achieving an effect of winsome charm and sentiment. During the nineteenth century popular derivations of this movement, allied to the historical sense which throve on the Romantic view of poverty, finally led to a glorification of folk life in all its manifestations.

350 **'Kleienkotzer'** (grotesque mill mask). Wood, painted. 19th century. Central Germany. Height *circa* 30 cm. Germanisches Nationalmuseum, Nuremberg.

The curious name (which literally means 'bran spitter') of these masks is derived from the fact that the wide open mouth ejects the bran when the milling mechanism is operating. It is an example of the type of grotesque mask where the features form a functional part of the implement concerned. The fixed stare, directness and very concreteness make a vivid impression. When the mill is operating the spurts of bran produce an extraordinary resemblance to a living organism. The bran-spitting mask is a perfect example of what we have called 'figur-

ation'. Its origin can be traced back to various kinds of grotesque fountains and gargoyles. The bran does not fall out of the mask evenly, and is thus somewhat reminiscent of humans vomiting, which is precisely what the name implies.

351 **Flax dolls.** Raw flax. 19th century. From the Brunswick region. Height *circa* 84 cm. Germanisches Nationalmuseum, Nuremberg.

The flax went through several operations during the combing process, to free it of all wooden particles and short fibres. It was then straightened up evenly and made ready for spinning. At this stage it was often formed into objects looking like plaits. In this shape it could be stored without becoming entangled. Interest in the human form extended even to making 'dolls' out of skeins of raw flax. They were known in Brunswick as *Rockendissen.* The womenfolk liked them as a decoration for their stores of flax.

352 **'Roland' figure.** Pine and lime. End of the 18th century. From Stördorf, Wilstermarsh, Holstein. Height 117 cm. Altonaer Museum, Hamburg.

In the 'Roland-riding game' 'it was left to village craftsmen to decide on the exact shape of such male figures, which had to be constructed to spin round on their axis. However, it was the prescribed rule that the horizontally extended left arm held in its hand a bag full of ashes or flour. The right arm, bent or extended, held a shield. Most 'Rolands' have a pipe in their mouth. The player gallops along on horseback and tries to break up the shield with a lance or to push it down. The impact whirls the figure around and the rider has to get away quickly or else the bag will strike him on the back and leave a mark which shows that he has failed to escape. This game on horseback is still played in Holstein at summer festivals. In Windbergen (Dithmarschen), for instance, it is a feature of Whitsuntide. Originally it was part of the carnival season, but it is not connected with the old ritual battle against receding winter, when a symbolic straw figure was burnt or destroyed. The game of 'Roland-riding' is more likely to be a descendant of riding at the quintain in the tournaments of the medieval knights once held at all courts in western Europe. When these finally came to an end, the sport was adopted by the commoners in the town and later in the country. In Schleswig-Holstein it has been preserved to this day.' (Hildamarie Schwindrazheim, *Altes Spielzeug aus Schleswig-Holstein,* Heide, 1957, p. 18).

353 **Carnival costume.** Various materials. 19th century. From the Altmühl valley, central Franconia. Germanisches Nationalmuseum, Nuremberg.

A folk costume, or for that matter any other garment, should be seen as an interpretation and stylized representation of the human body. The carnival costume is a mask that covers the whole body and is therefore a distortion, misrepresentation or even a transformation of it, sometimes into a demonic, animal-like creature. This

very simple example can give only a slight and incomplete indication of the basic principle, devoid as it is of colour, of the movements which can sometimes break into wild dancing and of all the scenic paraphernalia accompanying the procession. Nor is there any possibility of comparing it with everyday costume in the same area or with the clothes worn on other festive occasions, which may have been extremely stylized. Small rhomb-shaped designs with rough trimmings are also typical of the carnival costumes of other areas. Our illustrations offer only a glimpse of a wide field of popular creativity and inverted representation which is, in a sense, akin to the idea of 'figuration'.

354 **Mask of disgrace.** Sheet iron, painted. 18th century. Baden. Height 55 cm, length 57 cm. Badisches Landesmuseum, Karlsruhe.

An iron mask used to be put on the perpetrator of some minor offence. As a punishment he had to show himself wearing it in public. Such masks are seldom earlier than the seventeenth century. 'There is no implement of punishment which occurs in so many and such grotesque forms as the hood of disgrace. Large ears and noses, long tongues hanging out or pointed beaks, devils' horns, pigs' snouts and similar exaggerations are supposed to mirror the miscreant or his crime, which was sometimes also written on a little tablet. The masks with pigs' snouts seem to indicate obscene talk and those with long tongues slander.' (Wilhelm Funk, *Alte deutsche Rechtsmale*, Bremen and Berlin, 1940, p. 130.) The bow on top of the mask in our picture probably carried a bell to call the public's attention to the criminal.

355 **Carnival mask for 'little Hans'.** Lime, with painted and artificial flowers. Beginning of 19th century. Villingen, Baden. Height 26 cm. Badisches Landesmuseum, Karlsruhe.

This mask is known locally as a *Scheme*. Such masks were (and still are) worn by the Villingen *Hansel*. Apart from Überlingen and Elzach, Villingen in Baden is the best known place where this type of clowning is carried on. 'The mask is smooth and, unlike the frightening one from Elzach and the grotesque one from Kleinlaufenburg, wears a pleasant, sweetly smiling expression.' (H. E. Busse, *Deutsche Volkskunst*, vol. *Baden*, Weimar, n. d., p. 48.) The maker of the Villingen masks is called a *Schememoler*. He also paints the associated suits with lions, bears and flowers. (Cf. Pl. 346.)

356 **Handle of a mangle-board.** Beech. 1798. From north Friesland (?), Schleswig. Measurements of the board: height (with handle) 13.3 cm, length 63.5 cm, width 14.7 cm. Schleswig-Holsteinisches Landesmuseum, Schleswig.

The double-headed horse occurs all over the territory where one finds the horse-shaped grip on the handle of the mangle-board. It has given rise to a number of different interpretations, but this is not the place to discuss them.

357 **Pipe.** Wood, carved. 19th century. Acquired in the region of Bückeburg. Length 60 cm. Museum für Kunst und Kulturgeschichte der Stadt Dortmund, Cappenberg Castle, near Lünen, Westphalia.

This pipe consists of three parts. Carving such pipes was a popular hobby among amateurs during the nineteenth century. A very popular kind of pipe was the long one smoked by army reservists, but hunting and forestry themes were also favoured. This example belongs to the latter category. Various small touches betrayed the carver's individuality, but the farcical combination of motifs still suggests a rather limited conventional imagination. Occasionally individual achievements can be recognized which are most charming in their untutored naivety. (Cf. for instance Ulrich Bauche, 'Die Schnitzwerke des Wilhelm Uebbemann, Hofbesitzer und Gemeindevorsteher zu Asseln (Dortmund)', in: *Rheinisch-Westfälische Zeitschrift für Volkskunde*, 8, 1961, pp. 163–8.)

358–359 **Head-pieces depicting a sitting figure and Samson fighting the lion.** Oak with traces of painting. End of 15th century. From the former organ-loft in the Nicholas church in Kiel, Holstein. Length 61.5 cm. Schleswig-Holsteinisches Landesmuseum, Schleswig.

The tradition of carving the supports of timber-frame buildings in human shape was inherited from the late Middle Ages. These wooden supports are placed diagonally and are sometimes no more than logs to prop up overhanging parts. This piece does not come from the exterior of a secular building, where very original figures often occur, but from the interior of a church. A whole group of slightly grotesque shapes was assembled here. They are related to traditional medieval gargoyles. The one sitting on a heap of stones has patiently and with good grace put his back under a heavy load. The other figure clearly indicates the ideas that governed the transformation of a wooden pillar into a human image. Men renowned for their extraordinary strength were selected from the Bible or from legends, because parts of the gallery protruded far out and they had to bear a heavy burden; St. George the dragon-killer and Samson who fought the lion were favourites. Samson is here depicted as a rather grotesque figure, which however gains in expressiveness from its somewhat naive conception.

360 **Tombstone.** Granite boulder. 1640. On a grave in the cemetery at Keitum, Sylt, north Friesland, Schleswig. Height 54 cm, width 31 cm.

During the first half of the seventeenth century the standard of living of the population on Sylt was still rather low. Stones straight from the fields were used as tombstones. Apart from the year of death, only the initials of the deceased's name were roughly chiseled into them. In the case of this stone the initials are BPQ. (Quedens is a fairly common name on the islands.) A little later better-off families went over to using sandstone stelae. The poorer people still used rough stones from the fields like this one well into the nineteenth century.

361 **Grave stela of the family of Johann Haltermann,** (1709–83) from Seebergen. Sandstone. 1795. In the cemetery at Tripe-Lilienthal, Lower Saxony.

Terminating a design with a double arch also occurs on 18th-century cupboards and is of much older origin; the motif has been used in a witty form in this case. As early as 1700 stelae were being erected on the Lower Weser on which the double arch was formed by the heads of angels. This one depicts the heads of the carpenter, stonemason and blacksmith Johann Haltermann and his wife Ibecke Gefeken, who was one year his senior. In true hierarchical fashion the couple's children, six sons and four daughters, are lined up. To emphasize regularity and order they all appear to be of equal height, although smaller than their parents. Above the whole family is a crown of life modelled in the round. A few decades ago the paint which originally covered the whole stone could still be detected on the side shown here, the eastern one. 'The faces of both parents were yellowish with a flesh-coloured reddening, the lips red, and the hair brown. The suits of the six boys were indigo blue, the bodices of the girls a magnificent red, and the skirts were painted in a blue-green colour. On the western side the weather had already worn away all traces of colour.' (Diedrich Steilen, *Norddeutsche Grabmalkunst*, Bremen, 1938, p. 39. Both sides of the stela are illustrated in Hans Karlinger, *Deutsche Volkskunst*, Berlin, 1938, pp. 248 f.)

362 **Two anthropomorphic urns.** Earthenware. 19th century. Lower Bavaria. Height *circa* 8–11 cm. Bayerisches Nationalmuseum, Munich.

'The custom of making votive gifts, like that of sacred images, was connected with that of going on pilgrimages. In many cases objects from the donor's environment, as well as organs and parts of the body for which the protection and help of the saints was solicited, were reproduced and deposited on the altars. Besides these universally practised votive gifts, which openly depict the reason for the dedication, there are others which express the petition by a kind of symbolism. Clay vessels shaped like faces belong in the latter category. Filled with grain, they are sacrificial gifts designed to assure a happy married life, fertility, or freedom from headaches.' (Bernward Deneke, in: Germanisches Nationalmuseum, Nuremberg, *Führer durch die Sammlungen*, Munich, 1977, p. 264.)

363 **Grave stela.** Sandstone. 1792. In the cemetery of St. Johannis church, Nieblum, Föhr, north Friesland, Schleswig. Height above ground: 126 cm, width 61 cm.

This stone has a pictorial motif and an inscription on both sides. The side illustrated mentions Simon Türkis Groot from Midlum, who died in 1792. He was the captain of a whaler, and his dismantled ship is shown in relief. This not only denotes his calling but also indicates the end of life, i. e. mooring in the port of the hereafter. This interpretation is supported by the texts of other examples of this not uncommon symbol. The other side refers to one Sissel Siemens, who died in 1782. At the head of the stela Christ is depicted guiding a female

figure with his hands to receive a crown. It has not as yet been possible to assign this monument to any of the known stonemasons of Föhr.

364 **Memorial plaque in the church of Hallig Gröde,** north Friesland. Height 143 cm.

According to one authority this plaque 'was donated in 1700. A charming product of folk art. Wood, carved and painted. 143 by 69.5 cm. The main part of the plaque is framed with wavy tendrils and flowers. In the upper half is an inscription, in the lower pomegranates and other fruit, tulips and the Lamb of God (with restored head). Flanked by twisted columns. Head-piece and base perforated, with cartouche, tendrils, flowers etc. Inscription in three parts: "In honour of Santa Margreta this church has been erected here in 1636 in order to replace the Lamb of God which was lost, together with the church, in the icy flood in 1625; also to the glory of God and as a memorial to posterity by Councillor *(Raht)* M. Olde Jensen and Hans Ipsen Froke Oldens Amme Hans 1700." ' (*Die Kunstdenkmäler des Kreises Husum,* Berlin, 1939, p. 80.) The church also contains an epitaph, a divided plaque in the same style of 1704, in memory of Paye Knutzen and Hans Ipsen (illustrated in Pl. 221). It does not seem far-fetched to assume that Hans Ipsen was also the donor of this plaque, which was put up in memory of the former church destroyed by the flood.

365 **Cross on grave.** Wrought iron, formerly painted. *Circa* 1730. From Bavaria. Height 164 cm, width 98 cm. Bayerisches Nationalmuseum, Munich.

This cross cannot be located exactly. It must represent a whole category of popular iron monuments, which were particularly favoured during the eighteenth century in churchyards all over Germany. The art of the blacksmith had been developed by working on the great Baroque church and park railings, banisters and balustrades; it was then also deployed in such artistically wrought iron rods with leaf-shaped ends radiating outward from the centre of the cross in all directions. The sun, as a symbol of victory in the Christian sense, often crowns monuments of this kind. (Lenz Kriss-Rettenbeck, *Bilder und Zeichen,* Munich, 1965, Pl. 170.) The closed doors can be opened. They conceal a picture of Christ or of the Madonna. The one below may also have held a portrait of the deceased.

366 **Cross on grave.** Wrought iron. 1840. From Astedt, Brunswick. Height 180.5 cm, width 108.5 cm. Braunschweigisches Landesmuseum für Geschichte und Volkstum, Brunswick.

This is an impressive version of the theme of the Cross; other side-pieces are added to the cross-beam with the inscription. They are variants of the branch or twig motif, and also crown the actual cross with a double variation of the Cross theme. A comparison with the object in Plate 365 shows how a modest individual form can achieve great expressive power, how a simple turning movement can become a gesture. The inscription reads: 'Separation is our lot/reunion our hope.—Iohann Hein-

rich August, born 6. Sept. 1786/died 15. ... 184. ..., aged 56 years, 8 months, 9 days.'

367 **Epitaph of Clawes Syverdt in the church of Landkirchen,** island of Fehmarn, east Holstein. Wood, carved and painted. 1640, renovated 1740.

The painting shows the donor's family under a crucifix held by the Holy Father. The inscription beneath reads: 'Clawes Syverdt himself has made this tablet/to the glory and the protector./He is only a weak man/who cannot walk without support/1640.' The plaque is remarkable as an early example of layman's work. Judging by his own and his family's clothes, the maker and donor was well-off. He obviously belonged to the great farmers who became affluent by supplying grain to the Hanseatic city of Lübeck. The amateurish fretwork and painting, reminiscent of models dating from about 1600, place this panel in the category of folk art. The mouldings and decorative ledges are sculptured, everything else painted. Such memorials are rare.

368 **Display plate.** Pottery with relief, slip painting and lead glaze. Early 18th century (?). From the island of Fehmarn. Height 9 cm, diameter 42.5 cm. Heimatmuseum, Burg on Fehmarn.

The theme of this decoration is rarely found in folk art: in the centre, according to the inscription on the base, is Judith, with Adam and Eve to the left and right. Below the group are two small angels with the kerchief of St. Veronica and angels' heads all around. The theme of Judith showing the people the head of Holofernes (Book of Judith, chapter 13, verse 14–21) influenced Baroque painting (cf. A. Pigler, *Barockthemen,* I, Budapest, 1956, pp. 197 ff.). On this display plate Adam and Eve stand for the 'people', i. e. for humanity. As a parallel to the head of St. John the angels display the kerchief of St. Veronica bearing the features of Christ.
These and the other motifs combined on one side, all four with representations of Adam and Eve, seem to be a more or less random selection. They are meant to suggest one of the many themes which repay reflecting upon in some detail. Lutz Röhrich's monograph *Adam und Eva. Das erste Menschenpaar in Volkskunst und Volksdichtung* (Stuttgart, 1968) is an attempt at a study of sacred images. The material is vast and not easily mastered. It is doubtful whether precise cross-connections can be established between the pictorial representations in folk art and references to the same themes in popular poetry. The expression of religious feeling in images may be the result of an autonomous tradition. True, during the Middle Ages, close connections existed between religious plays and the pictorial arts. Nevertheless, the interaction between pictorial art and linguistic, literary and dramatic tradition remains a perpetual problem, even in the higher art forms. In folk art the problem would be even more complicated.

369 **Dish.** Pottery with slip painting and lead glaze. 1710. Made in Tönnisberg, Lower Rhine. Diameter

36 cm. Museum für niederrheinische Volkskunde, Kevelaer.

Because of the need for symmetrical order the somewhat childish forms of this representation of the Fall undergo a remarkable transformation. The sexes are still only distinguished by size and the length of their hair. The fauna of the Garden of Eden are indicated by two species, a pair of birds on Adam's side and two deer on Eve's. Is there any special significance in this selection and the way they are allocated? Both Adam and Eve hold an apple in one hand. This is not a pictorial narrative but a formal composition. Apart from the question of symmetry there are other aesthetic considerations. It is surely significant that the snake stretches its tail to the left and its head, particularly the mouth, to the right. The inscription, too, has a balancing effect. The reduction of the concept of the tree to a broad trunk is remarkable (it fills an important role as a support for the coils of the snake). The crown consists of seven apples and four leaves. The soil and the roots are stylized to form a wave pattern.

370 **Peep-hole in a living-room door,** with picture of Adam and Eve. Hardwood. From the house of Christine Carstensen, Wrixum, island of Föhr, north Friesland, Schleswig. Height *circa* 40 cm, width 40 cm. Heimatmuseum, Wyk, island of Föhr, north Friesland, Schleswig.

North Friesland is rich in uniquely treated, decorated and painted doors (cf. Pls. 48, 49, 54). From the late seventeenth century onwards they often contain small windows which made it possible to look out into the passage. The display side often contained incised texts and was painted with landscapes or otherwise decorated. It faced the interior of the room and was harmonized with the—mostly panelled—wall. This scene of the Fall was executed in perforated woodwork and formed, so to speak, an accessory to the window, i. e., it was set in front of the pane and was thus also recognizable from outside. The even filling of the space with vegetation signifying Paradise is notable. The leaves which originally covered Adam and Eve's nakedness have grown mightily in their hands until they resemble weapons. Adam already holds the apple in his hand. The same scene, carved in the style of the period in oak, can be seen on the door leading to the large room of Markus Swin, dated 1568. This may be a hint that the room, like the room of the door from Föhr, was also used as a bedroom. There is an illustration of the whole door in Gustaf Wolf, *Haus und Hof deutscher Bauern,* vol. I, *Schleswig-Holstein,* Berlin, 1940, p. 52.

371 **Group of figures:** Adam and Eve. Wood, sheet iron and hemp, painted. *Circa* 1830. From Upper Bavaria. Height 50 cm. Bayerisches Nationalmuseum, Munich.

Many different representations of the Fall were available for the living-room, placed either in the domestic shrine corner or on the chest of drawers. In this version the tree consists of wood and sheet iron, the snake of hemp, and the figures of wood. The Fall is not presented as an event,

but simply as a grouping of familiar symbols: the tree of knowledge, Adam and Eve, and the snake. This conveys the meaning adequately. The story is nevertheless given an added detail: on the tree-tops, between the rich foliage and the fruit, some birds have settled. (Cf. Lenz Kriss-Rettenbeck, *Bilder und Zeichen religiösen Volksglaubens*, Munich, 1963, Pl. II.)

372 **Letter of good wishes.** Paper, cut out, pierced, painted in water-colours and inscribed with the initials J. K. and O. J. K. 1842. From Oldsum, island of Föhr, north Friesland. Height 25 cm, width 37 cm. Schleswig-Holsteinisches Landesmuseum, Schleswig.

A sheet of this type must be regarded as a page in an album, except that it was presented as a single piece on a special occasion. It was meant to hang framed on a wall or to be stuck inside the lid of a chest. The two three-masted ships, cut out after holding the sheet, are supposed to depict the *Carl von Hamburg* and the *Christian of Köbenhavn*, flying the flags of Hamburg and the *Danebrog* respectively from the after-deck.

373 **Bentwood box with inset.** Wood and metal. 18th century. Made in Upper Bavaria. Height 45 cm, width 18 cm, depth 8 cm. Heimatmuseum, Berchtesgaden, Upper Bavaria.

This small piece is in many respects characteristic of the early work of Berchtesgaden box-makers *(Gadelmacher)*. When the lid of the box, painted with the monogram of Christ, between freely drawn flourishes and feathers, is lifted, the crucifix with the symbols of Christ's suffering can be seen. Below this is a two-tiered structure made of bone with small figures, one of the Archangel Michael killing a dragon, and the other of the Virgin.

374 **Ship's shrines** (or votive offerings). Wood and linen. 1770. Height 90 cm, length 115 cm. Church at Arnis-an-der-Schlei, Schleswig.

In the foreground is a model of the three-masted coaster *Privilegia*. Distinctive marks: 'wavy waterline; rounded stern; bowsprit with two spritsail yards; sails (also lee sails); pennons; *Danebrog* (the Danish national flag) under the gaff. Model of a whaler? Built by Captain Hans Haack, (1739–85), Arnis. Donated by him and Heinrich Klink, Johann and Hans Hinrich Kemmeter, Johann Gottfried Schulz, Johann Jürgen Tarkel and Hans Nissen, all of Arnis. "To the glory of God and for the decoration of the Church". Hung up on 31 March 1770. Repaired in 1874 and newly rigged in 1953. Shipping documents and photograph in the hull.' This information is given in Henning Henningsen. 'Schiffsmodelle in Kirchen in Nord- und Südschleswig', in: *Nordelbingen*, Heide, Holstein, 33, 1964, pp. 45–76, at pp. 62 ff. The photograph was taken before the re-rigging in 1953.

375 **Five votive offerings.** Wax. 17th–19th century. Denture from Oberhautzenthal. 7.5×6.5 cm. Windpipe and gullet from Dreieichen. Height 6.5 cm. Testicles and penis from Oberhautzenthal. Height 9 cm. Tongue from Günther's wax-chandlery in Bogen, Lower Bavaria. Height 8 cm. Bayerisches Nationalmuseum, Munich.

With modelled sacred offerings of this kind, the meaning is immediately clear. Parts of the body and organs are reproduced, and indicate the illness from which the supplicant prays to be healed. Although the reproduction is intended to be realistic, Christ's monogram is marked on the tongue to invoke a blessing. The intention was to give the parts of the body a certain monumental form; even the sets of teeth look like architectural arches. (Lenz Kriss-Rettenbeck, *Bilder und Zeichen religiösen Volksglaubens,* Munich, 1963, Pl. 345.)

376 **Three votive offerings in the shape of toads.** Wax. Bayerisches Nationalmuseum, Munich.

The toad was regarded as a symbol of the womb and was therefore brought as an offering by women supplicants. It was also used generally in cases of abdominal illness. Votive gifts of this nature are found all over southern Germany at places of pilgrimage.

377 **Animal votives: team of cattle.** Wrought iron. Date uncertain. From Bad St. Leonhard, Lavant valley. Height 8.5 cm and 6 cm; length 14 and 13 cm. Bayerisches Nationalmuseum, Munich.

'Animal on the right: an ox, fairly stout body, hind legs in one piece, forelegs welded to the body, horns wedged in, muzzle, nostrils and eyes punched and cut. Iron yoke bent around the necks. Animal on the left: a cow, somewhat shorter, with very fat belly; hind legs in one piece, forelegs welded to the body, as are the horns. Udder indicated by punching, as are muzzle, nostrils and eyes.' (Rudolf Kriss and Lenz Kriss-Rettenbeck, *Eisenopfer,* Munich, 1957, No. E 442.)

378 **Two animal votives: geese.** Wrought iron. Date uncertain. Both from Aigen am Inn. Left: height 6.2 cm; right: height 4.9 cm. Bayerisches Nationalmuseum, Munich.

Goose on the right: 'Forged from a piece of hoop-iron. Body hammered flat, the neck hammered into a four-sided rod. The wide part is split twice toward the back. The two outer parts are bent forward, the central part is twisted vertically.' Goose on the left: 'Body with a long neck, tail and feet made from a single piece of hoop-iron. Neck hammered together. Beak turned upward.' (Rudolf Kriss and Lenz Kriss-Rettenbeck, *Eisenopfer,* Munich, 1957, No. E 300 and E 83.)

379 **Devotional picture.** Paper, cut out and painted in water-colours. Third quarter of 18th century. Formerly in private collection, from north Friesland. Height *circa* 12 cm, width *circa* 7 cm. Sylt archives, Westerland, Sylt.

380 **Devotional picture.** Second quarter of 18th century. Found on Sylt. Sylt archives, Westerland, Sylt.

381 **Devotional picture.** Latter half of 18th century. Height 19.2 cm, width 16.6 cm. Private collection.

It is remarkable that distinctly Catholic devotional pictures are sometimes found in Protestant hymn-books of the late eighteenth and early nineteenth century. This is true of the specimens in Plates 379 and 380. The spelling of the name 'Dorodea' alone shows that they cannot have been produced in the north. The saints in the three pictures were probably quite unknown to the owners at the time they were produced. It is hardly possible to deduce where the pictures originated. Travelling salesmen, who may have been selling Berchtesgaden toys or Black Forest clocks all over Germany, could well have also carried such small pious pictures. Putting them in a hymn-book was hardly more than a superficial imitation of a Catholic custom.

382 **Votive tablet.** 1796. Pilgrimage church of St. Leonard, Siegertsbrunn, near Munich.

'Finauer and Kammerlodger of Frödmering.' The two couples, dressed in the costume of the period, are shown making offerings. The horses, cattle and sheep are commended to the protection of St. Leonard.

383–386, 388 **Votive tablets from Upper Bavarian places of Pilgrimage.**

383 **Votive tablet.** A bed-ridden patient dedicates himself to the Holy Trinity. The latter seem to be attending the coronation of the Virgin Mary. Oil on wood. 1857. From Eichelberg (?). Height 26.5 cm, width 20.5 cm.

384 **Votive tablet.** Oil on sheet iron in wooden frame. 1847. Pilgrimage church of St. Salvator. From Bettbrunn, Köschnig, Eichstätt district. Upper Bavaria. Height 37.5 cm, width 29.5 cm. Inscription: 'On 13th August 1847 the 4-year-old boy Anton Maier, son of Anton and Theresia Maier, a farmer from Deissing, fell on to a scythe which severed his knee cap, and was fully healed by invoking the Holy Saviour.'

385 **Votive tablet.** Oil on wood. 1830. From Bettbrunn, Köschnig, Eichstätt district, Upper Bavaria. Height 25.5 cm; width 17.5 cm. Inscription: 'Joseph Bickl was freed from vomiting blood by calling upon Saint Salvator and has dedicated this tablet. Kipfenberg, this 21st May 1830.'

386 **Votive tablet.** Oil on wood. 1830 (?). From Siegertsbrunn, near Munich, Upper Bavaria. Inscription: 'A certain person in a very sad condition pledged himself to St. Leonard and found succour through his intercession 1818.'

387 Votive tablet. Oil on canvas. 1735. In the pilgrimage church at Friedberg, near Augsburg, Bavaria.

We see here a married couple praying for help for a child who has fallen into a millstream and been sucked under the wheel of the mill; or perhaps they are offering thanks for the rescue of their child from such danger by the three men with long poles. The parents address themselves to the shrine in the pilgrim church of 'The Resting Place of Our Dear Lord', also called the Lord's Rest. At the time of the incident, 1735, the church, erected in 1731, was still new. The shrine, a late Gothic sculpture, is the centre-piece of the altar on the northern side. It shows Christ resting, a devotional scene very popular in the late Middle Ages, transferred to a Baroque setting. The 'suffering' Christ seems to sit on the Cross which lies on the ground; this, like the halo that shines through and overshadows the crown of thorns, was a new feature. A Baroque pathos pervades the picture, because the pew is located on a platform at a distance from the frightening scene and a piece of the background with a drawn curtain covers part of the picture. A later votive tablet from the same shrine, of 1855, shows the same curtain motif in an even more pronounced Baroque style. (See also Lenz Kriss-Rettenbeck: *Das Votivbild,* Munich, 1958, Pl. 3 and a tablet of 1747, ibidem, Pl. 150.)

388 Votive tablet. Oil on wood. 1753. From Siegertsbrunn, near Munich, Upper Bavaria. Inscription: 'In the year 1753 the whole parish of Kirchhamb, near Swabia, solemnly pledged themselves here to St. Leonardus because of the cattle-plague in the neighbourhood with this tablet and they fixed it here themselves with the most humble thanksgiving. Ex Voto.'

389 Souls in Purgatory. Small picture. Glass decorated on the back by painting *(verre églomisé).* 19th century. Made in the Bavarian Forest. Height 22 cm, width 16 cm. Dr. Schuster collection, Zwiesel, Bavarian Forest.

'Popular devotional pictures sometimes took the form of *verre églomisé.* Paintings of souls in Purgatory, usually tiny, were put up in the houses of small-holders above the stoup of holy water next to the door of the room as a permanent reminder of the departed in Purgatory.' (Gislind Ritz, *Hinterglasmalerei,* 2nd ed., Munich, 1975, p. 162, Pl. 152.)

390 Centre-piece. Bone and wood in glass. 18th century. Made in Berchtesgaden. Height 31 cm. Bayerisches Nationalmuseum, Munich.

The five glass bowls resting on turned dishes contain small painted and clothed figurines representing scenes from the Passion of Christ. The foot of the stand is painted in colour with two hearts surrounded by flourishes. (Lenz Kriss-Rettenbeck, *Bilder und Zeichen religiösen Volksglaubens,* Munich, 1965, Pl. 190; Elisabeth and Erwin Schleich, *Frommer Sinn und Lieblichkeit,* Passau, 1973, Pl. on p. 94.)

391 Devotional picture: the Holy Family. Glass decorated on the back by painting *(verre églomisé).* Circa 1800–20. Made at Raimundsreut, Bavarian Forest. Bayerisches Nationalmuseum, Munich.

The town of Raimundsreut was founded by a group of glass-blowers working at the glassworks in Schönstein. After 1759 it quickly became a centre of glass painting, although the place consisted of only eight houses. Around 1830 five master painters produced between 30,000 and 40,000 panes there. This mass production resulted in a much simplified, stereotyped method of painting. First the dark outlines, then the patterns and folds on the clothes, were traced from stencils placed under the glass. Then came the layers of the ground, the primary colours of the figures and haloes, and finally the colours for the sky and earth. Among the colours of the picture from Raimundsreut a bright vermilion, often on a blue base, usually predominated. The theme of the Holy Family with the growing Christ Child was one of the favourite motifs.

392 Crucifix. Ivory and braid; framed. 19th century. Made in monastery. From southern Germany (?). Height (with frame) 16.7 cm, width 12.9 cm. Schleswig-Holsteinisches Landesmuseum, Schleswig.

This small article of 'fancy work' was acquired in Kiel, whither it may have strayed from a Catholic region. Only the Cross and the body are made of ivory. The face is emphasized by dabs of paint. The remaining space is filled with metal spirals, chains, cords and coiled strips, about 8 mm thick. The flowers are formed from white and red pads of a very fine fabric (perhaps silk). The whole is sewn on to a piece of dark blue cardboard.

393 Fancy work. Left wing of a small Walburga box. 18th century. From Bavaria (?). Height 15 cm, width 8.8 cm. Bayerisches Nationalmuseum, Munich.

In the box-like glazed container are two small Walburga bottles and a silk ribbon 94 cm long. Printed on this are the words: 'Prayer: O good God in whom alone we trust and hope, that we may be, through the great merits and intercession of the saintly virgin and Abbess Walburga, graced by you with innumerable miracle cures, cured of all ills of body and soul through the use of her Holy Oil. Through Jesus Christ our Lord. Amen. Praise ye the Lord in his Saints. Ps. 1500.' (Lenz Kriss-Rettenbeck, *Bilder und Zeichen religiösen Volksglaubens,* Munich, 1963, Pl. 102.)

394 Weather charm. Fancy work. 18th century. From the vicinity of Reichenhall. Diameter 26 cm. Bayerisches Nationalmuseum, Munich.

A collection of the most diverse articles in metal frames under glass: 'In the centre the Agnus Dei. Around this, pilgrim badges, plaques with saints, double-beam crosses of different types, St. Sebastian's arrow, milling tool key (blank?), St. Nepomuk's tongue, a saint's emblem, nails of the Cross etc.' (Lenz Kriss-Rettenberg, *Bilder und Zei-*

chen religiösen Volksglaubens, Munich, 1963, Pl. 151; Elisabeth and Erwin Schleich, *Frommer Sinn und Lieblichkeit,* Passau, 1973, Pl. on p. 5.)

395 Glass decorated on the back by painting *(verre églomisé):* Anna Selbdritt. Last quarter of 18th century. Painted at Raimundsreut, Bavaria. Height 30 cm, width 18 cm. Dr. Schuster collection, Zwiesel, Bavaria Forest.

According to Gislind Ritz (*Hinterglasmalerei,* 2nd ed., Munich, 1975, p. 164) this picture of the Holy Mother St. Anne holding the Christ Child and the Virgin Mary depicted on the same scale as the child—a form known since the thirteenth century—is connected with a pilgrimage in honour of St. Anne to the Unterkreuzberg near Raimundsreut. In the upper half of the picture gold, red and mauve predominate. St. Anne's gown is white with grey-green folds. The blossoms are ochre-yellow and the leaves blackish-green. They are distributed generously and at random over the area extending from the centre of the lower edge of the picture outward.

396 Holy-water stoup. Pottery. 18th–19th century. Made in Kröning, Lower Bavaria. Height 31.5 cm. Bayerisches Nationalmuseum, Munich.

The rather playful manner of combining a religious object and a wall decoration is a particular feature of the pottery from the ceramics centre of Kröning. St. John of Nepomuk appears in a priest's regalia at the top, supported by two twisted volutes in the Baroque niche. The symbolism may also be interpreted as follows: he is principally known as the patron saint of bridges and as such he forms a bridge across the holy water. The small basin below bears the monogram of Christ in flat relief letters. The pairs of cords formed by twisted 'rolls' of clay imitate the twisted Baroque double columns familiar from contemporary altars. (Lenz Kriss-Rettenbeck: *Bilder und Zeichen religiösen Volksglaubens,* Munich, 1963, Pl. 62.)

397 Christmas crib. Paper, painted. End of 18th century. From Bavarian Swabia. Height of figures up to 16 cm. Bayerisches Nationalmuseum, Munich.

The scenes show, above: the Annunciation to Mary, the search for shelter, and the Annunciation to the shepherds; below: the Adoration of the shepherds.

398 Holy-water stoup. Pottery, painted and with lead glaze. 1788. From Westphalia. Height 35.8 cm. Museum für Kunst und Kulturgeschichte der Stadt Dortmund; now at Cappenberg Castle, near Lünen, Westphalia.

The potter has formed the basin, which as usual is provided with a high back by means of which it can be hung up, in the shape of a pulpit with a sounding board and put a preacher inside. He therefore is standing in the water. In the Catholic parts of Germany such basins for Holy Water are popular objects for decoration which occasionally even includes playful details, and at the same

time serve to ornament the room. In this respect, too, pottery workshops follow the examples of porcelain and faience manufacturers.

399 Display case with figures: the Three Kings in adoration before the Christ Child. Wood, framed in colour and other materials. Early 19th century. Height 33 cm, width 31 cm, depth 14 cm. Bayerisches National-museum, Munich.

From the late eighteenth century onwards the workshops of carvers of religious objects at Oberammergau, Upper Bavaria, in addition to many individual figures for Nativity scenes, also produced display cases containing the scene of adoration by the Three Kings or the shepherds. In farm-houses they were placed in the corner of the domestic shrine which was to some extent re-arranged according to the seasons of the church calendar.

400 Prayer-book and rosary. Bound in red velvet with mountings in silver filigree. 18th century. Binding: height 16 cm, width 11 cm; rosary: length 86 cm. Municipal Museum, Schwäbisch Gmünd.

Just as in Protestant regions the hymn-book was an indispensable requisite of the female churchgoer, her Catholic counterpart required (apart from the obligatory form of costume) her prayer-book and rosary. The latter was wound around the hand. A specially embroidered handkerchief was also part of her Sunday attire. The binding of the book demonstrated the degree of afflu-ence. Enclosures inside its pages included various devotional and sacred pictures as well as strongly scented leaves. The equivalent in northern Germany were silver scent-boxes shaped like urns or fish. Going to church was subject to ceremonial regulations, right down to details of dress, appurtenances and the way of carrying them.

401 Beam head. Oak. 1699. Height (of visible detail) *circa* 60 cm. Church at Keitum, island of Sylt, north Friesland, Schleswig.

The increase in the rural population toward the end of the seventeenth century and in the following period made it necessary to build galleries in village churches. This resulted in some joiners' work which comes within the realm of folk art. The supporting pillars of a gallery (or organ-loft) in the church at Keitum were cut into column shapes, the cubic abutment became a rosette, and the year was incised. The cross-cut timber of the gallery beam was turned into a grotesque mask. In the sixteenth century similar masks, generally blending into foliage patterns, were among the motifs current on furniture carved on the nearby mainland (the 'school' of Ribe).

402 End of pew. Oak. 1564. Width *circa* 30 cm. Church of Büsum, Dithmarschen.

Until 1559 Dithmarschen preserved the status of a free republic. The leaders of the local farming community emphasized their claim to a private seat in church by hav-ing their family crest carved into the side of their pews, in addition to the name. Sometimes such 'decoration' takes the form of a proclamation of faith. For example, on a pew dated 1564 in the church at Büsum the portrait of Martin Luther in a medallion appears, along with a crucifix. It was already a significant Protestant custom to introduce a portrait into a sacred Christian place, other than as a figure on a tomb or the features of a worshipper, but it amounts to a demonstrative Credo to depict Luther and the Crucified Lord in this manner on a pew.

403 Cake mould. Beech. Early 18th century. From Kiel. Holstein. Height 28 cm, width 19 cm. Schleswig-Holsteinisches Landesmuseum, Schleswig.

This is a comparatively modest example of the very widely practised popular craft in which picturesquely shaped pastry was made for festive occasions. In an unas-suming way this mould represents features that were so typical of a wide range of folk art, and were particularly familiar to anyone who worked with moulds: the simple patterns of bas-relief, the change from profile to frontal position, the systematic accumulation of simple forms to fill an area or to emphasize the lower edge. St. George remained an honoured hero whose help was solicited for a long time, even by the Protestant population. The initials DD are probably those of the maker. There are many indications that pattern-makers were active in Kiel in the eighteenth century, but so far their names are not known.

404 Cake mould. Wood. Early 19th century. From Bücken, Lower Saxony. Height *circa* 14 cm. Museum at Nienburg.

Former generations often liked to combine pictorial motifs like this one with earlier mythical traditions and to give fanciful explanations of the result. They came to be associated with festive occasions for which pastry in an appropriate shape was made. Today we tend to see rather the humour and the satire of such interpretations. It is obvious from the shape that an experienced pattern-maker was at work here. Three strokes with a round hol-low knife first in one direction, then in another, serve to create a lively chessboard pattern.

405, 407 Biscuit-cutters. Sheet iron. 19th century. From the island of Föhr. Height *circa* 15 cm. Heimat-museum, Wyk, island of Föhr.

These two examples have been selected from a large series of cutters in the museum. The others feature animals such as stag, horse, pig and fish. The cutters were used in the preparation of Christmas cakes from dough con-sisting mainly of flour and syrup. The figures were decorated with white icing. During the eighteenth cen-tury the figures became much smaller and were inserted as tin strips into a wooden base. In the nineteenth cen-tury a tin sheet replaced the wooden one and toward the end of the century the figures grew bigger until they were many times the original size. The pastry was known locally as *Kinjes Poppen*, meaning 'Infant Jesus Dolls'.

406 Cake mould. Copper-beech. 18th century. From the mill at Aarsleben, near Jordkirch, north Schleswig. Height 16 cm, width 23 cm. Schleswig-Holsteinisches Landesmuseum, Schleswig.

This cake mould carved (or perhaps only owned) by a man with the initials IK represents, in a simple way, one of the most popular of the many subjects in the realm of bakery: the coach. It does not appear to be a wedding coach because as far as one can see it is occupied only by a gentleman. It merely expresses in a single image the es-sence of high-class living, because driving—or rather being driven—in a coach in itself represents affluence and sumptuous living. In this simple form it does not imply criticism. It is no more than an evocation of wish-fulfilment. The carving on the other side of the block shows a crowned rampant lion. There are two signatures: IK and FB. It is always possible that initials are those of the owner rather than the maker. In this case both of them may be named.

408 Practice target. Oil-painting on wood. First half of 19th century. Made and used in Schliersee, Upper Bavaria. Royal Society of Riflemen, Schliersee.

This is one of numerous examples of a species of popular art which consisted of painted practice targets. It origi-nated in the sixteenth century and was particularly popu-lar in southern Germany; it has been preserved in many series showing localized features. (Alfred Förg, *Schiess-Scheiben. Volkskunst in Jahrhunderten,* Rosenheim, n. d.) A unique life-style is enshrined in this form of art—sometimes curious, sometimes trivial, sometimes con-ventional and sometimes original. It ranges from learned symbolism, and the emblematic to sentimental nineteenth-century genre pieces and even to true works of art in the manner of the twentieth-century *Scholle* art group in Munich. The picture shows Alpine riflemen in action—obviously meaning business. Their motto 'Free and Faithful' is explicitly stated. This is probably a refer-ence to the aftermath of the spirit and the patriotic fer-vour of the Tyrolean war of liberation. (Cf. A. Förg, Col. Pl. on p. 175.)

409 Love-letter. Paper, silhouette, painted in water-colours. 1796. From Schleswig-Holstein. Diameter 44 cm. Schleswig-Holsteinisches Landesmuseum, Schleswig.

Such letters, in more or less refined versions, were sent by a suitor to his beloved. The blank oval spaces contain verses of wooing and declarations of love—in four cases, pictures of landscapes (*Schleswig-Holsteinisches Jahrbuch,* Hamburg, 1928/29, p. 141). Similar artistic expressions on paper probably served the same purpose all over Ger-many. The painted tendrils, flowers etc. were generally cut out with a sharp knife. No doubt in many cases pro-fessionals were called in to execute this part of the work. Young men were given simpler papers, drawn and cut out in the form of knots as 'binding letters'. The recipi-ent then had to buy himself out of these 'bonds'.

410 **Silhouette.** Paper. End of 19th century. Originally from Fockbek, near Rendsburg, Holstein. Height 43 cm, width 36 cm. Private collection.

In this case the originator of the piece is known: she was Mrs. Catharina Lass, born Sievers (1825–1912) of Fockbek. She created many scissor-cuts of this type, mostly devotional pictures. 'She cut out her pictures, comprising predominantly biblical motifs, but also family groups, plants and animal figures, freely according to her own ideas, with a remarkably simple and unsophisticated style. She was also a mistress of coloured picture embroidery, to which a very fine piece in the Heimatmuseum at Rendsburg bears witness.' (Hans Schlothfeldt, *Die Chronik von Fockbek,* Rendsburg, 1962, p. 151). Similar silhouettes occur as devotional pictures in many German regions (cf. Konrad Hahm, *Deutsche Volkskunst,* Berlin, 1928, Pl. 104: an example from Posen).

411, 412 **Pierced-work pictures.** Paper, painted in water-colours. End of 18th century. From the province of Schleswig. 411: height 20 cm, width 15 cm. Respectively privately owned and Schleswig-Holsteinisches Landesmuseum, Schleswig.

Little pictures of this kind—amateurish, stiff and highly coloured—probably originated as a domestic craft. They can be compared with the pictures of birds with feathers stuck on which were mainly produced in the Egerland, or with the silhouettes made by individual women which turn up here and there. The perforations in the paper, the previous transfer of the drawing from a pattern, or from one sheet to the other, and the colouring-in were probably also done by women. In this laborious way they tried to earn a little money as an alternative to sewing or embroidering. Generally harmless insignificant scenes were chosen, like the presentation of a cavalier to a noble lady, as in the two versions illustrated here. A mother with children, or some similar subject, also occurs. The irregularity of the perforations shows that they were made one at a time and by hand, not, or only exceptionally, with a toothed wheel or some such implement. Individual features may appear on the socket which clamps the blocks together or on similar features. From these it may one day be possible to deduce the places of origin or even the individual makers.

413 **Nutcracker.** Wood (probably spruce), painted. 1912. Made in the Ore mountains (or perhaps in Thuringia). Height *circa* 50 cm, width 12–15 cm.

This figure represents a Turk. This motif had been part of the folk-art repertoire since the sixteenth century. It remained topical from the time of the Turkish wars and gained renewed interest from the models supplied by the fine arts (such as porcelain figures), and even from the habit of drinking coffee. In toy-making this figure, too, retained its stiff attitude. (Cf. Gertrud Benker, *Altes bäuerliches Holzgerät,* Munich, 1976, Pls. 71, 72.)

414 **Nutcracker.** Softwood, painted. *Circa* 1930. Made in Seiffen. Ore mountains (workshop of Albert Füchtner, 1875–1953). Height *circa* 50 cm. Formerly in the Landesverein für Sächsischen Heimatschutz.

The Landesverein für Heimatschutz actively promoted the trade of toy carving in the Ore mountains (Erzgebirge), and after the beginning of the twentieth century the Saxon branch was particularly active in this respect. The craftsmen took older forms as their models. Traditionally nutcrackers had for a long time—at least since the eighteenth century—been figures of soldiers standing to attention. Many of them were turned on the lathe.

415 **Toy: wedding coach with span of eight horses.** Spruce, painted with casein colours. First half of 19th century. Made in Berchtesgaden. Height of horses 4 5– 5 cm. Bayerisches Nationalmuseum, Munich.

Birds' feathers are stuck on the horses' heads. Animals, people and coach are painted in gay colours. Typical of this type of toy are the rosettes on the flanks of the horses which are reproduced in modified form on the spokes of the wheels. Until recently this toy was dated by the type of coach to the eighteenth century. The routine patterns, however, preserved the original form for decades. The world-wide trade in these goods from Berchtesgaden also tended to stabilize the form. These coaches were packed in a close-fitting bentwood box which was also decorated with star rosettes.

416 **Page from a toy pattern book.** Coloured lithograph. 1840. Height 27.5 cm, width 45 cm. Altonaer Museum, Hamburg.

This page comes from the toy pattern book by Carl Heinrich Oehme of Waldkirchen, Saxony. It shows a selection of pieces characteristic of the toy-making cottage industry of the Ore mountains (Erzgebirge) under the headings: poultry yard, hunting and circus, with bentwood boxes to match. The high numbers indicate the extensive output of the firm. During the years after World War II interest began to focus on the folklore connected with toy-makers' pattern books, especially after Karl Ewald Fritzsch had drawn attention to their value as a source ('Erzgebirgische Spielzeug-Musterbücher', in: *Deutsches Jahrbuch für Volkskunde,* IV, Berlin 1958, pp. 91–128). The almost encyclopaedic character of the illustrated catalogues of Nuremberg toy-making firms was already known in the early nineteenth century. Their importance as a source of information on the spread of knowledge and technical development as illustrated by the toy trade was recognized. It led to further publications, and also to the reprinting of whole pattern books of samples.

417 **Cut-out figures.** Light blue, vermilion, ochre and jet-black coloured woodcut. Augsburg or Nuremberg (?). *Circa* 1700. 20.7 × 29.7 cm (fragment). Germanisches Nationalmuseum, Nuremberg.

Cut-out figures like these two girls in linen shirts with other garments and fashionable trimmings were designed to serve as models for the everyday clothes worn by teen-age girls. They were very popular, and have not lost their numerous admirers even to this day. (Sigrid Metken, *Geschnittenes Papier,* Munich, 1978, Pl. 263.)

418 **Two puppets.** Wood and fabric. Middle to latter half of 19th century. From North Germany. Height *circa* 55 cm. Altonaer Museum, Hamburg.

These two figures will have to do duty here, however inadequately, for the vast army of their kind and all the other varied types of puppets. Only the material of their costumes allow us to estimate their date. It is uncertain how far they are typical of figures that appeared in puppet-shows in North Germany. This question would mean encroaching on a whole new area of cultural history without being able to do it justice.

419 **Jumping Jack.** Wood and papier-mâché. Middle of 19th century. From Hamburg-Altona. Made in the Ore mountains (Erzgebirge). Height 27 cm. Altonaer Museum, Hamburg.

For a similar specimen see Konrad Hahm, *Deutsche Volkskunst,* Berlin, 1928, Pl. 95.

420–421 **Baskets with handles** (market baskets). Wickerwork. *Circa* 1900. Basket Museum, Michelau, Franconia, Bavaria.

The craft of wickerwork was highly developed in Franconia. 'An important centre for the production of all kinds of work of this type is situated in Upper Franconia, in the districts of Lichtenfels, Kronach, Coburg with Michelau, Schwürbitz, Marktzeuln, Marktgraitz and Weidhausen—to name only the places where, according to the 1905 census, more than 300 weavers were listed. The first reports about basket-weaving in this region go back to the latter half of the eighteenth century. These activities spread in the first decades of the nineteenth century, not least because they provided poorer members of the rural population with an additional source of income. Moreover, the improvement of transport facilities toward the middle of the century opened up new outlets for more intensive trading. In this way the number of basket weavers doubled between 1847 and 1861 to reach 1700. The work of this home industry involved the whole family and fluctuated according to the state of the market. Its growth was closely allied to trade, which actively promoted the use of modern materials and of new, often short-lived patterns in so-called luxury and fancy goods.' (Bernward Deneke, *Volkskunst aus Franken,* Nuremberg, 1975, p. 19.)

422 **Needlework-basket.** Wickerwork. Latter half of 19th century. Basket Museum, Michelau, Franconia, Bavaria.

See caption to Plates 420, 421.

423 **Basket carried on the back.** Wickerwork, wood

and leather. Middle of 19th century. From Franconia. Height 42 cm. Private collection.

This bulb-shaped type of woven basket carried on the back *(Huckelkorb)* was common in the neighbourhood of Hersbruck, Lauf and Erlangen, *circa* 1840–50. Characteristic is the sledge-like understructure, the bulging form and the leather covering on the upper portion. The saddler has decorated this part with coloured leather strips, 'volutes', initials and the year. There are also leather appliqué decorations in green, red and yellow.

424 **Bowl-shaped basket.** Wickerwork. 19th century. Made in Lichtenfels, Franconia. Basket Museum, Michelau, Franconia.

On the subject of Franconian basket-weaving, see Fred Benecke: *Die Korbflechtereiindustrie Oberfrankens,* Leipzig, 1921. There is also a catalogue of the products of the basket factory of Konrad Gagel in Michelau in the first half of the nineteenth century. See the article by Gröber in the 1937 annual of the Bayerischer Landesverein für Heimatschutz, p. 57. (See also Hans Heine, *Korbflechterei in Oberfranken,* Munich and Berlin, 1910; Heinrich Meyer, 'Die Entwicklung der Korbflechterei und des Korbhandels am Obermain', in: *Geschichte am Obermain,* 4, 1966–7, pp. 131–51; Christoph Will, *Die Korbflechterei,* Munich, 1978.)

425 **Shopping-bag.** Woven bast, covered with leather. 1831. From Franconia. Height 27 cm.
Carrier-bag. Woven bast. 1817. From Straubing, Lower Bavaria. Height 34 cm. Both in the Germanisches Nationalmuseum, Nuremberg.

This form of bag, known locally as *Zegerer, Zeger* or *Zöger,* survives in a few specimens dating back to the early nineteenth century. Similar bags were used in other South German regions, e.g. in Upper Bavaria (Hans Karlinger, *Deutsche Volkskunst,* Berlin, 1938, p. 349). They were also used to carry schoolbooks. The leather is generally dyed, and the initials, year and small ornamental patterns added with thin leather strips, rather like the quill embroidery practised in Alpine regions.

426 **Pocket flask.** Glass with enamel painting. 1711. Made in central Germany (Upper Franconia?). Height 20.5 cm. Oberösterreichisches Landesmuseum (Schlossmuseum), Linz, Austria.

The scene on the display side shows a well-dressed man wearing a cap for indoor wear caressing a child lying in a cradle. Above this are interlaced ornaments, and at the back the verses:

> Would but as little as a tit I eat
> And sang just like a nightingale so sweet,
> Could I as often as a cock unite —
> I surely then would be my wife's delight. 1711.

(Franz Carl Lipp, *Bemalte Gläser,* Munich, 1974, pp. 167 ff.). The man holds in his hand what appears to be a long-handled pot, as he is about to feed the child.

427 **Mug with handle.** Enamel painting and pewter lid. 1699. Made in central Germany. Height 15.8 cm. Heinrich Heine collection, Karlsruhe.

On the side a pelican is depicted tearing open her breast to feed her offspring with her blood. The inscriptions read, on the left: 'Christ has redeemed us with His blood'; and on the right: 'Just as the pelican does to her young – 1699'. On the pewter lid: 'IFK 1724' is inscribed. (Franz Carl Lipp, *Bemalte Gläser,* Munich, 1974, p. 167.) The theme of the self-sacrificing pelican giving her young her own blood is frequently found in folk art. Here it appears on a secular drinking glass. Drink seems to be the only connection which, in view of the pious saying, is a remarkably profane attitude.

428 **Guild goblet of the journeymen-bakers of Regensburg.** Glass with enamel painting, 1679. Made in Franconia or northern Bavaria. Height 18.5 cm. On art market, 1974.

This goblet is familiar to the author only from illustrations, but it demonstrates the predilection, particularly prevalent among artisans, for painted glasses. A pair of veteran journeyman-bakers are holding up a *Pretzel* as the guild's emblem. As usual, the inscription toasts the 'brother members' and all bakers, and therefore contains an appropriate saying. 'The date 1679 indicates the town of Regensburg as the probable place of provenance. The style hints at Franconia or at northern Bavaria under Franconian influence as the place of origin.' (Franz Carl Lipp, *Bemalte Gläser,* Munich 1974, pp. 163 ff.)

429 **Goblet of a joiners' guild,** with enamel painting. 1745. Reputedly from Franconia. Height 24.5 cm, diameter on top 8.5 cm. Schleswig-Holsteinisches Landesmuseum, Schleswig.

Yellow stripes divide the cylinder into five zones. At the top is a man in the costume of the period with an axe over his shoulder and a T-square in his right hand. On the reverse side are carpenters' tools, grouped to form an emblem. The inscription reads: 'M.M. Vivat—Long may he live/long live the honourable craft of carpenters./ Empty me and put me upside down/it goes around to the good health of all carpenters. 1745.' The colours are yellow, blue, red, green and white. The base is painted white.

430 **Mug with handle.** Glass with enamel painting. 1808. Originally from central Germany. Height 18 cm. Private collection, Linz, Austria.

A pair of red oxen pulls a plough, led by an almost elegantly dressed farmer. The inscription reads:

> It's early morning, the time is now
> To yoke my oxen to the plough.

Characteristic of the popular choice of colours are bright red for the oxen and bright yellow for the plough. (Cf. Franz Carl Lipp, *Bemalte Gläser,* Munich, 1974, Pl. VIIIa.)

431 **Goblet with foot.** Glass with enamel painting. 1715. Made in Franconia. Height 12.5 cm. Oberösterreichisches Landesmuseum (Schlossmuseum), Linz, Austria.

The hunter in a green outfit behind a tree is aiming at a stag. The inscription reads:

> I am a huntsman, as you see here
> With my gun I've shot many a stately deer. 1715.

(Cf. Franz Carl Lipp, *Bemalte Gläser,* Munich, 1974, Pl. VIIIb.)

432 **Screw-top bottle.** Glass with enamel painting. 1770. Made in the Black Forest. Height 16.5 cm. Oberösterreichisches Landesmuseum (Schlossmuseum), Linz, Austria.

Similar bottles to hold spirits were carried by travelling journeymen into all parts of the country and were also spread widely by the market. The yellow (!) pigeons carry feathers in their beaks, probably for building nests. The inscription on the reverse side reads:

> Throughout my life I shall love thee,
> And when I die, go, pray for me. 1770

(Cf. Franz Carl Lipp, *Bemalte Gläser,* Munich, 1974, Pl. VIII c.)

433 **Pocket flask.** Glass with enamel painting. 1721. Made in the Bavarian Forest (or perhaps Austria). Height 27 cm. Oberösterreichisches Landesmuseum (Schlossmuseum), Linz, Austria.

Artisans and forestry workers were not the only travellers who liked to carry such bottles full of spirits on their journeys. As far as the forestry workers are concerned, this was very understandable in view of their working conditions in winter. The woodcutter on this bottle seems to be going to work with his axe over his shoulder in a more clement season. The reverse side shows two pigeons holding a garland. The inscription reads: 'Long live all good woodcutters', and on the reverse side:

> I like what is fine,
> Though it be not mine
> And I never can buy it —
> Yet I can enjoy it. A.D. 1721

(Cf. Franz Carl Lipp, *Bemalte Gläser,* Munich, 1974, Pl. VIIId.)

434 **Room in a farm-house.** Painting by Johann Sperl (1840–1914), oil on canvas. *Circa* 1875. Height 48.5 cm, width 58 cm. Kunsthalle, Bremen.

The painter, who was born in Buch near Fürth, Franconia, and studied in Munich, was a friend of Wilhelm Leibl and was much influenced by him. At first Sperl cultivated genre painting and created dry, anecdotal, but clear and accurate representations of Upper Bavarian folk life (see, for instance, *The Wood Grouse* and *Dressing for the Festival*). In the 1870s he freed himself from his earlier conventional models and cultivated painting from life. This allowed him to produce landscapes and vivid little sketches from nature. Artistically, the interior depicted

there belongs to this period. Is shows how the spaciousness and realism of everyday life attracted the interest of sensitive painters. Sperl himself lived in this room in Kutterling. (*Katalog der Gemälde des 19. und 20. Jahrhunderts in der Kunsthalle Bremen*, Bremen, 1973, text p. 315.)

435 **Room** *(Dörns)* **in Haus Agsen,** Lindholm, north Friesland. Oil-painting on canvas by Carl Ludwig Jessen, 1906 (?). Municipal Museum, Flensburg.

This is an example of the many room 'portraits' of north Frisian houses painted by C. L. Jessen (1833–1917) on the basis of meticulous measurements, with and without embellishments. It is typical of the simple rooms occupied by small peasants on the north Frisian mainland. In this case the wainscoting, the style and measurement of which still belonged to the Renaissance period, remained unpainted. The stay in the cross-wall, one of the props that carry the whole frame of the house, is remarkable. Between it and the outer wall is a built-in cupboard which has taken the place of the bench cupboard (cf. Pl. 34). The hatches in the centre conceal the wall-bed behind. Dutch faience plates are lined up on the shelf; large numbers of these came into the country as mementoes brought by sailors. The open door leads to a small room; the *Pesel* probably lies behind it. Typical of Jessen's interiors is the clear detail of the cross-wall. This was the pattern he followed since he started to paint. The fixtures were more important to him than a possible view of the garden through a window, artistic foreshortening or cross-section views.

436 **Room in a farm-house.** Painting by Theodor Schüz. Oil on canvas. *Circa* 1860–70. Height 28 cm, width 32 cm. Kunstmuseum, Düsseldorf.

'Black Forest peasant room with view of landscape. Equipment: cast-iron stove, clock, votive picture and armchair.' Thus runs the text in the catalogue of the Kunstmuseum, Düsseldorf, (vol. 2, *Die Düsseldorfer Malerschule,* Düsseldorf, 1969, p. 322). Instead of 'votive pictures' it should read 'devotional pictures'. Theodor Schüz, born in 1830 in Thumlingen near Freudenstadt, Baden, died in 1900 in Düsseldorf. He studied in Stuttgart and Munich, and worked in Düsseldorf from 1866 onward. 'The landscape, land and people of his Swabian home were combined in the themes of his pictures' (ibid.). He painted crowd scenes with obvious delight. All the more remarkable is this picture, hardly more than a study, in which he tries to capture the quiet atmosphere of a rural living-room, and in which he shows himself equally interested in the equipment.

437 **Interior of a house in Blankenese,** near Hamburg. Painting by Johann Wilhelm David Bantelmann (1806–77). Oil on paper on canvas. *Circa* 1870 (?). Height 42 cm, width 53 cm. Kunsthalle, Hamburg.

Bantelmann was a native of Hamburg and worked in his home town, except for his years of study in Berlin, Munich and Vienna. Like many contemporary Hamburg painters of his age he liked to set up his easel in nearby Blankenese in order to represent the life of the fishermen and pilots there. This freely painted picture shows clearly his interest in the spacious house, particularly the vestibule with its open fire-place, the recess with the servant at work under the staircase and, on the right, the divided door on the gable side. The background is not just part of an anecdotal genre scene but it is the main subject because of its significance in the spatial composition. Particular attention is paid to the light effect. (*Katalog der Meister des 19. Jahrhunderts in der Hamburger Kunsthalle,* Hamburg, 1969, p. 14.)

438 **Child's cradle.** Painting by Peter Philipp Rumpf (1821–96). Oil on canvas on cardboard. *Circa* 1860. Height 22 cm, width 29.8 cm. Kunsthalle, Bremen.

Rumpf was born in Frankfurt and, after studies in Paris and Italy, worked in his home town. In 1875 he moved to Cronberg in the Taunus, and then back to Frankfurt. The painted cradle was probably used in his home region of Hesse. To him it was just a picturesque object which he chose as the theme of his painting. (*Katalog der Gemälde des 19. und 20. Jahrhunderts in der Kunsthalle Bremen,* text vol., Bremen, 1973, p. 287.)

439 **Panel of a wardrobe door.** Softwood, painted, partly over silver foil. 1835. From Schollach, Baden. Measurements of detail: height 40 cm, width 32.5 cm. Augustiner-Museum, Freiburg im Breisgau.

The origin of this wardrobe is revealed by the inscription naming the owner: Martin Schwerer in Schollach. W. Ganter was found to be the painter. On a black background a plinth, a vase and a bunch of flowers are painted in glorious colours. A strong vermilion stands out, particularly on the roses. Green appears in many shades, from a nearly black dark green to an almost white light green. Blue is used sparingly. A strong Baroque influence is apparent in the bunch, but the vase betrays its nineteenth-century origin. The painter was probably a member of the same Ganter family in Bubenbach near Eisenbach to which Dionys (born 1800) and his brother Nikolaus belonged. Both had ambitions beyond panel painting and studied in art academies, but never forsook their native frame of reference. (Cf. exhibition catalogue: *Vom Schildermaler zum Professor, Schwarzwaldmaler im 19. Jahrhundert,* Augustiner-Museum, Freiburg im Breisgau, 1957.)

Bibliography

Note

The author realizes that this bibliography contains gaps. Many subjects are not treated fully, while others conventionally seen as part of folk art are not covered at all. Instead a number of small and even obscure publications have been included. These show the degree to which the relevant literature is scattered through a number of occasional regional journals and series, many of which had a limited life and changed their titles. Only a few of the many museum guides and exhibition catalogues, which are often of considerable value, could be included. There is no central agency in the Federal German Republic which collects and arranges material on folk art in systematic fashion. The *International Bibliography of Ethnography* no longer has a separate rubric for folk art, which makes it harder to keep up with recent publications. The general works listed here usually have extensive bibliographies.

ADLER, Fritz, *Mönchgut. Das Bild einer Volkskultur auf Rügen.* Greifswald, 1936.

ALBRECHT, Rudolf, *Töpferkunst in Kreussen.* Rothenburg, o. T., 1912.

ANDREE, Richard, *Votive und Weihegaben des katholischen Volks in Süddeutschland.* Brunswick, 1904.

ANDREE-EYSN, *Volkskundliches aus dem bayrisch-österreichischen Alpengebiet.* Brunswick, 1904.

ANGERMANN, Gertrud, 'Truhenbänke aus Friedewalde, Kreis Minden', in: *Rheinisch-westfälische Zeitschrift für Volkskunde,* 3, 1956, pp. 217–23.

—, *Stammbücher und Poesiealben als Spiegel ihrer Zeit nach Quellen des 18.–20. Jahrhunderts aus Minden-Ravensberg.* (Schriften der Volkskundlichen Kommission des Landschaftsverbandes Westfalen-Lippe, vol. 20.) Münster, 1971.

—, *Engel an Ravensberger Bauernhäuser. Ein Beitrag zum Wandel des Dekors vom 18. bis 20. Jh.* (Beiträge zur Volkskultur in Nordwestdeutschland, fasc. 2.) Münster, 1974.

APPUHN, Horst, 'Der Landesblock von Fehmarn', in: *Nordelbingen* (Heide in Holstein), 28–29, 1960, pp. 46–52.

— and HEUSINGER, C. von, 'Der Fund kleiner Andachtsbilder des 13. bis 17. Jhs. in Kloster Wienhausen', in: *Niederdeutsche Beiträge zur Kunstgeschichte,* 4, 1965, pp. 157–238.

—, *Kloster Wienhausen. Der Fund vom Nonnenchor.* n. p., n. d.

—, *Briefladen aus Niedersachsen und Nordrhein-Westfalen.* Museum für Kunst und Kulturgeschichte der Stadt Dortmund, Schloss Cappenberg, 1971.

—, 'Private Andachtsbilder in Kloster Wienhausen', in: *Volkskunst* (Munich), 1, 1978, pp. 77–82.

ARENS, F., 'Die ursprüngliche Verwendung gotischer Stein- und Tonmodel, mit einem Verzeichnis der Model in den mittelrheinischen Museen, bes. in Frankfurt, Mainz und Worms', in: *Mainzer Zeitschrift,* 66, 1971, pp. 106–31.

ARMBRUSTER, Brigitte, 'Fränkische Volkskunst von 1780–1820'. Unpublished Ph. D. dissertation, Würzburg, 1970. (MS; printed pp. 1–7, 44–96, 128–323.)

Art populaire. Travaux artistiques et scientifiques du 1er congrès international des arts populaires. Prague, 1929. 2 vols. (Institut International de coopération intellectuelle.) Paris, 1931.

BACHMANN, Manfred and LANGNER, Reinhold, *Berchtesgadener Volkskunst, Tradition und gegenwärtiges Schaffen im Bild.* Leipzig, 1957.

BALZER, Frida, 'Textiles Hauswerk in Ostpreussen um 1850', in: *Volkswerk,* 3, 1943, pp. 244–50.

BATTKE, Heinz, *Geschichte des Rings.* Baden-Baden, 1953.

BAUCHE, Ulrich, *Landtischler, Tischlerwerk und Intarsienkunst in den Vierlanden unter der beiderstädtischen Herrschaft Lübecks und Hamburgs bis 1867.* (Volkskundliche Studien, ed. Walter Hävernick and Herbert Freudenthal, vol. III.) Hamburg, 1965.

BAUER, Ingolf, *Treuchtlinger Geschirr.* Munich, 1971.

—, (ed.), *Volkstümliche Keramik aus Europa. Zum Gedenken an Paul Stieber.* Bayerisches Nationalmuseum, Munich, 1976.

—, *Hafnergeschirr aus Altbayern.* (Kataloge des Bayerischen Nationalmuseums, Munich, vol. XV, 1.) Munich, 1976.

BAUER, Oskar, 'Zehn Hafnergenerationen in einem Spessartdorf', in: *Volkswerk,* vol. 3, pp. 251–58.

BAUMBACH, von, 'Kratzputz in Hessen', in: *Hessenkunst* (Marburg), 1925, pp. 39–47.

BAUMHAUER, Friedrich, 'Bäuerliche Schnitzereien des ostpreussischen Oberlandes', in: *Jahrbuch für historische Volkskunde,* vol. III–IV, 1934, pp. 3–17.

BAUR-HEINHOLD, Margarete, *Fassadenmalerei.* Munich, 1952.

—, *Deutsche Bauernstuben.* (Blaue Bücher). Königstein im Taunus, 1961.

BAUSINGER, Hermann, *Volkskunde.* Berlin and Darmstadt. n. d.

— and BRÜCKNER, Wolfgang (eds.), *Kontinuität?* Berlin, 1969.

BENKER, Gertrud, *Altes bäuerliches Holzgerät.* Munich, 1976.

BERGHOLZ, Gerda, *Die Beckenwerker-Gilde zu Braunschweig.* (Braunschweiger Werkstücke, vol. 17.) Brunswick, 1954.

BERGMANN, A., *Die Schmiedekreuze der Oberpfalz.* 2 fascs., Kallmünz, 1970, 1972.

BERLINER, Rudolf, *Die Weihnachtskrippe.* Munich, 1955.

—, *Denkmäler der Krippenkunst.* 2 vols. Augsburg, 1926–

BERLING, Karl, 'Alt-Sächsisches Steinzeug aus Waldenburg und Zeitz', in: *Jahrbuch für historische Volkskunde,* vol. III–IV, 1934, pp. 53–77.

—, 'Metalle in der Volkskunst', in: Adolf Spamer (ed.), *Die Deutsche Volkskunde,* vol. 1, Berlin, 1934, pp. 469–76.

BILZ, Hellmut, *Die gesellschaftliche Stellung und soziale Lage der hausindustriellen Seiffener Spielzeugmacher im 19. und Anfang des 20. Jhs.* Erzgebirgisches Spielzeugmuseum, Seiffen, 1975.

BINDER, Fred, *Die Brotnahrung. Auswahl-Bibliographie zu ihrer Geschichte und Bedeutung.* (Schriftenreihe des Deutschen Brotmuseums, fasc. 9.) Ulm, 1973.

BISCHOFF-LUITHLEN, Angelika, 'Urväterhausrat im Älbler Bauernhaus', in: *Schwäbische Heimat,* 13, 1962, pp. 44–9.

BLAU, Josef, *Böhmerwälder Hausindustrie und Volkskunst.* 2 vols. Prague, 1917–

BOCK, G. von, 'Die Blütezeit der rheinischen Steinzeugproduktion', in: *Katalog 'Volkskunst im Rheinland',* Düsseldorf, 1968.

BORCHERS, Walter, 'Volkstracht und Volkskunst im Lieper Winkel auf Usedom', in: *Monatsblätter der Gesellschaft für pommersche Geschichte und Altertumskunde,* 45, 1931, pp. 2–10.

—, *Volkskunst im Weizacker.* Leipzig, 1932.

—, 'Volkskunst in Jamund und Lebus', in: *Das Bollwerk,* 8, 1937, pp. 287–92.

—, 'Pommersche Bauern- und Fischerkunst', in: ibid., pp. 358–64, 398–403.

—, *Alter und neuer bäuerlicher Hausrat in Pommern.* Stettin, 1938.

—, 'Glashütten und bäuerliches Glas in Westfalen und dem westlichen Niedersachsen', in: *Rheinisch-westfälische Zeitschrift für Volkskunde,* 2, 1955, pp. 39 ff.

—, 'Zur bäuerlichen Töpferkunst Westfalens', in: ibid., pp. 155 ff.

—, 'Bäuerliches Zinn in Westfalen und im angrenzenden Niedersachsen', in: ibid., 5, 1958, pp. 175 ff.

—, 'Kirche und Volkskunst in Westfalen', in: *Zeitschrift für Volkskunde,* 54, 1958, p. 247.

—, 'Bäuerliche Andachtsbilder und silberne Votivgaben im westfälischen Raum', in: *Beiträge zur deutschen Volks- und Altertumskunde,* 2–3, 1958, pp. 123–34.

—, 'Bäuerlicher Schmuck in Westfalen und im angrenzenden Niedersachsen', in: *Rheinisch-westfälische Zeitschrift für Volkskunde,* 6, 1959, pp. 69 ff.

—, 'Das Bauern- und Fischermöbel auf Hiddensee, Ummanz, dem Darss und Mönchgut', in: *Greifswald-Stralsunder Jahrbuch,* I, 1961, pp. 184–201.

—, 'Bemerkungen zur deutschen Fischer- und Seemannskunst', in: *Katalog 'Volkskunst aus Deutschland, Österreich und der Schweiz',* Cologne, 1969, pp. 25–7.

—, *Volkskunst in Westfalen.* (Der Raum Westfalen, vol. IV/4.) Münster, 1970.

BOSER, Renée, and MÜLLER, Irmgard, *Stickerei. Systematik der Stichformen.* Guide to the exhibition, 'Orientalische Stickereien', Museum für Völkerkunde, Basle, 1969.

BOSSERT, H. Th., *Volkskunst in Europa.* 1st ed., Berlin, 1926 and later editions.

BRAMM, Otto, 'Truhentypen', in: *Volkswerk,* 1941, pp. 154–86.

—, 'Deutsche Brautkränze und Brautkronen', in: *Jahrbuch für historische Volkskunde,* vol. III–IV, 1934, pp. 163–85.

BRANDES, Friedrich, 'Backstein-Ziermuster an ostfälischen Bauernhäusern', in: *Braunschweigische Heimat,* 38, 1952, pp. 22–4.

BRANDT, Gustav, *Wohnräume und Dielen aus Schleswig-Holstein und Lübeck.* Berlin, 1918.

—, 'Wohnungskunst in Schleswig-Holstein', in: *Innen-Dekoration,* 29, 1918, pp. 197–210.

—, *Wohnräume und Möbel aus Alt-Schleswig-Holstein und Lübeck.* Berlin, 1922.

BRAUN, Edmund Wilhelm, 'Schlesische Weihnachtskrippen', in: Michael Haberlandt (ed.), *Werke der Volkskunst,* vol. 3, Vienna, 1917, pp. 2–4.

BRAUN, Wolfgang, KLEIN, Walter, BÖHNE, Clemens and RITZ, Gislind, *Das Gmünder Schmuckhandwerk bis zum Beginn des 19. Jhs.* Schwäbisch Gmünd, 1971.

BRAUNECK, Manfred, *Religiöse Volkskunst, Votivgaben, Andachtsbilder, Hinterglas, Rosenkranz, Amulette.* Cologne, 1978.

BRINCKMANN, Justus, 'Die Namenstücher', in: Museum für Kunst und Gewerbe in Hamburg. *Bericht für das Jahr 1910,* in: *Jahrbuch der Hamburgischen Wissenschaftlichen Anstalten,* 28, 1911, pp. 5–33.

—, *Führer durch das Hamburgische Museum für Kunst und Gewerbe, zugleich ein Handbuch der Geschichte des Kunstgewerbes,* Hamburg, 1894.

—, 'Norddeutscher Bauernschmuck in den Elbniederungen', in: *Mitteilungen des Nordböhmischen Gewerbemuseums,* 7, 1889, pp. 84–6.

BRINGEMEIER, Martha, 'Die Abendmahlskleidung der Frauen und Mädchen in der Schaumburger und Mindener Tracht', in: *Rheinisch-westfälische Zeitschrift für Volkskunde,* I, 1954, pp. 65–91.

—, 'Stickerinnen und Stickereien der Schaumburger Tracht', in: *Volkswerk,* 3, 1943, pp. 199–212.

—, 'Volkskunde und Säkularisation', in: *Rheinisch-westfälische Zeitschrift für Volkskunde,* 16, 1969, pp. 228–38.

BRÜCKNER, Barbara, 'Volkstümliche Farben im Chiemgau'. Ph. D. dissertation, Univ. of Munich. Kallmünz, n. d.

BRÜCKNER, Wolfgang, *Bildnis und Brauch. Studien zur Bildfunktion der Effigies.* Berlin, 1966.

—, 'Hinterglasmalerei', in: *Keysers Kunst- und Antiquitätenbuch,* vol. III, Munich, 1967, pp. 69–99.

—, 'Expression und Formel in Massenkunst. Zum Problem des Umformens in der Volkskunsttheorie', in: *Anzeiger des Germanischen Nationalmuseums,* Nuremberg, 1968, pp. 122–39.

—, 'Volkskunst im Industriezeitalter', in: *Volkskunst* (Munich) I, 1978, pp. 63–9.

BRUNNER, Karl, 'Bauerntöpferei und volkstümliche Fayencen', in: *Zeitschrift des Vereins für Volkskunde,* 20, 1910, pp. 265–89.

—, 'Über Bandgewebegatter', in: ibid., 25, 1915, pp. 51 ff.

BUCHNER, Heinrich, *Hinterglasmalerei in der Böhmerwaldlandschaft und in Südbayern. Beiträge zur Geschichte einer alten Hauskunst.* Munich, 1936.

BÜDDEMANN, Werner, 'Westfälische Truhen', in: *Die Heimat* (Dortmund), 7, 1925, pp. 44–55.

BURGSTALLER, E., *Kulturgeographische Ergebnisse der modernen Gebäckforschung.* (Schriftenreihe des Deutschen Brotmuseums, 2, 1961, pp. 16–25.)

BUSSE, Hermann, *Deutsche Volkskunst,* vol. 13: *Baden.* 2nd ed., Weimar, 1942.

CLASEN, Karl Heinz, *Deutsche Volkskunst,* vol. 10: *Ostpreussen.* 2nd ed., Weimar, 1942.

COLLESELLI, Franz, *Bauernstube, Bauernmöbel in den Alpen.* Innsbruck, 1969.

CREUTZ, Max, *Deutsche Volkskunst,* vol. 3: *Die Rheinlande.* Munich, 1924.

DAMMANN, Walter H., *Nordelbinger Volkskunst.* (Kunstformen-Bibliothek, vol. 3.) Godesberg, [1924].

DENEKE, Bernward, 'Beziehungen zwischen Kunst-

handwerk und Volkskunst um 1900', in: *Anzeiger des Germanischen Nationalmuseums,* 1963, pp. 140–61.

—, 'Die Entdeckung der Volkskunst für das Kunstgewerbe', in: *Zeitschrift für Volkskunde,* 60, 1964, pp. 168–201.

—, *Zeugnisse religiösen Volksglaubens. Aus der Sammlung Erwin Richter.* (Bilderhefte des Germanischen Nationalmuseums, 2.) Nuremberg, 1965.

—, *Ältere Eisenmotive vornehmlich aus der Sammlung des Germanischen Nationalmuseums, Nürnberg',* in: *Bayerisches Jahrbuch für Volkskunde,* 1966–7, pp. 205–7.

—, 'Bauernmöbel', in: *Keysers Kunst- und Antiquitätenbuch,* vol. III. Munich, 1967, pp. 13–40.

—, *Bauernmöbel. Ein Handbuch für Sammler und Liebhaber.* Munich, 1969.

—, 'Unbekannte hessische Brautstühle', in: *Hessische Heimat,* 19, 1969, pp. 5–8.

—, 'Fragen der Rezeption bürgerlicher Sachkultur bei der ländlichen Bevölkerung', in: *Kultureller Wandel im 19. Jh. Verhandlungen des 18. Deutschen Volkskunde-Kongresses in Trier 1971.* Göttingen, 1973, pp. 50–71.

—, 'Eine Sammlung bäuerlicher Altertümer aus dem südlichen Oldenburg im Germanischen Nationalmuseum Nürnberg', in: *Das Oldenburger Münsterland, Jahrbuch 1973,* pp. 151–64.

—, *Volkskunst aus Franken. Eine Auswahl aus den Beständen des Germanischen Nationalmuseums, Nürnberg.* Nuremberg, 1975.

DENEKEN, Friedrich, *Die Sammlung niederrheinischer Tonarbeiten im Kaiser-Wilhelm-Museum, Krefeld.* Krefeld, [1914].

DEXEL, Walter, *Holzgerät und Holzform. Über die Bedeutung der Holzformen für die deutsche Gerätkultur des Mittelalters und der Neuzeit.* Berlin, 1934.

—, *Unbekanntes Handwerksgut. Gebrauchsgerät in Metall, Glas und Ton aus acht Jahrhunderten deutscher Vergangenheit.* Berlin, 1935.

—, *Hausgerät das nicht veraltet. Grundsätzliche Betrachtungen über die Kultur des Tischgeräts.* Ravensburg, 1938.

—, 'Deutsches Handwerksgut. Eine Kultur- und Formgeschichte des Hausgeräts', in: *Propyläen-Kunstgeschichte.* Berlin, 1939.

—, 'Zur Gefässkunde der deutschen Stämme', in: *Volkswerk,* vol. 3, 1943, pp. 36–49.

—, *Keramik, Stoff und Form.* Ravensburg, 1950.

DÖDERLEIN, Wilhelm, 'Alte Spanschachteln', in: *Die Kunst,* 1957, p. 96.

DOEGE, Heinrich, 'Die Trachtenbücher des 16. Jhs.', in: *Beiträge zur Bücherkunde und Philologie, August Wilmanns zum 25. März 1903 gewidmet,* Leipzig, 1903, pp. 429–44.

DÖLLGAST, Hans, *Alte und neue Bauernstuben.* 6th ed., Munich, 1962.

DÖPPE, Friedrich, *Deutsche Bauernmöbel.* Leipzig, 1955.

DÜNNINGER, Josef and SCHEMMEL, Bernhard, *Bildstöcke und Martern in Franken.* Würzburg, 1970.

EBER, Hans, *Creussener Töpferkunst.* (Bayerland-Bücherei.) Munich, 1913.

EICHLER, Hans Gert, *Gebäckmodel in Westfalen. Untersuchungen über Vorkommen und Ikonografie.* Ph.D. dissertation, Münster, 1970.

EICHLER, Hans, *Westfälische Museen,* Münster, 1971.

EINSIEDEL-SCHLÖMER, W.M., *Bauernkunst in Hohenlohe.* Schwäbisch Hall, 1972.

EITZEN, Gerhard, 'Frühformen der Truhe in Niedersachsen', in: *Niedersachsen,* 55, 1955, pp. 245–8.

ERICH, Oswald A., 'Gesichtspunkte für eine Bildgeschichte des figürlichen Gebäcks', in: *Oberdeutsche Zeitschrift für Volkskunde,* 6, 1922, pp. 153 ff.

—, 'Die Tonerden', in: Adolf Spamer (ed.), *Deutsche Volkskunde,* vol. I, Berlin, 1934, pp. 436–46.

—, 'Volkskunst und Volksindustrie', in: Wilhelm Pessler (ed.), *Handbuch der deutschen Volkskunde,* vol. 3. Potsdam, 1934–5, pp. 17–56.

—, and BEITL, Richard, *Wörterbuch der deutschen Volkskunde.* (Kröners Taschenausgabe, vol. 127–8.) Leipzig, 1936 (and many later editions).

—, *Die Museen in Bayern.* (Die deutschen Museen mit besonderer Berücksichtigung der Heimatmuseen, vol. I.) (Minerva-Handbücher, 3rd sec.) Berlin, 1939.

ERIXON, Sigurd, 'Volkskunst und Volkskultur', in: *Volkswerk,* I, 1941, pp. 36–49.

FALKE, Jakob, 'Die nationale Hausindustrie', in: *Gewerbehalle,* 10, 1872, pp. 1–3, 17–19, 33–6, 49–51.

—, *Die Kunstindustrie auf der Wiener Weltausstellung 1873.* Vienna, 1873.

FALKE, Otto von, 'Mittelalterliche Truhen', in: *Amtliche Berichte aus den Königlichen Kunstsammlungen* (Berlin), 37, 1915–16, cols. 231–43.

FASTNER, Herbert, *Bauernmöbel des Bayerischen Waldes.* Grafenau, 1976.

FIEDLER, A. and WEINHOLD, R., *Das schöne Fachwerkhaus Südthüringens (Alt-Henneberg, Grabfeldgau und Werraland).* (Veröffentlichungen des Instituts für Volkskunstforschung beim Zentralhaus für Volkskunst.) Leipzig, 1956.

FINDER, Ernst, *Die Vierlande.* (Veröffentlichungen des Vereins für Hamburgische Geschichte 3.) 2 pts., Hamburg, 1922.

FINKENSTAEDT, Helene and Thomas, *Stanglsitzerheilige und grosse Kerzen. Stäbe, Kerzen und Stangen der Bruderschaften und Zünfte in Bayern.* Weissenborn, 1968.

FLECHTNER-BOBACH, Alice, 'Die Kunst der Holzbearbeitung bei Niedersachsen und Friesen', in: *Zeitschrift des Vereins für Volkskunde,* 23, 1913, pp. 349–67.

FLEISCHER, M., *Holzdreherei und Holzschnitzerei im Odenwald und in der Rhön.* Frankfurt, 1913.

FÖRSTER, Hans, *Altländer Fahrten.* Hamburg-Blankenese, 1938.

—, *Alte volkstümliche Kunst Niedersachsens.* Hanover, 1926.

FORRER, R., *Von alter und ältester Bauernkunst.* (Führer zur Kunst, ed. Hermann Popp, vol. 5.) Esslingen, 1906.

FRAENGER, Wilhelm, *Der Bildermann von Zizenhausen.* (Komische Bibliothek.) Erlenbach-Zurich and Leipzig, 1922.

—, 'Zizenhausener Terrakotten', in: *Oberdeutsche Zeitschrift für Volkskunde,* I, 1927, pp. 109–26.

—, 'Deutsche Vorlagen zu russischen Volksbilderbogen des 18. Jhs', in: *Vom Wesen der Volkskunst.* (Jahrbuch für historische Volkskunde, II, ed. W. Fraenger, Berlin, 1926, pp. 126–73.)

FREYER, Kurt, 'Zum Problem der Volkskunst', in: *Monatshefte für Kunstwissenschaft,* 9, 1916, pp. 215–27.

FRITZSCH, Karl-Ewald, 'Vom Bergmann zum Spielzeugmacher', in: *Deutsches Jahrbuch für Volkskunde,* 2, 1956, pp. 179–211.

—, 'Erzgebirgische Spielzeugmusterbücher', in: ibid., 4, 1958, pp. 91–128.

FUESS, Hanna, *Bauernkunst im Bomannmuseum zu Celle.* Celle, 1927.

FUGER, Walter, *Bauernmöbel in Altbayern. Eine ikonographisch-volkskundliche Untersuchung.* Ph.D. dissertation, Munich, 1974.

FUGLSANG, Fritz, 'Zwei schleswigsche Ornamentmotive', in *Volkswerk,* 1942, pp. 114–20.

FUHRMANN, Irmingard, 'Zur Charakteristik volkstümlicher Weissstickerei in Deutschland', in: ibid., 3, 1943, pp. 213–30.

FUHSE, F., *Beiträge zur Braunschweiger Volkskunde,* Brunswick, 1911.

—, 'Braunschweiger Bauernschmuck', in: *Festschrift für Marie Andree-Eysn,* Munich, 1928.

—, *Handwerksaltertümer (in Braunschweig).* (Werke aus Museum, Archiv und Bibliothek der Stadt Braunschweig, VII.) Brunswick, 1935.

FUNKENBERG, Alexander and THIELE, Ernst-Otto (eds.), *Tracht und Schmuck der Germanen in Geschichte und Gegenwart.* Leipzig, 1938.

GANDERT, August, *Tragkörbe in Hessen. Kulturelle und wirtschaftliche Bedeutung des Korbes.* Cassel, 1963.

GATZ, Konrad, *Das deutsche Malerhandwerk zur Blütezeit der Zünfte.* Munich, n.d.

GEBHARD, Torsten, 'Volkstümliche Kinderwiegen in Altbayern und Bayerisch Schwaben', in: *Bayerischer Heimatschutz,* 31, 1935, pp. 1–6.

—, 'Die volkstümliche Möbelmalerei in Altbayern mit besonderer Berücksichtigung des Tölzer Kistlerhandwerks', in: ibid., 31, 1936, pp. 5–170 Also published separately, Munich, 1937.

—, 'Die landschaftliche Gliederung der süddeutschen Bauernschränke', in: *Süddeutsche Volkskunst,* ed. Josef Maria Ritz, Munich, 1938, pp. 18–28.

—, 'Aufgaben der deutschen Bauernmöbelforschung', in: *Volkswerk,* 1942, pp. 18–36.

—, 'Zur Technik der alten Möbelbemalung', in: *Das deutsche Malerblatt. Illustriertes Fachblatt für das Malerhandwerk* (Stuttgart), 20, 1949, pp. 90 ff.

—, 'Hell und Dunkel in der Volkskunst', in: *Bayerisches Jahrbuch für Volkskunde,* 1950, pp. 65–74.

—, 'Das Erlebnis des Pittoresken und die Entdeckung der Volkskunst', in: *Zeitschrift für Volkskunde,* 51, 1954, pp. 153–64.

—, 'Frühe Stufen volkstümlicher Schablonenmalerei und verwandte Werke aus der Zeit zwischen Gotik und Barock', in: *Carinthia,* I (Mitteilungen des Geschichtsvereins für Kärnten (Klagenfurt), 145, 1955, pp. 490 ff.)

—, 'Die Auswertung des Massivholzes in der volkstümlichen Sachkultur und verwandte Erscheinungen', in: *Bayerisches Jahrbuch für Volkskunde,* 1962, pp. 128–49.

—, 'Deutschland, Volkskunst', in: Torsten Gebhard and Hanika Josef (eds.): *Iro-Volkskunde.* Munich, 1963, pp. 11–16.

—, 'Volkskunstforschung. Bericht des Leiters der Arbeitsgruppe', in: *Arbeit und Volksleben. Deutscher Volkskundekongress 1965 in Marburg.* (Veröffentlichungen des Instituts für mitteleuropäische Volksforschung an der Philipps-Universität Marburg an der Lahn. Göttingen, 1967, pp. 156–9.)

—, 'Der Begriff der Echtheit in der Volkstracht', in: *Volkskultur und Geschichte. Festgabe für Josef Dünninger zum 65. Geburtstag,* ed. Dieter Harmening et al., Berlin, 1970.

—, et al., *Handbuch der Bayerischen Museen und Sammlungen,* 2nd ed. Regensburg, 1973.

GEBHARDT-VLACHOS, Sibylle, 'Kandern als Töpferstadt. Von der Bauerntöpferei zur Kunstkeramik', in: *Das Markgräflerland. Beiträge zu seiner Geschichte und Kultur,* new series, 1974, fasc. 3–4.

GERSTENFELD, 'Ländliches Hausgerät aus schleswig-holsteinischen Museen', in: Karl Mühlke (ed.), *Von nordischer Volkskunst,* Berlin, 1906, pp. 101–10.

GIERL, Irmgard, *Trachtenschmuck aus fünf Jahrhunderten.* Rosenheim, 1973.

GÖBELS, Karl, *Rheinisches Töpferhandwerk, gezeigt am Beispiel der Frechener Kannen-, Düppen- und Pfeifenbäcker.* Frechen, 1971.

GOOS, Johannes, 'Das Hörnschapp', in: *Schleswig-Holsteinisches Jahrbuch* (Hamburg), 1918–19, pp. 32–4.

GRÖBER, Karl, *Deutsche Volkskunst,* vol. 5: *Schwaben.* Munich, n.d.

—, 'Die Ofenwand im altwürttembergischen Schwarzwald', in: *Bayerischer Heimatschutz,* 21, 1925, pp. 92 ff.

—, *Alte Oberammergauer Hauskunst.* (Beiträge zur Volkskunstforschung und Volkskunde, ed. for Deutschen Volkskommission J.M. Ritz and A. Spamer.) Augsburg, [1930].

GROHNE, Ernst, *Tongefässe in Bremen seit dem Mittelalter, untersucht auf Grund von Bodenfunden.* (Jahresschrift des Focke-Museums, Bremen, 1940.)

GROSCHOPF, Günter, 'Die süddeutsche Hafnerkeramik', in: *Jahrbuch 1937 des Bayerischen Landesvereins für Heimatschutz,* pp. 37–46.

—, 'Die letzten Bauerntöpfer in Württemberg', in: *Volkswerk*, 1941, pp. 263–70.

—, 'Was ist Volkskunst?', in: *Volkswerk*, 1943, pp. 50–7.

GROTE, Ludwig, 'Expressionismus und Volkskunst', in: *Zeitschrift für Volkskunde*, 55, 1959.

GRUNDMANN, Günther and HAHM, Konrad, *Deutsche Volkskunst*, vol. 8: *Schlesien*. Munich, [1926].

—, 'Bunte schlesische Bauernstuben und Dorfkirchen', in: *Westermanns Monatshefte*, 79, 1935, pp. 357–60.

GÜTHLEIN, Hans, 'Drei fränkische Schäfer als Bildschnitzer', in: *Bayerischer Heimatschutz*, 24, 1928, pp. 53–8.

—, 'Der Schreinermeister Johann Michael Gerbing von Breitenau', in: ibid., 25, 1929, pp. 19–29.

—, 'Der westmittelfränkische Bräutelwagen in alter Zeit', in: ibid., 30, 1934, pp. 21–6.

HABERLANDT, Arthur, 'Begriff und Wesen der Volkskunst', in: *Jahrbuch für historische Volkskunde*, II, 1926, pp. 20–32.

—, *Die deutsche Volkskunde*. (Volk, Grundriss der deutschen Volkskunde in Einzeldarstellungen, ed. Kurt Wagner, vol. I.) Halle an der Saale, 1935.

HABERLANDT, Michael, 'Volkskunde und Kunstwissenschaft', in: *Jahrbuch für historische Volkskunde*, I, 1925, pp. 217–31.

—, 'Die europäische Volkskunst in vergleichender Betrachtung', in: ibid., II, 1926, pp. 33–43.

HABERLANDT, Michael and Arthur, *Die Völker Europas und ihre volkstümliche Kultur*. Stuttgart 1928. (Special issue of Buschan, *Illustrierte Völkerkunde*, II, 2.)

HÄHNEL, Joachim, *Stube, Wort- und sachgeschichtliche Beiträge zur historischen Hausforschung*. (Schriften der Volkskundlichen Kommission des Landschaftsverbandes Westfalen-Lippe, vol. 21.) Münster, 1975.

HÄVERNICK, Walter, 'Volkskunst' und 'temporäre Gruppenkunst'. Ein Diskussionsbeitrag zur volkskundlichen Nomenklatur, in: *Beiträge zur deutschen Volks- und Altertumskunde*, 9, 1965, pp. 119–25.

HAGER, Georg, 'Die Weihnachtskrippe', in: *Volkskunst und Volkskunde*, 2, 1904, pp. 105–14; 3, 1905, pp. 1–9.

—, *Die Weihnachtskrippe. Ein Beitrag zur Volkskunde und Kunstgeschichte aus dem Bayerischen Nationalmuseum*. Munich, 1902.

HAHM, Konrad, *Deutsche Volkskunst*. Berlin, 1928.

—, 'Grundzüge der deutschen Volkskunst', in: Adolf Spamer (ed.), *Die Deutsche Volkskunde*, vol. I, Berlin, 1934, pp. 400–13.

—, *Ostpreussische Bauernteppiche*. Jena, 1937.

—, *Deutsche Bauernmöbel*. Jena, 1939.

HANSEN, Hans Jürgen (ed.), *Europas Volkskunst und die europäisch beeinflusste Volkskunst Amerikas*. Oldenburg and Hamburg, 1967.

—, *Kunstgeschichte des Backwerks*. Oldenburg and Hamburg, 1968.

HANSEN, H. P., *Jydepotter og løb. Gamle danske husflid*. Copenhagen, 1944.

HANSEN, Wilhelm, 'Fachwerkbau im Oberweserraum', in: *Kunst und Kultur im Weserraum 800–1600. Ausstellung des Landes Nordrhein-Westfalen*, I. *Beiträge zu Geschichte und Kunst*. Corvey, 1966, pp. 296–313.

HARSING, Friedhard, 'Formenmodel für Marzipan und Honigkuchen im westlichen Niederdeutschland'. Unpublished Ph. D. dissertation, Göttingen, 1956.

HARTMANN, A., 'Zur Geschichte der Berchtesgadener Schnitzerei', in: *Volkskunst und Volkskunde*, I, 1903, pp. 61–9, 87–92.

HARTMANN, Karl O., *Die Wiedergeburt der deutschen Volkskunst als wichtigstes Ziel der künstlerischen Bestrebungen unserer Zeit und die Wege zu seiner Verwirklichung*. Munich and Berlin, 1917.

HARVOLK, Edgar, *Votivtafeln*. (Bilderhefte der Staatlichen Museen Preussischer Kulturbesitz, Museum für Deutsche Volkskunde, fasc. 32.), Berlin, 1977.

HECKMANNS, Fr., 'Wetterfahnen', in: *Die Heimat* (Krefeld), 5, 1926, p. 54.

HEINEMEYER, Elfriede and OTTENJANN, Helmut, *Alte Bauernmöbel aus dem nordwestlichen Niedersachsen*. (Nordwestniedersächsische Regionalforschungen, I.) Leer, 1974.

HELLWAG, Fritz, *Die Geschichte des deutschen Tischlerhandwerks*. Berlin, 1924.

—, 'Volkskunst und Möbeltischlerei', in: *Jahrbuch für historische Volkskunde*, 3–4, 1934, pp. 34–45.

HERMANN, Hans August, 'Der "Bauerntanz" in Holstein', in: *Nordelbingen* (Heide in Holstein), 14, 1938, pp. 138–64.

HERMANN, Manfred, *Volkskunst auf dem Hochberg bei Neufra. Zeugnisse der Volksfrömmigkeit auf der Zollernalb*. Sigmaringen, 1974.

HEYNE, Moritz, *Das deutsche Wohnungswesen von den ältesten geschichtlichen Zeiten bis zum 16. Jh.* (Fünf Bücher deutscher Hausaltertümer, vol. I.) Leipzig, 1899.

HILLENBRAND, Karl, *Schwäbische Ofenwandplättchen*. (Der Museumsfreund (Stuttgart), 12–13.)

—, *Bemalte Bauernmöbel aus württembergisch Franken*. Stuttgart, 1956.

—, *Dachziegel und Zieglerhandwerk*. n. p., n. d.

HÖCK, Alfred, 'Beiträge zur hessischen Töpferei', in: *Hessische Blätter für Volkskunde*, 56, 1970.

—, *Kurze Geschichte der Marburger Töpferei*. Marburger Universitätsmuseum für Kunst und Kulturgeschichte, exhibition guide, 1972.

— and KRAMER, Dieter, *Verzeichnis der volkskundlichen und kulturgeschichtlichen Bestände der hessischen Museen*. Marburg, 1970.

HÖFLER, M., 'Vogelgebäcke', in: *Globus*, 89, 1906, pp. 221–2.

—, 'Das Herz als Gebildbrot', in: *Archiv für Anthropologie*, new series, 5, 1906, pp. 263–75.

—, 'Gebäcke und Gebildbrote', in: *Zeitschrift für Volkskunde*, 24, 1914, pp. 305–9.

—, 'Gebildbrote in Tierform', in: Bayerische Hefte für Volkskunde, I, 1914, 3, pp. 145–55.

HÖRMANN, Konrad, 'Herdengeläute und seine Bestandteile', in: *Hessische Blätter für Volkskunde*, 1913–16 (vols. XII–XV).

HOFFMANN, Anna, *Die Tracht des Kirchspiels Ostenfeld*. Heide in Holstein, 1952.

—, *Die Landestrachten von Nordfriesland*. (Schriftenreihe des Schleswig-Holsteinischen Landesmuseums Kiel in Verbindung mit der Gesellschaft für Schleswig-Holsteinische Geschichte, vol. 2.) Heide in Holstein, [1940].

—, *Die Probsteier Volkstracht*. (Schriftenreihe des Schleswig-Holsteinischen Landesmuseums, Kiel, vol I.) Heide in Holstein, n. d.

HOFMANN, Josef, *Die ländliche Bauweise. Einrichtung und Volkskunst des 18. und 19. Jhs. der Karlsbader Landschaft*. (Karlsbader Heimatbücher, 5.) Karlsbad, 1928.

HOPF, Herbert, *Studien zu den Bildstöcken in Franken*. (Mainfränkische Hefte, 54.) Würzburg, 1970.

HORSCHIK, Josef, *Steinzeug des 15.–19. Jhs. Sachsen, Thüringen, Schlesien*. Dresden, 1976 (?).

HUMMEL, Georg, 'Thüringer Bauernmöbel', in: *Das Thüringer Fähnlein*, 4, 1935, pp. 202–6.

INGWERSEN, Katharine, 'Die Friesenstube', in: *Die Heimat* (Flensburg), 48, 1938, pp. 109–16.

ISENSEE, W., 'Braunschweiger Honigkuchen und Honigkuchenformen', in: *Braunschweiger Landeszeitung*, 1930, No. 217.

JAKSTEIN, Werner, 'Die alte Wohnungskunst im Bauernhause Schleswig-Holsteins', in: *Schleswig-Holsteinischer Kunstkalender* (Potsdam), 1914, pp. 68–73.

JAQUES, Renate, *Deutsche Textilkunst*. Berlin, 1942.

JEDDING, Hermann, *Volkstümliche Keramik aus deutschsprachigen Ländern*. (Bildhefte des Museums für Kunst und Gewerbe, Hamburg, 13.) Hamburg, 1976.

JOHNSEN, Wilhelm, 'Die Johannsen in Eddelak, ein ländliches Baumeistergeschlecht', in: *Sippe der Nordmark* (Kiel), IV, 1940.

—, 'Volkskunst in Dithmarschen', in: *Die Heimat* (Neumünster), 1951, pp. 318–21.

JOSTES, Franz, *Westfälisches Trachtenbuch. Volksleben und Volkskultur in Westfalen*. 2nd ed., revised by Martha Bringemeier, Münster, 1961.

—, 'Sechsschläfrige Betten', in: *Westfalen*, 4, 1912, pp. 103–4.

JÜTTEMANN, Herbert, *Die Schwarzwalduhr*, Brunswick, 1972.

KAMPHAUSEN, Alfred, 'Volkskundliches und Volkskunstforschung zur Unterbauung neuer kunstgeschichtlicher Betrachtung', in: *Beiträge zur Deutschen Volkskunde. Otto Lehmann zum 70. Geburtstage*, Berlin and Leipzig, 1935, pp. 78–88.

—, 'Von der Farbigkeit nordfriesischer Paneele', in: *Volkskunst* (Munich) I, 1978, pp. 26–30.

KARASEK-LANGER, Alfred, '350 Jahre Weihnachtskrippe in Oberschlesien', in: *Unser Oberschlesien.* 1966.

KARLINGER, Hans, *Deutsche Volkskunst*, vol. 4: *Bayern*, Munich, [1925], Berlin, 1938.

—, 'Grenzen der Volkskunst', in: *Bayerischer Heimatschutz*, 23, 1927, pp. 10–17.

—, *Deutsche Volkskunst.* (Propyläen-Kunstgeschichte.) Berlin, 1938.

KARUTZ, R., 'Ursprung und Formen der Wiege', in: *Globus*, 75, 1899, pp. 233–38.

KASTNER, Heinrich, 'Die Obstädter Kistler', in: *Bayerisches Jahrbuch für Volkskunde*, 1957, pp. 15 ff.

KASTNER, Otfried, *Ranzen, Gürtel, Federkiel. Alte volkstümliche Lederkunst.* Linz, 1974.

KAUFMANN, Gerhard, 'Zur Möbeltischlerei in der Wilstermarsch', in: *Volkskunst* (Munich) I, 1978, pp. 42–52.

—, *Bemalte Wandfliesen.* Munich, 1973.

KEUTH, Hermann, 'Bauerntruhen von der Saar', in: *Die Schule*, 8, 1955, pp. 1–6.

KIPPENBERGER, Albrecht, *Hessische Bauernkunst im Universitäts-Museum zu Marburg. Zugleich ein Bericht über Neuerwerbungen und Neuaufstellung.* Marburg, 1939.

KLEIN, A., *Rheinisches Steinzeug des 15. und 16. Jhs.* Darmstadt, 1957.

KLEIN, Dorothea, 'Beiderwand-Studien', in: *Jahrbuch für historische Volkskunde*, vol. III–IV, 1934, pp. 221–34.

KNAIPP, Friedrich, 'Hinterglasbilder', in: *Weltkunst*, 44, 1974, p. 1778.

KÖNIG, Felix, *Niederrheinische Truhen. Entwicklung und Gestalt in Zeit und Raum.* (Schriften zur Kulturgeschichte des Rheinisch-westfälischen Industriegebietes, I, Essen, 1960.)

KÖNIG, Maria Angela, *Weihegaben an Unsere Liebe Frau in Altötting.* 2 vols. Munich, 1939–40.

KÖSTER, Kurt, 'Mittelalterliche Pilgerzeichen und Wallfahrtsdevotionalien', in: *Rhein und Maas, Kunst und Kultur 800–1400*, Cologne, 1972, pp. 146–60.

KRAMER, Karl-S., 'Altmünchener Handwerk. Bräuche, Lebensformen, Wanderwege', in: *Bayerisches Jahrbuch für Volkskunde*, 1958, pp. 111–37.

KRISS, Rudolf, *Eisenopfer. Das Eisenopfer in Brauchtum und Geschichte.* Munich, 1957.

—, *Die Volkskunde der alt-bayrischen Gnadenstätten.* 3 vols., Munich, 1953–6.

KRISS-RETTENBECK, Lenz, *Das Votivbild.* Munich, 1958.

—, *Bilder und Zeichen religiösen Volksglaubens.* Munich, 1963.

— and HANSMANN, Liselotte, *Amulett und Talisman.* Munich, 1966.

—, 'Materielle und spirituelle Perspektive und Tiefenraum in volkstümlichen Krippen des 19. und 20 Jhs.', in: *Bayerisches Jahrbuch für Volkskunde*, 1970, pp. 192–203.

—, 'Was ist Volkskunst?', in: *Zeitschrift für Volkskunde*, 68, 1972, pp. 1–19.

—, *Ex Voto. Zeichen, Bild und Abbild im christlichen Votivbrauch.* Zurich and Freiburg i. B., 1972.

—, 'Der Hund "Greif" und die Frage "Was ist Volkskunst?"', in: *Pantheon* (Munich), XXXIII, 1975, pp. 145–52.

KRONBERGER-FRENTZEN, Hanna, *Die alte Kunst der süssen Sachen. Backformen und Waffeleisen vergangener Jahrhunderte.* Hamburg, 1959.

KRÜGER, Franz, 'Der Ziegelstein', in: *Jahrbuch für historische Volkskunde*, vol. III–IV, 1934, pp. 143–60.

LANGEMATZ, Rolf and NEDO, Paul, *Sorbische Volkskunst.* Bautzen, [1968].

LANGEWIESCHE, Fr., *Sinnbilder Germanischen Glaubens im Wittekindsland.* Eberswalde, 1935 [see only for the illustrations].

LAUFFER, Otto, 'Die Bauernstuben des Germanischen Museums', in: *Mitteilungen aus dem Germanischen Nationalmuseum*, 1903, pp. 3–55; 1904, pp. 3–37, 143–95.

—, *Zur Geschichte der Irdenware in Frankfurt a. M.* (Einzelforschungen über Kunst- und Altertumsgegenstände zu Frankfurt am Main, I, 1908, pp. 49–60.)

—, 'Zur Geschichte des Kachelofens und der Ofenkachel in Deutschland. Mit einer Beilage zur Geschichte der Fliese', in: *Wörter und Sachen*, 6, 1914–15, pp. 145–72.

—, 'Deutsche Volkskunst', in: *Zeitschrift für Deutschkunde*, 41, 1927, pp. 593–611.

—, *Der Weihnachtsbaum in Glauben und Brauch.* (Hort deutscher Volkskunde, I.) Berlin and Leipzig, 1934.

—, *Niederdeutsches Bauernleben in Glasbildern der neueren Jahrhunderte.* (Hort deutscher Volkskunde, 3.) Berlin and Leipzig, 1936.

—, *Farbensymbolik im deutschen Volksbrauch.* Hamburg, 1948.

LEHMANN, Otto, 'Die Wilstermarsch', in: *Das Hamburgische Museum für Kunst und Gewerbe*, Hamburg, 1902, pp. 195–99.

—, 'Die Volkskunst in der Internationalität', in: *Volkstum und Kulturpolitik, gewidmet Georg Schreiber*, Cologne, 1932, pp. 100–17.

—, *Deutsches Volkstum in Volkskunst und Volkstracht.* (Deutsches Volkstum, ed. John Meier, vol. I.) Berlin, 1938.

LEHMANN, Wingolf, 'Beiträge zur Geschichte des Töpferhandwerks in Westfalen', in: *Rheinisch-westfälische Zeitschrift für Volkskunde*, 17, 1970, pp. 101–27.

— (ed.), *Töpferei in Nordwestdeutschland.* (Beiträge zur Volkskultur in Nordwestdeutschland, ed. Volkskundliche Kommission für Westfalen. Landschaftsverband Westfalen-Lippe, fasc. 3.) Münster, 1975.

LEONHARD, Walter, *Schöne alte Wirtshausschilder.* Munich, 1977.

LINDNER, Werner, *Deutsche Volkskunst*, vol. 2: *Mark Brandenburg.* Munich, [1924].

LIPP, Franz Carl, *Bemalte Gläser. Volkstümliche Bildwelt auf altem Glas.* Munich, 1974.

LOCKNER, H.P., 'Das Handwerk der Beckenschläger. Zu den in Negative geschlagenen Messingschüsseln des 15. und 16. Jhs.' in: *Kunst und Antiquitäten*, 1977, pp. 24–30.

LÜHNING, Arnold, 'Bäuerliches Mobiliar im Kreise Pinneberg', in: *Jahrbuch für den Kreis Pinneberg*, 1967, pp. 21–34.

—, Schleswig-Holsteinische Museen und Sammlungen, 3rd ed., Flensburg, 1976. [4th ed. pending.]

LÜPKES, W., *Ostfriesische Volkskunde.* 2nd ed., Emden, 1925.

—, *Tracht und Schmuck in Ostfriesland.* Wittmund, 1932.

MANGOLD, Hans et al., *Museen in Hessen.* Cassel, 1970.

Masken zwischen Spiel und Ernst. Beiträge des Tübinger Arbeitskreises für Fasnachtforschung. (Volksleben, vol. 18.) Tübingen, 1967.

MEHL, Heinrich, *Bildstöcke im nördlichen Unterfanken.* Ph.D. dissertation, Würzburg, 1969.

MEYER, Hans Bernhard, 'Norddeutsche Backformen und ihre Motive', in: *Ostdeutsche Monatshefte*, 6, 1937, pp. 347–56.

—, *Deutsche Volkskunst*, new series, *Danzig*, Weimar, [1939].

MEYER (?), *Spielwarenindustrie im sächsischen Erzgebirge.* 1921.

MEYER-HEISIG, Erich, 'Die Heimatkultur des schlesischen Bauerntums der Vergangenheit: Die Möbel', in: *Schlesische Heimat*, 1938, pp. 15–21.

—, *Bauerntum in Schlesien. Kunstsammlungen der Stadt Breslau*, 2nd ed., Breslau, 1940.

—, 'Eine deutsche Bauernstube um 1500', in: Germanisches Nationalmuseum, Nuremberg, *95. Jahresbericht*, 1950, pp. 67–71.

—, *Die deutsche Bauernstube. Art und Entwicklung der Stube im deutschen Bauernhaus nebst einem Anhang mit Beispielen heutiger Stubengestaltung.* Nuremberg, 1952.

—, *Deutsche Volkskunst.* Munich, 1954.

—, *Deutsche Bauerntöpferei. Geschichte und landschaftliche Gliederung.* Munich, 1955.

—, *Weberei, Nadelwerk, Zeugdruck. Zur deutschen volkstümlichen Textilkunst.* Munich, 1956.

—, 'Das Herz in der Volkskunst', in: *Das Herz*, vol. 2, Biberach, n. d., pp. 107–36.

MICHAILOW, Nikola, 'Das bäuerliche Hinterglasbild', in: *Westermanns Monatshefte*, 1936, pp. 313–20.

MIELKE, Robert, *Volkskunst.* Magdeburg, 1896.

—, 'Bauernschmuck', in: *Mittheilungen aus dem Museum für Deutsche Volkstrachten und Erzeugnisse des Hausgewerbes zu Berlin*, I, 1897–1901, pp. 296–334; 2, 1903–6, pp. 25–39.

—, 'Bäuerliche Schmucksachen', in: *Das Hamburgische Museum für Kunst und Gewerbe*, Hamburg, 1902, pp. 200–4.

MILLER, Arthur Maximilian, *Kunstsinn und Erfindergeist*

im Bauernhof. Das Bauernhof-Museum in Illerbeuren. Memmingen, 1968.

MÖLLER, Theodor, *Der Kirchhof in Nebel auf Amrum und seine alten Grabsteine.* Neumünster, 1928.

MÖSSINGER, Friedrich, 'Bäckerwerk', in: *Volkswerk,* 1943, pp. 115–34.

—, 'Seltene Gebildbrote', in: *Hessische Blätter für Volkskunde,* 45, 1954, pp. 34–62.

—, *Bildstöcke im Odenwald.* Heppenheim an der Bergstrasse, 1962.

MÜHE, Richard, 'Die Entwicklung der Schwarzwälder Uhr', in: *Museumsfreund,* 2, 1962, pp. 4–22.

MÜHLKE, Karl (ed.), *Von nordischer Volkskunst.* Berlin, 1906.

MÜLLER, Heidi, *Volkstümliche Möbel aus Nordschwaben und den angrenzenden Gebieten.* Munich, 1975.

MÜLLER, Helmut, *Töpferei in Schermbeck.* (Beiträge zur Volkskultur in Nordwestdeutschland, 4.) Münster, 1976.

MÜLLER-BRAUEL, Hans, 'Niedersächsische Bauerntruhen', in: *Niederdeutsche Heimatblätter,* 2, 1925, pp. 206–9.

MÜLLER-WULCKOW, Walther, 'Niederdeutsche Volkskunst im Oldenburger Landesmuseum', in: *Velhagen und Klasings Monatshefte,* 41, 1926–27, pp. 41–56.

—, 'Die Truhen des Oldenburger Ammerlandes an der Wende vom Mittelalter zur Neuzeit', in: *Niedersachsen,* 60, 1960, pp. 16–22.

—, 'Oldenburger Truhen vor und nach 1600', in: ibid., 61, 1961, pp. 447–56.

NACHTIGALL, Helmut, *Schmuck an Fachwerkhölzern im Kreis Giessen. Betrachtungen zur Schmuckgestaltung in der Holzbaukunst.* Giessen, 1969.

NAUMANN, Hans, *Grundzüge der deutschen Volkskunde.* (Wissenschaft und Bildung, 181.) 2nd ed., Leipzig, 1929.

NAUMANN, Joachim (ed.), *Meisterwerke hessischer Töpferkunst. Wanfrieder Irdenware um 1600.* Staatliche Kunstsammlungen, Cassel exhibition catalogue. Cassel, 1974.

— (ed.), *Hessische Töpferei zwischen Spessart, Rhön und Vogelsberg.* Staatliche Kunstsammlungen, Cassel, exhibition catalogue, Cassel, 1975.

— (ed.), *Haubenschachteln.* (Schriften zur Volkskunde, 2.) Staatliche Kunstsammlungen, Cassel, 1977.

NEHMITZ, Hanshugo, 'Schlesische Brotschränke. Ein Beitrag zur Geschichte bäuerlichen Hausrates', in: *Schlesische Heimat* (Breslau), 1937, pp. 23 ff.

NEMEČ, Helmut, *Alpenländische Bauernkunst. Eine Darstellung für Sammler und Liebhaber.* Gütersloh, 1966.

—, *Alter Bauernschmuck.* Vienna and Munich, 1973.

—, *Schätze der Volkskunst.* Vienna, 1976.

NEUMANN, Siegfried, 'Lade und Koffer im bäuerlichen Mobiliar Westmecklenburgs', in: *Deutsches Jahrbuch für Volkskunde,* II, 1965, pp. 123–36.

OHM, Annaliese, *Volkskunst am unteren rechten Niederrhein. Sammlung und Aufnahmen im Kreise Reees.* (Werken

und Wohnen. Volkskundliche Untersuchungen im Rheinland, ed. Matthias Zender, vol. 3.) Düsseldorf, 1960.

OLSEN, Bernhard, 'Minnegaben', in: *Das Hamburgische Museum für Kunst und Gewerbe,* Hamburg, 1902, pp. 205–18.

OSTERTAG, Tilde, *Das Fichtelgebirgsglas.* (Beiträge zur fränkischen Kunstgeschichte, new series, vol. 2.) Erlangen, 1933.

OTTENJANN, Heinrich, 'Münsterländische Bauernwiegen', in: *Oldenburger Jahrbuch,* 39, 1935, pp. 67–71.

—, *Alte deutsche Bauernmöbel.* Hanover and Uelzen, 1954.

—, 'Ein Meister der Volkskunst von aussergewöhnlicher Gestaltungskraft' [deals with furniture from Hümmling], in: *Heimatkalender für das Oldenburger Münsterland,* 1957, pp. 70–5.

—, 'Ammerländer Bauernmöbel im Oldenburger Münsterland', in: *Niedersachsen,* 58, pp. 169–75.

OTTO, Günter, 'Figürliche Bienenstöcke im schlesischen Raum' in; *Volkswerk,* 1941, pp. 255–62.

PASSARGE, Walter, 'Zur stilgeschichtlichen Stellung der Schenkschive', in: *Festschrift aus Anlass des 25jährigen Eröffnungstages des Museumsgebäudes.* Kunstgewerbemuseum, Flensburg, 1928, pp. 83–99.

—, 'Probleme der Volkskunst', in: *Das Werk des Künstlers,* I, 1939–40, pp. 333–61.

PEESCH, Reinhard, *Holzgerät in seinen Urformen.* (Deutsche Akademie der Wissenschaften zu Berlin. Veröffentlichungen des Instituts für deutsche Volkskunde, vol. 42.) Berlin, 1966.

PELSER-BERENSBERG, F. von, *Mitteilungen über Trachten, Hausrat, Wohn- und Lebensweise im Rheinland.* Düsseldorf, 1909.

—, *Mittheilungen über alte Trachten und Hausrath, Wohn- und Lebensweise der Saar- und Moselbevölkerung.* 2nd ed. Trier, 1901.

PELTZER, R. A., 'Geschichte der Messingindustrie und der künstlerischen Arbeiten in Messing (Dinanderies) in Aachen und den Ländern zwischen Maas und Rhein von der Römerzeit bis zur Gegenwart', in: *Zeitschrift des Aachener Geschichtsvereins,* 30, 1908.

PESSLER, Wilhelm, *Deutsche Volkskunst,* vol. I: *Niedersachsen,* Weimar, 1923.

—, 'Niedersächsische Bauernstuben. Beispiele ländlicher Handwerkskunst im Niedersächsischen Volkstumsmuseum zu Hannover', in: *Niedersachsen,* 42, 1937, pp. 455–61.

PETRICH, Ernst, 'Eine ostfriesische Töpferwerkstatt', in: *Volkswerk,* 1941, pp. 270–76.

—, *Aufsätze über ostfriesische Wohnkultur.* (Schriften des Vereins für Heimatschutz und Heimatgeschichte Leer, No. 20.) n. p., n. d.

PFAU, Clemens, *Geschichte der Töpferei in der Rochlitzer Gegend.* 1905.

PFLUG, Walter, 'Die Kinderwiege, ihre Formen und ihre Verbreitung. Ein Beitrag zur Verbreitungsfrage von

Kulturgütern', in: *Archiv für Anthropologie,* new series, 19, 1923, pp. 185–223.

PIEPER, Paul, *Kunstgeographie. Versuch einer Grundlegung.* Ph. D. dissertation, Bonn, 1936.

PIESKE, Christa, 'Lübecker Marzipan — weit hergeholt', in: *Der Wagen* (Lübeck), 1967, pp. 123–28.

—, *Marzipan aus Lübeck. Der süsse Gruss einer alten Hansestadt.* Lübeck, 1977.

PLATH, Helmut, 'Mittelalterliche Keramik vom 12. bis zum 15. Jh. in Hannover', in: *Hannoversche Geschichtsblätter,* new series, 12, 1958, pp. 1–39.

—, 'Zur Typologie der Schaumburger und Stader Spangen', in: *Heimat und Volkstum. Jahrbuch des Vereins für Niedersächsisches Volkstum,* Bremen, 1959–60, pp. 45–61.

PRETZELL, Lothar, *Volkskunst und Volkshandwerk. 75 Jahre Museum für Deutsche Volkskunde.* Museum für Deutsche Volkskunde in Berlin, exhibition catalogue, Berlin, 1964.

RATTELMÜLLER, Paul Ernst, *Per Post und zu Fuss durch Oberbayern. Künstler entdecken eine Landschaft.* Munich, n. d., (2nd ed.).

—, *Dirndl, Janker, Lederhosen.* Munich, n. d.

RAUSCH, *Die Sonneberger Spielwarenindustrie.* 1901.

REDLEFSEN, Ellen, 'Möschenpötte und Wöchnerinnenschalen', in: *Die Heimat* (Kiel) 48, 1938, pp. 322–30.

—, 'Angeliter Brauttruhen des 17. Jhs.', in: *Nordelbingen* (Heide in Holstein), 23, 1955, pp. 71–7.

—, *Nordschleswig im Flensburger Museum.* Flensburg, 1969.

—, *Katalog der Möbelsammlung.* Städtisches Museum, Flensburg, 1976.

REINSTORF, E., *Elbmarschenkultur zwischen Bleckede und Winsen an der Luhe.* Harburg-Wilhelmsburg, 1929.

REITZ, G., 'Der Formschneider oder Modelstecher, ein schöpferisches Handwerk', in: *Sächsische Heimatblätter,* 5, 1959, pp. 226–35.

RICHTER, Erwin, 'Kasimir Brunner. Ein Tiroler Kistlermeister und Votivtafelmaler in Bayern', in: *Kultur und Volk. Beiträge zur Volkskunde aus Österreich, Bayern und der Schweiz.* (Veröffentlichungen des Österreichischen Museums für Volkskunde, 5.) Vienna, 1954, pp. 361–7.

RIEBELING, Heinrich, *Steinkreuze und Kreuzsteine in Hessen. Ein topographisches Handbuch zur rechtlichen Volkskunde.* Dossenheim, 1977.

RIEGL, Alois, 'Hessische Bauernstühle', in: *Mitteilungen des K. K. Österreichischen Museums für Kunst und Industrie,* new series, 3, 1891, pp. 11–15.

—, *Volkskunst, Hausfleiss und Hausindustrie.* Berlin, 1894.

—, 'Das Volksmässige und die Gegenwart', in: *Zeitschrift für österreichische Volkskunde,* I, 1895, pp. 1 ff.

RIEMANN, Erhard, 'Ost- und westpreussische Volkskunst', in: *Jahrbuch für ostdeutsche Volkskunde,* 15, 1972, pp. 7–21.

RINGLER, Josef, *Deutsche Weihnachtskrippen*. Innsbruck, 1929.

RIFF, Adolf, 'Volkskunst im Sundgau. Bauernhaus, Stube, Möbel und Hausgerät. Ein Beitrag zur Volkskunde des Oberrheins', in: *Oberdeutsche Zeitschrift für Volkskunde*, 16, 1942, pp. 41–70; 17, 1943, pp. 132–42.

RITZ, Gislind, 'Alois Riegls kunstwissenschaftliche Theorien und die Volkskunst', in: *Bayerisches Jahrbuch für Volkskunde*, 1956, pp. 39–41.

—, *Der Rosenkranz*. Munich, 1962.

—, 'Die bürgerlich-handwerkliche Hinterglasmalerei des 18. Jhs. in Augsburg', in: *Bayerisches Jahrbuch für Volkskunde*, 1964–5, pp. 47 ff.

—, *Hinterglasbilder*. (ettaler imago, 4.) Ettal, 1968.

—, 'Eigengesetzlichkeit in der Volkskunst', in: *Bayerisches Jahrbuch für Volkskunde*, 1969, pp. 176–91.

—, *Alte bemalte Bauernmöbel, Europa*. Munich, 1970.

—, *Alte geschnitzte Bauernmöbel*. Munich, 1974.

—, *Hinterglasmalerei. Geschichte, Erscheinung, Technik*. Munich, 1972, 2nd ed. 1975.

RITZ, Josef Maria, *Deutsche Volkskunst*, vol. 6: *Franken*, Munich, [1926].

—, 'Doppelschüsseln', in: *Zeitschrift für Volkskunde*, new series, II, 1930, pp. 192–5.

—, *Bauernmalerei*. (Meyers bunte Bändchen.) Leipzig, 1935 and later editions.

—, 'Holz' in: Adolf Spamer (ed.): *Die deutsche Volkskunde*, vol. I, Berlin, 1936, pp. 414–35.

—, 'Stock und Stab' in: Bayerischer Landesverein für Heimatschutz, *Jahrbuch 1937*, pp. 29–36.

—, 'Das fränkische Bauernmöbel und die volkstümliche Bemalung von Holzwerk', in: *Volkswerk*, 1941, pp. 144–53.

—, 'Altbayerische Kasten- und Truhenbetten', in: *Volkswerk*, 1943, pp. 193–8.

—, 'Vom Bett und ähnlichen Liegestätten', in: *Der Zwiebelturm*, 5, 1950, pp. 34–7.

—, 'Rhöner Bauernmöbel', in: *Bayerisches Jahrbuch für Volkskunde*, 1950, pp. 75–8.

—, 'Über den Stand der fränkischen Möbelforschung', in: *Fränkische Blätter* (Bamberg), 2, 1950, pp. 49–51.

—, *Deutsche Bauernmöbel*. (Wohnkunst und Hausrat einst und jetzt, ed. Heinrich Kreisel, vol. 2.) Darmstadt, [1953].

—, 'Mittelalterliche Eisenvotive in Franken', in: *Kultur und Volk. Beiträge zur Volkskunde aus Österreich, Bayern und der Schweiz. Festschrift für Gustav Gugitz*. (Veröffentlichungen des Österreichischen Museums für Volkskunde, 5, pp. 381–5.

—, 'Eine Sonderform der volkstümlichen Gefässe im westlichen Mainfranken', in: *Hessische Blätter für Volkskunde*, 49–50, 1958, pp. 230–5.

—, 'Datierte Volkskunst' in: *Bayerisches Jahrbuch für Volkskunde*, 1959, pp. 162–4.

—, and RITZ, Gislind, *Alte bemalte Bauernmöbel*. Munich, 1975.

RÖHRICH, Lutz, *Adam und Eva. Das erste Menschenpaar in Volkskunst und Volksdichtung*. Stuttgart, 1968.

RÖRIG, Maria, *Haus und Wohnen in einem sauerländischen Dorfe*. (Schriften der Volkskundlichen Kommission im Provinzialinstitut für westfälische Landes- und Volkskunde, 5.) Münster, 1940.

—, 'Zur westfälischen Haubentracht des 19. Jhs.', in: *Westfalen*, 24, 1939, pp. 178–93.

—, 'Hauben und Falgen im Sauerland', in: ibid., 25, 1940, pp. 115–19.

ROSENFELD, Hans-Friedrich, 'Urtümliche Holzbearbeitung nach Wort, Sache und Brauchtum diesseits und jenseits der Ostsee', in: *Deutsches Jahrbuch für Volkskunde*, 2, 1956, pp. 147–78.

RUMPF, Karl, 'Marburger Geschirr', in: *Hessenkunst* (Marburg), 1925, pp. 26–38.

—, 'Hessische Töpferkunst in Vergangenheit und Gegenwart', in: *Festschrift zum Verbandstag Cassel 1926 des Verbandes der Arbeitgeber des Töpfer- und Ofensetzergewerbes Deutschlands*, Berlin, 1926, pp. 13 ff.

—, 'Alte hessische Stickereien', in: *Hessenkunst* (Marburg), 1927, pp. 45–60.

—, 'Marburger Wandfliesen', in: ibid., 1929, pp. 53–62.

—, 'Oberhessische Hausehrn', in: *Heimatschollen* (Melsungen), 1933, pp. 63–8.

—, 'Löffelkörbchen', in: *Hessenland*, 47, 1936, pp. 15–19.

—, 'Bäuerliche Grabmalkunst in Oberhessen'. I. 'Trachtengrabsteine', in: ibid., 47, 1936, pp. 138–43; II. 'Totenkrone-Tugendkrone', 48, 1937, pp. 165–73; III. 'Die Sinnbilder', in: ibid., pp. 168–78.

—, *Alte bäuerliche Weisstickereien*. (Beiträge zur hessischen Volks- und Landeskunde, fasc. I.) Marburg, 1937.

—, *Handwerkskunst am hessischen Bauernhaus*. Marburg, 1938.

—, 'Hessische Bauernstühle', in: *Hessenland*, 49, 1938.

—, 'Hessische Brautstühle', in: *Volkswerk*, 1942, pp. 37–53.

—, *Eine deutsche Bauernkunst*. (Schriften des Hessischen Landesamtes für Volkskunde, vol. 1.) Marburg, 1943.

—, 'Rhöner Mehlkästen', in: *Hessische Heimat* (Melsungen), new series, I, 1951, pp. 21–6.

—, *Deutsche Volkskunst*, new series, Hessen, Marburg, 1951.

—, 'Die wandelbare Bettstelle', in: *Hessische Blätter für Volkskunde*, 48, 1957, pp. 26–30.

—, 'Frühformen hessischer Truhen', in: *Zeitschrift für hessische Geschichte*, 1957, pp. 185–94.

—, 'Hessische Holzlöffel', in: *Hessische Blätter für Volkskunde*, 49–50, 1958, pp. 249–57.

—, 'Schlangen- und Flechtmusterstühle', in: *Zeitschrift für Volkskunde*, 55, 1959, pp. 259–70.

—, 'Gefässformen der volkstümlichen, hessischen Töpferei', in: *Hessische Blätter für Volkskunde*, 51–52, 1960, pp. 235–76.

—, 'Hessische Haustüren des 16. und 17. Jhs.', in: *Zeitschrift des Vereins für hessische Geschichte und Landeskunde*, 73, 1962, pp. 93–102.

—, 'Das Bett im hessischen Bauernhaus. Zugleich ein Beitrag zur Geschichte des Bettes', in: ibid., 74, 1963, pp. 125–42.

—, 'Brettstühle. Englische und französische Stuhlmoden des 18. Jhs. als Vorbild', in: *Zeitschrift für Volkskunde*, 63, 1967, pp. 236–52.

—, 'Bauernmöbel, Oberhessische Schränke', in: *Hessische Blätter für Volkskunde*, 59, 1968.

SAGE, Walter, *Deutsche Fachwerkbauten*. Königstein im Taunus, 1976.

SAUERLANDT, Max, 'Vierländer Kunst', in: *Westermanns Monatshefte*, 1906, October.

SAUERMANN, Ernst, 'Eine nordschleswigsche Schnitzschule um das Jahr 1600', in: *Verwaltungsbericht des Flensburger Museums 1901–05*, pp. 71–91.

—, *Handwerkliche Schnitzereien des XVI. und XVII. Jahrhunderts aus Schleswig-Holstein*. Frankfurt a. M., 1910.

—, *Alt-Schleswig-Holstein und die freie Hansestadt Lübeck*. Berlin, 1911.

—, 'Über Arbeiten der Bildwirker in Schleswig-Holstein', in: *Schleswig-Holsteinischer Kunstkalender* (Potsdam), 1916, pp. 60–70.

—, 'Stilkunst und Volkskunst in der nordschleswigschen Hausausstattung', in: *Kunstkalender Schleswig-Holstein* (Hamburg), 1921, pp. 94–108.

—, 'Aus nordfriesischen Wohnräumen des 16. Jhs.', in: *Schleswig-Holsteinisches Jahrbuch* (Hamburg), 1922, pp. 83–95.

—, *Schleswigsche Beiderwand. Eine Sammlung von Geweben des 18. Jhs.* 2nd ed., Frankfurt, 1923.

—, 'Die Volkskunst [in the Schleswig-Holsteinisches Landesmuseum]', in: *Schleswig-Holsteinisches Jahrbuch für 1928–9* (Hamburg), pp. 33–7.

SAUERMILCH, Curt, 'Truhe und Schrank im Kreise Holzminden', in: *Braunschweigische Heimat*, 43, 1957, 3, pp. 80–5.

—, 'Sitzmöbel als Werke volkstümlicher Handwerkskunst im Kreise Holzminden', in: ibid., 43, 1957, I, pp. 8–12.

SCHAEFER, Karl, 'Deutsche Bauernstühle', in: *Mittheilungen aus dem Germanischen Nationalmuseum*, Nuremberg, 1897, pp. 74–9.

—, 'Die Bauernkunst der Hamburger Vierlande', in: *Mittheilungen des Gewerbe-Museums zu Bremen*, XVII, 1902, pp. 65–74.

SCHARFE, Martin, SCHENDA, Rudolf and SCHWEDT, Herbert, *Volksfrömmigkeit. Bildzeugnisse aus Vergangenheit und Gegenwart*. Introduction by Hermann Bausinger, Stuttgart, 1967.

SCHARFE, Martin, *Evangelische Andachtsbilder*. (Veröf-

fentlichungen des Staatlichen Amtes für Denkmalpflege, Stuttgart, series C: Volkskunde, vol 5.) Stuttgart, 1968.

—, 'Die Volkskunst und ihre Metamorphose', in: *Zeitschrift für Volkskunde*, 70, 1974, pp. 215–45.

SCHELL, Otto, *Altbergische Heimatkunst. Möbel, Innenarchitektur.* Elberfeld, n. d.

SCHERER, Peter, *Das Gmünder Schmuckhandwerk bis zum Beginn des 19. Jhs.* Schwäbisch-Gmünd, 1971.

SCHIEFER, Kilian, *Der fränkische Kratzputz.* (Beiträge zur Volkstumsforschung, ed. Bayerische Landesstelle für Volkskunde.) Munich, 1938.

SCHIER, Bruno, 'Johann Georg Fischer, ein Meister des Egerländer Fachwerkbaus', in: *Volkswerk,* · 1941, pp. 123–43.

—, *Das Flechten im Lichte der historischen Volkskunde.* Frankfurt a. M., 1951.

—, 'Von den mittelalterlichen Anfängen der weiblichen Kopftracht', in: *Homenaje a Fritz Krüger,* II, Mendoza, 1954, pp. 319–38.

—, *Die Kunstblume von der Antike bis zur Gegenwart.* (Deutsche Akademie der Wissenschaften zu Berlin. Veröffentlichungen des Instituts für deutsche Volkskunde, vol. II.) Berlin, 1957.

SCHIRMER, Erwin, *Die deutsche Irdenware des 11.–15. Jhs. im engeren Mitteldeutschland.* n. p., 1939.

SCHLEE, Ernst, *Deutsche Volkskunst,* new series: *Schleswig-Holstein.* Weimar, [1939].

—, 'Volkstümliche Schnitzereien von der Hallig Hooge', in: *Nordelbingen* (Heide in Holstein), 26, 1958, pp. 100–15.

—, 'Zur Volkskunst der holsteinischen Elbmarschen', in: *Steinburger Jahrbuch* (Itzehoe), 1960, pp. 7–20.

—, *Schleswig-Holsteinische Volkskunst.* (Kunst in Schleswig-Holstein, vol. 14.) Flensburg, 1964.

—, 'Bauerntruhen aus der Probstei', in: *Jahrbuch für Heimatkunde im Kreis Plön-Holstein* (Plön), 7, 1977, pp. 108–25.

—, 'Blumenmotive als Wanddekor des Hauses und auf Grabsteinen der Insel Föhr', in: *Volkskunst* (Munich), I, 1978, pp. 14–21.

SCHLEICH, Elisabeth and SCHLEICH, Erwin, *Frommer Sinn und Lieblichkeit. Vom Zauber der «schönen Arbeiten» in Altbayern.* Passau, 1973.

SCHMIDT, Karl F. L., 'Die bäuerliche Wohung', in: *Sächsische Volkskunde,* ed. Robert Wuttke, 2nd ed., Dresden, 1901, pp. 464–86.

SCHMIDT, Leopold, *Masken in Mitteleuropa.* (Sonderschriften des Vereins für Volkskunde in Wien, No. I.) Vienna, 1955.

—, *Volkskunst in Österreich.* Vienna and Hanover, 1966.

—, *Bauernmöbel aus Süddeutschland, Österreich und der Schweiz.* Vienna and Hanover, 1967.

—, 'Volkskunde heute, 1968', in: *Antaios* (Stuttgart), X, 1968, pp. 217–38.

—, 'Stuhl und Sessel', in: *Studia Ethnographica et Folkloristica in Honorem Béla Gunda,* Debrecen, 1971.

—, *Perchtenmasken in Österreich.* Vienna, Cologne and Graz, [1972].

—, *Alte Volkskunst aus dem Egerland. Katalog.* Österreichisches Museum für Volkskunde, Vienna, 1977.

—, 'Alte bemalte Möbel aus dem Egerland', in: *Volkskunst* (Munich) I, 1978, pp. 5–13.

SCHMIDT, Maria, *Das Wohnungswesen der Stadt Münster im 17. Jh.* (Schriften der Volkskundlichen Kommission des Landschaftsverbandes Westfalen-Lippe, fasc. 15.) Münster, 1965.

SCHMITZ, Wilhelm, *Westfälischer Blaudruck in alter und neuer Zeit.* (Aus Westfalens Museen, ed. Vereinigung Westfälischer Museen.) n. p., n. d.

SCHMITZ-VELTIN, Wilhelm, 'Gedanken zur Volkskunst', in: *Rheinische Blätter,* 14, 1937, fasc. 10, pp. 47 ff.

SCHMOLITZKY, Oskar, *Thüringer Volkskunst, Jena und Umgebung.* Weimar, 1950.

—, *Volkskunst in Thüringen vom 16. bis zum 19. Jh.* Weimar, 1964.

SCHOENEN, Paul, 'Niederrheinische Truhen', in: *Niederrheinisches Jahrbuch,* 3, 1951, pp. 111–13.

—, 'Niederrheinische Glasschränke', in: *Der Niederrhein,* 19, 1952, pp. 1–3.

SCHÖPP, Alexander, *Alte volkstümliche Möbel und Raumkunst aus Norddeutschland,* Elberfeld, [1920].

—, *Alte deutsche Bauernstuben, Innenräume und Hausrat.* Elberfeld, 1921; 2nd ed. Berlin, 1934.

SCHOLTEN-NEESS, Mechthild and JÜTTNER, Werner, *Niederrheinische Bauerntöpferei 17.–19. Jh.* (Werken und Wohnen. Volkskundliche Untersuchungen im Rheinland, ed. Matthias Zender, vol. 7.) Düsseldorf, 1971.

SCHONEWEG, Eduard, *Das Leinengewerbe in der Grafschaft Ravensberg.* Bielefeld, 1923.

SCHOUBYE, Sigurd, *Guldsmede-håndvaerket i Tønder og på Tønderegnen 1550–1900.* (Skrifter, udgivne af Historik Samfund for Sønderjylland, No. 24.), n. p., 1961. (With German summary.)

SCHRÖDER, Albert, *Bemalter Hausrat in Nieder- und Ostdeutschland.* Leipzig, 1939.

SCHRÖDER, Hans *Gotische Truhen.* (Festblätter des Museumvereins für das Fürstentum Lüneburg, No. 4.) Lüneburg, 1932.

SCHROETTER, H. von, 'Niedersächsische Schränke', in: *Niedersachsen,* 21, 1916, pp. 212–13.

SCHROTH, Inge, *Schwarzwaldmaler im 19. Jh.* Lindau and Constance, 1957.

—, 'Von der Uhrenschildermalerei in Furtwangen und Umgebung', in: *Der Museumsfreund. Aus Heimatmuseum und Sammlungen in Baden-Württemberg* (Stuttgart), 2, 1962, pp. 23–9.

SCHUBERT, Alfred, *Alte Volkskunst am Niederrhein.* Düsseldorf, [1938].

SCHUCHHARDT, Wolfgang, 'Textilien', in: Adolf Spamer (ed.), *Die Deutsche Volkskunde,* vol. I, Berlin, 1935, pp. 447–68.

—, 'Bilddamaste der deutschen und europäischen Volkskunst', in: *Volkswerk,* 1941, pp. 200–26.

SCHULTZE, F., 'Grabdenkmäler auf dem Kirchhofe in Prerow (Reg.-Bez. Stralsund)', in Karl Mühlke (ed.), *Von nordischer Volkskunst,* Berlin, 1906, pp. 137–44.

SCHULZE, O., *Bäuerliche Holzschnitzereien und Kleinmöbel aus Norddeutschland.* (Die Volkskunst in Einzeldarstellungen.). Elberfeld, 1924.

SCHURR, Ursula, 'Zur Bedeutung der Volkskunst beim Blauen Reiter'. Unpublished Ph. D. disseration, Munich 1976.

SCHUSTER, Raimund, *Hinterglasbilder der Neuenkirchner Schule.* Foreword by Gislind Ritz. Grafenau, 1970.

—, *Auf Glas gemalt. Hinterglasmalerei aus Winklarn.* Regensburg, 1973.

SCHWARZ, Erica and MOLODOVSKY, Nikolai, *Volkskunst zwischen Inn und Salzach.* Freilassing, 1973.

—, *Tracht und bäuerliche Auszier.* Freilassing, 1976.

—, *Berchtesgadener Handwerkskunst.* Freilassing, 1977.

SCHWARZE, Wolfgang, *Wohnkultur des 18. Jhs. im Bergischen Land.* Wuppertal-Barmen, 1964.

SCHWEDT, Elke, *Volkskunst und Kunstgewerbe.* (Untersuchungen des Ludwig-Uhland-Instituts der Universität Tübingen, vol. 28.) Tübingen, 1970.

SCHWEDT, Herbert, 'Moderne Kunst, Kunstgewerbe und Volkskunst', in: *Zeitschrift für Volkskunde,* 60, 1964, pp. 212–17.

—, 'Zur Geschichte des Problems "Volkskunst"', in: ibid., 65, 1969, pp. 169–82.

— and SCHWEDT, Elke, *Malerei auf Narrenkleidern. Die Häs- und Hanselmaler in Südwestdeutschland.* (Landesdenkmalamt Baden-Württemberg. Forschungen und Bericht zur Volkskunde in Baden-Württemberg, vol. 2.) Stuttgart, 1975.

SCHWEIGHART, E., 'Alte und neue Zimmermannskunst', in: *Bayerischer Heimatschutz,* 15, 1917, pp. 89–92, 133–8.

SCHWIETERING, Julius, 'Vom zeichenhaften Sinn der Volkskunst', in: *Niederdeutsche Zeitschrift für Volkskunde,* 1933, pp. 56–67.

SCHWINDRAZHEIM, Hildamarie, *Die Bauernstuben.* (Führer durch das Altonaer Museum, I.) Hamburg, 1950. New ed. (Schausammlungen des Altonaer Museums, fasc. 2.), Hamburg, n. d.

—, 'Überlieferung und eigene Gestaltung in niederdeutschen Stickmustertüchern', in: *Nordelbingen* (Heide in Holstein), 19, 1950, pp. 126–36.

SCHWINDRAZHEIM, Oskar, *Beiträge zu einer Volkskunst,* pts. 1–3. [Hamburg], 1890–2.

—, *Die Volkskunst.* (Tages- und Lebensfragen, 13–14.) Bremerhaven, 1892.

—, 'Vierländer Kunst', in: *Zeitschrift des Badischen Kunstgewerbevereins,* new series, XI, 1900–1, pp. 79–90, 111–15.

—, 'Von deutscher Bauernkunst', in: *Kunstwart,* XIV, 1901, pp. 427 ff., 489 ff.

307

—, 'Die Vierlande', in: *Das Hamburgische Museum für Kunst und Gewerbe,* Hamburg, 1902, pp. 186–94.

—, 'Das Alte Land.', in: ibid., pp. 186–94.

—, 'Vierländer Kratzputz (Sgraffito)', in: Karl Mühlke (ed.), *Von nordischer Volkskunst.* Berlin, 1906, pp. 171–79.

—, 'Die Huthalter der Vierländer Kirchen', in: ibid., pp. 179–94.

—, 'Deutsche Volkskunst', in: Buschan, *Völkerkunde,* 1922, pp. 357–412.

—, *Deutsche Bauernkunst.* 2nd ed., Vienna, 1931.

SEYFFERT, Oskar, *Von der Wiege bis zum Grabe. Ein Beitrag zur sächsischen Volkskunst.* Vienna, [1906].

—, *Das Landesmuseum für Sächsische Volkskunst.* Dresden, 1924.

SIEBER, Friedrich, *Bunte Möbel der Oberlausitz.* (Deutsche Akademie zu Berlin. Veröffentlichungen des Instituts für Deutsche Volkskunde, vol. 6.) Berlin, 1955.

—, 'Begriff und Wesen in der Volkskunstforschung', in: *Wissenschaftliche Annalen,* 4, 1955, pp. 22–33.

—, *Volk und volkstümliche Motivik im Festwerk des Barock.* Berlin, 1960.

SIEVERS, Kai Detlev, *Schleswig-Holsteinische Bauernstuben.* Heide in Holstein, 1963, 2nd ed. 1966.

SIGERUS, Emil, *Siebenbürgisch-sächsische Leinenstickerei.* 4 vols. Hermannstadt, 1906–29.

SIMMANG, Karl, *Alte Bürger- und Bauernmöbel. Die Grundlagen für die Konstruktions-Entwicklung und Formgebung der Holzmöbel.* Dresden, 1914.

SITZMANN, Karl, 'Beiträge zur Töpferkunst in Oberfranken', in: *Bayerischer Heimatschutz,* 26, 1930, pp. 50–64.

SOMMER, Karl, *Deutsche Volkskunst. Bauernmalerei,* new series. Munich, 1937.

SPAMER, Adolf, 'Volkskunst und Volkskunde, in: *Oberdeutsche Zeitschrift für Volkskunde,* 2, 1928, pp. 1–30.

—, *Das kleine Andachtsbild vom 14. bis zum 20. Jh.* Munich, 1930.

—, 'Vorbemerkungen zu einer Darstellung der hessischen Töpfer- und Zieglerkunst', in: *Hessische Blätter für Volkskunde,* 33, 1933, pp. 52 ff.

—, *Deutsche Volkskunde als Lebenswissenschaft vom deutschen Volkstum.* Leipzig and Berlin, 1933. On folk art: pp. 295–98.

—, *Hessische Volkskunst.* Jena, 1939.

—, *Deutsche Volkskunst,* new series. Sachsen, Weimar, 1943; 2nd ed. 1954.

SPANNAGEL, Fritz, *Das Drechslerwerk. Ein Fachbuch für Drechsler, Lehrer und Architekten.* Ravensburg, 1940.

SPIES, Gerd, *Hafner und Hafnerhandwerk in Südwestdeutschland.* (Volksleben, Untersuchungen des Ludwig-Uhland-Instituts der Universität Tübingen, vol. 2.) Tübingen, 1964.

SPIESS, Karl von, *Deutsche Volkskunde als Erschliesserin deutscher Kultur.* Berlin, 1934.

—, *Bauernkunst, ihre Art und ihr Sinn. Grundlinien einer Geschichte der unpersönlichen Kunst.* 2nd ed. Berlin, 1935.

—, *Marksteine der Volkskunst I und II.* (Jahrbuch für historische Volkskunde, founded by Wilhelm Fraenger, continued by Walter Krieg, vols. V, VI.) Berlin, 1937.

—, *Deutsche Volkskunst.* (Stubenrauchs deutsche Grundrisse. Die Schwarze Reihe: Deutsche Kultur, vols. 3–4.) Berlin, 1940.

STEENSBERG, Axel, *Danske Bondemøbler.* 3rd ed. Copenhagen, 1973.

STEGMANN, Viktor, 'Die Holzmöbel des Germanischen Nationalmuseums', in: *Anzeiger des Germanischen Nationalmuseums,* Nuremberg, 1902, pp. 62–70, 98–113, 142–58; 1903, pp. 65–91, 105–30; 1904, pp. 45–70, 101–20; 1905, pp. 18–38, 63–75; 1907, pp. 102–23; 1909, pp. 25–58; 1910, pp. 36–88.

STEILEN, Dietrich, *Norddeutsche Grabmalkunst.* (Abhandlungen und Vorträge, ed. Bremer Wissenschaftliche Gesellschaft, year II, fasc. 3–4.) Bremen, 1938.

STEINMANN, Fritz, *Das Drachenornament in der Volkskunst Niedersachsens.* Ph. D. dissertation, Bonn, 1948.

STETTINER, Richard, 'Die Vierlande', in: *Das Hamburgische Museum für Kunst und Gewerbe,* Hamburg, 1902, pp. 176–85.

STIEBER, Paul, 'Statistische Vorbemerkungen zur Hafnerei Altbayerns und der österreichischen Nachbarländer zum Anfang des 19. Jhs.', in: *Bayerisches Jahrbuch für Volkskunde,* 1964–5, pp. 87–93.

—, 'Deutsches Hafnergeschirr', in: *Keysers Kunst und Antiquitätenbuch,* vol. III, Munich, 1967, pp. 241–92.

—, 'Formung und Form. Versuch über das Zustandekommen der keramischen Form', [2nd revised version] in: *Bayerisches Jahrbuch für Volkskunde,* 1970–1, pp. 7–73.

—, *Die Kröninger Hafner-Ordnung von 1428. Vollständiger Text und Kommentar.* (Schriften Deutschen Hafner-Archivs, fasc. 8.) Munich, 1972.

STIERLING, Hubert, 'Vierländer Schmucksachen. Zu ihrer Ausstellung im Museum für Kunst und Gewerbe', in: *Hamburger Nachrichten,* 6.6.1924.

—, 'Die Wilstermarschstuben', in: *Heimatbuch des Kreises Steinburg,* vol. 2, Glückstadt, 1926, pp. 205–24.

—, 'Westwind (Friesische und holländische Einflüsse im Gold- und Silberschmuck der deutschen Nordseeküsten-Landschaften)', in: *Festschrift des Kunstgewerbemuseums der Stadt Flensburg,* 1928, pp. 231–53.

—, *Der Silberschmuck der Nordseeküste,* Neumünster, 1935.

STOLZ, J., *Vom Ursprung der Gebildbrote und ihrer früheren Bedeutung,* n. p., 1931.

STRACKE, Johannes C., *Tracht und Schmuck Altfrieslands nach den Darstellungen im Hausbuch des Häuptlings Unico Manninga.* (Quellen zur Geschichte Ostfrieslands, vol. 6.) Aurich, 1967.

STRASSER, Willi, 'Von alten Bauernmöbeln in unserer Heimat', in: *Die Oberpfalz,* 50, 1962, pp. 163–9.

STRAUSS, Konrad, *Alte deutsche Kunsttöpfereien.* Berlin, 1923.

STRÖBEL, Rudolf, 'Schwenninger Schildmalerei', in: *Der Museumsfreund* (Stuttgart), 2, 1962, pp. 36–43.

STRZYGOWSKI, Josef, 'Zur Rolle der Volkskunde in der Forschung über bildende Kunst', in: *Wiener Zeitschrift für Volkskunde,* 31, 1926, pp. 1 ff.

TANGE, Peter Josef et al., *Museen in Nordrhein-Westfalen.* Recklinghausen, 1974.

THIELE, E., *Waffeleisen und Waffelgebäcke in Mitteleuropa.* Cologne, 1959.

THOMSEN, Helmuth, 'Bäuerliche Stuhlformen an der Niederelbe. Ein Beitrag zur Geographie der niederdeutschen Volkskunst', in: *Ehrengabe des Museums für Hamburgische Geschichte zur Feier seines hundertjährigen Bestehens,* ed. Otto Lauffer, Hamburg, 1939, pp. 79–93.

TIETZE, Hans, 'Volkskunst und Kunst', in: *Die bildenden Künste,* 2, Vienna, 1919, p. 225.

TIMMERMANN, Gerhard, 'Seemanns-Volkskunst aus Tauwerk', in: *Altonaer Museum in Hamburg, Jahrbuch 1963,* pp. 149 ff.

TÖPFER, August, 'Über Bauernmöbel', in: *Mittheilungen des Gewerbe-Museums zu Bremen,* 4, 1889, pp. 73–6.

—, 'Bauernkunst', in: ibid., 14, 1899, pp. 1–4.

TSCHIRA, Arnold, 'Eine Baaremer Bauernstube. Der Häuslihof in Bad Dürrheim und sein Hausrat', in: *Badische Heimat,* 25, 1938, pp. 185–210.

UEBE, F. Rudolf, *Deutsche Bauernmöbel.* (Bibliothek für Kunst- und Antiquitäten-Sammler, vol. XXIII.) Berlin, 1924.

—, 'Westfälische Hungertücher', in: *Die Heimat* (Dortmund), 1926, fasc. 4, pp. 106 ff.

—, *Deutsche Volkskunst,* vol. 9: *Westfalen,* Munich, [1927], reprinted Weimar, [1942].

—, 'Westfälische Wiegen', in: *Die Heimat* (Dortmund), 9, 1927, pp. 17–21.

URBACH, Hans Hermann, *Geschichtliches und Technisches vom Sgraffitoputz.* Ph. D. dissertation, Brunswick, 1928.

VASEL, A., 'Volkstümliche Schnitzereien an Gerätschaften im Lande Braunschweig', in: *Beiträge zur Anthropologie* (Brunswick), 1898, pp. 135–54.

WAGNER, Margarete, *Aus alten Backstuben und Offizinen.* Esslingen, 1961.

WALBE, Heinrich, *Das hessisch-fränkische Fachwerk.* (Schriften der Volks- und Heimatforschung, vol. 4.) Darmstadt, 1942.

—, *Das hessisch-fränkische Fachwerk,* Giessen, 1954.

WALCHER VON MOLTHEIM, Alfred, 'Geschlagene Messingbecken', in: *Altes Kunsthandwerk* (ed. Walter von Moltheim), Vienna, 1927, pp. 1–10.

WALTER, Max, 'Die Odenwälder Bauernstube', in: *Ekkehart. Jahrbuch für das Badner Land,* 7, 1926, pp. 62–71.

—, 'Die Kunst der Ziegler', in: *Oberdeutsche Zeitschrift für Volkskunde,* I, 1927, pp. 5–19.

—, *Die Volkskunst im badischen Frankenland.* (Heimatblätter: Vom Bodensee zum Main, 33.) Karlsruhe, 1927.

—, 'Wege zur Erkenntnis der Volkskunst', in: *Oberdeutsche Zeitschrift für Volkskunde*, 3, 1929, pp. 86–100.

—, 'Bemalte Bauernmöbel im hinteren Odenwald', in: *Bayerisches Jahrbuch für Volkskunde*, 1954, pp. 37–48.

WALZER, Albert, 'Springerlesbilder', in: *Schwäbische Heimat*, I, 1950, pp. 242–7.

—, *Schwäbische Weihnachtskrippen aus der Barockzeit.* Constance, 1960.

—, *Liebeskutsche, Reitersmann, Nikolaus und Kinderbringer. Volkstümlicher Bilderschatz auf Gebäckmodeln, in der Graphik und Keramik.* Constance, 1963.

—, 'Typen alter Holzmodel für Gebäck und für Teige, die getrocknet werden', in: *Der Museumsfreund* (Stuttgart), 3, 1963, pp. 18–57.

—, 'Spätmittelalterliche und Renaissancemodel aus Stein und Ton', in: *Schwäbische Heimat*, 19, 1968, pp. 10–13.

—, 'Baden-württembergische Bauernmöbel, I. Bauernschränke', in: *Der Museumsfreund* (Stuttgart), 8–9, 1968; II. in: ibid., 10–11, 1969.

—, 'Das Herz als Bildmotiv', in: *Das Herz*, 2 vols., Biberach, n. d., pp. 134–80.

WEINHOLD, Gertrud, *Das schöne Osterei.* Cassel, 1965.

WEINHOLD, Rudolf, *Töpferwerk in der Oberlausitz.* (Veröffentlichungen des Instituts für deutsche Volkskunde. Deutsche Akademie der Wissenschaften zu Berlin.) Berlin, 1958.

WEISMANTEL, Gertrud, *Ross und Reiter. Studien über die Formbestände der Volkskunst.* (Quellenbücher der Volkskunst, ed. Leo Weismantel and Gertrud Weismantel, vol. I.) Berlin, 1948.

WEISMANTEL, Leo, *Buch der Krippen.* Bonn, 1930.

WENDT, Ralf, *Bauernkultur in Mecklenburg*, III. *Die Keramik.* (Katalog der Volkskundlichen Sammlungen des Historischen Museums Schwerin.) Schwerin, 1976.

— and VOSS, Marianne, *Bauernkultur in Mecklenburg*, II. *Das Mobiliar.* (Staatliches Museum Schwerin. Volkskundliche Sammlungen.) Putbus, Rügen, [1967].

WENINGER, Peter, *Volkskunst in den Alpen.* Introduction and revision by Franz Colleselli. Innsbruck and Frankfurt a. M., 1971.

WESTHEIM, Paul, 'Heimatkunst', in: *Dekorative Kunst*, 19, 1911.

WICHERT-POLLMANN, *Das Glasmacherhandwerk im östlichen Westfalen. Eine volkskundliche Untersuchung.* Münster, 1963.

WIETEK, Gerhard, *Altes Gerät für Feuer und Licht*, Oldenburg and Hamburg, 1964.

—, *Galionsfiguren.* [Continuation of the exhibition catalogue of the Altona Museum of 1961 for the Hamburg Hafen- und Lagerhaus-Aktiengesellschaft.]

WILDHABER, Robert (ed.), *Osterbrauchtum in Europa.* (Schweizerisches Archiv für Volkskunde, 53, 1957, fasc. 2–3.)

—, *Volkstümliche Weihnachtskrippen.* (Special issue of *Der Hochwächter.*) [Berne], 1958. [Guide to the Schweizerische Museum für Volkskunde, Basle.]

—, 'Gesichtsmasken. Bemerkungen zur Typologie und Verbreitung im europäischen Raum', in: *Masken zwischen Spiel und Ernst.* (Volksleben, vol. 13.) Tübingen, 1967.

—, 'Zur Begriffsbestimmung der Volkskunst', in: *Volksüberlieferung. Festschrift für Kurt Ranke.* Göttingen, 1968.

—, *Schweizerische Volkskunst.* [Guide to an exhibition.] Pro Helvetia, Zurich, 1969.

—, 'Eierschalen in europäischem Glauben und Brauch', in: *Acta Ethnographica Academiae Scientiarum Hungaricae*, 19, 1970, pp. 435–57.

WIRTH, Alfred, 'Stube und Küche im Bauernhaus um 1875 in Anhalt', in: *Mitteldeutsche Blätter für Volkskunde*, I, 1926, pp. 8–11.

WITTICHEN, Ingeborg, *Der Hirsch in der Volkskunst des niedersächsischen Gebietes zwischen Weser und Elbe einschliesslich des Hamburger Bezirks.* Ph. D. dissertation, Göttingen.

WITZLEBEN, Elisabeth von, *Bemalte Glasscheiben*, Munich, 1977.

WOEDE, Hans, *Wimpel der Kurenkähne.* Würzburg, 1965.

WOLFF, D., 'Alkoven und Schuppelbett', in: *Hessenland*, 23, 1918, pp. 105–7.

WOLFF, Hellmuth, *Die Volkskunst als wirtschaftsästhetisches Problem*, Halle an der Saale, 1909.

WÜNNENBERG, Rolf, *Andechser Votivkerzen*, Augsburg, 1966.

ZABORSKY, Oskar von, *Urväter-Erbe in Deutscher Volkskunst.* (Deutsches Ahnenerbe, Volkstümliche Schriftenreihe, No. I.) Leipzig, 1936.

ZELL, Franz, *Bauernmöbel aus dem bayerischen Hochland*, Frankfurt a. M., 1899.

—, *Volkskunst im Allgäu. Original-Aufnahmen aus der Ausstellung für «Volkskunst und Heimatkunde» in Kaufbeuren, September 1901.* Kaufbeuren, Munich and Zurich, 1901.

ZENDER, Matthias, *Gestalt und Wandel. Aufsätze zur rheinisch-westfälischen Volkskunde und Kulturraumforschung*, ed. H. L. Cox and G. Wiegelmann. Bonn, 1977.

ZIETING, Annemarie, *Bäuerliche Stickereien aus der Winser Elbmarsch.* Berlin, 1942.

ZINK, Theodor, *Deutsche Volkskunst*, vol. 12: *Die Pfalz*, Weimar, [1931].

ZIPPELIUS, Adelhart, *Katalog zur Ausstellung Volkskunst im Rheinland.* (Führer und Schriften des Rheinischen Freilichtmuseums in Kommern, No. 4.) Düsseldorf, 1969.

—, *Handbuch der europäischen Freilichtmuseen*, Cologne, 1974.

Index

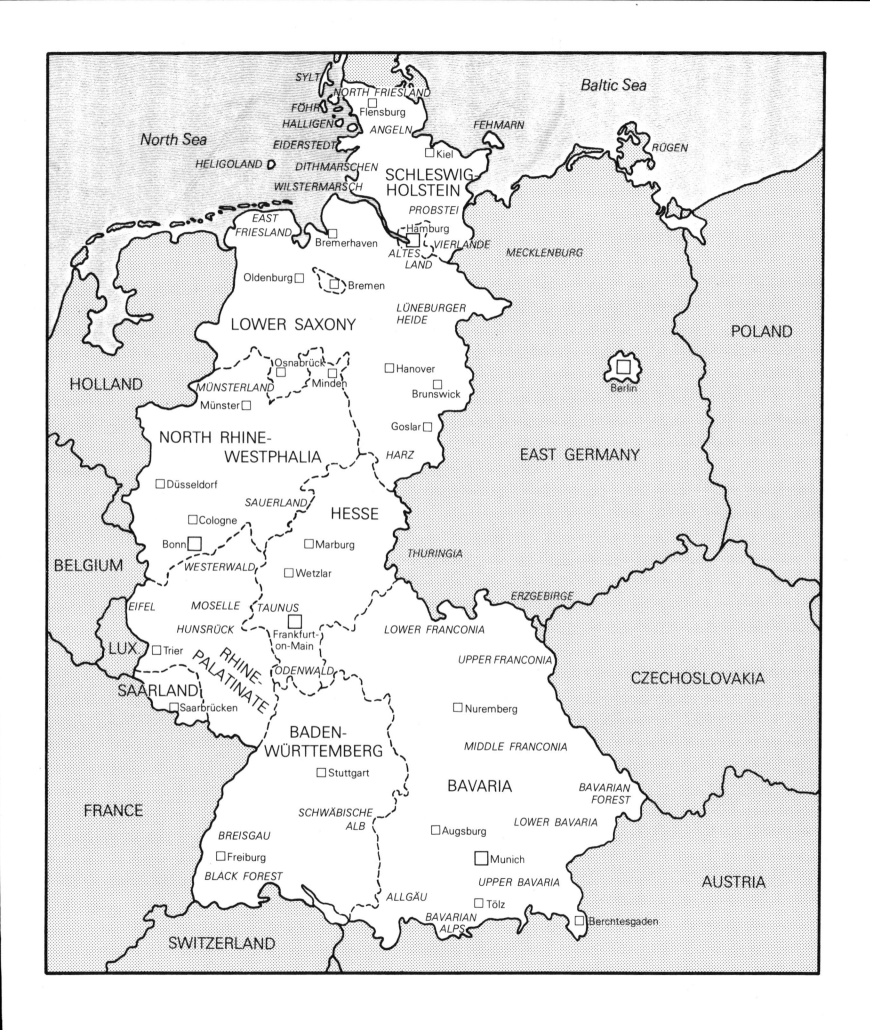

Photo Credits

Altonaer Museum, Hamburg 63, 65, 76, 148, 150, 167, 178, 188, 199, 204, 207, 345, 416, 418
Archiv Callwey Verlag, Munich 397
Badisches Landesmuseum, Karlsruhe 91, 179, 244, 258, 300, 354, 355
Bahnmüller, Wilfried; Gelting 16, 52, 55
Bartl, Edith; Ottobrunn 426, 430, 431, 432, 433
Baur, Helmuth; Munich 24, 46, 157, 221, 222, 223, 270
Baur-Heinhold, Margarete; Munich 25
Bayerischer Landesverein für Heimatpflege, Munich 384, 385
Bayerisches Landesamt für Denkmalpflege, Munich 373
Bayerisches Nationalmuseum, Munich 82, 84, 85, 117, 124, 131, 144, 249, 330, 331, 332, 347, 348, 349, 362, 365, 371, 375, 376, 377, 378, 390, 391, 393, 394, 396, 399, 415
Bomann-Museum, Celle 58
Burkholz, Alfred; Würzburg 78, 141
Deininger, Feuchtwangen 98, 99, 100, 257, 267, 269
Deutsche Fotothek, Dresden 81, 413, 414
Deutsches Korbmuseum, Michelau 424
Deutsches Museum, Munich 191
Dithmarscher Landesmuseum, Meldorf 60
Focke-Museum, Bremen 9, 187, 238, 296
Foto Marburg 71, 208, 281, 282, 283
Foto Saebens, Worpswede 19
Germanisches Nationalmuseum, Nuremberg 44, 53, 80, 83, 89, 108, 109, 110, 122, 123, 125, 143, 160, 169, 174, 181, 183, 197, 198, 227, 251, 259, 266, 272, 273, 304, 350, 351, 353, 417, 425
Göbel, Helmut; Lübeck 62
Hansmann, Claus; Munich 67, 408
Happe, Otto; Brunswick 366
Hauptamt für Hochbauwesen, Nuremberg 39
Heimatmuseum, Kaufbeuren 47
Hillenbrand, Karl; Straubenhardt 236
Historisches Museum am Hohen Ufer, Hanover 12, 14, 15, 17, 18, 57, 73, 158, 159, 185, 186, 216, 229, 232, 245, 309, 310, 312, 316, 326, 327, 361, 404
Institut für Volkskunde, Munich 20, 21, 22
Kaiser, A.; Baratzhausen 383
Kleinhempel, Ralph; Hamburg 437
Kunsthalle, Bremen 434
Kunsthandel 428
Landesamt für Denkmalpflege Schleswig-Holstein, Kiel 364, 367
Landesbildstelle Rheinland, Düsseldorf 436
Landesmuseum für Kunst- und Kulturgeschichte, Oldenburg 64
Mainfränkisches Museum, Würzburg 75
Molodovsky, N. P.; Prien am Chiemsee 50, 51, 86
Müller, F.; Legau 45
Museum für Deutsche Volkskunde, Berlin 121, 139, 145, 161, 189, 190, 202 and illustration on jacket 203, 210, 211, 213, 214, 289, 290, 294, 306, 317
Museum für Kunst und Gewerbe, Hamburg 237, 242, 243, 254, 261, 271, 274, 277, 284, 308

Museum für Kunst- und Kulturgeschichte der Stadt Dortmund, Schloss Cappenberg 77, 79, 106, 107, 114, 357, 398
Museum für niederrheinische Volkskunde, Kevelaer 369
Pfistermeister, Ursula; Fürnried 248
Photoatelier Rheinländer, Hamburg 97, 196, 226, 419
Photodokumentation Aberle, Wuppertal 177
Retzlaff, Hans; Berlin 13
Rheinisches Bildarchiv, Cologne 303
Sammlung Heinrich Heine, Karlsruhe 427
Schleswig-Holsteinisches Landesmuseum, Schleswig 2, 3, 5, 6, 7, 8, 23, 27, 28, 35, 49, 54, 59, 61, 66, 74, 92, 101, 103, 104, 111, 116, 130, 134, 136, 137, 138, 147, 153, 154, 155, 156, 162, 163, 164, 165, 166, 168, 170, 171, 172, 175, 180, 192, 193, 194, 195, 205, 206, 209, 212, 215, 217, 218, 219, 224, 230, 231, 234, 235, 239, 240, 241, 246, 250, 252, 253, 255, 260, 262, 263, 264, 265, 275, 276, 278, 279, 280, 285, 286, 287, 288, 291, 292, 295, 297, 298, 301, 305, 307, 323, 343, 344, 356, 358, 359, 360, 363, 368, 370, 372, 374, 379, 380, 381, 392, 401, 403, 405, 406, 407, 409, 410, 411, 412, 429
Schmidt-Glassner, Helga; Stuttgart 10, 11, 26, 29, 36, 38, 40, 41, 42, 48, 56, 68, 69, 70, 72, 87, 88, 90, 93, 94, 95, 96, 102, 105, 112, 113, 115, 118, 119, 120, 126, 127, 128, 129, 132, 133, 142, 151, 152, 176, 182, 184, 247, 315, 319, 320, 324, 325, 328, 329, 333, 334, 335, 336, 337, 338, 339, 340, 341, 342, 346, 382, 386, 387, 388, 389, 395, 400, 439
Schölermann, W.; Heide i. H. 402
Spacek + Co, Husum 4
Staatliche Fachschule für Korbflechterei, Lichtenfels 422
Staatliche Kunstsammlungen, Cassel (Margaret Büsing) 268
Staatliche Landesbildstelle, Hamburg 352
Stadtmuseum, Villingen 173
Städtisches Museum, Flensburg 30, 31, 32, 33, 34, 37, 135, 140, 149, 200, 201, 228, 233, 299, 302, 311, 313, 435
Stickelmann, Bremen 438
Thomsen, Th.; Flensburg 1
Verlag Karl Robert Langewiesche Nachfolger, Hans Köster, Königstein im Taunus (Thomsen, Flensburg) 43
Westfälisches Landesmuseum für Kunst- und Kulturgeschichte, Münster 220, 225, 256, 293, 314, 318, 321, 322
Will, Christoph; Nuremberg 420, 421, 423

The author would like to thank all those museum authorities who have helped him to procure the material for the illustrations. He is especially grateful to Dr. Nina Gockerell (Bayerisches Nationalmuseum, Munich), Dr. Bernward Deneke (Germanisches Nationalmuseum, Nuremberg), Dr. Ulrich Fliess (Historisches Museum am Hohen Ufer, Hanover) and Professor Dr. Gerhard Kaufmann (Altonaer Museum, Hamburg) as well as to the Schleswig-Holsteinisches Landesmuseum, Schleswig.